ANCIENT GREEK ART AND ICONOGRAPHY

WISCONSIN STUDIES IN CLASSICS

General Editors
Barbara Hughes Fowler and Warren G. Moon

E. A. THOMPSON
Romans and Barbarians: The Decline of the Western Empire

JENNIFER TOLBERT ROBERTS
Accountability in Athenian Government

H. I. MARROU
A History of Education in Antiquity
Histoire de l'Education dans l'Antiquité, translated by George Lamb
(originally published in English by Sheed and Ward, 1956)

ERIKA SIMON
Festivals of Attica: An Archaeological Commentary

G. MICHAEL WOLOCH
Roman Cities: Les villes romaines by Pierre Grimal,
translated and edited by G. Michael Woloch,
together with A Descriptive Catalogue of Roman Cities
by G. Michael Woloch

WARREN G. MOON, *editor*
Ancient Greek Art and Iconography

Ancient Greek Art and Iconography

Edited by Warren G. Moon

THE UNIVERSITY OF WISCONSIN PRESS

Published 1983

The University of Wisconsin Press
114 North Murray Street
Madison, Wisconsin 53715

The University of Wisconsin Press, Ltd.
1 Gower Street
London WC1E 6HA, England

First printing

Printed in the United States of America

For LC CIP information see the colophon

ISBN 0-299-09250-X

This volume honors our Emeriti in two departments, Classics and Art History:

Friedrich Solmsen Herbert Howe
John Paul Heironimus Charles Edson
Murray Fowler James Watrous

The editor dedicates his efforts, affectionately, to
ROBERT L. SCRANTON
Professor Emeritus of Classical Art and Archaeology
and of Classical Languages and Literatures,
The University of Chicago

CONTENTS

CONTRIBUTORS

D. A. Amyx
Professor Emeritus of the History of Art
University of California, Berkeley

Evelyn Elizabeth Bell
Assistant Professor of Art History
Dominican College of San Rafael

William R. Biers
Professor of Art History and Archaeology
University of Missouri-Columbia

John Boardman
Lincoln Professor
 of Classical Archaeology and Art
Ashmolean Museum, Oxford

Beth Cohen
Assistant Professor of Art History
 and Archaeology
Columbia University

Ellen N. Davis
Associate Professor of Art History
Queens College, City University of New York

Barbara Hughes Fowler
John Bascom Professor of Classics
University of Wisconsin-Madison

Jiří Frel
Curator of Ancient Art
J. Paul Getty Museum

N. G. L. Hammond
Fellow
Clare College, Cambridge

Lilly Kahil
Professor of Classical Archaeology
University of Fribourg
Director of Research at the CNRS, Paris

Eva C. Keuls
Professor of Classics
University of Minnesota

Warren G. Moon
Professor of Ancient Art and of Classics
University of Wisconsin-Madison

Gloria Ferrari Pinney
Associate Professor of Classical
 and Near Eastern Archaeology
Bryn Mawr College

Brunilde Sismondo Ridgway
Rhys Carpenter Professor
 of Classical and Near Eastern Archaeology
Bryn Mawr College

Konrad Schauenburg
Professor of Classical Art and Archaeology
University of Kiel

Karl Schefold
Professor Emeritus
 of Classical Art and Archaeology
University of Basel

H. A. Shapiro
Assistant Professor of Humanities
Stevens Institute of Technology

Andrew Stewart
Associate Professor of the History of Art
University of California, Berkeley

ACKNOWLEDGMENTS

Loretta Freiling, Administrator of the Institute for Research in the Humanities, the University of Wisconsin-Madison, expertly managed the mechanics of the Burdick-Vary Symposium; she coordinated budget, travel, and the festivities which welcomed visitors to the Madison campus. Mrs. Freiling's consistently cheerful attitude and many thoughtful services were most heartily appreciated by all. She typed and checked most of the Greek in the volume and helped to give order to the project in many ways. Her assistance made the efforts of symposium and volume more pleasurable to undertake and to bring to conclusion.

Robert O'Neil, President of the University of Wisconsin System, was kind enough to open the symposium despite his busy schedule. Malcolm Wiener, Carol Lawton, Ira Mark, Fannie LeMoine, and John Boardman presided over sessions, linking the parts of the symposium into a meaningful whole. We are very grateful to them. Robert Kingdon, Director of the Institute for Research in the Humanities, supported these projects from the start; Emmett L. Bennett, Jr., and Fannie LeMoine, my colleagues in the Classics Department, helped me write the proposal which gained such generous University approval. Professor Bennett read proof; myriad thanks to him for this. We thank E. David Cronon, Dean of the College of Letters and Science and Chair of the Anonymous Fund, and his committee which made the principal financial arrangements for the symposium.

Katherine Mead, Director of the Elvehjem Museum of Art, made the facilities of the museum available for the symposium and for the receptions which accompanied it. Professors Barbara and Murray Fowler provided elaborate hospitality for the speakers. For their grand reception we also thank the faculties of the Classics and Art History Departments and Anne Lambert, Curator of Education at the Elvehjem, and her organization of docents who contributed their time and recipes: Sara Boush, Virginia Dymond, Elizabeth Erbe, Jane Eisner, Carolyn Gaebler, Florence Greville, M. J. Hamilton, Loni Hayman, Pat Luberg, Helene Metzenberg, Elaine Nadler, Linda Nichols, Jane Pizer, Miriam Sacks, and Ann Sauthoff. The graduate forum of the Art History Department prepared a wonderful luncheon and assisted in the operation of the symposium. We thank the following for their hard work: Mark Spencer, Richard Sundt, Sandra Katz, Elizabeth Burke, John Marshall, Morteza Sajadian, Avery and Carl Springer (Classics), Louise Clark, Udayan Sen, Martin Gohlinghorst, Rita Sherb, Sally Ceeley, Michael Rische, and R. Stephan Sennott. Christine Sundt, Curator of Slides in the Department of Art History, gave freely of her time in the management of the projection equipment both before and during the symposium.

The Burdick-Vary Trust of the Institute for Research in the Humanities, and the Anonymous Fund of the College of Letters and Science were the principal sponsors of the symposium; a generous grant from the Fairchild Foundation assisted the publication of the volume and we are very grateful. Ezra S. Diman, Peter Givler, and Elizabeth Steinberg of the University of Wisconsin Press helped initiate *Wisconsin Studies in Classics,* to which series this volume belongs; they and their staff, particularly Jocelyn Riley, Debra Bernardi, Carol Olsen, Holly Yasui, Wil-

liam Day, Brian Keeling, Stuart Fullerton, Gardner Wills, Mary Wyer, and Shirley Bergen, took a special, personal interest in the publication of this symposium. I am especially indebted to Harvey Retzloff for the superb design of this book. With commitment and patience, Thomas M. C. Barcz checked footnotes and other references, designed computer services for the bibliography, and prepared the indices. He freed the manuscript of much error. We all are most grateful to him. Morteza Sajadian and John Marshall managed interlibrary loans and helped in innumerable ways. James Gallagher prepared the fine drawings which accompany the article by Professor Hammond. I thank Professor Barbara Fowler for commenting on the Introduction.

Jocelyn Riley had the difficult task of copy editor for the volume. She caught infelicities of expression and harmonized modes of citation and documentation. Lynn Kubista and Kathy Pulvermacher, Program Assistants in the Art History Department, graciously lent their expertise. Lynn typed drafts of various parts of the volume, including my own paper, with competence and, always, with a smile. A grant from the Graduate School of the University of Wisconsin-Madison greatly facilitated the editor's work on this volume. Lastly and especially, for the kindness and encouragement of close friends, many thanks.

WARREN G. MOON

EDITOR'S NOTE

Abbreviations used in this volume are those prescribed by the *American Journal of Archaeology* ("Notes for Contributors, and Abbreviations," *AJA* 82 [1978] 3–10 and *AJA* 84 [1980] 3–4) and the *Oxford Classical Dictionary*,² eds. N. G. L. Hammond and H. H. Scullard (Oxford 1978) with the following emendations: Arias-Hirmer for Paolo Arias, Max Hirmer, and B. B. Shefton, *A History of 1000 Years of Greek Vase Painting* (New York 1962); CB for L. D. Caskey and J. D. Beazley, *Attic Vase Painting in the Museum of Fine Arts, Boston* (Boston 1931—1963); *CorVP* for D. A. Amyx, *Corinthian Vase Painting of the Archaic Period* (Berkeley and Los Angeles forthcoming); *Vasenlisten*³ for Frank Brommer, *Vasenlisten zur Griechischen Heldensage*³ (Marburg 1973). We have used shortened titles for books and articles frequently referred to in a single paper. The University of Wisconsin Press uses *Webster's Third International Dictionary* and prefers American spellings throughout the volume; the sole exception is the British "sherd" rather than the American "shard." Ancient Greek personal names in most cases retain Greek spelling; place names have been latinized. Where no translator has been given following a passage from an ancient author it is presumed that the contributor did the translation. When the same translation of the same work is quoted consistently in an article, we give the translator's name at the first citation only.

Greek vases are often cited by city or locale, for example, neck-amphora, London B 210, refers to a vase in the inventory of the British Museum, which has the principal collection in that city. When a piece is in a smaller collection the name of the museum (or collector) is given, for example, Victoria and Albert Museum 4815, 1901. When there are several large collections in a city, such as Paris, again the museum is designated, for example, Cab. Méd. 254 (Cabinet des Médailles). For such listings and abbreviations of museum names the reader should be familiar with the Index of Collections in this volume and other such indices in various reference works of J. D. Beazley: *Attic Black-figure Vase-painters* (Oxford 1956); *Attic Red-figure Vase-painters*² (Oxford 1963); *Paralipomena* (Oxford 1971). The photocredits sometimes contain information regarding "funds, gifts or purchase" of the piece reproduced, as prescribed by the museum for permission to illustrate and/or publish.

A selected glossary of specialized terms has been provided; the nonspecialist is also directed to the glossary in G. Becatti's *Art of Ancient Greece and Rome* (New York n.d.) which is broader in scope. The nomenclature for some ancient artists might seem somewhat odd to those new to Greek art. "The Elbows Out Painter," "the Affecter," "the Painter of Berlin 1686," and "Group E" are labels, like epithets, given to artists whose real names have not been preserved through history. J. D. Beazley was the major taxonomist in the field of Greek vase-painting. Beazley demonstrated that every artist had a personal system of expression, an artistic "handwriting," with formulae for rendering hands, eyes, ears, and so on. To the scholar the observation of such formulae is the surest basis for attribution and discussion of style. Similar to the researcher who finds a new variety of flower and names it, so too the art historian supplies a sobriquet which may either refer to some char-

acteristic of the ancient's style such as "Elbows Out," or to a particular vase which may be representative (or the first vase studied) of the ancient hand, such as "the Painter of Berlin 1686" (see C. M. Robertson, "Attic Red Figure Painters," *JHS* 85 [1965] 90–91). w.g.m.

PREFACE

The essays in this volume were presented as papers in Madison, Wisconsin, 9–11 April 1981, as the fourth Burdick-Vary Symposium of the Institute for Research in the Humanities, the University of Wisconsin–Madison. The responsibility for organizing the Institute's symposia customarily goes to the Institute's Johnson Visiting Professor, but since this position had fallen vacant for 1981, the officers of the Madison Society of the Archaeological Institute of America, who have close ties with the Humanities Institute, proposed the subject, "Ancient Greek Art and Iconography." Such a topic is always timely in Madison because of the community's long-standing interest in the Classical past and because of the history and membership of the Humanities Institute itself.

The occasion for such a symposium was further suggested by other colloquia held a year or so earlier, though admittedly these were quite different in content and focus. "The Greek Vase," for instance, which was held at Hudson Valley Community College, 27–28 April 1979, discussed the form and function, the aesthetic and iconographical impact, that this art form enjoyed across time. "Macedonia and Greece in the Late Classical and Early Hellenistic Times," sponsored by the National Gallery's Center for Advanced Study in the Visual Arts, 14–15 November 1980, investigated Macedonian history and Macedonian tomb architecture and its painted decoration, and coincided in Washington, D.C., with the opening of the exhibition "The Search for Alexander." "Mythologie Gréco-Romaine, Mythologies Périphériques," 17 May 1979, was held at Paris under the auspices of the Centre National de Recherche Scientifique and examined classical iconography in the broadest sense, both in terms of the ingredients supplied by and the results and inspiration taken from the classical experience by peoples and civilizations on the fringes of the classical world. It should be noted that superb papers accompanied the opening of the exhibition, "The Art of South Italy: Vases from Magna Graecia," which was organized by the Virginia Museum of Fine Arts, Richmond, 12 May–8 August 1982, and that Professor D. A. Amyx's article, "Archaic Vase-Painting vis-à-vis 'Free' Painting at Corinth," an expanded version of which is published in this volume, was a lecture which opened an exhibition of vase-painting at the Art Institute of Chicago, 22 December 1979–24 February 1980, "Greek Vase-Painting from Midwestern Collections." Several scholars who participated in these symposia and colloquia also came to Madison, among them D. A. Amyx, Andrew Stewart, N. G. L. Hammond, and Lilly Kahil. In turn, these conferences have anticipated "Image et céramique grecque: Recherches métholdologiques et iconographie d'Héraklès," a symposium again sponsored by CNRS held at Rouen, 25–26 November 1982. In fact, several papers published in this volume may have bearing on the discussions in the Rouen symposium, particularly W. G. Moon, "The Priam Painter: Some Iconographical and Stylistic Considerations," E. E. Bell, "An Exekian Puzzle in Portland: Further Light on the Relationship between Exekias and Group E," and perhaps H. A. Shapiro, "Painting, Politics and Genealogy: Peisistratos and the Neleids." Another symposium, "Ancient Greek and Related Pottery," is being organized by the Allard Pierson Museum, Amsterdam, for 12–15

April 1984. It will treat the more technical aspects of ceramic production.

The breadth of the Madison symposium makes it slightly different from these others we have mentioned. Participants were given freedom in selecting topics and there were no limitations to the length of presentation at the symposium itself or in this volume, nor to the number of illustrations. The vigor of exchange between younger scholars and those better established finds best expression in the immedi-acy of the symposium-colloquium format. The event was designed to serve local needs and fields of research, for those interested in numismatics and history as well as vase-painting and Bronze Age Greece. By committing the proceedings to permanent record, the officers both of the Humanities Institute and of the Madison Society of the AIA hope the volume will be useful to a wider audience.

WARREN G. MOON

INTRODUCTION

The essays in this volume illustrate the changing modes of storytelling and of style in ancient Greek art from the Bronze Age of the fifteenth century B.C. through the Greco-Roman period. They treat the little-known world of the Minoan civilization; the still-puzzling Geometric period; the high heroic of the Archaic age; the Classical fifth-century concern with the rise of the individual and with the events of daily life; the paradoxical and occasionally playful nature of the Hellenistic period; and, finally, the influence of the Greek achievement during the early Christian era. The essays present a selective history of Greek art and give a sense of the broad sweep of the Greek cultural endeavor and of the many scholarly approaches to it.

Although much of the emphasis of the volume is on painting, particularly vase-painting, it deals with other media as well: mural painting, sculpture (both relief and in the round), coins, bronzes, and mosaics. The essays also represent a variety of methodologies. Some show the influence of the media upon one another. Others treat the relationship of literary and historical texts to works of art. Some are quite strictly iconographical; others combine iconography with stylistic analysis. Some are political or sociological in approach; others expose new relationships between workshops and clientele. Some essays provide a reassessment of familiar works; others introduce significant works of art published and illustrated here for the first time, leading to a reconsideration of the careers of some important artists, Euphronios and Exekias most notably.

In "Euphronios and His Fellows," for instance, Jiří Frel presents two previously unpublished psykters by Smikros, one of youths fishing, the other of young men in a gymnasium. One of these psykters, Frel shows, adds to our knowledge of Euphronios and his love, Leagros, and as such is rare and valuable evidence for the mingling of the lowerborn with the aristocratic. Through the hetaira Syko, Frel then makes a connection with other vase-paintings by Smikros, Phintias, and Euphronios and throws additional light upon the social and artistic milieu in which these painters lived and worked. And we are made acquainted with new vases, still only very little known, by Euphronios himself, which enhance our understanding of Euphronios' early work as a pupil of Oltos.

An amphora type B, recently acquired by the Toledo Museum of Art and signed by Exekias as potter, is discussed for the first time, alongside a little-known amphora from the Portland Art Museum, of similar shape, which Evelyn Bell suggests was a type invented by Exekias when he was a member of the Group E pottery. Her essay, "An Exekian Puzzle in Portland: Further Light on the Relationship between Exekias and Group E," investigates Exekias' connection with this workshop. She does this chronologically, by the developments in the iconography of Herakles' struggle with the Nemean Lion and by the close style of the portrayal of horses and tack and of the composition of chariots "wheeling around." Barbara Fowler, who also discusses Exekias, adds the refreshing perspective of a philologist and literary critic. In "The Centaur's Smile: Pindar and the Archaic Aesthetic," Fowler treats the relationship between a literary text and the visual arts. She isolates the aesthetic elements common to Pindar and to sixth-century sculp-

ture to elucidate a puzzling passage in Pindar's ninth *Pythian Ode.*

Several essays consider stylistic and iconographic problems in the works of a single artist, or of closely related groups of artists, and use literary evidence to corroborate the argument. In "Stesichoros and the François Vase," Andrew Stewart, referring to texts of Homer and Stesichoros, shows how the friezes on the vase are connected in subject matter, the many themes intersecting "in the motif of Dionysos' amphora and its twin promises of death and immortality." Then, using another structuralist, literary model, he shows that the relationships on the obverse are syntagmatic, those on the reverse paradigmatic. He compares Kleitias' technique with that of Homer and Stesichoros, explaining that verbal narratives are necessarily strongly temporal, that is, paradigmatic in character, while vase-painting, being spatial, is the better able to present syntagmatic relationships. Kleitias' artistry is expertly contrasted with that of the master, Sophilos. Stewart's inventive methodological approaches point the direction for further vase research, in this first generation after Beazley.

The very distinguished scholar, Sir John Beazley (1885–1970), shaped the study of vase-painting, and of Greek art more broadly speaking, into a field which he ordered like a science. His successors can now begin to discuss transformations in Greek fashion and habit, the metaphors of Greek politics, and the archaeology of war and sport. A number of essays in this volume are directly concerned with these topics and with the artistic language—that degree of license or sheer imagination—with which these subjects were portrayed by the ancient artist. Gloria Pinney in "Achilles Lord of Scythia," for instance, demonstrates that Scythian costume seems to have conjured up saga, referring to the squires of Achilles and to northern people over whom the hero may actually have ruled. She draws us to the cult of Achilles in the territory of Olbia, to his interment on Leuke, to the story of his passing recounted in the *Aithiopis,* and to a significant but little-known relief pithos in Boston which, at 650–625 B.C., is *terminus ante quem* for the story and for the creation of archers in Scythian garb. Concerning his depictions of foreigners and foreign dress, Pinney is properly critical of the ancient artist's truth to representation. "Are the scenes [in Greek art] staged in straightforwardly modern dress, or did the artist aim at a suitably fabulous or heroic effect by recalling the form of things ancient in his time, and by inventing some that never existed?"

In his "Symbol and Story in Geometric Art," John Boardman takes a fresh look at Geometric and Archaic art and challenges the view that it represents the "generalized heroic." He lays to rest the Siamese twins, the Molione, shows that the Dipylon shield does not often appear in the so-called myth scenes, and believes in and marshals archaeological evidence for the actual existence of the Boeotian shield. Even though the Geometric artist depended upon pattern and symbol, he seems nonetheless to have been expressing what he saw; he did not, like Homer, have the extensive repertoire of formulae to perpetuate for him a memory of the Mycenaean age which he is often thought to be trying to represent. As instances of artistic language Boardman convicingly interprets certain patterned arrangements of lines, which on Argive Geometric pottery are usually taken as mere filling ornament, to present the ripplings of water in a stream or pond. These wavy lines are genuine depictions of water and other geometric motives are seen to stand for horses' stabling and tack. The vases then corroborate Homer's description of Argos as "horse-breeding" and "thirsty." Ellen N. Davis's article, "The Iconography of the Ship Fresco from Thera," presents an entirely new interpretation of that painting, and her argument properly takes into account discrepancies in and differing modes of artistic language. On the one hand, the Aegean artist seems able and ready to record specifics of dress and locale, while on the other, he relies on fixed schemes and stylized convention, such as ribbon-colored waterways and banded rocks that look like "Easter eggs." Davis concludes that the painting represents Therans, not Minoans or Mycenaeans, on a military expedition either to North Africa or the Levantine, and includes a stop, for trading purposes, on Crete.

Scholars increasingly are looking through art onto the daily activities and politics, the sexual roles and mores of the ancients. M. Lefkowitz, S. Pomeroy, S. McNally, and C. M. Havelock, among many other distinguished scholars, have made significant contributions to our knowledge of the iconography and social history of women. Though the issue has not yet been sufficiently well explored, the construct of Greek society seems to have been altered, from matrilineal to patrilineal domination, perhaps from the middle of the seventh century B.C. This change should not necessarily give rise to the view, however, that Greek men lacked respect for women and fidelity to their wives, although special strain between the sexes—as art seems to sug-

gest—may have come about with the institution of democracy at the end of the sixth century. Eva Keuls' "Attic Vase-Painting and the Home Textile Industry" presents us with many scenes from everyday life, at the fountain houses, the shops, and at the loom, in red-figure vases of the fifth century B.C. Her feminist approach gives us new insight into what she calls the "male voyeurism" of the many scenes; into the iconographic confusion of mirrors and distaffs; and into the phallic significance of the money pouch. Lilly Kahil's essay, "Mythological Repertoire of Brauron," also discusses women, particularly the involvement of young girls in the cult of Artemis, and shows the relationship of Euripides' *Iphigeneia in Tauris* and various other texts to the archaeological remains and worship of the goddess in Attica. Women were especially devoted to Artemis, who is seen as a goddess of procreation, of childbearing, of social and civic life, in addition to such other roles as *Potnia Theron*.

When the Burdick-Vary symposium was organized and this volume assembled, it was intended that "art and iconography" be examined broadly, by art historians, classicists, and a classical historian. N. G. L. Hammond, in "The Lettering and the Iconography of 'Macedonian' Coinage," investigates the language of coin design—the marks and pictures which identified mint and the issuing authority or personality who guaranteed value—from the time of Peisistratos in the sixth century B.C. through Philip II of Macedon, the father of Alexander the Great, in the fourth. The coin designer—and some of Greece's greatest artists designed coin types—was faced with the problem of conveying much information in a limited field or space, and reacted to the challenge by developing symbols and conventions of representation not dissimilar in thinking from those of artists in other media and periods.

The reader should note that seventeen papers were actually presented at the symposium; an additional essay, "A Dionysiac Procession on a Monumental Shape 8 Oinochoe" by Konrad Schauenburg, appears in this volume. His essay had been prepared for presentation in Madison, but reasons of ill health prevented Professor Schauenburg from making the journey. By a series of meticulous comparisons Schauenburg attributes a significant and hitherto unpublished oinochoe of unusual type and size to a member of the circle of the Painter of Naples 1959. It is unique in being of Lucanian, not Apulian and Campanian, manufacture and dates ca. 320 B.C., making it the latest of the surviving monumental oinochoai. In "Some Thoughts on the Origins of the Attic Head Vase," William R. Biers also deals with a most curious vase type. He examines workshop, clientele, and subjects, i.e., Ethiopians, blacks, and beautiful women, whose molded images decorate this vase type. Because of the appearance of protomes, which are associated with the workshop of Nikosthenes on Attic vases of the second half of the sixth century B.C., Biers suggests products from that workshop may also have been intended, in part at least, for the Etruscan market, as well as for an increasingly sophisticated Athenian clientele.

Several essays deal with the most vexing problems of the interrelationship of one medium of art with another. In "Archaic Vase-Painting vis-à-vis 'Free' Painting at Corinth," D. A. Amyx considers the known vase representations in seventh- and sixth-century Corinth of Herakles' struggle with the Hydra and reveals a wide variety in the treatment of the theme, vase to vase. Though some of these vase depictions have the grandeur of conception and execution that one ordinarily associates with mural or large-scale painting, literal visual copying of a mural prototype, Amyx asserts, could scarcely have allowed these variations within a single theme. But certainly by the fifth century, vase-painters seem to have taken inspiration, when it suited their purposes, from large-scale, free or mural painting; Beth Cohen and Brunilde Ridgway separately cite the Orvieto krater by the Niobid Painter as proof. Ridgway reminds us, "Its [the vase's] pictorialism—the occasional tree to suggest open country, figures standing or disappearing behind rises in the ground–is so atypical of this vase-painter that inspiration from a different medium is indisputable."

The interconnections of sculpture, vase-painting, and mural painting are innovatively explored in Beth Cohen's essay, "Paragone: Sculpture versus Painting, Kaineus and the Kleophrades Painter." Cohen finds the Kleophrades Painter's vase rendition of the Kaineus story, in its dramatic moment, to be similar, though still Archaic, to the later famous Classical painting, the *Hades,* by the muralist Polygnotos. "Could the conception of both be attributed to a single creator—the great Polygnotos—at earlier and later phases of his career?" Is the scene on the Kaineus vase in the Louvre an excerpt from a lost wall-painting and is wall-painting a relatively new art form in Athens at the time? Cohen asks. From her discussions of the changing elements in one particular myth, ultimately we learn more about the separate natures of the Archaic period and of the Classical and, most important,

about the points of change and transition between the two. The integration and interrelationship of painting with sculpture are also considered by Brunilde Ridgway in "Painterly and Pictorial in Greek Relief Sculpture." Illusionistic ("pictorial") effects of spatial penetration and depth perspective in relief sculpture, particularly funerary and votive reliefs, were in many cases produced or at least greatly enhanced by the use of paint, Ridgway asserts. And certain kinds of relief sculpture depend primarily on drawing techniques and therefore partake of all the formal devices open to painting. She reviews the interrelationships between media chronologically from the Archaic period through the Hellenistic, from the stele of Aristion and the Sikyonian metopes through the late, well-known relief of the *Freeing of Prometheus* which has been considered by some a sculptural rendering of a painting by Euanthes.

The concept of the hero Herakles, his origins, escapades, political signification, has been the focus of much scholarly writing and debate in the past ten years; it was the theme for a symposium held in Rouen in November 1982. In our volume Herakles' battle with the Lernean Hydra and with the Nemean Lion and his apotheosis by chariot are given special consideration. The hero's struggle with the Hydra, which Amyx investigates, and with the Lion, which Bell discusses, may have been popular in Archaic Corinth because the loci for these legends—Lerna and Nemea—were near the city of Corinth. The appearance and later popularity of the battle with the Nemean lion in Attic black-figure vase-painting may have been related in part to the reorgainization of the athletic contests at Nemea, ca. 573 B.C.

My essay, "The Priam Painter: Some Iconographic and Stylistic Considerations," demonstrates that the Priam Painter's versions of the apotheosis of Herakles are not, as has been previously argued, an allegory of Peisistratos' entrance into Athens with Phye, the "brummagem Athena." Rather, I have seen Herakles as the symbol of the middle class, the body politic from which the Peisistratids drew their power, but not as the surrogate image of the tyrant himself. The motif may have been earlier than that charade, may have become popular because of a famous vase-painting by Exekias, and seems to disappear, not with the Peisistratids, but largely with the black-figure technique itself. These scenes were, furthermore, equally popular with the Etruscans, who worshiped Herakles and believed in the afterlife, and for whose tombs scenes of Herakles' apotheosis would have been appropriate. I also include a stilistic reappraisal of the art of the Priam Painter, particularly of the painter's little-known Lerici amphora. But political reference, though of a different kind, may still have been possible in Greek art. Beginning with texts of Herodotos and Pausanias, in "Painting, Politics, and Geneaology: Peisistratos and the Neleids," H. A. Shapiro shows how the iconography of Attic vases and the shrine of Kodros, Neleus, and Basile may have reflected the Peisistratids' claim to descent from Nestor of Pylos. These broader issues of the political and commercial factors governing the ceramics industry, as reflected in the iconography, and of the specialization of certain potters or painters who produced their work for the export trade, still need further exploration.

A wide range of methodologies are represented in this volume. Thus, Boardman combines pure iconography with reference to Homer; he also takes into account the implications of the formulaic method of composition. I combine a consideration of clientele with stylistic and iconographic analysis. Keuls combines iconography with social analysis; Frel social with stylistic analysis. Karl Schefold's essay, "Some Aspects of the Gospel in Light of Greek Iconography," is, by contrast, iconographical in a broader sense. Christ, he tells us, presupposes the Attic concept of humanity as prefigured in the bronze kouros, discovered in the Piraeus in 1959, which Schefold interprets as "the unique, preserved cult statue of Apollo." Christ incorporates the type of the teaching philosopher, Sokrates, and the heaven-gazing prince, Alexander the Great. He appears in early Christian art in Greek clothing, as do Moses' teachers in the cycle of mosaics in the church of Santa Maria Maggiore in Rome, which may go back to an Alexandrian illustrated scroll of the period of Ptolemy II (285–246 B.C.) The fabric of early Christian art, as H. P. L'Orange and others have written, is a complex interlace of many traditions, the Greek being only one. Professor Schefold, nonetheless, synthesizes the Greek achievement, its conception of man's destiny, and the freedom of Greek thought which motivated and conditioned its art. Through Christianity, Professor Schefold feels personally, Hellenism is conveyed to modern times. His lecture fittingly concluded our symposium and this volume.

WARREN G. MOON

ANCIENT GREEK ART AND ICONOGRAPHY

The Iconography of the Ship Fresco from Thera

ELLEN N. DAVIS

To my teacher, P. H. von Blanckenhagen

The new miniature fresco from Thera deserves the close attention it has received since its discovery in 1972.[1] No more elaborate landscape depiction is known from the ancient world before the Odyssey Frieze of the late Hellenistic period. No more vivid picture remains of the Aegean world of the Late Bronze Age. While important contributions have been made toward understanding it, there has been no general agreement about the key issue: the interpretation of the narrative scene.

The question is crucial for our understanding of a significant time in Aegean prehistory. When the fresco was painted, Cretan civilization was at its height in the New Palace period. If we believe the later historical tradition of the "Minoan thalassocracy," Crete held sway over much of the Aegean. The rich Shaft Graves at Mycenae, which are contemporary with the fresco, indicate that the Greeks on the mainland were enjoying a sudden rise in wealth and power, one that is still unexplained. A short time after the cataclysmic destruction of Thera that preserved the fresco, the Mycenaeans seem to have gained control of Crete in one phase of their expansion over much of the Mediterranean. The scene on the fresco, if we can interpret it, offers evidence for the balance of power in the Aegean in the period just before these key events took place.

The preserved portions of the fresco,[2] which decorated Room 5 of the West House at the site of Akrotiri, consist of a large almost complete section from the south wall on which is depicted a fleet of elaborate ships sailing between two towns (figs. 1.1, 1.2), and two large fragments and a number of smaller ones from the north

wall on which men meeting on a hill and warriors marching through a countryside above a shipwreck scene (fig. 1.4) are preserved. A smaller frieze of animals in a river landscape connected the north and south portions of the fresco along the east wall (fig. 1.3).

P. Warren in a recent valuable study sums up the interpretations that have been offered so far.[3] The main questions are: Who is represented? Minoans, Mycenaeans, and Therans have all been suggested. Is the ship procession merely a ceremonial one, or part of a serious military expedition? Where do the actions occur? My own conclusion is that Therans, rather than Minoans or Mycenaeans, are represented, and they are shown engaging in a military expedition, either to lands to the south, i.e., perhaps to North Africa as the excavator of the site, S. Marinatos, originally suggested,[4] or to the east, to the Levantine coast. My specific identification of the scenes, however, differs substantially from that of Marinatos.

Before considering the questions of interpretation, it is important to establish where the scene begins and where it ends. The interpretations offered so far have treated the narrative as if it began on the north wall and ended on the south. But enough evidence remains from the room in which the fresco was found to permit the conclusion that the ship procession on the south wall was the beginning of a long narrative frieze that originally continued over the west wall and ended on the north.[5]

The plan of Room 5[6] shows the distinctive four-part window arrangements, so far unique in Aegean architecture, that took up most of the space of the north and west walls. The miniature

frieze must have occupied the area above the windows, since that is the only place left for it.[7] The areas below the windows on both walls were painted in exactly the same way, with imitation stone revetments separated by vertical bands.[8] The bands were painted yellow to imitate wood, and they corresponded to the actual wooden window posts. The small remaining portions of the two walls not taken up by the windows were decorated with very similar frescoes of naked fisherboys holding strings of fish.[9] With the entire lower and middle portions of the north and west

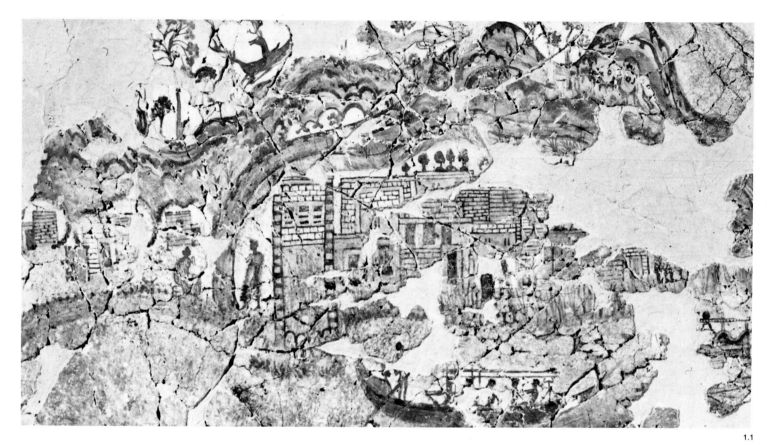

1.1

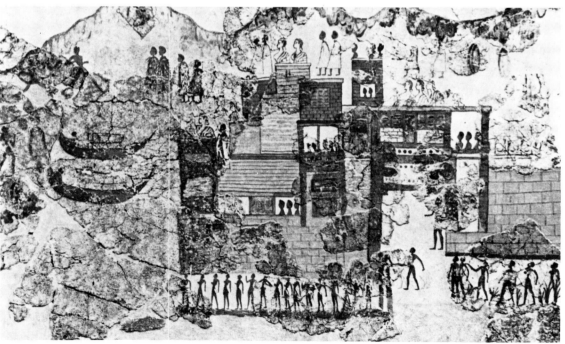

1.2

1.1. Ship fresco from Thera, first town on south wall. Photo: Courtesy Hirmer Verlag.

1.2. Ship fresco from Thera, second town on south wall. Photo: Courtesy TAP.

1.3. Ship fresco from Thera, exotic landscape. Photo: Courtesy TAP.

1.4. Ship fresco from Thera, scene from north wall. Photo: Courtesy TAP.

walls the same, is it conceivable that the frieze did not continue along the top of the west wall? Is it likely that the windows of the west wall were higher? Or that the wall space above them was left undecorated? Or that it was decorated with something different? Paintings that continued

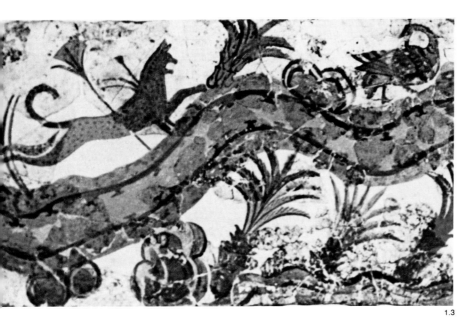

1.3

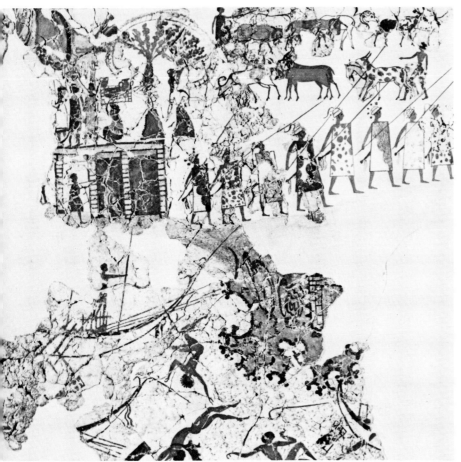

1.4

over three walls of a room were common in the Aegean, both on Crete and on Thera.[10] The narrative scene was originally such a continuous frieze. It ran from the south wall to the north for a total length of about 12 meters, and was meant to be viewed from left to right as the movement of the figures indicates.

The end and the beginning of the narrative scene were bridged along the east wall by a landscape frieze of an entirely different character (fig. 1.3). It constitutes a break in the narrative, rather than a continuation of it. It is only half the height of the narrative frieze, which is ca. 40 cm. It contains no human figures, and it has an altogether different, more ornamental character. An important fragment newly discovered from the southeast corner of the room shows us exactly how the two friezes related to one another: the small landscape was centered along the height of the large one.[11] There was an abrupt break at the corner, with sharp color changes of all the painted areas and no continuity between them. The northeast corner must have been similarly treated. It is not clear why the east strip was narrower.[12] Perhaps it was due to the structure of wooden cupboards that originally covered the east wall.[13] In any case, the artist needed to divide the scene. A narrative has a beginning and an end, and such a scene cannot flow endlessly around the room. The pigment overlaps on the corner fragment prove that the artist painted the ornamental strip first, as if he considered it a framing element, and then proceeded to execute the narrative frieze.

Does the ornamental strip (fig. 1.3) belong in any way to the narrative? The excavator of the fresco, Marinatos, originally dubbed it the "Subtropical Landscape," but it has recently been argued that it constitutes an Aegean setting, along with the landscape in the narrative scene.[14] A closer look, however, reveals that the artist has carefully differentiated all the plants and animals of the two landscapes. In the narrative scene above the first town (fig. 1.1), a lion pursues deer amidst trees that are probably olives, since they resemble those usually shown in Aegean art. The deer can be identified by their antlers as fallow deer, actual bones of which have been excavated at Knossos.[15] The scene is, in short, a familiar one, and along with the architecture of the town, it represents an Aegean setting. As such, the fresco contributes to the recent archaeological evidence that there were indeed lions in the Aegean in the Bronze Age.[16]

The east wall strip, in contrast, contains exotica. The Griffin is an especially jarring motif that

suggests a fabulous locale. The other predator (fig. 1.3) is a large wildcat, the same kind represented on the "Nile dagger" from Shaft Grave V at Mycenae.[17] The Thera fresco gives us new information about the cat: the large ears, the outsides tipped with black, and the general scale and proportions permit its identification as the serval,[18] a wildcat exclusive to Africa, where it inhabits watered areas and is remarkable for its ability to spring upon birds and catch them in midair, exactly as it is shown on the dagger. The papyrus plants of both the dagger and the fresco are also exotic elements, perhaps specifically Nilotic. Although the papyrus may be a species that grew in the Aegean,[19] there are indications that the artists of both the dagger and the fresco were using their imaginations in rendering it. The conventionalized clumps of alternating blooms and buds of the papyrus on the dagger seem to be derived from Minoan paintings of crocuses.[20] In the fresco, the individual stalks of papyrus are even further removed from nature, where papyrus grows in multiple stands. The date-palm trees also suggest an exotic clime. Whether they grew in the Aegean or not, which is also a question under debate,[21] the artist is applying a standard formula with ornamental variations of color and form, rather than rendering the trees from observation.

Almost all the elements in the exotic landscape—the palm trees and the papyrus, the Griffin and the wildcat, the goose and the duck—occur elsewhere in Aegean art. The rendering of the terrain in undulating striations of color with a ribbonlike waterway and "Easter egg" rocks follows normal Aegean conventions.[22] Even so, the elements do not add up to an Aegean setting. The important factor is the artist's deliberate differentiation of the two landscapes. This tells us that he meant to convey a foreign place on the east wall. He has accomplished something that is rather difficult. He has applied a familiar artistic vocabulary to evoke the unfamiliar. The awkwardness of the Griffin in this context suggests that the Thera artist may have been inventing here in making a new use of a standard Aegean religious image to suggest an exotic locale.

This is an instructive case, one that indicates how the rest of the fresco ought to be "read." We must keep in mind that Aegean artists worked with an impressive, but nonetheless limited, vocabulary of motifs. The majority of the elements of the Thera fresco have counterparts in other works of Aegean art. These comparable works provide evidence of the pictorial tradition within which the Thera artist worked, a tradi-

tion that appears to have been developed in Minoan Crete. In this respect, Aegean art of the early fifteenth century B.C. is analogous to Greek vase-painting in the early sixth century B.C. One is reminded of the struggles of Corinthian and Attic painters to adapt what is initially a rather limited vocabulary of human and animal forms and chariots to illustrate particular myths. It is from this point of view that we can best appreciate the achievements of the especially talented vase-painters when they invent new schemes to expand the artistic possibilities. Although the evidence of the Aegean pictorial tradition is much more fragmentary than that of Archaic painting, it is useful to view the Thera fresco from this perspective. If we consider the general artistic vocabulary at the artist's disposal, we can gain a clearer idea of the use he has made of it and a better understanding of what he intended to convey.

This idea, that the artist of the Thera fresco was applying currently available imagery, is also important for the consideration of a major question asked about the narrative scene. Does it depict a particular or a general event? The question has been asked about every Aegean narrative representation. It is ultimately unanswerable, precisely because the artist is always using a general vocabulary of images. Yet when similar narrative scenes in landscapes occur later, in Egypt and in Assyria, the accompanying inscriptions tell us that specific military actions were intended. Inscriptions are the major means that early Greek vase-panters used to identify their scenes as particular myths. Aegean painters did not use this device. Yet there is some evidence that a particular scene was intended here too. The way the river branches to surround the first town on the south wall is rather awkward artistically, since it divides the landscape rather than unifies it. It suggests a particular topographical fact. It is very similar to the way specific waterways sometimes characterize particular cities in the later narratives, for example, on the Egyptian reliefs of the battle of Kadesh,[23] or the Assyrian relief from Nineveh of the Elamite city, Madaktu.[24] The waterways in those reliefs are represented in a portraitlike manner, even when the other forms of figures and architecture are much more standardized than they are in the Thera fresco.

The specific character of the narration is also suggested by the actual links with the site itself that others have pointed out. Eight cabin structures like those occupied by the captains of the ships on the south wall were painted on a large

scale in the adjoining Room 4 of the West House.[25] Their association with the image of a young priestess burning incense in the same room suggests that the cabins were objects of ritual.[26] The multiple hide-covered cabins are reminiscent of the multiple oxhide shields on frescoes from Knossos, Tiryns, Thebes, and Mycenae.[27] Such shields also occur in ritual contexts,[28] perhaps related to their protective functions. In the procession of ships on the south wall, one ship is obviously singled out as the most important. It is the most lavishly decorated, with more prow ornaments than the others, the most elaborate painted hull, and the only one with ornamental pendants hanging from the rigging. The captain's cabin on this ship is distinctly larger than the others, and the only one decorated with "Waz lily" finials, which, as Immerwahr has pointed out,[29] occur on all the cabins painted in Room 4. Marinatos made the persuasive interpretation that the captain of this ship was the owner of the West House.[30] If he was not the "admiral" of the fleet as Marinatos suggested, and the West House does not seem impressive enough for such a conclusion, he was at least depicted as its most prominent participant.

Like the other captains, the "admiral" carries a long staff. He appears to be bearded, as do a small number of the remaining members of the fleet, including at least one of the warriors from his own ship.[31] This warrior, like many although not all of the others, has a boar's tusk helmet hung above his head. The same helmets are worn by the warriors marching in formation with oxhide body shields on the large fragment preserved from the north wall (fig. 1.4). It is on the basis of the beard, the helmets and shields, and the general martial character of the scene that the warriors have been identified as Mycenaeans.[32] The evidence, however, both iconographical and archaeological, does not support this conclusion. Only the iconographical questions can be dealt with here; the archaeological arguments against the identification have been summed up recently by J. Davis.[33]

The iconographical evidence indicates that it is Therans who are represented. The most important indication is the garments worn by the members of the expedition: they are sleeveless cloaks of gray or brown fur or white or brown cloth. The cloaks, shown more completely on the figures on land (fig. 1.1) are completely unlike any other garment depicted in Minoan or Mycenaean art.[34] These distinctive cloaks, unique to this fresco, must be the garments of the Therans. The artist appears to have carefully distinguished them from the garments worn by non-Therans. There is no reason to identify the men as Mycenaeans or Minoans on the basis of beards or no beards. We know little about the appearance of Theran men apart from this fresco. Only two images of adult males are preserved from the site: a sherd with the front part of a beardless face,[35] and a fresco fragment that Marinatos and others have considered a depiction of an African because of the curly hair and snub nose.[36] Very little is known about the appearance of Cycladic men in general. A few extant images, such as the fisherman stand from Phylakopi[37] and the fresco fragments from Kea[38] show beardless men. In these images the men, like those in the Thera fresco, wear distinctive garments that differ from those of the Minoans and Mycenaeans.

The general notion that all Mycenaeans wore beards and all Minoans were beardless ought to be reevaluated. The rather sizable percentage of bearded men on the portrait seals from Crete indicates that a significant number of the most important men wore beards. J. Betts, who has recently collected the portrait seals, has shown convincingly that the amethyst portrait seal from Shaft Grave Gamma at Mycenae that has been compared with the Thera "admiral" as evidence that he is a Mycenaean is actually a traditional Minoan product.[39] The image, with the open mouth, more likely portrays a chanting Minoan priest, rather than an energetic Mycenaean.[40] And is it true that all Mycenaeans were bearded? Of the six gold masks from the Shaft Graves at Mycenae, only one has a beard indicated, and the moustache differentiates it from the images on the Cretan seals and in the Thera fresco.[41] An informal survey of the male figures in the Shaft Graves, which does not include any of the stelai, gives the following count:[42]

Beards: fifteen
No beards: twenty-four
Not clear: eight.

It seems that in the Aegean, both in Crete and on the Greek mainland, the wearing of beards was optional, at least for men of distinction. This seems to have been true for the Therans as well. It seems more reasonable to let the fresco tell us what they looked like, than to exclude them on so little evidence.

Similarly, the helmets and shields are not sufficient grounds for identifying the warriors as Mycenaeans. It is not clear who introduced the boar's tusk helmet into the Aegean, but they seem to have been generally current by the time

the fresco was painted.[43] The helmets in the fresco have a special feature: various curved elements are shown projecting from the sides. These do not occur on other Aegean helmets, but somewhat different triangular projections appear on a helmet incised in relief from Kea,[44] and hooklike projections are shown on zoned helmets of warriors on a Minoan faience ewer from Shaft Grave III at Mycenae.[45] This evidence suggests that the islands may have developed their own characteristic versions of the helmet. The shields too differ in precise detail from those depicted elsewhere. Most such "tower shields" have curved upper rims for better protection of the face; the two examples that do not have distinct wide borders along the edges, which are lacking on the shields in the fresco.[46] The armor, therefore, like the garments, appears to be distinctive to Thera, and contributes to the evidence that it is Therans who are depicted.

The fresco, therefore, represents a fleet of Theran warriors, with the owner of the West House prominently figured. The narrative begins at the southeast corner with the ships setting out. It follows from this that the first town ought to be the hometown of the fleet, the settlement at the site of Akrotiri. The men of the town all wear the same distinctive fur or cloth cloaks that the members of the fleet wear. The wide open windows on the ground story of the houses are a special feature of the town's architecture as it has emerged from the excavations. It may be possible someday, when the excavations are enlarged, to verify the distinctive river arrangement that characterizes the town.

If the first town is the settlement at Akrotiri, what is the second town at the right end of the south wall (fig. 1.2)? Both towns are shown in the usual Aegean convention as agglomerates of flat-roofed structures. But here again it is important to consider how the artist has differentiated the two. The second town has none of the animals that give a rural character to the first. It is much larger. Originally it was substantially greater than it now appears in the restoration. Its right-hand limit is not known. From the scale of the published photographs, it can be estimated that about 3.5 meters of the south frieze is preserved, which leaves about 0.5 meter of space before the corner which the architecture could have occupied. There are indications that the extant fragments should be spread out more to the right. At present, the fragments at the right interfere with the gateway. The second town, in short, is actually a city. It is distinguished from the first by its wall, either a fortification, or more

likely because of the ashlar masonry, a unified lower story suggestive of a palace. The city has "horns of consecration," both on the wall at the right and on the towerlike structure at the left. It also has courses of masonry with round beam ends, and more beam ends line the lintel, which is framed with curved forms similar to the "rosette and triglyph friezes."

The location of the city in the fresco, not at the end of the journey, but at a point less than one-third along its length, makes it unlikely to be the place to which the fleet returns, as it has generally been interpreted. It is not a city on Thera, for it is some distance away, across the open sea. Yet it is not far, since the ships are all propelled by paddlers and only one has begun to set sail. The most likely candidate for the location of the city is Crete, as Immerwahr has suggested,[47] only sixty-five miles south of Akrotiri and visible from it on a clear day. The architectural features definitely point to Crete. Although one "horns of consecration" has been excavated at Thera, they are much more frequent in Crete, as are the frieze of beam ends and the "rosette and triglyph frieze." The "horns of consecration" together with the unifying walls of ashlar masonry suggest the palatial rule in the name of the divinity that we associate with Minoan Crete.

The inhabitants of the city bear out this identification. While the men of the first town all wear the same cloaks as the warriors of the fleet, the men of the city wear loincloths. A few men in cloaks are present, but they are all outside, behind the city. The men in loincloths exhibit a distinctly formal behavior in the manner in which they line up in front of the walls. While women are scarce in the first town—fragmentary traces of only one are preserved—there are a number of women inside the city, one of them accompanied by a child. The women gesture toward the fleet. The behavior of the inhabitants is puzzling at first, but it becomes very clear when we realize that the artist has modified the usual depiction of a city under siege, as we see it on the silver "Siege Rhyton" from Mycenae.[48] In the representation on the rhyton, men are lined up in front of the walls to defend the city, while women are figured prominently inside. They gesticulate wildly and tear their hair to dramatize the attack and to express the vulnerability of the town under siege. The city in the fresco is not under attack, so the men are unarmed and the women wave rather than lament. The artist has adapted the standard siege scene to represent something different: a foreign people who are not under attack. The people are well acquainted

with the Therans and on friendly terms with them, yet decidedly formal in their response. This fits well with what we know about the Minoans, a distinct and separate people who were in close contact with the Therans.

The very specific actions in the harbor area in front of the city need more careful consideration. They have generally been regarded as excited reactions to the homecoming of the fleet. Two small ships are docked in the harbor. They are identical to the ship in front of the first town, manned by ten rowers and a steersman, with a captain seated in the stern in a special seat with a curved back. The captains are similarly seated in the two vessels in the harbor, but their crews have left the ships. It must be two of the missing crew members who walk up on shore immediately to the left of the ships carrying sticks from which bundles are suspended. Above them, a number of men run excitedly, three toward the harbor town and two toward a group of four men in fur cloaks who stand calmly by the shore. At least five more men in white cloaks stand behind them, all outside the town. Since the artist has been careful to show this garment on all the men of the first town and none of the men of the city, the men in cloaks must represent Therans who are present in Crete. The most likely explanation for the scene, which has no counterpart in Aegean art to help with the interpretation, is that it represents trade. The smaller oared craft are different from the large ships of the fleet. They may be vessels that carried out local trade. The men in cloaks by the shore might be Therans who visited Crete or perhaps lived there for trading or other purposes. The great quantities of Minoan pottery found at Akrotiri, which the current excavator, C. Doumas, has estimated to be about 20 percent of the total,[49] indicates frequent and extensive trade with Crete. Marinatos specifically reported an unusually large quantity of Minoan vases from the West House itself,[50] which is what we might expect from the home of a ship's captain. It seems that in the mind of the Theran artist, and perhaps of his patron, Theran commercial presence was a characteristic of a Cretan city, one important enough to be indicated in the representation. Trade is a difficult subject to translate into visual terms, and one must admire the economy with which the artist has indicated it by means of a few representative figures.

The distinction between the active men in loincloths and the calm men in cloaks may reflect the same social stratification we see in the ships, where the upper class of warriors is distin-

guished from the crew. The complex question of why the ships are paddled rather than rowed is beyond the scope of this paper. The paddling and the elaborate ornamentation of the ships have led to the theory that they are not fitted for serious navigation, but are merely engaged in a ceremonial procession.[51] It follows, however, from the fact that the fresco continued over the west wall to the north, where military action is represented, that the fleet is setting out on a military expedition. Additional evidence that this is so is provided by new fragments of at least one paddled ship from the north wall that have been recently incorporated into the restoration.[52]

We can only guess at what was represented on the missing west portion of the fresco, although there may be additional new fragments to provide some evidence. The flotilla may have been shown sailing across the open sea, or perhaps passing other landmarks. One major question that newly excavated fragments may shed some light on is whether the scene was a continuous narration. Were the same ships shown again in more advanced stages of the journey, as in the Odyssey Frieze, or were different ships represented? It is still an open question whether Aegean art ever employed continuous narration—the major evidence for it is the "Quiet cup" from Vaphio, on which three different stages of entrapment may involve the same bull.[53] Since the ships on the south wall have been individualized by their hull paintings, a close examination of the new fragments of paddled ships may provide the answer to this question.

The missing scene on the west wall may have been organized like that on the south, with points of land framing the sailing ships. When we pick up the narrative again on the left portion of the north wall, the setting is again on land. A steep hill is represented with men ascending from the left and right to meet at the summit. This seems, as Immerwahr has suggested, to be a conference between two different ethnics.[54] The men who approach from the left wear garments that are quite similar to those of the Therans, and the scene would make sense if they were Therans. Some fine distinctions in their clothing, however, may be the artist's way of indicating another people. The men wear loincloths, but fuller versions than those of the crew members, and the foremost figure wears a white cloak that has more borders than those of the Therans and a tassel at the back. The garments of the men who approach from the right are different. Their cloaks are significantly shorter, falling just below the knees, and they have scarf-

like cloths at the neck. The two groups face each other at the top of the hill. Two of the men in loincloths gesture to dramatize the otherwise static scene. The other figures cannot gesture because of their unsleeved garments. One of them, however, turns his head completely around. His action suggests a communication: apparently a decision has been reached. He does not face his comrades, however, but gazes over their heads to the right.

The figure turned around seems to be communicating with the four men on the pavilion-like structure to the right on the large preserved fragment (fig. 1.4). The men have climbed up on the structure as if to view the meeting on the hill; they gaze intently as if awaiting the results. The conference on the hill, another scene for which there is no parallel in Aegean art, seems to be a response to the invasion of the Theran fleet. These coastal people appear to be spared, since the line of Theran warriors marches by them. But the "bucolic scene" behind the marching warriors must be related to the event. Shepherds drive sheep and cattle into a sheepfold, which is surrounded by a low wall and shaded by two trees. Two women carry jars on their heads, similar to those placed on the structure in front of the sheepfold, which has been identified as a well.[55] Warren, who has collected all of the pertinent comparative material for the imagery of the fresco, has provided the evidence for interpreting the scene. He has convincingly interpreted a fragmentary stone rhyton from Knossos with a man dragging a goat above a figure of a helmeted warrior as a scene of livestock raiding.[56] The fragment indicates that such scenes were a standard part of Aegean battle imagery,[57] and it seems that again the Theran artist has adapted a standard scene to a particular case. These villagers have apparently come to terms with the Therans, and are collecting the livestock and provisions as their part of the bargain.[58] This would explain the close juxtaposition of the armed warriors who march by them in an attack directed at others.

The line of warriors and the shipwreck scene below them imply violence, yet the preserved fragments show no element of direct conflict. In the shipwreck scene, it is difficult to determine how the bowsprit of the front ship got broken or what catapulted the airborne crew members into the sea. Their nudity, except for one man who wears a skin, and their small shields and the curved implement flying in the air characterize them as foreign warriors under attack. The artist has carefully distinguished their ships from those

of the Therans by the plain hulls and decks in the forecastle. While the warriors setting out are repetitive forms, with only the details of their helmets and the oxhide of their shields varied, the falling warriors assume a great variety of individual poses. A number of new fragments of men falling into the sea which have not been published add to this variety.

All of these characteristics of the scene place it clearly within the Minoan artistic tradition. The treatment of violence is very similar on the Boxer Rhyton from Hagia Triada,[59] where the victors assume rigid positions that are strikingly repetitive when compared with the variety of poses of the losers. Their positions, some of them airborne, like those of the shipwrecked figures in the fresco, defy any mechanical explanation. The same treatment can be observed in the Town Mosaic from Knossos, which provides specific parallels for many of the motifs of the fresco.[60] Along with flat-roofed architecture, the Town Mosaic contained figures standing or marching with spears who seem quite similar, while their defeated enemy were shown floundering in the water in many different positions. The helpless opponents in the Town Mosaic were distinguished from the other figures by a darker skin color, which led Evans to speculate that they represented Africans.[61] The motif of helpless victims in the sea was a standard one in Minoan art. Warren has correctly pointed out that the figures on the Swimmers Dagger from Vaphio must be drowning men.[62] A great many such figures (portions of at least twelve are preserved) were represented on the Siege Rhyton from Mycenae, which of all Aegean monuments provides the closest counterpart to the Thera fresco.[63]

The rhyton has most generally and correctly been considered a Minoan work.[64] The sophisticated techniques of its manufacture, which include solid-cast parts that were silver-plated and gilded, place it clearly among the products of Minoan workmanship.[65] What is not clear is whether it was a traditional Minoan product or one made on the Greek mainland under Mycenaean patronage. The decoration of a vessel type that seems to have served ritual purposes in Crete with secular subject matter may suggest that it was made for the Mycenaeans. Warren has shown that most of the relief rhyta from Crete bear religious imagery.[66] The very few that do not, including the fragment with the livestock raid mentioned above,[67] and a fragment of a bearded archer on a ship from Knossos,[68] are not from dated contexts, and it is possible that they

were made under Mycenaean patronage after the take-over of Crete. However, even if this is the case, the artists who made them were Minoan, and they drew on the pictorial tradition that had been developed in Crete.

It is not true that the scenes of hunting and fighting so popular in Mycenaean art are absent from Crete. What is true is that the art of Crete primarily served religious purposes, and such secular representations are rare. There is also a distinct tendency in Minoan art to avoid direct conflict. However, the extant images do include some forceful confrontations, and a number of the combat scenes, such as those on seal impressions from Hagia Triada, Knossos, and Zakros, clearly predate the Mycenaean take-over of Crete.[69]

There is no doubt that a predominance of violent scenes characterizes Mycenaean art. The assemblage of objects with hunting, fighting, and animal combat scenes from the Shaft Graves of Mycenae would never be found on Crete. They reflect a distinct Mycenaean taste, and the different purposes which art served for the Mycenaeans. But violent subject matter is not itself a sufficient criterion for distinguishing Mycenaean products among the individual objects found there. The subject matter would be what a Mycenaean patron would request from a Minoan artist or trader. The sharp discrepancy between the style and technique of the grave stelai, which were surely carved locally at Mycenae, and those of the sumptuous objects found within the graves gives a strong indication of how much the figural scenes on the objects rely on the Minoan pictorial tradition. This is not the place to discuss the attributions of specific objects from the Shaft Graves, which is a controversial question. The important point is that the Town Mosaic, the Siege Rhyton, the stone rhyta from Knossos, and a number of Minoan seals and impressions all reflect a highly developed tradition in Crete of representing battle scenes in landscape settings. The artist of the Thera fresco was acquainted with the Minoan imagery, and he made his own application of it. Surely there were Minoan paintings with such battle scenes.[70] Actual finds should eventually document this.

The Minoan landscape scenes may have included ships with paddlers like those in the Thera fresco. S. A. Immerwahr has made an important observation about the style of the fresco: "There is a tendency to string the figures out paratactically, rather than to group them in the 'shorthand perspective' of the Knossian miniature frescoes."[71] The painter of the Thera fresco

apparently valued clarity over the spatial dimension that Minoan massed figures evoke. He has gone to great lengths to present his figures clearly against empty backgrounds and to avoid overlapping. In view of this, the paddlers of the ships are a surprise. They are rendered in sketchy strokes of brown, with their hair and eyes lightly indicated in black.[72] Their simple execution and their overlapped positions at the bulwarks of the ships allow a crew of twenty-one paddlers per ship to be represented in an unobtrusive fashion. The light sketchy technique with which they are rendered is comparable to the extraordinary device used by the miniature painters at Knossos and Tylissos for rendering crowds: whole areas were covered with the brown or white skin colors of males and females, then individual figures sketched over them.[73] Evans aptly termed the device a "shorthand technique"; it is something different from "miniature painting," or the painting of figures on a small scale.[74] No such device was used in the miniature fresco from Kea, although the artists there used more overlapping than the artist of the Thera fresco.[75] The rendering of the paddlers in the Thera fresco is in the same spirit as the Minoan device, and definitely qualifies as a "shorthand technique." Such a rendering belongs exclusively to painting, of course. Although the evidence here is indirect, the difference in approach behind the light suggesting of the multiple paddlers and the unusual clarity of the other figures in the fresco suggests that they were derived from another source, very possibly from Minoan painting.

Before the Thera fresco was discovered, the best evidence for Aegean landscape painting was the scene on the silver Siege Rhyton.[76] The subject depicted on it was the same as that of the north wall of the Thera fresco: an attack on a foreign town by warriors arriving from the sea. Large portions of both scenes were given over to the helpless victims of a sea battle floundering in the water. There is no reason to believe that the outcome of the attack was different on the rhyton. The slingers and archers and men wearing shields who defend the city must have faced a group of attackers. The marching warriors in the fresco must have advanced toward defenders like those on the rhyton. The line of marching warriors is another element that is found in Crete on seal impressions.[77] A similar line of warriors appears on a fragmentary stone rhyton from Epidaurus in a scene with dolphins, objects in the sea, and part of a ship's cabin that must have been similar to the scenes on the silver rhyton and the fresco.[78] It is a fortunate coincidence that

the best-preserved portion of the Siege Rhyton provides the scene that is missing from the fresco. It permits us in a general way to imagine what the portion at the right end of the north wall might have looked like. Details of the architecture and the arms of the defenders would presumably have differed from those on the rhyton. The artist would probably have omitted the "horns of consecration" from the architecture, since he had already used them to characterize the Minoan city. But although details would have differed, the fresco would have included such a scene. Although the major portion of the long frieze was given to the voyage of the fleet and other events prior to the attack, the scene eventually culminated in a climactic battle representation.

The important question of where the final battle took place cannot be answered at present. It is not clear whether the pavilionlike architecture and the short cloaks of the villagers are actually descriptive, or merely the artist's means of designating other peoples. The garments of the women, like those of the women in the town under attack on the Siege Rhyton, are typically Aegean. One detail of the foreign architecture may be actually descriptive. Marinatos observed the black triangular projections from the wall of a structure near the shipwreck scene, which do not occur elsewhere in Aegean architecture or representations; he interpreted them as wooden beams used in conjunction with mud-brick architecture.[79]

An expedition that set out from Thera and passed by Crete might have been headed either south or east. In either case, they would have been sailing with the prevailing winds.[80] The ornamental strip with the exotic landscape that spanned the east wall between the final destination and home might have some bearing on where they went, but it is not clear how we are to understand it. Did the artist intend the landscape as merely exotic? Or, with the papyrus and the serval, was it specifically Nilotic? If we assume, merely for the sake of speculation, that it was Nilotic, there are still two ways we can interpret its place in the scheme of the decoration:

(1) It may be a place the Therans will pass on their voyage home. If so, they have probably traveled to the African coast, perhaps to Libya as Marinatos originally suggested. The prevailing winds and currents dictate counterclockwise travel in the Eastern Mediterranean.

(2) The Nilotic landscape may represent the geographical area that lay between the destina-

tion and Thera. In that case, the Therans have probably sailed eastward, to the Levantine coast, Cyprus, or perhaps to the southern coast of Turkey.

Whatever their destination, the Therans have represented themselves, as apparently the Minoans had also, as a proud fleet, setting out on an organized expedition to raid foreign coastal towns. Although the fresco may well exaggerate their impressiveness, the Therans must have constituted a significant force in the Aegean world. We must not overlook this evidence when we consider the subsequent shifts of power that occurred after their island was destroyed.

NOTES

1 This paper is a preliminary report of a more extensive study of the fresco, which is in preparation. It was presented before the author had the opportunity to examine the fresco firsthand.

2 The reader is referred to the excellent color photographs published in the preliminary report, S. Marinatos, *Excavations at Thera* VI (Athens 1974) color pls. 7–9. Good photographs of parts of the fresco are found in S. Marinatos and M. Hirmer, *Kreta, Thera und das Mykenische Hellas* (Munich 1973) pls. XL–XLII, and *History of the Hellenic World* I, *Prehistory and Protohistory* (Athens 1974) between pp. 224 and 225.

3 P. Warren, "The Miniature Fresco from the West House at Akrotiri, Thera, and Its Aegean Setting," *JHS* 99 (1979) 115–29.

4 Marinatos, *Thera* VI, 44–60; S. Marinatos, "The 'Libya Fresco' from Thera," *AAA* 7 (1974) 87–96.

5 Marinatos, *Thera* VI, 24, reported only a single frag. recovered from the west wall, and left the question open whether the fresco continued there.

6 Marinatos, *Thera* VI, plans 3 and 4; Warren, "Miniature Fresco" 117, fig. 1.

7 This is explained by S. A. Immerwahr in her valuable study, "Mycenaeans at Thera: Some Reflections on the Paintings from the West House," in *Greece and the Eastern Mediterranean in Ancient History and Prehistory, Studies presented to Fritz Schachermeyr* (Berlin 1977) 173–74; and Warren, "Miniature Fresco" 115.

8 Marinatos, *Thera* VI, 22, pl. 38a–b.

9 Ibid. 35–38, pls. 85, 88, 90, color pl. 6.

10 These include the Bluebird fresco from Knossos, M. A. S. Cameron, "Unpublished Paintings from the 'House of the Frescoes' at Knossos," *BSA* 63 (1968) 1–31, fig. 13; the Partridge fresco, *PM* II, 108–16 and frontispiece; the landscape from Hagia Triada, which W. Stevenson Smith has argued was an uninterrupted frieze, *Interconnections in the Ancient Near East* (New Haven and London 1965) 77–79, figs. 106–9; and the Spring fresco from Thera, Marinatos, *Thera* IV, color pls. A–B.

11 K. Iliakis, "Morphological Analysis of the Akrotiri Wall-Paintings of Santorini," in C. Doumas, ed., *Thera and the Aegean World* I (London 1978) 617–28, pl. 7.

12 M. A. S. Cameron, "Savakis's Bothros: A Minor Sounding at Knossos," *BSA* 71 (1976) 6–7, n. 17.c and f, has noted two different heights for the Flying Fish fresco from Phylakopi.

13 Marinatos, *Thera* VI, 22–23, pl. 41a–c.

14 Warren, "Miniature Fresco" 121–29.

15 Ibid. 123 and n. 30.

16 Warren, "Miniature Fresco" 123 and n. 29 provides a valuable survey of evidence for the lion in the Aegean and reports actual finds of lions' teeth at Kea. A lion's foot bone has been recently identified at Tiryns, *JHS-AR* 1978/1979, 16.

17 Marinatos and Hirmer, *Kreta* pl. XLIX, above, L, above.

18 This identification, first suggested to me by B. Cohen, has been verified by J. G. Dogherty, Curator of Mammals of the New York Zoological Society and B. Bertram of the London Zoo. For the serval and its behavior, see J. Kingdom, *East African Mammals* III (London, New York, and San Francisco 1977) 318–23; H. C. Grzimek, *Animal Life Encyclopedia* 12, *Mammals* III (New York 1975) 307; D. R. Rosevear, *The Carnivores of West Africa* (London 1974) 413–20.

19 P. Warren has identified the species as *Cyperus papyrus,* and argued that it grew in the Aegean; Warren, "Did Papyrus Grow in the Aegean?" *AAA* 9 (1976) 89–95; and idem, "Miniature Fresco" 122–23; See O. Rackham, "The Flora and Vegetation of Thera and Crete before and after the Great Eruption," in Doumas, *Thera and the Aegean World* I, 757.

20 *PM* I, 506, fig. 364a, b; Cameron, "Unpublished Paintings" pl. 5.1–2 (nos. 31–32), pl. 6.3–4 (nos. 38–39), color pl. B, 1–2.

21 Warren, "Miniature Fresco" 122 and n. 22; Rackham, "Flora and Vegetation of Thera" 757.

22 As seen, for example, in the Bluebird fresco and the Nile dagger.

23 Stevenson Smith, *Interconnections* 171–73, figs. 216–17.

24 R. D. Barnett, *Assyrische Skulpturen im British Museum* (Recklinghausen 1975) pl. 159.

25 Marinatos, *Thera* VI, 24–26, pls. 52–57, color pl. 4.

26 Ibid. color pl. 5. For the ritual implications see L. Morgan Brown, "The Ship Procession in the Miniature Fresco," in Doumas, *Thera and the Aegean World* I, 640–41.

27 This comparison has been made by M. C. Shaw, "Painted 'Ikria' at Mycenae?" *AJA* 84 (1980) 177, who interprets them as emblems of power, rather than as objects of ritual. For the figure-eight shield paintings see I. Kritseli-Providi, "Toichographia Oktoschemou Aspidos ek Mykenon," *AAA* 6 (1973) 176–81.

28 G. Mylonas, *Mycenae and the Mycenaean Age* (Princeton 1966) 157–58. The most important evidence is provided by the gold ring from Vaphio, *CMS* I, no. 219. The large silver shield from Shaft Grave IV at Mycenae, which I have suggested is a rhyton, should also be considered, E. N. Davis, *The Vapheio Cups and Aegean Gold and Silver Ware* (New York and London 1977) 230–33.

29 Immerwahr, "Mycenaeans at Thera" 177.

30 Marinatos, *Thera* VI, 54, pl. 108.

31 Ibid. pls. 100 and 107.

32 Immerwahr, "Mycenaeans at Thera" 180–83; S. Iakovidis, "Thera and Mycenaean Greece," *AJA* 83 (1979) 101–2; M. A. S. Cameron, "Theoretical Interrelations among Theran, Cretan and Mainland Frescoes," in Doumas, *Thera and the Aegean World* I, 589.

33 J. Davis, "Mycenaeans at Thera: Another Look," *AJA* 85 (1981) 69–70.

34 The long robes on the Hagia Triada sarcophagus, which have been compared, are sleeved garments, not cloaks, although the relation of the garment to the arms of the figures is unclear in places. C. R. Long, *The Ayia Triadha Sarcophagus, SIMA* 41 (Göteborg 1974) 22, 36–38, discusses both robes and hide garments. Minoan cloaks or mantles are also discussed by E. Sapouna-Sakellarakis, *Minoikon Zoma* (Athens 1971) 104–10; and S. Marinatos, *Kleidung, ArchHom* I A (Göttingen 1967) A25. No cloaks are represented in Mycenaean art.

35 Marinatos, *Thera* IV, color pl. G.

36 Marinatos, *Thera* II, 54, pl. B, 3–4.

37 See the drawings in T. D. Atkinson, et al., *Excavations at Phylakopi, JHS Supplementary Paper* (London 1904) 124, fig. 95; J. Sakellarakis, "Le Thème du pêcheur dans l'art préhistorique de L'Égée," *AAA* 7 (1974) 371, fig. 2.

38 K. Abramovitz, "Frescoes from Ayia Irini, Keos. Parts II–IV," *Hesperia* 49 (1980) 57–71, pls. 4.59–60; 5.77, 100–102.

39 J. Betts, "The Seal from Shaft Grave Gamma—A 'Mycenaean Chieftain'?" *Temple University Aegean Symposium* 6 (1981) 2–8, D–G and J–L. An eighth "portrait seal" with a frontal bearded head has been found by Warren at Knossos, *JHS-AR* 1979/1980, 49–50.

40 This can be inferred from the association with animal heads on two of the gems (which led S. Marinatos, "Minoische Porträts," in *Festschrift Max Wegner* [Münster 1962] 9–12, to interpret the figures as royal herdsmen), and the rare hairstyle, cut short across the forehead, which is identical with that of a figure on a hematite seal from Vathy Pediados, who carries an ax and wears the fringed robe associated with priests (J. Boardman, *Greek Gems and Finger Rings* [New York, n.d.] pl. 89).

41 See *History of the Hellenic World* I, 256–57 for a color pl. with all six masks.

42 These include the six masks; the seals, *CMS* I, nos. 5, 9, 11–12, 15–16, (six with beards and six without); the Lion Hunt dagger, Marinatos and Hirmer, *Kreta,* pls. XLIX, center, L (four without beards and one with chin hidden); the Battle krater, A. Sakellariou, "Un cratère d'argent avec scène de bataille provenant de la IVᵉ tombe de l'acropole de Mycènes," *AntK* 17 (1974) 3–20 (two with beards and seven with faces not preserved); faience jug frags., G. Karo, *Die Schachtgräber von Mykenai* (Munich 1930), nos. 123–24, fig. 16 (one beardless, one with chin not preserved); the Siege rhyton, A. Sakellariou, "La scène du 'siège' sur le rhyton d'argent de Mycènes d'après une nouvelle reconstruction," *RA* (1975) 195–208 (six bearded, eight beardless among the figures with heads preserved).

43 For helmets, see Warren, "Miniature Fresco" 128–29; J. Borchhardt, *Homerische Helme* (Mainz 1972) 26–27; J. Borchhardt, "Helme," *ArchHom* I E, E62.

44 Borchhardt, *Homerische Helme* 73, pl. 7.7.

45 Karo, *Schachtgräber,* nos. 123–24, fig. 16; K. Foster, *Aegean Faience of the Bronze Age* (New Haven and London 1979) 125–26, has maintained that the jug is a mainland product, but the material and technique, as well as the shape of the vessel and the style, suggest Minoan workmanship.

46 H. Borchhardt, "Frühe griechische Schildformen," *ArchHom* I E, E25–26. Add to her list in n. 214, the Battle Krater, Sakellariou, "Cratère d'argent." The shields of the defenders on the Siege rhyton are not rectangular, but angled to fit under the left arm; those on the faience frags. have curved upper rims. The only rectangular shields with straight upper rims like those in the fresco are the shield seen from inside on

the Lion Hunt Dagger, where the artist may have simplified the rendering because of the complicated overlapping of figures and spears at that point, and a shield on a pictorial vase from Tiryns, *JHS-AR* 1979/1980, 29, fig. 51. Both shields have distinct borders at the upper rim.

47 "Mycenaeans at Thera" 174–75.

48 Sakellariou, "Scène du 'siège' " 195–208.

49 In a lecture presented to the New York Aegean Bronze Age Colloquium on 23 October 1979.

50 *Thera* VI, 33.

51 L. Casson, "Bronze Age Ships: The Evidence of the Thera Wall Paintings," *IJNA* 4 (1975) 3–10; and Morgan Brown, "Ship Procession" 629–44. Others have maintained that the Thera ships were suitable for serious navigation: A. F. Tilley and P. Johnstone, "A Minoan Naval Triumph?" *IJNA* 5 (1976) 285–92 and T. Gillmer, "The Thera Ships: A Re-analysis," *Mariners Mirror* 64 (1978) 125–33.

52 These frags. are included in the recent photograph of the north wall in Doumas, *Thera and the Aegean World* I, pl. K.

53 Davis, *Vapheio Cups* 14–15.

54 Immerwahr, "Mycenaeans at Thera" 182–83.

55 *Thera* VI, 41.

56 Warren, "Miniature Fresco" 126–27 and n. 46, fig. 4.

57 Goats and a bull were also represented in the Town mosaic from Knossos, *PM* I, 309, fig. 228 b–e; see p. 310.

58 This interpretation was suggested to me at the Burdick-Vary Symposium at Madison by W. Biers.

59 Marinatos and Hirmer, *Kreta* pls. 106–7; P. M. Warren, *Minoan Stone Vases* (Cambridge 1969) 85, P469. The repetitiveness, somewhat exaggerated by the restoration procedure, is best appreciated in the flat drawing of the lower two zones in *PM* I, 690, fig. 511.

60 *PM* I, 301–14; Foster, *Aegean Faience* 99–114.

61 *PM* I, 310; Foster, *Aegean Faience* 110.

62 Warren, "Miniature Fresco" 126 and n. 44. The technique of cold-hammered inlaying without the use of "niello" indicates that the dagger is of Minoan manufacture, E. N. Davis, "Metal Inlaying in Minoan and Mycenaean Art," *Temple University Symposium* 1 (1976) 306.

63 Sakellariou, "Scène du 'siège' " 207–8.

64 Ibid. 195, 208; and Sakellariou, "Cratère d'argent" 18–19. Sakellariou cites previous bibliography and discusses the style of the Siege Rhyton, concluding that it was made by a Minoan artist working on the mainland. E. T. Vermeule, *The Art of the Shaft Graves of Mycenae. Lectures in Memory of Louise Taft Semple* 3 (Cincinnati 1975) 17 and 38; and Immerwahr, "Mycenaeans at Thera" 175, believe that the Siege Rhyton is a Mycenaean product.

65 Davis, *Vapheio Cups* 328–35.

66 Warren, *Minoan Stone Vases* 175–78.

67 Warren, "Miniature Fresco" 126 and n. 46, fig. 4.

68 Warren, *Minoan Stone Vases* 85, P473.

69 J. Betts, "New Light on Minoan Bureaucracy," *Kadmos* 6 (1967) 19, fig. 9, has identified sealings from Hagia Triadha (D. Levi, "Le Cretule di Haghia Triada," *ASAtene* 8–9 [1925/26] 123, no. 114, fig. 130, pl. VIII and 144, no. 144, fig. 160a–b) and from Knossos (*PM* IV, 600, fig. 594; *BSA* 60 [1965] 87, fig. 4) as impressions from the same ring. Other Late Minoan Ib sealings with battle scenes were found at Zakros, D. G. Hogarth, "The Zakros Sealings," *JHS* 22 (1902) 78, nos. 12–13, pl. VI; and Hagia Triada, Levi, "Le Cretule" 122–24, nos. 112, 113, 115, figs. 128, 129, 131, pls. IX, XII, XIV.

70 Warren ("Miniature Fresco" 127–28) has compared a number of fragmentary frescoes which may have depicted war or raiding scenes, but the interpretation is uncertain. The Kea fresco (Abramovitz, "Frescoes from Ayia Irini" 57–62) appears to have been a scene of festivity, as does the fresco from Tylissos, M. C. Shaw, "The Miniature Frescoes of Tylissos Reconsidered," *AA* 1972, 171–88. If Cameron is correct in his attribution of the Warriors Hurling Javelins from Knossos to the Sacred Dance fresco, they too are part of a festivity: *PM* III, 82, fig. 45; *Knossos Fresco Atlas*, 28–29, pl. IV.1–2; M. A. S. Cameron, "Notes on Some New Joins and Additions to Well Known Frescoes," *Europa. Studien zur Geschichte und Epigraphik der frühen Ägäis, Festschrift für Ernst Grumach* (Berlin 1967) 67–74, nos. 16–18, pl. IV.d, fig. 7.b. The yellow objects they hold do not look like javelins or spears; they are apparently difficult to ascertain on the frags. and Shaw ("Miniature Frescoes of Tylissos" 187) has interpreted the scene as "a leader facing a line of cheering men."

71 Immerwahr, "Mycenaeans at Thera" 179–80.

72 This is clear in the drawings in Marinatos, *Thera* VI, 51, fig. 6 and outside color pl. 9.

73 *PM* III, 48; Shaw, "Miniature Frescoes of Tylissos" 187.

74 Cameron, "Savakis's Bothros" 9–10 has distinguished "artistic shorthand" from "miniature painting." One can disagree with his characterization of the Knossian "artistic shorthand" as an "essentially linear technique." Many of the added details are areas of color rather than line, and the brushwork has a distinctly two-dimensional character.

75 Abramovitz, "Frescoes from Ayia Irini" pl. 4, 69; pl. 5, 77, 91; pl. 6, 96.

76 It is thoroughly discussed in this regard by Stevenson Smith, *Interconnections* chap. 5.

77 *PM* I, 694, fig. 516; *PM* III, 313, figs. 204–5. *ASAtene* 8–9 (1925/26) 124, no. 116, pl. XIV and fig. 132.

78 Warren, "Miniature Fresco" 126–27, fig. 5; A. Sakellariou, "Scène de bataille sur un vase mycénien en pierre?" *RA* (1971) 3–14.

79 Marinatos, *Thera* VI, 45.

80 P. J. Riis (*Sukas* I [Copenhagen 1970] 163–65, fig. 58) discusses winds and currents in the Eastern Mediterranean.

Symbol and Story in Geometric Art 2

JOHN BOARDMAN

My intention in this essay is to explore some of the problems of early figurative art in Iron Age Greece. It is a well-worn subject by now and goes back virtually to the days when Geometric art was first recognized as being, after all, Greek, and not Egyptian or Near Eastern.[1] It is only in the last fifty years, however, that a proper appraisal of the subtlety of the Geometric artist has been made, and the vases studied with that attention to detail which had far longer accompanied studies of black- and red-figure.

In such a discussion the familiar stock-in-trade of the modern iconographer of Geometric, Dipylon shields and Siamese twins, cannot be avoided, but I save them for a later part of the article, and hope to be able first to explore some ground which may be less familiar to all but the dedicated.

There have been two major areas of discussion in the study of early Geometric narrative and figure art in the Iron Age—its origins and its content. To mention only two recent scholars who have devoted time to this, we have J. L. Benson's stimulating exploration of possible debts to the Bronze Age past and to contemporary Egypt in his *Horse, Bird and Man* (Amherst 1970),[2] and G. Ahlberg's studies[3] which turned rather to the Near East for probable sources of inspiration. The media of influence are easiest to suggest for the Greek Bronze Age, less so for the east, least for Egypt, and there will always be those ready to raise the banner of "native invention," and rightly so. Almost every year too brings new discoveries to fill out our knowledge of what, by way of figure art, was possible in Greece between the Bronze Age and the eighth century (especially from Crete[4]) and to chart more clearly the pattern of influence from the east.

For the content of Geometric figure art we can define the two quite untenable extremes of view: that all scenes before 700 B.C. depict contemporary life and manners, and that all scenes before (and most after) 700 B.C. depict the heroic past. As usual, a compromise solution must be the correct one, although in some areas no compromise is feasible, and the most thoughtful protagonist in this field, A. M. Snodgrass, seems to have been moving from somewhere near the latter extreme to a solution that appears to allay most qualms. It is best expressed in his *Archaic Greece* (1980) 65–77 and in an article in *AthMitt* 95 (1980) 51–58. As well as important arguments about specific problems he offers the notion of a "generalized heroic" atmosphere in Geometric art, which eschews the need to identify or name the particular. It is a point of view close to that of several other scholars and may be correct, though I am uncertain and it cannot hurt to ask questions and probe anew.

The discussion has always centered on Attic Geometric vases, sometimes to the point at which one wonders whether the writers have forgotten that there were other Geometric arts in Athens, that there were other centers for Geometric art in Greece. In the first half of this essay Attic Geometric will be mentioned only in passing. It is time we tried a new approach; that we tested whether what is being alleged about Athens is applicable throughout Greece (and if it is not, I submit, there is something badly wrong); that we test a different and prolific area of Geometric art to try to discover principles of com-

position and depiction which have a validity of their own, and may even help us better to comprehend the Attic scenes that have haunted the study so far.

We turn therefore to the Geometric figure-decorated pottery of Argos and the Argolid. It is not so much less prolific than Attic, and it is endued with a very distinctive character, worth exploring in its own right. It has too readily been dismissed as a vulgarly repetitive demonstration of the best that could be managed by artists who lacked Attic wit and imagination. Even its foremost exponent is not immune from this attitude. But the Argives of the eighth century B.C. breathed the same air as the Athenians, their culture was basically the same, their influence and wealth (to judge from later record) perhaps greater than the Athenians. Their art and its conventions must also have been basically the same, but perhaps differently exercised and for different purposes. If the rather tentative conclusions I draw from a closer study of it fail to convince, I hope they will at least show that it deserves attention, and that through it we might learn something more of the Greek Geometric artists' purpose and method.

P. Courbin's exhaustive study of Argive Geometric pottery (*CGA*) reaches the following general conclusion about the significance of the figured scenes on the vases (p. 495): "On the whole Argive Geometric iconography seems essentially objective: very rarely symbolic, very rarely funerary, even less often mythological or epic. It is descriptive, sometimes, it may be, of religious ceremonies, but for the most part of daily reality. The significance of Argive decoration is simply representational."

With this I would wholeheartedly concur, but on the way to this conclusion Courbin also dismisses virtually all interpretation of abstract or figure motifs as other than decorative or as simple depictions of contemporary life. This, I think, does little justice to the Argive painters, and it reduces their work to baldly repetitive statements of the everyday obvious, padded with filling ornament chosen either to fit the available space or through subservience to the technical convenience of the multiple brush (which is in fact little used within the figured scenes). Fill for fill's sake is easy enough to identify, but where special patterns recur in special places we must think again. The contemporary Attic Geometric artist is demonstrably most capable of subtlety in detail and composition, in skills which come close to narrative. That two or more generations of Argive artists, however conservative in their basic choice of figure scenes, could not rise above the banal, seems improbable, and if true it should have led rapidly to trivial reproduction. We can certainly observe, with Courbin, a degree of simplification and translation of motifs as time passes; still, to the very end, there is originality in the use of decoration, even in the apparently repetitive repertory of horse, or two horses, or man with horse/two horses, which account for most of the scenes. Oddly enough, Argive Geometric has in the past been one of the most favored grounds for detection of elaborate symbolism. Here A. Roes found solar symbols and Iranian sun standards.[5] B. Schweitzer found in the horse-and-man scenes intimations of the cult of Poseidon Hippios, and took the fish which commonly appear beneath the horses as "determinatives" of the god,[6] but he offered no very detailed interpretation of the ornament. J. N. Coldstream gives an excellent and wholly pragmatic account of Argive figure drawing.[7] Most recent accounts have been skeptical, and I see little likelihood of any serious revival of support for sun symbols or even Poseidon.

There is, however, more to learn about, and from, a proper understanding of the Geometric artist's use of ornament, and we surely dismiss too much as mere "filling." In an essay in 1968 N. Himmelmann-Wildschütz considered the possibilities of this line of study with some care.[8] For our purpose his most valuable observation is that Geometric ornament can be used for different purposes, from the purely decorative space filler to a geometricized symbol for, or actual representation of, an object. The same significance is not required for an ornament wherever it appears. Given the liberties that a Geometric artist takes with natural forms, this fuller license with ornament is not surprising. The difficulty comes in proving the identity of the aliases of ornaments when they are serving some other purpose. Some are simple—Geometric patterns that can serve as a snake, a horse's harness, a shroud, a *kline* mattress. Some are virtually unverifiable, such as Himmelmann-Wildschütz's suggestions about vegetable intentions of meanders and some angular pattern bands. Some become recognizable as more than fortuitous associations of figure and pattern, when they are repeated often and especially if they are repeated on different wares. A case in question is the line of linked circles or lozenges, sometimes dotted, which appears as a pattern band on many Geometric wares, without being commonplace (except in Attic). It is a pattern which is found pendent from a horse's mouth too often for it to

2.1. Argos Museum C 209. Detail of pyxis. After P. Courbin, *La Céramique Géometrique de l'Argolide* (Paris 1966) pl. 101.

2.2. Argos Museum C 201. Detail of krater. Photo: École Française d'Athènes.

2.3. Athens, N. M., Pyxis from Tiryns. Photo: DAI, Athens.

be taken as other than a representation of a rope or halter. We can find it in Attic,[9] Boeotian,[10] and Samian[11] Geometric, and in Laconian[12] where it clearly derives from Argive. Its appearance on Argive vases (fig. 2.1) is taken by Courbin[13] as a filling device ineptly continued to the horse's muzzle (which, he points out, it fails to do on only one vase; which means that the "ineptitude" is in fact the rule). His explanation is not easy to accept when the pattern takes the position of the straight or wavy line which runs from the muzzle and can only be a halter. If this is accepted, then some other patterns in the same position might also be taken to represent the halter, such as the line meanders.[14]

Because the linked circles or lozenges can represent halters in some cases does not mean that they must represent ropes or the like in other scenes. Once we have taken the hint, however, it is reasonable to look for the use of these geometricized ropes elsewhere. On Argos C 201[15] the linked circles (each one crossed) appear pendant in the arms of an odd tripodlike device which is shown beneath the horses in four panels (fig. 2.2). The way they are attached at the top suggests no mere filling. Courbin takes the whole device for the earliest type of manger, probably of tripod form. Only once, however, does anything like this, longer-legged and with dots between its legs, stand between two horses;[16] there is never any depth of receptacle at the top; and on several examples the outer legs do not reach the ground. But the whole thing is an object, not mere filling, and to it are usually attached the two ropes.[17] That the normal form of manger, a square mounted on a single leg, appears beneath horses on Argos C 210,[18] where we also find in other panels the tripod device, seems to suggest that they are not likely both to represent the same type of object. We may go on to wonder whether indeed the manger (beneath the horse top left in fig. 2.3) is properly identified, since it seldom appears between the horses.[19] The horses are more commonly tethered to mangers in non-Argive scenes, where the box may project from the side of the panel, which itself then serves as the stable wall.[20] Finally, note that wheel motifs are sometimes associated with both the manger and the tripod device (fig. 2.2).[21] Possibly both are feeding receptacles of some sort, the tripods being provided with tethering ropes. I had wondered whether the manger might in fact be a chariot floor and pole, but now dismiss the idea. The tripod, however, often short-legged at the sides, could easily be some sort of yoke for a heavier

Symbol and Story in Geometric Art 17

2.4a

2.4b

2.5

2.6

cart—more to do with the yoke of Priam's cart (Hom. *Il.* XXIV.269) εὖ οἰήκεσσιν (rings or chains?) ἀρηρός, than any Bronze Age or Iron Age chariot.[22] Relative scale is clearly unimportant. None of these answers, old or new, may be correct, but the questions are proper ones and it should be possible, maybe with the help of more explicit scenes, to identify the realia impersonated by these patterns.

For the next pattern to discuss—multiple wavy lines—we fortunately do have one explicit scene to indicate what the significance certainly was on one occasion. Courbin (p. 475) sees the motif as the offspring of the old multiple-brush patterns (not that these, freehand, *are* so old) and their multiplication encouraged by ease of technique. But the boldest of them are not made by the multiple brush, and even if this were their origin it would not deny them the possibility of serving a more realistic purpose too. On the important fragment, Argos C 240, (figs. 2.4a, 2.4b),[23] the quadruple zigzag in the panel clearly represents water, beside water bird and fish, and with a horse and man on the stony bank. The idea that the last is a *nuage de poussière* is rightly dismissed by Courbin (p. 478) yet he seems unwilling to adopt a less ambitious but realistic explanation. Coldstream can see the scene as a whole, but even he admits the possibility that "the various elements were not intended to form a connected scene, but are simply taken at random from the 'pattern-book' of an ambitious and inventive painter."[24] He calls it "the earliest Argive figured scene."[25] It is perhaps the first real picture in historic Western art. For the moment it tells us that, at this early stage, an artist saw his multiple zigzags as water, and we may proceed to discover whether his followers ever did the same. In one or two other scenes substantial areas of multiple wavy lines, which are most commonly found in separate friezes or panels, are admitted to the figure panel (as on Argos C 240) with the Argives' favorite quadruped. On a vase from Mycenae[26] they run below a group of a man with two horses, and vertically at the side of the group. On Argos C 645[27] they run below two horses, with a separate group of lines running up between them (fig. 2.5). The lines run vertically, and splaying, between the horses on Argos C 2441[28] and vertically before one horse on Argos C 4501.[29] All these vases come late in the series. It is difficult to escape the conclusion that the artists are depicting horses beside water, and where the water is drawn up between them in the position of a manger, it is offered them to drink (Argive horses never bow the neck). Other versions of the zigzag motifs between horses, but often with a man too, may enhance the intention of a water setting,[30] and some vertical rows of chevrons might have a similar intention or be a hint of it. Occasionally the water motif appears on a manger[31] or in the corner panels which we have yet to discuss.

On Argos C 240 the motifs of water, fish, water bird, horse, and man appear in one panel (fig. 2.4b). Commonly these are motifs which may appear in separate panels or friezes on the same vase. C 240 suggests that motifs set in separate panels may in fact be read together, which is apparent from other Geometric vases including Attic. (Think of the apparently separate "boxed" mourners in some Attic funerary scenes.[32]) So a zigzag frieze or panel juxtaposed to a panel with a water bird, or a row of water birds, or fish, or horse-and-man, might be read together by a Geometric artist as readily as even we can read the unique scene on C 240 where the motifs are not discrete. This is a very important Geometric compositional device to which we must return. If the observation is just, the watery aspect of Argive Geometric vases assumes an importance equal to, if not exceeding, the horsey. The ubiquity of the pattern, and variants upon it, is perhaps the most characteristic feature of Argive compared with other Geometric wares. Of the rim patterns of the larger vessels the most popular is the row of water birds, then the row of vertical lozenges (fig. 2.11, on which more later), then varieties of zigzag lines (fig. 2.6), which persist on Argive well into the seventh century (on the famous Polyphemos fragment[33]). That there should be a watery motif, water birds or waves, at the lip of a container for liquids is not remarkable. In the sixth century artists may place here ships or swimming dolphins.

We come now to the fish. It is the commonest motif to appear beneath the horses on Argive (figs. 2.5, 2.7). It seldom appears elsewhere—and then usually beside a horse, and hardly ever as an independent motif.[34] It is sometimes replaced beneath a horse by a hatched lozenge (fig. 2.3; cf. fig. 2.11)[35], but since this too can be given a tail and fins (fig 2.3), it is no more than a more fully geometricized fish, or yet another real object masquerading as a pattern. On a small panel on the big Argos pyxis C 209 we see a water bird (standing on the riverbank[36]) with two of these hatched fishes (fig. 2.8), but the fish it has caught in its beak is merely a lozenge with a line in it. Might this simplest of all fish patterns have the same significance elsewhere? On Argos

2.4a. Argos Museum C 240. Krater fragment. Photo: École Française d'Athènes.

2.4b. Argos Museum C 240. Krater fragment. Detail. Photo: École Française d'Athènes.

2.5. Argos Museum C 645. Krater. Photo: École Française d'Athènes.

2.6. Argos Museum C 201. Krater. Photo: École Française d'Athènes.

C 3397[37] it is the core pattern of a real fish, attached oddly to a horse's head. Elsewhere it very easily could signify fish, and it occupies places where otherwise we find the water zigzags—on lips and in panels over horses. This must be a most hesitant suggestion. It is relevant to note that these separately drawn lozenges are very much a speciality of Argive, and of derivative Laconian Geometric. On other wares the comparable motif is normally executed as a continuous double-zigzag band with the resultant diamond-lozenges dotted rather than lined. This is an easier way to draw it too, but abandoned for this special version in Argos, where a multiple brush can, however, sometimes be used. The motif can also be used as a net pattern or as the "leaves" of a rosette, as on C 1019.[38]

We return to the fish beneath horses. When not taken for determinatives of Poseidon they are regarded simply as a convenient shape of filling pattern, and the way they can be placed by a lozenge (not in fact a replacement, as we have seen, but a different version of the same) is thought to prove their nonsignificance. The early Argos C 240 (fig. 2.4b) which showed the man and horse on the stony riverbank, with the water, fish, and water bird, tells us what the whole association was, and just as we have found a few other scenes where the horses and water share one panel, so, far more easily and far more often, the fish can also be accommodated in the panel. Horse-and-water seems almost more important than horse-and-man as dominant linked themes.

The water birds, which appear less often below the horses but are not uncommon in these scenes, answer the need to demonstrate another element of the same theme in the same way. They also direct our attention to the small panels over the horses' backs, but we may summarize first the Argive choice of motifs *under* horses. Nearly half are fish or what we take for fish. Nearly a quarter are structures—what we take for mangers (on a stand), or tripods (possibly mangers or yokes or other equipment), or boxes on the ground (very probably mangers or troughs since one appears between horses and is decorated with hatched zigzags[39]). There are almost half as many water birds (fig. 2.9, an unusual specimen)[40] as structures, and only one of the other motifs which appear under horses calls for remark. It is a large vertical tongue, which Courbin[41] seems ready to take as a purely abstract pattern, a soft triangle. Once it holds a large fish (fig. 2.10), and in its triple border J. M. Cook surmised an indication of water, like

the water canopy in Byzantine baptisms.[42] Others have fish too.[43] Once it contains a pendent attached row of dotted lozenges,[44] like our ropes. Others are plain.[45] I hesitate to suggest nets, though the fish and rope would suit them; but I cannot accept that they are mere pattern filling. A peculiarly elaborate version of the motif appears between wavy lines on the neck of an amphora, Argos C 849. In the same position we see also an elaborated triangle with registers,[46] and this can reappear between horses.[47]

Another special place for decoration in the Argive scenes is over the horses' backs. In almost two out of three examples the device is "boxed" in a linear, hatched, or dotted border, occasionally shaped at one side to run parallel to the horse's neck. The commonest single motif, about 20 percent of all, is water birds (figs. 2.2, 2.6), with nearly as many unboxed as boxed. Nearly as common are multiple zigzags, always boxed (figs. 2.3, 2.11). If the latter is a water motif, and these boxed panels are to be read with the whole scene, it is understandable that it should be boxed when it is shown in its least realistic position, over the horse's back and not beneath their feet or before them. There are no real fish in these small panels, but several rows of lined lozenges (figs. 2.1, 2.3),[48] whose possible fishy associations have been discussed. Some other patterns recall mangers or structures.[49]

Now we turn to the motif in front of or between the horses, regardless of whether they are attended by a man. We have considered the multiple wavy lines that lead up between them, and comparable watery motifs are very common, though also perhaps more readily dismissed as convenient filling. There are some half dozen examples of a fish prominent here,[50] at least three standed mangers and a watery tub,[51] with other objects which seem to some degree structural.[52] The commonest single motif is a vertical, hatched, broken meander, composed of separate angles and zeds, usually beside a man (figs. 2.2, 2.6).[53] This appears also sometimes in the corner panels over the horses' backs (boxed and unboxed, fig. 2.5) but it is not a very common motif elsewhere on the vases. It surely signifies something, although I cannot suggest what with any conviction—structural? paving? The occasional line meanders and squares in this position may also be related,[54] and perhaps the checkered diamonds.

The ambivalent character of pattern, even of the simple vertical panel-dividing patterns, is nowhere better demonstrated than by the ten or so examples where the horse's head is allowed to

2.7. Argos Museum c 928. Amphora fragment. Photo: École Française d'Athènes.

2.8. Argos Museum c 209. Detail of pyxis. After Courbin, *La Céramique Géometrique de l'Argolide* pl. 103.

2.9. Bryn Mawr, Ella Riegel Memorial Museum P 738. Krater fragment. Photo: Museum.

2.10. Nauplion Museum, from Mycenae, Agamemnoneion. Krater fragment. After *BSA* 48 (1953) 38.

2.7

2.8

2.9

2.10

overlap into the vertical strip before it (fig. 2.11)—a characteristic of Coldstream's Fence Workshop.[55] The fill of the strip is usually watery (fig. 2.12) like a trough. Finally we can do no more than draw attention to the hatched triangles attached to the panel borders, which commonly occur framing the head of the man with the horses, and occasionally on the panel side before him or the horse; and to the very common depiction of a wheel below the horse's head, which does seem something like a determinative of its function as a cart or chariot horse.

This, to my mind rich, imagery of Argive painting nearly expires with the decline in use of the great cemeteries of the Argolid in the early seventh century and on the latest near-Orientalizing examples of the Argive Geometric figure style. It is not altogether forgotten, however, and in the bleaker first half of the seventh century one cheerful Argive, who has at last succeeded in mounting his horse, rides on an amphora from the Heraion between two great fish (fig. 2.13).[56] It has been remarked already that the horse and water seem almost more important as themes, even joint themes, than the horse and man, but it has naturally proved easier to identify the horses than the water. The emphasis is readily explained. Argos' reputation for horse breeding is apparent from the common Homeric epithet ἱππόβοτον, which is repeated in later writers.[57] Whatever the horse meant in Attic Geometric— wealth or status symbol, it may be—it had a very real significance in Argos. And the water? The other Homeric epithet for Argos is πολυδίψιον, "thirsty." This was true of much of the plain, where water supply and irrigation must have been a prime concern. Much of the Argolid was well watered, however, even marshy (Lerna). Argos itself was very well supplied and enjoyed open water channels in its streets in the third century and perhaps earlier.[58] Danaos and his daughters had arranged Argos' water supply (Hes. fr. 128, West) and the Danaids found wells at Lerna.[59] After the men and horses, the commonest major motif in Argive Geometric is the dances of women,[60] commonly set in filling patterns of wavy lines, and sometimes with large areas of multiple wavy lines in the same panel,[61] even overhead (fig. 2.14), which never happens with the horses. They are perhaps celebrating the Danaids' gifts, just as their menfolk do the horse rearing on C 240. The vases seem to dwell upon two main factors of Argos' life and economy.

Much of this investigation of Argive Geometric is of course highly speculative, and unprovable, but it is not all pure speculation. We should

2.11

2.12

2.13

be ready to see in Argive Geometric scenes, not deeply symbolic expressions of the Argive subconscious, but quite straightforward though sometimes detailed statements of animal motifs, and of settings of paramount importance to the Argive in the street or farm, demonstrated in the simple conceptual code of Geometric art, to which the subsequent history of Western art has all but blinded us.[62] There is still much to learn and understand; and we may have caught some red herrings in the Geometric ornament, but I believe that the wholly skeptical will be losing much in appreciation of the Geometric artist's achievement if he dismisses all possibility of such expression in Geometric Greek art.

The code is not a very complicated one: we know the language even if not all the words. It may help us to understand it if we look away to the art of another ancient culture where a similar code was applied in a more sophisticated manner—Egypt. I hasten to say that I am not suggesting that Egyptian art had any direct influence on Argive Geometric (despite Danaos and his daughters who came from Egypt), and I remain skeptical about its iconographic influence on Attic Geometric, which has been skillfully argued by J. L. Benson.[63] But the principles of composition and simple visual symbolism of Egyptian art find many echoes in Greek Geometric and may help us to understand it. An important source is H. Schäfer's great study *Principles of Egyptian Art,* in the English translation by J. Baines (Oxford 1974). We have suspected the Greek Geometric artist of placing in juxtaposed panels motifs which are to be read together. This isolation of motifs is not uncommon in Egyptian art where, however, the greater realism of the parts makes it easier to comprehend the whole. Odd, but comprehensible, the elevated panel of zigzags indicating a lake between date palms (fig. 2.15)[64] and closer perhaps to Greek usage, the ducks in open water between papyri shown in three panels (fig. 2.16).[65] So, when the Argive artists put horses in separate panels, and between them a panel with various water elements (figs. 2.3, 2.6, 2.12)—water birds, zigzags, the wandering meander (another Argive speciality which I suspect of being watery)—they may be doing no more than presenting, discretely, what might be placed in a single panel, with the birds (still possibly apart in a corner box) and water motifs.[66] In Egypt the multiple zigzags are both the hieroglyph for water and the artist's convention for depicting water. Figure 2.17 shows the zigzags rising up in a bay or inlet between the boats,[67] as it does to the horses on the vases. The

2.11. Argos Museum C 738. Krater fragment. After Courbin, *La Céramique Géometrique de l'Argolide* pl. 34.

2.12. Argos Museum C 171. Krater. Photo: École Française d'Athènes.

2.13. Athens, N. M., from the Argive Heraion. Detail of amphora. After Courbin, *La Céramique Géometrique de l'Argolide* pl. 8.

2.14. Krater fragment from Tiryns. After H. Schliemann, Tiryns (London 1886) pl. 16 below.

2.15. After H. Schäfer, *Principles of Egyptian Art* (Oxford 1974) figs. 265a,b.

2.16. After Schäfer, *Principles of Egyptian Art* fig. 266.

shape of the inlet, with its fish, is not altogether unfamiliar to us either. The popularity of the water zigzags as a pattern on the lips and belly of Argive vases goes back far earlier than their figured vases, and it can be used in the same way in Egypt.[68] Lines of figures facing or moving from left and right to the center can be shown in Egyptian art to represent parallel files.[69] Applied to the Attic funeral scenes this makes processions of mourners to the bier or accompanying it, rather than static groups. A remarkable parallel to the "determinative" wheels by the Argive horses' heads (figs. 2.1–2.3, 2.6) seems to be the eggs shown beside birds, even when in flight.[70] And when I look at the way Egyptian artists display a courtyard scene, in plan with its figures and doors in elevation (fig. 2.18),[71] I wonder why the Argive artist of the remarkable c 240 chose the odd, archlike asymmetrical pattern beside his picture (fig. 2.4). It is not dictated by the vase handle or the available space.

None of the parallels I have drawn are, of course, exact, nor could we expect them to be, but they serve to demonstrate more lucidly than do the Greek scenes how an artist may conceive and distribute parts of a scene which, in later Western art, we choose to present and understand as a continuous whole, and they also serve to demonstrate the use of pure pattern for elements of the physical world.

Before we embarked on this exploration of Argive Geometric the hope was expressed that it might teach something about other Geometric arts of Greece. There are many comparable scenes to the Argive in other wares, especially the horse-with-man or horse-at-manger. Several present the motif of a wood ax poised over the horse's back, where the Argive has his patterned panel. It is again simply an indication of setting—the stable and valuable much-used equipment—but it is odd that the Argive shuns it almost totally.[72] And when we look for other, irregular motifs such as those which proved so suggestive on the Argive vases, they seem singularly lacking. This is not the place for an analysis of the Geometric ornament of other centers, but on the Attic vases it seems that the artist usually fills his background with quite simple, and, to me, generally meaningless decorative patterns, which are gradually overtaken by the multiple-wavy-line fill, inspired less by any significance in the motif as such, as by the ease with which it could be executed by a multiple brush.[73] In this respect the Argive artist seems to have compensated for his lack of range in figure scenes by greater subtlety and variety in their presentation,

2.17

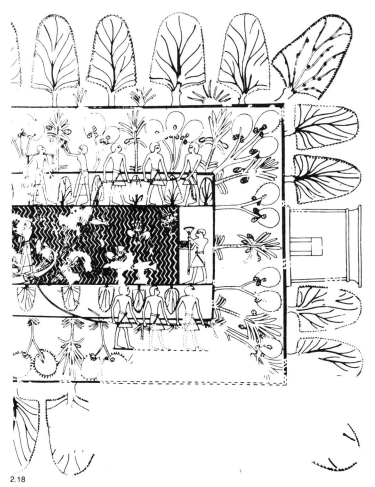

2.18

2.17. Cf. Schäfer, *Principles of Egyptian Art* pl. 42. Photo: Hirmer.

2.18. After Schäfer, *Principles of Egyptian Art* fig. 263.

while the Athenian's greater preoccupation with his figures promised more for the future of narrative art in Greece.[74]

And what now of this narrative art in Attic Geometric? Nothing in Argive demands a heroic or mythical setting. Are we to believe that in Athens the mood is totally different? At first, of course, we see in Athenian Geometric the stray horses, which more probably record status and are not especially heroic, or the odd mourner, certainly a mortal and contemporary. Then the animals are used in friezes as pseudo-abstract patterns. When the fuller figure scenes appear must we believe that, suddenly, the setting is heroic, or even "generalized heroic," an extreme sophistication for the period, whatever its new interest in the tombs of the long dead or epic poetry[75] may or may not have been?

But must the Muse of Attic Geometric be so inscrutable?

> Will no one tell me what she sings?
> Perhaps the plaintive numbers flow
> For old, unhappy, far-off things,
> And battles long ago;
> Or is it some more humble lay,
> Familiar matter of today?

The argument that the Attic Geometric scenes may be "generalized heroic" is supported by appeal to the "generalized heroic" scenes in later Archaic art. But it is a very different matter to believe in a period and art in which all scenes are "generalized heroic"—especially when the most elaborate are of funeral occasions conducted in a manner which does not conform particularly closely to the "heroic" tradition—and to believe in some "generalized heroic" scenes on, for instance, Attic black-figure, where there is already a rich repertory of identifiable heroic scenes as well as everyday ones. Indeed, we might be wary about how much deliberate "generalized heroic" we are obliged to admit even in the later period. When we see a black-figure Judgment of Paris without goddess attributes or inscriptions we still recognize it as the Judgment of Paris with some confidence. When we see a black-figure battle over a fallen warrior, without inscriptions, can we be so sure that the artist does not have a specific scene in mind?[76] The way in which, sometimes, a single hero name is added to identify a whole scene, be it a fight or a wedding, rather suggests that he does. Such generalization is more readily argued for scenes of everyday—the sort of generalization we have, I suspect, in the Geometric scenes of contemporary behavior. Much, of course, in the later Archaic can be fairly called "generalized heroic"

because it is unlikely that when the hacks of the Athenian potters' quarter, to whom we owe a good proportion of extant vases, repeated stock martial themes, they had much specific in mind; but *some* had, and the themes themselves almost certainly derive from specific heroic scenes or are adapted versions of them. It is repetition and lack of imagination that leads to this sort of "generalized heroic" art, rather than a conscious desire to depict the heroic past in terms of a generalized "good old days." If it *did*, we might have expected the themes to go beyond those for which mythical prototypes can easily be identified or posited. But if we admit even this degree of doubt in the later Archaic, it cannot as readily be admitted in the Geometric period. That, within the first two generations of a prolific figure style, the intention of the figure scenes should be ambivalent, may appear a safely uncontroversial compromise solution, but I think it also defies common sense.

A review of the alleged mythical occasions in Attic Geometric is unnecessary here, but I cannot pass over the twins, the so-called Molione, without comment. In 1965 I was able to describe fully their appearance on the New York krater,[77] and some arguments against their identification as the Molione have never been answered. On the krater they appear in the prothesis at the end of a line of men bringing gifts of food to the dead; on the back of the vase they confront a tripod; and they appear twice, in consecutive chariots, on a body frieze. Supporters of the Molione have to take this double appearance as an oversight,[78] which could be just plausible if they were well apart, but since they are on adjacent chariots it tells very strongly against any single specific identity for them. The skeptic sees them as a rather ungainly convention for showing two men standing side by side, using exactly the formula used by the Geometric artist for a team of horses: a parallel which has been called "a perhaps inappropriate application of logic,"[79] although any application of logic in this area might, I would have thought, be welcome. Ahlberg, who takes a proper view of the Attic funeral scenes as of contemporary behavior, still singles out the New York krater as showing a specific funeral, for King Amarynkeus of Elis, which the Molione attended. Why such an obscure event demanded depiction on an Attic vase is not easy to fathom. The suggestion, made first by T. B. L. Webster and supported by Coldstream,[80] that the Molione were a badge of the Neleid family in Athens, does not bear close inspection. Nestor never beat the Moli-

one, indeed they beat him, so they would be an odd choice for Nestor's descendants; and if they were so important to the Athenian family why do they and their story disappear from Athenian art and literature at exactly the time that Geometric figure conventions disappear? These objections were voiced in 1970[81] and are still unanswered.

The variety of the settings in which the twins appear in Geometric art seems also to tell against their identity. If scenes like prothesis or man-and-horse soon acquired a consistent iconographic scheme, why not an allegedly identifiable scene of myth? Their ubiquity is troublesome too—few Geometric studios are unscathed—Attic, Corinthian, Argive, and Laconian vases; Peloponnesian and Boeotian metalwork—a handsome distribution of interest in a story or figure which at the end of the Geometric period disappears entirely from Greek art. It does not appear again until an isolated occurrence on the throne at Amyclae over 150 years later. Detaching scenes of the twins in Geometric art to be adversaries of Herakles seems no solution, and together they outnumber all other suspected Geometric Greek myth scenes put together. But I fear the Molione will long be with us, to tax the ingenuity of their defenders. On the famous Agora jug (fig. 2.19), where they are doing different things in different directions behind a single rectangular shield,[82] it is even claimed, in support of the identity, that their helmet crests are joined together. This is not altogether apparent on the vase itself, where it could have been made quite explicit, and I suspect here another success for the eye of faith.

If the "generalized heroic" has to be abandoned, the major stumbling block to recognizing myth scenes in Geometric art remains the lack both of specific actions and of recognizable attributes which, often with inscriptions, helped both us and the contemporary viewers in later Archaic art. It is impossible to believe that the eighth-century Greek could do without these aids in the face of the scenes often cited as mythical. Most probably, as others have argued, myth is present, in scenes borrowed at first from the foreigners' arts, like the man and lion, then readily identified as a specific Greek mythological occasion. We see the same process with a local monster—the horse-man becoming a Centaur, and with foreign monsters—lion-women becoming the Sphinx, bird-women becoming the Sirens. But besides these problems there is another property in the Geometric artists' repertory which has given heart to those who people Geo-

2.19

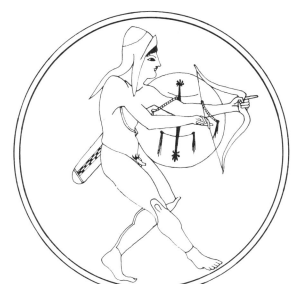

2.20

2.19. Agora Museum P 4885. Detail of oinochoe. American School of Classical Studies at Athens. Photo: M. A. Frantz.

2.20. Basel BS 459. Cup tondo. Drawing by Marion Cox after *Auktion, Münzen und Medaillen* XXVI, pl. 44.

2.21. After R. Tölle, *Frühgriechische Reigentänze* Beil. 4.

2.22. Clay seal impression from Knossos. After A. J. Evans, *Palace of Minos* III (1930) 313, fig. 205.

2.21

metric vases, even if only Attic ones, with heroes. It is the Dipylon shield.

The problems and possibilities provoked by study of the Dipylon shield and its apparent successor, the Boeotian shield, have long exercised scholars. There is perhaps little new that can be said, but the question is taken up again here, partly because in the rather partisan warfare some of the facts have been forgotten, and partly because there are problems of method as well as of interpretation.[83]

The problem is of a type common enough in archaeology—the deception practiced upon us by our terminology, so that we find it difficult to identify or admit anything which does not correspond readily to our classification of, in this case, a tower shield, or a figure-of-eight shield or a hoplite shield, or a pelta. When painters draw something we do not understand, we are perhaps too ready to say that it was they who did not understand, lacking our deeper insight into their life-style and the taxonomy to which we subject it. For example, on a vase by Oltos[84] we see a shield devised for an archer's left arm, leaving his hand free for his bow (fig. 2.20)—not a hoplite shield though like a small one, and given a shield band for a nonexistent porpax; not the shape of a pelta, but clearly lightweight. Does it need to be unreal? Is there anything plausible but unreal in Greek art of these years? A question to which we must return.

Identifiable mythological occasions on Geometric vases may be hard enough to justify, even by the devoted, but the Dipylon shield seemed to offer a clue. Webster suggested that it stamped the scenes as heroic because the shield did not exist in eighth-century Greece but was an echo of the Bronze Age figure-of-eight shield. Many scholars have found this difficult to believe, but Snodgrass, for instance, follows this view, lightly adjusted, and takes it as an obsolete or imaginary shield. However, he believes it to have been used "to underline the artists' general intention to convey the heroic status of a combat scene"[85]—the "heroic generalization" we have already discussed. J. Carter has reviewed the case for the reality of the shield most succinctly,[86] and not all the points have been adequately answered: for instance, why the shield begins to disappear in Late Geometric II, just when possible myth illustrations on the vases *begin* to appear. The intermittent use too is disturbing, with the shield appearing almost haphazardly beside other shield shapes, if it is meant to serve as a recognized convention for the heroic age. It seems about as effective a convention as "heroic

nudity" in Classical Greece; in other words, not a convention at all. A simple test of its significance, and of the identification of the alleged mythological scenes in Geometric art, would be to see how often the shield is shown in these scenes. It ought, if an indication of the heroic, to be commonplace. The question seems not to have been asked before. Of the fifteen vases or other objects listed by Hampe[87] as showing the "Molione" warrior twins, on only one, an early seventh-century Boeotian fibula, do they, and their adversary, carry the shield.[88] On almost all the others it is not even shown held by other figures on the vase or object bearing them. On the ten or more other Geometric vases or objects held to depict myth scenes it is worn by a so-called heroic figure only on the Lambros jug, on which K. Friis Johansen, followed by almost no one, it seems, saw the Trojan exchange of gifts between Ajax and Hektor.[89] On the London Sailor's Farewell krater there is one on the ship's stern.[90] On all the others it appears either not at all or, in a minority, with figures not connected with the alleged heroic group or action. This is not a particularly reassuring record for those who claim it as the badge of a hero, or even of the generalized heroic. It may even damn the idea completely.

Other arguments for its reality we need not rehearse. If the Dipylon shield is a distorted memory of a Bronze Age shield, that memory can only have been jogged by surviving specimens kept as curios or by the discovery of objects representing the shield. The latter is the more plausible and is favored by Webster and Snodgrass. Many have pointed out that the Dipylon shield (fig. 2.21)[91] does not in the slightest degree resemble the most often represented of the Bronze Age shield types—the figure-of-eight (fig. 2.22). True, a very few Bronze Age representations show cutouts at the sides rather than the simple double circle,[92] but they are a tiny minority and some clearly are to be explained by the technical needs of fitting a bezel to a ring or drilling details on a hard stone bead. At any rate, these few resemble the late Boeotian shield, not the Dipylon. All this has been often said and the counterarguments begin to carry a whiff of despair. If Geometric and Early Archaic warriors are "heroic," we may feel bound to ask why this is demonstrated by a shield form not described in Homer nor conspicuously like surviving Bronze Age forms, and not by, for example, the boars' tusk helmet, which is both described in Homer and was a piece of real Bronze Age equipment.

2.22

So what is the Dipylon shield? Many, from G. Lippold[93] on, have explained it quite satisfactorily and we need not dwell on detail. As I understand it, the normal type of light shield from the Bronze Age to the Classical period, and until the eighth century possibly the only type of shield, was made of animal hide stretched on frames of varying shapes. In size it could range from near body height to a small target. It usually had a single handgrip and was carried by a baldric round the shoulders. Its construction, the stretching, bending, and usually desired convexity, gave it an outline of curves and arcs. The earliest type we know is the largest, the Bronze Age figure-of-eight shield, but it could be straighter vertically, like a slice of a cylinder—the so-called tower shield. It could be circular or a deep crescent, as on the Mycenae Warrior vase.

perhaps on an ivory,[100] and thereafter it is shown worn by warriors who have to keep their hands free—charioteers. The bulging form is unmistakable on terra-cottas and vases. The only Classical form of our light shield is the arc-shaped pelta, covered with sheep- or goatskin.[101] This is commonly shown with hoplite fittings inside—*porpax* and *antilabe*—showing that these are not incompatible with the light shield.

The appearance of the shield with charioteers on Archaic vases is, it is said, another piece of conscious antiquarianism, because chariots were not used in battle in Greece after the Bronze Age. There are two things to remark here. The chariot itself is not an antiquarian element, since chariots of exactly the type depicted, from the Geometric period on, certainly existed at the very least for ceremonial or racing. Representations

2.23. Corinth CP 2096. Aryballos from Lechaion. After Snodgrass, *Armour* pl. 15.

2.24. Athens, N.M. 4082. Clay chariot group from Tanagra. Photo by author.

2.23

And at the end of the Bronze Age, to judge from an incomplete representation on a sherd from Iolcus,[94] it could have incurving sides and curved top, rather like a Dipylon shield. This must be the type used in succeeding centuries, but we are denied a view of it in the virtual absence of figure art,[95] until it appears as the Dipylon shield on Geometric vases of the eighth century, alongside other, smaller shapes, possibly of the same construction or of wicker, which can be circular, square, or rectangular. The iron shield bosses, if that is what they are, of various periods and places, may have embellished some of the smaller round shields.[96] The Dipylon shield is ubiquitous in Geometric art—which is itself odd if it was a piece of conscious antiquarianism on the part of the artist. It is seen on vases and other objects from Attica, Boeotia, Euboea, Thessaly, the Argolid, Cyclades, Chios, Samos, Crete, Arcadia—virtually wherever any Geometric figure art was practiced.[97] And there are and had been versions of it in the arts and hands of foreigners, Hittites and Syrians.[98] But by about 700 the heavier, round hoplite shield had been invented—many still, I suspect, covered with hide but stretched over a solid wooden backing, not a frame. The light shield's history is now more restricted. In its bilobed Dipylon form it is carried in battle on a Corinthian vase of the first quarter of the seventh century (fig. 2.23)[99] and

of their use in battle is another matter—not antiquarian but narrative of events in which the poets recorded that the chariot took its part. We must, however, absolve the shield of any heroic connotation now, since the important person in the chariot is not the charioteer but his passenger, and *he* carries a hoplite shield (fig. 2.24).[102] But with war chariots sung about, depicted, and chariots much used for ceremonial and racing, can we be so sure that it could find no role at all in military affairs? Certainly not for mass attacks in the Bronze Age manner, but perhaps as a sta-

2.24

tus symbol, and a useful one to carry a heavily armed hoplite and his gear to where he is needed—a practice Homer understood in his warfare, indeed normal at Troy although the fighting was nonhoplite and the chariot traffic very heavy. It may even have had a role once battle was joined; we know so little about the conduct of an Archaic battle. A horse and squire would be a more natural way, perhaps, for the wealthy hoplite,[103] but we cannot get away from the fact that Homer and other Archaic Greeks were well aware of the use of war chariots by others, and with the examples of them also in their poetry and art, I find it hard to believe that all Greeks, everywhere, totally excluded them in military affairs. In the Greek homeland we have no more than art to guide us, and the surely Archaic account of the Eretrian military parade for Artemis Amarysia of 3,000 hoplites, 600 cavalry, and 60 chariots (Strab. 448). On the periphery of the Greek world it was another matter. In Homer's day the Assyrians were using war chariots. In fourth-century North Africa chariots were used both against and for Greeks (Diod. xx.10.5–6; 12.1; 38.1).[104] In the early fifth century Cypriot war chariots receive a mention in Herodotos' account (v.113.1) of events in the Ionian Revolt. And, more importantly, Lydian war chariots were well known to Sappho[105] (fr. 16) and to Aischylos (*Pers.* 45–48). The Lydians were neighbors and often adversaries of the Ionians. Homer was an Ionian, and at this point we reach an obligatory and inevitable digression on Homer, and must leave the shields for a while.

By Homer I mean the poet or poets of the *Iliad* and *Odyssey.* First, two general propositions: 1. that Homer probably never saw an Attic Geometric vase in his life and that the only sophisticated figure art he knew was probably foreign (this is not the moment to discuss his blindness); 2. that no Attic Geometric artist had ever read or heard recited a single line of Homer (who may, at any rate, not have been composing until somewhat later—a view of some philologists in which I find some appeal, especially in the light of the so-called hoplite passages).[106] Next, a simple reminder about Homer's life and work is in order. He was a north Ionian, with Chios and Smyrna laying the best claims. His poems drew heavily on lays, or the material for lays, brought over to the eastern shores of the Aegean in the Dark Ages, and these were studded with recollections of life and behavior in the preceding Bronze Age of Greece. What Homer added was the brilliance of composition and perception of a great poet. But he betrays too a great deal about himself and his world in those parts of his poem which carry nuances of description, or which are added to heighten the dramatic qualities of his narrative—notably the similes. They are, as it were, his handwriting, like those personalized unconscious details of drawing by which we recognize artists of red-figure. These show Homer the Ionian: his knowledge of the topography and fauna of western Anatolia which goes far beyond the epithet-ridden allusions to the cities of the Greek homeland; his acute observation of the behavior of lions in the wild and as a threat to human settlement—experience which could be won in the valleys and hills of Anatolia, but not in homeland Greece; and, I would add, his acute observation of the structure and behavior of chariots on all sorts of ground, including a battlefield.[107] (We should not expect, at the dawn of Western literature and in poetry, specifications as consistent as those of a car manufacturer's manual.) The war chariots of the Lydians must have been as familiar to Homer's Ionians as the lions on the slopes of Mount Tmolus, heraldic animals of the Lydians, and often no less a threat.

The discussion has taken us from the Dipylon shield of the eighth century into the myth representations of sixth-century art and has shown, I hope, that it cannot be lightly assumed that the trappings of the heroic battle scenes were either imaginary or consciously antiquarian, although, through the demands of the traditional narrative, the behavior depicted was to some degree removed from that of contemporary life and battle. This brings us back to the shields, and to another type which appears often in the sixth-century scenes, and which also has links with both the Dipylon shield and its successors. I refer, of course, to the so-called Boeotian shield. Its shape, oval with side cutouts, clearly has much to do with the other shields we have been discussing. We know it only from representations—as indeed we know almost all Greek shields, except for some of the metal attachments or facings to hoplite shields. It is generally held today that the Boeotian shield did not exist, whatever view is taken of the reality of the Dipylon shield. It is perhaps difficult to be more reactionary than to propose not only that the Dipylon shield was a real shield, but also that speciments of the Boeotian shield really existed, whether carried into battle or not. But I am comforted by the thought that it is better to be reactionary than wrong, and as long as doubts linger they should be expressed.

First we must define our Boeotian shield.[108] It is constructed like a hoplite shield, not necessar-

ily more convex, and with *porpax* and *antilabe* within. It differs from the hoplite shield both in its shape and in having a baldric which is slung around the neck of the wearer.[109] This suggests that it is conceived rather as the Dipylon shield and other light shields, as one which can be carried on the back, though it need not be confused with the charioteer's light shield, often smaller but of similar outline. Its baldric suggests that it too is thought of as a light shield, compared with

2.25

the full hoplite shield, although it is often shown far more elaborately decorated. Its resemblance to the lighter shields is also indicated by the occasional representation in which it is supplied with cross straps for the warrior's forearm (fig. 2.25),[110] not the hoplite *porpax*. This is not a matter of inconsistency on the part of the artist, as might be claimed, and to call it so assumes that our classification and expectations of what we call a Boeotian shield override the representational evidence. If we take the representations at face value we have a narrow range of probably light shields, which can be carried and used like hoplite shields. Even the lightest of shields, the pelta, has the double grips within, but may otherwise be given cross straps for the forearm, exactly like some Boeotian shields. There is some variety in vase representations of round shields too, while, on the whole, the Boeotian shield is the most uniform in its trappings and use. Thus, we see some round shields slung at the back,[111] implying some sort of baldric, which is in fact sometimes shown.[112] These imply a light shield which has hoplite arm grips but can also be slung.

The Boeotian shield is normally fixed along the forearm, not across it, as are most long shields in other periods and places. This is an advantage since the shield then lies along the side, protecting as much or more of the body than the hoplite shield, without requiring the forearm to be bent at ninety degrees to support it, and in action it can be brought obliquely across the body, as it is shown in many vase scenes. In other words, the new tactics and hoplite fittings gave it a different role from the old Dipylon shield, just as the round shield too had changed its size, form, and function. The earliest representation of its use

2.25. Louvre G 1. Amphora by Andokides Painter. Detail. After FR pl. III.

2.26. Aryballos from Perachora. After T. J. Dunbabin, *Perachora* II, pl. 57.

2.26

worn like a hoplite shield and along the arm (fig. 2.26)[113] is only a little later than the last representation of the larger Dipylon shield in the battle line, and also on a Corinthian vase, worn by Achilles and others.

So far all seems perfectly realistic, and artists are no more confusing in their depiction of it than they are in their depiction of many other real objects. In art it is carried by warriors in a number of anonymous battle scenes, but it looks very much as though for artists the Boeotian shield was not a generalized piece of heroic property but a specific shield type, well understood and especially appropriate to certain heroic figures. Thus, it is most commonly worn by Ajax and Achilles, sometimes by Herakles and Amazons.[114] Ajax's *sakos* calls for special comment in Homer[115] and Achilles' shield, of course, with the rest of his armor, was divinely wrought and described in detail by Homer, but after Eastern, not Greek, models.[116] Herakles' shield for his fight against Kyknos was famous, though the Hesiodic *Aspis* (early sixth century) does not describe it as Boeotian.[117] That Amazons carry it is a reflection of its function as a light shield for ladies; during the Late Archaic period they abandon it for the pelta which is fitted in the same way, with grips or straps. When Neoptolemos carries one we may assume that the Achilles connection is strong, and when Telamon[118] does, as often in Herakles' Amazonomachies, the Ajax connection, perhaps reinforced by the meaning of his name "baldric." Aineias (carrying Anchises) may be influenced by Ajax (carrying Achilles).[119] Others bearing it are few and far between.[120]

It has been this heroic (but not *generalized* heroic) use of the Boeotian shield in art that has been the main source of skepticism about its reality, and has led to its being regarded as an imaginary form, inspired by the either equally imaginary or out-of-date Dipylon shield, and an indication of the heroic status of its bearer.

There are other difficulties, however. Are we really to believe that in this case, and perhaps in this case only so far as can be seen, Greek artists depicted a plausible object which did not exist? I can see no parallel in Archaic Greek art apart from magical objects like thunderbolts or wheeled and winged thrones; and perhaps Athena's helmet, still based on a real helmet type but trimmed for wear by goddesses and Amazons; and perhaps the persistent representation of high crests for helmets, left over from the earlier Archaic (and real) Kegelhelm. And if it is an invented heroic form, with no real antecedents,

it is surely remarkable that this fiction should be so wholeheartedly adopted by artists all over the Greek world. There is no major series of figurative scenes in Archaic Greek art in which it does not appear.[121]

It seems by no means unreasonable, and even demanded by the evidence, to believe that Boeotian shields existed. They may not have ever or anywhere been in general battle use, and in the standard hoplite phalanx we would certainly expect the standard round hoplite shield. But for others, some officers, perhaps not themselves in the phalanx, it might have been useful, being lighter and decidedly distinctive. In an art which was committed to representing mythological events in modern dress, it would have been the obvious, indeed only, alternative hoplite shield form to employ for the distinctive armor of figures like Ajax and Achilles, and we often see how readily it lent itself to appropriately elaborate decoration. This may have abetted other real roles for it, in ceremonial or for votive purposes, and this we might remember.[122]

Part of the argument hinges on the impossibility of such a piece of conscious antiquarianism in Archaic Greek art. Homer, it might be said, could be antiquarian, and mention objects long out of use—the bronze weapons, the boar's tusk helmet—so why not an artist? But this is not conscious antiquarianism so much as a manifestation of a continuing tradition.[123] If Homer was being a conscious antiquary he might have described his heroes' shields as the Dipylon shield or Boeotian shield, and he very clearly does not, so I doubt whether he would have cast either in the role so often claimed for them. In these subjects Homer is to a large extent dealing with prefabricated descriptions, duplicated perhaps over centuries by the repetition of verse. The artists' material is quite different and the only natural thing for him to do is to present his narrative in modern dress. Only when comparable prefabrication and duplication in art is possible—with the clay mold or coin die—do we commonly find comparable conservatism of out-of-date types. "Modern dress" for figurative art was surely the rule: exceptions have to be proved. We miss the point to say "an artist would render an apparently unexceptionally contemporary scene and then transform its setting by the mere addition of a few heroic names as captions to the figures."[124] There was no other way in which an artist *could* envisage a heroic scene. And surely it is the immediacy of this contemporary image for heroic stories, in art or on the stage, which so much enhanced their function, often on the

stage and sometimes in art, as a comment on contemporary life and problems. If the Greeks had presented their myth history in a setting of antiquarian make-believe, it would not have played the profound and effective role it did in Greek culture.

What we need is evidence from outside Greek art, not bedeviled by what we believe possible or impossible in the terms of Greek artistic conventions; or some sort of physical evidence. Both, perhaps, are not altogether lacking.

Reliefs in different places on buildings of both Dareios and Xerxes at Persepolis, of the first half of the fifth century, show troops of the royal guard carrying what at first sight seems to demand the title Boeotian shields (fig. 2.27).[125] "There are several possible explanations," says Snodgrass, "—conceivably Ionian influence."[126] One certain explanation is that shields of this shape existed. There is nothing in the hands of the figures on the Persepolis reliefs which is not real; indeed they are renowned for the carefully observed detail of dress and armor, even of obscure subject peoples. And whatever the part Ionians played in the execution of the Persepolis reliefs it is impossible to believe that they could impose on representations of the royal guard a Greek artistic antiquarian figment that existed neither in Greece nor Persia. But we must be even more cautious. Although the shape is right, with the cutouts and most of them with a clearly defined flat border,[127] it is clear that they are held with the forearm going *across* the narrow axis and not along the length of the shield (fig. 2.28). Since they are almost as broad as they are high and are not in any sense "long shields" this is understandable. The reliefs therefore demonstrate at the very least that a shield of this shape did exist. What it owes to the Boeotian shield is not easy to judge but it is the only local shield type shown on the Persepolis reliefs and seems to have been used by a select hoplite-style guard.

For evidence *in corpore* for the Boeotian shield we are naturally harder pressed, given the nature of the materials from which it must have been made. L. Ognenova's attempt to reconstruct one from fourth-century fittings at Trebenishte which match the patterns on a Boeotian-shieldlike pattern on a Late Bronze Age ivory gaming board at Megiddo has understandably not won much support.[128] Before we look again, however, a word about the modern nomenclature of the shield—"Boeotian"—is in order. It has no ancient authority. The main reason for its use is the appearance of the shield as a device on coins of Boeotia from the end of the sixth into the fourth

century.[129] It is commonly thought[130] that the ancient etymology of the name Boeotia, from βοῦς (bull), and the material with which the shield was covered, was enough to determine the choice of device. (How such knowledge of the construction of an object which is held to be a fiction was obtained is not explained; nor the fact that other shield types may well have been covered with hide.) I imagine there are other possibilities, even the resemblance of the shield to the initial letter of the city Thebes. Pindar calls Thebe χρύσασπι "golden-shielded" (*Isthm.* I.I). What shield is this? A famous dedication or display piece, perhaps, though hardly one held by any statue of the city's eponymous heroine. At the time of the battle of Leuctra in 371 it was observed that the arms were missing from the Temple of Herakles, which showed that the hero had taken the field himself (Xen. *Hell.* VI.4.7).[131] Whatever the reason, the association seems clear and indeed it may be that cattle-rearing Boeotia was a prime source of hide shields. Ajax's great shield was made by a Boeotian, Tychios of Hyle (Hom. *Il.* VII.219–21), an association which must be at least as early as the seventh century but need not be Bronze Age. (Hyle is not certainly located.)

We return to the shield itself. It is often shown fitted as a hoplite shield with *porpax* and *antilabe,* the *porpax* fastened by a shield band, which on a real shield is made of bronze and is an object readily recognized *in corpore* in the Archaic period, from the excavations at Olympia and elsewhere. The round hoplite shield, in the action position, is held with the forearm horizontal, so the shield band runs from the top to bottom. Where the band is decorated with figured panels these are therefore arranged one above the other. The Boeotian shield, as it appears on vases, has the forearm running along the shield and most (although admittedly not all) blazons show that it was usually carried with the long axis vertical. So the shield bands for its *porpax* are horizontal, they are relatively much shorter and might even therefore be broader, and when decorated the figure panels would be side by side, not one above the other as on a round hoplite shield. If we look at E. Kunze's list of Archaic bronze shield bands we do in fact find a significant minority in which the panels are set side by side or the decoration is a frieze, even an example in which there seems to be a broader strip of two rows, superimposed. We cannot be absolutely sure that they are shield bands and they are often thought to be from wooden boxes, but they closely match the vertical shield bands

2.27

2.28

in size and decoration, lacking, in the fragmentary specimens preserved, the palmette finials normal on the vertical bands and sometimes shown in the representation of Boeotian shields. A rough count of the finds of these horizontal bands is as follows:

Olympia	possibly one (out of dozens of vertical bands)
Corinth	three or four
Perachora	one
Eleutherai in Boeotia	perhaps seven
Eutresis in Boeotia	one
Orchomenus in Boeotia	two or more
Ptoion sanctuary in Boeotia	eight

Over 70 percent of the examples, then, come from Boeotia; every site in Boeotia that has yielded the bronze reliefs at all is represented; at Eleutherai and Orchomenus only this type is represented; and at the Ptoion they outnumber the vertical bands by two to one.[132]

There are elements of a case for the existence of shield bands suited to Boeotian shields rather than the round hoplite shields, for their existence especially in Boeotia, and their quality, at least as votives.

The evidence is, admittedly, scrappy and indecisive, but in a subject which, in common with others that are becoming increasingly popular in classical archaeology, tends to deal more and more with the speculative than the real, it is perhaps salutary to return to where all our archaeological studies should begin, and of which they should never lose sight, the evidence from the ground, and the exercise of our eyes as well as of our imaginations.

2.27. Persepolis, Council Hall. Drawing by Marion Cox after E. F. Schmidt, *Persepolis* I, pl. 63.

2.28. Persepolis, Council Hall. Drawing by Marion Cox after E. F. Schmidt, *Persepolis* I, pl. 63.

NOTES

1 R. M. Cook, *Greek Painted Pottery* (London 1972) 292, 297.
2 Cf. review by J. N. Coldstream in *Gnomon* 46 (1974) 273–78.
3 Esp. G. Ahlberg, *Fighting on Land and Sea in Greek Geometric Art* (Stockholm 1971).
4 H. Sackett, "A New Figured Krater from Knossos," *BSA* 71 (1976) 123–25, pl. 16; *JHS-AR* 1976/1977, 15–16.
5 P. Courbin, *La Céramique Géometrique de l'Argolide* (Paris 1966) 475–83 on these theories.
6 B. Schweitzer, *Greek Geometric Art* (London 1969) 62–63. Cf. J. Bouzek, *Homerisches Griechenland* (Prague 1969) 192—Apollo.
7 J. N. Coldstream, *Greek Geometric Pottery* (London 1968) 129–44, cf. 362–64; idem, *Geometric Greece* (London 1977) 141–45; idem, *Deities in Aegean Art: Before and after the Dark Age* (London 1977) 12.

8 N. Himmelmann-Wildschütz in *Über einige gegenständliche Bedeutungsmöglichkeiten des frühgriechischen Ornaments* (Wiesbaden 1968).
9 *CVA* Laon 1, pl. 2.3.
10 A. Ruckert, *Frühe Keramik Böotiens* (Bern 1976) pl. 17.1, cf. pl. 26.3 and the left-hand man on the New York krater, *JHS* 86 (1966) pl. 2b (left).
11 Coldstream, *GGP* pl. 64k.
12 Ibid. pl. 46o.
13 Courbin, *CGA* 405, n. 2.
14 *BSA* 48 (1953) pl. 17 A3, A10.
15 Courbin, *CGA* pls. 44, 45.
16 Argos c 870; Courbin, *CGA* pl. 62.
17 Thus on Argos c 201. Also on c 1 (Courbin, *CGA* pl. 28; no "ropes" and very short side legs); c 210 (pls. 41, 42); cf. c 4511 (pl. 133; biped, with "rope"); c 3399 (pl. 141; no "ropes"); A. Frickenhaus, W. Müller, and F. Oelmann, *Tiryns* I (Athens 1912) pl. 15.3 (crossed "ropes"); *BCH* 78 (1954) 411, fig. 2 (Argos).
18 Courbin, *CGA* pls. 41, 42.
19 Frickenhaus, Müller, and Oelmann, *Tiryns* I, pl. 15.1; Argos c 11 (Courbin, *CGA* pl. 137).
20 E.g., Coldstream, *GGP* pls. 8d, 14c, 35, 36a, 45a.
21 With tripods, Argos c 210, c 201: with mangers, Argos c 210, c 158.
22 J. Wiesner, *Fahren und Reiten, ArchHom* I F (Göttingen 1968) F7.
23 Courbin, *CGA* pl. 40.
24 Coldstream, *Geometric Greece* 141.
25 Coldstream, *GGP* 129.
26 *BSA* 48 (1953) pl. 17 A12.
27 Courbin, *CGA* pl. 36.
28 Ibid. pl. 63.
29 Ibid. pl. 136.
30 E. g., *BSA* 48 (1953) pl. 17 A12 (already very damp); oblique panels of zigzags rising up to the horses' heads on *Deltion* 26B (1971) pl. 100b; Argos c 3268 and 3494 (Courbin, *CGA* pl. 133), and c 3944 (pl. 142; with vertical, hatched, double zigzags); R. Hampe, *Frühe griechische Sagenbilder* (Athens 1936) 6, fig. 27 (Tiryns).
31 *BSA* 48 (1953) 37 fig. 10 A4; *Deltion* 28B (1973) pl. 115γ (beside it); Frickenhaus, Müller, and Oelmann, *Tiryns* I, pl. 15.1; on a tub between two horses, Argos c 13 (hatched zigzags); with fish, *BSA* 48 (1953) pl. 17 A.10.
32 As Coldstream, *GGP* pls. 7a, 8b.
33 *BCH* 79 (1955) 3, fig. 1 and pl.1.
34 Courbin, *CGA* 397–403, 480–81.
35 Ibid. pl.103.
36 Cf. Argos c 759, ibid. pl. 129.
37 Ibid. pl. 133.
38 Ibid. pl. 49. And more like ropes, dotted and joined, on *AthMitt* 78 (1963) Beil. 14.3.
39 Argos c 13; Courbin, *CGA* pl. 31.
40 Strangest, this boxed bird with an angular eel on a frag. in Bryn Mawr, P 738.
41 Courbin, *CGA* 371–73.
42 *BSA* 48 (1953) 38, fig. 11 A9 and p. 40.
43 *BCH* 77 (1953) pl. 29 bottom right.
44 C. Waldstein, *The Argive Heraeum* II (Boston 1904) pl. 56.21; recalling the bipod in this position on Argos c 4511 (Courbin, *CGA* pl. 133); a wavy line like a halter on *BCH* 78 (1954) 411, fig. 2 (Argos) and alone on Argos c 155 (Courbin, *CGA* pl. 119); between women on *BCH* 77 (1953) pl. 29 center top, one down.
45 Argos c 2362 (Courbin, *CGA* pl. 37), c 1146 (pl. 65) and from Mycenae (pl. 82) cf. c 756 (pl. 65) panel

and rim patterns; *BCH* 77 (1953) 98, fig. 3 and pl. 25 right of center (crosshatched); *BCH* 78 (1954) 413, fig. 5.

46 Courbin, *CGA* pl. 5.

47 *BCH* 85 (1961) 677, fig. 6; *Deltion* 28B (1973) pl. 115γ.

48 E.g., from Asine (Courbin, *CGA* pl. 12); Argos C 214 (pl. 84); from Mycenae (pl. 83, over "water"); C 209 (pls. 100–101); cf. C 22 (pl. 58).

49 E.g., *Deltion* 28B (1973) pl. 115b; Argos C 1 (Courbin, *CGA* pl. 28); C 236 (pl. 72); C 2590 (pl. 135); C 159 (pl. 142); Coldstream, *GGP* pl. 28a; *AAA* 7 (1974) 18, fig. 10; O. Frödin and A. W. Persson, *Asine* (Stockholm 1938) 327, fig. 222.6. To these perhaps should be added the fairly common quatrefoil patterns, e.g., Argos C 928 (Courbin, *CGA* pl. 7); from Asine (pl. 12); C 1 (pl. 28); C 1018 (pl. 35); C 1017 (pl. 36); C 210 (pl. 42); in Paris (pl. 48); C 1237 (pl. 134); C 1020 *bis* (pl. 141); *BCH* 77 (1953) pl. 24, left, one down, and pl. 29 bottom right.

50 Argos C 1019 (Courbin, *CGA* pl. 49); C 871 (pl. 57); C 2462 (pl. 137); C 4437 and 3462 (pl. 141); *Argive Heraeum* II, pl. 57.4; *BCH* 77 (1953) pl. 29 below center.

51 Frickenhaus, Müller, and Oelmann, *Tiryns* I, pl. 15.1; Coldstream, *GGP* pl. 29b (tethered horses); Argos C 11 (Courbin, *CGA* pl. 137); C 13 (pl. 31). Cf. *Asine* 327, fig. 222.6.

52 *Deltion* 26B (1971) pl. 100b (troughs?); 28B (1973) pl. 115γ; Argos C 14 (Courbin, *CGA* pl. 29); C 870 (pl. 62); from Mycenae (pl. 82); *BCH* 77 (1953) pl. 24, left, three down.

53 E.g., Argos C 1018 (Courbin, *CGA* pl. 35); C 1017 (pl. 36); C 210 (pls. 41, 42); C 201 (pls. 44, 45); C 3959 (pl. 54); *AAA* 7 (1974) 18, fig. 10; *BSA* 48 (1953) 37, fig. 10A4; Coldstream, *GGP* pl. 29d; Frickenhaus, Müller, and Oelmann, *Tiryns* I, pl. 15.3, 13; *Argive Heraeum* II, pl. 57.3; H. Schliemann, *Tiryns* (London 1886) pl. 18; *BCH* 99 (1975) 616, fig. 57 (Asine); *JHS-AR* (1974/1975) 10 fig. 13 (Asine).

54 E.g., Argos C 928 (Courbin, *CGA* pl. 7); MN 231 (pl. 32); C 4029 (pl. 51); *Argive Heraeum* II, pl. 57.1, 3; *AthMitt* 78 (1963) Beil. 16.2–3 and 17.1. And cf. Argos C 890 (Courbin, *CGA* pl. 64); C 1146 (pl. 65); *BCH* 77 (1953) 98, fig. 3; Schliemann, *Tiryns* 99.

55 Coldstream, *GGP* 134–35, pl. 28c, d. Argos C 738 (Courbin, *CGA* pl. 34; two heads in a strip with broken meander); C 239 (pl. 48); C 171 (pl. 61); C 3279 (pl. 133; verticals only); C 4258 (pl. 134; dotted trellis); C 1203 (pl. 136); Nauplion 10006 (pl. 11); Frickenhaus, Müller, and Oelmann, *Tiryns* I, 147, fig. 13 (Berlin); *Argive Heraeum* II, pl. 56.20; cf. *Asine* 321ff., figs. 219.8, 220.1.

56 Courbin, *CGA* pl. 8.

57 E.g., Eur. *Tro.* 1087, *Supp.* 365; cf. Strab. 388.

58 R. A. Tomlinson, *Argos and the Argolid* (London 1972) 10–11, 27, 65.

59 Cf. the Danaids' words in Aesch. *Supp.* 23, 1026–29; Strab. 371 on Lerna. On Aristotle's observation about dryness in the Argolid (*Mete.* 1.14), see G. L. Huxley, "Aristotle as Antiquary," *GRBS* 14 (1973) 275–76.

60 R. Tölle, *Frühgriechische Reigentänze* (Waldsassen 1964) 41–48.

61 Ibid. pl. 23c (Tiryns); Frickenhaus, Müller, and Oelmann, *Tiryns* I, pl. 19.2; Schliemann, *Tiryns* 95, pl. 16 below; *BSA* 48 (1953) 39, fig. 12 A.17; with fish on Argos C 2551, 2556, 2568 (Courbin, *CGA* pl. 144) and ibid., for the dotted-lozenge shoals.

62 Yet even this may do less than justice to the Argive

artist and what he tells us. There are remarkable parallels to be drawn with the apparent water imagery of man's very earliest essays in art, and often in combination with horses. Cf. A. Marshack, "Upper Paleolithic Symbol Systems of the Russian Plain; Cognitive and Comparative Analysis," in *Current Anthropology* 20 (1979) 271–311 and "The Maeander as a System" in *Form in Indigenous Art,* ed. P. J. Ucko (Canberra 1977) 285–317, esp. the Ardales horses and water, 316, pl. 45. I am indebted to Marshack for reprints and D. E. Thompson for making the connection.

63 J. L. Benson, *Horse, Bird and Man* (Amherst 1970).

64 H. Schäfer, *Principles of Egyptian Art,* trans. J. Baines (Oxford 1974) 249, fig. 265a, b.

65 Ibid. 250, fig. 266.

66 E.g., Argos C 201 (Courbin, *CGA* pl. 43); C 239 (pl. 48); C 171 (pl. 61); Nauplion 10006 (pl. 11); from Asine (pl. 12, neck); upper panels on vase from Mycenae (pl. 83); *Asine* 317, fig. 218.5; *BCH* 99 (1975) 616, fig. 57 (Asine).

67 Schäfer, *Principles Egyptian* pl. 42.

68 Ibid. 143, fig. 128.

69 Ibid. 219, fig. 230 and pl. 20.

70 Ibid. 182, fig. 179.

71 Ibid. 248, fig. 263.

72 An exception is *Argive Heraeum* II, pl. 58.7 (a very austere panel). The double ax is not a weapon. The warlike use of an ax in Homer is alien (H. Lorimer, *Homer and the Monuments* [London 1950] 305–6) or special to ship fighting, though A. M. Snodgrass, *Early Greek Armour and Weapons* (Edinburgh 1964) 166, seems to wish to believe in it. Hom. *Od.* v.234 gives the proper use for a double ax by a Geometric Greek—cutting down trees; cf. Hom. *Il.* XXIII.114 and Hom. *Il.* XXIII.851 for its value as a prize. Its only appearance as a weapon in Geometric art is in a Boeotian boar hunt (*AthMitt* 26 [1901] pl. 5; cf. H. G. Buchholz et al., *Jagd und Fischfang, ArchHom* I J [Göttingen 1973] J98) not in any of the regular battle scenes, and its common placing on vases, usually over horses, is in a position not otherwise occupied by any weapon. Its appearance in the Argos panoply grave is explained by the firedogs also present (cf. Boardman, *KrChron* 13 [1971] 7–8). H. W. Catling, in *Lefkandi* I, eds. M. R. Popham and L. H. Sackett (London 1980) 256, finds the idea frivolous, but it answers the evidence. Later too the double ax is a civilian woman's weapon (Klytaimnestra, Thracian women, Agaue's friends) not a military woman's (Amazons, who take to a double ax only in the Hellenistic period).

73 Thus, close analysis of Attic filling ornament, as by G. Ahlberg in *Prothesis and Ekphora in Greek Geometric Art* (Gothenburg 1971) seem less rewarding than study of the Argive.

74 A very few other non-Argive scenes may be viewed, keeping in mind what we have thought to learn from the Argive. These are just a sample: In Attic, the construction of the manger or trough in Coldstream, *GGP* pl. 8d. In Boeotian, the construction between horses on Ruckert, *Böotiens* pl. 15.4; the way a truncated strip of the vertical dividing panel is used to serve as manger, ibid. pl. 19.1; the geometricization of the manger stand, ibid. pl. 26.2; the constructions behind the birds, ibid. pl. 27.4 and between them on pl. 27.5; the combination of halters and manger on Hampe, *Sagenbilder* pl. 28 top. In Corinthian, of course, the combination of wire birds and multiple wavy lines, as Coldstream, *GGP*

pl. 19f, g, k. In Euboean, the way the meander in the panel between horses on one side of the Scheurleer krater (*BICS* 18 [1971] pl. 2e) intrudes into the mangers and forms part of them on the other side (Schweitzer, *GGA* pl. 80).

75 J. N. Coldstream, "Hero-cults in the Age of Homer," *JHS* 96 (1976) 8–17, for the fullest view of these. It is to be hoped that the recent discovery of a "Homeric" burial (bones wrapped in cloth in an urn) of the tenth century B.C. at Lefkandi will subdue speculation about Greeks and Cypriots arranging their interments with a copy of the *Iliad* in their hands.

76 In this volume (p. 127) G. F. Pinney has given a specific mythical context to another of the "generalized heroic" scenes of the sixth century—the warrior departing with a bowman.

77 *JHS* 86 (1966) 1–5. See further K. Fittschen, *Untersuchungen zum Beginn der Sagendarstellungen bei den Griechen* (Berlin 1969) 68–75—skeptical; Courbin, *CGA* 493–94—skeptical; Ahlberg, *Prothesis* 240–52; A. M. Snodgrass, *Archaic Greece* (London 1980) 76–77; Coldstream, *Geometric Greece* 352–54; R. Hampe, s.v. "Aktorione" in *Lexicon Iconographicum Mythologiae Classicae* I (1981); J. Carter, "The Beginning of Narrative Art in the Greek Geometric Period," *BSA* 67 (1972) 52–53; E. Walter-Karydi, "'Ἕνα φρεσὶ θυμὸν ἔχοντες," *Gymnasium* 81 (1974) 177–81—skeptical; S. Brunnsåker, "The Pithecusan Shipwreck," *Opus Rom* 4 (1962) 203–4—inseparable twins or sworn brothers.

78 So Hampe "Aktorione" and Ahlberg, *Prothesis* 240–52.

79 Snodgrass, *Archaic Greece* 77.

80 Coldstream, *GGP* 351.

81 The writer in *Gnomon* 42 (1970) 501.

82 B. Sparkes and L. Talcott, *Athenian Agora* VIII (Princeton 1962) pl. 17, no. 304. The published drawings are misleading on this detail.

83 In "Towards the Interpretation of the Geometric Figure-scenes," *AthMitt* 95 (1980) 53–55, Snodgrass usefully reviews the discussion so far. My own view is adumbrated in *The European Community in Later Prehistory: Studies in Honour of C. F. C. Hawkes* eds. J. Boardman, M. A. Brown, and T. G. E. Powell (London 1971) 126–27, and *CR* 25 (1975) 288–89.

84 Basel BS 459; *Paralipomena* 327, no. 50 *bis; Auktion, Münzen und Medaillen* XXVI (Basel 1963) pl. 42, no. 125 I, and pl. 44. Cf. the small round shield held by the archer on *Ars Antiqua* IV (Lucerne 1962) pl. 45, no. 133 (*ARV²* 351, no. 6, Bonn Painter).

85 Snodgrass, "Interpretation" 54.

86 In an excellent article, Carter, "Beginning of Narrative" 54–58; and Fittschen, *Untersuchungen* 36–39; Ahlberg, *Fighting* 59–66.

87 Hampe, "Aktorione."

88 Ibid. no. 14; R. Hampe et al., *Neuerwerbungen 1957–1970* (Heidelberg 1971) pl. 87, no. 123A.

89 K. Friis Johansen, *Ajas und Hektor* (Copenhagen 1961); cf. Fittschen, *Untersuchungen* 39–41, fig. 12; Carter, "Beginning of Narrative" 53–54.

90 K. Schefold, *Myth and Legend in Early Greek Art* (London 1966) pl. 5c.

91 A range of the types shown in Tölle, *Reigentänze* Beil. 4. The shapes are, of course, stylized away from the natural to the same degree as human figures are stylized by the Geometric artist.

92 P. Cassola Guida, *Le armi defensivi dei micenei nelle figurazioni* (Rome 1973) 38–44, with list and illustrations. Snodgrass, "Interpretation" pl. 12.1–2.

93 G. Lippold in *Münchener Archäologische Studien. Dem Andenken Adolf Furtwänglers gewidmet* (Munich 1909) esp. 417–20, and Ahlberg, *Fighting* 59–66 for the best accounts.

94 Snodgrass, *Armour* 58–59; Cassola Guida, *Armi* 38–44 and pl. 35.1. On the Bronze Age shield types see H. Borchhardt in *Kriegswesen* I, *ArchHom* I EI (Göttingen 1977).

95 A square shield (?) held by a hunter on the ninth-century Cretan vase, *JHS-AR* 1976/1977, 16, fig. 34, and cover.

96 Carter's account of these, "Beginning of Narrative" 56, is useful.

97 Some occurrences outside Attica and Boeotia: Argive—Courbin, *CGA* 158, 428; Euboean—*BICS* 18 (1971) pls. 2b, 3e; Cycladic—Schefold, *Myth and Legend* pl. 24c; Arcadia—Boardman in *European Community* 125–27 (cf. *Deltion* 16A [1960] 63–71, pls. 28A–33); Thessaly—S. Karousou, *AthMitt* 91 (1976) pls. 5, 6—Karditsa bronze, as Achilles; Crete—*BSA* 57 (1962) 32, fig. 3; Chios—J. Boardman, *Excavations at Chios, 1952–1955: Greek Emporio* (London 1967) 108, fig. 64x; Samos—Coldstream, *GGP* pl. 64h.

98 Hittite on an Egyptian relief, Lorimer, *Monuments* 163–64. Zinjirli—Snodgrass, *Armour* 229, n. 85 and "Interpretation" pl. 13.2 That a Cypriot artist was confused by the extreme stylization of the Greek Geometric body-plus-shield is not altogether surprising (ibid. 56, pl. 12.3). This does not reflect on the shield's reality in Greece since the artist in this period uses conceptual formulae, not the life class, and the foreign formula did not, in this case, register its significance in the artist's mind. Karageorghis and des Gagniers describe the confusion well, suggesting that the artist took the shield's lower border for a tunic (ibid. n. 24); and compare an Argive, *AthMitt* 78 (1963) Beil. 17.1. There are, it seems, no Dipylon shields in Cypriot art, only round shields. The figurine, Lorimer, *Monuments* pl. 8.2, is surely later and carries a Greek Boeotian shield.

99 Snodgrass, *Armour* pl. 15; Carter, "Beginning of Narrative" pl. 12c.

100 T. J. Dunbabin, *Perachora* II (Oxford 1962) pl. 177.A 35, as not later than about 660. Another early occurrence is on a relief pithos in Eretria Museum (unpublished).

101 J. G. P. Best, *Thracian Peltasts* (Groningen 1969) 3; J. K. Anderson, *Military Theory and Practice in the Age of Xenophon* (Berkeley and Los Angeles 1970) 112–13. Small circular Burmese wicker shields in Oxford (Tradescant Coll.) have two grips within.

102 The clay group from Tanagra, Athens, N.M. 4082; P. A. Greenhalgh, *Early Greek Warfare* (Cambridge 1973) 29, fig. 20; or Amphiaraos and Baton on Acr. 2112 (B. Graef and E. Langlotz, *Die antiken Vasen von der Akropolis zu Athen* I [Berlin 1925] pl. 92; *ABV* 58, no. 120, C Painter).

103 Greenhalgh (*Warfare*) explores all this well. Reviews, favoring limited Greek use of chariots in the eighth century, by M. Littauer in *CP* 72 (1977) 363–65, by J. Bouzek in *Gnomon* 47 (1975) 520–21; and cf. Anderson (next n.).

104 J. K. Anderson, "Homeric, British and Cyrenaic Chariots," "Greek Chariot-Borne and Mounted Infantry," *AJA* 69 (1965) 349–52 and 79 (1975) 175–87. Greenhalgh, *Warfare* 14–18, "The Dendra Charioteer," *Antiquity* 54 (1980) 203–4 for the Bronze Age.

105 D. L. Page, *Sappho and Alcaeus* (Oxford 1955) 54–55.

106 Snodgrass, *Armour* 176–79.

107 That he exaggerates their use and prefers them to horse riding is clear (whence the ditch-jumping problem; Greenhalgh, *Warfare* 54) but that does not mean that he was totally ignorant of their role and behavior in battle.

108 The best discussion remains Lippold, *Andenken Furtwänglers* 410–42.

109 Also carried by its baldric on Toledo 55.225 (*CVA* I, pl. 7.2).

110 Aineias on Cambridge 8/17 (*CVA* I, pl. 23.1); on Louvre G I (*ARV²* 3, no. 2, Andokides Painter; *JHS* 71 [1951] pl. 17; Lippold, *Andenken Furtwänglers* 439, fig. 13); on a calyx-krater by Oltos in the Louvre (where also a pelta similarly fitted). With *porpax* and *antilabe* as well as straps for Oltos' Herakles on London E 8 (*ARV²* 63, no. 88; J. Boardman, *Athenian Red Figure Vases* [London 1975] fig. 65) and on his hydria (*Paralipomena* 327, no. 6 *bis*); cf. the archer's shield, our fig. 2.20.

111 Several Amazons—D. von Bothmer, *Amazons in Greek Art* (Oxford 1957) pl. 63.1, 2, 7; perhaps Exekias' Demophon and Akamas (*ABV* 143, no. 1; E. Pfuhl, *Malerei und Zeichnung der Griechen* [Munich 1923] fig. 228); in Corinthian, Baton on the Amphiaraos krater (ibid. fig. 179); cf. Anderson, "Mounted Infantry" 185–86.

112 For a warrior by Psiax (Cleveland 76.89; *ARV²* 7, no. 7 and *Paralipomena* 321; Boardman, *ARFV* fig. 15; *AntK* 22 [1979] pl. 13.2). On a clay relief from Apollonia Pontica, for a trumpeter-hoplite (Å. Åkerström, *Die architektonischen Terrakotten Kleinasiens* [Lund 1966] pl. 2.1). There are also reversible hoplite shields with two *antilabai* (references in M. Robertson, "The Gorgos Cup," *AJA* 62 [1958] 59).

113 *Perachora* II, pl. 57, no. 27; clearly not to be taken for a Dipylon shield, *pace* Snodgrass, *JHS* 94 (1974) 225–26 (cf. Snodgrass, *Armour* 230, n. 94). Little later in proto-Corinthian on K. Friis Johansen, *Les Vases Sicyoniens* (Paris 1923) pl. 33, and cf. the long shields on ibid. pl. 34.2 (both these vases by the Macmillan Painter—*BSA* 48 [1953] 179—who had an eye for martial scenes, as on the Chigi vase).

114 Lippold, *Andenken Furtwänglers* 425–37, 487–88. For Achilles, see S. Karousou, "Ein frühes Bild des Achilleus?" *AthMitt* 91 (1976) 28.

115 Borchhardt, "Kriegswesen" E3–E4 (E23–E24 for a brief account of the Boeotian shield).

116 Hom. *Il.* XVIII 478–608; K. Fittschen, *Der Schild des Achilleus, ArchHom* 2 N (Göttingen 1973).

117 Ibid. 18–23.

118 Bothmer, *Amazons* chap. 2 *passim*.

119 Lippold, *Andenken Furtwänglers* 437, n. 1 for this suggestion, and for other associations of the scenes, S. Woodford and M. Loudon, "Two Trojan Themes," *AJA* 84 (1980) 25–40.

120 Lippold, *Andenken Furtwänglers*. Sometimes for foreign or unfriendly figures—a giant on *CVA* New York IV, pl. 22.1 and H. Hoffmann, *The Centuries that Shaped the West* (Houston 1971) 381, cf. 382;

Geryon on E. Gerhard, *Auserlesene Vasenbilder* (Berlin 1840–1858) pl. 104, unless the drawing is confused.

121 Lippold, *Andenken Furtwänglers* 421–24.

122 The round shield could complement it by bearing it as a blazon, just as the Late Geometric round shield (hoplite or otherwise) could the (real) Dipylon shield. For those who shrink from Archaic war chariots, the use of the Boeotian shield by charioteers in art may be taken as another example of its adoption for a suitable, if not always identifiable, figure in mythical battles. This would still not reflect on its reality.

123 On this "conscious antiquarianism" of Homer see Snodgrass, *Archaic Greece* 69–70 and "Interpretation" 58.

124 Snodgrass, *Archaic Greece* 70.

125 E. F. Schmidt, *Persepolis* I (Chicago 1953) pls. 19, 25, 26, 63, 100, 101.

126 "Interpretation" 56.

127 Exceptions on a slab in Worcester (ibid. pl. 13.1) where the proportions are odd (the cutouts low) and some have no cutouts at all. The frieze may be unfinished (or modern?). They also lack the wheel-shaped boss shown in the reliefs in the *Persepolis* volume. Of these an example *in corpore* is suspected at Samos (*AthMitt* 83 [1968] 292, no. 116, pl. 124.1, cf. 2). Cf. O. M. Dalton, *The Treasure of the Oxus* (London 1926, 1964) 13, no. 24; and the bone wheel from a Late Geometric (or later) grave in Athens (*AthMitt* 18 [1893] 124, fig. 22). The motif appears also in representations of Boeotian shields, as Bothmer, *Amazons* pl. 16 (*ABV* 104, no. 123) and of hoplite shields, as Gerhard, *Auserlesene* pls. 269–70 (*ARV²* 373, no. 48).

128 L. Ognenova, "Sur l'origine du bouclier échancré dit 'Béotien,'" *BIABulg* 26 (1963) 107–14.

129 It is also used, but far less, on Salamis (the Ajax connection), at Chalcis, in Crete, and as a "money-er's mark": Lippold, *Andenken Furtwänglers* 419, 421.

130 L. Lacroix, "Le bouclier, emblème des Béotiens," *RBPhil* 36 (1958) 7–30.

131 On a late fifth-century coin of Thebes the shield is decorated with a club: C. M. Kraay, *Greek Coins* (London 1966) fig. 458. The shield of Amphitryon, Herakles' mortal father, had been used as his cradle (Theoc. XXIV.4–5). Herakles, it may be recalled had a twin brother. They might have seemed better bedded in a Boeotian shield than in a round shield. I think there is little to recommend J. Jüthner's suggestion that the *hoplitodromoi* celebrating Plataea much later still carried Boeotian shields because they were "armed to the feet": *Philostratos über Gymnastik* (Leipzig and Berlin 1909) 201 on 138, 21; cf. *Leibesübungen der Griechen* II (Vienna 1968) 122.

132 Data and references in E. Kunze, *Archaische Schildbänder* (Berlin 1950) Register; and for the Ptoion, J. Ducat, *Les Trépieds du Ptoion* (Paris 1971) 324–34.

Archaic Vase-Painting vis-à-vis "Free" Painting at Corinth

<div style="text-align:right">3</div>

D. A. AMYX

The scene in which Herakles is shown banqueting in the house of King Eurytos of Oichalia appears on one of the largest and most magnificent Corinthian vases, the famous Eurytios krater in the Louvre.[1]

With its breadth and grandeur of conception and execution, this scene appears to be one which might just as well have graced the wall of an important building in Corinth. Indeed, there is a common belief among scholars that such scenes in Corinthian (and other Archaic) vase-painting were copied from, or at least heavily influenced by, mural originals.

The urge to make this assumption comes from two main considerations. First, there is the certain knowledge that Archaic mural paintings did exist at Corinth; and, second, there is an overwhelming desire somehow to compensate for the deplorable fact that not one of those paintings has survived—not physically, nor even in any literary reference. In Pliny the Elder we have a reference to a tradition that credited either Corinth or nearby Sikyon with the "invention" of painting (*HN* XXXV.5). This is obviously a naive account, much colored by popular notions about art, and there is no mention of dates, nor any of subject matter. Still, the passage does give the names of three Corinthian artists who are said to have participated in what was regarded as the earliest beginnings of painting in Greece. In addition to that, even though no Archaic mural painting has survived at Corinth itself, there is concrete physical evidence that it once existed there. In the Isthmian Sanctuary of Poseidon, which is a Corinthian preserve, the remains of an Archaic temple have been found which include fragments of wall-painting on a prepared stucco surface.[2] Too little has been recovered to permit identification of any subject matter, but these meager scraps do put us into direct contact with Corinthian mural painting of the seventh century B.C.

In this frustrating situation, desiring through the vase-paintings to gain some notion of what Early Archaic Greek wall-painting was like, the wish has fathered the thought that, since the vase-paintings are assumed to be in some respect "copies" of their supposed mural prototypes, the actual appearance of these mural paintings can, by extrapolation, be deduced from the appearance of the vase-paintings. That assumption has provoked the present inquiry, in which an attempt is made to answer two main questions: whether Archaic Corinthian vase-painting is to any considerable extent dependent upon mural painting; and whether we can hope, by examining the vase-paintings, to recapture any of the appearance of the lost Archaic mural paintings at Corinth.

Here a brief digression is necessary, in order to face certain problems of terminology. The three terms that are most commonly set over against vase-painting are "free," "monumental," and "mural." In formulating a title for this paper I wavered between "free" and "mural," choosing "free" only because it seems to have a wider application. But the choice is still not altogether a happy one, for it seems to imply a contrast which is derogatory to vase-painting. Other problems arise if we wish to substitute for "free" the term "mural"; for, even with its wider range of colors, the latter is no more "free" than vase-painting. A mural is produced to cover an already existing wall surface, which would not

lose its function even if the painting were removed from it. The only really "free" painting in antiquity is the painting on portable panels, such as that on the wooden plaques from Pitsa,[3] for these panels have as their only excuse for existence the painting that is on them. It is from them that easel painting, in the modern sense, evolved. Our third term, "monumental," leads us into further troubles, because of its essential ambiguity. If it refers to mural painting, it suggests to most persons large-scale work. But much of the mural painting of antiquity, such as Minoan and Mycenaean painting, is actually miniature in scale, living side-by-side with other examples that were rendered on a much larger scale. Contrast, for instance, two well-known mural paintings, both from Thera, but on widely different scales—one showing the harbor scene, which E. N. Davis discusses earlier in this volume (Davis, figs. 1.1–1.4, pp. 4–5), the other showing antelopes.[4] And while we are thinking of scale, we should remind ourselves that the wooden plaques from Pitsa are barely twelve inches long. Therefore, it seems wrong to associate "monumentality" with sheer size, and to conclude, as some scholars have done with reference to vase-paintings like the scene on the body of the great proto-Attic amphora in Eleusis,[5] that, just *because* of its large scale, that is to say, its "monumentality," this is evidence that the vase-painting itself must be derived from a large-scale mural painting depicting the same subject, thus serving to reveal something of the appearance of its putative prototype.[6] No argument could be more circular.

But let us return to our original questions, concerning the relationship between Archaic vase-painting and mural painting at Corinth.

Many Corinthian vase-paintings, especially among those depicting scenes from heroic legend, have a richness and a complexity of treatment that seem analogous to what we might have expected to find in a mural painting of the same period. For the assumption that they are, at least in some cases, actually derived from mural paintings illustrating these same themes, we have the blessing of H. Payne. There are in *Necrocorinthia* three important passages in which Payne expresses or implies a belief in the derivation of specific vase-paintings from "free," or mural, paintings.

(1) The first of these refers to an early Middle proto-Corinthian pointed aryballos in Oxford, dated in the first decades of the seventh century B.C., of which the main body picture is published in an "unrolled" drawing (fig. 3.1).[7] Concerning this vase-painting, Payne remarks on the "archaizing" nature of this scene, which is rendered in pure silhouette technique, with no incision, and states, "Perhaps the principal scene may be a copy of a Geometric wall-painting in a temple."[8]

(2) With reference to the Late proto-Corinthian "Chigi olpe,"[9] Payne cites the polychrome technique and the overlapping of figures "in a three-dimensional manner" as indications of borrowing from an alien medium, namely "free" painting.[10]

(3) In his lengthy discussion of the main subjects on the great Amphiaraos krater (figs. 3.2a, 3.2b),[11] Payne points out the close correspondence of these scenes with the descriptions of the same subjects on the Chest of Kypselos, and also with those in two non-Corinthian vase-paintings, and concludes that all four representations go back to a common, perhaps mural, source.

At this stage we must, I think, seriously question the validity of the arguments that are based on these three examples.[12]

(1) Returning to the first example, on the proto-Corinthian aryballos, it must be observed that, attractive as this picture itself may be, there is no evidence whatever that mural painting was produced at Corinth in the Geometric period,[13]

3.1. Oxford G 136. Unexplained mythological subject. Drawing of main frieze after *JHS*.

3.2a, 3.2b. Formerly Berlin F 1655. Side A, departure of Amphiaraos; side B, chariot race at funeral games for Pelias. Drawings of main scenes after Furtwängler and Reichhold.

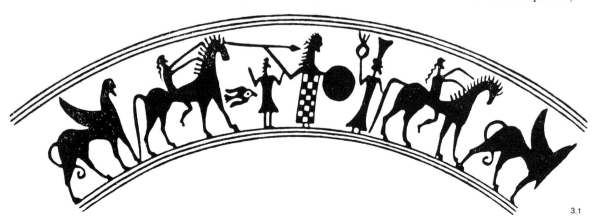

3.1

3.2a

3.2b

and also that Corinthian Geometric pottery itself was singularly weak in figural subject matter. Furthermore, the "archaizing" effect of the main subject, partly due to the "sub-Geometric" use of silhouette forms, without incision, was not at all uncommon within this period; and *if* the vase-painting was copied from something else, it could very well have got its inspiration from some nonmural source—for instance, from another vase-painting.

(2) The second case, that of the Chigi olpe, presents some complications. As we look at its colorful scenes we must bear in mind that Corinthian vase-painting, throughout practically all of its history, made use of the normal "black-figure" technique. This factor remains constant throughout the period that concerns us. Payne rightly finds reason to believe that the "style magnifique," of which the Chigi olpe is the finest manifestation, extends the use of colors beyond the normal range of that technique. In the end, however, he is forced to acknowledge that it was a very special phenomenon, of limited duration,

saying, "The Chigi group is evidently the achievement of a single artist, or of a small circle of artists, working under a special influence. *The tradition which it represents was not destined to survive*" (italics mine).[14]

In referring to the top frieze of the olpe, Payne cites the overlapping of figures "to give a three-dimensional effect" as evidence of a very advanced technique, alien to vase-painting; but the use of overlapping figures to indicate depth of field was already extensively used in the Geometric period, and would have been nothing new at the time of the Chigi Group. So, too, Payne's argument of "monumental" inspiration, based on the scale of figures (see above), seems strained, especially since the example that he cites is on a fragment in Aegina, where the height of the whole figure in question as suggested by the text would have been 9.5 to 10 cm, or barely four inches.[15] Finally, again with regard to the Chigi olpe, Payne refers to the flesh tones of the figures as evidence of influence from "free" painting, then compares the figures on the terra-cotta

3.3a

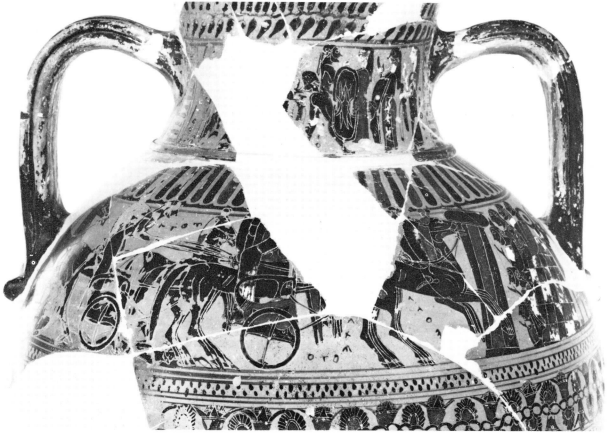

3.3b

metopes from Thermon,[16] without mentioning the fact that the metopes were themselves made of baked clay. To contrast the wider range of color used in "free" painting, we need only return to the painted wooden plaques from Pitsa.

While we are on the question of colors, it seems advisable to speak of the technique of the Late Corinthian red-ground vases, on which there is a greatly increased use of white, further enhanced by glaze-wash, and glaze-wash blended with white, set against the enriched "reddish" tone of the background, all used to produce a striking effect of *poikilia* (see Fowler fig. 11.3, p. 162) which might at first glance seem to suggest an influence of "free" painting. But this enrichment of colors is produced entirely within the traditional technical means of ceramic art: nothing new has really been added. Therefore it appears that, to the extent that vase-painting borrowed from other media, this "borrowing" would have been limited essentially to the subject matter, the composition, and to a lesser extent the style, with *technique* having only a very minor part in this process.

(3) This brings us back to the Amphiaraos krater, on which much of the argument for mural copying by vase-painters is based. On one side (fig. 3.2a), there is shown the departure of the hero Amphiaraos for the War of the Seven against Thebes; on the other side (fig. 3.2b), a chariot race at the funeral games of Pelias.

As F. Hauser had already observed, both of these subjects—including many of the labeled characters—agree closely with the corresponding scenes on the Chest of Kypselos, as seen and described many centuries after its creation by Pausanias.[17] Payne also cites, following Hauser, two non-Corinthian Archaic vases, one an Attic ("Tyrrhenian") neck-amphora in Florence (figs. 3.3a, 3.3b),[18] the other an Etruscan ("Pontic") neck-amphora in Munich (figs. 3.4a, 3.4b),[19] both of which represent, in somewhat similar fashion, the same, or similar, themes as the krater. From this evidence Payne concludes, "It is obvious that these four representations are inspired by a common motive, *perhaps a famous wall-painting at Corinth*" (italics mine).[20]

In the case of Amphiaraos, the four versions are indeed inspired by the same *story*, but they differ widely in the way in which they represent it. First, let us compare with the Corinthian version the scene as it appears on the Attic "Tyrrhenian" amphora (fig. 3.3a). There are likenesses: the hero departing by chariot; the boy with the pleading gesture; one woman carrying a small child on her shoulder; the grieving seer in

front of the chariot. These figures more than amply identify the subject with that which is shown on the krater, but *do* they indicate *copying* from a common source? If we look at the differences between the two representations, they seem to lead us to the opposite conclusion. Just to mention a few: on the neck-amphora there are no written names, only mock inscriptions; Eriphyle's necklace is not shown; there is no architectural backdrop; the hero is not mounting his chariot; the charioteer's shield is of a different form and is differently suspended; the seer crouches, but does not sit on the ground; and there is a row of five grieving women facing the chariot from the right end of the scene.

Now let us look at the scenes on the other sides of the two vases (figs. 3.2b, 3.3b). Payne's conjecture refers primarily to the departure of Amphiaraos, but the concurrence of the chariot race is also an essential part of his argument. The only real similarity of the scene on the amphora with that on the krater is that it shows *a* chariot race, and a tripod, which was no doubt one of the prizes. There is no indication that this race has to do with the funeral games for Pelias, and the Attic artist has given us several details that are not found on the krater, most remarkably, at the left end, the wrecked chariot with the fallen horse and driver; and, at the right end, the fat Doric column, and the grandstand filled with spectators, recalling not the Amphiaraos krater, but Sophilos' funeral games for Patroklos.[21] Add to all these discrepancies two further ones: that the two chariot races move in opposite directions, and that the chariots are quadrigae on the krater, bigae on the amphora. One is then entitled to wonder how they both could have been copied from a common visual source.

The other vase, the Etruscan Pontic neck-amphora in Munich (figs. 3.4a, 3.4b), carries us still farther afield. Here again, we have the essential "core" elements which serve to identify the *subject*: the hero mounting his chariot, looking back; the boy raising his hands in entreaty; a tiny woman, perhaps Eriphyle, with arms outstretched; and the grieving seer in front of the horses. Apart from these common features, the Etruscan version shows striking differences. We need to cite only a few. The direction of movement is reversed, now going from right to left. There is no sign of Eriphyle's necklace, nor any indication of a palace; the charioteer wears a short chiton instead of a long robe; the chariot wheel has six spokes rather than four; the chariot is evidently a triga, drawn by three horses; the grieving seer is seated on a folding stool; and

3.3a, 3.3b. Florence 3773 (and Berlin 1711, fr). Side A, departure of Amphiaraos; side B, chariot race. Drawings of main scenes after Thiersch. Photos of the same after removal of restorations: Courtesy Soprintendenza alle Antichità, Florence.

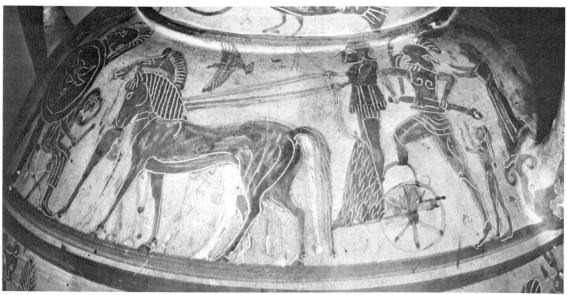

3.4a

3.4a, 3.4b. Munich 838. Side A, departure of Amphiaraos; in lower frieze, chariot race. Photos: Courtesy of Staatl. Antikensammlungen und Glyptothek.

3.5. Etruscan bronze relief in Florence. Departure of Amphiaraos, and two unexplained subjects. Drawing after *Notizie degli Scavi.*

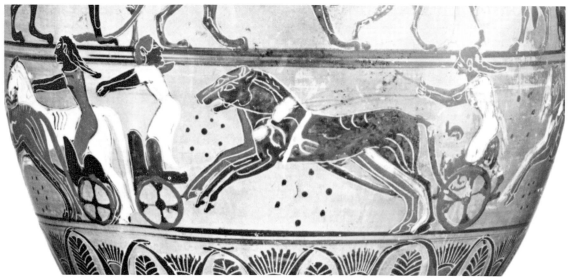

3.4b

the only supernumeraries are two warriors marching ahead of the chariot. Literal, visual copying could scarcely have allowed these variations.

The chariot race also bears little resemblance to the scene on the Amphiaraos krater. On the Etruscan vase, the chariots are bigae, drawn by two horses, and they are spread thinly rather than thickly overlapping; there are no judges, and no prizes are shown. What is most damning of all is that these figures do not come from a matching panel to the Amphiaraos scene, but belong instead to a lower frieze running all around the vase, and are not subject to *any specific* "narrative" interpretation. On the Etruscan vase, the pendant subject to the Amphiaraos theme is Herakles fighting two Centaurs.

In summary, then, the scenes on the two vases which have been compared with those on the Amphiaraos krater, to the extent that they *do* represent the same subjects, do so in widely different ways. But we are not quite done with this theme. Payne refers also to an early Etruscan bronze relief in Florence,[22] on which the decoration consists of three repeating subjects (fig. 3.5). Payne agrees with L. Curtius[23] in identifying the middle subject as a departure of Amphiaraos (the other two subjects are obscure). In the middle, we can recognize the core group: Amphiaraos moving left, drawing his sword, his head turned back; a youth and a woman, both pleading, with gestures. The subject is here represented in its barest essentials, and Payne takes it to be copied from a very early representation on the (so-called) Argive-Corinthian bronze reliefs,[24] thus taking us back to a stage much earlier than that of the Amphiaraos krater and its supposed congeners, and still further antecedent to that of an Attic version, with frontal chariot, illustrated by Payne.[25] This last Payne takes to be a third stage in the visual development of the theme. Back of this conclusion lies an even more rigidly schematic interpretation by Curtius, who, mistakenly believing the Etruscan Pontic amphora to

be earlier than either the Amphiaraos krater or the Attic Tyrrhenian amphora, seems to suggest that, not including the Attic scene with frontal chariot, which was unknown to him, there were already three different stages, exemplified by the bronze relief, the Etruscan vase, and the Amphiaraos krater. In keeping with this theory he assumes that the subject was developed by successive stages of accretion through the addition of details, thus providing the scene with ever-increasing richness and complexity. This approach is too mechanistic, one must insist, and leaves out of consideration the fact that artists, vase-painters or others, would not have worked in this way. On the contrary, on the evidence of the actual monuments, they must have enjoyed and exercised far greater fluidity and spontaneity in the choice and treatment of their themes. Furthermore, it seems arbitrary in the extreme to suppose that, at each stage of this supposed "development," there was only *one* "archetypal image" that was available for "copying." For favored themes, there must have been dozens of "versions" simultaneously in existence, from which the artist would have been free to choose, to mix, to alter, to condense, or to enrich inventively as he pleased.[26]

Many of the larger Corinthian vases (such as kraters, hydriai, and amphorae) are decorated with pictorial representations of scenes from heroic legend. These are of such imposing quality and importance that we may, for the moment and without prejudice, call them "quasi-mural"— that is, works good enough to be compared with fine mural paintings. Besides the Eurytios krater and the Amphiaraos krater, there are many excellent examples, among which we need only cite a few others that come most readily to mind. The New York krater with the wedding of Paris and Helen (fig. 3.6)[27] has the degree of grandeur needed to qualify in that context. Another, a krater in the Vatican,[28] which depicts an unidentified but equally heroic event, can also be

3.5

included. The long horizontal frieze composition with its plentiful retinue of attendant figures certainly points to a major, "monumental" purpose on the part of the artist. Yet another grand theme appears on a krater in the Louvre[29] showing Peleus, identified by a label above his head, in the act of surprising the sea nymph Thetis, whose companions run away in fright. On the great Astarita krater in the Vatican[30] the total length of the frieze is extended by having the same story continue around on the reverse side of the vase. Of this representation, Beazley was moved to remark that the whole scene, if unrolled, would extend to a length of more than five feet. Another majestic theme, represented on a hydria in the Louvre,[31] is that of the sea nymphs mourning the dead Achilles. In the panel decoration of two amphoras there are complex scenes: Perseus rescuing Andromeda from the sea monster,[32] and Tydeus killing the Theban princess, Ismene, caught *in flagrante* with her lover, who is running away at left.[33] Returning to friezelike compositions, there is the scene on a krater in Boston (fig. 3.7)[34] in which Herakles is rescuing another maiden, Hesione, from another sea monster. The contrast between the main, violent, action and the stiffly posed chariot gives to this rendering an especially dramatic quality.

We have looked at only a quick sampling, drawn from a much larger repertory of elaborately presented subjects.[35] In Corinthian vase-painting most of the representations of scenes from heroic legend appear, as in each of the examples just cited, only once. This lack of conflicting evidence gives some encouragement to those theorists who would assume back of each major vase-painting a mural prototype. For, with no negative evidence to contradict them, they can draw their own conclusion, that the vase-paintings are "copies" of the lost mural paintings for the appearance of which some clue is being desperately sought. Furthermore, the very size of the larger vases, and the grandeur of their themes, tends to suggest a certain kind of "monumentality," which, as we have observed, is then thought to reflect the influence of "monumental"—that is, "mural"—painting. But there is one serious flaw in this line of reasoning. Of all the many themes from heroic legend that we find represented on Corinthian vases, there is not one that can be traced to a specific visual prototype, whether in actual survival or in any literary record. So, even if there is no negative evidence to contradict the theory of mural prototypes, neither is there any positive evidence to support it. Therefore the argument based on their uniqueness in Corin-

3.6

3.6. New York 27.116. Side A, wedding chariot of Paris and Helen. Drawing of main scene: Courtesy Metropolitan Museum of Art, purchase 1927.

3.7. Boston 63.420. Side A, Herakles rescuing Hesione from the sea monster. Photo of main subject: Courtesy Museum of Fine Arts, Boston, Helen and Alice Coburn Fund.

3.7

as in no. 3, or even a corselet, as in no. 10. He usually attacks with his sword, but once, in no. 13, he uses his club; in another case (on no. 3), his club and bow are shown but are not in use. The crab is usually present, but it is missing from nos. 3 and 13, two of the finest renderings of the story. Iolaos usually wears a chiton, but he is nude in no. 7.

Injury to the Hydra is indicated in several cases, but not in any consistent manner. The whole central grouping is switched from left to right in no. 4. Athena may or may not be present, and she carries different attributes in different examples. Chariots, when they appear, are shown in a variety of arrangements and poses; and, on nos. 3 and 9, without any apparent narrative justification, a rider and a riderless horse wander into the picture. Sirens and birds appear, ominously, it seems, in three examples, nos. 4, 6, and 13, but their presence is not mandatory. There may or may not be inscriptions, and for the name Iolaos we have two different spellings. There are still other variations of details, but those just cited are enough to point toward some definite conclusions.

The most important conclusion is that Corinthian vase-painting was not to any significant extent dependent on mural paintings as models for direct copying.

Instead, it seems far more likely that certain basic narrative configurations, once established through their invention in *any* medium, were then adopted, *with variations,* into subsequent works, in the same or in any other medium. As we have noted, such transmissions need not have been concerned with *techniques* or *styles,* but only with *types* of representation, so that the exact source of the borrowing really did not matter, nor need it have been limited to any particular medium, such as mural painting in the present instance. A bronze relief or engraving; a relief sculpture in stone (which would have been *painted*); a Chest of Kypselos; or another vase-painting, could equally well have served as the vehicle of transmission. The stock-in-trade of visual clichés used in the rendering of any one story could, furthermore, at any one time have included different versions, and examples in a variety of media. Mural painting may have had its place in this process, but not in the sense of having provided models for exact copying, which seems to have been intended in the discussion of such "prototypes."[54]

Coming back to the vase-paintings: our study of the representations of Herakles and the Hydra has shown how, within that medium, the artists freely made use of a central, stock motive, but were equally free to alter it, to twist it around, and to add to or subtract from the supernumerary figures surrounding the essential central triad. Also, in looking back at the Amphiaraos krater, we can recognize a parallel situation. The variations in rendering *these* scenes, *though found in part outside of Corinthian vase-painting,* are manifestations of a process similar to that which we observed in the case of the Hydra story. So also, with reference to the other Corinthian renderings of major narrative themes, examples of which were shown earlier, and which I have somewhat facetiously called "quasi-mural," there is no positive reason to suppose that any of them is copied from a wall-painting. Thus we are brought back full circle to the vase that was mentioned at the beginning of our discussion: the Eurytios krater in the Louvre. If, as I think we should, we grant this great work the status of an original creation, we can easily deduce that the common run of unidentified Middle and Late Corinthian banquet scenes and battle scenes are directly or indirectly derived from that source. The "model" that is followed by these vase-painters is the vase-painting itself.

The result of this investigation is to suggest that, whatever Archaic Corinthian vase-painting may have owed to mural painting, that debt would not have been manifested in literal copying of whole scenes, but in the free use and adaptation of stock formulae and established configurations, "borrowed," in exactly the same way as from works in all other media. Vase-painting itself, with its strong pictorial tradition, must have been an essential instigator as well as a conspicuous vehicle of transmission, and certainly must have enjoyed its share of infuence upon works in other media, perhaps including wall-painting itself.[55] To deny to the best of the vase-painters this degree of originality is to do them less than justice as the truly creative artists that they were.

NOTES

This report has been in the making for some time. Before the paper was presented at Madison, an earlier, unpublished version had been delivered at the Art Institute of Chicago on December 20, 1979; and, before that, the part which deals with the Hydra story was the subject of a paper read at the meeting of the Archaeological Institute of America in Vancouver, B.C., December 28–30, 1978, under the title, "Herakles and the Hydra in Corinthian Vase-Painting" (brief summary in AIA *Abstracts* 3 [1978] 42).

1 Louvre E 635. *CorVP* 147, with lit., and pl. 57:1a–b: the main side, Arias-Hirmer 282 and pls. 32 and IX (color).

2 Broneer, *Isthmia* I. *Temple of Poseidon* (Princeton 1971) 33f., 41, fig. 54, and pls. 5A–C. The actual frags. are of course less brilliant, but the color scheme is clearly discernible in the originals (which are on display in the Isthmia Museum).

3 A. Orlandos in *EAA* VI (1965) 201–5, figs. 225, 226 and color pl. Pinax A is also illustrated (in color) in M. Andronicos, *The Greek Museums: National Museum* (Athens 1975) fig. 49; and the four pinakes (black and white) in F. Lorber, *Inschriften auf Korinthischen Vasen* (Berlin 1979) pls. 45, 46, no. 154. The illustrations of Pinax A in color are made from the copies in the National Museum, Athens. I have not seen the original plaques, but I have been informed that they are (naturally) less brightly colored than the copies. This difference does not, however, have any bearing on the present argument.

4 Besides those black-and-white photos supplied in this volume (Davis figs. 1.1–1.4), there are good color illustrations of the former in S. Marinatos and M. Hirmer, *Kreta, Thera, und das mykenische Hellas* (Munich 1973) pls. XL–XLII, and Andronicos, *Greek Museums* 42f., figs. 16–17; of the latter ibid. 40, fig. 13, also in Marinatos and Hirmer, *Kreta* pl. 149 (black and white). Among other small-scale mural paintings are the "Miniature fresco" from Knossos (*PM* III, pls. XVI, XVIII); the Flying Fish fresco from Phylakopi (M. Robertson, *Greek Painting* [Geneva 1959] color illustration on p. 21); and the Boar-Hunt fresco from Tiryns (H. T. Bossert, *Altkreta*³ [Berlin 1937] pl. 26, fig. 35).

5 G. Mylonas, *O Protoattikos Amforefs tis Elefsinos* (Athens 1957); see esp. the unrolled drawing of the main scene, pl. 10. By now this vase has been widely illustrated: e.g., H. W. Janson, *History of Art* (New York 1962 and later editions) 78, fig. 117; R. V. Schoder, S.J., *Masterpieces of Greek Art* (Greenwich, Conn. 1960) pl. 8 (color).

6 On the "mural" and "monumental" aspects of proto-Attic pottery, see especially K. Kübler, *Altattische Malerei* (Tübingen 1950) *passim*. For Corinthian pottery, cf., e.g., J. L. Benson, *Die Geschichte der korinthischen Vasen* (Basel 1953) 87–90; Lorber, *Inschriften* 111–12.

7 Oxford G 136. *JHS* 24 (1904) 295, no. 504, whence (parts) K. Friis Johansen, *Les vases sicyoniens* (Paris 1923) pl. 20:1a–b; *CVA* Oxford 2, III C, pl. 1:5 (photo); and (drawing of main frieze, after Friis Johansen) K. Schefold, *Myth and Legend in Early Greek Art* (New York 1966) 42, fig. 10; *MemLinc* ser. 8, 19 (1976) pl. 90:1 ("not Corinthian," according to Mingazzini, ibid.).

8 H. Payne, *Necrocorinthia* (Oxford 1931) 8, n. 1; so also in *CVA* Oxford 2, III C, text to pl. 1:5.

9 Villa Giulia 22679. *CorVP* 32, Chigi Painter, no. 3, with lit.; good illustrations in Arias-Hirmer color pl. IV; Robertson, *Greek Painting*, color illustrations on pp. 48–49; E. Homann-Wedeking, *The Art of Archaic Greece* (New York 1966) illustration on p. 60.

10 Payne, *Necrocorinthia* 92–98, for a general discussion, and esp. 95–97 with regard to the "style magnifique."

11 Lost, formerly Berlin F 1655. *CorVP* 263, Amphiaraos Painter, no. A-1, with lit. See esp. FR III, pls. 121–122 (the source of nearly all subsequent illustrations from drawings). For the discussion, see Payne, *Necrocorinthia,* 139–41; but see also H. Thiersch, *"Tyrrhenische" Amphoren* (Leipzig 1899) 59, and fig. p. 61.

12 Of course this is not the first expression of skepticism concerning the supposed domination of mural (or "monumental," or "free") painting over Archaic Greek vase-painting. See the very sensible observations by R. M. Cook, *Greek Painted Pottery* (London 1960, 1966; rev. ed., 1972) 174–76 and the stimulating article by M. Robertson, "The Place of Vase-Painting in Greek Art," *BSA* 46 (1951) 151–59. Cf. also H. von Steuben, *Frühe Sagendarstellungen in Korinth und Athen* (Berlin 1968) 81. The difference is that I am here attempting to present a systematic rebuttal to that supposition.

13 Cf. Cook, *GPP* 176: "Probably free painting began in the seventh century, since it is hardly conceivable in the Geometric style as we know it." The wording is slightly different in the rev. ed. (1972) 174.

14 Payne, *Necrocorinthia* 97.

15 I have not been able to identify this frag., at Aegina or in any publication.

16 Lorber, *Inschriften* 26–28, with lit.; the basic color reproductions, *Antike Denkmäler* II (Berlin, from 1887) pls. 51–52; and cf. Robertson, *Greek Painting* color illustration p. 50 (Chelidon metope). These metopes were "restored" with fresh paint in the Classical period, but that fact does not affect the present argument.

17 F. Hauser in FR III, 1–12; but with due attention to the differences.

18 Florence 3773 (+ Berlin 1711, fr.). Thiersch, *"Tyrrhenische" Amphoren,* 58–60, and pls. 3, 4; *ABV* 95, no. 8 and *Paralipomena* 36, no. 8; also (after Thiersch), FR III 4f., figs. 2–3.

19 Munich 838. J. Sieveking and R. Hackl, *Die Königliche Vasensammlung zu München* I (Munich 1912) 100–103, pl. 33 and figs. 100–107 whence (part, figs., 102 and 105) FR III, II, figs. 4–5; T. Dohrn, *Die schwarzfigürigen etruskischen Vasen* (diss., Berlin 1937) 149, no. 134; idem, "Originale etruskische Vasenbilder?" *BonnJbb* 166 (1966) 122, figs. 9–10 (details of side A). The Amphiaraos scene on the neck-amphora in Basel, Antikenmuseum (ex-Coll. Züst), R. Hampe and E. Simon, *Griechische Sagen in der frühen etruskischen Kunst* (Mainz 1964) 18f., figs. 8–11; Dohrn, "Originale?" 113–25 and figs. 1–8, is, as Dohrn has convincingly demonstrated, a forgery, slavishly dependent on the Munich vase.

20 Payne, *Necrocorinthia* 139. Cf. L. Curtius in *Festschrift Paul Arndt* (Munich 1925) 37 (referring to the Amphiaraos krater): "weil auch dieses mit einem schon bekannten berühmten Gemälde in Verbindung zu bringen ist."

21 Athens, N.M. 15499. *ABV* 39–40 and 681, and *Paralipomena* 18, no. 16; J. Charbonneaux, R. Martin, and F. Villard, *Archaic Greek Art,* trans. J. Emmons and R. Allen (New York 1971) color pl. p. 57, top; and often.

22 *NSc* 1905, 232, fig. 25, whence Curtius, *Festschrift Paul Arndt* 37, fig. 1, and my fig. 3.5.

23 Curtius, *Festschrift Paul Arndt* 36–44.

24 Here I find Curtius and Payne very hard to follow, esp. in their reference to the filling ornament (loosely rendered "dot-in-circle," or "dot-in-spiral" motives) on the bronze reliefs as evidence of a connection with Early Corinthian or, more exactly, Transitional (pottery).

25 Oxford G 137.53. Payne, *Necrocorinthia* 140, fig. 50; *CVA* Oxford 2, III He, pl. 1:36; *ABV* 96, no. 11.

26 Payne cites (*Necrocorinthia* 140) but does not discuss, the fragmentary lekanis by the C Painter, Athens, Acropolis: 2112: B. Graef and E. Langlotz, *Die*

antiken Vasen von der Akropolis zu Athen I:4 (Berlin 1925) pl. 92; *ABV* 58, no. 120. He does not mention two Tyrrhenian amphorae in Leipzig, *ABV* 96, nos. 9, 10. Again, the renderings of these three examples differ so widely among themselves and with those discussed by Payne as to tell against the notion that a single "famous wall-painting" could have been their common model. The evidence of the bronze "Amphiaraos" reliefs found at Olympia, after Payne's time, is even more strongly negative. The best preserved of them (Olympia M 78) is published, with an illuminating commentary, by A. Yalouri ("A Hero's Departure," *AJA* 75 [1971] 269–75 and pl. 64). She has demonstrated that numerous features of this representation are "Ionic" (or East Greek) in character, yet three of the basic iconographical elements agree with those seen in Corinthian and Attic representations. The other two examples, B 103 (*OlBer* I [1937] pls. 30–31, and *OlBer* III [1941] pl. 69) and B 1529 (*OlBer* III [1941] pl. 68) are likewise East Greek in style, but less well preserved. One of them (B 103) has beneath the picture zone a strip of cable pattern, a feature cited by Payne in connection with the Etruscan relief as evidence of an Argive-Corinthian connection. Yalouri hesitates to state flatly that these reliefs represent specifically the departure of Amphiaraos, but that is one possible interpretation of them.

27 New York 27.116. *CorVP* 196 and pl. 79:1a–c, Detroit Painter, no. A-5, with lit.

28 Vatican 126. *CorVP* 198, Cavalcade Painter, no. A-8, with lit. Main picture (side A) in color, Arias-Hirmer pl. XI.

29 Louvre E 639. *CorVP* 266, "Near the Poteidan Painter," no. B-1, with lit. Cf. Schefold, *Myth and Legend,* pl. 70, b–c (main zone of side A, after cleaning).

30 Vatican, Astarita Coll., *CorVP* 264, "The Astarita Krater," with lit. The basic publication is J. D. Beazley, "Ἑλένης Ἀπαίτησις," *ProcBritAc* 43 (1957) 233–44 and pls. 11–16.

31 Louvre E 643. *CorVP* 264f., Damon Painter, no. A-1, with lit. Illustrations in color: M. Wegner, *L'art grec* (Fribourg 1955) fig. 68; F. Chamoux, *Greek Art* (Greenwich, Conn. 1966) 25, fig. 15.

32 Berlin F 1652. *CorVP* 268 and pl. 123:2a–b, Andromeda Group: Central, no. A-4, with lit. Schefold, *Myth and Legend* pl. 44b (side A, panel picture).

33 Louvre E 640. *CorVP* 270, Tydeus Painter, no. A-6, with lit. Arias-Hirmer pls. 33 (side A) and XII (color), whence Schefold, *Myth and Legend* pl. V.

34 Boston 63.420. C. Vermeule, "Greek and Etruscan Painting," *BMFA* 61 (1963) 159–64, figs. 10–12; *Engagement Calendar 1965 (The Trojan War in Greek Art)* fig. 2.

35 This is not meant to imply that the subject of every Archaic mural painting was legendary or mythological. "Secular" subjects were no doubt also represented. For example, a row of horsemen, such as that which was actually "monumentalized" in relief sculpture on the Archaic temple at Prinias in Crete (Charbonneaux, Martin, and Villard, *Archaic Greek Art* 13, figs. 11–13), and which is often represented on Corinthian column-kraters, would have been a fitting subject for a wall-painting. The point is, rather, that subjects from myth and legend offer more attractive bait to the searcher for "lost" mural prototypes of vase-paintings.

36 *Vasenlisten*³ 88f., C; Steuben, *Sagendarstellungen* 23–28, 114.

37 *Vasenlisten*³ 81f., C (Brommer's nos. 8 and 11 refer to the same vase); Steuben, *Sagendarstellungen* 19–23 and 113; K. Fittschen, *Untersuchungen zum Beginn der Sagendarstellungen bei den Griechen* (Berlin 1969) 147–50; Amandry and D. A. Amyx, "Héraclès et l'Hydre de Lerne dans la céramique corinthienne," *AntK* 25 (1982) 104–16, figs. 1–6, pls. 18, 19. I warmly thank my collaborator for graciously allowing me to appropriate materials from our article, in a way which, I hope, will neither duplicate nor unduly conflict with our joint effort.

38 E.g., Lorber, *Inschriften* 111–12.

39 Fittschen, *Untersuchungen* 147f., nos. SB 28, SB 29, and SB 30. The first is London BM 3205: Schefold, *Myth and Legend* pl. 6a; A. Birchall and P. E. Corbett, *Greek Gods and Heroes* (London 1974) fig. 20. The second is Philadelphia, private: R. Hampe, *Frühe griechische Sagenbilder in Böotien* (Athens 1936) 108 and pl. 8, no. 135. The third is Heidelberg, Univ.: B. Schweitzer, *Herakles* (Tübingen 1922) 163f., fig. 34. The subject is also represented on a relief plaque in Herakleion; on a fragment of a bronze tripod leg in Olympia; and in a fragmentary ivory relief in Sparta (Fittschen, *Untersuchungen* nos. SB 31, SB 32, and SB 33).

40 See supra, note 37.

41 Athens, N.M., from Vari. *Vasenlisten*³ 81, C-8 and C-11 (same vase); D. Callipolitis Feytmans, "Dinos Corinthien de Vari," *ArchEph* 1970, 86–113, figs. 1–6, pls. 30–34.

42 Corinth C-71-321. Illustrated in *AntK* 25 (1982), fig. 1:2 opp. p. 102, and pl. 18:2.

43 Canellopoulos Coll. 392. *Vasenlisten*³ 81, C-10; F. Brommer, "Vier Mythologische Vasenbilder," *AAA* (1972) 45–60, figs. 10–13; P. Amandry, "Collection Paul Canellopoulos (III)," *BCH* 97 (1973) 189–95; *CorVP* 164, "Near the Boar-Hunt Painter," no. B-3.

44 Lost, once Breslau. Payne, *Necrocorinthia,* no. 481 and p. 127, fig. 45A; *Vasenlisten*³ 81, C-1.

45 Lost, seen in Argos. Payne, *Necrocorinthia* no. 942 and p. 127, fig. 45C; *CorVP* 185, Pholoë Painter, no. 2.

46 Basel BS 425. *Vasenlisten*³ 81, C-9; K. Schefold, *Antike Welt* 5 (1974) 11, fig. 12; idem, *Wort und Bild* (Basel 1975) pl. 1:7; idem, *Götter-und Heldensagen der Griechen in der spätarchaischen Kunst* (Munich 1978) 268, fig. 360; H. Gropengiesser, *AA* 1977, 600, figs. 25–26; *CorVP* 180f., "The Basel Hydra Aryballos;" Museum postcard (color); J.-P. Descoeudres, *CVA* Basel 1 (Switzerland 4) 41–53 and pl. 11.10–13.

47 Milan, Museo Civico, Fond. Lerici MA 121/3. *CorVP* 208, Dodwell Painter, no. A-44; illustrated in *AntK* 25 (1982), figs. 4:7 and 5:7 opp. p. 102, and pl. 18:1.

48 Louvre CA 2511. Payne, *Necrocorinthia,* no. 994; *Vasenlisten*³ 81, C-2; *CorVP* 204, "Gorgoneion Group: Unattributed Kylixes," no. 4.

49 Jena, Univ. 137. Payne, *Necrocorinthia,* no. 987 and p. 127, fig. 45B; *CorVP* 204, "Gorgoneion Group: Unattributed Kylixes," no. 2.

50 Palermo, N.I. 1708. Payne, *Necrocorinthia,* no. 1194; *Vasenlisten*³ 81, C-4; *CorVP* 198, "Related to the Cavalcade Painter," no. C-1; illustrated in *AntK* 25 (1982) fig. 2:10, opp. p. 102.

51 Bonn 697.82. A. Greifenhagen, "Ausserattische schwarzfigurige Vasen im Akademischen Kunstmuseum zu Bonn," *AA* 1936, cols. 360, 362, fig. 16 (right); E. Kunze, *Archaische Schildbänder, OlForsch* II (Berlin 1950) 102, n. 2 ("eher lakonisch?"). From autopsy, I am convinced that, as Greifenhagen had stated, the frag. is Corinthian.

52 Athens, T.J. Dunbabin, *Perachora* II (Oxford 1962)

pls. 102, 110, no. 2481; *Vasenlisten*³ 81, C-7; illustrated in *AntK* 25 (1982) figs. 2:12, opp. p. 102, and p. 112, fig. 6:12, with frag. rearranged.

53 Louvre CA 3004. *Vasenlisten*³ 81, C-6; *CorVP* 190 and pl. 73:2, Samos Painter, no. A-4. P. Lawrence has convinced me that this vase-painting should be dated earlier, perhaps no later than c. 580 B.C.

54 In our joint article, Amandry and I considered whether a single common source (in whatever medium) could have served as a model for all subsequent representations of the Hydra scene. After readily granting that the basic central grouping was fairly regularly followed throughout the whole series, we nevertheless found so many variations, spread over a span of at least half a century, as to preclude the notion of repeated copying from some studio sketch (or *carton d'atelier*). An artist working at any particular time could have had before his eyes a vase-painting giving a current rendering of the theme, or an earlier representation on a vase that had lived on as a private heirloom or as a votive offering in some shrine. This latter situation would serve to explain the apparent anachronisms in some of our vase-paintings, which are most clearly present on the Basel flat-bottomed aryballos, no. 7. What we see in these documents is then a mixture of invention and free adaptation of traditional forms. And, as for mural paintings (to quote ourselves): "La série des vases corinthiens donne plutôt l'impression d'une libre adaptation d'un schéma non fixé dans une grande oeuvre."

55 Cf. Robertson, "Place of Vase-Painting" (supra, note 12) 154: "It would be going beyond the evidence to assert that the earliest Greek painters on panel or wall were vase-painters or vase-painters' pupils who turned to the new craft, but I think it likely; certain, that vase-painters set about finding new formulae for vase-decoration with no sense of inferiority to free painters."

Stesichoros and the François Vase 4

ANDREW STEWART

In the century and a quarter since its discovery, the François vase has rightly occupied a pivotal place in the history of Athenian vase-painting. Its sheer size and splendor, its richly presented array of narrative subject matter, its vigorous yet exquisitely detailed drawing style—all combine to place its makers, the painter Kleitias and the potter Ergotimos, at the forefront of Athenian art of the earlier sixth century (figs. 4.1a–4.1d).[1]

Most modern discussions of the vase, which number in the dozens, are in agreement that Kleitias' choice of subject matter was not determined by any particular governing theme or program. The fortunes of the house of Peleus certainly dominate the obverse, where (in chronological order) Peleus himself hunts the Calydonian boar and marries Thetis, then his son Achilles pursues the youth Troilos and superintends the funeral games for Patroklos. Yet most scholars have found it hard to see much connection between these scenes and those of the reverse. Here (the continuation of the wedding frieze apart), Theseus leads the rescued Athenians in the dance (the so-called Crane Dance) celebrating their return from the Labyrinth, then takes a rather inconspicuous role in the defeat of the Centaurs; thirdly, around the lower belly, Dionysos escorts Hephaistos back to heaven in order that he may free Zeus and Hera, trapped in the magic thrones he sent them in requital for his expulsion from Olympus. With the handles we return to Achilles, as he is hauled lifeless out of battle by Ajax, while around the foot pygmies fight cranes in a tragicomic analogue of the heroic monster battles so beloved of Greek painters and poets alike.

Yet some, unsatisfied with the notion that the vase is but a kind of mythological encyclopedia, have looked for deeper or more indirect connections. Thus, E. Simon and L. Watrous have argued that Athenian local politics were influential in the choice of themes and characters; K. Schefold has maintained that the opposition of Achilles and Theseus is real and inspired by literary models, so that now "separate episodes are not simply picked out in isolation, but are bound together by intellectually conceived connections"; and finally, M. Robertson suggests another line of approach with his remark that "not only is the main theme a marriage and the glory of its offspring; also the three scenes on the back of the vase which are not directly connected with the main story have all a bridal connection."[2] Certainly, the very uniqueness of the vase—its novel shape, its size, splendor, complexity, and unprecedented wealth of detail, down to the occurrence of not one but two double signatures, all perhaps justify us in looking for something unusual in the planning of its decoration.

As will emerge in the course of this paper, my feelings on the issue are not far from those of Schefold and Robertson, but this is to anticipate matters. Before passing to iconography proper, it may be worthwhile to glance at the composition of the vase, on the chance that this might reveal something about how the painter intended the scenes to be viewed.

To begin with the obverse (fig. 4.1a): here one notices immediately that a very careful compositional sense is indeed at work. The two outer scenes are each organized, quite strictly, along symmetrical lines, focused at the top on the boar,

4.1a

4.1b

4.1a–4.1d. Florence, Museo Archeologico 4209. The Fran-çois vase. Signed by Kleitias as painter and Ergotimos as potter. Photos: Courtesy of Soprintendenza alle Antichità d'Etruria, Firenze.

4.1c

4.1d

who runs to our left, and at the bottom on Achilles and Troilos, who speed toward our right. Meanwhile the two inner scenes move rightward, but at two distinct tempi: on the shoulder the chariots and entourage of the gods parade in stately fashion up to Peleus, while on the neck the chariots of the heroes race toward his son, Achilles. Together, this careful cultivation of balance and pronounced accentuation of the central vertical axis of the vase by the two outer friezes, and of its central horizontal axis by the two inner ones, combine to direct our attention toward their crossing point: here we find no less a personage than Dionysos (fig. 4.2). He, though heavily burdened by the great amphora on his shoulder (notice how he buckles at the knees) and no doubt anxious to reach his goal, pauses to look out directly toward us. Characterized in this very direct way as the focal point of the whole complex, he clearly merits some further investigation.

A. Rumpf first noticed, almost thirty years ago,[3] that there is something strange about the amphora. Conspicuously lacking a lid, and carried at a steep angle, it cannot be full of wine without severely imperiling the integrity of Dionysos' carefully braided coiffure. Yet it is clearly very heavy, as evidenced by the god's exertion. One deduces that it must be empty and made of a heavier substance than clay, namely metal. In other words, as Rumpf himself argued and others have since accepted,[4] it is almost certainly that golden amphora of which Homer speaks in both the *Iliad* and *Odyssey*. The context for the first reference, in book XXIII of the *Iliad,* is Patroklos' speech to Achilles in a dream, a few hours after Hektor's death:

Do not have my bones laid apart from yours, Achilles,
but with them, just as we grew up together in your
 house, where
Peleus brought me carefully up, and named me to be
 your henchman.
Therefore, let one single vessel, the golden two-han-
dled amphora
that your mother gave you, hold both our ashes.
 (Hom. *Il.* XXIII. 83–92, trans. R. Lattimore)

When the amphora reappears, this time at the end of the *Odyssey,* the poet ventures a little more information. It is Agamemnon now who speaks to Achilles in the Underworld, consoling him with details of his funeral:

But after the flame of Hephaistos had consumed you
 utterly,
Then at dawn we gathered your white bones, Achilles,
 together
with unmixed wine and unguents. Your mother gave
 you

Stesichoros and the François Vase 55

an amphora, all of gold. She said that it was a present from Dionysos, and was the work of renowned Hephaistos.

In this your white bones are laid away, O shining Achilles,

mixed with the bones of the dead Patroklos, son of Menoitios.

(Hom. *Od.* XXIV.71–77)

This is all Homer tells us of the amphora's history. Yet a poem by the early sixth-century lyric poet Stesichoros evidently pursued that matter further, as we learn from a scholiast:

Dionysos hosted Hephaistos when he was in Naxos, one of the Cyclades, and received from him in return a golden amphora as a gift. Pursued later by Lykourgos and fleeing into the sea, he was received in friendly fashion by Thetis, and gave her the amphora that Hephaistos had made. And she gave it to her son so that his bones might be laid in it after his death. So wrote Stesichoros.

(fr. 234 PMG)

Stesichoros, it appears, not only made explicit what Homer's audience would have had to work out for themselves (for the Lykourgos episode is narrated toward the beginning of the *Iliad* and then only briefly and without mention of the amphora),[5] but also embellishes Homer's story with two very interesting facts: that Hephaistos was the original donor of the vase as well as its maker,[6] and that when Thetis gave the vase to Achilles it was with the explicit purpose of providing a receptacle for his bones. That some of Achilles' later exploits, his death included, are narrated on the François vase both above and below the figure of Dionysos itself, and on the handles, should not need repeating here—but more of this later.

Do we have any evidence that Kleitias knew of Stesichoros' account? I think we do. Scanning the guests that immediately follow Dionysos (figs. 4.1a, 4.2, 4.3) one encounters first the Horai, then three chariots driven respectively by Zeus and Hera, Poseidon and Amphitrite, and Ares and Aphrodite (these last two pairs are thought of as passing behind the handle where it joins the body of the vase, and are only identifiable because the painter has written their names alongside the horses). Accompanying them are the nine Muses, named as they had been in Hesiod's *Theogony*—but with one exception. For Terpsichore, the muse of choral lyric poetry and dance—exactly the province of which Stesichoros was the acknowledged master in antiquity—the painter substitutes the name Stesichore (ΣΤΕΣΙΧΟΡΕ: fig. 4.3).[7] This substitution is unique in both Greek literature and Greek art, and I find it a very remarkable coincidence.

The remainder of this essay is divided into three main parts and a coda. The first of these will engage the question of Stesichoros' influence upon the main frieze and upon two slightly earlier vases by Sophilos that carry the same subject. The second will leave Stesichoros to fend for himself for a while, and will turn to the subsidiary friezes, with a view to defining their relationship to the main frieze. The third will attempt to synthesize whatever results have emerged, using the narrative techniques of the epic poets and Stesichoros as a foil to elucidate certain key aspects of Kleitias' own narrative style. Finally, the coda will offer some thoughts upon the vase's purpose and the ways in which that purpose may be seen to resonate within its iconography as a whole.

To proceed, then, with the matter of Stesichoros and the main frieze. Who was this Stesichoros, renowned in antiquity for his power, in Quintilian's phrase (*Inst.* 1.62), at "sustaining on the lyre the weight of epic song"?

In recent years, Stesichorean scholarship has been something of a growth industry, with the discovery in 1967 of substantial fragments of his *Geryoneis* and *Iliou Persis* among the Oxyrhynchus Papyri, and the recognition in 1977 that a papyrus in Lille containing parts of a *Thebais* was also his work.[8] In addition, the influence of the *Geryoneis* on sixth-century vase-painting has been argued in a pioneering article by M. Robertson, and that of his *Oresteia* in a study by M. I. Davies, though recent scholarship, notably the careful and judicious study by P. Brize, has tended once more to the side of caution. Meanwhile, Stesichoros himself continues to remain something of a shadowy figure. As M. L. West has recently remarked:

Histories of literature tend to treat Stesichoros as just one of the lyric poets, like Alcman or Anacreon. But the vast scale of his compositions puts him in a category of his own. It has always been known that his *Oresteia* was divided into more than one book; *P.Oxy.* 2360 gave us fragments of a narrative about Telemachus of a nearly Homeric amplitude; and from *P.Oxy.* 2617 it was learned that the *Geryoneis* contained at least 1,300 verses, the total being perhaps closer to two thousand. Even allowing for the shorter lines, this was as long as many an epic poem. Indeed, these *were* epic poems, in subject and style as well as in length: epics to be sung instead of recited.[9]

The *Souda* tells us that Stesichoros was born in 632 and died in 556. Although these dates themselves are probably fictitious, a floruit of around 600 is accepted for him by most scholars.[10] He is listed as a contemporary of Sappho and Alkaios, but most of his life was spent, it seems, in south-

4.2. The François vase. Main frieze, with the wedding of Peleus and Thetis. After Furtwängler-Reichhold, *Griechische Vasenmalerei* pls. 1–2. (For an emended key to the participants, see table 4.1, p. 62.)

4.3. The François vase. Main frieze, detail of the three Muses, Stesichore, Erato, and Polymnis, behind the chariot horses of Ares and Aphrodite. *Above,* Ajax carries the body of Achilles from battle; Artemis, Mistress of the Animals. After Furtwängler-Reichhold, *Griechische Vasenmalerei* pls. 1–2.

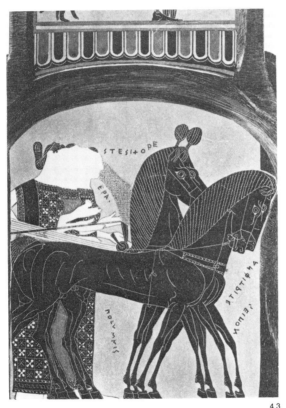

4.3

ern Italy and Sicily. He may have traveled to the Peloponnese, and the appearance of his name in such a suggestive context on the François vase around 570 indicates that his work was indeed known in Athens by that date; it was certainly known there twenty years later, as Robertson has shown.[11] He was extremely prolific: in later antiquity his works occupied no fewer than twenty-six books, although today only thirteen of what must have been a much larger number of titles survive. Pseudo-Longinus calls him "Homerikotatos" of poets,[12] an epithet which Quintilian explains in a brief but valuable description of his style:

The greatness of the genius of Stesichoros is shown by his choice of subject, for he sings of the greatest wars, and the most glorious of chieftains, sustaining on the lyre the weight of epic song. For in both speech and action he invests his characters with the dignity that is their due, and if only he had been capable of more restraint, he might perhaps have proved a serious rival to Homer. But he is redundant and diffuse, a fault that is reprehensible indeed but nevertheless a product of the very amplitude of his work.

(Quint. *Inst.* 1.62)

To this the *Souda* adds that his name may be explained by his being the first to organize a chorus to accompany his playing on the lyre.[13] In other words he was, as West has shown, a virtuoso soloist in his own right, singing his lyric epics to his own accompaniment on the cithara, preferably with a chorus to dance out the drama in addition, and perhaps to aid in the singing as well.[14] No wonder that Kleitias chose to honor him through the persona of Terpsichore, "she who delights in the dance," mistress of the lyre par excellence and later renowned as mother of the Sirens.[15]

At this point a few remarks on Stesichoros' poetry as it may relate to Kleitias' picture are perhaps in order. The fragment concerning the golden amphora is by no means unique: he often describes vases of precious metal and their genealogies, like the silver-gilt vase given by Menelaos to Telemachos in his *Nostoi* and the golden dinos of the sun borrowed by Herakles to cross to Erytheia in his *Geryoneis,* an incident later vividly recalled on a well-known early fifth-century cup in the Vatican.[16] He makes great use

4.4a–4.4j. Fragments of an Attic black-figure dinos signed by Sophilos as painter. Wedding of Peleus and Thetis.
a Thetis' house
b Thetis' house and foot of Peleus
c Iris(?), Hestia, Demeter, Leto, and Chariklo
d Hera and Zeus
e Chariot of Zeus (8) and horses following
f Heads of Amphitrite and Poseidon
g Heads of two Nysai facing Kalliope
h Chariot, with heads of two horses behind
i Okeanos' tail, with two figures in background
j Palmette chain
Ht. of frieze 8.5 cm. Athens, N. M., Akr. 587. From the Akropolis. Photo: Courtesy of G. Bakır.

of catalogs, be they of favorite horses in his *Funeral Games of Pelias* or of the hunters of the Calydonian boar in his *Boarhunters*, of which more later.[17] Finally, to quote Eustathius, "not only did Hesiod begin his poems with an invocation to the Muses, . . . but also Stesichoros in his 'Come hither, clear-toned Kalliope . . .' "; in Kleitias' picture Kalliope appears with the syrinx, facing the spectator as if actually to "announce the strain" to him, as yet another unplaced Stesichorean fragment has it.[18] As J.D. Beazley once remarked of this figure, "in archaic painting the frontal face is not used haphazard," a remark with which one may in this case certainly concur.[19]

The possibility that Kleitias is drawing on a performance of a poem by Stesichoros, presumably entitled something like *Epithalamion for Peleus and Thetis,* is somewhat strengthened when one turns to two slightly earlier vases by Sophilos that carry the same theme. It should be stressed at the outset that these are the *only* three vases in extant Attic painting that depict this stage of the story:[20] several later black-figure pots show the wedded pair in a chariot attended by the gods, but none carry the actual reception, as here.[21]

Best known of the two Sophilan vases is the very fragmentary dinos from the Akropolis (figs. 4.4a–4.4j).[22] Here we find (fig. 4.4a) Thetis'

4.4d

4.4e

4.4f

4.4g

4.4h

4.4i

4.4j

house with the artist's signature, and to the right a part of a fishtail and the tail of a donkey or horse. On the analogy of the François vase and, as we shall see, the second Sophilan piece, this must be Okeanos and Hephaistos bringing up the rear of the procession. Another sherd (fig. 4.4b) with the left-hand corner of the house and a foot facing to our left comes next: this should belong to Peleus, waiting to receive the guests. A third fragment, the largest (fig. 4.4c), is introduced by a female figure (her flesh is white) with wings on her ankles and so probably Iris; behind her are Hestia, Demeter, Leto, and Chariklo, all of whose names are inscribed. A fourth (fig. 4.4d) has Hera and Zeus in their chariot, to which may

belong yet another fragment of chariot body and the team following (fig. 4.4e). Next (fig. 4.4f), we have the heads of Amphitrite and Poseidon, and to the left what may be the mane of yet another horse from the chariot immediately behind. A seventh piece (fig. 4.4g) gives the heads of two Nysai, Dionysos' companions, facing back toward a third woman who is familiar from her frontal face and syrinx: she is of course Kalliope. Then come two fragments recently added by G. Bakır: the heads of two horses with part of the chariot in front (fig. 4.4h) and more of Okeanos' fishtail with two standing figures in the background, one of them definitely male (fig. 4.4i). Finally, there is a small piece of palmette

4.5a

4.5b

chain, whose exact position cannot be fixed (fig. 4.4j).

The other, a magnificent vase over two feet high, is the so-called Erskine dinos in the British Museum (figs. 4.5a–4.5d).[23] It is also signed by Sophilos and was acquired in 1971. It is far more complete (but not absolutely so), is richly inscribed, and treats the procession in much the same way as the Akropolis fragments and the François vase. Once again there is the house with the artist's signature, then in order come Peleus, Iris, Demeter, Hestia, Leto, and Chariklo. Dionysos follows, a more staid figure this time, bereft of his amphora and shown now in profile. Hebe comes next, dressed in conspicuous finery, then Cheiron with his branch and quarry. Themis (not shown on the François vase, unless she is the richly attired woman with the three Moirai on

the reverse) then follows, leading three nymphs. Then come the chariots, each accompanied by a group of women, as is normal on the François vase too: thus three unidentified women walk beside the chariot of Zeus and Hera, the Charites escort Amphitrite and Poseidon, and five Muses (the central one facing out with a syrinx, and so once again Kalliope) walk before Aphrodite and Ares. Three more Muses accompany Apollo and Hermes, and three Moirai Athena and Artemis. Last are Okeanos (bull-horned only, not bull-headed as Kleitias drew him) and Hephaistos with his donkey; Okeanos' wife Tethys walks with them, in company now with Eileithyia, goddess of childbirth—a delicate allusion to the offspring of the coming union.

After this brief introduction, it is time to examine the three pictures together and some-

4.5a–4.5d. London 1971.11-1.1. The Erskine dinos. Attic black-figure dinos signed by Sophilos as painter. Wedding of Peleus and Thetis. Photos: Courtesy of the Trustees of the British Museum.

4.5c

4.5d

TABLE 4.1

what more closely. A chart listing the cast of each in order of appearance may help (table 4.1): names that are inscribed are in italic.

It is quite evident that all three are very much in agreement over their handling of the theme. All else apart, they are of course very close in date. The problem is, how far is Kleitias indebted to Sophilos for the iconography of his picture, and how much—or how little—is each taking from Stesichoros? Questions of this sort are naturally very difficult to answer at this distance in time, given the incomplete nature of the remains, but it is incumbent upon us to try.

First, Kleitias clearly knew Sophilos' vases (or others very similar) and set himself to compete with them. Thetis' house is identical in type in all three pictures, Doric and distyle *in antis,* but Kleitias' version is by far the most elaborate and carefully drawn: compare its anta capitals, architraves and molded frieze crown with Sophilos' far simpler structure on the Erskine dinos. In addition, Kleitias adopts Sophilan iconography for several of his key figures, like fleet-footed Iris in her eminently practical jogging shorts, and Kalliope with her frontal face and syrinx. Yet the glimpse he gives us of Thetis inside the house and his Hephaistos seated sidesaddle on the mule by a bullheaded Okeanos are surely intended once again to improve upon Sophilos, who shuts Thetis away in purdah, makes Hephaistos walk, and only gives Okeanos a human head with horns grafted on. The spirit of competition between younger aspirant and old master seems very much alive here. After all, the three vases could be as little as five years apart in date of manufacture, maybe even less.

So then, is Sophilos the "onlie begetter" of the series, and Stesichoros merely a relatively minor influence on Kleitias alone? I think not: not only is Kleitias' acknowledgment to Stesichoros unique in Attic vase-painting, as far as I know,[24] and thus strongly suggests a significant relationship between painter and poet, but the way in which the group as a whole relates to the major literary tradition is in every way consistent with this. While the participants, or at least the protagonists, are exactly those one would expect from the extant literary sources, the setting unanimously adopted by the two painters is very different from that recorded in the *Kypria,* Hesiod, and other extant Greek poetry, which opts for Cheiron's cave on Mount Pelion.[25] In fact, of all the many accounts in ancient literature only one, Catullus 64, places the reception in the Thetideion at Pharsalus, and this the poet does for his own reasons.[26] As for the gifts, here

	(1) Akr. 587 frr.	(2) Erskine Dinos	(3) François Vase
→	House *Peleus* (?) []	House *Peleus*	House + Thetis *Peleus* Altar
→ → →	[] *Iris* (?) *Hestia* *Demeter* *Chariklo* *Leto*	*Iris* *Hestia* *Demeter* *Chariklo* *Leto*	*Cheiron* *Iris* *Demeter* *Hestia* *Chariklo*
→	[]	*Dionysos*	*Dionysos*
	[]	*Hebe* *Cheiron* *Themis* *3 Nymphs*	*3 Horai*
(I) →	[] *Hera* *Zeus*	3 women *Hera* *Zeus*	*Kalliope* *Ourania* *Zeus* *Hera*
(II) →	[] *Amphitrite* *Poseidon*	*3 Charites* *Amphitrite* *Poseidon*	*Kleio* *Euterpe* *Thaleia* *Melpomene* (*Amphitrite*) (*Poseidon*)
(III) →	*2 Nysai* *Kalliope* (?) []	2 Muses *Kalliope* (?) 2 Muses *Aphrodite* *Ares*	*Stesichore* *Erato* *Polymnis* (*Ares*) (*Aphrodite*)
(IV)	[]	3 Muses *Apollo* *Hermes*	3 women *Leto* (?) *Apollo* (?)
(V) →	[]	*3 Moirai* *Athena* *Artemis*	*Nereus* *Doris* *Athena* *Artemis* (?)
(VI)	[]		*3 Moirai* + *Themis* (?) *Maia* *Hermes*
(VII)			3 women [*Tethys* (?)] [*Eileithuia* (?)]
→ →	Okeanos Hephaistos	Okeanos *Tethys* *Eileithuia* *Hephaistos*	Okeanos *Hephaistos*

Key to Table 4.1
Arrows indicate participants in all three scenes
Italicized names are inscribed
Square brackets indicate lacunae
Names in curved brackets indicate figures obscured by the handles of the vase, but identifiable by inscription

only the two complete vases help: the golden amphora occurs only in the François vase, Cheiron's ash branch for the making of Peleus' great spear in both, and Hephaistos' own present, a new suit of armor, in neither.[27] Such a relatively self-consistent yet, in terms of the extant literary record, at times heavily aberrant pictorial tradition suggests a common source: Stesichoros, inventive and sometimes iconoclastic in his handling of epic materials,[28] is certainly apropos.

Yet what of the discrepancies in the iconography, the occasional changes in position for some of the major figures like Cheiron, the increasing variability in the grouping of the gods toward the rear of the procession, the remarkable freedom with which the minor figures exchange identities and locations (cf. table 4.1)? While some key figures like Iris and Kalliope are all but identical, others such as Dionysos could hardly be more unalike. Yet while these iconographic differences surely preclude these pictures from close dependence upon a *visual* source (in other words, a monumental painting), they could be generally consistent with common recollection—albeit to differing degrees—of an *oral* source, presumably a poem of that same Stesichoros who is so neatly acknowledged by Kleitias in his picture. Since it is almost certain, given what we know or can reasonably infer about the transmission of Archaic Greek poetry, that no *text* would have been in general circulation,[29] a *performance* remembered with varying degrees of precision and adapted with varying degrees of freedom in each case, may go far to explaining the complications of the evidence.[30]

To proceed, now, to the other narratives on the obverse of the François vase. Here, my remark that Dionysos is the key figure for understanding the program of this whole side was not quite accurate. Actually, he is aided by two others, disposed symmetrically about him, namely Kalliope and Cheiron (fig. 4.2). These three together help to link the other friezes and the handle scenes to the main frieze in a manner that is both subtle and fascinating to trace.

First, the Hunt of the Calydonian boar, the beast sent by Artemis (who fittingly appears as Mistress of the Animals on the handles to the sides: figs. 4.1b, 4.1d, 4.3) to ravage the land of Oineus in Aetolia. Although we know that Stesichoros wrote a poem on this, called the *Suotherai* or "Boarhunters,"[31] it is evident from one of the three surviving fragments that in contrast to the main frieze, it probably did *not* provide the source for Kleitias' picture. The fragment preserves the names of Prokaon and Klytios (sons of

Thestios), Eurytion and a son of Elatos, perhaps Kaineus.[32] Now Kleitias is very conscientious about naming his figures (he even names their dogs) yet none of these characters appears in his picture despite their importance in the myth: the sons of Thestios, we know, were killed by Meleagros in a dispute over the spoils, and Eurytion was speared by mistake by Peleus in the hunt itself, an act that led him to flee for his life. This should caution us against seeing a Stesichoros under every mythological bed, as it were: his influence upon Kleitias may well have been limited to the main frieze alone, or even (as an extreme skeptic could argue) to the motif of the amphora, its history and its function.[33] In any case, vase-painters have their own ways of organizing narratives and serve their own purposes in doing so, a point which will receive further consideration shortly.

Here, then, we have nine names from myth and eleven from contemporary life.[34] Of the mythical names, all are participants well known from both literature and painting except one: Akastos, king of Phthia, whose presence is only attested elsewhere in a rather wayward early black-figure dinos from the Agora and a half line of Ovid's *Metamorphoses*.[35] A possible motive for his selection by Kleitias emerges if one turns to Pindar's accounts in *Nemean* IV and V of the Muses' song at the wedding of Peleus and Thetis itself. First, *Nemean* V:

ON PELION
The loveliest choir of Muses sang.
They sang first of holy Thetis and Peleus,
—How the luxurious daughter of Kretheus,
Hippolyta, wished to snare him by a trick;
By elaborate craft she had won the help
Of her lord who watched over the Magnesians.
She rigged a false, lying tale
That Peleus tried to sleep with her,
The bride of Akastos, in his marriage bed.
The truth was the opposite,
For at once he scorned her embraces—
He was afraid of his father's anger, the God of Guests.
But cloud-mover Zeus, King of Immortals,
Marked well and promised from the sky that soon
He would wed a sea-maiden from the golden-spindled
 Nereids.
(Pind. *Nem.*V.22–37, trans. C. M. Bowra [abridged])

Nemean IV is even more explicit, naming Cheiron as Peleus' rescuer from Akastos' ambush:

He saw the fine seats in a circle
Where the Kings of Earth and Sky
Took their places and showed favors
And power to his race.
(Pind. *Nem.* IV.57–68)

From these one may, I think, hazard that the choice of the Hunt and the inclusion of Akastos

by Kleitias serve not only to illustrate the heroic qualifications of Peleus in actual combat, as many have already recognized, but also to allude to that episode which firmly established him in the ancient tradition as the most pious, *eusebestatos,* of heroes.[36] This, the spurning of Akastos' wife as she tried to seduce him, was an incident that soon followed the hunt and led directly to the gods' gift of Thetis to him.[37] The presence in the main frieze of Kalliope, who as it were "announces the strain" of the wedding hymn itself to the spectator, and of Cheiron, Peleus' rescuer from Akastos' ambush, thus become indirect yet crucial links within the scheme as a whole.

Concerning the offspring of the marriage, Achilles (educated, one may recall, by Cheiron in the arts of war *and* of the Muses),[38] it would have been possible for Kleitias to select a whole range of stories for his vase. Why, then, did he choose the Pursuit of Troilos, the Funeral Games of Patroklos, and the rescue of Achilles' body from battle by Ajax? A clue, I think, lies in the golden amphora and what it portends for the hero. In Homer and even more explicitly in Stesichoros, the golden amphora symbolizes two interlocking themes in the Achilles story: first that he is doomed to die young but in glory, and second that this will ensure him ultimate immortality on the Isles of the Blest.

As regards the first, Thetis was quite explicit to her son, almost brutally so. Achilles speaks:

For my mother Thetis the goddess of the silver feet
 tells me
I carry two sorts of destiny toward the day of my
 death. Either,
if I stay here and fight beside the city of the Trojans,
my return home is gone, but my glory shall be ever-
 lasting;
or if I return home to the beloved land of my fathers,
the excellence of my glory is gone, but there will be a
 long life
left for me, and my end in death will not come to me
 quickly.
(Hom. *Il.* IX.410–16)

So, to put it another way, Thetis' gift of the amphora to Achilles before his death indicates that his fate is sealed: as he himself says to his mother, he has lost a safe return home (*nostos*) but will instead have unfailing glory (*kleos*).[39] And just as the Muses foretold his *kleos* in song at his father's wedding, so did they sing his dirge at his funeral.[40] "And thus," says Homer, "not even in death did you lose your name, but for-ever will you have fair *kleos* among men, Achilles"[41]—*kleos,* one may say, that justifies the

perpetuation of Achilles' deeds on this vase as it justifies them in epic, the historical successor to the original dirge of the Muses.[42]

Now the *kleos* of song is indeed immortal, but it is not to *poetic* immortality that the golden amphora refers, but to that conferred upon the hero by the complementary institution of cult. As G. Nagy has recently remarked:

The traditional emphasis on the hero's bones in cult represents a formal commitment to the promise of immortalisation. The discipline of anthropology can help us here, with its vast reservoir of experience about parallel social institutions, taken from actual field work . . . [And as for the gift of the amphora] from what we know about the symbolic function of bones in general and about regeneration in particular, we may see in this formal token the promise of an ulti-mate immortality in store for the hero of the *Iliad.*[43]

It should be superfluous to note at this point that the material of the amphora, gold, incorruptible and eternal, the "child of Zeus,"[44] makes Nagy's point even more explicit still.

It is in the Pursuit of Troilos that the first stage in the promise—or threat—of the amphora is fulfilled. The appearance of Hektor with the res-cue party shows that this episode is to be thought of as taking place well before the *Iliad* opens, probably in fact just after the first landing of the Greeks at Troy, as the author of the *Kypria,* among others, relates.[45] All sources concur that this was the act that eventually led directly to Achilles' own death by fatally arousing Apollo's ire against him. Here one may note that Achilles, for the first and last time on the vase, wields his bronze-tipped ashen spear. This spear had a his-tory, retailed in both the *Iliad* and the *Kypria*: it was the only piece of the hero's armor that was not made by Hephaistos. Rather, it was inher-ited from Peleus, to whom it had been given by Cheiron on his wedding day. It was made of Pelian ash, cut by Cheiron himself and given to Peleus "to be death to heroes."[46] Achilles, taught by Cheiron on Mount Pelion, was after Peleus the only man who could wield it, and it was the only piece of his panoply that Patroklos did not take with him when he went out to meet Hektor in Achilles' place, with such fatal results. It was therefore safely in its owner's tent when Hektor killed and despoiled Patroklos, and remained in Achilles' possession till his own death.

It is the original branch from which this spear was cut that, I submit, Cheiron carries in the main frieze above. Beazley calls this branch a fir,[47] but this is contradicted by its appearance and very detailed drawing. I am indebted to R. A. Cockerell of the Forestry Department at the

4.6. *Above:* details of branches carried by the Centaur Cheiron (*left*) and another (*right*). From the François vase, side A (main frieze) and side B (neck frieze) respectively: cf. figures 4.1a–c, 4.2. After Furtwängler-Reich-hold, *Griechische Vasenmalerei* pl. 1–2, 11–12. *Below:* branches of the Mediterranean ash (*Fraxinus excelsior*). From H. J. Elwes and A. Henry, *The Trees of Great Britain and Ireland* vol. 4 (Edinburgh 1909) pl. 262 (*left*) and R. Rol, *Flore des Arbres* vol. 1: *Plaines et Collines* (Paris 1962) p. 51 (*right*).

University of California, Berkeley, for an opinion: he believes, as I do, that in its stylized form here it stands in the same relation to the Mediterranean ash, Fraxinus Excelsior (fig. 4.6), as Dionysos' vine does to a real member of that species.[48] One detail to support this: the buds of the fir grow not at the bases of the leaves, as in the picture, but at their ends. The buds of the ash, on the other hand, grow precisely in the position indicated by Kleitias.

Now, a recent monograph by R. Shannon has explored the connotations of the bronze-tipped ashen spear at great length.[49] As he points out, bronze and ash are emblems of the blood-crazed Third Generation of Hesiod's cosmogony, bent on nothing but *hubris* and war:

And Zeus made another Generation of mortal men, the Third.
And he made it Bronze, not at all like the Silver.
A Generation born from ash trees, violent and terrible.
Their minds were set on the woeful deeds of Ares and acts of *hubris*.
(Hes. *Op.* 143–46, trans. G. Nagy)

The homicidal atavism of these men has a bearing on the character of Achilles, whose darker side is just as much integral to the *Iliad* as is his peerless heroism—the two extremes are, as it were, opposite sides of the same coin. Thus he is regularly presented in the *Iliad* as the personification of naked force, *biē*, and malevolent savagery. As Nagy has remarked concerning Shannon's thesis, "In sum, the diction of the entire *Iliad* makes the bronze-tipped ash spear an emblem of Achilles just as surely as the birthmark of a spear characterizes the wanton Spartoi, or as bronze and ash wood characterize the equally wanton Bronze Men." Or, as we may add, as what also appear to be ash branches characterize the equally wanton and atavistic Centaurs on the actual reverse of the François vase itself (fig. 4.1c).[50]

This dark and savage side of Achilles' character is nowhere more evident than in the Troilos saga, where the Archaic version even had him kill Troilos as he takes refuge by Apollo's altar, in his sanctuary.[51] So, to return to the two wedding gifts themselves, just as the golden amphora is a theme that connects the child of the marriage, Achilles, with his immortal mother,[52] so is the ash spear a reaffirmation of his connection with his mortal father, who here clasps the hand of its donor Cheiron in friendship. The one contains a promise, the other a warning—a warning that here Achilles deliberately flouts. In place of his father's piety, *eusebeia,* in this instance his sheer heroic potency leads him to *asebeia,* impiety—and as Apollo warns on the left of this frieze, he will pay the penalty with his life.

Yet here the coming storm is still only a cloud on the horizon. The altar and sanctuary are omitted, and Apollo is impotent and isolated on the fringe of the picture. What strikes the eye first and foremost is not these distant rumblings of disquiet, but the extraordinary way in which Achilles has managed to overtake a galloping horse even though clad in full armor. True, his swiftness was legendary, and celebrated in Homer by that most characteristic of his epithets, *podōkēs* ("fleet of foot"), but here Kleitias has gone one better: so swift is Achilles that his giant strides even propel him off the ground—a discovery that has lost nothing of its effectiveness through twenty-five centuries, up to and including the world of the animated cartoon.

Next in time come the Funeral Games of Patroklos, Achilles' surrogate and shadow,[53] the first of the pair to feel Apollo's wrath and now the first whose bones will occupy the golden amphora. Note once again how the chariots of the heroes race to Achilles as the chariots of the gods paraded to honor his father Peleus on the frieze below: a funeral replaces a wedding, and augurs more death in its turn. For the direct result of Patroklos' death will be the killing of Hektor, from which Achilles himself gets the *kleos* of immortalization in song. By the time of this race, Patroklos' burial in the amphora was a foregone conclusion[54]—Achilles, it will be recalled, had assented to it only a few hours before, in conversation with his friend's ghost. In addition, then, to heralding Achilles' own glory in the triumph over Hektor, the games can also be said to presage *his* forthcoming death and burial in the amphora—for where the shadow leads, he who casts it can never be far behind.[55]

The inevitable denouement follows on the handles of the vase, where Achilles has become a huge, lifeless corpse, sustained by his comrade Ajax in much the same way as Dionysos carried the amphora itself (figs. 4.1b, 4.1d, 4.3). It is no coincidence that of these two scenes of Achilles' death, one is placed directly above the maker of the amphora, Hephaistos, as he brings up the rear of the wedding procession, the other above the irate figure of Apollo as he rails against the death of Troilos. The message is clear: Apollo, finally, has had his revenge, and Achilles his immortality.

Does this vast complex of heroic narrative bear interpretation as a whole? Clearly, the intricate and subtle web of interconnections that Kleitias

has woven for us is not easily summarized without doing gross violence to his achievement. From the foregoing analysis one may, I think, hazard that the choice of themes was made with some care, not merely to chart the history of a family but to characterize its two most prominent members, Peleus and Achilles, in a very particular way. Greeks of the seventh and sixth centuries, as we know from their poetry, were much concerned not merely with the glory of the heroic enterprise per se, but with what actually marks off a hero from other men, what defines him against the mass of his contemporaries. This special quality of heroes (or of their would-be successors, the aristocrats of their own era) they called *aretē*, an almost untranslatable word inexactly rendered by the English "virtue," "merit," or "excellence of character." *Aretē*, of great concern to Greeks of all periods, is in fact a man's strength relative to his world,[56] in an aristocratic society such as this a combination of high birth, inner fortitude, sheer bodily strength, and of course divine favor.[57]

Thus, Peleus' prowess in combat and piety amidst temptation are both facets of his *aretē*, as are Achilles' peerless heroism, unequaled swiftness, unmatched devotion to his friend, and mighty, savage wrath. And at the focus of this vast exposé of heroic *aretē*, its failings and its triumphs, the painter justly chooses to place the Wedding of Peleus and Thetis, making all the other themes adjuncts to it. For it was this event, explicitly sanctioned by all the gods,[58] that proved to be the watershed in the fortunes of the heroic world. This was the last act of union between mortal and god: in it are embodied at once Peleus' reward for his surpassing *aretē*, the promise of yet greater rewards for his even mightier son, and a foretaste of that universal strife to come (I refer of course to the Judgment of Paris, brought on by events at the Wedding itself)—strife in which that son's troubled yet glorious destiny was to be played out.[59] Appropriately, all these themes intersect in the motif of Dionysos' amphora and its twin promises of death and immortality. These promises are reinforced through Cheiron's gift of the ash branch, with its predictions of mighty prowess and warnings of equally terrible *hubris*, and Kalliope's inauguration of the Muses' song, her gift, with its forecast of everlasting *kleos* through the epics of Homer, Stesichoros, and others—and, we may add, through the medium of the visual arts as well.

How does the reverse of the vase square with this interpretation? First, once again, a look at its composition (fig. 4.1c). The wedding procession continues on the shoulder, binding together the two sides of the vase, but now it is given no focal point at its center. Above is the Centauromachy, with groups of struggling men and beasts centered around a duel between the Lapith Hoplon and the Centaur Petraios.[60] On the far left of the fight is Theseus, who also appears diagonally opposite on the far right of the frieze on the lip above, where he greets Ariadne and her nurse. (See Cohen p. 176.) This somewhat unexpected feature may conveniently serve to introduce the compositional schema that in its turn brackets this, the Return of Theseus, with the Return of Hephaistos on the lowermost register, namely a balanced or diagonal asymmetry. Both these outer scenes are asymmetrically divided into two sections, the smaller riotous and complex, the larger quiet and relatively static. Each is diagonally opposite to its corresponding section in the other frieze, creating a kind of chiastic balance that both unites the two friezes themselves and spans the entire side. Once again, Kleitias' careful quest for structural coherence among what is, after all, exceedingly disparate subject matter, is affirmed in no uncertain manner.

If we are being encouraged to *look* at this side as a unity, are we also meant to *read* it as a unity? Here one turns to Robertson's acute observation that all three ancillary themes are connected, in one way or another, with marriage.[61] One may also note in passing that all three also involve, in one way or another, Dionysos.

Thus, the two outer friezes, mirror images of each other in composition, also reflect a common jubilation on the part of the spectators (the Athenian sailors and Dionysos' chorus of satyrs and maenads) at the weddings that will shortly ensue. To this end, complications are either ignored or played down. For according to the early tradition (which Kleitias must surely have known) Ariadne's elopement with Theseus was adultery, pure and simple. She was already married to Dionysos, who was so enraged at her elopement that he persuaded Artemis to kill her when the fugitives reached Delos.[62] Yet here they perform the Crane Dance to the goddess (shown on the handles at each side) with not a hint of the wrath to come, while Ariadne proffers the ball of twine to Theseus at far right. This looks rather like an early stage in that whitewashing of Theseus so assiduously practiced by the Athenians in later years, as he rose to become *the* national hero, *sans peur et sans reproche*.[63]

As for the Return of Hephaistos, his terms for agreeing to free Zeus and Hera from their prison-chairs were none other than his acquisition of Aphrodite herself as his bride. Flanked by the contending parties, Dionysos and Aphrodite negotiate the deal, a scene into which Kleitias injects no little irony and humor. Her reluctance, which was to result in a tempestuous and occasionally embarrassing future for both parties,[64] is here turned into a comedy.

Finally the Centaurs on the neck frieze. It was of course their overindulgence in the gifts of Dionysos that led them to try and rape the bride at the wedding of Peirithoos and Deidameia, a deed for which Theseus and the other heroes repaid them in kind. Here their story acts as a sort of foil to the two outer narratives, both in composition and in content: this is how beasts, not heroes and gods, get brides.

It is arguable, I think, that these images function in relation to the main theme in very much the same way as a series of exempla do in epic poetry, to comment upon and to deepen one's understanding of the point at issue. Thus in Proclus' summary of the *Kypria* we read that after Helen's abduction:

Menelaos returns home and plans an expedition to Troy with his brother, and then goes to see Nestor. Nestor in a digression tells him how Epopeus was utterly destroyed after seducing the daughter of Lykos and [then adds] the story of Oedipus, the madness of Herakles and the story of Theseus and Ariadne. They then travel about Greece together to gather the leaders. (p. 103, 20–23 Allen)

In this text, the word for "digression" is the Greek *parekbasis,* which literally means a "going aside from"—a spatial metaphor well suited to Kleitias' usage of these three exempla as ancillaries to the main frieze on the reverse of his vase.

Yet in this case the painter does not merely ape the poet, but beats him at his own game. His *parekbaseis* are more varied in tone, more rich in nuance than those cited above, which boil down to a kind of Guinness book of disastrous passion. Thus the sensitive observer, looking at the François vase, would probably have remembered the tradition that Peleus' acquisition of his bride also required a certain amount of force (he had to wrestle her to win her),[65] but that this coercion was explicitly sanctioned by the gods, as witness their appearance en masse at the wedding. Now force also played a part in all three of the narratives illustrated on the reverse, but in each case the painter's address to circumstance is different. With the Theseus and Ariadne scene, it is both out of sight and so largely out of mind.

With the Return of Hephaistos it is both present and palpable (for Zeus, Hera, and Aphrodite herself consent only under duress) but transmuted into near farce. With the Centaurs, however, the painter becomes deadly serious, for their violence strikes at the heart of all divinely established values, a transgression for which they must pay with their lives. Both individually and collectively, these three themes provide not merely a set of comparanda for the events of the main frieze, but a commentary on them, a commentary which locates them even more precisely in the network of heroic/divine relationships already constituted on the other side of the vase.

So much for the details of the program: what of the vase as a whole, its narrative structure, its "message," and its original purpose? It is time for a synthesis.

As I have tried to show, the subject of heroic *aretē* in divinely sanctioned marriage not only seems to bind together the two sides of the vase in the physical sense, but is developed in different ways on both obverse (handles included) and reverse through the addition of secondary material. Since Kleitias' starting point seems to have been a lost poem of Stesichoros, it may not be irrelevant at this point to introduce two complementary notions from literary studies to reach a somewhat closer analysis of the relation of these ancillary narratives to the wedding scene. When literary critics, taking their cue from Saussure, Barthes, Jakobsen, and others, describe distributional relations within a text as either *syntagmatic* or *paradigmatic,* they are setting up a structure which has powerful implications for a system of interlinked narratives such as we find here.[66] In F. Culler's definition:

Syntagmatic relations bear on the possibility of combination: two items may be in a relation of reciprocal or non-reciprocal implication, compatibility or incompatibility. Paradigmatic relations . . . determine the possibility of substitution . . . [so that here] the meaning of an item depends on the differences between it and other items which may have filled the same slot in a given sequence. . . . The analysis of *any* system [my italics] will require one to specify paradigmatic relations (functional contrasts) and syntagmatic relations (possibilities of combination).[67]

It will at once be evident that this is precisely the situation that confronts us on the François vase: a combination (or sequence) on the obverse, and a set of functional contrasts on the reverse.

Thus, on the front of the vase Kleitias constructs a system around what one may call the "line of fate"[68] generated by the golden amphora. Although the binding element is at first sight the history of a family, the relationship between the

scenes is in fact only in the weakest sense to be described as diachronic. Indeed, a strictly chronological approach requires the eye to jump about the vase in a most irregular manner, thus:

Calydonian Hunt	—Lip-Handles (Artemis)
Wedding of Peleus and Thetis	—Shoulder
Pursuit of Troilos	—Belly
Funeral Games of Patroklos	—Neck
Death of Achilles	—Handles

Instead, the painter actually concerns himself in the first instance not with chronology but with possibilities of combination, with evocative *syntagmatic* relations rather than purely temporal ones. The wedding necessarily, therefore, occupies the place of honor on the shoulder, and is bracketed by the two scenes that most evoke the destiny fated for its offspring by the gift of the amphora, namely the Pursuit of Troilos and the Funeral Games of Patroklos. Note once again how Achilles in the former is placed directly below the amphora and how the two chariot scenes are structurally so similar but in content and implication so different—evocative combinations to say the least. Peleus' exploits in the Hunt are important as motivation for the Wedding, so are assigned to the lip, where their relatively isolated position is quite eye-catching. Finally, as we have seen, Achilles' death is twice integrated into the structure in a manner that precisely specifies its dual status as both revenge and reward. Relations in all cases are those of "reciprocal or non-reciprocal implication," as Culler puts it: a syntagmatic structure of noninterchangeable parts determines the quality of the whole.

On the reverse, however, what matters is the possibility of interchange or substitution. Each part acts as a kind of gloss on the others and on the main frieze, and each could be exchanged for another, similar narrative without undue damage to the syntax. What the painter produces here is that other, complementary structure, the paradigmatic, where the wedding theme is developed through comparison and contrast. Solemnity and joy, seriousness and comedy, harmony and brutality, divine sanction and divine displeasure—the painter's selection engages all these issues and more. Thus of the three paradigms presented to us, the two paired examples—the Returns of Theseus and of Hephaistos—function respectively as analogue to and comic inversion of the main narrative. More explicitly than was the case on the obverse, *arete* is manifested

through human and divine ingenuity and fortitude in adversity, and in each case its reward is the triumphant return of the fugitive to a wedding: inevitably one recalls Peleus' escape from Akastos and his own subsequent reward. The Centauromachy, on the other hand, provides the antithesis to the main narrative, where *arete's* opposites, *hubris* and lustful assault, result in the grim pursuit of the outcasts away from the wedding, and their subsequent slaughter in the field. In all three cases meaning is now defined through an investigation of the possibility of substitution of paradigms, with the result that the significance of the Wedding of Peleus and Thetis is seen to depend, to repeat Culler's formulation, "on the differences between it and the other items which may have filled the same slot": it is a paradigmatic structure of functional contrasts that this time determines the quality of the whole.

The relationship structures that link these narratives (items of theoretically equal status)[69] are exhaustive: as both linguists and critics agree, no others at this level are possible—though my own analysis of them is, no doubt, less complete. At any rate, it is to Kleitias' supreme credit that he is, to my knowledge, the first Greek painter to have intuitively recognized these differing possibilities inherent in the combination of narratives, and employed them so powerfully to develop his point.[70] This point itself may now be redefined one final time through, as it happens, the medium of a vivid and beautiful fragment of Stesichoros, at present unplaced in his corpus but certainly appropriate to the theme of an epithalamion for Peleus and Thetis:

Muse, who has driven War clean away, if you love me
 Come join with me in chorus:
Sing of the weddings of gods and the feastings of men,
And the joys of the blest.
(fr. 210PMG)[71]

To Kleitias, as we may imagine to Stesichoros himself, *arete*, though problematic in nature, is unquestioned as a goal. Indeed, if the gods take time to smile upon one, the rewards are the highest to be hoped for: eternal bliss among the *makares,* the blest, in paradise.

So much for the similarities between Kleitias' handling of his iconography and the structures of verbal communication. What of the differences?

First, one may point out the obvious fact, already aired in a preliminary way rather earlier in this essay, that verbal narratives are necessarily strongly temporal in character, requiring as they do a certain length of time to perform, and at best only weakly spatial.[72] The situation is the

opposite with pictorial narratives, where the spatial aspect is self-evidently the stronger, the temporal the weaker. Thus, while Kleitias' ability to handle sequential action is necessarily inferior to, say, Homer's or Stesichoros', his capacity to evoke structural relationships is much greater.[73] In the diffuse and protracted medium of the epic the force of syntagmatic relations such as those generated by the golden amphora are much weakened, and paradigms such as the *parekbaseis* of Nestor in the *Kypria* are not heard in the first instance as functional contrasts or comparisons but as interruptions in the time-flow. The vase, however, may be taken in at a glance by the spectator, who is then free to peruse it at his leisure, to savor combinations and to recognize contrasts, and finally to arrive at a comprehension of the whole with the whole still before him. Vases, in sum, are not derivative of texts in anything like the same way that texts may be derivative of texts. The constraints and opportunities generated by the two media are very different, and to a great degree almost compel a painter's independence from his ostensible "source."

Second, there is the question of what one might call narrative style. In chapter 1 of his provocative book *Mimesis,* E. Auerbach summarizes the differences between the narrative styles of Homer and the author of Genesis in the following way:

It would be difficult to imagine styles more contrasted than those of these two equally ancient and equally epic texts. On the one hand, externalized, uniformly illuminated phenomena, at a definite time and in a definite place, connected together without lacunae in a perpetual foreground; thoughts and feeling completely expressed; events taking place in leisurely fashion and with very little of suspense. On the other hand, the externalization of only so much of the phenomena as is necessary for the purpose of the narrative, all else left in obscurity; the decisive points of the narrative alone are emphasized, what lies between is nonexistent; time and place are undefined and call for interpretation; thoughts and feeling remain unexpressed, are only suggested by the silence and the fragmentary speeches; the whole, permeated with the most unrelieved suspense and directed toward a single goal (and to that extent far more of a unity), remains mysterious and "fraught with background."[74]

The matter of unity apart, it is easy to see how closely such a description as Auerbach gives of Homer's narrative style can be applied also to the François vase: wholly objectified, uniformly illuminated phenomena, absolute clarity and fullness of description, completely externalized emotions and so on—all are markedly characteristic of the epic style of Kleitias too, as against,

say, that of Exekias.[75] Note, also, how the "perpetual foreground" of the Homeric style tends to exclude what Auerbach calls "background": the undercurrents of psychology, multiplicity of meaning, the concept of becoming, the perception of the problematic in life. Exekias, with his concentration and economy, may begin to address these issues directly; Kleitias, on the other hand, while still as absolutely under the spell of the Homeric style as was his probable informant, Stesichoros, enables us by his skillful handling of spatial form at least to catch a glimpse of some of them, while simultaneously refining the pictorial-epic style to its limit. No wonder that the François vase apparently had no true successors.

Finally, the question of purpose. A speculative venture on Kleitias' part seems unlikely, considering the sheer complexity and cost of the piece. Beazley once admitted the possibility that the artist was advised from outside,[76] and indeed it is difficult to see how such an ensemble as this could have come about other than by close consultation between artist and patron. At every stage the painter's aim is to contextualize, to locate marriage (here represented by the most fateful of all marriages) right at the center of that network of human and divine relationships and moral imperatives which characterize the society of heroes, the fabric, as it were, of heroic arete. Given this concentration on marriage and the glory of its offspring it seems difficult to doubt that the François vase was actually commissioned for an aristocratic wedding, as surely were the two vases of Sophilos on the same theme. Dinoi, we know, were wedding gifts par excellence,[77] and a great krater such as this would certainly be appropriate for mixing the wine at a wedding feast of one of the premier aristocratic families—all else apart, only they could have afforded it.

If this were the case (and it can only remain a hypothesis), the selection of a wedding blessed by all the gods, the celebration of the *arete* of Peleus and Achilles, the inclusion of Theseus' dance and Hephaistos' riotous return, all were no doubt recognized at the time for what they surely were—a rich and varied panegyric upon the groom, his bride, the ceremony itself and the hoped-for offspring of the coming union. Indeed, one wonders whether the gift of the golden amphora might even have been intended as, in one sense, an analogue for the François vase itself: both vessels, after all, carry messages of promise and warning to their recipients, implicit in the one case, explicit in the other through

actual narration. Yet the François vase of course differs from Dionysos' gift in the precise use to which it will be put—which is perhaps why Kleitias included two apotropaic Gorgons on the inner sides of the handles, hovering immediately over the wine that was to fill its interior: a more immediate caution, this, considering the likely outcome of the ingestion by its users of such enormous quantities of the Dionysiac spirit. Yet just to show that heroic/aristocratic life is nevertheless not to be taken too seriously, that he is no killjoy at the party, Kleitias signs off by including, around the foot, a parody, the Battle of Pygmies and Cranes, like the pseudoheroic Battle of Frogs and Mice, a commentary upon the tragicomedy of human pretensions.[78]

The purchasers must, I think, have been Athenians. A commission direct from Etruria, where the vase was found, seems unlikely on several grounds. First, only Greeks steeped in the mythological, epic, and lyric traditions of their homeland could have appreciated its intricate and subtle iconography. Second, Theseus and the numerous Athenian personal names on the two lip-friezes (among whom, as J. Boardman has noted, may be the highly self-assertive contemporary sculptor Phaidimos: fig. 4.1c)[79] are surely topical references for local consumption. Third, the vast majority of the vases of both Kleitias and Sophilos come from Attica and its environs, only a tiny handful from the West,[80] so it is in any case inherently unlikely that such a piece would be ordered new from far-off Chiusi, where around 570 Kleitias was almost certainly completely unknown.

Unfortunately, neither the vase itself nor the historical record furnish any but the most tenuous grounds for locating Kleitias' patron. The appearance of Ajax on the handles together with Lysidike and Epiboia in the Return of Theseus, already noted long ago, could be stretched to suggest a connection with Salamis and the Philaid clan, among Athens' oldest and most distinguished.[81] Of the scions of this family Hippokleides (of "don't care" fame in Herodotos)[82] and Miltiades III were about the right age, but no whisper of a marriage appears in the sources, though Hippokleides was clearly in the market, as it were, at the time. This apart, the texts are so scanty as to be almost valueless for the purpose. Yet though the recipient will almost certainly remain anonymous, one imagines that he cannot have failed to recall, as he surveyed Kleitias' magnificent creation, the prophecy concerning the bride in the picture, that she was destined to bear a son greater than his father.[83]

NOTES

I would like to thank S. Alpers, D. A. Amyx, E. N. Davis, M. Griffiths, M. Morrissey, A. J. Newcombe, G. F. Pinney, and T. G. Rosenmeyer for their kind and generous assistance in the preparation of this paper. They are, of course, not to be held responsible for my conclusions, or for my errors.

The fragments of the Greek epic and lyric poets are cited after the following editions:

Allen *Homeri Opera* v, ed. T. W. Allen (Oxford 1912).

LP *Poetarum Lesbiorum Fragmenta,* eds. E. Lobel and D. L. Page (Oxford 1955).

MW *Fragmenta Hesiodea,* eds. R. Merkelbach and M. L. West (Oxford 1967).

Nauck² *Tragicorum Graecorum Fragmenta²,* ed. A. Nauck (Leipzig 1889, 1926).

PMG *Poetae Melici Graeci,* ed. D. L. Page (Oxford 1962).

Radt *Tragicorum Graecorum Fragmenta* iv: Sophocles, ed. S. L. Radt (Göttingen 1977).

SLG *Supplementum Lyricis Graecis,* ed. D. L. Page (Oxford 1974).

Snell *Pindari Carmina cum Fragmentis* ii, eds. B. Snell and H. Maehler (Leipzig 1975).

West *Iambi et Elegi Graeci* i, ed. M. L. West (Oxford 1971).

1 Florence 4209: *ABV* 76; *Paralipomena* 29. Extensive descriptions, bibliographies, and complete or near-complete pictures of the vase and its many friezes prior to the new restoration are given in FR I, 1–14 and 54–62b, pls. 1–3, 11–13; A. Minto, *Il Vaso François* (Florence 1960) 8–9 (to 1922), pls. 1–33; Arias-Hirmer 286–92, pls. 40–46; E. Simon and M. Hirmer *Die griechischen Vasen* (Munich 1976) 69–77, pls. 51–57. For the new restoration itself, and over 250 superb pictures of the vase, see M. Cristofani, "Materiali per servire alla storia del vaso François," *BdA* 72 (1980) Serie Speciale 1.

2 Simon and Hirmer, *grVasen* 77; L. Watrous, *College Art Association: Abstracts of Papers* 67 (1979) 6; K. Schefold, *Myth and Legend in Early Greek Art* (New York 1966) 58–63; M. Robertson, *A History of Greek Art* (Cambridge 1975) 126.

3 A. Rumpf, *Gnomon* 25 (1953) 470.

4 E.g., Shefton, in Arias-Hirmer 289; Simon and Hirmer, *grVasen* 70. The black color of the vase is no bar, incidentally, to this interpretation: the tripod under Damasippos' horses in the frieze is black too (Cristofani, "Materiali" fig. 71). On the SOS amphora (Cristofani, "Materiali" fig. 132) see most recently A. W. Johnston and R. E. Jones, *"The 'SOS' Amphora,"* *BSA* 73 (1978) 103–41, esp. 133. By ca. 570 its lifespan was either over or nearly over: could Kleitias have selected the type as an antique, or even as a joke (since the SOS was hardly high-class ware)? I owe these suggestions, and the reference, to G. F Pinney.

5 Hom. *Il.* VI.130–40; one should note that since Hephaistos was, as it were, traveling light at the time of his sojourn with Thetis, the amphora could in any case hardly have been given to her then. Apparently the only scholar to have noticed the relevance of this fragment to the vase is J. Boardman, "The Kleophrades Painter at Troy," *AntK* 19 (1976) 12, n. 34; cf. also infra, n. 20.

6 On Hephaistos at Naxos see Preller-Robert I., 176 and n. 3; his return from exile on this occasion is, of course, narrated by Kleitias on the reverse of the vase (fig. 4.1c).

7 Hes. *Theog.* 36–103, esp. 77–80; cf. Cristofani, "Materiali" figs. 79, 194. Nineteenth-century scholarship sometimes argued that Stesichore was the *original* name of this Muse, and therefore (1) should be restored in line 78 of Hesiod's text, and (2) should be considered the inspiration for the poet's name, not vice-versa: cf. E. Braun, *AdI* 20 (1848) 314; P. Weizsäcker, "Neue Untersuchungen über die Vase des Klitias und Ergotimos," *RhM* 32 (1877) 43; U. von Wilamowitz-Moellendorf, *Nachrichten der Göttinger Gesellschaft, Philologisch-Historische Klasse* (1895) 221, n. 9; further references, and counter arguments, in M. L. West's edition of the *Theogony* (Oxford 1966) 181. In fact, the other variations reduce to two Atticisms (ΚΑΛΙΟΠΕ, ΟΡΑΝΙΑ) and one trivial misspelling (ΠΟΛΥΜΝΙΣ for ΠΟΛΥΜΝΙΑ: Cristofani, "Materiali" figs. 195, 199, 200). Cf. infra, n. 10.

8 *Geryoneis* and *Iliou Persis*: frs. 7–132 *SLG; Thebais:* P. J. Parsons, "The Lille Stesichorus," *ZPE* 26 (1977) 7–36; M. L. West, "Stesichorus at Lille," *ZPE* 29 (1978) 1–4; further recent bibliography in *L'Année Philologique* 48 (1977) 309–10; 49 (1978) 314. Cf. M. Robertson, "Geryoneis: Stesichorus and the Vasepainters," *CQ* n.s. 19 (1969) 207–21; M. I. Davies, "Thoughts on the *Oresteia* before Aischylos," *BCH* 93 (1969) 214–60 (I owe this last reference to M. Griffiths, whose help on matters Stesichorean has been invaluable); P. Brize, *Die Geryoneis des Stesichoros und die frühe Griechische Kunst, Beiträge zur Archäologie* 12 (Würzburg 1980). Boardman, "Kleophrades" 11–13 is more skeptical, but now see Brize, *Geryoneis* 28–29, 63–65.

9 M. L. West, "Stesichorus," *CQ* n.s. 21 (1971) 302.

10 So, e.g., P. Maas, s.v. "Stesichoros," *RE* 3A² (1929) cols. 2458–59; C. M. Bowra, *Greek Lyric Poetry* (Oxford 1936) 77–79; A. Lesky, *A History of Greek Literature*² (London 1966) 151; H. Fränkel, *Early Greek Poetry and Philosophy* (Oxford 1975) 281; Brize, *Geryoneis* 11–12; *contra,* West, "Stesichorus" 302–6—though my private enquiries among specialists in the field have failed to turn up any support for this. The *Souda,* N.B., tells us that his original name was Teisias, and that it was his innovations with the chorus that led him to adopt the name "Stesi-choros"—a statement that has bearing on the issue discussed in n. 7, supra.

11 Supra n. 8; the best summary of the "facts" (such as they are) on Stesichoros is West's article, "Stesichorus" 302–14 passim.

12 [Longinus], *Subl.* XIII.3.

13 *Souda* s.v. "Stesichoros"; on "programmatic" names for archaic poets see G. Nagy, *The Best of the Achaeans: Concepts of the Hero in Archaic Greek Poetry* (Baltimore and London 1979) 296–300.

14 West, "Stesichorus" 307–14.

15 Ap. Rh. *Argon.* IV.893–96; *RE* 5 A¹ cols. 789–90.

16 Fr. 209 *PMG* col. II (cf. Hom. *Od.* XV. 113–29); fr. 185 *PMG* (= 17 *SLG*); *ARV²* 449, no. 2; J. Boardman, *Athenian Red Figure Vases: The Archaic Period* (London 1974) fig. 300.

17 Frs. 178 *PMG,* 222 *PMG;* cf. fr. 179 *PMG* with two lists from the Pelias poem, one of victors in the competitions, the other (rather incongruously) of favorite foods offered to a girl!

18 Frs. 240 *PMG* (cf. Hes. *Theog.* 79; Alkman fr. 27 *PMG*), 250 *PMG.*

19 *Development* 28, with n. 4; on frontal faces and masks see T. B. L. Webster, *Greek Art and Literature 700–530 B.C.* (London 1959) 73, n. 15 (information from Y. Korshak).

20 List, H. von Steuben, *Frühe Sagendarstellungen in Korinth und Athen* (Berlin 1968) 120; *Vasenlisten³* 320, to which add the rather dubious evidence of some early black-figure skyphos fragments from the Akropolis tentatively accepted by Steuben, *Sagendarstellungen* 55: B. Graef, *Die antiken Vasen von der Akropolis zu Athen* I (Berlin 1909) no. 603, pl. 29 (foot procession with Dionysos, Aphrodite, Apollo [?], Artemis, Demeter, and others moving to left, winged female at front [Iris] greeted by a man and a woman [Peleus and Thetis?]; below, Ismene; inscription ΠΙ [ει] ΕΥ). Interestingly, L. A. Milani, *Il Reale Museo Archeologico di Firenze* I (Florence 1912) 148 (followed by Minto, *Vaso François* 19) also derived the entire main frieze from a Stesichorean *Epithalamion for Peleus and Thetis,* but apparently without noticing the relevance either of the Stesichoros name to his hypothesis!

21 List, *Vasenlisten³* 318–19; cf. I. Krauskopf, "Eine attisch schwarzfigurige Hydria in Heidelberg," *AA* 1977, 13–37.

22 Akropolis 587; *ABV* 39; Graef, *Akropolis* I, pl. 26; G. Bakır, *Sophilos* (Mainz 1981) no. A.2, figs. 5–9, 187–94; restoration, M. Heidenreich, "Zur frühen attischen Bildschöpfung der Peleushochzeit," *MdI* 5 (1952) 134–40 and fig. 1.

23 London 1971.11-1.1; *Paralipomena* 19, no. 16 bis.; A. Birchall, "A New Acquisition. An Early Attic Bowl with Stand, Signed by Sophilos," *BMQ* 36 (1972) 107–10, pls. 34–37; Bakır, *Sophilos* no. A.1, figs. 1–4.

24 None of the later "Stesichorean" vases with the *Geryoneis* (cf. Brize, *Geryoneis*) carries any such explicit acknowledgment, nor do the fifth-century vases apparently commissioned to celebrate dithyrambic victories (cf. H. Froning, *Dithyrambos und Vasenmalerei in Athen, Beiträge zur Archäologie* 2 [Würzburg 1971]). The only near parallels are the two vases painted ca. 500 by the Gales and Kleophrades Painters with Anakreon doing his Maenad dance (*ARV²* 36, no. 2; 185, no. 32: cf. Boardman, *ARFV* fig. 131). Vases showing poets and performers (like the Phrynichos and Pronomos kraters, *ARV²* 1145, no. 35; 1336, no. 1; cf. Sappho, *ARV²* 1060, no. 145), but not the narratives they performed, are not apropos, nor are vases with "portraits" of poets (e.g., Kydias, *ARV²* 31, no. 6; 173, no. 2; Anakreon again, *ARV²* 62–63, no. 86; Sappho, *ARV²* 300; Sappho and Alkaios, *ARV²* 385, no. 228: Boardman, *ARFV* figs. 47, 261; idem, *Athenian Black Figure Vases: A Handbook* [London 1975] fig. 311). On such vases as "special commissions," with some more marginal examples, see T. B. L. Webster, *Potter and Patron in Classical Athens* (London 1972) 46–48, 53–54, 60, 110; see also, in general, A. D. Trendall and T. B. L. Webster, *Illustrations of Greek Drama* (London 1971).

25 *Kypria* fr. 3 Allen (cf. Hes. fr. 211 MW); Alkaios fr. 42 LP; perhaps, too the Chest of Kypselos, Paus. v.19.7; Pind. *Nem.* v.22–37; Pind. *Isthm.* VIII.41–45; Eur. *IA* 704–5, etc. On the myth in general see A. Lesky, s.v. "Peleus," *RE* 19.1 (1937), cols. 290–301; idem, "Peleus und Thetis im frühen Epos," *StItal.* 27–28 (1956) 216–26. On the Chest of Kypselos see W. von Massow, "Die Kypseloslade," *AthMitt* 41 (1916) 95 and pl. 1; Schefold, *Myth and Legend* 72–73, fig. 26; Steuben, *Sagendarstellungen* 55.

26 Cf. *Catullus, The Poems,* ed. K. Quinn (London 1970) 308 on the crescendo that climaxes in the *ekphrasis* of the coverlet.

27 For the amphora, see pp. 55–56; for the ash branch, Hom. *Il.* XVI.143–44; *Kypria* fr. 3 Allen (where it is clear that the branch was trimmed later); for the armor, Hom. *Il.* XVII.194–97; XVII.82–85; cf. Steuben, *Sagendarstel-*

lungen 55. The armor was that lost by Patroklos to Hektor in Hom. *Il.* XVI–XVII; the spear remained with Achilles (XVI.139–44): see further below.

28 For Stesichoros' original contributions to well-known myths see Bowra, *Greek Lyric* 86–109, and for his heretical ones N.B. esp. his *Helen* (frs. 187–191 *PMG,* cf. 192 *PMG*).

29 Cf. F. W. Hall, *A Companion to Classical Texts* (Oxford 1913) 22–27; R. Pfeiffer, *A History of Classical Scholarship* (Oxford 1968) 3–9; texts, if any, seem to have been jealously guarded within the families of poets and rhapsodes, like the Homeridai of Chios. The mother of the Muses was, after all, Memory.

30 One small observation may help to support this: on the two Sophilos vases Hera is shown overlapped by, and a little in front of Zeus, while on the François vase the opposite is the case. This is exactly the kind of variation, it seems to me, that could result from a reminiscence of an orally delivered catalog of participants—for no poet would speak of background and foreground. In any case, whatever the truth may be, I must stress that I am not arguing that these pictures *illustrate* Stesichoros, merely that each could be, to differing degrees, inspired by him: on the distinction see Brize, *Geryoneis* 28–29.

31 Frs. 221–22 *PMG;* A. A. Barrett, "*P. Oxy*, 2359 and Stesichorus' ΣΥΟΘΗΡΑΙ," *CP* 67 (1972) 117–19.

32 Fr. 222 *PMG* col. 1 with Page's notes.

33 Cf. Apollodorus *Bibl.* 1.8.2, III.13.1–2. N.B. here the pertinent remarks of Boardman on the subject of Stesichorean influence, "Kleophrades" 11–13, with Steuben, *Sagendarstellungen* 88–91, and Brize, "Geryoneis" 28–29, 63–65, 106–7.

34 Mythological names (from left to right): Melanion and Atalante, Peleus and Meleager, Ankaios (under the boar), Polydeukes and Kastor, Akastos and Admetos. For all of them, and the others, see Cristofani "Materiali" 177–78 and figs. 147–59.

35 On the early iconography of the Hunt see *Vasenlisten*³ 310–12, with D. von Bothmer, "An Attic Black-figured Dinos," *BMFA* 46 (1948) 42–48; K. Schauenburg, "Eine neue Sianaschale," *AA* 1962, 765–75; R. Blatter, "Dinosfragmente mit der Kalydonischen Eberjagd," *AntK* 5 (1962) 45–47, pl. 16; G. Daltrop, *Die Kalydonische Jagd in der Antike* (Hamburg and Berlin 1966); Steuben, *Sagendarstellungen* 42–44. For the Agora dinos, *ABV* 23, see R. S. Young, "A Black-figured Deinos," *Hesperia* 4 (1935) 430–41, figs. 1–4, with Ov. *Met.* VII.306.

The following literary accounts of the hunt and lists of hunters survive: (1) Hom. *Il.* IX.529–99; (2) Stesichoros frs. 221–22 *PMG;* (3) Bacchyl. V.70–135; (4) Eur. *Meleager* frs. 515–39 Nauck²; (5) an early Hellenistic elegiac fr., published in appendix 1 to Hollis's commentary on Ovid, *Metamorphoses* VIII; (6) Apollod. *Bibl.* 1.8.2; (7) Hyg. *Fab.* 173–74; (8) Ov. *Met.* VIII.270–546; (9) Paus. VIII.45. On this last account, and the Classical and post-Classical iconography of the Hunt, see the present author's *Skopas of Paros* (Park Ridge, N.J. 1977) chaps. 2–3 and appendix 2; F. S. Kleiner, "The Kalydonian Hunt. A Reconstruction of a Painting from the Circle of Polygnotos,"*AntK* 15 (1972) 7–19.

36 Pind. *Isthm.* VIII.40, with Pind. *Nem.* IV.60–61, and Lesky, "Peleus" cols. 294–95. This is entirely consistent with the earliest detailed account, Hesiod fr. 211 MW line 8, where he gets Thetis as a "gift" (δῶρον) from Zeus; this fragment seems to have followed closely upon frs. 208–9 MW, which narrate parts of the Akastos incident. The possibility that the Hunt was an "illustration," as it were, of the Muses' song seems first to have been raised by Weizsäcker, "Neue Untersuchungen" (1877) 48, but has been ignored in recent years.

37 Supra n. 36, with *Kypria* frs. 1–2 Allen; Pind. *Nem* IV.60–68, etc.

38 Preller-Robert II.1, 21–22.

39 On the implications of this passage see Nagy, *Best* 29, 35–41, 95, 102.

40 Hom. *Od.* XXIV.60–62; Pind. *Isthm.* VIII.56–62; cf. Nagy, *Best* chap. 10.

41 Hom. *Od.* XXIV.93–94.

42 Supra nn. 40–41, with, e.g., Hes. *Theog.* 98–103; Nagy, *Best* 95–96, 184. On the inaugural power of the Muses' song at the wedding of Kadmos and Harmonia see Pind. *Pyth.* III.85–97 with Theognis 15–18 West: Nagy, *Best* 299.

43 Nagy, *Best* 208–9; cf. 179–80.

44 Pindar fr. 222 Snell; N.B. here the apparent persistence of heroic custom in Macedonia, as proved by the recent finds at Vergina: M. Andronikos, "Vergina. The Royal Graves of the Great Tumulus," *AAA* 10 (1977) 1–72; M. E. Caskey, "Newsletter from Greece," *AJA* 82 (1978) 344–45, fig. 11; *The Search for Alexander* (Boston 1980) 32, 87, no. 172, and color pl. 35.

45 *Kypria*/Procl. 105, lines 10–12 Allen (cf. Hom. *Il.* XXIV.257); Apollod. *Epit.* III.32 with Frazer's note; Preller-Robert III.2, 1122–26 on the two traditions. For the vases with the Troilos saga see Steuben *Sagendarstellungen* 58–63, 121; *Vasenlisten*³ 357–66; in the earliest ones (e.g., *ABV* 51, no. 4; *Development* pl. 8.2) Achilles occasionally carries a spear (but not, e.g., in *ABV* 64, no. 27), in the later ones nearly always a sword (cf. e.g., *JdI* 85 [1970] 53–57, figs. 19, 20). In Sophokles *Troilos* he used a spear (p. 266 Nauck²; p. 453 Radt).

46 Supra n. 27, with Hom. *Il.* XVII.194–97.

47 *Development* 28; detail, Cristofani, "Materiali" fig. 133.

48 For a general description of the type, R. D. Meikle, *British Trees and Shrubs* (London 1958) 129–32: "The branches are grey or ash-coloured, with conspicuous black, velvety buds. Leaves . . . are opposite and pinnate, 8–12 inches long, with about 7–13 oval or lanceolate, serrated leaflets, each leaflet about 2–4 inches long and 1 inch wide. . . ." On the vase, taking Peleus' height to be about five and one-half feet (1.7 m), the scale dimensions of the branch are exactly right for this and the example shown in fig. 4.6 (from R. Rol, *Flore des Arbres* I [Paris 1962] 50–51), where the scale is in centimeters; the other illustration in fig. 4.6 is taken from H. J. Elwes and A. Henry, *The Trees of Great Britain and Ireland* IV (Edinburgh 1909) pl. 262.

49 R. S. Shannon, *The Arms of Achilles and Homeric Compositional Technique* (Leiden 1975); cf. Nagy, *Best* 156–59.

50 Nagy, *Best* 159. In Pindar fr. 167 Snell and Apollod. *Epit.* II.5.4 the Centaurs fight with firs (as B. Cohen reminds me), in pseudo-Hesiod, *Aspis* 188–90 and Diod. IV.12.5 with pines, and in Ov. *Met.* XII.245–535 with pines and oaks; I have yet to find any mention of ashes. Yet besides the François vase, an oinochoe in Jena and a kantharos in Berlin (*AA* 1962, 755, fig. 7; Boardman, *ABFV* fig. 122; *ABV* 436, no. 1 and *Paralipomena* 72, no. 1) definitely show ash branches, as do several of the vases illustrated in Cohen's lecture.

51 Supra n. 45 with, e.g., E. Kunze, *OlForsch* 2 (1950) 140–42, pls. 5 and 42; cf. Schefold *Myth and Legend* 86–87, figs. 34–35.

52 Shannon, *Arms of Achilles* 31.

53 As his ghost reminds Achilles just prior to asking for burial in the amphora and on the eve of the funeral and games themselves: Hom. *Il.* XXIII.82–92. Cf. also Hes. fr. 212 MW, with Nagy, *Best* 102–14 on the name of Patroklos. The only other black-figure picture of the Games is by Sophilos, *ABV* 39, no. 16: Arias-Hirmer pl.

39; Simon and Hirmer, *grVasen* pl. 50; Boardman, *ABFV* fig. 26.; Bakır, *Sophilos* no. A. 3, figs. 10–14.

54 Hom. *Il.* XXIII.83–92 (dream), 250–57 (cremation and interim placing of bones in a gold phiale in the hut), 262–533 (race).

55 It may fairly be objected at this point that Kleitias seems to have had no access to or chose to ignore the narrative of the race as presented in Hom. *Il.* XXIII, given the almost total lack of overlap between the order and identities of the contestants in each (only Diomedes is common to both, and in Homer he came first, not third). This puzzling discrepancy could be variously explained, but in any case does not seriously damage the thesis advanced here, which continues to rest primarily on the evidence of Stesichoros. Stesichoros himself could have pursued the motif of the amphora this far and in detail (it would not have been out of character), or the association may be due to Kleitias alone: we have no means of telling. At any rate, the *general* sequence of events was surely known to the painter, as to the poet before him.

56 On *aretē* in Archaic Greek thought see the provocative study by A. W. H. Adkins, *Merit and Responsibility* (Oxford 1960) chaps. 3–4, with the more traditional (and generally less tendentious) discussion by Fränkel, *Poetry and Philosophy* 122–23, 157, 229–32, 307–14, 407–20, etc.: index A, sections 5.2 and 5.7. The term "strength relative to his world" is taken from an essay by A. Fletcher in *Northrop Frye in Modern Criticism,* ed. M. Krieger (New York 1966) 34–35.

57 For a list of "typical definitions" see Fränkel, *Poetry and Philosophy* 532–33.

58 As Hera forcefully reminds Apollo when he threatens revenge on Achilles, Hom. *Il.* XXIV.55–63. On Peleus as the shining example of "ancient *aretai*" see Pind. *Nem.* III.32–36, and on the connection between his *eusebeia,* his marriage, and the consequent *aretē* of Achilles, Pind. *Isthm.* VIII.38–60, esp. 40 and 48.

59 *Kypria*/Procl. p. 102, lines 13–19 Allen, cf. *Kypria* fr. 1 Allen with Hom. *Il.* XXIV.25–30; Nagy, *Best* 62, 129–31. The Judgment of Paris was, of course, a theme well known to artists in both Corinth and Athens: for bibliography and recent additions see *Vasenlisten* ³ 459–60.

60 Cf. pseudo-Hesiod, *Aspis* 178–90; a concordance of names is given by Weizsäcker, "Neue Untersuchungen" (1878) 370–71.

61 Robertson, *Greek Art* 126.

62 Hom. *Od.* XI.321–25; Hes. *Theog.* 947–49 and fr. 298 MW; cf. *Kypria*/Procl. p. 103, lines 20–23 Allen. On the early history of the myth see T. B. L. Webster, "The Myth of Ariadne from Homer to Catullus," *Greece and Rome* n.s. 13 (1966) 22–24, with H. Herter, s.v. "Theseus," *RE* supp. 13 (1973) cols. 1134–36. I do not intend to address here the question of whether the scene is set on Crete or Delos: recent discussion, Simon and Hirmer, *grVasen* 72–73, 77 (bibliography).

63 Select bibliography: Plut. *Thes.;* Preller-Robert II, 676–756; H. Herter, "Theseus der Athener," *RhM* 88 (1939) 244–86, 289–326; idem, "Griechische Geschichte im Spiegel der Theseussage," *Die Antike* 17 (1941) 209–28; idem, s.v. "Theseus," *RE* supp. 13 (1973) cols. 1045–47 and passim; M. P. Nilsson, *Cults, Myths, Oracles, and Politics in Ancient Greece* (Lund 1951) 49–65; K. Schefold, "Kleisthenes." *MusHelv* 3 (1946) 65–77; idem, *Götter- und Heldensagen der Griechen in der spätarchaischen Kunst* (Munich 1978) 150–68. Against Theseus as a Peisistradean favorite see esp. the often-neglected remarks of Jacoby, *FGrHist* III. B. supp. 2, notes, p. 344, n. 20; idem, *Atthis* (Oxford 1949) 219–21; also the pertinent comments by D. Williams on the whole subject, "political pots" included, "Ajax, Odys-

seus and the Arms of Achilles," *AntK* 23 (1980) 144, n. 55.

64 Cf. the song of Demodokos, Hom. *Od.* VIII.266–366.

65 Again, a very popular theme in both art and literature: cf. *Vasenlisten*³ 321–29; Lesky, "Peleus." The question of which version lies behind Kleitias' picture (and so Stesichoros' poem) is a tricky one. If Lesky is right, the "Gratitude" version of the *Kypria* and Hesiod would exclude the wrestling motif (cf. Alc. fr. 42 LP); the "Themis" variant, however, presupposes it (cf. Pind. *Isthm.* VIII.44–45 with Apollod. III.13.5). Two observations may be pertinent here: (1) Themis is named on the Erskine dinos, fig. 4.5a, and, as others have argued, is perhaps to be recognized in the elaborately attired woman grouped with the Moirai on the reverse of the François vase, fig. 4.2 (E. Gerhard, *AZ* 1850, 263; Weizsäcker, "Neue Untersuchungen" [1877] 46; Shefton, in Arias-Hirmer 290; Simon and Hirmer, *grVasen* 71; detail, Cristofani, "Materiali" fig. 129). (2) according to Themis' prophecy, any son of Thetis was bound to be "greater than his father" (Pind. *Isthm.* VIII.26–36); this would accord with the prominence of Achilles on the obverse, and would contrast neatly with the lack of offspring from the events treated on the reverse. Yet neither of these points is any sense decisive: if in spite of all we indeed have the "Gratitude" variant here, then the relation of the main frieze to its subsidiaries on side B must be reassessed, perhaps in terms of bride-getting that is straightforwardly peaceful to that which is, in various ways, not so.

66 Discussion, bibliography, and criticism in J. Culler, *Structuralist Poetics* (Ithaca 1975) 10–16, 32–54, etc. I thank T. G. Rosenmeyer for his kind help with an unfamiliar field.

67 Culler, *Structuralist Poetics* 13.

68 The term is taken from the title of an essay on Michelangelo by L. Steinberg, "The Line of Fate in Michelangelo's Painting," *Critical Inquiry* 6 (1980) 411–54.

69 Cf. Culler, *Structuralist Poetics* 12.

70 It may perhaps be objected that no such organizational sense is detectable on, e.g., the Chigi vase (Arias-Hirmer pls. 16–17 color pl. iv; Simon and Hirmer, *grVasen* pls. 25–26, color pl. VII) or in the account of the Chest of Kypselos given by Paus. v.19.7; Schefold, *Myth and Legend* 58 seems to recognize the point at issue. In fact, the matter really resolves itself into how far one can second-guess the artist's intention, a futile task. All one can do is point to the evidence of the pictures themselves and ask whether the scheme deduced here can possibly be coincidental: I do not think it can. As for supporting evidence, this falls into three categories: (a) vases painted prior to ca. 570; (b) vases painted after ca. 570; (c) monumental sculpture.

(a) See above. Yet the François vase is unique in many ways, so why not in this? But perhaps this is to beg the question. Actually, other Peleus and Achilles scenes suitable for long friezes were already in the repertoire (cf. Steuben, *Sagendarstellungen* 54–55, 64–65, 118–20) and one or two were even used elsewhere by Kleitias himself, so given the links that have emerged between the scenes, his choice here ought logically to be regarded as a calculated one.

(b) Later Archaic vases, being far less elaborate, cannot be taken as evidence one way or the other, though even here linked themes are not rare, and narrative sophistication (as in the Theseus cups) is sometimes considerable. Clearly, though, tastes have changed within a decade or so of the manufacture of the François vase, which once again emerges as a unicum.

(c) Architectural sculpture was still in its infancy ca.

570. Yet excluding I. Beyer's controversial Akropolis pediments ("Die Reliefgiebel des alten Athena-Tempels der Akropolis," *AA* 1974, 639–51, esp. fig. 10), some of the buildings erected at Delphi between ca. 570 and ca. 490 do perhaps furnish some pointers. Thus, the sculptures of the Sikyonian and Siphnian treasuries are perhaps anti-Argive (anti-Dorian?) in spirit in the first case (cf. Hdt. v.67: P. de la Coste-Messelière, *Au Musée de Delphes* [Paris 1936] 19–23) and variations on the theme of *hubris* punished in the second (cf. L. V. Watrous, AIA *Abstracts* 5 [1980] 31). The sculptures of the Athenian treasury put the *aretē* of the Attic Theseus on a par with that of Herakles, perhaps now increasingly identified with the Peloponnese if not with the tyrants, while those of the temple of Apollo dwell heavily on the god's role as guardian of the sanctuary and punisher, once again, of *hubris* and excess (P. de la Coste-Messeliere, *Fouilles de Delphes* IV.4 [Paris 1957]; J. Dörig, "Lesefrüchte," in *Gestalt und Geschichte: Festschrift K. Schefold, AntK Beiheft* 4 [Bern 1967] 102–9).

I am well aware that none of this is any way conclusive, but to ask for "proof" in a field where so much is uncertain is to place one's sights impossibly high. To the entrenched skeptic all I can say is that the foregoing interpretation is at least solidly based at every turn on what is actually there in the pictures themselves, which is seldom the case with those attempts, currently fashionable, to politicize Archaic Greek iconography wherever possible.

71 This fr., the first of three quoted in the parabasis of Aristophanes' *Peace* (lines 775–78, 797–99, 800: frs. 210 *PMG,* 211 *PMG,* and 211 *PMG* respectively) is somewhat problematic. Metrically, if the second line is excised (which also removes the verb) it is the exact counterpart to fr. 212 *PMG,* which the scholiast assigns to Stesichoros' *Oresteia.* Yet some editors have found it difficult to reconcile its joyous tone and subject matter with the bloody and brutal tale of Orestes (so, e.g., Platnauer's 1964 edition of the *Peace,* ad loc.: but *contra,* e.g., Davies, "*Oresteia*"). Possibly, then, the second line belongs and the fr., unattributed by the scholiast, is not from the *Oresteia* at all—which in any case had no monopoly on this kind of meter—but another poem. And what better description for Thetis, Peleus, and Achilles than "blest," the *makares* who are destined, sooner or later, for eternal bliss? (On these, see E. Vermeule, *Aspects of Death in Early Greek Art and Poetry* [Berkeley 1979] 72–74.)

72 On these two concepts see esp. *Critical Inquiry* 6, no. 3 (1980), "The Language of Images," esp. the two essays by R. P. Morgan, "Musical Time/Musical Space" 527–38 and W. J. T. Mitchell, "Spatial Form in Literature: Toward a General Theory" 539–67. My thoughts on this issue have also profited greatly from a recent lecture by A. J. Newcombe to the University of California, Berke-

ley, Arts Club.

73 See, in general, *Critical Inquiry* 7, no. 1 (1980), "On Narrative," esp. the essays by N. Goodman, "Twisted Tales; or, Story, Study, and Symphony" 103–19 and P. Ricoeur, "Narrative Time" 169–90—I thank L. Partridge for drawing my attention to this reference—with the recent study of Greek narrative techniques P. G. P. Meyboom, "Some Observations on Narration in Greek Art," *Meded* 40 (1978) 55–82; cf. also Steuben, *Sagendarstellungen* 88–91. N.B. too the pioneering study by C. Robert, *Bild und Lied, Philologische Untersuchungen* 5 (1881) chap. 1, esp. 16–18, with recent comments by Brize, *Geryoneis* 106–7.

74 E. Auerbach, *Mimesis,* trans. W. B. Trask (Princeton 1953) 11–12.

75 E.g., the Boulogne amphora, *ABV* 145, no. 18; *Development* pl. 32, 1; Boardman, *ABFV* fig. 101; Simon and Hirmer, *grVasen* pl. 76.

76 *Development* 35.

77 See, most recently, I. Krauskopf, "Hydria" 21–22 with references. The hypothesis has often been raised, but seldom argued, in the literature: cf., e.g., Milani, *Firenze* I, 148–49; Minto, *Vaso François* 19; Boardman, *ABFV* 228.

78 See, most recently, B. Freyer-Schauenburg, "Die Geranomachie in der archaischen Vasenmalerei. Zu einem pontischen Kelch in Kiel," in *Wandlungen: Festschrift E. Homann-Wedeking* (Munich 1975) 76–83.

79 J. Boardman, *Greek Sculpture: The Archaic Period* (New York 1978) 74; Cristofani, "Materiali" fig. 161. On the personal names see Weizsäcker, "Neue Untersuchungen" (1877) 51–54; (1878) 377–79; Simon and Hirmer, *grVasen* 72–73, 77; U. Kron, *Die zehn attischen Phylenheroen, AthMitt-BH* 5 (1976) 172, 190–91.

80 Statistics from Bakır, *Sophilos* 64–75; *ABV* 76–79; *Paralipomena* 29–30:

	Sophilos	Kleitias and Ergotimos
Italy and the West:	6	1
Attica and Environs:	37	11
Greece (other sites):	1	1
Islands:	2	0
Asia Minor and Levant:	7	2
Naukratis:	8	5
Unprovenanced:	7	5

81 Weizsäcker, "Neue Untersuchungen" (1878) 377; Preller-Robert II. 692–93; Simon and Hirmer, *grVasen* 74 (where the connection is interpreted in terms of "Solonian" politics and the struggle with Megara); cf. Cristofani, "Materiali" figs. 171, 173, 246, 248.

82 Hdt. VI.128–29; cf. J. K. Davies, *Athenian Propertied Families* (Oxford 1971) 295, 299–300.

83 Pind. *Isthm.* VIII.33–36.

An Exekian Puzzle in Portland: Further Light on the Relationship between Exekias and Group E

EVELYN ELIZABETH BELL

Group E is the "soil from which the art of Exekias springs, the tradition which on his way from fine craftsman to true artist he absorbs and transcends."[1] Thus did J. D. Beazley succinctly characterize the close relationship between Group E and Exekias, who began his career as a potter, and perhaps also as a painter, in the workshop of Group E. Beazley, however, did not clarify either in terms of style or chronology the exact relationship between the soil of Group E and its flower Exekias. M. B. Moore has dealt with this question to some extent in her article "Horses by Exekias," in which she attempts very plausibly to establish the relative chronology of Exekias through a study of his representations of horses.[2] The examination of two Attic black-figured amphorae of the mid-sixth century B.C., one by a follower of Exekias, the other signed by him as potter, should help to illuminate further the connection between Exekias and the workshop of Group E. In addition, both vases provide fascinating studies in themselves, particularly in terms of their iconography.

The first vase with which we shall deal is an amphora of type B, which was acquired by the Portland Art Museum in 1932 (figs. 5.1a–5.1f).[3] The provenience is unknown. As restored, the vase stands just over 48 cm tall. It is a standard amphora of type B, with broad picture panels surmounted by a palmette-lotus chain; a wide mouth with reserved top; large, round handles; and rays at the base. The original echinus foot has been lost and replaced by an ancient double-curved foot, which would seem more appropriate to a red-figured stamnos of the Ripe Classical period. A near parallel to our foot appears on the well-known stamnos in Naples by the Dinos Painter, which features Maenads at an image of Dionysos.[4] Beneath the foot of the Portland amphora, there is a graffito which consists of a *pi* and a short vertical stroke (π /). A near match appears on a stamnos in Stockholm, of the late fifth century B.C., by the Danae Painter.[5]

The amphora in Portland is an example of the new elegant, elongated form, which first appears around 540 B.C. The lip is broad and flaring; the neck and handles are tall; and the body has a pronounced double curve, which reaches its widest point just above the center of the vase. As already observed, the foot should be of the normal echinus type. Our amphora is closely comparable in shape to Exekias' amphora of type B in Boulogne (see Fowler fig. 11.2), one of the painter's earliest works and the only certain amphora of this kind known to have been decorated by him.[6] These two vases are quite different in form and feeling from many of the early members of Group E, such as the Geryon amphora in Los Angeles,[7] which look heavy, squat, and decidedly old-fashioned in comparison. The new form of type-B amphora may have been created by Exekias while he was a member of the workshop of Group E.

The floral ornament on the amphora in Portland, which consists of alternately inverted lotuses and palmettes linked by interlaced tendrils, finds a near parallel on an amphora in San Simeon by the Swing Painter, the shape of which is also closely similar to that of our amphora.[8] This floral is an old-fashioned type, which from ca. 540 B.C. on gradually yields to the form seen on Exekias' Boulogne amphora: opposed lotuses and palmettes linked by a chain.

5.1a

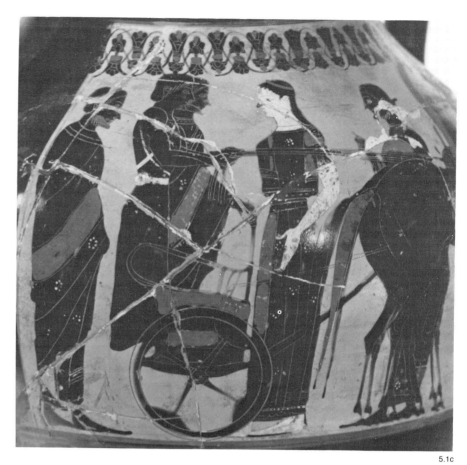

5.1c

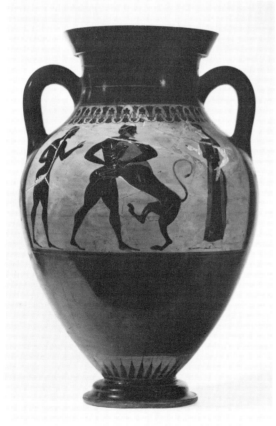

5.1b

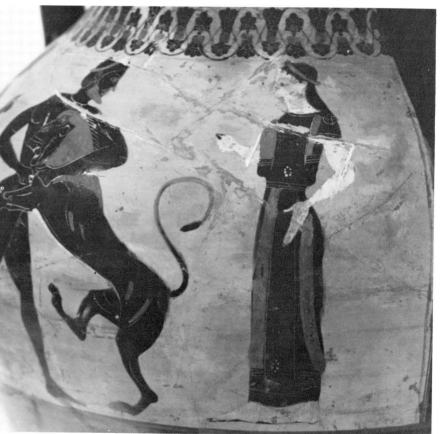

5.1e

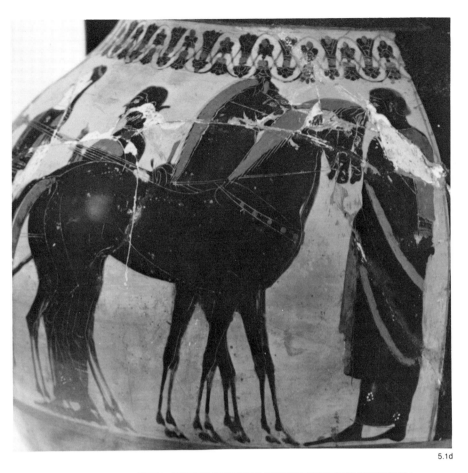

5.1d

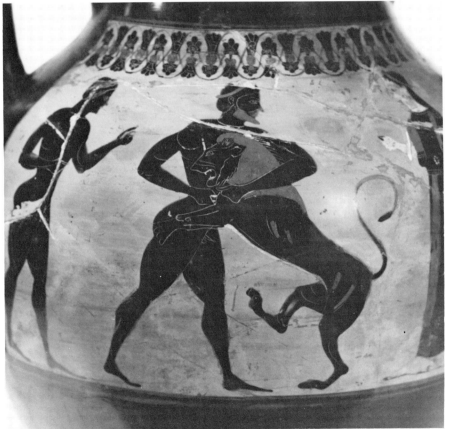

5.1a. Portland, Oregon 32.829.
Side A, departure of a chariot.
Photo: Courtesy of the Portland
Art Museum.

5.1b. Portland, Oregon 32.829.
Side B, Herakles and the
Nemean Lion. Photo: Courtesy
of the Portland Art Museum.

5.1c. Portland, Oregon 32.829.
Side A (detail), departure of a
chariot. Photo: Courtesy of the
Portland Art Museum.

5.1d. Portland, Oregon 32.829.
Side A (detail), departure of a
chariot. Photo: Courtesy of the
Portland Art Museum.

5.1e. Portland, Oregon 32.829.
Side B (detail), Herakles and the
Nemean Lion. Photo: Courtesy
of the Portland Art Museum.

5.1f. Portland, Oregon 32.829.
Side B (detail), Herakles and the
Nemean Lion. Photo: Courtesy
of the Portland Art Museum.

5.1f

The amphora in Portland displays conventional scenes, one of a genre nature, the other heroic, set in broad panels. Within Group E and the circle of vases around Exekias, we often encounter a similar pairing of subjects drawn from mythology and daily life. On side A (figs. 5.1a, 5.1c, 5.1d) there appears the departure of a chariot with attendant figures. The youthful charioteer, dressed in a long, sleeveless chiton, holds the reins, while beside him in the chariot stands a bearded man, wearing a chiton and himation, which is decorated with dot-rosettes. Behind the chariot, there is another man similarly dressed. A woman stands facing left beside the chariot. She wears a fillet, necklace, and peplos, which is ornamented with dot-rosettes and, on the shoulder, an incised emblem. A small error on the part of the vase-painter is worth noting: he has drawn a white dot-rosette on the tail of the pole horse which overlaps the woman's skirt. Beyond the horses, a bearded man stands to left, dressed in a chiton ornamented with dot-rosettes and a himation; while, at their heads, there appears a similar figure. Restoration in plaster has obscured parts of the heads and upper bodies of both men. The spirited horses, drawn with sensitivity and an understanding of anatomy, appear eager to be off. The trace horses have red manes and tails, the pole horses red manes and black tails. All four animals apparently wear collars adorned with red rosettes.

Side B of the Portland amphora (figs. 5.1b, 5.1e, 5.1f) features the first Labor of Herakles, the Nemean Lion. The hero, shown nude, save for a baldric and fillet, has grasped the Lion around the neck and is attempting to kill the animal by plunging his sword into its chest—an exercise in futility, for the Nemean Lion was invulnerable to conventional weapons. The creature rears up against Herakles, snarling in rage, lashing its tail, and trying to claw him with its right hind leg. At left there stands a nude, filleted youth, surely Herakles' nephew Iolaos, who gestures with his left hand. A female figure, probably Athena, although she has no attributes, observes the battle at right. Like the woman on side A, she wears a fillet around her hair and a peplos, which is decorated with white dot-rosettes and an incised pattern on the shoulder. Her right hand is raised as though she were holding a spear, but no trace of a weapon remains. The composition is symmetrically balanced, with the pyramid consisting of Herakles and the Lion framed on either side by the figures of Iolaos and Athena.

The amphora in Portland cannot as yet be attributed to a particular hand. In style it lies very near Group E and the early work of Exekias. It is especially close to an amphora of type B in the Louvre, by the Painter of London B 174, an artist near Group E.[9] The depiction of Herakles and the Nemean Lion on side B of that vase offers near parallels in the composition and renderings of the figures to the analogous scene on the Portland amphora. On side A, Theseus fights the Minotaur between pairs of women in peploi and draped men, who recall the men and women in the Portland chariot scene. The shape of the Louvre amphora is like that of the other vase, except for its slightly shorter neck; and the floral ornament belongs to the same type as ours. All told, we would not be far wrong in placing the amphora in Portland near the Painter of London B 174.

An amphora of type B in Naples, near Group E, is also close in style, composition, and shape to the Portland amphora.[10] Like the latter, it has an alien, but ancient, foot of double-curved shape. The representation of Herakles and the Nemean Lion, between Iolaos and Athena, on the reverse (unfortunately preserved only in part) is closely comparable to its equivalent on the Portland vase. On the obverse, Herakles battles Geryon, flanked by Athena and a draped male figure, a subject quite popular among the artists of Group E.[11]

Within Group E, the one member nearest in style to our vase is an amphora of type B in Hannover, which A. B. Follmann has recently assigned to the group.[12] The drawing is looser, and the figures are more sketchy in treatment than on the Portland vase; yet the depiction of Herakles and the Lion on side A affords numerous points of comparison to our picture, as, for example, the poses and gestures of the figures and the drawing of Herakles' hands and the face and forepaw of the Nemean Lion. On the shoulder of Athena's peplos, there is an incised circle divided into four quarters, each with a central dot. The same pattern appears on the shoulders of both female figures on the Portland amphora. The pattern occurs as well on the sleeves of women on several vases of Group E and of Exekias and his circle, including the master's neck-amphora in Boston, with a harnessing scene.[13] This pattern is not exclusive to women's garments, for it decorates the shoulder of the *zeira,* or Thracian cloak, of the horseman on an unattributed hydria of ca. 540 B.C., in a Swiss private collection.[14] The meaning of the pattern is elusive. It may be an ornament woven into the

garment or a dress pin. The latter suggestion is less probable, for the pattern is at least once overlapped by the neckline of a peplos (that of the woman on side B of Exekias' neck-amphora in Boston). This ornament has a definite span of time, the years around the middle of the sixth century B.C., and stylistic environment, for it appears only on vases within the circle of Group E and Exekias, with the exception of the hydria in the Swiss private collection. The pattern therefore, may have been both a fashionable detail of women's dresses of the period and a hallmark of a particular potter's shop in the Athenian Kerameikos.

Let us return for a moment to the Group E amphora in Hannover. On side B, a chariot, carrying a driver and a bearded man, wheels to the right. The spirited horses share certain details in common with the horses on the Portland amphora, most notably the flattened, hooked line of the shoulder; the long, curved incision for the barrel; and the short double lines defining the brow. The renderings of the heads of the charioteer and passenger on each vase also deserve comparison.

Stylistic and typological similarities also exist between the amphora in Portland and early works of the Swing Painter, who was himself a close follower of Exekias. For example, the chariot scene on our vase finds strikingly close parallels in the representation of the departure of a chariot on side A of the Swing Painter's amphora in Toledo.[15] The explanation of this phenomenon must lie in the fact that both artists' work was touched by the spirit and influence of Exekias.

The subject matter, as well as the style, of the amphora in Portland reveals the inspiration of Exekias. A detailed consideration of the iconography of the vase therefore may lead to a better understanding not only of our artist and his relationship to Exekias but also to the career and achievements of the master himself. We turn first to the depiction of Herakles and the Nemean Lion on side B (figs. 5.1b, 5.1e, 5.1f). The first Labor which King Eurystheus of Tiryns imposed upon Herakles was to kill and flay the Lion of Nemea. This ferocious beast, the offspring of Typhon, of the Chimaira and the dog Orthros, or of Selene, was sent by Hera or by Selene herself to punish the inhabitants of the Nemean Valley for their failure to perform prescribed sacrifices.[16] The Lion dwelt in a cave, which is said to be still visible in the hills above the valley. Very occasionally in late black-figure, there is a suggestion of the Lion's abode, as on a lekythos in Oslo of the Haimon Group.[17] Before he set out to slay the Nemean Lion, Herakles enjoyed the hospitality of Molorchos of Kleonai, a peasant whose son the animal had killed. From his host, Herakles learned that the Lion was invulnerable to sword, arrows, or stones and could be overcome only by strangling. The Lion's invulnerability is explicitly shown on an amphora in the Villa Giulia, of the circle of the Antimenes Painter, where Herakles' bent and useless sword lies beneath his feet.[18] On quitting the home of Molorchos, Herakles eventually came upon the Nemean Lion and wrestled it to death or, according to Theocritus (XXV.256), stunned the creature with his club and then strangled it. After his victory, Herakles fell into a deep sleep; upon awakening he crowned himself with native wild celery, which later formed the wreaths of victors in the Nemean Games. He then delivered the body of the Lion to King Eurystheus, who was so terrified of the monster, even in its dead state, that he sought refuge in a capacious bronze caldron, his customary retreat under similar circumstances. Herakles skinned the Nemean Lion with its own claws and thereafter wore the animal's invulnerable hide as his armor. According to Plutarch (*Thes.* XXV.4), the hero commemorated his victory over the Lion by reorganizing the Nemean Games, which were formerly celebrated in memory of Opheltes, and dedicating them to Zeus.

We can trace the motif of Herakles and the Nemean Lion in Greek art back as far as the eighth century B.C., to a Late Geometric bronze fibula now in London.[19] A possible representation of the subject appears on a clay stand of ca. 720 B.C., from the Athenian Kerameikos, which displays a nude warrior attacking with spear and sword a leonine creature.[20] In Corinthian vase-painting, the earliest portrayal of Herakles and the Nemean Lion may figure on a Transitional alabastron in Syracuse; however, it is not at all certain that Herakles is here intended.[21] None of these early representations shows Herakles and his adversary engaged in close combat, as they are on the amphora in Portland and on most of the Attic black-figured vases. This closed scheme of battle appears first on a Middle Corinthian kylix from Perachora, dated shortly after 600 B.C.[22] The combatants, both turned to the right, are wrestling in a standing position; Herakles has his name written beside him.

Unless the painter of the Late Geometric stand in the Kerameikos Museum meant to portray Herakles and the Lion, it would appear that Corinthian artists were the first to represent the

theme in Greek vase-painting. Perhaps relevant to this question, as J. K. Anderson has pointed out to me, is the proximity of Corinth to Nemea. It remained to Attic vase-painters, however, to give the motif its full visual expression. Credit for introducing the theme into Attic black-figure is due the C Painter, who, shortly before 570 B.C. and perhaps under Corinthian influence, represented it in the tondos of a Siana cup now in Berlin and a fragmentary kylix of the same shape in Kavalla.[23] From about a decade later come several Siana cups with Herakles and the Lion by the Heidelberg Painter. One example, in the Cabinet des Médailles, shows Herakles holding the Lion around its neck with his left arm, while he grasps a forepaw with his right hand.[24] This picture displays one of the conventional early schemes for representing the contest, in which Herakles' gestures are derived from the standard neck hold used in ancient wrestling. None of the several men and women observing the battle is identifiable as Iolaos or Athena, who do not regularly attend Herakles' Labors until the mid-sixth century B.C. The Heidelberg Painter has drawn a most unorthodox lion, with a frontal panther's head and a spotted neck, which looks as though it might have stepped out of a Corinthian animal frieze. Since these early representations of Herakles and the Lion appear during the period in which the Nemean Games were traditionally established (573 B.C.), it seems logical to connect them with this historical event.

The motif of Herakles and the Nemean Lion reaches its full bloom in Attic black-figure of the mid-sixth century B.C., among the works of Group E and the circle of Exekias. In their depiction of the contest, the painters of Group E tend to follow a scheme, apparently of their own invention, which F. Brommer has designated as *Stehkampf* type C.[25] An amphora in New York of Group E provides a typical example of this scheme: flanked by Athena and Iolaos, Herakles and the Lion stand to the right, the animal turning its head around.[26] Herakles has plunged his sword into the Lion's neck, in a futile attempt to kill the animal. The painters of Group E usually include the useless sword, not necessarily because they were unfamiliar with the tradition of the Lion's invulnerability, but perhaps because they wanted to capture Herakles' first savage attack on the animal. The *Stehkampf* type C, a relatively rare configuration, appears earliest and almost exclusively on vases of this group. It occurs once in the work of the Swing Painter, on an amphora in Berlin, and once each on vases by the Lysippides and Euphiletos Painters.[27]

An alternate scheme for the standing battle between Herakles and the Nemean Lion, which Brommer has called the *Stehkampf* type B, enjoys a longer history and wider distribution in Attic black-figure than the type C scheme.[28] It first appears ca. 560, on an amphora in the Cabinet des Médailles by Lydos.[29] In this version, Herakles and the Lion meet face-to-face, as on the later amphora in Portland. Lydos' scheme, which was followed by a few vase-painters of his time, including Sakonides, was soon overshadowed by the variant introduced by artists of Group E. Indeed, the type B scheme might have died an early death had not Exekias, seemingly aware of the power and immediacy of the composition, adopted it for his only extant version of the standing battle between Herakles and the Lion, on his early neck-amphora in Berlin, possibly painted when he was still in the workshop of Group E.[30] To the left stands Iolaos, nervously wringing his hands, and to the right Athena, properly armed with a shield and helmet. The painter has dispensed with the sword and shown Herakles choking the Lion to death.

A few late members of Group E, such as the painter of the amphora in Hannover discussed above, portray Herakles and the Nemean Lion in the confronted, or type B, scheme. Their works are very probably later than Exekias' Berlin amphora and dependent upon it. If this proposal is correct, it offers further proof of the relative position of Exekias within the historical development of Group E: he began working with the group when it was already well established; but, due to his evident superiority as both a painter and potter, he soon proved himself worthy of imitation in both capacities.

The confronted scheme for the representation of Herakles and the Lion blossomed quickly among vase-painters near Group E and Exekias, such as the decorator of the amphora in Portland. This artist may well have derived his representation of Herakles and the Lion from an Exekian model, as we shall see he did the chariot scene on the opposite side of the vase. The composition and the poses of the figures follow closely those on the Berlin neck-amphora, although the quality of the drawing, as we might expect, is far inferior. On Exekias' amphora, Iolaos indicates his emotional state by wringing his hands, while on the vase in Portland, he raises his left hand with one finger pointed. This gesture may signify the *apagoreuein*, the traditional signal of defeat in athletic contests.[31] Usually an athlete will raise one or two fingers to indicate his defeat, as, for example, on a Panath-

enaic amphora in Boston, by the Mastos Painter.[32] Very occasionally, however, judges or referees or even spectators at Herakles' contests use the same gesture. For example, a Leagran neck-amphora in Naples shows Hermes, god of the palaestra, raising his forefinger to signal the defeat of the Nemean Lion.[33]

Around 530 B.C., Exekias seems to have created an entirely new scheme for the contest between Herakles and the Nemean Lion, the ground-wrestling battle, or *Liegekampf*, derived from the Pankration.[34] Fragments of an amphora in Ensérune by Exekias, recently discussed by Boardman, preserve what may be the earliest example of this scheme.[35] The hero bears down upon the Lion, locking his hands around the unfortunate animal's neck, as he often does when fighting the sea-monster Triton. Before the initial publication of these fragments by J. Jully in 1974, the Andokides Painter was thought responsible for creating the motif of Herakles wrestling the Nemean Lion on the ground.[36] Now it appears that he derived the composition from his master Exekias. We are thus able to place, independently of their style, the Ensérune fragments late within the career of Exekias, for the Andokides Painter was one of his last pupils. Further evidence for their relative chronology comes from the fact that vase-painters of Group E and others close to Exekias do not use the ground-wrestling scheme to depict the first Labor of Herakles.

Exekias' new composition soon fired the imaginations of both black-and red-figure vase-painters, as, for example, Psiax, who employed it for the representation of Herakles and the Lion on his amphora in Brescia.[37] The ground-wrestling scheme enabled artists to capture the very climax of the battle, when the opponents, all their forces unleashed, are locked in a life-or-death struggle; furthermore, it challenged the painters' mastery of anatomy and complex poses and allowed them to convey, more effectively than the old *Stehkampf* schemes, the compressed strength of hero and Lion. The new composition is more interesting in that the horizontal or low diagonal formed by the combatants contrasts to the verticals of the spectators and occasional landscape elements, such as the tree, from which hang Herakles' chlamys and quiver, in Psiax's picture.

We have already noted the possible connection between the first appearances of the motif of Herakles and the Lion in Archaic Attic vase-painting and the reorganization of the Nemean Games in 573 B.C. At least three Attic black-figured amphorae of the second half of the sixth century B.C. may illustrate events from the games. On all of them, the combination of themes of athletic victory and the motif of Herakles wrestling the Lion becomes the determining factor. The three vases, which may have been intended as gifts for Attic victors in the Nemean Games, are a neck-amphora in Munich of Group E, a panel-amphora also in Munich by the Swing Painter, and a neck-amphora in Orvieto by the Red-line Painter.[38] For our purpose, it will be sufficient to single out for discussion the most ambitious of the three pieces, the Group E amphora in Munich. The obverse shows a race in armor, the *hoplitodromos*, the reverse a foot race; beneath the handles stand tripods and caldrons, prizes for the victors, while on either side of the shoulder, Herakles wrestles the Nemean Lion. The appearance of the *hoplitodromos*, which enjoyed special importance at the Nemean Games, strongly suggests a connection between this vase and the contests.

Let us now consider in detail the iconography of the chariot scene on the amphora in Portland (figs. 5.1a, 5.1c, 5.1d). The subject is the departure of a draped man and his young charioteer in a quadriga, a variant of the more common theme of a warrior and charioteer departing for battle. The same format governs other black-figure chariot motifs, such as a wedded pair, probably Peleus and Thetis, and Athena and Herakles on their way to Olympus (see Moon figs. 7.2a–7.2b, 7.15). The meaning of our motif is not immediately clear; however, if it is connected with that of Herakles and the Lion on the other side of the vase, it may portray a wealthy Athenian horse breeder departing with his charioteer and team for the horse races at the Nemean Games. The similar representation of a man and youth on a neck-amphora in Oxford, near Group E and Exekias, lends support to this interpretation.[39] The occupants of the chariot are dressed in richly patterned himatia, and, significantly, they are accompanied by a winged goddess, probably Nike, the personification of victory and of speed. These factors would suggest that the quadriga is returning home triumphant, after taking a first in a chariot race.

A chariot scene similar in composition to the one on the Portland amphora decorates side A of an amphora in Munich of Group E, which is also near in shape to our vase.[40] An interesting detail of the Munich picture is the bellyband of the near trace horse, which serves to prevent the collar from slipping. This band, however, is much more important for the pole horses than for the trace horses. Apparently this fact was realized by

the vase-painters shortly after the middle of the sixth century B.C., since trace horses on Group E and earlier vases, such as those on the François krater,[41] regularly have the bellyband, whereas those on vases after the time of Group E, as, for example, the horse on the Portland amphora, do not. This distinction is made clear in the representation of Herakles driving a chariot on a neck-amphora in Boston, of the Three-line Group, in which the pole horses wear a bellyband, while the trace horses do not.[42] I know of only one instance of the reappearance of the bellyband on a trace horse in later Attic vase-painting, that on Pelops' horse on a red-figured neck-amphora in Arezzo, of ca. 410 B.C., in the manner of the Dinos Painter.[43] The band also occurs on a painted marble tablet in Naples, from Herculaneum, believed to be a Roman adaptation of a Greek original of ca. 400 B.C.[44]

Undoubtedly the most interesting aspect of the amphora in Portland, and that which makes it worthy to be called an "Exekian puzzle," is its close relationship to Exekias' amphora in Boulogne.[45] This vase, an early work of Exekias, bears on side A the poignant scene of Ajax contemplating suicide and on side B a conventional chariot scene, which understandably has attracted far less attention than the superb psychological study on the obverse (see Fowler fig. 11.2). In shape the Portland amphora, save for the alien foot, is very much like the one in Boulogne. Both vases may be works of the same potter, perhaps Exekias himself. The figure scene on side A of our amphora is almost a carbon copy of Exekias' chariot picture. Particularly close are the horses, in their stance and conformation; the draped male spectators, placed one beyond the horses and one on either side of the chariot group; the woman; and the two men in the chariot. The only appreciable difference between the two scenes consists in Exekias' addition of a small boy at right, who resembles the lad bearing Kastor's fresh clothing, oil bottle, and stool on the Vatican amphora.[46] Exekias cannot have painted the chariot scene on the Portland vase, for the drawing is not up to his quality; thus, the uncanny resemblance between the two paintings is probably best explained by the fact that Exekias' picture served as a model for the one on the Portland amphora, whose artist must have been active in the same workshop as the master.

Exekias signed thirteen known vases, eleven as potter and two as both potter and painter.[47] Two facts stand out concerning his career as a potter: it was long, for one of his earliest works,

the neck-amphora in Berlin, and one of his latest, the great Vatican amphora, bear his signature as potter, as well as painter;[48] and it embraced an impressive variety of shapes, including neck-amphorae, panel-amphorae, a dinos, probably a calyx-krater, and at least three types of kylikes. Exekias began his career as a potter, and perhaps also as a painter, in the workshop of Group E. We know this because his signature as maker appears on a superb amphora of type B in the Louvre, which belongs to Group E and is earlier in style than any of the vases thus far attributed to Exekias as a painter.[49] The Louvre amphora may have been decorated by Exekias. Beazley at one time entertained this idea, but preferred to keep the vase apart from the painter's oeuvre.[50] Powerful in conception and masterly in drawing, the piece displays on side A Herakles and Geryon and on side B a warrior leaving home in a chariot. Inscriptions are plentiful, naming—besides the potter—the figures, the magnificent horses, and a young man Stesias as *kalos*. The *kalos* name Stesias and the names of the warrior Anchippos and his horse Kalliphora appear on other vases either by Exekias or closely connected with him.[51]

5.2a. Toledo, Ohio 1980.1022. Side A, war chariot wheeling. Photo: Courtesy of the Toledo Museum of Art.

5.2b. Toledo, Ohio 1980.1022. Side B (detail), war chariot wheeling. Photo: Courtesy of the Toledo Museum of Art.

5.2c. Toledo, Ohio 1980.1022. Lid. Frieze of panthers and stags. Photo: Courtesy of the Toledo Museum of Art.

5.2d. Toledo, Ohio 1980.1022. Profile of lid. Photo: Courtesy of the Toledo Museum of Art.

5.2a

Until very recently, the only known vase of Group E which carried the potter's signature of Exekias was the Louvre Geryon amphora. Then, in 1980, a companion piece of this vase came to light as a new acquisition of the Toledo Museum of Art (figs. 5.2a–5.2d).[52] Signed by Exekias as maker and painted by the same hand as the Louvre vase, this magnificent amphora of type B displays on either side a wheeling chariot, carrying a warrior and charioteer. In each instance, the hoplite wears a helmet with a tall crest that overlaps the ornamental frame and carries a spear and Boeotian shield. The charioteer is dressed in a chiton, nebris, and petasos, which on side B is topped by a crescent ornament. Both men have long hair and beards. The ornament above the picture on side A consists of an old-fashioned lotus-and-palmette festoon; that on side B of an early example of the new form of lotus-and-palmette chain, similar to that on the Louvre amphora. The vase is 46 cm tall, including the lid, which is decorated with a frieze of alternating panthers and stags. The pomegranate knob of the lid has been restored on the basis of the lid-finial of the amphora in the Louvre. The new amphora in Toledo is a masterpiece in form, composition, and drawing. The shape is beautifully balanced; and the broad picture panels, filled with the powerful, curved forms of the horses, complement the form of the vessel.

Although they are works of the same potter, the amphorae in Toledo and Paris exhibit somewhat different shapes. The former, slightly smaller than its companion, which with the lid stands 50 cm tall, is more thickset and has a lower center of gravity. The handles are both thicker in profile and broader than those of the other vase, and the foot has the normal echinus shape. In the Louvre amphora, Exekias experimented with a new kind of concave disk-foot. Despite these differences, the two amphorae appear to have been made as a pair: they are works of the same potter and painter (very probably two separate artists); they share the same basic shape, many of the same inscriptions, and an interest in the war-chariot motif; and both are believed to have come from Vulci.

Certain details of the iconography of the amphora in Toledo—the charioteer's cap and the harness of the horses—deserve our attention. The headgear of each driver is a soft, peaked hat with a brim, made perhaps of felt or wool. On

5.2b

5.2d

5.2c

side B, it is crowned by a crescent ornament of unknown significance, which recalls in type, if not in form, the fleur-de-lis ornament of King Arkesilas' cap on the well-known Laconian kylix in Paris.[53] The petasoi on the Toledo amphora find a close parallel in the cap of the charioteer on an amphora in London of Group E, which is near in style to our vase and, like it, decorated with a war chariot wheeling.[54] On the amphora in the Louvre made by Exekias, Geryon's herdsman, Eurytion, also wears a similar peaked cap. The petasos was traditionally worn by hunters and herdsmen, such as Eurytion, and by Hermes; only rarely does it appear on charioteers. The examples of the last category come mainly from Attic vases of the middle of the sixth century B.C., evidence which suggests that the peaked cap enjoyed a brief period of popularity in Athens during that time. The association of the petasos with the charioteer seems natural, considering that it was particularly at home in the horse-raising region of Thessaly.[55]

The pride of the Toledo amphora is its horses, powerful, fine-boned, spirited creatures, caught in a wheeling gallop. Careful attention has been paid to their manes and tails, which are textured in fine, wavy lines; to their inner markings; and to the parts of their harness. The near trace horses have bellybands to secure their collars and, attached to their bits, a spiked plate, which would have given the handler greater control. This device, called a bit-burr, is worn by Kastor's mount Kyllaros on Exekias' Vatican amphora.[56] Apparently it was used to control both riding and driving horses. Each horse on the Toledo amphora wears a fancy, tooled collar. In the center of all four collars on side A and one on side B, there is an eye motif, similar to those on Greek ships and shields and like them probably apotropaic, as well as decorative, in purpose.

The amphora in Toledo carries several inscriptions. On the obverse, there appears the signature of Exekias as potter, the *kalos* name Stesias, and the names of two horses, Pyrrichos ("a fiery red-brown horse") and Kalliphora ("a horse with a beautiful mane and tail"). Kalliphora and the other horses named on Attic vases of the period (see Moon pp. 98, 101) may have been famous chariot or riding horses, acknowledged in similar fashion as were the handsome, prominent young men featured in the *kalos* inscriptions. The reverse of the amphora carries a single name, that of the warrior Anchippos. Besides the potter's signature, three of the inscriptions on the amphora in Toledo reappear on the Geryon

amphora in the Louvre: the *kalos* name Stesias, the name of the warrior Anchippos, and that of the horse Kalliphora.

The new acquisition of the Toledo Museum of Art is clearly by the same painter as the Louvre Geryon amphora. Stylistically the two vases are especially close in the renderings of the horses, the faces and hands of the figures, the helmeted heads of the warriors, and the ornament above the picture panels. Their artist was an extremely gifted member of Group E, who was active during the decade ca. 550–540 B.C., perhaps the master craftsman of the workshop. Was this vase-painter the young Exekias "on his way from fine craftsman to true artist," as Beazley has described him?[57] In *Development* Beazley suggested that the Louvre Geryon amphora might be an early work of Exekias; however, in *ABV* he wrote that the vase "was hardly decorated by Exekias himself."[58] Other scholars have accepted the attribution to Exekias. With the appearance of the Toledo amphora, it seems appropriate to reexamine this question of authorship, limiting our discussion to the new piece.

On the evidence of the horses alone, the argument for recognizing the hand of Exekias in the Toledo amphora is quite compelling. The animals are very close in conformation and details to the horses of Damophon and Akamas on Exekias' early neck-amphora in Berlin, which must be of about the same date as the Toledo vase.[59] We may compare the set of the profile heads, the long hooked line of the chests, the double curved lines of the shoulders, and the rippled incision in the manes and tails. The horse Kalliphora appears on both vases. Also comparable to the Toledo horses are those on the fragments of a neck-amphora in the Cahn collection, Basel, another early work of Exekias.[60] In this work, the rippled tail, with the root clearly indicated; the four parallel curved lines on the flank; and the wrinkles of flesh just above the foreleg point to the same hand as the Toledo vase. Hanging from the side of the horse on the upper left fragment of the Basel amphora, as shown in the published illustration, is a bit whose cheekpiece has a bit-burr similar to those of the trace horses on the amphora in Toledo. The horses on Exekias' amphora in Boulogne, which is at least as early as the amphorae in Berlin and Basel, are not, however, especially near in style to those of the vase in Toledo.[61] They are drawn with less facility and detail, but this may be due to the fact that Exekias expended less effort on the subsidiary chariot group than on the suicide of Ajax on side A.

When we turn to the figures or to the small-scale animals on the lid of the Toledo amphora, we find much less stylistic agreement with the early works of Exekias. For example, the Toledo hoplites have coarser features, longer hair, and more rounded and compressed helmets than the warriors on Exekias' Berlin amphora or those on his neck-amphora in Boston.[62] And the charioteers bear little resemblance to the bearded men in the Boston harnessing scenes; compared to Exekias' figures, they appear thickset and even somewhat boorish. Similar problems occur when we set the small animals on the lid of the Toledo amphora against Exekian creatures. The stags and panthers, which possess a certain Little Master quality, bear a generic resemblance to the miniature animals below the main pictures on Exekias' neck-amphora in Boston; yet they can scarcely be by the same hand. Weighing all the stylistic evidence, it seems best to keep the amphora in Toledo and its companion piece in Paris apart from the oeuvre of Exekias. They appear to be works of a mature, accomplished painter, especially skilled in drawing horses, who may have influenced Exekias in the formation of his style or, conversely, been himself inspired by the talented young craftsman.

The artist of the Toledo vase, whom we may call the Geryon Painter after his amphora in Paris, was probably responsible for creating the motif of the wheeling chariot, whose curvilinear pattern is so well suited to the swelling forms of the panel-amphora. The magnificent chariot groups which decorate both panels of the vase are the earliest of their type in Attic vase-painting and the source for the many wheeling quadrigae in Group E and later black-figure. Quite similar chariots, carrying a warrior and charioteer in a peaked cap, appear on two amphorae of Group E in London and in a Paris private collection.[63] When it first appears, the wheeling chariot turns to the right; in late black-figure, it faces left. This change in direction probably occurred because the vase-painters wanted to display the shield blazons of the hoplite and charioteer.

The splendid amphora in Toledo, which is so closely related to the work of Exekias, and the amphora of lesser, but still respectable, quality in Portland testify that Exekias' career, both as a potter and as a painter, begins within the workshop of Group E, although he cannot be considered a member of the group as such. The earliest works of the master, which may be dated ca. 545 B.C., overlap the later ones of Group E. The group as a stylistic entity comes to an end ca. 540

B.C., but the workshop of Group E, which once may have been managed by the Geryon Painter (Exekias' teacher?), perhaps continued under the direction and even the ownership of Exekias until ca. 525 B.C., the date of his latest known works. At that time, on the retirement or death of the master, the workshop would have been inherited by his star pupil the Andokides Painter, who, like Exekias, probably worked as both a potter and a painter.

NOTES

1 *ABV* 133. On Group E, see most recently H. Williams, in *Greek Vase-painting in Midwestern Collections,* eds. W. G. Moon and L. Berge (The Art Institute of Chicago 1979) 62–63.

2 M. B. Moore, "Horses by Exekias," *AJA* 72 (1968) 357–368.

3 Portland, Oregon 32.829: *AJA* 61 (1957) 107; *JdI* 80 (1965) 79, n. 11; *Vasenlisten*³ 133, no. 11.

4 Naples 2419: *ARV*² 1151–52, no. 2; *Paralipomena* 457; B. Philippaki, *The Attic Stamnos* (Oxford 1967) 135, no. 8.

5 Stockholm 2105: *ARV*² 1075, no. 3; Philippaki, *Attic Stamnos* 141 and fig. 17.

6 Boulogne 558: *ABV* 145, no. 18; *Paralipomena* 60; *AJA* 72 (1968) pl. 120, fig. 3.

7 Los Angeles 50.14.2 (A 5832.50-137): *ABV* 133, no. 7; *Paralipomena* 55; *CVA* 1, pl. 3.

8 San Simeon 5476 (SSW 9968): *Catalogue Sotheby 12 July 1927,* pl. 7, no. 148; D. von Bothmer *apud* P. Amandry, review of L. B. Ghali-Kahil, *Les enlèvements et le retour d'Hélène, AJA* 62 (1958) 339; E. Bell, "The Swing Painter's Amphora in San Simeon," *CSCA* 12 (1979) 21–38 and pls. 1–3.

9 Louvre F 33: *ABV* 141, no. 3; *Paralipomena* 58; *Vasenlisten*³ 121, no. 11.

10 Naples 112849: *ABV* 138, below, no. 2; *Vasenlisten*³ 122, no. 21.

11 On the Labor of Herakles and Geryon, see P. A. Clement, "Geryon and Others in Los Angeles," *Hesperia* 24 (1955) 1–24.

12 Hannover 1962.78: *CVA* 1, pls. 7.2, 8; *Vasenlisten*³ 121, no. 2.

13 Boston 89.273: *ABV* 144, no. 4; *Paralipomena* 59; *AJA* 72 (1968) pl. 120, fig. 4; *CVA* 1, pls. 29–32. A slightly different pattern, with a small hook in each quarter of the circle, adorns the shoulder of the woman in the chariot on side B of Exekias' neck-amphora New York 17.230.14 (*ABV* 144, no. 3; *Paralipomena* 59; *AJA* 72 [1968] pl. 121, fig. 9; *CVA* 4, pls. 16–19).

14 *Auktion 34. Kunstwerke der Antike. 6. Mai 1967.* Münzen und Medaillen AG Basel, pl. 31, no. 121. On the *zeira,* see H. A. Cahn, in *RA* 1973, 13–15 and 13, n. 2; E. Bell, "Swing Painter" 29.

15 Toledo 23.3123: *CVA* 1, pl. 3.

16 The principal sources for the genealogy of the Nemean Lion are Hesiod (*Theog.* 326–32) and Epimenides (Philosophus fr. 2 [Diels, *Vorsokr.* 1, 32–33]).

17 Oslo, Hamran: *Paralipomena* 277 (Class of Athens 581, ii); *Vasenlisten*³ 138, no. 53.

18 Villa Guilia M. 472: *ABV* 291; *Paralipomena* 127.

19 London, BM 3204: H. B. Walters, *Catalogue of the Bronzes, Greek, Roman, and Etruscan in the Department of Greek and Roman Antiquities, British Museum* (London 1899) 373, no. 3204, and 372, figs. 85–86.

20 Athens, Kerameikos 407: K. Kubler, *Kerameikos* 5:1 (Berlin 1954) pl. 69.

21 Syracuse (*sine inv.*): H. Payne, *Necrocorinthia* (Oxford 1931) 275, no. 83, and 126, fig. 44 *bis*; *Vasenlisten*³ 141, no. 11.

22 Perachora 2542: T. J. Dunbabin, *Perachora* II (Oxford 1962) 262–63, no. 2542, and pls. 106, 110, 163; *Vasenlisten*³ 141, no. 10.

23 Berlin 1753: *Paralipomena* 23, no. 94; *Vasenlisten*³ 127, no. 1. Kavalla (*sine inv.*): *Paralipomena* 24, no. 89 *ter*; *Vasenlisten*³ 130, no. 14.

24 Cab. Méd. 314: *ABV* 65, no. 41; *Vasenlisten*³ 127, no. 6.

25 *Vasenlisten*³ 126–27.

26 New York 56.171.11: *ABV* 133, no. 2; *Paralipomena* 54; *Vasenlisten*³ 126, no. 16.

27 Swing Painter: Berlin 1693 (*ABV* 305, no. 25; *Vasenlisten*³ 126, no. 3). Lysippides Painter: Bologna 151 (*ABV* 255, no. 5; *ARV*² 4, no. 10; *Paralipomena* 113; *Vasenlisten*³ 126, no. 12). Euphiletos Painter: Villa Guilia 933 (*ABV* 323, no. 17; *Vasenlisten*³ 127, no. 22). A few other black-figure painters, all minor hands, use the type C scheme to represent Herakles and the Lion.

28 *Vasenlisten*³ 119–26.

29 Cab. Méd. 206: *ABV* 109, no. 27; *Vasenlisten*³ 121, no. 13.

30 Berlin 1720: *ABV* 143, below, no. 1; *Paralipomena* 59; *Vasenlisten*³ 119, no. 4.

31 On the *apagoreuein*, see Philostratus (*Imag.* II.6).

32 Boston 01.8127: *ABV* 260, no. 28; *CVA* 1, pl. 56.

33 Naples Stg. 148: *ABV* 371, no. 141; *Paralipomena* 162; *Vasenlisten*³ 109, no. 22.

34 On the *Liegekampf*, see *Vasenlisten*³ 109–18.

35 *AJA* 82 (1978) 14 and illus. 1; *OpusRom* 8 (1974) 59, pl. 10; *AJA* 84 (1980) 417, n. 3.

36 J. Boardman, "Exekias," *AJA* 82 (1978) 14 and n. 14.

37 Brescia (*sine inv.*): *ABV* 292, no. 1; *Paralipomena* 127; *Vasenlisten*³ 111, no. 7.

38 Munich 1471 (Group E): *ABV* 137, no. 60; *Paralipomena* 55; *CVA* 7, pls. 346–347; *Vasenlisten*³ 119, no. 8. Munich 1395 (Swing Painter): *ABV* 305, no. 24; *Vasenlisten*³ 121, no. 4. Orvieto, Faina, 72: *ABV* 371, no. 142, and 604, no. 65; *Vasenlisten*³ 110, no. 24. The possible reference of the pictures on the Swing Painter's vase to the Nemean Games was suggested to me by H. M. Fracchia.

39 Oxford 1960.1291: *Paralipomena* 59; *CVA* 3, pls. 6.1–2; 7.

40 Munich 1396: *ABV* 135, no. 39; *AJA* 72 (1968) pl. 119, fig. 2.

41 Florence 4209: *ABV* 76, no. 1; *Paralipomena* 29–30.

42 Boston 01.8059: *ABV* 667–68, s.v. "Hippon"; *CVA* 1.26–27 (attribution by D. von Bothmer) and pls. 36; 38.1–2.

43 Arezzo 1460: *ARV*² 1157, no. 25; *Paralipomena* 458.

44 Naples 9564: J. Charbonneaux, R. Martin, and F. Villard, *Classical Greek Art,* trans. J. Emmons (London 1972) 277, illus. 317.

45 Boulogne 558: supra n. 6.

46 Vatican 344: *ABV* 145, no. 13; *Paralipomena* 60; *AJA* 72 (1968) pl. 119, fig. 1.

47 For vases with the signature of Exekias as potter, see *ABV* 143 and 146–47; *Paralipomena* 61. To Beazley's lists, add Toledo 1980.1022 (infra n. 52).

48 Berlin 1720: supra n. 30. Vatican 344: supra n. 46. On the relative chronological placement of these vases within Exekias' *oeuvre,* see Moore, "Horses by Exekias" 361, 365–67.

49 Louvre F 53: *ABV* 136, no. 49; *Paralipomena* 55.

50 *Development* 63; *ABV* 133.

51 Stesias *kalos:* Paris, Seillière (*ABV* 133, no. 9; *Paralipomena* 55); Berlin 1698 (*ABV* 136, no. 54); Toledo 1980.1022 (infra n. 52); Anchippos: Florence 70994 (*Development* 64 and 112, n. 5); Toledo 1980.1022; Kalliphora: Berlin 1720 (supra n. 30); Berlin 1811–26 (*ABV* 146, nos. 22, 23; *Paralipomena* 60; *AJA* 72 [1968] 358, no. 15); Toledo 1980.1022. Of the above vases, only Florence 70994, an unattributed black-figure hydria, is not connected with Exekias or Group E.

52 Toledo 1980.1022: *The Museum Collects: Treasures by Sculptors and Craftsmen* (Toledo Museum of Art 1980) 8–9. I owe my knowledge of this vase to K. T. Luckner, Curator of Ancient Art at the Toledo Museum of Art, who has kindly provided me with photographs and full information on the piece. Since the writing of this chapter, Luckner and I have agreed that a third piece, the amphora London B 147 (*ABV* 135, no. 44; *Paralipomena* 55), is also by the same hand as the vases in the Louvre and Toledo.

53 Cab. Méd. 4899: Arias-Hirmer pls. 74, XXIV; J. Charbonneaux, R. Martin, and F. Villard, *Archaic Greek Art,* trans. J. Emmons and R. Allen (New York 1971) 78–79, illus. 83–84.

54 London B 194: *ABV* 136, no. 56; *Paralipomena* 55.

55 *LSJ* s.v. "πέτασος." A cap which looks as though it were made of sturdier material than felt or wool is worn by the charioteer on the oinochoe London B 524, by the Amasis Painter (*ABV* 154, no. 47; *Paralipomena* 64 and 179, above, no. 1 [Class of London B 524]).

56 Vatican 344: supra n. 46. On the bit-burr, see J. K. Anderson, *Ancient Greek Horsemanship* (Berkeley and Los Angeles 1961) 48–49, 58–59, and pls. 20–23; M. B. Moore and D. von Bothmer, "A Neck-amphora in the Collection of Walter Bareiss," *AJA* 76 (1972) 8.

57 *ABV* 133.

58 *Development* 63; *ABV* 143.

59 Berlin 1720: supra n. 30.

60 Basel, Cahn 300: *Paralipomena* 60, no. 1 *bis*; *AJA* 72 (1968) pl. 121, fig. 5a–d.

61 Boulogne 558: supra n. 6.

62 Boston 89.273: supra n. 13.

63 London B 194: supra n. 54; Paris, Larosière: *Paralipomena* 56, no. 56 *bis*.

Painting, Politics, and Genealogy: Peisistratos and the Neleids

<div align="right">6</div>

H. A. SHAPIRO

An ancient tradition, preserved in different forms by different authors, maintained that at some time after the Trojan War several descendants of Neleus, king of Pylos, left the Peloponnesus and came to Athens, where they established a dynasty of kings, displacing that of Theseus.[1] In addition, several Athenian clans in the historical period were reputed to descend from the Pylian royal family. The principal exponents of the latter tradition are Herodotos and Pausanias, whose accounts do not always agree. Herodotos (v.65) says that Peisistratos and his family were Neleids and that the Tyrant was named after the son of Nestor (Hom. *Od.* III.36). He adds that this is also the family of Kodros and Melanthos, two of the Neleid kings of Athens. The descent of Melanthos from Neleus is attested, with a full genealogy, in the fifth century, by Hellanikos (*FGrHist* I 4 F 125).

Pausanias (II.18.8–9) refers to three branches of the Neleid family who fled from Messenia, where they had gone after Herakles sacked Pylos. This took place, he says, two generations after the Trojan War, at the time of the Dorian invasions and the Return of the Herakleidai (IV.3.3). Of the three groups, two settled in Athens and became the ancestors of the Alkmeonidai and the Paionidai. Pausanias is *not* aware of a Neleid ancestry for the Athenian Peisistratidai, though he does mention a third contingent of Neleids, led by Peisistratos son of Peisistratos, saying he does not know where they ended up. Presumably it was not Athens. A fourth Athenian family, the Medontidai, were said to be descended from Medon, son of Kodros (Paus. IV.5.10).

Of the Paionidai and Medontidai in Attica we hear relatively little in the historical period.[2] The Peisistratids and Alkmeonids, on the other hand, are not only prominent and well documented over many years, but were of course arch-rivals through most of the sixth century. It is interesting, therefore, that both should have been connected at different times with the same mythical progenitor.

There is some difficulty in reconciling the testimony of Herodotos and Pausanias. Although R. Hampe has convincingly disposed of the older view that Herodotos believed the Alkmeonids were autochthonous in Attica,[3] it still remains true that he gives us quite a bit of their family history and probably would have mentioned a Pylian origin if he had been aware of it. Since Pausanias' account is not corroborated by any other author,[4] we should be inclined, *ceteris paribus,* to trust the author with the advantage of greater proximity to the people in question. There were still active members of the Alkmeonid family in Herodotos' time, and even if there were no longer direct descendants of Peisistratos, Herodotos would have had informants who could remember when there were. This, together with the unassailable evidence of Peisistratos' name, is enough to suggest that the descent of the Peisistratids from Neleus and Nestor was generally acknowledged in the sixth and fifth centuries.

It is not hard to imagine why a tyrant who had thrice seized power by ruse or by force would want to publicize his descent from the Neleids of Pylos. The facts both that the family had been in Attica for many generations, since the end of the heroic age, and that it numbered among its members several ancient kings, including the good Kodros who martyred himself to save Ath-

6.1

6.2a

6.1. London 97.7-27.2. Tyrrhenian amphora. The sacrifice of Polyxena. Photo: Courtesy of the Trustees of the British Museum.

6.2a, 6.2b. Athens, Agora P 4885. Attic Late Geometric oinochoe, Nestor and the Molione (?). Photo: Courtesy of the American School of Classical Studies.

6.3. Athens, American School of Classical Studies (E. Vanderpool). Relief pithos fragment. Antilochos. Photo: M. Caskey.

ens, would have helped legitimize the Tyrant's rule.[5] That Peisistratos was genuinely concerned that his rule be viewed as legitimate we may surmise from the general picture, most fully painted by Aristotle *(Ath. Pol.* 14–16), of a man who in every way eschewed the image of a ruthless tyrant, but instead governed according to the ancient laws. Just how conscious the Peisistratids were of their Neleid ancestry is nowhere explicitly stated, but the evidence of Peisistratos' name alone is strongly suggestive. Almost without exception, historical Athenians of the Archaic and Classical periods did not bear the names of epic heroes, as their descendants often do in Greece today; Peisistratos is the one exception. Even the other members of his family have standard Athenian names (Hippokrates, Hipparchos, and so on), though the name Nelonides son of Nelon on a gravestone of around the 520s is also suggestive.[6] If the Tyrant did want to exploit his heroic and royal ancestry, we should expect to find some indications, in art and in cult, of an attempt to promote awareness of and interest in the Neleids in sixth-century Athens. The evidence for this is scrappy and often inconclusive, but it may be worthwhile at least to assemble it here.

Neleus himself does not appear in Attic vase-painting, apart from a single fragmentary instance in the late fifth century.[7] Nestor is better represented, but is still far from a common figure, in spite of the enormous popularity of Trojan subjects in both black- and red-figure. Perhaps this is because the vase-painters often favor scenes of combat, and in the *Iliad* Nestor is a man of many words, but little action. His earliest certain appearance in Attic art is on a well-known Tyrrhenian amphora of the mid-sixth century or slightly earlier, now in London (fig. 6.1).[8] The subject is the sacrifice of Polyxena at the pyre of Achilles. Three Greek soldiers hold the victim's body horizontal, while Neoptolemos delivers the death blow. Nestor stands at the far left as a spectator, in civilian clothes but holding a spear. His age is alluded to in the receding hairline. Although all the figures are neatly labeled, the inscription beside Nestor is remarkable: ΝΕΣΤΟΡ ΠΥΛΙΟΣ. Such poetic epithets are very rare in vase inscriptions.[9] It could have helped to emphasize the Pylian association of the family whose leading member, Peisistratos, had just risen to prominence in the 560s.[10]

Nestor is not seen again until early red-figure, but we might mention here attempts to recognize his combat with the Aktorione-Molione on several Attic Late Geometric vases (figs. 6.2a,

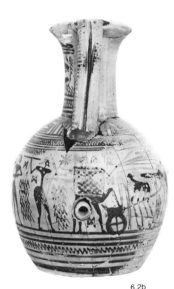

6.2b

6.2b).[11] Nestor himself recounts his battle with these Siamese twins in the *Iliad* (XI.750–52). Although Nestor cannot be securely identified on any of the vases, and Herakles also fought the same pair, a few scholars have opted for Nestor on the basis of his connection with early Attic genealogy. (But against this view, see Boardman pp. 25–26.) Thus Coldstream took the scene as a "family crest" employed by Athenian families of Neleid descent in the eighth century on their funerary markers.[12] Peisistratos cannot have been born later than about 600,[13] and the father who named him for Nestor's son takes us back into the seventh century. The Peisistratos who was archon in 669/668 is almost certainly an ancestor of the Tyrant named for the same Neleid hero.[14] The possibility, then, that the family was already active in Athens and proud of its descent

6.3

in the late eighth century is not altogether inconceivable.[15]

The next generation of Neleids after Nestor was represented at Troy by his son Antilochos. He was too young to go when the Greek army first left for Troy, but after five years made his way there on his own and later, to save his father he died at the hand of Memnon.[16] The partial figure of a warrior and an inscription naming Antilochos are preserved on a recently found fragment of an Early Archaic relief pithos (fig. 6.3).[17] It was found at Pikermi, in eastern Attica near Brauron, where the Peisistratids had their ancestral residence.[18] Its date, in the mid-seventh century, is unusually early for a Trojan subject,[19]

so that the choice of Antilochos, a relatively minor figure in the epic, is the more striking. It perhaps lends added credence to the Late Geometric Nestor vases only two or three generations earlier.

The duel of Memnon and Antilochos and the subsequent duel between Memnon and Achilles over Antilochos' body were narrated in the *Aithiopis*[20] and inspired several Archaic vase-paintings. The earliest in Attica, of ca. 530, is on Exekias' amphora in Philadelphia (figs. 6.4a, 6.4b).[21] Here Antilochos lies dead, but instead of the duel over his body, three Greeks chase away two of Memnon's Negro followers, to prevent them from despoiling the corpse. The pair of Menelaos attacking a Negro on the other side of the vase, beside Ajax and the dead Achilles, may also belong with the Antilochos scene.[22] Boardman has recently documented in detail Exekias' innovative interest in Trojan subjects, especially those dealing with Achilles and Ajax and those episodes not told in the *Iliad*,[23] so it is little wonder that the dead Antilochos occurs first in his work.

The actual fight over Antilochos' body, then, is not certainly shown in Attic vase-painting, though it does occur on a pseudo-Chalcidian amphora on the art market[24] and a Chalcidian amphora in Florence,[25] with inscriptions insuring the identification on both. Many Attic scenes of a single combat over a corpse may also be intended for the same subject, but in the absence of inscriptions, several other episodes are equally possible.[26]

A little more information about Antilochos is added by a black-figure fragment in the collection of Herbert Cahn (fig. 6.5).[27] It belongs in Group E and is probably a bit earlier than Exekias' amphora. Antilochos, carrying a spear in one hand and three sprigs in the other, takes leave of a woman labeled Euryteleia. This should be his mother, though in Homer she is given the name Eurydike (*Od.* III.452). A third figure, now lost, is represented only by a hand holding a spear; perhaps this was Nestor. Antilochos competing in the funeral games for Patroklos has been identified by K. Schefold on a Band cup in a private collection.[28]

Antilochos and Nestor are both extremely rare in red-figure, though, interestingly, they are shown together twice on vases by Oltos. On a cup in Berlin signed by the painter and by Euxitheos as potter,[29] Antilochos prepares to mount a chariot while Achilles converses with Nestor. H. Sjövall has convincingly interpreted the subject as Antilochos' arrival at Troy, derived from

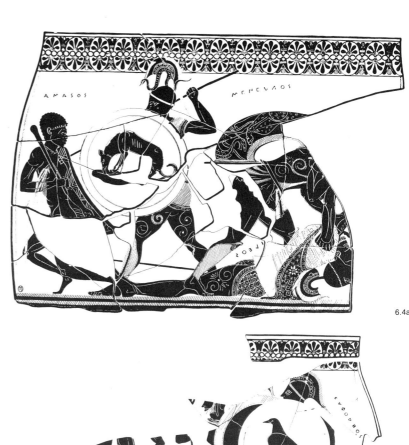

6.4a

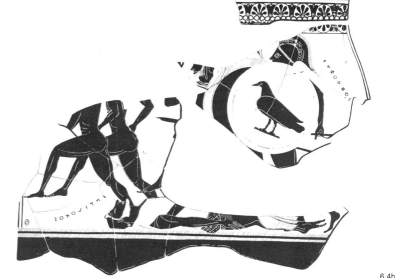

6.4b

6.5

6.4A. Philadelphia MS 3442.
Amphora by Exekias. Side A,
Ajax lifting the body of Achilles.
Drawing: Courtesy of the Uni-
versity Museum, Philadelphia.

6.4b. Philadelphia MS 3442.
Amphora by Exekias. Side B,
the death of Antilochos. Draw-
ing: Courtesy of the University
Museum, Philadelphia.

6.5. Basel HC 875. Black-figure
fragment (H. Cahn). Departure
of Antilochos. Photo: Archaeo-
logical Institute, Würzburg.

6.6. Boston 01.8026. Amphora
by the Amasis Painter. Athena
and Poseidon. Photo: Courtesy
Museum of Fine Arts, Boston,
Pierce Fund, purchase of E. P.
Warren.

6.6

the story as we have it first in Philostratos.[30] On an unpublished cup in the Astarita Collection,[31] Nestor, whose name is inscribed, and a young warrior, taken by J. D. Beazley to be Antilochos, are shown in a scene of extispicy. Nestor is not specifically mentioned in Homer as an interpreter of omens, though his seniority and reputation for great wisdom would be consistent with such a talent. The two cups are close in date and could be contemporary with the last years of the Peisistratid tyranny. In later red-figure Nestor and Antilochos disappear, but for two or three instances.[32]

Such is the modest body of depictions of Neleid heroes in Archaic Attic art. One might have hoped for a Neleid king of Athens, especially Kodros, but he does not seem to have aroused any interest until the mid-fifth century. But this does not exhaust the subjects with possible Neleid associations, and these too deserve to be brought into the discussion.[33]

Since Neleus was fathered by Poseidon, we may presume that all the Neleids considered themselves descended from that god, or at least under his protection. Poseidon appears first on Attic vases in the second quarter of the sixth century, at the wedding of Peleus and Thetis[34] and the birth of Athena.[35] By mid-century he is an active participant in the Gigantomachy.[36] Through the rest of the century he is not one of the most often represented Olympians and has relatively little mythology. But he *is* conspicuous in the work of the two finest black-figure artists, Exekias and the Amasis Painter. The latter depicts him so often and with such prominence that one scholar speculated that this was because Amasis came from East Greece, where the worship of Poseidon was strong.[37] This explanation, however, is not necessary, since, as we shall see, there was at least one active cult of Poseidon in Attica in the Archaic period.

On three of his best vases, the Amasis Painter shows a quiet, almost solemn scene of Poseidon and Athena standing together (fig. 6.6).[38] There is no narrative here, but since Athena is clearly shown as the city goddess of Athens, in full armor, the implication is that Poseidon too is a protector of the city. The story of their contest for Athens, as it is shown, for example, in the west pediment of the Parthenon, may not have been known in the sixth century, but one of Poseidon's oldest cults in Attica was one shared with Athena: Poseidon Hippios and Athena Hippia on Kolonos Hippios.[39]

This aspect of Poseidon, as master of horses who first taught men how to tame them,[40] is a

6.7a

6.7b

very old one, and Linear B tablets have shown
that Poseidon was the chief god at Pylos.[41] Inter-
estingly, Homer depicts Nestor and his people
conducting a great sacrifice and feast in honor of
Poseidon just as Telemachos arrives at Pylos (*Od.*
III.3ff.). The son of Odysseus and the disguised
Athena are welcomed by Nestor's son, Peisistra-
tos, who particularly impresses Athena with his
wisdom and good judgment (*Od.* III.36–53). We
could speculate that the Neleids brought the cult
of Poseidon with them from Pylos to Attica at
the end of the Bronze Age. Poseidon's associa-
tion with horses is mirrored in the Neleids' rep-

utation as outstanding horsemen: Γερήνιος
ἱππότα Νέστωρ.

In the sixth century Poseidon is mostly shown
in his newer and more canonical aspect of sea-
god, with trident, but the old Poseidon Hippios
is not forgotten. The most remarkable pictorial
reference to Poseidon's association with horses
is, again, by the Amasis Painter (figs. 6.7a,
6.7b).[42] On his cup in the Norbert Schimmel
Collection, one side shows Poseidon's epiphany
on the battlefield at Troy to encourage the Greeks
(Hom. *Il.* XIII.125ff.). On the other side, grooms
harness four horses in an elaborately rendered

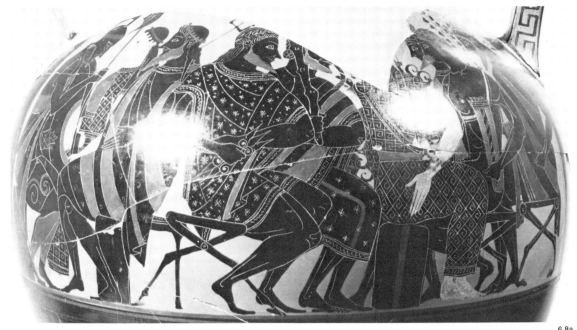

6.8a

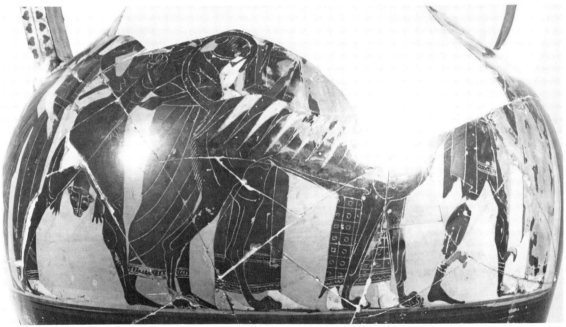

6.8b

6.7a. New York (N. Schimmel). Cup by the Amasis Painter. Side A, Poseidon at Troy. Photo: Metropolitan Museum of Art.

6.7b. New York (N. Schimmel). Cup by the Amasis Painter. Side B, the stables of Poseidon. Photo: Metropolitan Museum of Art.

6.8a. Orvieto, Faina 78. Amphora by Exekias. Side A, Herakles among the gods in Olympus. Photo: DAI, Rome.

6.8b. Orvieto, Faina 78. Amphora by Exekias. Side B, Herakles and Kerberos. Photo: DAI, Rome.

stable, which must be Poseidon's.[43] The god's two realms are merged in a few representations which show him riding a hippocamp, as on a lekythos of about 520 in Oxford.[44]

It would be natural for Peisistratos to want to promote this joint cult of Poseidon and Athena, given his ancestral link with the former and the protection he received from the latter, made explicit in the story of his first return from exile (Hdt. 1.60).[45] It is also possible that Athena and Poseidon were worshiped together from early times on the Akropolis, in the "strong house of Erechtheus."[46] Though we do not hear of the

Peisistratids specifically as horsemen, any more than other noble families of the time, they at least maintained their propensity for horsey names, for example, the tyrant's father Hippo-krates and his sons Hippias and Hipparchos.

Exekias includes Poseidon three times on vases showing Herakles' apotheosis: the calyx-krater from the Akropolis[47] (see Moon p. 115, n. 9) and an amphora in Orvieto,[48] which both depict the chariot ride to Olympus; and another amphora in Orvieto (figs. 6.8a, 6.8b)[49] with Herakles already seated among the assembled gods. Though the subject, especially with chariot, is

extremely popular in black-figure, Poseidon's presence, outside Exekias' work, is quite rare.[50] If J. Boardman is correct in arguing for Peisistratos' special interest in Herakles and in this scene in particular,[51] then it seems most appropriate that Poseidon should form part of the welcoming party of Olympian gods.

The second named Orvieto amphora leads on to one final, perhaps tenuous, link with Pylos and the Neleids. The reverse of the vase shows one of the earliest Attic versions of Herakles' capture of Kerberos. Boardman has already argued for Peisistratos' interest in this subject because of its association with the Eleusinian cult, with which the tyrant was much concerned.[52] Another aspect of the myth may also have interested him. Of all Herakles' Labors, the capture of Kerberos, with the hero's *nekuia*, most clearly prefigures his eventual apotheosis, the triumph over death. Surely Exekias had this in mind when he paired the Kerberos episode on the Orvieto amphora with the scene of Herakles among the Olympians. It seems likely that in an early version of the myth, the story that Herakles had once wounded Hades (another triumph over death) was tied in with the Kerberos Labor: perhaps Hades tried in vain to prevent the taking of the dog. This version may lie behind the earliest Kerberos representation in art, on a Corinthian cup of the early sixth century, on which Herakles tries to throw a stone at Hades, but is restrained by Athena.[53] Homer, however, implies that the wounding of Hades took place in the context of Herakles' attack on Pylos and slaying of all the sons of Neleus, save only Nestor (Hom. *Il.* v.395–97; xi.690–93).[54] Somewhere along the line, probably very early on, there has been a confusion of Nestor's Pylos and the πύλαι, the gates of Hades where Kerberos stands guard. Though Hades is seldom shown in Attic Kerberos scenes, he is present, with Persephone, on Exekias' amphora. The subject, then, could have been one way of alluding to the old association of the greatest Greek hero with the ancestors of Peisistratos.[55]

A study of the Neleids in Athens would be incomplete without some mention of the very problematical shrine of Kodros, Neleus, and Basile somewhere south of the Acropolis, perhaps near the Ilissus, where Pausanias (1.19.5) was shown the site of Kodros' death.[56] All we know of the cult and the sanctuary is contained in an inscription of 418/417 (IG I² 94) defining its boundaries and giving regulations for the leasing of the temenos. These imply that the cult was already in existence, and a boundary stone associated with the sanctuary belongs to the mid-fifth century,[57] but there is no direct evidence, archaeological or otherwise, to take it back to the sixth. Nevertheless, in the light of all we have seen, we might suggest the Peisistratid period as a likely time for the founding of the cult.

In the absence of any literary testimonia, the purpose and associations of the cult are obscure. Because Kodros seems only to become important in the second half of the fifth century, F. Brommer argued that he was a late and artificial construction of that period.[58] The occasion for the inscription and the reorganization it implies can conceivably have been the addition of Kodros to an earlier cult of Neleus and Basile.[59] The latter is a completely unknown figure and has been given various interpretations, none satisfactory.[60] It is perhaps simplest to understand her as a personification of kingship (βασιλεία), companion of the ancient kings of Athens (Kodros) and Pylos (Neleus). Since the later fifth century is the period when such abstract personifications particularly crop up,[61] it may be that Basile joined the cult only when Kodros did, and before that it had been a shrine of Neleus alone.

Even with Neleus there is a complication; is the king of Pylos intended, or a descendant of the same name, the son of Kodros? The latter would be an appropriate object of cult worship in Athens, because, according to a tradition known to Herodotos (IX.97) and probably much older,[62] the younger Neleus left Athens, after a dispute with his brother Medon over the succession to the throne, and founded Miletus and other cities of the Ionian Dodecapolis.[63] This was the mythological basis of Athens' claim in the sixth and fifth centuries to being the πρεσβυτάτη γαῖα ᾿Ιαονίας (Solon fr. 4). It is mostly in the period of the Delian League, after 480, that we hear Athens proclaiming herself mother city of the Ionians, but Peisistratos too was eager to publicize that role. This was no doubt the reason for the purification of Delos, which he undertook probably soon after the firm establishment of his third tyranny (Hdt. 1.64). That one of his own ancestors had first led the Athenians to Ionia would have helped strengthen Peisistratos' right to assert Athens' claim to a leading place among Ionian Greeks.

We should probably conclude that the Neleus who received cult worship was, at one time or another, both: the ancestor of the last kings of Athens and the ancestor of the Ionians of Asia Minor. Both could have served equally Peisistratos' desire to invoke his heroic ancestors to win approval for his political and religious policies.

The vases which can be related to the Neleids should not be taken as evidence of painters in the employ of the tyrants carrying out a planned campaign of mythological propaganda. Rather they suggest only that myths, places, and characters—Nestor and Antilochos, Pylos and Poseidon—were in the air in the Peisistratid period due to an awareness of the family's descent and, perhaps, to the existence of the relevant cults. And if it is only, or primarily, in the work of a few of the most thoughtful painters of the time— Exekias, the Amasis Painter—that we find these reflections, that should not surprise us.

NOTES

I would like to thank R. Cromey for making available to me two unpublished papers, as well as for much helpful discussion. I am also grateful to M. Ostwald and R. M. Frazer for reading and commenting on this paper. The following very kindly provided photographs of objects in their collections: H. Cahn, E. Vanderpool, and N. Schimmel.

1 For the archaeological evidence for this migration see C. Sourvinou-Inwood, "Movements of Populations in Attica at the End of the Mycenaean Period," in *Bronze Age Migrations in the Aegean,* eds. R. A. Crossland and A. Birchall (London 1973) 215–22.

2 See W. Kroll, "Medontidai," in *RE* 15 (1931) 113; R. Cromey, "Attic Παιανία and Παιονίδαι," *Glotta* 56 (1978) 62–69.

3 R. Hampe, "Die homerische Welt im Licht der neuen Ausgrabungen," in *Vermächtnis der antiken Kunst,* ed. R. Herbig (Heidelberg 1950) 55.

4 F. Jacoby, *FGrHist* III Hellanikos, Commentary n. 1 and n. 36, believes Pausanias' source in this passage is an *Atthis,* possibly that of Philochoros.

5 Diogenes Laertius, *Solon* 53–54, records a fictitious letter from Peisistratos to Solon, in which the former points to his descent from Kodros to justify his right to rule.

6 EM 12870. *IG* I² 983; L. H. Jeffery, in *BSA* 57 (1962) 127, no. 19. The metrical epitaph and signature of the sculptor Endoios were carved on the pedestal base for a kouros. The monument was damaged soon after it was made, and on this basis J. N. Svoronos, *apud* Philadelpheus, in *BCH* 46 (1922) 33, suggested that it was a Peisistratean monument destroyed after 510. A. E. Raubitschek, *Dedications from the Athenian Akropolis* (Cambridge, Mass. 1949) 493, prefers to think it was Alkmeonid.

7 See *Hesperia* 24 (1955) 78 and pl. 34a. F. W. Hamdorf, *Attische Vasenbilder der Antikensammlung in München* II (1976) 36, identifies as Neleus and his sons the four warriors on Euphronios' Geryon cup in Munich (pl. 17). They were said to have tried to steal the cattle of Geryon as Herakles was driving them back to Mycenae (Philostr. *Heroikos* IV.2).

8 London 97.7-27.2. *ABV* 97, no. 27; L. Stella, *Mitologia greca* (Torino 1956) 752.

9 There is another on the same vase: ΑΙΑΣΙΛΙΑΔΕΣ (= son of Oileus). H. R. Immerwahr has called my attention to a few other similar vase inscriptions of epic inspiration, including Hermes Kyllenios on another Tyrrhenian amphora, Berlin 1704: *ABV* 96, no. 14; A. B. Cook, *Zeus* III (Cambridge 1940) pl. 54.

10 In about 565 Peisistratos distinguished himself in the Athenian campaign against Megara (Herodotos 1.59).

11 See most recently C. King, "Another Set of Siamese Twins in Attic Geometric Art," *ArchNews* 6 (1977) 29–40, with earlier bibiliography. Nestor does appear, outside Attica, on fragments of a Caeretan hydria in the Louvre: *CVA,* III Fa, pl. 11–12. His name is inscribed, together with those of Ajax and Odysseus (ΟΔΙΟΣ). Thus the scene was probably the embassy to Achilles, to which Nestor in the *Iliad* offers his advice (IX.179–81).

12 J. N. Coldstream, *Greek Geometric Pottery* (London 1968) 351, and now *Geometric Greece* (London 1977) 352. The idea had previously been advanced by T. B. L. Webster, "Homer and Attic Geometric Vases," *BSA* 50 (1955) 41. The interpretation is doubted by J. Boardman in *Gnomon* 42 (1970) 501.

13 See J. K. Davies, *Athenian Propertied Families* (Oxford 1971) 445.

14 See T. J. Cadoux, in *JHS* 68 (1948) 90; Davies, *APF* 445. The name Peisistratos scratched on a sherd from the Agora is associated with the early archon by L. H. Jeffery, *Local Scripts of Archaic Greece* (Oxford 1961) 70 and pls. 2 and 9e.

15 Cf. Hampe, "homerische Welt" 56.

16 The story is told in part by Philostratos, *Heroikos* III.2.

17 E. Vanderpool, "A Relief Pithos Fragment from Attica," *AAA* 4 (1971) 75–76.

18 Cf. the comment of Sourvinou-Inwood, "Movements" 216, that four of the seven Attic sites discovered on the Attic eastern coast, belonging to LH IIIC— which would correspond to the period of the arrival of the Neleids—are concentrated around Brauron.

19 Cf. the even earlier relief pithos from Mykonos with scenes of the Ilioupersis: M. Ervin, "A Relief Pithos from Mykonos," *Deltion* 18A (1963) 37–75.

20 See G. L. Huxley, *Greek Epic Poetry* (London 1969) 145. Antilochos' death is alluded to also in the *Odyssey* (IV.187–88).

21 Philadelphia 3442: *ABV* 145, no. 14; *Development* pl. 30.

22 So *Development* 68–69. A different interpretation is offered by J. Boardman, "Exekias," *AJA* 82 (1978) 17, n. 36.

23 Boardman, "Exekias" 17, n. 36.

24 F. Canciani, *JdI* 95 (1980) 145–46, figs. 7–9. The fabric may be East Greek: cf. E. Langlotz, *Studien zur nordostgriechischen Kunst* (Mainz 1975) 187. Canciani (p. 162) sees influence from several regions.

25 Florence 1783: G. E. Lung, *Memnon: archäologische Studien zur Aithiopis* (Diss., Bonn 1912) 35 (see Pinney, p. 142 n. 36).

26 Cf. Lung, *Memnon* 34–36. The duel over a dead warrior on the north frieze of the Siphnian Treasury at Delphi has sometimes been identified as Achilles, Memnon, and Antilochos: cf. E. Reisch, "Zu den Friesen der delphischen Schatzhäuser," in *Wiener Eranos* (Vienna 1909) 296–98.

27 Herbert Cohn Coll. HC 875: *Paralipomena* 59; the inscriptions are discussed by Beazley in *AJA* 33 (1929) 362.

28 K. Schefold, *Götter- und Heldensagen der Griechen in der spätarchaischen Kunst* (Munich 1978) 235 and figs. 314, 315.

29 Berlin 2264: *ARV²* 60, no. 64; A. Bruhn, *Oltos* (Copenhagen 1943) figs. 5, 6.

30 Cf. supra n. 16; H. Sjövall. "Die Antilochosdarstellung der Oltosschale in Berlin," *OpusAth* 2 (1955) 61–66.

31 *ARV²* 1623, no. 64 *bis*.

32 Nestor and Antilochos on an amphora by the Tithonos Painter, Louvre G 213: *ARV²* 309, no.4; *CVA* pl.40; Nestor arming on a skyphos, the name-vase of the Euaichme Painter, Boston 01.8097: *ARV²* 785, no. 2; *JdI* 17 (1902) pl.2; Antilochos(?) and Thetis with Achilles on a stamnos by the Hephaisteion Painter, Leiden PC 88: *ARV²* 298, no. 2; B. Philippaki, *The Attic Stamnos* (Oxford 1967) pl. 26. 1–2.

33 See my p. 94 on the shrine of Kodros, Neleus, and Basile.

34 E.g., the dinos by Sophilos, London 1971.11-1.1: *Paralipomena* 19, no. 16 *bis; BMQ* 36 (1972) pls. 34–37.

35 Tripod-pyxis by the C Painter, Louvre CA 616: *ABV* 58, no. 122; *Development* pl. 9.

36 See M. B. Moore, "Poseidon in the Gigantomachy," in *Studies in Classical Art and Archaeology,* Festschrift Blanckenhagen (Locust Valley, N. Y. 1979) 24–27.

37 U. Heimberg, *Das Bild des Poseidon in der griechischen Vasenmalerei* (Freiburg 1968) 72.

38 Cab. Méd. 222: *ABV* 152, no. 25; S. Karouzou, *The Amasis Painter* (Oxford 1956) pl. 31; Boston 01.8026: *ABV* 152, no. 26; Karouzou, *Amasis Painter* pl. 36; Florence 3791: *ABV* 153, no. 42; Stella, *Mitologia* 403.

39 Paus. 1.30.4; see P. Siewert, "Poseideon Hippios am Kolonos und die athenischen Hippeis," in *Arktouros,* Festschrift Knox (Berlin 1979) 280–89. He argues for the extreme antiquity of the cult, possibly Mycenaean in origin (p. 284). On Athena Hippia see N. Yalouris, "Athena als Herrin der Pferde," *MusHelv* 7 (1950) 19–101, esp. 57f.

40 Soph. *OC* 707–19.

41 See W. Burkert, *Griechische Religion* (Stuttgart 1977) 84. He refers also to Nestor's huge offering to Poseidon described at *Odyssey* III.4–11.

42 *Paralipomena* 67; O. W. Muscarella, *Ancient Art: The Norbert Schimmel Collection* (Mainz 1974) no. 56.

43 The interpretation of the stable as Poseidon's was first made by H. Jucker in *Studia Oliveriana* 13–14 (1965–1966) 42, n. 132. Poseidon is seen in his stables at *Iliad* XIII.21f.

44 Oxford 247: *ABL* pl. 44.4. References to Poseidon continue into the fifth century: see R. Janko, "Poseidon Hippios in Bacchylides 17," *CQ* 30 (1980) 257–59.

45 Cf. E. Simon, *Die Götter der Griechen* (Munich 1969) 83–84.

46 Hom. *Od* VII.81; see Hom. *Il.* II.546–51 and R. M. Frazer, Jr., "Some Notes on the Athenian Entry, *Iliad* B 546–56," *Hermes* 97 (1969) 262–66. Frazer cites E. Wüst, in *RE* 22 I (1953) 508, who adduces this passage from the Catalog of Ships as evidence of a joint cult of Athena and Poseidon-Erechtheus.

47 Athens, North Slope: *ABV* 145, no. 19; *Hesperia* 6 (1937) 475, fig. 4.

48 Orvieto, Faina 187: *ABV* 145, no. 11; W. Technau, *Exekias* (Leipzig 1936) pl. 10.

49 Orvieto, Faina 78: *ABV* 144, no. 9; Technau, *Exekias,* pl. 11.

50 Heimberg, *Bild Poseidon* 100, n. 14, gives only two other examples.

51 J. Boardman, "Herakles, Peisistratos and Sons," *RA* (1972) 57–72.

52 J. Boardman, "Herakles, Peisistratos and Eleusis," *JHS* 95 (1975) 1–12.

53 H. Payne, *Necrocorinthia* (Oxford 1931) 127, fig. 45c.

54 As Boardman, "Eleusis" 6, suggests, the story that Herakles deliberately spared only Nestor (Ael., *V.H.* IV.5) sounds as if it could have been inspired by Peisistratos himself.

55 Boardman, "Eleusis" 6, points out another instance of the same association, in the person of Pylios (presumably a Neleid) who adopted Herakles for initiation at Eleusis.

56 See Travlos, 332. Of the fuller discussions, see esp. R. E. Wycherley, "Neleion," *BSA* 55 (1960) 60–66.

57 Travlos 334.

58 F. Brommer, "Attische Könige," in *Charites,* Festschrift Langlotz (Bonn 1957) 161. The earliest, and only, vase representation of Kodros is in the 430s: Bologna PU 273: *ARV²* 1268, no. 1; *EAA* II, 738, fig. 981.

59 C. Lawton has suggested to me that the very fragmentary relief above the text of the inscription (*ArchEph* 1884, pl. 10) might represent Athena and Kodros, as though the city goddess were overseeing the initiation of Kodros' cult.

60 See Cook, *Zeus* III, 60.

61 See F. W. Hamdorf, *Griechische Kultpersonifikationen der vorhellenistischen Zeit* (Mainz 1964).

62 Mimnermos frs. 9–10, in the early sixth century, refers to settlers to Ionia from Pylos. See also M. L. Lazzarini, "Neleo a Samo," *RivFC* (1978) 179–91.

63 See van der Kolf, "Neleus," in *RE* 16 (1935) col. 2280.

The Priam Painter: Some Iconographic and Stylistic Considerations 7

WARREN G. MOON

for K. Schefold

The Priam Painter has received no extensive attention in the scholarly literature. This seems an oversight for an artist gifted in image-making, talented and independent in the practice of the black-figure technique and in his approach to style. Some new attributions have been made recently[1] and, in terms of iconography, a few scholars have commented on individual vase-paintings.[2] For instance, some have remarked the presence of political, pointedly Peisistratean metaphors in the story of the apotheosis of Herakles and have strengthened their argument with curious renderings of the scene by the Priam Painter.[3] Such interpretation implies that artist and clientele were aware of and concerned about the inner workings of Athenian urban society. Quite differently, another story, Aineias carrying his father, Anchises, painted by the Priam Painter on a vase in the Astarita Collection (733: *Paralipomena* 147, no. 30) (figs. 7.1a, 7.1b), suggests to others that the intended audience was Italic or at least West Greek because of aspects of the Aineias legend

itself.[4] This presupposes the artist's familiarity with customs and tastes far removed, by distance if not otherwise, from the Athenian potter's quarter where the Priam Painter worked, ca. 515–500 B.C.[5]

From what we imagine of the likely humble social status of vase-painters one holds in suspicion a painter's ability to devise metaphor and, not having traveled, to interpret foreign tastes. On the other hand, with the meteoric popularity of the red-figure technique, which was still relatively new at this time, it might very well have been that success in the potter's quarter depended on versatility, the more so for an artist who persisted exclusively in the old-fashioned silhouetted style. Our discussion then will review the strengths and variety of the Priam Painter's vase-paintings, examining those factors from within and from without which might have affected the image-making process, for our man and, more generally, for late black-figure. I intend to expose difficulties with recent interpretations of the Priam Painter's choice of subjects; this article can

7.1a

7.1a. Astarita Collection 733. Ilioupersis. Photo: Courtesy K. Schauenburg.

7.1b. Astarita Collection 733. Detail: Aineias carrying Anchises. Photo: Courtesy K. Schauenburg.

7.1b

only anticipate a fuller study, in progress, of the vexing problems of this painter's workshop associations.

Perhaps the Priam Painter can best be introduced by one of his favorite subjects, the preparations for Herakles' introduction to Olympus, i.e., the first stage of the hero's deification, particularly because there is a fine rendition of this scene on a pleasing hydria by the Priam Painter in the Elvehjem Museum of Art[6] (figs. 7.2a, 7.2b). Herakles could be riding to or from one of his Labors in such scenes, but because of the number of gods, besides Athena, frequently included in the entourage, this seems doubtful (fig. 7.3). Instead, the occasion is Herakles' rescue by his patroness, Athena, from his funeral pyre on Mount Oeta. The granting of immortality, the concept of an infernal (or celestial) heyday, is uncommon with the Greeks; it was shown some years ago, however, that such chariot scenes with Athena and hero refer to Herakles' apotheosis.[7]

On the Elvehjem hydria, as with most versions of the story by our painter, in the main panel, on the far left, Athena steps into her chariot which will transport Herakles,[8] who stands before the car, to immortality on the sacred mount. Hermes turns to check the progress of the ensuing journey from his position aside the team; with winged boots and traveling hat Hermes exemplifies journey. A woman sporting a fillet in her hair frames the scene on the far right. She may be Hebe, Herakles' would-be wife, or an anonymous mortal who serves as interlocutor between the earthly level and the soon-to-be divine. A figure in this position, sometimes of this description, often but not always a mortal, appears regularly with the Priam Painter, and such figures, usually women, are typically part of "leave-taking scenes." The hustle and bustle of the moment is well conveyed by certain elements of the design which break the confines of the picture panel: Hermes' staff, Herakles' knotty club, Athena's helmet and goad. The viewer remains convinced that when Athena completes her step into the chariot, the procession will begin. The goddess's arched foot and Herakles' exaggerated gesture (looking like the *apagoreuein,* see Bell p. 86, n. 31) lend motion and a sense of expectation to the scene. Even in earlier art the Greeks liked comings and goings, as one senses in scenes such as Hephaistos' return to Olympus.

The Priam Painter's artistry is not unique in portraying the momentary. Exekias had often chosen to represent that instant of greatest physical or psychological concentration in preparation for (or as the result of) some deed. One of Exekias' own designs of Athena in her chariot accompanied by Herakles seems particularly charged with a sense of futurity and excitement which previous renditions of the scene seem to lack and later ones may very well imitate. This vase, a calyx-krater, a new shape likely invented by Exekias himself and perhaps the first example of it, may have been on public display, judging from its findspot.[9] This scene of Herakles' apotheosis, designed when Exekias himself was an old man, may have contributed more to the persistence of the theme in later black-figure than we now imagine, other factors mentioned further in this article notwithstanding.

Allowing for some variety in presentation, this scene of apotheosis by chariot occurs on more than 170 vases of the period and of these nearly all are painted in black-figure. The Priam Painter chooses this scene at least nine times, of the more than fifty vases at present attributed to him. In Attic vase-painting this departure scene, the preparation for the journey, appears roughly six times more often than the pendant scene of Herakles' actual arrival on the mount, before Zeus and the assembled gods. This statistic is not easy to explain because the latter episode would seem to be of greater mythological consequence. A hydria by the Priam Painter in the British Museum, London B 345 (*ABV* 332, no. 20; *Paralipomena* 146, no. 20), actually shows Herakles in such company of gods and goddesses (figs. 7.4a, 7.4b).

Commonly in the late sixth century and likewise with the Priam Painter other notable personages are seen to ride in chariots: Dionysos, Poseidon, Hermes, Artemis, Apollo, Leto, Amphiaraos, unidentifiable knights, heroes, married couples, and many others. That the Greeks and other contemporary peoples bred horses, prized them highly as symbols of wealth, and were fond of representing them needs no lengthy defense here. The popularity of Herakles' apotheosis by chariot may be explained in some part then by a widespread love of horses and chariots for aristocratic customers and artist alike. Scenes of departure by chariot seem to have been something of an artistic and iconographic *topos* in later black-figure, Herakles' apotheosis by chariot a variant.

The Priam Painter appears to have been more familiar with these noble steeds than most of his contemporary painters.[10] On his name-piece in Madrid (fig. 7.5), for example, letters spill from the mouth of the further pole horse, κίονις

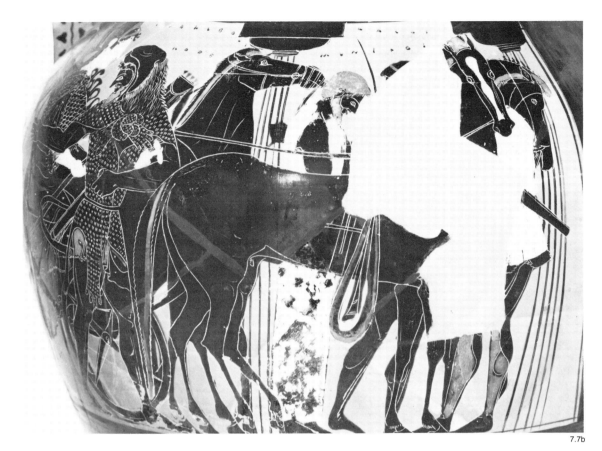

7.7b

7.7a

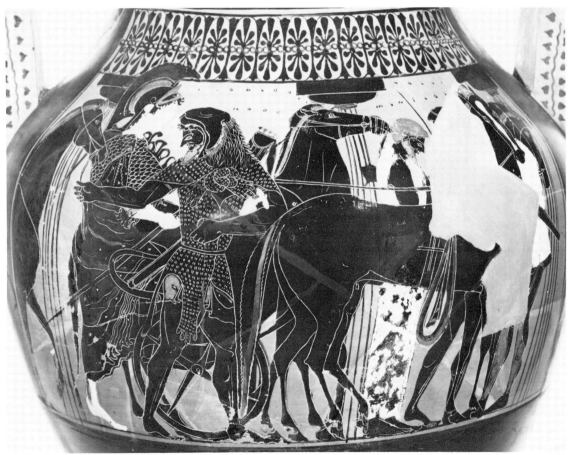

7.7a. Oxford 212. The harnessing of Athena's chariot. Photo: Ashmolean Museum.

7.7b. Oxford 212. Detail. Photo: Ashmolean Museum.

7.7c. Oxford 212. Detail. Herakles harnessing Athena's chariot. Photo: Ashmolean Museum.

7.7c

The Priam Painter 103

Because of its surfeit of detail in presentation, the architectural setting for the Oxford harnessing scene is advanced as corroborating evidence for the political metaphor. Diminishing the efficacy of this observation, the settings of several of our painter's vases seem as rich as Oxford's, or even more so, and the painter liked to include architectural elements even in scenes where such are not required. For instance, the grotto on the reverse of the recently discovered Marescotti amphora[17] (figs. 7.19a–c, p. 112) is certainly extravagant, as are the ornate fountain houses both on hydria London B 329 (fig. 7.8)[18] and hydria London B 332 (figs. 7.9a, 7.9b).[19] The setting is also impressive on hydria Munich 1702 A, which shows women in an orchard picking fruit (fig. 7.10).[20] Herakles' adventure in the garden of the Hesperides—if indeed we can speculate—is presented by the Priam Painter with the help of architectural setting (fig. 7.11).[21] One of the painter's renditions of Herakles' killing of the giant, Alkyoneus, uses architecture, unnecessarily and uniquely so for this episode in Attic vase-painting (fig. 7.12).[22] In various ways the last two paintings, like the scene of the dragging of Hektor's body on London 99.7–21.3 (fig. 7.6), show the Priam Painter's association with the Leagros Group, but this is another discussion.[23]

The most convincing evidence on the Oxford amphora for political innuendo is the inscription Ηερακλέους κόρε (figs. 7.7b, 7.7c) painted near the heads of Athena and the hero. "Hera-

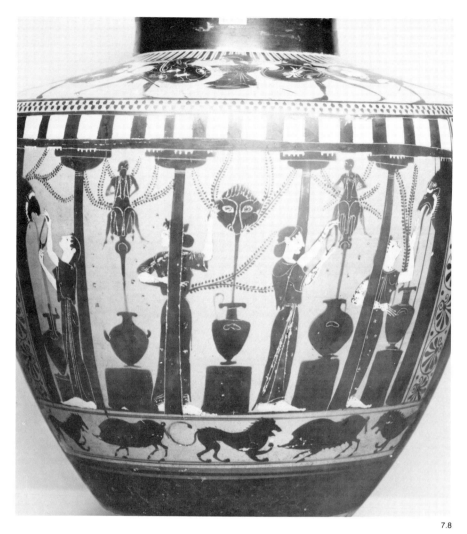

7.8

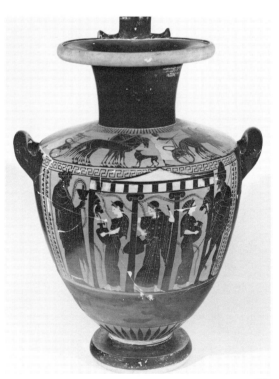

7.9a

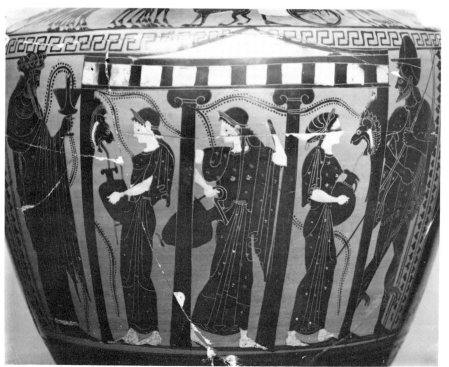

7.9b

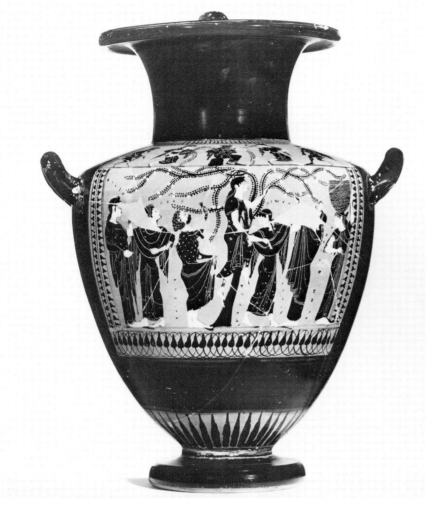

7.10

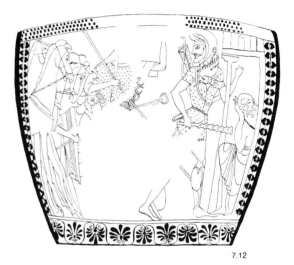

7.12

7.8. London B 329. Women
fetching water. Photo: Courtesy
of the Trustees of the British
Museum.

7.9a. London B 332. Women
fetching water; Dionysos and
Hermes. Photo: Courtesy of the
Trustees of the British Museum.

7.9b. London B 332. Panel
detail. Women at fountain, with
Dionysos and Hermes. Photo:
Courtesy the Trustees of the
British Museum.

7.10. Munich 1702 A. Women in
an orchard. Photo: Antiken-
sammlungen, Munich.

7.11. Boulogne 406. Herakles
and a serpent. Photo: Laborato-
ries Photographiques Devos.

7.12. Reconstruction Civitavec-
chia-Munich fragments. Hera-
kles and Alkyoneus.

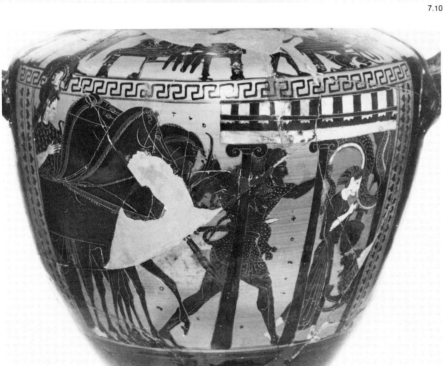

7.11

kles' girl, Herakles' daughter or maid," as it translates, appears to be unusually flippant, or so it has seemed to some,[24] but no more so than the equation of Phye with Athena, recalling that sacrilegious masquerade. J. Boardman inventively has proposed the famed Phye, who was allegedly married to Hipparchos, the tyrant's son, for the subject of "Herakles-Peisistratos' daughter" or "daughter-in-law." But the Priam Painter employs epithets often: "olde soft gums," and, for describing charioteers on two of his vases, "olde dusty one" or "he who makes the horses dusty by hard driving."[25] On a hydria in Paris, Louvre F 286 (fig. 7.13) beneath Triton's caudal parts, which are rendered with a certain animal charm, is the inscription: σικολις which perhaps should read σκολιός; this translates: tangled, twisted, or curving, a good qualifier describing the beast above. "Handmaiden of Herakles" might only have referred to the assistance which the goddess Athena lavished on her hero. *Kore* is a respectable word, applied to young girls often but frequently enough to older women. Virginity seems to be the keynote throughout, and so the goddess is labeled on another of the Priam Painter's vases.[26]

Proposed political allusions for other of his vases provide us the occasion to view more of our man's vase-paintings. On that pretty hydria in Paris, Louvre F 286 (fig. 7.13), and on an amphora type A in Dijon (side A, 1246) the Priam Painter chooses the battle between Herakles and Triton, which may have recalled, according to some, "the amphibious operation against Megara, safeguarding Salamis for Athens, in which Peisistratos first won public acclaim in 566 B.C."[27] However, in Euripides' list (HF 359–429), the battle with the sea monster is counted as one of Herakles' original Labors. This alone could explain the popularity in Archaic art of this story and others such as the fight against Kyknos, also listed as one of his original tasks; Euripides' list may indeed have originated with Archaic sources.

Like the Oxford amphora, another vase near the Lysippides Painter, Louvre F 295, shows Herakles' apotheosis by chariot with Iolaos, the hero's nephew and sometime companion. Herakles carries his own club and Iolaos, curiously, has one too. This duplication has led to the interpretation of the scene in light of Herodotos' remark that Peisistratos, when seizing power for the first time, tricked the Athenians into giving him a bodyguard of club-bearers.[28] Again the impression cast by the historian is one of deceit and trickery, poor substance vis-à-vis political sym-

bolism, on the part of a supposed partisan artist. As his surviving vases show, the Priam Painter sometimes favored stock, rather common scenes: departures by chariot and women at the fountain in particular. To avoid monotony in his designs (and his own boredom) the painter customarily added and subtracted details from whatever type, so that no two examples of the same theme are exactly alike. It seems reasonable to assume that this toying with detail is the cause for the extra club depicted on the Paris hydria.

A sculptural comparison for certain chariot scenes as the last has been forced by a relief on a statue base found in the Themistoklean wall in Athens.[29] A dignified, bearded warrior mounts a chariot, which C. Seltman saw to be driven by none other than Athena, the pair accompanied by soldiers on foot. As Seltman has interpreted, this could be Phye as Athena, driving Peisistratos into Athens, to seize power in accordance with Herodotos' narrative. The statue base he has dated to the time of Hippias. Very generously, by letter, B. S. Ridgway informs me that "the charioteer in this relief is male, not the goddess, Athena, that the function of the base is funerary, that there is some suggestion that the group of tombs from which the bases were taken belonged to the Alkmeonidai, opponents of the Peisistratidai, and that the relief is dated not earlier than 510 B.C., when Peisistratid propaganda would have been on the wane."

The incidences of Herakles' apotheosis by chariot, for which we have findspots, are revealing: twenty-eight or more from Vulci, at least thirteen from other Etruscan and Italic sites, only six or so from Greece. The Etruscans had special affinity for chariot scenes. This is certainly not to imply that the scene of Herakles' apotheosis by chariot was designed specifically for the export market. But the funerary, heroic associations of the chariot, traditional in Greece at least since the games for Patroklos, were also important to the Etruscans. Given the Etruscan preoccupation with the afterlife, Herakles' apotheosis would merely have been appropriate to the tomb. In fact, full-size chariots have actually been found in Etruscan tombs, in the Regolini-Galassi Tomb, and in a tomb at Monteleone. The latter chariot displays figurative scenes in repoussé on the front and both sides: warrior receiving armor (front), warriors dueling (right), and a warrior in a chariot drawn by winged horses (left) (fig. 7.14).[30] These winged horses surely were meant to suggest apotheosis. Herakles himself, as mentioned, is known to have

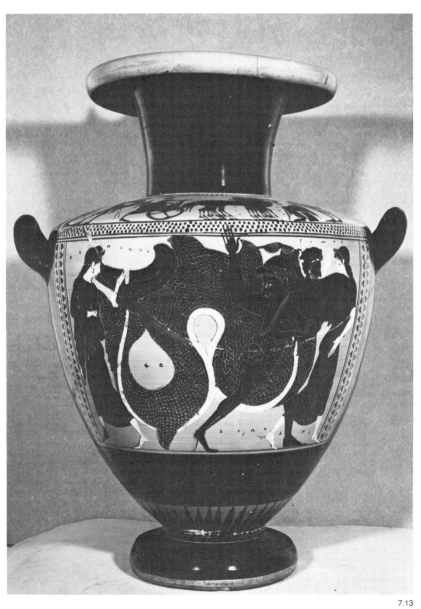

7.13

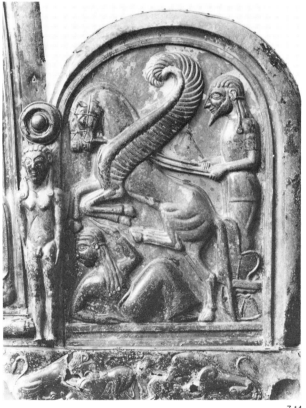

7.14

7.13. Louvre F 286. Herakles and Triton. Photo: Chuzeville, Courtesy Musée du Louvre.

7.14. Left wing of bronze chariot from Monteleone. Photo: Courtesy the Metropolitan Museum of Art (Rogers Fund 1903).

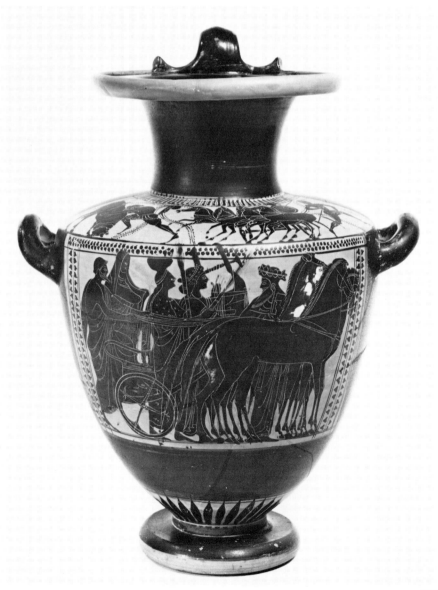

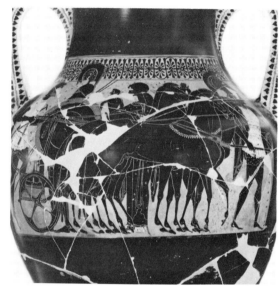

7.16a

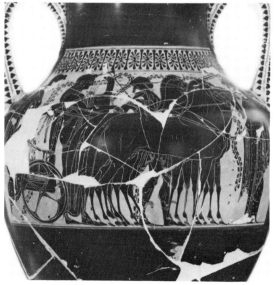

7.15

7.16b

ridden in a winged chariot, on the cup by Lydos in Taranto.[31] On the end panel of the famous Etruscan Peperino sarcophagus from Vulci, now in Boston, husband and wife, deceased, travel to their afterdays in a biga[32] and, similarly, on the long side of another well-known Etruscan sarcophagus in Copenhagen, a man in a chariot, recently deceased, drives to meet his loved ones who are also in chariots, and now are accompanied by the death guardian, signifying life hereafter.[33] A married couple mounting a chariot in the company of gods, for example, on vases by the Priam Painter, one in Naples (112847; *ABV* 333, no. 29), and on another formerly in the Spencer-Churchill Collection, now Oxford 1965.108: *Paralipomena* 146, no. 25 (fig. 7.15), seems to depict a wedding (Peleus and Thetis); curiously, since we are prone not to credit the sixth-century Greek male with uxoriousness. This is a quite different matter with the Etruscans, as myriad depictions of man and wife on cinerary urns and sarcophagi seem to illustrate. Attic vase scenes depicting man and wife were also popular with the export trade as the archaeological record suggests. The Monteleone chariot dates ca. 530–520 B.C. and is therefore contemporary with the burgeoning interest in the scenes of Herakles' apotheosis by chariot in Attic black-figure.

Herakles was beloved and worshiped among the Etruscans early in the seventh century; furthermore, the hero's name seems to come into the Etruscan language with the earliest Greek influence. As in Greece, his image itself was ever an analogy for human perseverance. Herakles stands as everyman and, in the aspirations of the religiously susceptible, the hero, much like the deceased Etruscan, was carried off to a different state of living, as demonstrated in his apotheosis by chariot. In the same fashion Iphigeneia may be shown being rescued from the sacrificial table by Artemis and Apollo, if one follows a recent interpretation of the Etruscan Campana plaques from Cerveteri,[34] also ca. 530–520 B.C. Vase scenes treating Amphiaraos have recurring popularity with Corinthian and Athenian potteries, and seemingly with the Etruscans.[35] This hero is commonly shown in a chariot and, like Herakles, he too has an uncommon passing, having been swallowed up in a cleft in the earth made by Zeus' thunderbolt. Among his early vases the Priam Painter shows Amphiaraos mounting a chariot on an amphora type A found in Etruscan Chiusi, Chiusi 1794 (figs. 7.16a, 7.16b).[36]

D. H. Lawrence, in his *Etruscan Places*, speaks to the significance of the journey, and to scenes of chariots, while recording his initial reaction to the antiquities from Volterra. "Fascinating are the scenes of departure, journeyings in covered wagons drawn by two or more horses, accompanied by driver on foot and friend on horseback, and dogs, and met by other horsemen coming down the road. Under the arched tarpaulin tilt of the wagon reclined a man, or a woman, or a whole family: and all moves forward along the highway with wonderful slow surge. And the wagon, as far as I saw, is always drawn by horses, not by oxen. . . . This is surely the journey of the soul."[37] As O. Brendel eloquently has taught, the Etruscans were a nonliterary society eager to adopt and purchase certain Greek images, while projecting these on Etruscan custom and practice.[38] Undeniably, a very high percentage of late black-figure vases was found at Etruscan Vulci, perhaps because at Vulci, wall-painting, large-scale free painting, at least as the archaeological record now suggests, was scarce. Greek vases, large and with impressive, expansive scenes, may have satisfied some of the need for funerary iconography, which local painters did not regularly supply or did not have to.

Toward political symbolism, it has been argued that the many scenes of fountain houses, which appear on hydriai in the last decades of the sixth century, could have evoked Peisistratean sentiment.[39] Fountain scenes were another specialty of the Priam Painter. The Peisistratids were known to have improved the water supply in the city with newly built and refurbished fountain houses. Munificence on the people's behalf would have been ready means of winning popular support. On the other hand or, at least, in addition, E. Simon now has suggested that fountain scenes on hydriai may have referred to the celebration of the *Hydrophoria,* on the last day of the festivals of the *Anthesteria,* which were held in Attica for Dionysos, at the beginning of spring, when the new wine from the previous fall vintage was sampled.[40] And at this festival of wine the dead were given drink too; "according to our sources in the public rite of the *Hydrophoria* water was carried for the dead." Simon here rightly points to E. Diehl's interpretation of various procession scenes of women carrying water vessels.[41] The dead propitiated in the *Hydrophoria* were those supposedly taken by Deukalion's Flood. We know that Hermes had a significant role during the enactments of the *Anthesteria,* as *Chthonios* or *Psychopompos.* Hermes was worshiped with cereals and grain cakes and his success at the duties of "trans-

7.15. Oxford 1965.108. Man and woman (Peleus and Thetis?) in chariot in the company of deities. Photo: Ashmolean Museum.

7.16a. Chiusi 1794. side A, Departure of Amphiaraos. Photo: Courtesy Soprintendenza alle Antichità d'Etruria-Firenze.

7.16b. Chiusi 1794. Side B, Artemis mounting chariot. Photo: Courtesy Soprintendenza alle Antichità d'Etruria-Firenze.

porter of souls" complies with the last formal words spoken at the *Anthesteria*: "off with you, ghosts, the *Anthesteria* are finished." The water for the "souls" may have been drawn from the "nine-spouted" fountain erected by the tyrant or by his sons in the southeast corner of the Agora. This was the most famous fountain house in the city and one whose waters, some ancient sources imply, were used for sacred purposes. With regard to Simon's association of fountain scenes with the *Hydrophoria*, a hydria by the Priam Painter in the British Museum, London B 332 (figs. 7.9a, 7.9b) may help to substantiate her argument, in illustration of local practices, at least for some versions of these scenes.[42] In the main panel, three lovely women—and the Priam Painter treats women graciously—fill water jugs in a fountain building which has ornate fixtures

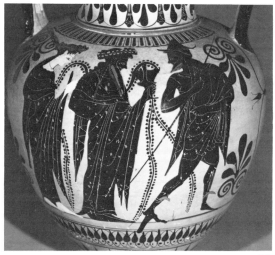

7.17

and revetment. Towering above the architecture on the left stands Dionysos and, to the right, Hermes, the latter in his expected attitude of guide. Their large size is in keeping with the ancient convention of differentiating, by scale, gods from mortals. Men and women make a fountain house special by draping it with wreaths, alas again in the company of Hermes and Dionysos, on the shoulder of a black-figure neck-amphora by a member of the Leagros Group (*ABV* 365, no. 71).

On the second night of the celebrations for the wine god, Dionysos supposedly married the wife of the *archon basileus,* the *basilinna* or queen, and ancient sources tell us that the sacred wedding, an important ceremony in these Dionysiac vegetation rites, took place in the *Boukoleon,* near the *Agora* (Arist. *Ath. Pol.* 3.5). On a neck-amphora by the Priam Painter in the British Museum, London B 259 (fig. 7.17), a tall Hermes

leads Dionysos and a woman, both wreathed, in what may be an enactment of this wedding, a ritual which guaranteed fertility for the season ahead.[43] The festivities during the *Anthesteria* were a time of renewal in the city. In the potter's quarter, too, this marked the beginning of a new year of production, emerging from a short but wet winter, in what must have been a somewhat seasonal corporate industry.

Fountain scenes seem basic to hydriai, since these vessels were meant to contain water; scenes dealing with water, such as Herakles battling the sea monster, were thus especially appropriate to the vase shape. The vase-painter was anxious to represent new fountains in town and the very beautiful women who gathered around them. As was the case with the artist's dependence on chariot pictures, fountain scenes too, in their essentials, offered reliable, flexible compositional devices for artists less ready, in the face of production, to tackle more penetrating narrative. The great variety in the presentation, of what statistically was a common vase scene at the time, was doubtless a credit to the artist's power of observation, time and again, of the social interactions at the city wells. On the Lerici amphora (figs. 7.18a–7.19c) the Priam Painter seems to have been particularly observant to a degree most uncommon in Archaic art.[44]

This amphora (type B) by the Priam Painter, found at Monte Abetone (Cerveteri) merits separate attention because of its beauty and Ionian sophistication. On side A Dionysos sits beneath a canopy of feathery grapevines, which are laden with fruit. This is the vintage. Seven dwarfed Satyrs collect grapes, having already filled to the brim three large, rather vaselike baskets (figs. 7.18a, 7.18b, 7.18c). Young people had a part in the *Oschophoria,* Dionysos' October celebration of wine making, and these pictures, perhaps in parody, may pertain.[45] The Priam Painter's scene has only one parallel, so far as I know, on side B of an amphora (type A) in the Museum of Fine Arts, Boston 63.952, which is earlier, and close to the hand of Exekias (*Paralipomena* 62, middle). In discussing the latter, H. Hoffmann has seen in the picture a hybrid of two conventional scenes in black-figure: Dionysos seated, and Satyrs vintaging.[46] The reverse of the Lerici-Marescotti amphora has young girls, perhaps Nymphs, swimming—a very rare and exceptional subject indeed (figs. 7.19a, 7.19b, 7.19c). Again only one close comparison from contemporary vase-painting comes to mind, the scene of Amazons swimming in the open sea as drawn by the Andokides Painter on the reverse of his

7.17. London B 259. Dionysos and woman (Ariadne?) with Hermes. Photo: Courtesy of the Trustees of the British Museum.

7.18a. Lerici-Marescotti amphora. Side A, Dionysos and Satyrs vintaging. Photo: Courtesy DAI, Rome.

7.18b. Lerici-Marescotti amphora. Detail, left side of panel.

7.18c. Lerici-Marescotti amphora. Detail, right side of panel.

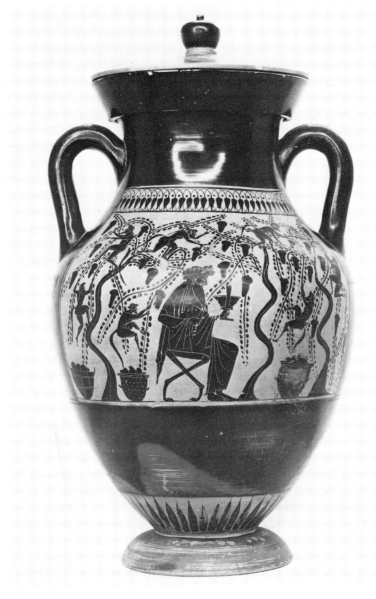

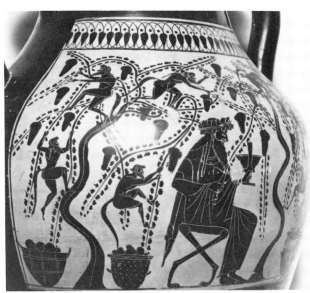

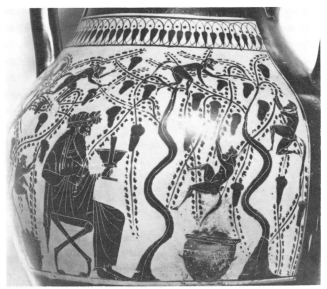

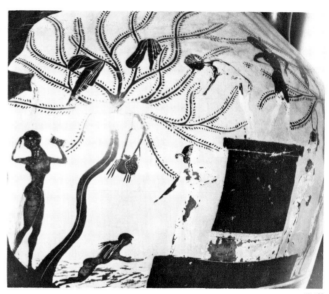

7.19b

7.19a

7.19c

amphora in Paris, Louvre F 203, which is late in the artist's "early" period.[47] Psiax, an artistic companion of the Priam Painter, has ties with the Andokides Painter at this time, in style and subject, notably with regard to certain genrelike scenes of musical performance, as mentioned recently by J. R. Mertens.[48] During his "transitional" period the Andokides Painter treats Exekian themes, perhaps influenced by the Lysippides Painter. It is from this context that the Lerici-Marescotti amphora rises, though later. Likewise, two of the earliest depictions of the story of Aineias carrying his father Anchises are painted by Exekias and by the Priam Painter (figs. 7.1a, 7.1b) and share some essentials of presentation.[49]

The young girls on the Lerici amphora, all shapely, bathe in a cool remote grotto. They are seven in number and in their relaxation can be contrasted with the seven laboring Satyrs on the obverse of the vase. As the playful grace of the Priam Painter's scene conveys, the Greeks must have loved swimming, but we have startlingly few references in art and literature for this delight. The Priam Painter's vignette seems doubly important. It is rendered in an extraordinarily painterly style. Unless my esteem for the painter deceives me, the girl swimming, insofar as she is farther from the viewer, has been depicted smaller in scale from her near companion on shore. The treatment of the water too lends a sense of distance, extending the viewer beyond the diving platform. The sides of the picture panel are contoured to suggest the rocky setting and help establish the reality of the space which unfolds. In this the Priam Painter may have been influenced by mural painting, but there is an interest in spatial development and landscape elements with some of his contemporaries, though to a much less sophisticated degree. Members of the Leagros Group, for example, created a window effect in their vase-paintings by truncating parts of the design using the sides of the picture panel. The viewer is thus made to look on to a scene progressing in the distance. The Theseus Painter and others also combine genre and landscape. At times our painter may appear conventional, with series of horse and chariot scenes and those of fountain houses; nonetheless, he can readily be ingeniously spontaneous and creative, in this the eleventh hour of black-figure.

Perhaps in an effort to duplicate free painting, or, in any event, to equal those golden washes and occasional textured effects of the red-figure technique, the Priam Painter has brushed white

slip loosely to the breeze-blown water—for the glistening. Two small-leafed trees bracket the scene, laden, in this instance, with the ladies' accessories and clothing. Surely the Priam Painter's fine design tends to make us forget the limitations of the vase shape as a pictorial field.

The Priam Painter's masterpiece should briefly be discussed against two other paintings, mural, not vase scenes: the slightly later ceiling panel from the Tomb of the Diver at Paestum and the contemporary Etruscan wall-paintings from the Tomb of Hunting and Fishing at Tarquinia. The former has sometimes been tortuously interpreted.[50] With some justification the discoverer of the Diver Tomb believes in the funerary aspects of the genrelike scene.[51] Symbolically the figure diving has been taken as the Pythagorean image of the passage of the soul through the purification of water. The side panels in the Tomb of the Diver are of symposium, with emphasis on music making, furthering, according to some, Pythagorean reference. In fact, a lyre was found as an offering in the tomb. Banquet and sport, along with music making and dance, are assembled in the Tomb of Hunting and Fishing at Tarquinia. Here a family convivially partakes of a meal, a hunting party troops through a forest, little boys fish in a boat with simple hook and line, a fellow shoots at birds with a slingshot, and a youngster dives off an Aegean-styled rock into the Tyrrhenian Sea. Is this diver, like the one at Paestum, that Pythagorean soul, in ritual passage? We seem to have depicted, nevertheless, everyday pleasures, images of life, which, as in Egyptian painting, would necessarily guarantee these enjoyments in the afterlife. Perhaps it is for this reason that genre pictures were more popular with the Etruscans and seemingly much earlier than with the Greeks.[52]

The practice of burying vases with the dead, most popular with the Etruscans but by no means exclusive to them, at least as it concerned late black-figure vase-painting, must certainly have been an *essential* economic factor in the Athenian ceramic industry. Because of this funerary practice many vases were not recycled, reused, after they were made and bought. This created a strong and constant demand for the production of more vases at Athens. This is not to say that appealing to the Etruscan market was the primary thrust of Late Archaic vase iconography. But there is sufficient evidence to show that certain scenes like Herakles' apotheosis by chariot were nonetheless quite appropriate for an Etruscan tomb and were quite regularly found

7.19a. Lerici-Marescotti amphora. Side B, girls bathing.

7.19b. Lerici-Marescotti amphora. Detail, left side of panel.

7.19c. Lerici-Marescotti amphora. Detail, right side of panel.

there. At Athens and elsewhere with the Greeks such scenes may have had different signification. At home, equestrian scenes and those of other kinds of sport seem to have fallen from favor in Attica not only because they had grown artistically threadbare but because the general tenor of affection for the leisured class which such scenes served and promoted was very rapidly changing.[53] This seems to have happened without regard to a particular noble family. Likewise, those rather horrifying scenes of Achilles dragging Hektor's dead body, which appear in late black-figure, fall from the vase-painter's repertoire with the creative force of that technique. Could this also have been because of growing humanitarian awareness, toward 500 B.C., of the horror of oppression and of tyrannical brutality?[54] One still wonders at what liberty the painter himself was to invent vase pictures. Certainly some painters were original but the workshop owner and the various merchandizers must have known better the changing tastes of whatever market. This is not to say that a painter's powers of observation and ability to expand and rework formulae were inhibited in this circumstance, but perhaps a decorator's ability to express political sympathy would have been. As Frel nicely demonstrates (see p. 147 and p. 158, n. 10), Euphronios and his fellows could quip and exchange innuendo on vases. And elsewhere political symbolism may not have been impossible, but for the Priam Painter it seems not to have been a preoccupation. Iconographical studies must take into consideration the totality of an artist's style before assigning meaning to individual elements.

NOTES

This paper has been improved by kind suggestions from and discussions with K. Sacks, G. F. Pinney, B. Cohen, R. Guy, N. G. L. Hammond, and B. H. Fowler; my colleagues in the Department of Art History, G. Geiger and N. Menocal, helped obtain photographs. I thank them all warmly.

1 M. Moore, *Horses on Black-Figured Greek Vases of the Archaic Period: circa 620–480 B.C.* (Ph.D. diss., New York Univ. 1971) 110–12, her nos. A 755 *bis*, A 755 *ter*, A 755 *quarter*, A 770, A 771 (the initial three by Bothmer, the last two by Moore). Additionally for the hand: *JHS* 51 (1931) 301; *JHS* 72 (1952) 157; *CVA Oxford* 100; *ABV* 330–34 and 334–35; *Paralipomena* 146–48, where the A. D. Painter was merged with the Priam Painter; J. Boardman, *Athenian Black Figure Vases* (London 1974) 112–13 and 222–25; also Moon, *infra* n. 6. A black-figure hydria can be given to the Priam Painter (Los Angeles, Basel, New York market: see R. J. Myers Auction 8, 10 October 1974, lot 102). The hydria shows in the main panel Hermes mounting a chariot, in the company of Dionysos and two females, and, on the shoulder, shows Herakles

battling the Nemean Lion with Athena, Hermes, and two youths present. There is a predella of boars and lions (figs. 7.20a–7.20c). R. Guy has attributed to the painter an amphora type B, which is now in an American private collection. It belongs to the Priam Painter's "early" period. Side A depicts a harnessing scene which is similar in composition to the main scene on the Madrid hydria (10920; fig. 7.5). Side B has Herakles battling the Nemean Lion (crouching pose), with Iolaos, Athena, and Hermes. This amphora is further discussed on my pp. 101–2 and also nn. 10 and 11.

2 Among them: B. Andreae, "Herakles und Alkyoneus," *JdI* 77 (1962) 174–76; K. Schauenburg, "Ilioupersis auf einer Hydria des Priamosmalers," *RömMitt* 71 (1964) 60–70; K. P. Stähler, *Grab and Psyche des Patroklos* (Münster 1967) 52–54; J. Boardman, "Herakles, Peisistratos and Sons," *RA* (1972) 57–72.

3 Boardman, "Sons" 64–70.

4 K. Schauenburg, "Äneas und Rom," *Gymnasium* 67 (1960) 176–91; G. K. Galinski, *Aeneas, Sicily and*

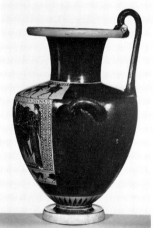

7.20a

7.20b

7.20a. Whereabouts unknown. Hermes mounting chariot. Courtesy H. Cahn. Photo: D. Widmer.

7.20b. Detail of figure 7.20a. Shoulder scene. Herakles and the Nemean Lion. Courtesy H. Cahn. Photo: D. Widmer.

7.20c. Detail of figure 7.20a. Profile view. Courtesy H. Cahn. Photo: D. Widmer.

7.20c

Rome (Princeton 1969) 122ff. R. Carpenter, *Folk Tale, Fiction and Saga in the Homeric Epic* (Berkeley 1962) 63–65.

5 One agrees with the positioning of the Priam Painter on M. Moore's time line: *Horses* illus. 1. To my knowledge only one of the painter's vases has a published archaeological context. The Lerici-Marescotti amphora Type B (infra n. 17) was excavated: M. Moretti, "Tomba Martini Marescotti," *Quaderni di Villa Giulia* 1 (Milan 1966), and L. Vanoni, "La Tomba Martini Marescotti," *Prospegioni Archeologiche* (1966) 18. The excavation was conducted by the Geophysical Research Excavation of Monte Abetone (Cerveteri); the Marescotti tomb is no. 610, and the excavators believed that the tomb was pillaged in the nineteenth century. Because of an unusual archaeological circumstance, many vases were missed or considered expendable by the robbers. Fragments of vases and some whole pieces were embedded in cement-hard mud. Near the door of the main room of the tomb was found a kylix by Oltos (*Paralipomena* 327, no. 66 *bis*) and aside of it this amphora type B by the Priam Painter (*Paralipomena* 146, no. 8 *ter*). Other vases found with these have been attributed to the Dot Ivy Group, the Michigan Painter, the Group of Faina 75, the Light-Make Group, and the Class of Athens 581.

6 Elvehjem Museum of Art, Madison 68.14.1, gift of Mr. and Mrs. Arthur J. Frank, described, with brief discussion and bibliography: W. G. Moon, *Greek Vase-Painting in Midwestern Collections*, eds. W. G. Moon and L. Berge (The Art Institute of Chicago 1979) 116–17, no. 66. The Elvehjem hydria is also Moore, *Horses* A 768 and *Paralipomena* 146, no. 26 *bis*. The Elvehjem hydria has the same schemes of subsidiary decoration as Astarita 733: *Paralipomena* 147, no. 30; Boulogne 406: *ABV* 332, no. 21; and London B 332: *ABV* 333, no. 27 and *Paralipomena* 146, no. 27. The Elvehjem hydria has been attributed to the Potter of the Heavy Hydriai as have Boulogne 406 and London B 332, among others, see H. Bloesch, "Stout and Slender in the Late Archaic Period," *JHS* 71 (1951) 29–39.

7 G. M. A. Richter, "A Greek Silver Phiale in the Metropolitan Museum," *AJA* 45 (1941) 370, "where the occasional presence of a funeral pyre beneath the chariot definitely points to Herakles' apotheosis, etc." T. B. L. Webster, *Potter and Painter in Classical Athens* (London 1972) 261–63. P. Mingazzini, "Le rappresentazione vascolari del mito dell' apoteosi di Herakles," *MemLinc* ser. 6, no. 1 (1925) 417–90.

8 Herakles is routinely drawn in fine style by the Priam Painter. On his image in general and physicality: Pind. *Isthm.* IV.90; H. Payne, "A Bronze Herakles in the Benaki Museum at Athens," *JHS* 54 (1934) 163; E. Gardiner, *Athletics of the Ancient World* (Cambridge, Mass. 1939) 55; V. Lenzen, "The Figure of Dionysos on the Siphnian Frieze," *University of California Publications in Classical Antiquity* (1946) 10–14, and apud Lenzen, M. H. Sheldon *et al.*, *Varieties of Human Physique* (Berkeley 1940) 270.

9 *ABV* 145, no. 19, with earlier bibliography; Boardman, *ABFV* 56–58, fig. 103. J. D. Beazley, *Development* 70–71, says of this vase, "This is the earliest and an exceptionally solid and massive example of what soon became one of the leading shapes in Attic vase-painting. . . . It is possible that Exekias invented the shape. . . . On the front, a chariot scene. The occupants of the car are missing, but the end of Herakles' name is preserved, and the spear of Athena; it

is her chariot, in which she is conducting the hero to Olympos." O. Broneer, "A Calyx-krater by Exekias," *Hesperia* 6 (1937) 469–86; see also infra n. 46. M. Moore, *Horses* A 387.

10 The painter's enthusiasm for the beast in the recording of details of anatomy, tracing, and harnessing tells us much of actual practice and, in the manner and kinds of detail presented, exposes testimony of the painter's workshop affiliations: e.g., the manner in which the cheek strap divides the mane at the poll is a rare detail apparently found only with Psiax, the Priam Painter, and the Rycroft Painter, the latter two perhaps pupils of the former (Moore *Horses* 279). The three painters are again related in the way of incising the mane, *Horses* 274; in the mode of depicting ribs, *Horses* 313; their horses' unusual knees, *Horses* 350. The study of some such details also shows comparison with members of the Leagros Group: *Horses* 351, 358, 360, and elsewhere. Aspects of the stylistic and iconographic relationship between the Priam Painter and the Rycroft Painter have recently been discussed: J. Mertens, "A Black-Figure Hydria of Red-Figure Date," *Indiana University Art Museum Bulletin* (1979) 6–12. The newly attributed amphora type B, which surely falls early in the Priam Painter's·career and which at present is in an American private collection (herein mentioned pp. 101–2 and nn. 7 and 11) provides another iconographic link between these two painters. The reverse scene of Herakles battling with the Nemean lion, the pair in the crouching position, is the rare example by the Priam Painter of this design in large format which his companion, the Rycroft Painter, seems to have used at least twice on amphorae type B: on Orvieto, Faina 74: *ABV* 336, no. 9, and on the unattributed Berlin 3214, which in fact may be by the latter's hand. It should be noted that Mertens mentions, "Hydria" 11, and illustrates, as fig. 10, the Priam Painter's hydria in Paris, Louvre F 286, which shows Herakles' battle with Triton. She also refers to the Priam Painter's name-piece, the hydria Madrid 10920, in n. 61, particularly with reference to its reserved horizontal handles. The last two hydriai are my figs. 7.13 and 7.5 respectively. R. Guy has brought to my attention three vases which he attributes to the Rycroft Painter. The first is a hydria on the London market, which in the main panel has Apollo and Herakles struggling over the tripod and has chariots and hoplites on the shoulder of the vase. Like the Priam Painter's Madrid hydria and the Rycroft Painter's new hydria in Bloomington, it too has reserved horizontal handles (see Mertens, "Hydria" 11–12 for the possible implications of handles of this type) and a reserved lip. The second vase is an amphora type B, with Dionysos and Maenads on side A and a chariot scene on side B (Sotheby's Antiquities Auction "Thessaly" 13 May 1980, p. 41, item no. 220); the third is a neck-amphora: *Collection of Roger Peyrefitte*, Paris, Auction 26 May 1977, lot 37. Close too is an oinochoe shape 1 in the Friburg market: Galerie Günter Puhze *Kunst der Antike* Katalog 1981, no. 147, wedded pair in chariot.

11 On the basket muzzle: Xen. *on Equitation* V.3; J. K. Anderson, *Ancient Greek Horsemanship* (Berkeley and Los Angeles 1961) 43, 46, 56, and 93; also Moore, *Horses* 401, for rectangular bit-burr.

12 Among such studies: J. Boardman, "Herakles, Delphi and Kleisthenes of Sikyon," *RA* (1978) 227–34, with other bibliography. Boardman, "Sons" 57–72; J. Boardman, "Exekias," *AJA* 82 (1978) 18, whence

"Herakles, as Athena's protégé, has a clear political role in Athens under Peisistratos," also his p. 24 for Exekias' alleged, opposing political views; J. Boardman, "Herakles, Peisistratos and Eleusis," *JHS* 95 (1975) 1–12; L. V. Watrous, "The Sculptural Program of the Siphnian Treasury at Delphi," *AJA* 86 (1982) 159–72; R. Glynn, "Herakles, Nereus and Triton: A Study of Iconography in Sixth Century Athens," *AJA* 85 (1981) 121–32, particularly her p. 130: "the most recent interpretation investigates the possibility of myth-symbolism, examining changes of iconography against their historical background. It is now accepted that Herakles was the hero of Peisistratean Athens, and that once the tyrant family had been driven out, it was Theseus who became the hero of the democracy." H. A. Shapiro, "Hippokrates, Son of Anaxileos," *Hesperia* 49 (1980) 289–93, esp. p. 292, n. 25 and n. 7. On the other hand, discussing Herakles' popularity in the fifth century and his association with his democrat cousin, Theseus, see S. Woodford, *Exemplum Virtutis: A Study of Hercules in the Second Half of the Fifth Century B.C.* (unpublished diss., Columbia Univ. 1966) and Woodford, "Cults of Hercules in Athens," *Studies Presented to George M. A. Hanfmann* (Mainz 1971) 211–25. Arguing against political symbolism: D. Williams, "Ajax, Odysseus and the Arms of Achilles," *AntK* 23 (1980) 144, n. 55 and M. Moore, "Exekias and Telemonian Ajax," *AJA* 84 (1980) 417–34. Herakles as political symbol is made less tenable when one considers his characterization in Archaic and Classical literature: see G. H. Galinsky, *The Herakles Theme, the Adaptations of the Hero in Literature from Homer to the Twentieth Century* (Oxford 1972) 9–22, particularly 20: "Herakles was almost the ideal embodiment of the Greek settler (West Greek) who destroyed aboriginal monsters and gave peace to the regions which he traversed." Apud Galinsky n. 20 see E. Sjöquist, "Herakles in Sicily," *OpusRom* 4 (1962) 117–23.

13 M. Tiberios, *Ho Ludos kai to Ergo tou* (Athens 1976) pl. 32; *ABV* 112, no. 65; *Paralipomena* 44, no. 65, where the driver of the chariot is given as Hermes and not Iolaos.

14 *Vasenlisten*³ 159–69.

15 Boardman, "Sons" 64, n. 2 with bibliography; also Moore, *Horses* A 756.

16 *ABV* 332, no. 17; Moore, *Horses* A 760 with additional bibliography; supra n. 11; for harnessing scenes see Moore, *Horses* 410.

17 Supra n. 5; J. Charbonneaux, R. Martin, and F. Villard, *Archaic Greek Art*, trans. J. Emmons, R. Allen (New York 1971) pls. 350, 351; *Paralipomena* 146, no. 8 *ter*; R. Ross Holloway, "High Flying at Paestum: A Reply," *AJA* 81 (1977) 554–55, fig. 1; L. G. Nelson, *The Rendering of Landscape in Greek and South Italian Vase Painting* (unpublished diss., State Univ. of New York at Binghamton 1977) fig. 4. In the latter there is surprisingly little discussion of the Lerici-Marescotti amphora. See also my nn. 20, 50, 51, and pp. 110, 113.

18 *ABV* 334, no. 1, with earlier bibliography; *Paralipomena* 147, no. 1 bottom; originally the name-vase of the A. D. Painter; also Potter of the Heavy Hydriai; see n. 6.

19 *ABV* 333, no. 27; for a fuller discussion of this vase see my p. 113 and n. 42; for secondary decoration, n. 6.

20 *ABV* 334, no. 6; *Paralipomena* 147, no. 6. The baskets here are like those shown in a scene of vintaging in the tondo of a cup (type A), Cab. Méd. 320: *ABV* 389 middle and *Paralipomena* 171 bottom. The scene on this cup somewhat recalls that on side A of the Lerici-Marescotti amphora type B.

21 *ABV* 332, no. 21; *Paralipomena* 146, no. 21; *Vaselisten*³ 71 bottom and 79, no. 14; Boardman, "Sons" 67–68 and his n. 2; for shape and decoration see my n. 6. A most confounding scene: Herakles, sword drawn, grabs and attacks a giant serpent which seems to guard a fountain. At the back of the fountain is a rocky outcropping and before it a woman, seemingly unaware of Herakles, is drawing water. The forepart of a lion, paws raised, projects from the lower right border of the panel and seems menacing. Clearly the lion protome is not a spout. The design of the lion recalls those lions in the predella on the hydria London B 329 (*ABV* 334, no. 1) and, in the same position, on the Myers hydria (fig. 20 a–c). This fountain scene with its large snake may have been intended to refer to Herakles' episode in the Garden of the Hesperides and, if so, it would count as an early depiction of the story. The tree and special fruit, however, are not to be seen. Maidens at the fountain as elements of the story can be substantiated easily enough, e.g., on London E 772: *ARV*² 806, no. 90 which is recently illustrated, S. R. Roberts, *The Attic Pyxis* (Chicago 1978) fig. 103.3. Certain crucial iconographic elements are known to have been omitted on other vases, most likely mistakenly, e.g., Hektor's body is not shown in what seems to be a scene of the dragging of the body around the tomb of Patroklos: *Paralipomena* 164, no. 31 *ter*, hydria by the Leagros Group in Münster.

Elements of the story on the Boulogne vase create a picture of horror: Athena's gesture, the stance of the team, the outstretched paw of the pelt worn by the hero, and the roaring lion at the maiden's feet. If one were to believe in political symbolism, one could turn to the story of Leaina (Paus. 1.21.1). "Among the objects on which Hippias vented his fury was a woman named Leaina [lioness] . . . He tortured Leaina to death, knowing that she was Aristogeiton's mistress and supposing that she was not ignorant of the plot. As recompense, when the tyranny was put down, the Athenians set up a bronze lioness in memory of the woman." One of the very earliest scenes of Herakles in the Garden of the Hesperides, i.e., on a Siana cup by the Heidelberg Painter, has recently been discussed: H. F. Miller, *The Iconography of the Palm in Greek Art: Significance and Symbolism* (unpublished diss., Univ. California, Berkeley 1979) 21–21, no. 75. Curiously, Hekataios the late sixth-century Ionian logographer "refuted the popular tradition of the grisly monster-dog Cerberus and asserted that Cerberus was merely a serpent, albeit a fiercer one than others," Galinsky, *Herakles* 24, n. 1; see Vasenlisten³ 71 bottom. The scene still defies interpretation.

22 *ABV* 332, no. 22; *Paralipomena* 146, no. 22; Andreae, "Herakles und Alkyoneus" 174, no. 7. Herakles is moving toward the porch of a building with Doric columns. Alkyoneus sits, full face, sleeping on the porch. Though my drawing may not well-enough convey it, at first glance the giant seems of human size, but sitting on the floor, he is nearly as tall as Herakles. To my knowledge the addition of the building is the personal variation of the Priam Painter and in this regard unique in the more than thirty examples of the scene now known. The architectural enclosure and the truncated horses recall the Leagros

Group.

There is another rendition of this story by the Priam Painter, newly attributed to the painter by Bothmer: Moore, *Horses* 110, no. A 755 *bis*. This is a fine amphora type A in Paris, Louvre F 208, which Andreae had listed as the earliest instance of the story in vase-painting, p. 168, no. 1. Andreae curiously had attributed this amphora to the Andokides Painter (see my pp. 110, 113, and nn. 2 and 47). Here the Priam Painter depicts the story quite differently and, as is typical of his early work which certainly this is, the painter labels the figures. Alkyoneus rests on a mountain as in Pind. *Isthm.* VI.32. He is deep in sleep, with eyes tightly closed, head down-turned and his arm hanging limp. The scene is inventive and very effective as are many by this painter. This same design is repeated by a member of the Leagros Group: *CVA* Toledo, Ohio I, pl. 27. Again this demonstrates the Priam Painter's association with this workshop, while not formally being one of its members.

23 On the London amphora by the Priam Painter, quite unlike most other examples of the scene, the action moves to the left, has a calm quiet dignity, and includes the messenger goddess, Iris. Of the seventeen examples of the story known so far (*Vasenlisten*³ 345–46) these characteristics appear on two other vases, both associated with the Leagros Shop: on the shoulder of a hydria in Munich (1719: *ABV* 361, no. 13) and on a lekythos from Delos (546: *ABV* 378, no. 257 with other bibliography). Both are illustrated conveniently: Stähler, *Grab und Psyche* 68, nos. 13 and 11. These three vases have strong similarities in composition. On the extreme right is the tomb of Patroklos, on which is a snake whose body is roughly in the shape of an omega, and above the tomb is the *eidolon* of the hero, running left. Achilles stands, facing right, above Hektor's body which is in front of or near the tomb. At Achilles' back is the charioteer and chariot, as I mentioned, oddly moving left. On the Delos and London vases Iris is immediately in front of the chariot car, while on the Munich hydria she is at the head of the team. These three vases seem to illustrate *Iliad* XXIV.12 where Zeus dispatches Iris to Thetis in order that Achilles' mother beseech her son to stop the excessively brutal treatment of Hektor's body. All three vases show the same conflation of the story, having Iris speak directly to Achilles. One is justified in assuming a strong workshop affiliation for these painters and, additionally, a common sketch, or prototype in vase-painting or free painting. Other varieties of the scene, many of which seem derivative of the stock "warrior-leaving-home" motif, are discussed: K. Friis Johansen, *The Iliad in Early Greek Art* (Copenhagen 1967) 151. As on most of his "early" vases the Priam Painter labels his figures. *Konisos* is inscribed near the charioteer and Beazley has taken this to mean "he who makes the horses dusty by hard driving": *JHS* 51 (1931) 301. Nearly the same appears over a charioteer in the shoulder scene on the Paris hydria, Louvre F 286: *ABV* 333, no. 28 and my fig. 7.13.

24 Boardman, "Sons" 64–65 and n. 2.

25 Supra n. 23, end comment.

26 Naples 2514: *ABV* 332, no. 19. The inscription is discussed *CVA* Oxford 100, elaborately.

27 Boardman, "Sons" 59–60. Glynn, "Herakles, Nereus and Triton" 130. The Dijon vase is Moore, *Horses* A 770, p. 112. Louvre F 286 is *ABV* 333, no. 28; *Paralipomena* 146, no. 28; *Vasenlisten*³ 146, no. 9.

28 Boardman, "Sons" 63, fig. 2.

29 C. Seltman, *Athens Its History and Coinage Before the Persian Invasion* (repr. Chicago 1974) 45–47, fig. 33. A. R. Burn, *The Lyric Age of Greece* (Minerva 1967 ed.) 306, n. 9. Boardman, "Sons" 62, n. 1. This is not to suggest that Boardman believes in this: J. Boardman, *Greek Sculpture: The Archaic Period* (Oxford 1978) 164, 169, and fig. 241.

30 O. Brendel, *Etruscan Art* (New York 1978) 148–49, figs. 98 and 99. Note that the figures are reversed in the book: the apotheosis scene is the left side of the chariot car.

31 Supra n. 13.

32 Museum of Fine Arts, Boston A 1281. Peperino sarcophagus from Vulci: illustrated, among other places, E. Richardson, *The Etruscans: Their Art and Civilization* (Chicago 1964) pl. XLIV top, left.

33 Brendel, *Etruscan Art* 383, fig. 295, drawing.

34 Brendel, *Etruscan Art* 175, fig. 114, n. 23. It may be noted that Artemis is identified as the winged figure even though her flesh is not painted white as is Iphigeneia's.

35 Brendel, *Etruscan Art* 452, n. 13.

36 *ABV* 330, no. 1; *Paralipomena* 145, no. 1; Moore, *Horses* A 752. G. Geiger went to great trouble to obtain these photographs for me; many thanks.

37 D. H. Lawrence, *Etruscan Places* (London 1932) 190–91.

38 Brendel, *Etruscan Art* 144.

39 Shapiro, "Hippokrates" 291–92; Boardman, "Sons" 68.

40 E. Simon, *Festivals of Attica* (Madison 1982) 92–101.

41 Ibid. 99, n. 49.

42 Supra n. 19. Boardman, "Sons" 68, n. 2: "Divinity intervenes only on the vase by the Priam Painter where Dionysos and Hermes stand at either side of a fountain house which looks like a simplified version of that on the Boulogne vase (406; my n. 21). Beazley suggested that they (the gods) indicate the setting of the fountain near a sanctuary." It should be noted, however, that the Priam Painter seems to favor depicting and contrasting these two deities and this may or may not reduce any special signification. For instance: the two appear bracketing Apollo on a neck-amphora in the British Museum, London B 255: *ABV* 331, no. 14. Dionysos on the left and Hermes on the right again enclose Apollo and muses on a very late small hydria in the British Museum, London B 347, which is "near" but perhaps not by the Priam Painter: *ABV* 334, no. 3 top.

43 London B 259: *ABV* 331, no. 12. The figure of Hermes here, on the right, is nearly a duplicate of the god in the same position on another neck-amphora by the Priam Painter in the Toledo, Ohio, Museum of Art (29.48): *Paralipomena* 146, no. 15 *bis* and these two renditions of Hermes are similar to the Hermes who leads Triptolemos' chariot on the Priam Painter's neck-amphora Compiègne 975; see infra n. 45.

44 Supra n. 5 and n. 17.

45 There is something of parody on the Priam Painter's neck-amphora in the Musée Vivenel, Compiègne 975: *ABV* 331, no. 13. On one side of the vase Hermes leads Triptolemos who rides in a chariot car and on the other side a Satyr, carrying vessels, precedes Dionysos, who rides in a winged car. On this mild parody and on the winged car as a possible stage property see: N. G. L. Hammond and W. G. Moon, "Illustrations of Early Tragedy at Athens," *AJA* 82 (1978) 376, figs. 5 and 6. For the winged car on Compiègne 975 see H. Kienle, *Der Gott auf dem Flügelrad*

(Wiesbaden 1975) pl. 4, no. 2. On the *Oschophoria:* Simon, *Festivals* 89–91.

The woman bathing on the Lerici amphora may have been part of the Bacchic train who are cleansing themselves after a day's service with the god: see Miller, *Iconography of the Palm* 21 for a discussion of the Phineus cup and other vases on which Satyrs watch women bathing.

46 *CVA* Boston 1, pl. 12.3 and commentary on p. 10. One may note the similarity here to the ornamentation under the handles of Exekias' calyx-krater, supra n. 9 and Boardman, "Exekias" 13. One is reminded again of the tondo design of Cab. Méd 320, supra n. 20. The charm of such scenes is equaled on several vases by the Antimenes Painter, particularly on a neck-amphora recently in the Swiss market: M. Laforet, *Vente publique* (Geneva, 12 June 1980) no. 19. Side A has a cortège of Satyrs under a grape arbor; one Satyr rides a goat while another is on an ass.

47 B. Cohen, *Attic Bilingual Vases and Their Painters* (New York 1978) 156, pl. XXIX.2 and for fuller discussion pp. 153–57.

48 J. R. Mertens, in Moon and Berge, *Midwestern Collections* 104, no. 60.

49 Boardman, "Exekias" fig. 2 can be compared with figs. 7.1a and 7.1b in this article. Anchises in both cases sits especially high on Aineias' shoulders.

50 W. J. Slater, "High Flying at Paestum," *AJA* 80 (1976) 423–25, with earlier bibliography.

51 M. Napoli, *La Tomba del Tuffatore* (Bari 1970) 158 and R. Bianchi-Bandinelli, review of Napoli, *DialAr* 4–5 (1970–1971) 135–42 both *apud* R. Ross Holloway, "High Flying at Paestum: A Reply," *AJA* 81 (1977) 554–55 (where the Lerici-Marescotti amphora by the Priam Painter is fig. 1), n. 5. The funerary symbolism discussed with reference to such scenes coincides well with other ideas set forth in this article.

52 Brendel, *Etruscan Art* 123 and 187–91 for a fuller discussion of the Tomb of Hunting and Fishing. For some of the problems with the Etruscans' reception of Greek themes, etc.: T. Dohrn, *Die schwarzfigurigen etruskischen Vasen aus der zweiten Hälfte des sechsten Jahrhunderts* (Berlin 1937); J. Oleson, "Greek Myth and Etruscan Imagery in the Tomb of the Bulls at Tarquinia," *AJA* 79 (1975) 189–200; R. Hampe and E. Simon, *Griechische Sagen in der frühen etruskischen Kunst* (Mainz 1964); I. Krauskopf, *Der thebanische Sagenkreis und andere griechische Sagen in der etruskischen Kunst* (Mainz 1974); see also A. Stibbe-Twist, "Herakles in Etruria," *Thiasos: sieben archäologische Arbeiten,* ed. T. Lorenz (Amsterdam 1978). Concerning Etruscan trade and Greek vase manufacture: A. Johnston, *Trademarks on Greek Vases* (London 1979) 12; F. Giudice, "Observazioni sul commercio dei vasi attici in Etrurie e in Sicilia: su una lekythos dal pittore della Gigantomachia con l'incrizione 'Lasa Sa,'" *Chronache di Archeologia* 18 (1979) 1–10; J. Bazant, "On Export Models in Athenian Vase Painting," *Dacia* 26 (1982) 145–52.

53 H. A. Shapiro, "Courtship Scenes in Attic Vase-Painting," *AJA* 85 (1981) 142 and n. 65.

54 Supra n. 23.

Some Thoughts on the Origins of the Attic Head Vase

8

WILLIAM R. BIERS

The earliest examples of plastic vases in the form of human heads are the so-called face kantharoi, originally placed at the beginning of the Attic series by J. D. Beazley and dated to approximately 530 B.C.[1] They are actually cups with high-swung handles with a painted male human face rendered in relief on the curving body of each cup. Beazley originally considered these face kantharoi as made for the Etruscan market, a suggestion that will be returned to in another context, and as Attic, but he changed his mind in an addendum to *ARV²* in 1963, in which he agreed to an apparently unpublished suggestion by E. Kunze that they were actually East Greek.[2] Their attribution to Samos has since been argued by E. Walter-Karydi[3] and can be accepted. Excavations in the Heraion on Samos have in fact added a fragment of another example to the seven complete and fragmentary face kantharoi already known.[4] Samos has also produced a number of plastic vases of various types of the seventh and sixth centuries B.C., including a fragment of what appears to be a seventh century, B.C. predecessor of the later face kantharoi.[5] The many Samian finds will eventually provide new evidence for the vexed question of the various centers of production of plastic vases in the seventh and sixth centuries.

The Samian origin of the cups and their very shape divides them quite clearly from all other, later, Attic head vases, a fact already noted by Beazley.[6] In the kantharoi, the human features are essentially spread over the surface of the cup; the later head vases are containers in the form of a fully rounded and modeled human head to which feet, handles, and vase neck and lip are attached. The later group of head vases is the concern of this paper. The many problems of relationships, attributions, and history of the Samian workshops will have to wait until another time.

Beazley grouped the Attic head vases in some eighteen "classes" on the basis of the plastic part of the vessel. The earlier groups, belonging still to the sixth century B.C., raise a number of questions, and Beazley's groups Abis to C will be considered here as belonging to the last twenty years or so of the sixth century B.C. However, close dating is difficult, based on the one hand on parallels in major stone sculpture, which may not be completely valid, and on the other on dates for painters who decorated the cup portions of some of the head vases.

An analysis of the shapes and subjects of the earliest Attic head vases yields some interesting information. Taking the lists in *ARV²* and later additions, one is struck by the number of aryballoi in the early groups and by the fact that along with white women's heads, heads of blacks are very common. In fact, the black may have been the subject chosen for the earliest true head vase. This primacy of the black as a subject is, however, hard to document. The painted decoration on the fine mug in Boston (fig. 8.1) from Beazley's earliest group Abis was associated by him with the Group of Vatican G 57, dated about 510 B.C.[7] An aryballos in Athens carries the name of the ubiquitous Leagros, thus belonging probably to the last two decades of the century.[8] Finally, a janiform aryballos (white females) of Beazley's Class B bears the *kalos* name Epilykos, which is found on vases of early red-figure painters of the last quarter of the sixth century. This vase was

apparently found in a tomb in Greece together with another very similar janiform aryballos (white female, black male) clearly of the same date; the two perhaps formed a pair.[9]

Of the thirteen complete vases in Beazley's first four groups and subgroups, twelve are fully, or in the case of janiform vases, half modeled in the head of a black. The black would then appear to be a popular subject for the newly created head-vase form in the last quarter of the sixth century B.C.[10]

F. Croissant has recently commented on the difficulty of assigning these vases in the form of black heads to Beazley's groups, as reflected in the changes Beazley himself made.[11] He has also emphasized the individual traits shown in many of the examples, as for instance the seemingly intentional "aging" on the Boston mug by the addition of crow's feet around the eyes and the wrinkles on the forehead (fig. 8.1). This has been noticed by other scholars,[12] some of whom would like to see blacks actually in Athens serving as models, and G. H. Beardsley even went so far as to suggest that there might have been at least eight particular individuals involved.[13] If the physical existence of blacks in Athens is necessary to explain their sudden appearance in the art of the sixth century, where did they come from and why were they there?

Greeks had been familiar with various Negroid peoples since the seventh century, and it is reasonable to suggest that a number made their way back to Athens. The traditional view that they came only as servants or slaves is not the only possibility and may be wrong. They are often shown as warriors, particularly in vase-paintings beginning in the third quarter of the century in association with Memnon (see Pinney pp. 131–32), but the plastic vases have no military associations.[14] Although blacks are quite often seen in the art of the earlier sixth century, does the sudden appearance of fully plastic representations of them reflect a particular influx in the fourth quarter of the century? Unfortunately, there seems to be no real historical evidence for blacks in Athens at this time. Mercenaries might be an obvious suggestion, but although we hear of mercenaries in relation to Peisistratos, there is no evidence they were blacks. The unrest of Athens following the assassination of Hipparchos in 514 would be an ideal moment for foreign mercenaries, but our sources are silent.

There is plenty of iconographical evidence for blacks near Greece if not in Athens itself. Terra-cotta masks are known from Sicily in late sixth or early fifth century B.C., and F. M.

8.1

Snowden, Jr., identifies some stone statues from Ayia Irini on Cyprus of about 560 B.C. as representing blacks, perhaps in the service of the Egyptian occupiers of the island.[15]

The subjects chosen for the Attic head vase may have a relation to the use of the pot. Along with the heads of blacks, particularly popular in the early years of production, and of white women, the head-vase repertoire includes Dionysos, Satyrs, Herakles, and even, toward the end of the series, an "Eastern Princess."[16] Often two heads are combined in a single vase, sometimes combining a black and a white head. The choice of Herakles, Satyrs, and Dionysos is clearly understandable when adorning a drinking or pouring vessel as appropriate for a drinking party or symposium. Various scholars, however, have made a number of suggestions concerning the special significance of the use of one or more of these subjects, and particularly on the use of the black. These suggestions range from the simple, or even frivolous, to philosophical, sociological, religious, or even theatrical. Beazley's comment that "it seemed a crime not to make negroes when you had that magnificent black glaze"[17] has seemed too simple an explanation for most writers. For Beardsley, the use of black and white heads in conjunction on a vase is only significant as racial contrast.[18] Snowden would go further and see such a juxtaposition as a reference to the anthropological contrast between northerners and southerners—environmental theories known in Greek literature and which he sees first in a preserved fragment of Xenophanes.[19] I. Richter believes that the use of a black head expressed subordinate social position and that in a combination of black head and white head the symbolism was that of slave and master—"Sklave als Diener des Herrn, Gefäss als dienendes Objekt."[20] E. Simon suggests that head vases in general may have been derived from theatral masks and that blacks in particular may be seen as sort of "silens of Aphrodite" and are hence seen first adorning such vases as oil pots, which are appropriate to her cult.[21] Others see the representations as having a specific reference to the contents — oil from the East, wine from Africa. Perhaps, however, head vases were just exotic luxury items of unusual shape to grace the banquets of the wealthy with little significance beyond entertainment value.

What models existed that might have caused or influenced the development of the Attic head vase? Human heads as vessels are known from the Bronze Age, and the head as an ornament for the neck of a vase is well known from the East.

Examples occasionally appear in the Greek world in the eighth century,[22] and similar vases are known in the following century from a number of Greek sites. After the middle of the seventh century the first vases that take the form of the human head are found, but there are relatively few of them, and they come from various parts of the Greek world. A well-known example is the bronze head vase with a high foot in Oxford from the Idean Cave, dated by J. Boardman to the middle of the century.[23] An extraordinary wooden head vase of perhaps slightly later date from Samos[24] indicates the importance of the East. Here, in the late seventh and sixth centuries the familiar series of small perfume or unguent flasks was produced. These vases, "small, compact, and cosy in the hand," as Beazley said,[25] were made in many forms, including animals, legs, warrior's heads, women's busts, Gorgons, and so on. A large number were made on Rhodes, others at another East Greek center or centers as well as in Corinth, Etruria, and occasionally elsewhere. By just after the middle of the sixth century their production began to die out except at Rhodes where there was a continuation but in an alternate painting technique.[26] Similar small vases in faience are also known from this period, apparently having a mixed Rhodian and Egyptian parentage.[27] Although all these small vases are quite different from the later Attic series and mostly stop being produced well before the Attic series start, many scholars have directly derived the one from the other, often through the intermediary of wandering Ionian artists.[28] It is interesting to note in this context the striking similarities between the white female of the janiform Class G head vase of the Canellopoulos Collection and Rhodian protomes. Croissant dates the vase as close to 510 B.C. and believes that the similarity to the Rhodian protome is so close as to indicate that it was made by a Greek of Asia Minor who had come to Athens to live.[29]

The use of the head of a black for the earliest Attic examples is difficult to derive from the earlier series of plastic vases. This subject is very rare; however, a fragment of such a plastic vase is known, presumably a squatting or standing figure. It was apparently found, interestingly enough, in Boeotian Thebes on the Greek mainland (figs. 8.2a, 8.2b).[30] There are also a few faience double-head vases that depict a Syrian and a black. Webb's recent study listed only four known examples, and she relates these to Saite art, deriving them from the Egyptian practice of decorating Pharaoh's furniture with representa-

tions of Egypt's traditional enemies in submissive postures. The faience double-head vases are to be dated in the sixth century B.C., perhaps in the first half of the century.[31] These little vases are aryballoi in shape, and the fact that some of the earliest Attic head vases were also aryballoi and hence may have had some sort of relationship with the earlier examples is pointed out by some scholars.[32]

Thus, diverse artistic currents may have come together to form the Attic head vase and various influences can be seen even in some of the later examples.[33] It would seem that it might be a mistake to seek a single inspiration for all the features of the Attic head vase.

A type of plastic object expressly not considered by Beazley are the small, applied plastic heads found on hydriai, oinochoai, kyathoi, and epinetra—"small and usually petty plastic adjuncts," he called them.[34] Although plastic human-headed protomes are known on Corinthian vases of the first half of the century and may stand behind the Attic examples, these plastic heads were quite popular in Athens in the second half of the century on these shapes and are sometimes quite elaborate, seemingly imitating metal prototypes. A number of these protomes adorn pots painted in the white-ground style, especially oinochoai, which are associated with the workshop of Nikosthenes. Those painted by the Painter of London B 620 are particularly associated with this workshop and are dated, according to the latest study on white-ground by J. Mertens, to about 520 B.C.[35] Their attribution to the Nikosthenic Workshop is strengthened by the fact that the two earliest examples of this shape of oinochoe (ca. 530 B.C.) are signed by Nikosthenes as potter (if "epoiesen" means potter!). The white-ground oinochoai Louvre F 116 and F 117 (figs. 8.3a, 8.3b, 8.4a, 8.4b) have had little exposure since Hoppin but are of some interest.[36] One (F 117) bears a female head below the lip opposite the handle and the other (F 116) a bearded and mustachioed male protome strikingly different from the clean-shaven but also mustachioed contemporary mask kantharoi. These protomes appear highly modeled in the round, standing out in greater relief than many plastic adjuncts; are very carefully formed and painted; and are not really "petty" in the usual meaning of the word. Similar care was taken in the protomes ornamenting the two kyathoi decorated by the painter Psiax in Milan (fig. 8.5) and in Würzburg (figs. 8.6a, 8.6b),[37] and these vases have also been closely associated, in shape as well as protome, with Nikosthenes.[38] The

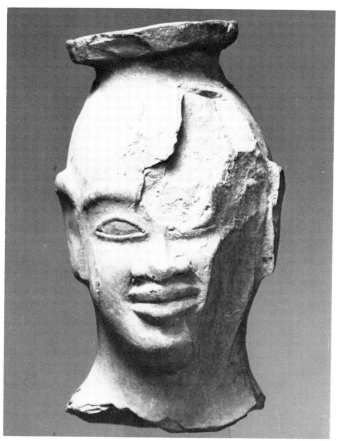

8.2a

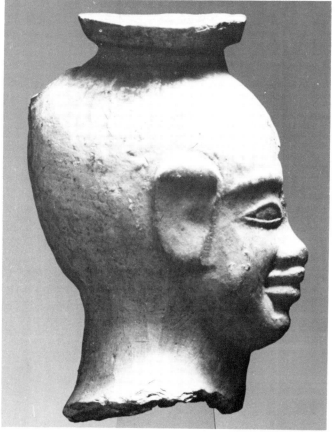

8.2b

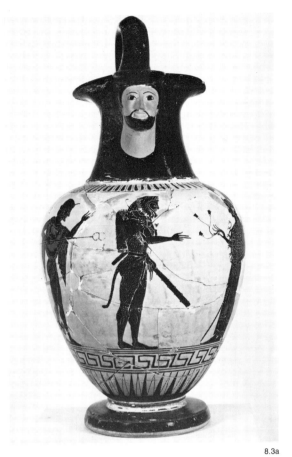

8.3a

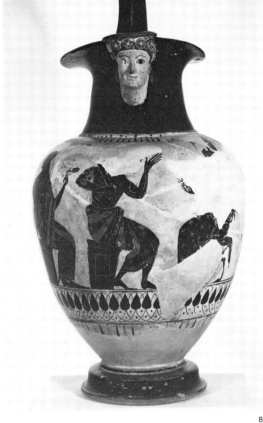

8.4a

8.2a. Heidelberg 18. Head of plastic vase. Front view. Photo: Courtesy Archäologisches Institut der Universität Heidelberg.

8.2b. Heidelberg 18. Side view.

8.3a. Louvre F 116. Oinochoe. Front view. Photo: Chuzeville. Courtesy Musée du Louvre.

8.3b. Louvre F 116. Protome. Detail Chuzeville.

8.4a. Louvre F 117. Oinochoe. Front view. Photo: Chuzeville. Courtesy Musée du Louvre.

8.4b. Louvre F 117. Protome. Detail. Photo: Chuzeville.

8.3b

8.4b

8.5

8.6a

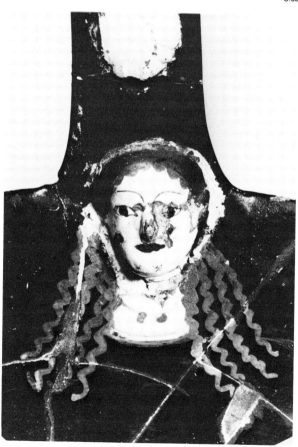

8.6b

8.5. Milan, Museo Poldi-Pezzoli
482. Kyathos by Psiax. Front
view.

8.6a. Würzburg, Martin von
Wagner Museum L 436. Kyathos
by Psiax. Front view. Photo:
Courtesy Museum.

8.6b. Würzburg, Martin von
Wagner Museum L 436. Kyathos
by Psiax. Detail of protome.

example now in Milan bears a striking Satyr's head, while that in Würzburg has a rather restored female protome. Both of the Louvre oinochoai and the kyathoi were found in Etruria, at least three of them at Vulci, and the commercial ties of the Nikosthenic Workshop with the West are of course well known.

The workshop of Nikosthenes has become one of those archaeological collection points for various inventions in the field of Greek painted pottery. At one time or another the workshop has been credited with the invention of Six's Technique and of the white-ground style, as well as the introduction of various Corinthian, Etruscan, and even Eastern shapes to the Attic repertoire, including the kyathos, which is often ornamented with plastic protomes, as we have seen.[39] The introduction of shapes such as the well-known small, flat-handled "Nikosthenic" amphora and the kyathos might make Nikosthenes a leading possibility as the "inventor" of the head vase, given his inventiveness and the modeled character of his early protomes. One must also consider the ancient interest in such objects among his clients, the Etruscans, who had anthropomorphic pots in their tradition since at least the seventh century B.C.[40] One thus comes back to Beazley's original suggestion, referring to the face kantharoi, that the form might have been developed for the Etruscan market. Unfortunately, the recorded provenances of the earliest Attic head vases are not exclusively from the west (nor are all vases signed by Nikosthenes, for that matter) and there is no hard evidence connecting them with Nikosthenes, although at least one "maker," Charinos, is loosely associated with the Nikosthenic Workshop, and all his vases that have a provenance were found in the west.[41] It is entirely possible that the main market for these luxury objects was the increasingly sophisticated Athenian society.

A further possible connection between Nikosthenes and the early head vases is pointed out by Mertens, who finds the artists who decorated the vases (largely kyathoi) of the Group of Vatican G 57 stylistically dependent on Psiax and links the group to the Nikosthenic Workshop. It will be remembered that the painted scene on the cup neck of the early head mug in Boston was attributed by Beazley to the Group of Vatican G 57.[42]

In short, from what we know of Nikosthenes' activitites, his originality, his interest in plastic forms, his associates, and his market, it is likely that his workshop introduced the idea of the true head vase to the Attic market of the late sixth century B.C.

NOTES

1 J. D. Beazley, "Charinos," *JHS* 49 (1929) 38–78; *ARV²* 1529.

2 *ARV²* 1697.

3 *CVA* Munich 6 (1968) 40–41, dated 540–530 B.C.

4 E. Walter-Karydi, *Samische Gefässe des 6. Jahrhunderts v. Chr.*, Samos 6:1 (Bonn 1973) 30, pl. 57.479. The author believes that five examples are from the same mold and dates the group to the thirties of the century.

5 Ibid. "Gesichtsnapf": pl. 61.478. Dated as from the end of the seventh century B.C. (p. 30): from "Fundgruppe XL," "vor 560," p. 96.

6 "This group stands well apart from the others," Beazley, "Charinos" 40.

7 Boston 00.332. Beazley, "Charinos" 77, no. 1; *ARV²* 1529, no. 1. The author would like to thank N. Johnson of the Museum of Fine Arts for permission to publish the photo of this vase. For the Group of Vatican G 57, see *ABV* 610–14, 711; E. Langlotz, *Griechische Vasen in Würzburg* (Munich 1932) 82, no. 437. This vase has recently been seen as an "apprentice work" of the slightly later "maker" Charinos, R. Guy, "A Ram's Head Rhyton Signed by Charinos," *Arts in Virginia* 21 (1981) 6.

8 Beazley, "Charinos" 77, no. 8; *ARV²* 1594, no. 51; F. M. Snowden, Jr., "Iconographical Evidence on the Black Populations in Greco-Roman Antiquity," in *The Image of the Black in Western Art* I (New York 1976) 142, fig. 153. For Leagros, see J. Boardman, *Athenian Black Figure Vases* (New York 1974) 201.

9 *ARV²* 1530, no. 1 (Epilykos vase), no. 2 (other janiform aryballos). For the original descriptions and comments on these vases, see E. Pottier, "Epilykos, étude de céramique grecque," *MonPiot* 9 (1902) 135–40. Epilykos appears on vases by Skythes (J. Boardman, *Athenian Red Figure Vases* [London 1975] 59–60) and is shown as an athlete on a vase by Phintias (ibid. 60; Beazley, "Charinos" 43, n. 26).

10 The vases of the "maker" Charinos, Beazley's Group C dated to the end of the sixth century B.C. (Beazley, "Charinos" 43–44; *ARV²* 1531–32), show a majority of white female heads, as do the succeeding groups. Some of the earliest examples from these groups may reach back as far as the last quarter of the sixth century, and some of them at least are black heads.

11 F. Croissant, "Collection Paul Canellopoulos (IV): Vases plastiques attiques en forme de têtes humaines," *BCH* 97 (1973) 208–9.

12 E. Buschor, "Das Krokodil des Sotades," *MJb* 11 (1919) 42; G. H. Beardsley, *The Negro in Greek and Roman Civilization* (Baltimore 1929) 32; K. S. Gorbunova, "Attic Vases in the Form of Human Heads in the Hermitage Collection," *Trudy Grossoudarstvemouo Ermitaja* 7, no. 3 (1962) 30.

13 Beardsley, *Negro* 37. See the comments by Buschor, "Krokodil" 36.

14 For a study of the representations of the black in Greek art, see Snowden, "Iconographical Evidence" 133–245; idem *Blacks in Antiquity* (Cambridge, Mass. 1970). Boardman has suggested that the painter Amasis may have been "dusky-skinned," J. Boardman, "The Amasis Painter," *JHS* 78 (1958) 1–3 and idem, *The Greeks Overseas²* (London 1980) 152.

15 Snowden, "Iconographical Evidence" 146–48; idem, *Blacks* 24, 33 (fig. 1), 122–23.

16 *ARV²* 1550, no. 2.

17 Beazley, "Charinos" 39.

18 Beardsley, *Negro* 36.

19 Snowden, *Blacks* 169–78; idem, "Iconographical Evi-

dence" 146, 299, n. 54. The fragment, fr. 16 in Diels (H. Diels, *Die Fragmente der Vorsokratiker*[10] I [Berlin 1961] 133), contrasts the black snub-nosed gods of the Ethiopians with the red-haired and blue-eyed gods of the Thracians.

20 I. Richter, *Das Kopfgefäss: Zur Typologie einer Gefässform* (Cologne 1967) 38.

21 E. Simon, "Aphrodite Pandemos auf attischen Münzen," *SNR* 49 (1970) 8–10, 16–17; idem, *Die griechischen Vasen* (Munich 1976) 93. We know of no connection between blacks and the early theater, but masks of Dionysos, which appear on vases in the sixth century, may be connected with theatrical events. See the recent comments in E. Bell, "Two Krokotos Mask Cups at San Simeon," *CSCA* 10 (1977) 9–11.

22 A North Syrian aryballos with its elongated neck modeled in the form of a human head was found at Pithekoussai in a late eighth-century context. Such objects could have provided some of the stimulus for the later series of East Greek plastic head vases of the late seventh and sixth centuries B.C. D. Ridgway, "The First Western Greeks: Campanian Coasts and Southern Etruria," in C. and S. Hawkes, eds., *Greeks, Celts and Romans* (Totowa, N. J. 1973) 5–38; 14, fig. 2b.

23 J. Boardman, *The Cretan Collection in Oxford* (Oxford 1961) 80–87. Other examples of head and bust vases known up to this time are collected here.

24 G. Kopcke, "Neue Holzfunde aus dem Heraion von Samos," *AthMitt* 82 (1967) 115–16.

25 Beazley, "Charinos," 40.

26 For a general discussion of these seventh- and sixth-century plastic vases, the best treatment remains R. A. Higgins, *Plastic Vases of the Seventh and Sixth Centuries B.C.* (British Museum, Catalogue of the Terracottas II, London 1959), and the earlier M. I. Maximova, *Les vases plastiques dans l'antiquité*, trans. M. Carsow (Paris 1927). J. Ducat has studied the Rhodian series, *Les vases plastiques rhodiens* (Paris 1966), and laid the groundwork for the Corinthian examples, "Les vases plastiques corinthiens," *BCH* 87 (1963) 431–58.

27 V. Webb, *Archaic Greek Faience* (Warminster, England 1978) 122–30.

28 Buschor, "Krokodil" 36; Maximova, *vases plastiques* 149–50; K. Tuchelt, *Tiergefässe in Kopf- und Protomengestalt* (Berlin 1962) 75. Richter believes that both the motif of the black and the unguent jar needed the stimulation of Ionic predecessors, *Kopfgefäss* 37.

29 Croissant, *Canellopoulos* 216–18.

30 Heidelberg, Archaeological Institute 18. *CVA* Heidelberg 1, pls. 4, 8, 9; Buschor, "Krokodil" 35, figs. 53, 54; Ducat, *vases rhodiens* 153. Perhaps a local, Boeotian work? I must thank H. Gropengiesser for permission to illustrate this object.

31 For figured aryballoi see Webb, *Faience* 122–35, esp. 130, for double-head vases.

32 For instance, Beardsley, *Negro* 30.

33 A. Kozloff has recently shown that the strange appendages dangling below the lips of some heads from Beazley's Toronto Class of Attic head vases are paralleled by similar appendages on Archaic Cypriote sculpture of the first half of the century. In sculpture it represents a tuft of beard; its appearance much later in the third quarter of the fifth century B.C. on Attic head vases is an interesting sidelight on the artistic currents in the ancient world. See A. Kozloff, "Companions of Dionysos," *Bulletin of the Cleveland Museum of Art* 67 (1980) 209.

34 Beazley, "Charinos" 39. The last ten years have seen detailed studies on two of these shapes: M. Eisman, *Attic Kyathos Painters* (Ph.D. diss., Univ. of Pennsylvania 1971. University Microfilms 1972); P. F. Benbow, *Epinetra* (Ph.D. diss., Harvard Univ. 1975).

35 J. Mertens, *Attic White-Ground* (New York 1977) 70.

36 *ABV* 230, nos. 1, 2; Mertens, *Attic White-Ground* 31; J. C. Hoppin, *A Handbook of Greek Black Figured Vases* (Paris 1924) 254–55, nos. 48, 49. Thanks go to F. Villard for permission to publish new photos of these two vases.

37 Milan, Museo Poldi-Pezzoli 482. G. M. A. Richter, "A Kyathos by Psiax in the Museo Poldi-Pezzoli," *AJA* 45 (1941) 587–92, figs. 1–5; *ABV* 293, no.15. I would like to thank the Museo Poldi-Pezzoli for providing a new photo of the kyathos and for permission to publish it. Würzburg, Martin von Wagner Museum L 436, *ABV* 294, no. 16. Appreciation must be given to G. Beckel for providing new photographs and publication permission.

38 Mertens, *Attic White-Ground* 37–38, suggests that the shape of these two kyathoi, including the protomes, was a particular one, perhaps invented by Nikosthenes (see below). The introduction to the Attic market of plastic heads as adornment for vases was also assigned to Nikosthenes by Perrot; G. Perrot and C. Chipiez, *Histoire de l'art dans l'antiquité* X (Paris 1914) 260–61. Another white-ground kyathos probably painted by Psiax is in the J. Paul Getty Museum in Malibu, California (Getty 78.AE.5). Although the shape is largely restored, a striking female protome is preserved. It is modeled in high relief and is very carefully decorated, with flowing, white painted tresses extending down the interior sides of the bowl.

39 For Nikosthenes as the inventor of the kyathos, see Eisman, *Attic Kyathos Painters* 46; idem, "The Nikosthenic Workshop as the Producer of Attic Kyathoi," *AJA* 74 (1970) 193 (summary of paper).

40 For earlier examples of Etruscan vessels utilizing human heads as decoration, see M. Pallottino, *Art of the Etruscans* (New York 1955) nos. 20, 21, 43.

41 *ARV*[2] 1531–32; Mertens, *Attic White-Ground* 63, 65. Charinos has also been linked with Psiax, who is in turn linked with Nikosthenes, as has been seen. See T. B. L. Webster, *Potter and Patron in Classical Athens* (London 1972) 29.

42 See fig. 8.1. Mertens, *Attic White-Ground* 85. The connection of both Psiax and the Group of Vatican G 57 with the Nikosthenic Workshop is also made by Eisman, *Attic Kyathos Painters* 133, 142.

Achilles Lord of Scythia

GLORIA FERRARI PINNEY

Αἰθίοπές τε ⟨θεοὺς σφετέρους⟩ σιμοὺς μέλανάς τε
Θρῆκές τε γλαυκοὺς καὶ πυρρούς ⟨φασι
πέλεσθαι⟩.

(Xenophanes, fr. 16)

Often the most difficult task in interpreting illustrations of myth and epic on ancient vases concerns not the action, but details of dress, furnishings, accessory figures: their function, reality, and historical date. Are the scenes staged in straightforwardly modern dress, or did the artist aim at a suitably fabulous or heroic effect by recalling the form of things ancient in his time, and by inventing some that never existed? Representations on vases are frequently used as documents of the time in which they were painted, but the approach is sound only when the information gained from them can be checked against external evidence. This is the case of the hypothesis that the SOS amphora that Dionysos shoulders on the François vase may confirm archaeological evidence demonstrating that the amphorae continued to be made in the sixth century.[1] (See Stewart fig. 4.2.) At other times scholars are forced to place greater trust in the pictures. The cup in Vienna (3694) with arming scenes, for instance, is considered a reliable source for the equipment of the Greek soldier of the early fifth century.[2] The strength of the argument lies in the fact that, by and large, armor and weapons correspond to those appearing on vases and other monuments of the same period. There are, however, indications that the setting here is epic, and that the depiction of details may be less than candid. The linen corselet is the equipment of Homeric heroes; its latest mention occurs in a fragment of Alkaios, written—one should note—at the time of the bell-shaped corselet. The old king (Vienna 3694, A, left) belongs to myth or epic. The cap of the helmet on the left, side B, is divided into horizontal sections, each decorated with an oblique pattern on dark ground. Is this simply ornament, or does it try to suggest a boar's tusk helmet?[3]

It is by no means obvious that the realia of legendary scenes on monuments of a given period showing some coherence among themselves are trustworthy representations of men and things of the time. They may be images that begin and end in the realm of the visual arts, and combine in their appearance the true and present with the imaginary and distant. The question is crucial for the interpretation of figure scenes on Late Geometric vases, since dress and equipment are among the very few clues available to determine if they portray contemporary events or epic sagas, but it is no less important for later representations.[4] This essay is devoted to a character familiar to students of Attic Late Archaic vases, the archer in Scythian garb, to explore the possibility that he belongs neither wholly to history nor to fancy, but is a hybrid creature whose nature and looks partake of both.

The bulk of the representations of Scythian archers belongs to the years between 530 and 500 B.C., preceded by a few, and followed by sporadic examples after the turn of the century. They virtually disappear around 480 B.C.[5] No single explanation seems to fit the bewildering variety of the images, and inconsistencies start with the features of the archers. They are seldom given specific morphological traits. When they are characterized, as on the amphora Munich 1408 (fig. 9.1), the most remarkable feature is the beard, short, thin, and pointed, growing on the chin but not on the cheeks, and very different from the full beards of the Greeks.[6] The Amasis Painter, on the cup in the Schimmel Collection,

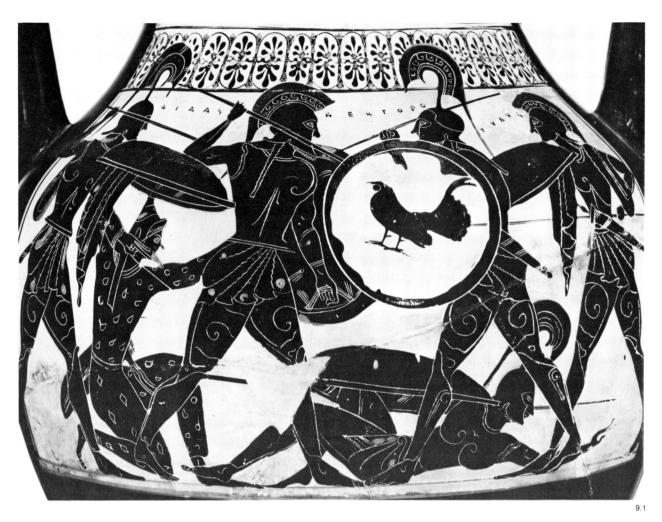

9.1

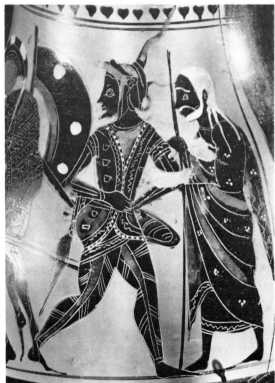

9.2

9.3

9.4

also tries to characterize the Scythians by means of the beard, which is shorter than that of Posei- don, with dots that indicate scantiness or fair- ness.[7] The hydria in Los Angeles in the manner of the Antimenes Painter shows a striking face, with short upturned nose, low-cut beard, and no mustache.[8]

As a rule of thumb, one tells a Scythian by the costume, which appears in its most distinctive form on the olpe in Altenburg (fig. 9.2).[9] The cap of soft material extends to the shoulders with flaps at the back and sides of the neck. Here the back flap is tucked into a band that encircles the cap; the latter appears to be made in sections, ending in a long narrow point. The dress con- sists of a long-sleeved top and jacket over long trousers, all made of patterned material and trimmed by decorated strips along the seams. The equipment includes the bow, *gorytos,* and ax. In its basic traits the costume corresponds to that described by Herodotos (VII.64), and to that worn by Scythians on Persian reliefs, although on the reliefs they are shod, and on the vases normally barefoot.[10]

Few of the archers, however, wear precisely this costume. Some of the variants are easily explained as simplifications or elaborations of a decorative sort: the belt may be omitted, and the jacket-trousers combination may become a one- piece suit that looks like leotards, as on the amphora by Exekias in Philadelphia (fig. 9.3).[11] Other variants are radical departures from the standard attire; of those the most frequent and remarkable is the short, belted tunic.[12] If phy- siognomic traits and jacket-trousers combination are used haphazardly, the telling elements are reduced to two: the equipment and the tall,

pointed cap. Even this last, however, varies, sometimes replaced by one with a rounded top curling forward, akin to the Persian cap, but stiff.[13]

One wonders if the variations in the degree of physiognomic accuracy with which the archers are depicted and in the rendering of the costume are meaningful, but no intelligible pattern emerges from a tabulation of the variants. It is in fact to be excluded, however sensible an assumption it may seem, that the pictures are at the beginning true- to-life, and become less so, through the painters' whim or carelessness, near the end of the century. The earliest instance of physiognomic characteri- zation, on the Schimmel cup by the Amasis Painter, is not among the first depictions of the bowman in pointed cap on Attic vases, but thirty or forty years later.[14] In a fitful manner, represen- tations exhibiting some degree of characterization continue for as long as the Scythians appear on vases. On a cup of the Thorvaldsen Group, for instance, a nude symposiast who wears the cap with rounded crown has the typical sparse beard and mustache, rendered in thinned glaze as though he were fair (fig. 9.4).[15] The short tunic is not a sporadic and late variant, as Vos suggested, but an alternate form of dress, which precedes both the jacket-trousers outfit and the one-piece suit, and occurs just as frequently throughout. In the scene of heroic combat on the interior of a cup in the manner of Lydos, the archer wears the tunic and the pointed cap (fig. 9.5); in another early vase, the lekythos by the Taleides Painter, archers in tunics alternate with others in trousers.[16]

One turns to context, only to find that a large number of the scenes which include Scythians are incapable of clear interpretation, although it is

obvious that some depict a specific episode, such as the so-called scenes of extispicy.[17] When the subject is intelligible to us, it is normally not myth, but the Trojan epic: the ambush of Troilos; the departure of Priam for the Greek camp; Achilles and Ajax at the board game; Ajax carrying the body of Achilles; Aineias leaving Troy. It would be rash to conclude that the archers are a fixture of the Trojan saga, because the exceptions are too numerous to be ignored. They appear twice in scenes with Herakles, once more with Herakles and Athena, twice again in battle scenes against Athena.[18] If these should be considered aberrations, others should not. On a hydria by Psiax in Würzburg, the Scythian precedes a chariot in motion, in which stand the driver and a warrior in full armor. The warrior is labeled *Adretos,* and the identification as Adrastos is confirmed by the fact that one of the horses is called Arion.[19] His appearance in an episode of the Theban cycle shows that the archer is not confined to Troy, but may be used to illustrate other epic themes: his identity and role are such, at least at this time, that he may be used in a generic manner. There are other indications of the man's adaptability. On a hydria in Madrid (see Moon fig. 7.5) the archer is identified. The subject is the harnessing of the chariot of Priam: the "Scythian" stands on the left, wearing yet another variant of the costume, a one-piece suit under a kilt of different material. His cap ends not in the distinctive point, but in the rounded stiff crown.[20] The inscription painted above his head identifies him, after a fashion, as Paris, suggesting that, with meaningful corrections and additions, Scythian attire can be disassociated from its specific ethnic meaning, and employed to cover a wider range of Asians, or to indicate the function of archer.[21]

Beginning with K. Wernicke's study, the ubiquitous quality of the archers has been explained as the result of their presence in Athens, where their colorful aspect would have caught the painters' fancy.[22] Their appearance in epic and mythological scenes would be no more than a detail of setting borrowed from contemporary Athenian life. This premise still underlies the fullest account of the Scythians on Attic vases, M. F. Vos' monograph of 1963. Vos concluded that the vase-painters depicted archers who arrived in Athens at the time in which representations on vases become frequent, between 540 and 530 B.C., and left when these begin to dwindle, around 500 B.C. Their function would have been that of a specialized army corps, at the service not of the tyrant, but of the Athenian state.[23]

9.5

9.5. New York 25.78.6. Fletcher Fund 1925. Heroic combat. Photo: Courtesy Metropolitan Museum of Art.

Her theory forces the author to discard much of the evidence earlier than 530 B.C. and, on many counts, does not stand close examination. Since its weaknesses have been plainly shown by K. W. Welwei, only a few observations are presented here.[24]

Vos's interpretation, like earlier ones, is based on two false assumptions: that the painters could not have gained knowledge of the type by any means other than daily contact with the Scythians, and that the representations of the costume are coherent and accurate at first, and become progressively less faithful near the end of the century.[25] It is easy to see, however, that inconsistency is the rule from the start—typical instances concerning physiognomy, dress, and context were submitted above. If the vases do not offer a believable likeness of the Scythians' attire nor of their aspect, the hypothesis founded on the accuracy of the representations no longer holds, and the argument that between 540 and 500 B.C. there were Scythians in Athens because they appear on the vases becomes perfectly circular.

The fallacy of the assumption that the artists drew more or less immediately from what they saw is demonstrated by the fact that precisely the

opposite seems to be true: Scythian archers disappear from the vases very near the time at which Scythians are in fact brought to Athens, where they will remain at least until the end of the century.[26] As Welwei pointed out, there is no evidence that archers formed part of the army in the sixth century; there may be some to the contrary, if it is true that the Athenians had no archers at Marathon.[27]

The solution to the puzzle should be found in the vases themselves. Their examination does justify a few remarks of general character, although none is without exception. To begin with, the setting in which the archers are placed is nowhere explicitly contemporary. They do not appear in the company of gods, but of heroes—most often, when we recognize the story, those who fought at Troy. Even when the character of the scene is not made explicit by inscriptions, there are often elements which are recognizably epic. It has been acknowledged that this is true of the war chariot, long out-of-date in sixth-century Athens, but the same may be said of the manner in which the Scythians fight. Like that of their presence in Athens, the notion that the archer was paired with the hoplite is based exclusively on the pictures, where the two are shown parading side by side, and together in action, the archer shooting at a distance or beside the warrior. While we have no information concerning the sixth century on this point, we know that during the Peloponnesian War the archer performed not alongside the heavily armed infantryman, but with other lightly armed troops.[28] The method of combat shown on the vases, as on the cup by the Triptolemos Painter in Berlin, is heroic, and is described in the *Iliad* (VIII.267–72) where Teukros fights alongside Ajax, under cover of the warrior's great shield.[29]

It is also clear that the Scythians' role is, with few exceptions, that of minor characters rather than protagonists. Their secondary importance is shown by the fact that, when they march in pairs, the warrior normally overlaps the archer.[30] They watch the performance of extispicy; they are side figures in scenes of Ajax carrying the body of Achilles, or of Aineias leaving Troy. When the warriors come to close combat, the archers may be inclined to run.[31] They are not heroes, but companions of the heroes, of the warriors in full panoply often called, by what is surely a misnomer, "hoplites." The two as a pair are the most consistent element of all scenes in which Scythians are present. The motif is taken up in scenes of Amazonomachy, where the "warrior" Amazon, in corselet, helmet, and greaves, is accompanied by the "archer" Amazon, in Scythian garb.[32]

A third characteristic, besides their epic quality and secondary rank, is the archers' great flexibility. The strong characterization with which they are occasionally depicted assures us that the type was meant to show actual barbarians of the northeastern regions, but it is also clear that this ethnic quality can become blurred, since Paris is painted in Scythian dress and, although more plausibly, so are Amazons. National identity, or allegiance to a given state, is difficult to reconcile with scenes in which the archers fight on either side.[33] A paradoxical development of this flexibility comes with the Negro alabastra. These date to the first quarter of the fifth century, and comprise alabastra on which Amazons or, more often, Negroes are represented wearing a version of the Scythian costume: the cap is normally omitted, and the patterned trousers may be worn with the corselet.[34]

In her recent study of the alabastra, J. Neils has come to the conclusion that the interchangeability of the types is the product of contaminations which took place within the vase-painting tradition, without external prompting.[35] The Amazon would have appeared first, as she fled from battlefield to sanctuary. The type was reemployed in an arming scene, and finally transferred to the Negro. The association of the two barbarian figures, Neils proposed, stems from their common participation in the defense of Troy. Her study demonstrates the advantages of tracing the transformations of the stock of images which formed the repertoire of the painters. It has also the merit of showing that the motif transferal was not whimsical, but ultimately justified by a connection established in the epic legends. There remains to be explained why both Amazon and Negro wear an Oriental costume strongly reminiscent of the Scythian. Is there a common denominator to all three barbarian types, and one that can be expressed best by means of Scythian dress?

The factor which underlies the shifting of attributes from one to the other is not just their participation in the Trojan War, but their function as attendants and followers of great warriors—the Ethiopians of Memnon, the Amazons of Penthesileia, and, it will be argued in the pages that follow, the Scythians at Achilles' side.

On Attic vases it is the image of the Ethiopian squire that can be followed most clearly, precisely because it is not frequent. The attendants of Memnon appear first on vases by Exekias, the neck-amphora London B 209, and the amphora

of type A in the University Museum (figs. 9.6a, 9.6b).[36] Their attire varies, but their distinctive weapon is the club. Very soon after, on a neck-amphora near Exekias in New York, there is incongruity and contamination: they carry the club, but also the bow and *gorytos,* and one is bearded.[37] On a neck-amphora by the Swing Painter the Ethiopian stands between two Amazons, and is represented as an archer.[38] Neils describes a fragmentary, unpublished cup by Psiax, on which the Ethiopian wears a "sleeved and trousered costume" in a scene that is probably the duel of Memnon and Achilles.[39] The contradiction implicit in the fusion of the Scythian with the Ethiopian may be only apparent, if one takes the view that the artist makes two distinct points: the Negro's nationality expresses his allegiance to Memnon; his costume defines his role as that of a squire.

Transformations of the iconography of the Scythian squire are not easy to follow, but there is something to be gained by an examination of the vases preceding its indiscriminate use in the last quarter of the sixth century.

The earliest Attic picture of archers in pointed caps is on the François vase, in the Calydonian boar hunt. The tunics they wear, and their participation itself in the enterprise, make it doubtful that they simply stand for barbarian types; the name *Kimerios* with which one is tagged establishes, however, a firm connection with the northeastern countries.[40] Close in date to the François vase are a fragment of a cup by the C Painter, and fragments of two vases from the Akropolis, both probably decorated with the same subject: the battle of mounted warriors, spearmen on one side, archers in pointed caps on the other.[41] The only vase which can be confidently dated before mid-century on which Scythians appear as attendants of the warriors in full armor is a dinos in the Louvre attributed to the Tyrrhenian Group.[42] It is decorated with an Amazonomachy, and the archers in Scythian caps fight alongside the Greeks, as well as with the Amazons. A number of Little-Master cups on which Scythians are represented can be dated between 550 and 530 B.C. Two confirm the geographical associations of the type, since they represent the battle of the Arymaspians with the Griffins.[43]

In the years corresponding to the old age of Lydos and to the early work of Exekias, not long before 540 and no later than 530 B.C., the image of the hero with the Scythian squire becomes well established. It does not occur on vases attributed to Lydos himself, nor on any of Group E, but it

9.6a. Philadelphia MS 3442. Fight over the body of Antilochos. Photo: Courtesy of the University Museum, Philadelphia.

9.6b. Philadelphia MS 3442. Fight over the body of Achilles. Photo: Courtesy of the University Museum, Philadelphia.

is found on three cups closely connected with the late work of Lydos.[44] In this generation it is Exekias who paints Scythians most often: they appear on four of the vases attributed to him. On an amphora in the Louvre a Scythian is shown in the foreground, overlapping the warrior. Both are mounted; the archer, nude and carrying a pelta, struggles to control a stumbling horse.[45] On the Roš amphora he appears again, on the far side of two warriors running into battle alongside a chariot. One of the trace horses has tragically fallen on its side, and the next one is about to follow.[46] On a fragmentary amphora in the University Museum, Philadelphia, warrior and Scythian are shown grazing their horses one on each side of the vase. The consistency of their association in other scenes and the sameness of the action suggest that we are to think of them as being together, as on the alabastron by Psiax from Odessa.[47]

Another amphora in Philadelphia finally presents us with a well-known subject. One side shows the moment following the end of the combat of Memnon with Antilochos. Antilochos lies on the field; Memnon's Ethiopians are on the left, running away, as three from the Greek side come after them (fig. 9.6a). One of the pursuers

is in Scythian garb—only the head is left, enough to show the distinctive cap with flaps at the sides of the neck. The other side of the vase shows Achilles already dead: Ajax bends to lift the body by the arms, while Menelaos overtakes an Ethiopian (fig. 9.6b).[48] This scene presents difficulties, the most conspicuous of which is that Memnon's squire is still on the battlefield, although his lord has been killed in an earlier episode. To explain his presence here as spilling over from the other side is visually awkward. The moments chosen are typically Exekian: not the action at its most explicit and loudest, but the moment that either precedes or follows, suggestive and charged with emotion for those who know the story.[49] It is perhaps indicative of the same approach that the two pictures on the vase give us snatches of the story of the *Aithiopis* taken on either side of the central episode: the duel of Achilles and Memnon, followed by the death of Achilles at the hands of Paris and Apollo. To the mind of the informed viewer, the duel is no less present for being omitted—it is strongly suggested by the depiction of Memnon's attendants in both scenes.

It is important to note that, on the Philadelphia vase just examined, Ethiopians and Scythians are on opposite sides and that in epic scenes they are the only ones who receive racial characterization: contraposition and analogy are pointed. The contrast of Scythians and Ethiopians as dwellers of the extreme regions of the earth is in fact an ancient *topos*.[50] Opposing but corresponding elements are present in the portrayal of Memnon and Achilles: both are the offspring of a minor goddess and a mortal, both are granted immortality by exception. Proclus' summary of the *Aithiopis*, scant as it is, relates that Memnon too wore a suit of armor made by Hephaistos.[51] These analogies, together with the scenes by Exekias, prompt the hypothesis that the Scythian archer may have been conceived as the counterpart of Memnon's Ethiopian, that is to say, as the attendant of Achilles. This is confirmed by the traces of a tradition linking Achilles not just to the regions at the extreme north of Greece, but to the land and populations beyond.[52]

In the epic there existed two versions of Achilles' destiny after death. In the Homeric poems the hero dies at Troy, and joins the shadows in Hades; his ashes are buried at Sigeion together with those of Patroklos and Antilochos.[53] Apparently in contrast with this, the other tradition granted Achilles immortality, and established his presence in an altogether different region. In the *Aithiopis* Achilles is not cremated: Thetis rescues the body from the pyre and transports it to Leuke. The epitome does not mention immortality, which is however suggested in later sources.[54] In historical times Leuke was thought to be an island in the northern Pontus Euxinus, the modern Phidonisi, opposite the site of Olbia, a Milesian colony founded on Scythian land near the mouth of the Borysthenes.[55]

The importance of Achilles in the territory of Olbia is indicated by many toponyms, and especially by the cult devoted to him. Worship of the hero is attested by inscribed dedications recovered from the islands of Phidonisi and Berezan, from the city itself, and from a wide area around it.[56] It continued until the third century A.D., and was certainly in existence in the late sixth century B.C.[57] It is plausible that, as Rohde proposed, the island was at first an imaginary place near the end of the earth, and that its identification with a specific site followed the Greek penetration in the Black Sea.[58] Precisely when the discovery took place is not easy to determine. Drews has argued, on good grounds, that colonization of the southeastern shores began in the eighth century; there are indications that exploration of the northern coast began at an early date.[59] Leuke might have been identified as Achilles' immortal residence long before the area received the first Greek settlers, shortly after the middle of the seventh century—but it is not likely. A hero's physical presence, even in the form of ashes and bones, is the crucial element in his cult: establishment of a grave and worship are closely linked events.[60] It is therefore also plausible, if difficult to prove, that both the identification of Leuke and the cult of Achilles were the product of colonization from Miletus. In this light it is at least uncanny that the story of Achilles' translation should be told in the epic of the Milesian Arktinos: the coincidence, as many have noted, reveals a partisan coloring of the saga, giving emphasis to matters of local import.[61]

Does Achilles' popularity in a state bordering with Scythia point to a connection between him and the nomadic populations to the north? The phenomenon is suggestive, but does not by itself constitute a link. The connection is at best tenuous and indirect, coming down to no more than geographical proximity, and having no reference to the hero's eventful lifetime. The insight to be gained from the Olbian cult concerns rather the *Aithiopis*. It appears that this epic contained elements local in outlook and related to the colonization—the characteristics akin to *ktisis* poetry.[62]

The point has some bearing on the question of Scythians in epic context, and will be taken up in the concluding section.

An explicit link between Achilles and Scythians is attested by a fragment of a poem by Alkaios, just one line: Ἀχίλλευς ὁ τὰς Σκυθί-κας μέδεις, Achilles lord of Scythia.[63] It has been stressed that the appellative recalls the formula of dedications from the territory of Olbia, and seems akin to that of *Pontarches,* with which the hero was honored in Roman Imperial times. Alkaios' line has been understood as a reference to the hero's presence on Leuke and to his cult: Scythia would be simply a geographical allusion, its connection with Achilles a product of the cult, belonging therefore entirely to the time after his death.[64]

The current interpretation of the verse is not without difficulties. The shift between the idea of Scythia and that of Leuke and the Olbian coast that the synecdoche would require seems unnatural when one reflects that Achilles was worshiped not by Scythians but by Greeks, travelers and Olbians, and that the cult is firmly localized within the *chora* of the Milesian colony: hardly, to a Greek's mind, Scythian land. The obvious frame of reference for Achilles on Leuke is not Scythia, but the sea, as the dedications and the mentions of the place by fifth-century poets show.[65] A literal reading of the line as the statement of a direct relationship between Achilles and the Scythians can be supported by the analysis of visual sources: a Cycladic pithos of the seventh century B.C., and a red-figure cup of the end of the sixth.

The pithos in the Museum of Fine Arts, Boston 95.506, has been assigned to the Tenian-Boeotian group of the third quarter of the seventh century B.C.: it is perhaps earlier, and definitely not much later, than the earliest settlement in Berezan.[66] It has two decorated areas. On the shoulder is a row of archers on horseback moving toward the right (fig. 9.7a). They wear nothing, it seems, except the *gorytos,* carried vertically in the Greek fashion, and a brimless pointed cap decorated with small designs, and hold the bow in their left hand. Their identity is far from certain, but the stiff narrow point of the cap suggests that Scythians are meant, or at least exotic bowmen.[67] On the neck of the jar is a procession moving toward the left, opposite in direction to the row of archers, led by a woman in splendid attire, in embroidered dress and mantle, and carrying a staff (fig. 9.7b). She is followed by four other women, obviously not her equals, because they are a little smaller, have no mantle, and

wear their hair in a simpler arrangement (fig. 9.7c). The four women carry on their heads, and support with one hand, a long boxlike object, whose far left and center sections are missing. This is also decorated with patterns like the ones stamped on the clothes and on the archers' caps; a small round star protrudes from the rectangular outline at the lower right corner.

The appearance of embroidered cloth produced by the stamped decoration has led to an explanation of the scene in the light of *Iliad* VI.85–95 as the offering of the peplos to Athena by Queen Hekabe followed by the Trojan ladies.[68] The object does not look like the peplos: it is neither unfolded nor properly folded, and is handled like a heavy thing. There is an interpretation that accounts for the disparate elements, and has the further advantage of connecting the picture on the neck of the pithos to that on the shoulder. The neck illustrates the legend told in the *Aithiopis:* Thetis has removed Achilles from the pyre and leads the Nereids who carry the body of the hero, wrapped in a magnificent shroud, to Leuke.[69] There are few visual parallels for the scene, since it is the lying in state of the dead that is preferred in funerary representations from Late Geometric times onward. When the *ekphora* is shown, one sees not the pallbearers of the epic, but the bier placed on the cart that will take it to the cemetery.[70] To my knowledge the only representation corresponding to the scene on the neck of the Boston pithos is on a one-handled kantharos of the late sixth century, where the body is carried on the shoulders of men, and is wrapped in a richly embroidered shroud.[71] The projection marked by the rosette at the lower right corner of the shroud on the pithos must be the weight sewn at the end of the cloth, as on the miniature terra-cotta cart from a tomb in Vari.[72] If this interpretation of the main scene is correct, the presence of the "Scythian" horsemen is understandable: they are Achilles' people, following in the cortege led by Thetis. The reliefs are to be read in boustrophedon fashion, like the ones on the Dance pithos.[73] By virtue of its date, the pithos makes it unlikely that the link between Achilles and the Scythians expressed by Alkaios is a consequence of the cult of the hero in Olbia.

The most striking indication that the title of lord of Scythia belonged to Achilles during his lifetime is given by the Sosias cup, in which Achilles is depicted tending the wounded Patroklos (fig. 9.8).[74] The painting is unique in style for the rendering of the eye in profile view and for the addition of white; in subject, because the

9.7a. Boston 95.506. Cycladic pithos. Body; detail. Photo: Courtesy Museum of Fine Arts, Boston.

9.7b, 9.7c. Boston 95.506. Cycladic pithos. Neck; details. Photo: Courtesy Museum of Fine Arts, Boston.

9.8. Berlin, Antikenmuseum 2278. Achilles and Patroklos. Photo: Courtesy of the Museum.

9.7b

9.7a

9.7c

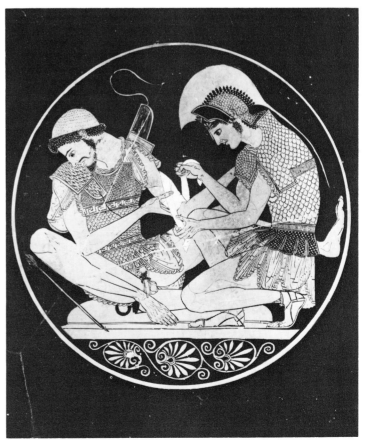

9.8

episode is otherwise unknown. Patroklos is bearded—to indicate, it has been suggested, that he is the older of the two, and so, in the tradition that makes them lovers, the *erastes*.[75] The wispy mustache, with its transverse strokes, lends to the face a certain barbarian look; the beard grows in a curious way, dipping in the center of the cheek to the edge of the jaw, and flowing from the mound of the chin like a goatee. This is the type of beard by which the painters characterize the Scythians—when they do—as on the amphora by the Kleophrades Painter in Würzburg (fig. 9.9). On the Sosias cup the characterization is subtle, not stressed by dress or function: Patroklos' features are not unlike Achilles', and he wears the heroic armor.[76] It is clear, nevertheless, that the first and dearest of Achilles' companions is here a Scythian.

9.9

The link that Exekias' amphora in Philadelphia suggested between Achilles and the archers in Scythian dress is confirmed by sounder evidence. The Boston pithos provides a terminus ante quem of 650–625 B.C. for the existence of the story and for the creation of the archers in exotic garb. They are not an Athenian creation, and their appearance on the François vase is comparatively late. Their role in the Calydonian boar hunt becomes understandable in the light of A. Stewart's interpretation of the friezes on that side of the vase as illustrations of the heroic nature and fate of Achilles, and of his recognition of cross-references between the strips.[77] Like

the spear of ash, the archers may appear in the hunt as one of the attributes of Peleus that will be inherited by Achilles.

In the third quarter of the sixth century the archers are widely employed as generic figures of attendants in scenes of epic character. Their original identity as the followers of one particular hero must not have been clear to the vase-painters, because in their work this notion survives only in sporadic and anomalous ways. The connection between Achilles and the Scythians is explicitly maintained in works of exceptional quality: the amphora by Exekias, whose iconographic repertoire indicates remarkable creativity—or a source of inspiration outside vase-painting; the tondo of the Sosias cup, which in all ways stands outside contemporary vase-painting, and may be indebted to free painting.[78] Another form of the survival of the identity of the archer consists of its juxtaposition to the Negro. The Scythian, who could be characterized as well, if not better, by his costume as by his physiognomy, while the Ethiopian could not, was adopted as the universal lightly armed attendant, but some feeling of the contraposition was not lost. Like the Scythian, the Ethiopian is sometimes depicted alone;[79] on two related vases, the mastos by Psiax on the Swiss market and the mastoid skyphos near Psiax in a private collection, they are conceived in the same manner, and something of a pair.[80] They meet again, for the last time, on the Negro alabastron from Ampurias.[81]

The manner in which Achilles' squire became just a squire cannot be followed on monuments of the first half of the sixth century, but can be understood through a comparison of representations of Ajax carrying the body of Achilles with those of Aineias fleeing Troy with Anchises on his shoulders. In his version of the Ajax scene, Exekias did not include the archer, who appears, however, on vases near him in date, such as the amphora in Melbourne, where the archer has been identified as Teukros, known as such from the *Iliad* and half brother of Ajax.[82] An identification of the Scythian as the squire of Achilles, rather than as Teukros, has the advantage of focusing the attention on the dead hero, in a manner coherent with the other secondary figures, the bereaved old man and woman. Many versions of the Aineias story include a Scythian archer. Borrowings between the two series of scenes have been noticed, and it has been proposed that in most cases the Ajax scenes are at the receiving end.[83] But two considerations argue for the opposite conclusion at least for this detail: representations of Ajax with the archer are, in

9.9. Würzburg, M. S. Wagner Museum 507. Detail. Extispicy. Museum photo: Courtesy E. Simon.

the surviving vases, earlier; the presence of the archer is relevant in the Ajax scene, but not in the other, suggesting that the figure was lifted from a meaningful context, and reemployed in a generic manner in another. In both the archer's presence is justified by the epic setting.

Matters of definition have been postponed up to now, since, for clarity's sake, it seemed best to use the current terms "Scythian" and "attendant" or "squire" to qualify the archer's relationship to the warrior in heroic armor. Attendant or squire are not intended as the precise equivalent of the Homeric *therapon*; the least misleading definition of the figures is a visual one: the Ethiopian squires of Memnon. Their function seems akin to that of *hyperetai,* some of them also characterized as barbarians of the northeastern regions.[84] The term "Scythian" also calls for qualification, since it has a geographical as well as an ethnic meaning. Did the archers, in the seventh-century saga, represent the nomadic riders of the north—Thracians, Cimmerians, later succeeded in some areas by the Scythians — or do they belong strictly to the Scythian nation?

The mention of Scythia in the fragment of Alkaios seems to recommend the second possibility, but there are strong points in support of the first. The costume of the archers, minimal at first, becomes more detailed as time goes on. On the Boston pithos all that is visible is the cap (without flaps); on the François vase it consists of an embroidered tunic and of the cap (with flaps). On the fragment of a cup by the C Painter the archer's cap has no flaps.[85] Later, more circumstantial representations of the costume find correspondence on Persian reliefs, and, as Welwei noted, in the passage in Herodotos which describes the Saka troops in the Persian army: it is not certain, therefore, that they illustrate the attire of Pontic Scythians. Welwei suggested that Cimmerians may be meant at first, on the François vase, and that later representations were inspired by the appearance of the Scythians who served in the army of the Persian king.[86]

If, as it was argued above, the archers were conceived as figures of the epic legends, it is unlikely that vase-painters intended to portray different historical populations at different times. I think that they meant to show the nomads of the north, and did so with the means at their disposal, which, around 530 B.C., included some notion of the attire and looks of real Scythians. While the artists painted the archers in "modern" dress, they also made their mythical character plain by introducing fantastic and improbable variations. Adapting to new historical circum-

stances, the costume and even the name of the bowman in pointed cap changes—from *Kimerios* to *Skythes*—but his basic nature does not. His original role is illuminated by a comparison with that of the Ethiopians, with whom he shares the task of representing the extreme regions of the earth.[87] That the point is geography, not nationality, is indicated also by the adaptation of the type to the depiction of Arymaspians.[88]

The *Iliad* and the *Odyssey* contain no mention of populations of the northern shore of the Pontus Euxinus, nor of archers attached to Achilles.[89] This fact is not surprising, since it has long been recognized that certain elements of the saga, those of magical or miraculous character and romantic or exotic ingredients, have no place in the Homeric poems. They retain no trace of the tradition concerning Achilles' immortality, or of the one of his love for Penthesileia, which was known, it seems, to the poet of the *Aithiopis*.[90] They ignore the story—preserved in Pindar and, much earlier, on a Middle Proto-Attic vase—in which Achilles was fed on the entrails of wild beasts.[91] Such colorful tales must have been the material of the folk sagas, and were often the source of inspiration for the vase-painters. One need only think of Thetis' metamorphoses as she struggles with Peleus, a theme reduced to the civil πολλὰ μάλ᾽οὐκ ἐθέλουσα in *Iliad* XVIII.434, but developed in the *Kypria,* and exploited with delight by Late Archaic painters.[92]

J. Griffin has recently argued that fantastic and exotic elements of the Trojan cycle are not absent from the Homeric poems because they are later developments, but that they were deliberately omitted. Homer's selective use of the store of material that the epic tradition placed before him would reveal his worth and character as an individual poet. Another view has been briefly presented by G. Nagy, according to whom the exceptional traits of the Homeric poems are not the result of a personal choice, but of the transformation of the epic from local to Panhellenic, requiring the abandonment of elements tied to local traditions.[93] The identification of the archers in Scythian dress as Achilles' attendants may contribute something to the question, because they fit most comfortably in an epic that has apparent ties with one particular city.

The scenes on the Boston pithos (95.506) and on the amphora in Philadelphia (University Museum MS 4873) illustrate the story told in the *Aithiopis*. In the poem the exotic element was liberally used, if we are to judge from the fact that Ethiopians and Amazons were not distant allusions, but main characters. The same poem

9.10a

9.10b

9.11a 9.11b

9.10a, 9.10b. Cherson Museum. Stele of Leoxos. After *Arkheologicheskaja Komissia Izvestija* 58 (1915) pl. 2.

9.11a, 9.11b. Odessa, Archaeological Museum. Drawing by L. F. Hall after *AJA* 38 (1934) 548.

contained the legend of Achilles' translation to Leuke and, presumably, of his immortality. The author of the *Aithiopis* is, we are told, Arktinos of Miletus. It seems hardly a coincidence, it was noted above, that the site of Achilles' dwelling and cult was located in the territory of a Milesian colony.[94] The Scythians may have been another exotic component in the epic which linked Achilles to Miletus, and to the colonization of the Black Sea. If so, it was perhaps well-suited to its time and place, but incompatible with the image of a hero venerated by all Greeks.

Legends concerning Achilles' presence in the Euxine survive in late sources. For instance, Pomponius Mela mentions a victory celebration held by the hero at the *Dromos Achilleios* and Diktys relates the legend according to which he secretly conveyed Iphigeneia to the Scythian king.[95] To generations of scholars, both ancient and modern, the idea of an Achilles lord of Scythia was distasteful—to be discounted or explained away. From Eustathius we learn that some, who quoted Alkaios' "Achilles lord of Scythia," argued that there was another Achilles, a Scythian king who loved Iphigeneia. The existence of the clone is accepted by Escher, but not by Page, whose comment on Alkaios' verse is,

however, "an eccentric legend."[96] Recently Schauenburg has explained away as an error of the painter the half-Scythian, half-Thracian garb that Achilles wears in the pursuit of Troilos on an amphora by the Dutuit Painter.[97]

Returning in conclusion to the remarks made at the beginning of this essay, the archers in Scythian dress on Attic late sixth-century vases belong, as regards their nature, entirely to the epic legends. Their original identity and their attire exhibit changes: the followers of one hero become generic squire figures, and the costume, for all its fantastic variety, reflects some knowledge of contemporary Scythians. As documents of Athenian institutions and history they should be handled warily, but they have much to offer to our understanding of the development of the epic sagas, and of the enterprise and limitations of the vase-painters.

APPENDIX: THE STELE OF LEOXOS

As the only representation of the hero-archer pair outside of Attic vase-painting, and for its provenience from Olbia, the stele dedicated to, or by, Leoxos son of Molpagoras deserves discussion here.

The amphiglyphon had been reemployed in the Hellenistic cemetery of the city. Only the central section survives, broken above the knees of the figures carved on either side: a nude youth holding a long staff, or spear, and an archer in Scythian costume (figs. 9.10a, 9.10b).[98] Not enough remains to be sure that the youth is a warrior rather than an athlete—the shaft in his hand may belong to a javelin for practice as well as to a spear, and his left hand rests on the hip in the easy gesture of the *akontist* on the amphora in Munich by the Triptolemos Painter.[99] He may be thought a warrior, however, on the strength of a comparison with the alabastron from Odessa, painted by Psiax with a figure on either side: a young warrior, nude except for greaves, shield, spear, and helmet, and an archer in Scythian dress (figs. 9.11a, 9.11b).[100] Although the youth on the stele has no shield, the similarity in subject between stele and alabastron is reinforced by the archer's gesture, which is the same in both: he holds an arrow point down, the tip with his left hand, the feathered end with his right, obliquely on the vase, almost vertically on the stele, possibly for lack of space.

An interpretation of the stele as a representation of the deceased with his attendant has been advanced.[101] What has been proposed in the preceding essay should confirm that view, by allowing us to recognize in the pair Achilles with his

9.12

9.12. Musei Vaticani. Death of Hektor. Photo: Courtesy of the Museum.

Scythian attendant. The hypothesis that the youthful nude is Achilles finds support in Pliny's reference to nude statues of youths holding a spear, which stood in gymnasia and were called Achillean.[102] But the objections voiced by H. Hiller to the interpretation of the figures as a master-servant pair are well founded. It is especially true that in that case the Scythian should be smaller than the youth, like the boy on the reverse of the Thracian Komotini stele; he is instead slightly larger.[103] Assuming that, as on the Komotini stele, the two should be combined in the viewer's mind to form one picture, the gesture of the archer seems ill-suited to the inactive pose of the youth. The Scythian is not performing some helpful task, nor standing in the anonymous attitude in which he is portrayed on the vases in scenes other than battles. Here he has chosen an arrow, and, before fitting it to his bow, is making sure that its shaft is straight, so that it will reach its target. The Scythian, in other words, is about to shoot. Depictions of this gesture are not frequent. The archer is normally shown alone, and the scene taken as no more than an illustration of real life, a vignette.[104] The Odessa alabastron suggests a different interpretation, submitted here as no more than possible, since irrefutable evidence seems out of reach.

The figures on either side of the alabastron, and of the stele, may be conceived as forming a scene, in a scheme of composition favored by the Berlin Painter, but neither his invention nor exclusively his.[105] The nude youth can, as we have seen, be thought to be Achilles. The form and decoration of the archer's cap open the possibility that he is Paris, not an ordinary Scythian.

That Paris may be shown as an archer wearing a variant of the costume—with modifications that would make his identity clear—can be seen on a Little-Master cup once on the Swiss market.[106] The scene has been interpreted as the death of Achilles. The archer who has just killed Achilles wears a helmet, but also a striped one-piece suit, while the one on the opposite side wears a tunic and stiff pointed cap. On the Odessa alabastron the archer's cap is not of the more common pointed sort, but of the type with high rounded crown, and is decorated with two large flowers. On the hydria by the Priam Painter (see Moon fig. 7.5), roughly contemporary with the alabastron, a cap of this shape is worn by an archer in the following of Priam, qualified by an inscription as *Paris kalos*.[107] The flowers may also be an allusion to the exceptional nature of the Odessa archer. Among hundreds of Scythian caps, very few have applied decoration, and the ones which do are of the rounded-crown variety. The most remarkable belongs to the archer on a fragment of a hydria in Munich, that shows him stringing his bow in a cap decorated with wings.[108] Furtwängler associated the Munich fragment to the archer in "Scythian" dress from the west pediment of the temple of Aphaia on Aegina. The latter also has a cap with rounded crown, on which remain holes for the insertion of some detail: comparison with the archer on the hydria fragment suggested that the missing detail may be wings. The identification of the Aegina archer with Paris was rejected by Furtwängler, but is maintained in Ohly's most recent description of the sculptures.[109] If wings and flowers have any meaning and are not pure embellishments, they may mark the figure as not just Paris, but as Apollo in his guise as he deliv-

ers the shot that will kill Achilles.[110]

Turning from the dress to the gesture, an enlightening parallel appears on three red-figure vases, among them the hydria in the Vatican by the Eucharides Painter (fig. 9.12).[111] The subject is the duel of Achilles and Hektor, who has fallen back, obviously defeated. Athena is on the left, and on the right, facing Achilles over Hektor's body, Apollo brandishes one arrow pointed in the direction of his enemy. The meaning of the gesture here is plain: the arrow in Apollo's hand is the one that will kill Achilles. On the Odessa alabastron, and on the stele from Olbia, the archer's garb and his gesture, by means of which one arrow is singled out, and even his size, suggest that he is Apollo in the semblance of Paris, and that the contraposition of the two figures illustrates, in an elliptical and subtle manner, the accomplishment of Achilles' fate. The conception of the scene, and the choice of the moment, are illuminated, on a less literal level, by the formal analogies that have been recognized between god and hero, by what Nagy called their "ritual antagonism." As Achilles confronts the god, about to die but still untouched, he is shown briefly as *daimoni isos*.[112]

NOTES

For advice and helpful references I thank M. J. Mellink, R. Hamilton, B. S. Ridgway, and, particularly concerning the Olbian material, A. J. Graham. I. Ozgen shared with me her knowledge of Anatolian costume, J. Haldenstein of Little-Master cups. M. E. Caskey showed me the Boston pithos, and for that I am very grateful. The cost of photographs and interlibrary loans was met by a grant from the Rosalyn R. Schwartz Fund of Bryn Mawr College. Although the manuscript was completed in July 1981, two works that have appeared since should be brought to the attention of the reader: A. Kossatz-Deissman, "Achilleus," *LIMC* (1981) 37–200; W. Raeck, *Zum Barbarenbild in der Kunst Athens im 6. und 5. Jahrhundert v. Chr.* (Bonn 1981) esp. 10–66.

1 A. W. Johnston and R. E. Jones, "The 'SOS' Amphora," *BSA* 73 (1978) 133.

2 Vienna 3694: *ARV²* 427, no. 3, Douris; *CVA* Vienna, 1, 14–15, pl. 10.

3 On the corselet, see A. M. Snodgrass, *Arms and Armour of the Greeks* (Ithaca, N. Y. 1967) 50, 90–92. For illustrations of boar's tusks helmets, see J. Borchhardt, *Homerische Helme* (Mainz 1972) 22, and pls. 2–8.

4 A. M. Snodgrass, "Towards the Interpretation of the Geometric Figure-scenes," *AthMitt* 95 (1980) 51–58, gives a critical review of the problem.

5 M. F. Vos, *Scythian Archers in Archaic Attic Vase-painting* (Groningen 1963) includes a catalog of nearly all the representations known up to its date of publication, and a full discussion of chronology and problems. Vases which have been published after 1963 are taken into account, but this essay makes no attempt to supplement Vos's list.

6 *ABV* 368, no. 106, Antiope Group; Vos, *Archers* 103, no. 131.

7 *Paralipomena* 67; H. Hoffmann in O. W. Muscarella, ed., *Ancient Art: The Norbert Schimmel Collection* (Mainz 1974) no. 56.

8 50.8.5 (A5933.50.11), *ABV* 277, no. 6; *CVA* Los Angeles 1, pl. 18.

9 Altenburg 203: Vos, *Archers* no. 364 and, on the costume in general, 40–51.

10 See, e.g., E. F. Schmidt, *Persepolis* I (Chicago 1953) pl. 37. Discussion of the correspondence of the costume of the archers on Attic vases and of the Saka on Persian reliefs is found in Vos, *Archers* 46, and in K. W. Welwei, *Unfreie im antiken Kriegsdienst* I (Wiesbaden 1974) 12–16.

11 University Museum MS 4873: *ABV* 145, no. 16; *Development* 69.

12 See my p. 129 and n. 16.

13 Vos, *Archers* 41–43.

14 The earliest appearance of the figure, on the François vase, belongs to the 570s B.C. See my p. 132.

15 Berlin 2270: *ARV²* 455, no. 3; Vos, *Archers* no. 421 and p. 90; her pp. 52–60 contain a review of the debate, nearly a century old, over the nationality of the archers.

16 Vos, *Archers* 58. Cup in the manner of Lydos: New York 25.78.6 (*ABV* 116, no. 9); M. Tiberios, *Ho Ludos kai to Ergo tou* (Athens 1976) pls. 68, 69; Vos, *Archers* 19, no. 214. Lekythos by the Taleides Painter: *ABL* pl. 13.1; Vos, *Archers* no. 95. Both examples were chosen from the group which Vos considers the earliest true-to-life depictions of the Scythians (Vos, *Archers* 4, 40–41), but one should note that the tunic is by far most frequent on earlier vases, her nos. 1–14.

17 Vos, *Archers* nos. 325–31.

18 Vos, *Archers* 38–39.

19 Würzburg 319: *ABV* 293, no. 10; K. Schefold, *Götter- und Heldensagen der Griechen in der spätarchaischen Kunst* (Munich 1978) 182, fig. 242.

20 Madrid 10920: *ABV* 332, no. 17; Vos, *Archers* no. 70. Above the head of the figure is the *dipinto*, *Paris kalos*.

21 The cap with rounded crown may serve to identify Paris in other instances (see my Appendix) but surely not in all cases. On a black-figure amphora in the British Museum, for instance, it is worn by two of the three archers represented; London B 184; Vos, *Archers* no. 44; *AthMitt* 41 (1916) pl. 25.

22 K. Wernicke, "Die Polizeiwache auf der Burg von Athen," *Hermes* 26 (1891) 63–67, proposed that the Scythians on late sixth-century vases were inspired by mercenaries hired as a mounted bodyguard by Hippias. After the tyrant's death, they would have been transferred to the service of the community, forming the earliest core of the Athenian Scythian police. Wernicke, "Polizeiwache" 70, distinguished sharply between the Scythian archers and the archers employed in war. W. Helbig, in the first of his two influential studies on the subject, "Eine Heerschau des Peisistratos oder Hippias auf einer schwarzfigurigen Schale," *SBMünchen* II (1897) 259–320, esp. 259–67, gave the question of whether the representations belong to the realm of epic or to historical reality serious consideration. He concluded in favor of the latter possibility, and in this he was followed by most other scholars who dealt with the archers, with few exceptions, notably E. H. Minns, *Scythians and Greeks* (Cambridge 1913) 55. See Vos, *Archers* passim for a critical review of earlier theories and for the pertinent references.

23 Vos, *Archers* 61–80 and passim.

24 Welwei, *Unfreie* 9–17. He effectively disposes of the notion of the archers' residence in Athens as part of the army by analyzing the diverse forms of dress, and by pointing to the lack of evidence that an archers' corps existed before the 480s B.C. He recognizes the epic legends as the proper context for the figures, and their function of escorts of the warriors in heroic panoply.

25 Vos, *Archers* 58, but see also 1–5.

26 Andokides, περὶ εἰρήνης 5 (cp. Aeschines περὶ παραπρεσβείας 173) states flatly that after the Persian Wars the Athenians bought 300 Scythian archers. The date of the purchase cannot be determined any more precisely than falling between 480 and 450 B.C.; see Welwei, *Unfreie* 51, who favors a date near the middle of the century.

27 The theory that the Athenian army had no archers in the sixth century is based on Herodotos VI.112.2, where it is said that at Marathon they fought without the support of either cavalry or archers. Vos, *Archers* 85–88, argues that the Athenian corps of Scythian archers became extinct between 510 (following a hypothetical loss of contacts with the Euxine) and 490 B.C., when the Athenians confronted the Persians at Marathon, and subsequently sought the help of Cretan mercenaries. On Cretan archers in the Athenian army see Ktesias, *Persica, FGrHist* III C, F 13, 30; Wernicke, "Polizeiwache" 70; Welwei, *Unfreie* 76, n. 33.

28 See Vos, *Archers* 70–78 for examples and a summary of the evidence.

29 Berlin 2295: *ARV²* 364, no. 45; *CVA* Berlin 2 pl. 66.6. On this point see again Welwei, *Unfreie* 16, and the laconic statement of N. Himmelmann, "Archäologisches zum Problem der griechischen Sklaverei," *Akademie der Wissenschaften und der Literatur, Mainz. Abhandlungen der Geistes- und Sozialwissenschaftlichen Klasse* (1971, no. 13) 44.

30 Examples are plentiful in a variety of contexts, e.g., Vos, *Archers* nos. 109, 132, 154, 160. There is a handsome file on an amphora by the Swing Painter in Richmond, Virginia, 56.27.3: *Paralipomena* 133, no. 4 *bis; Münzen und Medaillen A. G., Auktion* 16 (Basel 1956) no. 96, pl. 23. The view that the Scythians functioned as squires—at the service of Athenian hoplites of Peisistratean times—was first expressed by Helbig, "Heerschau" 272–78, and was widely accepted. Vos, *Archers* 61–66, argued against a special connection of the archer with the warrior.

31 Representations of extispicy—at any rate of entrails held out to a warrior—are collected by Vos, *Archers* nos. 325–31. The Ajax and Aineias scenes are treated on pp. 136–37. As examples of Scythian archers leaving the battlefield, see the volute-krater in Warsaw, *ABV* 194, no. 1; *CVA* Goluchow 1, pl. 9, and the frag. Heidelberg 228, *CVA* Heidelberg 1, pl. 34.13. On barbarians in battle scenes and on the problem of distinguishing Scythians from Persians, see K. Schauenburg, *AthMitt* 90 (1975) 106–18; idem, "Siegreiche Barbaren," *AthMitt* 92 (1977) 91–100.

32 Splendid illustrations are found in the Amazonomachies by Euphronios (*ARV²* 15, no. 6) and by the Berlin Painter (*ARV²* 1634, no. 30 *bis*), M. Schmidt, "Zu Amazonomachiedarstellungen des Berliner Malers und des Euphronios," *Tainia*, Festschrift R. Hampe (Mainz 1980) 153–68. Amazons as archers in pointed caps appear on the earliest Amazonomachies, e.g., on the Early Corinthian alabastron from Samothrace, known only from a drawing; see F. Lorber, *Inschriften auf korinthischen Vasen* (Berlin 1979) 25, no. 24. Amazon archers in "Oriental" garb, however, are not frequent before the last quarter of the century. See the examples discussed by D. von Bothmer, *Amazons in Greek Art* (Oxford 1957) 17, 60–63.

33 The earliest instance is on the dinos Louvre E 875, by a painter of the Tyrrhenian group, *ABV* 104, no. 123; Bothmer, *Amazons* 8, no. 25; Vos, *Archers* 2, no. 5. For other examples see Vos, *Archers* 20–22 passim.

34 On the garb, see the brief descriptions in the list assembled by J. Neils, "The Group of the Negro Alabastra: A Study in Motif Transferal," *AntK* 23 (1980) 15–20, 22.

35 Neils, "Negro Alabastra" 20–23.

36 London B 209: *ABV* 144, no. 8; W. Technau, *Exekias* (Leipzig 1936) pl. 26. Philadelphia MS 3442: *ABV* 145, no. 14. For a general treatment of Memnon and his Ethiopians, see G. E. Lung, *Memnon: Archäologische Studien zur Aithiopis* (Bonn 1912) 9–11; A. D. Fraser, "The Panoply of the Ethiopian Warrior," *AJA* 39 (1935) 35–45.

37 New York 98.8.13: *ABV* 149; *CVA* MMA 4, pl. 21.

38 Brussels A 130: *ABV* 308, no. 82; F. M. Snowden, Jr., *Blacks in Antiquity* (Cambridge, Mass. 1970) fig. 15.

39 Center Island, New York, private coll.: Neils, "Negro Alabastra" 22, n. 48.

40 Florence 4209: *ABV* 76, no. 1; E. Simon and M. Hirmer, *Die griechischen Vasen* (Munich 1976) pl. 55; Vos, *Archers* 1–4; see also Welwei, *Unfreie* 14.

41 The frag. by the C Painter, Akropolis 1613, has only part of an archer and remains of figures of warriors; not enough is preserved to identify the subject of the scene. The cap is pointed, but has no neck-covering flaps. See Vos, *Archers* 2; *ABV* 57, no. 117; B. Graef and E. Langlotz, *Die antiken Vasen von der Akropolis zu Athen* I (Berlin 1925) pl. 82. For Akropolis 606 (*ABV* 81, no. 1) and 2626 (Vos, *Archers* nos. 3–4), see Graef and Langlotz, *Akropolis* I, pls. 31 and 32.

42 Supra n. 33 and Vos, *Archers* no. 5. Bothmer, *Amazons* 13, places the dinos "half-way between the Camtar Painter and the Timiades Painter," adding that it is "rather late in the group."

43 Angers, Musée Pincé: Vos, *Archers* 3, no. 13, pl. I. Louvre A 242: Vos, *Archers* no. 14; *CVA* Louvre 9 pl. 90.10 and 91.4.

44 New York 25.78.6 (see supra n. 16) and two cups signed by Epitimos as potter: New York 25.78.4, *ABV* 119, no. 9, and Copenhagen 13966, *Paralipomena* 48. See Vos, *Archers* nos. 9, 11, 214.

45 Louvre F 206; *ABV* 145, no. 12; M. B. Moore, "Horses by Exekias," *AJA* 72 (1968) 358, pl. 122, fig. 6.

46 Zurich, Roš: *ABV* 147, no. 5, manner of Exekias. The amphora has since been cleaned and attributed to Exekias himself by H. Bloesch, "Heilsame Wäsche," *Wandlungen*, Festschrift E. Homann-Wedeking (Waldsassen 1975) 84–89. The attribution is supported by M. B. Moore, "The Death of Pedasos," *AJA* 86 (1982) 578–81.

47 Philadelphia University Museum MS 4873: *ABV* 145, no. 16. On the Odessa alabastron see my Appendix.

48 Philadelphia University Museum MS 3442: *ABV* 145, no. 14; *Development* 68; M. B. Moore, "Exekias and Telamonian Ajax," *AJA* 84 (1980) 430.

49 For the legends illustrated on the vase, see Proclus,

Chrestomathia, ed. A. Severyns, *Recherches sur la "Chrestomathie" de Proclos* IV (Paris 1963) 88, and Quintus of Smyrna, *Posthomerica* III.231–65. Beazley (*Development*) considered the possibility that the scene of Menelaos' pursuit of Amasos may be part of the picture on the other side of the vase. J. Boardman, "Exekias," *AJA* 82 (1978) 17, n. 36, plausibly suggested that it may serve as a "thematic link" between the two sides. On Exekian themes and compositions see also Moore, "Exekias and Ajax" 431–32.

50 The contrast of the extremes (Scythians vs. Egyptians-Libyans) serves well the author of περὶ ἀέρων ὑδάτων τόπων, see W. Backhaus, "Der Hellenen-Barbaren-Gegensatz und die hippokratische Schrift περὶ ἀέρων ὑδάτων τόπων," *Historia* 25 (1976) 170–75 and passim. Well before this treatise the concept is found in the pre-Socratic Xenophanes, H. Diels, *Die Fragmente der Vorsokratiker⁵* (Berlin 1934–1937) fr. 16: Ethiopians vs. Thracians; in Herodotos' *Histories*, e.g. II.2.2: Ethiopians vs. Scythians. The contrast is not as pointed in a line of Hesiod preserved in Strabo VII.3.7: Ἀἰθίοπάς τε Λίγυς τε ἰδὲ Σκύθας ἱππημολγούς. For a general account of the *topos* see Snowden, *Blacks* 171–76. J. Wiesner, "Zu einem attischen Bildmotiv der Peisistratiden-Zeit," *Mitteilungen der anthropologischen Gesellschaft in Wien* (Festschrift F. Hancar) 92 (1962) 294–98, saw the Scythian archers as a *Grenzmotiv* that assumed the role of the Eastern Ethiopians of the myth, but he explained their presence on Archaic Attic vases as the result of contacts with the Scythian populations east of the Caspian Sea. He recognized the proverbial contraposition of extremes on the François vase, where to the Scythians (*Kimmerisch-Iranisch*) on the uppermost frieze correspond, in the bottom one, the Pygmies. See also Welwei, *Unfreie* 13–15.

51 Proclus, *Chrestomathia*. A. Dihle, *Homer-Probleme* (Opladen 1970) 17–20, argued that Achilles' translation to Leuke was modeled on that of Memnon; cp. G. Nagy, *The Best of the Achaeans: Concepts of the Hero in Archaic Greek Poetry* (Baltimore and London 1979) 207.

52 Although he was worshiped in many parts of the Greek world, Achilles' place is the northern Aegean: Thessaly is his home, and celebrations took place each year at his tomb at Sigeion. For the sources concerning Achilles' life and the sites of his cult, see J. Escher, *RE* I (1893) 221–245, and D. Kemp-Lindemann, *Darstellungen des Achilleus in griechischer und römischer Kunst* (Frankfurt 1975) 242–48. Nagy, *Best* 342–44, stresses the close association of Achilles with the area of the Hellespont.

53 *Iliad* XIX.408–24; XXII.359–60; *Odyssey* XI.483–91; XXIV.80–84. On the two conflicting traditions see Kemp-Lindemann, *Achilleus* 227–31; Dihle, *Probleme* 17, and esp. J. Griffin, "The Epic Cycle and the Uniqueness of Homer," *JHS* 97 (1977) 42–43. An attempt at reconciliation is made by Nagy, *Best* chaps. 9–10.

54 Proclus, *Chrestomathia* 88: καὶ Θέτις ἀφικομένη σὺν Μούσαις καὶ ταῖς ἀδελφαῖς θρηνεῖ τὸν παῖδα· καὶ μετὰ ταῦτα ἐκ τῆς πυρᾶς ἡ Θέτις ἀναρπάσασα τὸν παῖδα εἰς τὴν Λευκὴν νῆσον διακομίζει. The omission of any reference to Achilles' immortality is probably due to the extreme brevity of the text. See Pindar (*Nem.* IV.47–50): . . . ἀτὰρ Αἴας Σαλαμῖν' ἔχει πατρῴαν. ἐν δ' Εὐξείνῳ πελάγει φαεννὰν Ἀχιλεὺς νᾶσον; Euripides, *IT* 435–38, and

Andr. 1260–63, where Thetis promises Peleus immortality and life in Nereus' palace, from which he will see Achilles who inhabits an island in the Euxine λευκήν κατ' ἀκτήν.

55 The earliest reference to the location of the island in the Black Sea is Pindar's, and Euripides' mention of a λευκὴ ἀκτή is generally taken as an allusion to the name; see supra n. 54. Recent surveys of sources and literature concerning the identification of Leuke with Phidonisi are: R. Bravo, "Une lettre sur plomb de Berezan: Colonisation et modes de contact dans le Pont," *Dialogues d'histoire ancienne. Annales litteraires de l'Université de Besançon* 166 (1974) 135–41; H. Hommel, "Der Gott Achilleus," *SBHeidel* (1980) 1 Abh. 13–15.

56 On the toponyms see E. Diehl, *RE* XXII, 1 (1953) s.v. "Pontarches." Diehl's treatment of the cult of Achilles in Olbia, in *RE* and in his review of I. I. Tolstoi, *Ostrov Belyi i Tavrika na Jevksinskom Ponte* (Petrograd 1918), in *Gnomon* 3 (1927) 633–43, remains important. The dedications on stone found in earlier explorations of the area are collected by V. V. Latyschev, *Inscriptiones antiquae orae septentrionalis Ponti Euxini* (Petrograd 1885–1901) I² (1916) 57–61, 91, 152–53, 271–79, 506–7; IV (1901) 11–12, 28. For recent finds see Hommel, "Gott Achilleus" 8–9. Dio Chrysostomus, *Or.* XXXVI.9, records the Olbians' affection for Achilles, and the existence of two temples, one in the city, the other on the island of Achilles, which may or may not be identical with Leuke. General accounts of the Olbian cult of the hero, containing references to earlier literature, are: E. Belin de Ballu, *Olbia: cité antique du littoral nord de la Mer Noire* (Leiden 1972) 77–82—not always reliable; Bravo, "Berezan" 134–49; Hommel, "Gott Achilleus" 7–51.

57 A terminus ante quem is given by graffiti on sherds, the earliest dating to the late sixth century, produced by recent investigations on the coast opposite Berezan and on Leuke. A summary note of the finds given by Hommel, "Gott Achilleus" 8–9, refers to the publication of A. S. Rusjaeva in *Archeologija* 2 (1971) 22–29, and to correspondence with J. G. Vinograd. The graffiti confirm the date suggested by the recovery on Leuke of a fragment of Attic red-figure signed by Nikosthenes and Epiktetos, *ARV²* 77, no. 87. The island was uninhabited apart from the sanctuary of Achilles. The search for the shrine itself, both in this century and in the last, has not been rewarding; see Latyschev, *Inscriptiones* 271–74, and K. S. Gorbunova, "Archaeological Investigations on the Northern Shore of the Black Sea in the Territory of the Soviet Union, 1965–70," *JHS-AR* 1971/1972, 49.

58 E. Rohde, *Psyche* II (Tübingen and Leipzig 1903) 369–72.

59 See A. J. Graham, "The Date of the Greek Penetration of the Black Sea," *BICS* 5 (1958) 25–42; R. Drews, "The Earliest Greek Settlements on the Black Sea," *JHS* 96 (1976) 18–31; J. Boardman, *The Greeks Overseas* (London 1980) 238–40.

60 On the vital connection between the hero's remains and his cult, see Rohde, *Psyche* I, 159–66, and Nagy, *Best* 116, 167 with references to earlier studies.

61 D. B. Monro, "The Poems of the Epic Cycle," *JHS* 5 (1884) 16–17 was among the first to point out the meaning of the coincidence. For a recent reconstruction of events, see Hommel, "Gott Achilleus" 12–13.

62 Nagy, *Best* 140–41.

63 E. Lobel and D. L. Page, eds., *Poetarum Lesbiorum*

Fragmenta (Oxford 1955) 273, no. 354 (z 31); T. Bergk's emendation of ταϚ to γαϚ is often preferred.

64 For the inscriptions, see Latyschev, *Inscriptiones* I, 506–7; the earliest appears to be the graffito from Leuke with Glaukos' dedication Ἀχιλλῆι ΛευκῆϚ μεδέοντι, Hommel, "Gott Achilleus" 9. R. Hampe and E. Simon, *Griechische Sagen in der früheren etruskischen Kunst* (Mainz 1965) 62, formulate the current understanding of the text of Alkaios, as it is found also in earlier authors, e.g., Rohde, *Psyche.* The appellative is given particular importance by Hommel, as an element supporting her main thesis, that the conception of Achilles as a god of the underworld precedes and underlies that of Achilles as a hero. In this it is difficult to follow her, nor is it easy to believe that Alkaios would begin a hymn composed on the occasion of a celebration at Sigeion with the mention of Achilles' *cult* in the northern Euxine.

65 This is obvious in the title of Pontarches, but also earlier dedications refer to the island, as Leuke or *nesos;* see Hommel, "Gott Achilleus" 9, n. 8. In the passages of Pindar and Euripides (supra n. 54) it is the sea that defines the location of the island.

66 M. E. Caskey, "Notes on Relief Pithoi of the Tenian-Boiotian Group," *AJA* 80 (1976) 19–41, esp. 26 and 29, with references to earlier literature. The Eusebian date for the foundation of Olbia, 647/6 B.C. has not, so far, been confirmed by archaeological material. The oldest pottery from Berezan, which housed the earliest Greek settlement, has been dated near the end of the seventh century; see Boardman, *Overseas* 250, and, for a discussion of the date and the form of the early settlement, Bravo, "Berezan" 111–87.

67 A vague resemblance of the exotic riders to Scythians (and Amazons) was noticed by A. De Ridder, "Amphores béotiennes à reliefs," *BCH* 22 (1898) 462–65; J. Schäfer, *Studien zu den griechischen Reliefpithoi des 8–6. Jahrhunderts v· Christ aus Kreta, Rhodos, Tenos und Boiotien* (Kallmünz 1957) 86, suggested that they may be Lydians.

68 R. Hampe, *Frühe griechische Sagenbilder in Böotien* (Athens 1936) 69, followed by K. Schefold, *Frühgriechische Sagenbilder* (Munich 1964) 42. A summary of the various interpretations is given by K. Friis Johansen, *The Iliad in Early Greek Art* (Copenhagen 1967) 272–75, where he proposed, tentatively, that the picture on the neck of the pithos may show the rescue of King Thoas, carried to safety in a larnax by the women led by Hypsipyle.

69 For the *Aithiopis* see supra n. 54. In the *Odyssey* XXIV.55–61 Thetis and the Nereids perform the funeral lament, while the Muses sing the threnos. Quintus of Smyrna, *Posthomerica* III.785–88, adds that the Nereids accompanied Thetis. The infrequent representations of the mourning of Achilles are collected by Kemp-Lindemann, *Achilleus* 227–28.

70 D. C. Kurtz and J. Boardman, *Greek Burial Customs* (London 1971) 144f.; E. Vermeule, *Aspects of Death in Early Greek Art and Poetry* (Berkeley, Los Angeles, and London 1979) 18–21, with references to earlier literature.

71 Cab. Méd. 353: *ABV* 346, no. 7; *CVA* Bibliothèque Nationale 2, pls. 71.7–9; 72.3. The resemblance of the object to the shroud on Late Geometric vases was noticed by Hampe, *Sagenbilder* 69.

72 Illustrated in R. Hampe, *Ein frühattischer Grabfund* (Mainz 1960) fig. 46.

73 For the Dance pithos see Caskey, "Relief Pithoi" 27; N. Kontoleon, "Die frühgriechische Reliefkunst," *ArchEph* 1969 (1970) 227–31, pls. 48–50. Both Caskey and Kontoleon point to the fact that there is frequently a thematic connection between the scene on the neck and that on the body of the pithos. Another episode of the *Aithiopis* was probably illustrated on the fragment of a pithos from Pikermi (Caskey, "Relief Pithoi" 35).

74 Berlin 2278: *ARV²* 21, no. 1.

75 A. Greifenhagen, *CVA* Berlin 2 (1962) 7.

76 *ARV²* 181, no. 1. E. Simon, *grVasen* 102, rightly notes in the figure of Patroklos on the Sosias cup several un-heroic elements: he sits with legs spread apart, like a *banausos,* wears the felt-cap, and his expression of extreme pain seems hardly justified by the minor wound.

77 A. Stewart, "Stesichoros and the François Vase," in this volume. Wernicke, "Polizeiwache" 63, n. 2, understood the archers on the François vase as mythical, perhaps Kimmerian heroes, and different in nature from the later Scythian archers.

78 On the number and originality of the themes introduced by Exekias see Boardman, "Exekias" 11–25. Both J. Boardman, *Athenian Red Figure Vases* (London 1975) 36, and M. Robertson, *A History of Greek Art* (Cambridge 1975) 229, attribute the exceptional quality of the tondo of the Sosias cup to a momentary abandonment of artistic conventions in favor of direct observation. E. Simon (Simon and Hirmer, *GRVasen* 102) suggests that the painter may have normally worked in another medium, perhaps in metal.

79 E.g., on a red-figure cup in the Louvre, G 93, *ARV²* 225, no. 4; *CVA* Louvre 19, pl. 53.

80 J. R. Mertens, "Some New Vases by Psiax," *AntK* 22 (1979) 24–30, pls. 9.5–6; 10.5–6.

81 Neils, "Negro Alabastra" 18, no. 46; *RA* (1913) 99, fig. 1.

82 Melbourne 1729.4: *Paralipomena* 58, no. 4 *bis,* Painter of London B 174; A. D. Trendall, *The Felton Greek Vases* (Canberra 1958) pls. 5, 6. The scene is analyzed by Moore, "Exekias and Ajax" 424–31.

83 S. Woodford and M. Loudon, "Two Trojan Themes," *AJA* 84 (1980) 25–40, examine the iconography of the two scenes as related series, and point to contaminations, e.g., the transferal of two figures of women from the Aineias to the Ajax scene. The archer, although he appears in both, is not taken as a shared motif, but tentatively identified as Teukros in the Ajax scenes, as "local color" in the others. The earliest representations of Aineias' flight that include an archer belong to the generation of the Antimenes Painter, and none seems as early as the amphora in Melbourne (supra n. 82).

84 They are certainly not *therapontes* in the sense proposed by G. Stagakis, "Therapontes and Hetairoi in the *Iliad* as Symbols of the Political Structure of the Homeric State," *Historia* 15 (1966) 408–19. On two Attic marble lekythoi, the attendant of the heroized dead wears a Thracian helmet, and is smaller than his master, but hardly a *pais,* since he is bearded; C. Blümel, "Grabvasen aus dem Bezirk des Polystratos Deiradiotes," *AthMitt* 51 (1926) 57–59. On a Melian relief the tone is, as Himmelmann notes, heroic, and the attendant's characterization may be racial rather than an indication of age; P. Jacobsthal, *Die melischen Reliefs* (Berlin 1931) 85–88, pl. 62, no. 106. See Himmelmann, "Sklaverei" 26, 29.

85 See my pp. 132–33.

86 Welwei, *Unfreie* 12–15.

87 Supra n. 50. One should not expect precision—Strabo 1.2.27 states that in ancient Greece the known countries of the north were lumped together under the name of Scythia, corresponding, he argues, to Ethiopia at the extreme south: φημὶ γὰρ κατὰ τὴν τῶν ἀρχαίων Ἑλλήνων δόξαν, ὥσπερ τὰ πρὸς βορρᾶν μέρη τὰ γνώριμα ἐνὶ ὀνόματι Σκύθας ἐκάλουν ἢ νομάδας, ὡς Ὅμηρος . . . οὕτω τὰ μεσημβρινὰ πάντα Αἰθιοπίαν καλεῖσθαι τὰ πρὸς ὠκεανῷ (Strab. *Geographica,* Q. Meinecke ed. [Leipzig 1866] 43). See also Minns, *Scythians* chap. 4, particularly p. 35.

88 See my p. 136, and, on the location of the Arymaspians in Scythian territory, K. Wernicke, *RE* II, 1 (1895) 826–27. On Skythes see Vos, *Archers* 57–58.

89 Unless an awareness of the legend shows in *Iliad* XXII.205–8, when Achilles pursues Hektor around the walls:

> λαοῖσιν δ᾽ἀνένευε καρήατι δῖος Ἀχιλλεύς
> οὐδ᾽ ἔα ἱέμεναι ἐπὶ Ἕκτορι πικρὰ βέλεμνα
> μή τις κῦδος ἄροιτο βαλών ὁ δὲ δεύτερος ἔλθοι.

In the poem βέλεμνα is used twice again, at XV.484 and 489, to mean Teukros' *arrows.*

90 Griffin, "Epic Cycle" 44–45.

91 *CVA* Berlin 1, pl. 5; J. D. Beazley, "Two Swords: Two Shields," *BABesch* (1939) 4–6. D. S. Robertson, "The Food of Achilles," *CR* 54 (1940) 177–80, demonstrated that the gruesome detail of taking the entrails of victims not yet dead is not a Roman invention (Stat. *Achil.* 95–98), but is found in Pindar (*Nem.* III.48–49) and was therefore probably part of the Archaic saga. Such behavior, Robertson notes, quoting Herodotos, IV.64, is comparable to that of Scythians.

92 Griffin, "Epic Cycle" 41. A notion of the popularity of the theme of Peleus' capture of Thetis with the vase-painters may be gained from *Vasenlisten*[3] 321–29.

93 Nagy, *Best* 7–8, n. 14.4.

94 Supra n. 61; see also Nagy, *Best* 167, and esp. Hommel, "Gott Achilleus" 21–24, where the tale of Achilles' immortality by Arktinos of Miletus and the localization of the hero's presence and cult in Leuke are seen as components of a version of the saga that springs from the enterprise of Milesians in the Black Sea.

95 Pomponius Mela, *Chorographia,* C. Frick ed. (Leipzig 1980) II.5, 28–29; Dictys, *Ephemeris belli Troiani* I.22.

96 Eustathius, on the *Periegesis* of Dionysios, 306; J. Escher, *RE* I (1893) 241; D. L. Page, *Sappho and Alcaeus* (Oxford 1955) 283.

97 K. Schauenburg, "Achilleus als Barbar; ein antikes Missverständniss," *Antike und Abendland* 20 (1974) 88–89.

98 H. Hiller, *Ionische Grabreliefs der ersten Hälfte des S. Jahrhunderts v. Chr.* (Tübingen 1975) 44–46; 128; 154–55, pl. 6.1–3, dates the stele ca. 490–480. Following G. Bakalakes, *Hellenika amphiglypha* (Thessalonike 1946) 39, she takes the two figures to represent the same man, once as an athlete, once as a warrior.

99 Munich 2314: *ARV*[2] 362, no. 14; *CVA* Munich 4, pl. 197.

100 *ARV*[2] 7, no. 5. B. Cohen, *Attic Bilingual Vases and Their Painters* (New York and London 1978) 223, noted that on the alabastron the warrior holds up the middle and index fingers of his right hand, and compared the signal to that given by Ajax in the board game with Achilles, on the amphora Boston 01.8037 by the Andokides Painter (*ARV*[2] 4, no. 7). The meaning of the game, and perhaps of the gesture, may be more complex than the simple indication of points drawn, because the scene is repeated on the exterior of a black-figure cup in Copenhagen, where the game is played not by heroes but by winged daimones; Vermeule, *Death* 159–60. The gesture is that of *apagoreuein,* to admit defeat, and in this meaning it is employed by the athlete on the fragment of a column-krater by the Painter of Akropolis 606; see C. Sweet, "Six Attic Vases in the San Francisco Bay Area," *CSCA* 2 (1969) 276, n. 14. Scythians also are shown raising their right hand with middle and index finger distended, the last two fingers firmly tucked in: on the neck-amphora in Munich, 1484, *CVA* Munich 8, pl. 417, and on another in Würzburg, 202, *ABV* 341; E. Langlotz, *Griechische Vasen in Würzburg* (Munich 1932) pl. 56. On the first, a departure scene with chariot, the archer stands facing an old man who sits on a stool; on the Würzburg vase, the archer accompanies a warrior, and the old man stands. In both, the gesture of women present, with their hands wrapped in their mantle, introduces a feeling of mourning. No doubt the scenes tell a story which we cannot identify. These instances suggest that the gesture indicates defeat in a broad sense, but it is difficult to apply this meaning to the scene of homosexual courtship on the reverse of the amphora by Lydos in the Cabinet des Médailles, 206, *ABV* 109, no. 27; Tiberios, *Ludos* pl. 27β. I owe the reference to Vermeule's passage to A. A. Donohue, and that to Lydos' amphora to A. R. Steiner.

101 N. Himmelmann-Wildschütz, *Studien zum Ilissos-Relief* (Munich 1956) 41; E. Pfuhl and H. Möbius, *Die ostgriechischen Grabreliefs* (Mainz 1977) 12–13.

102 Pliny, *H.N.* XXXIV.18; see Kemp-Lindemann, *Achilleus* 249–50.

103 Hiller, *Grabreliefs* 44, n. 119, and (the Komotini stele) 36–40, 151–52, pl. 4. On the characterization of the *pais* as a small figure no matter what his age, see Himmelmann, "Sklaverei" 22. On the small size that at times characterizes Scythian archers, see E. Kunze-Götte, *CVA* Munich 8 (1973) 74.

104 Vos, *Archers* 23–39 passim.

105 On the other alabastron by Psiax, Carlsruhe 242, *ARV*[2] 7, no. 4, the figures on either side are unrelated, but there are many late sixth-century vases on which the two sides share the action or the theme. See, e.g., the neck-amphora Leningrad 610, *ARV*[2] 18, no. 2: A, Herakles shooting, B, the Hydra; or the amphora by Oltos, London E 258, *ARV*[2] 54, no. 4: A, Achilles, B, Briseis.

106 Vos, *Archers* 2, pl. 2a. Paris may wear a cap with rounded crown, but neither high nor stiff, on the tondo of a cup by Oltos, *Paralipomena* 327, no. 50 *bis* (cp. the related 125 *ter*); see Hampe and Simon, *Sagen* 57, n. 24.

107 See my p. 130.

108 *ARV*[2] 32, no. 2, near the Dikaios Painter; T. Seki, "Eine neue Schale mit Bogenschützen," *AA* 1981, 49, fig. 4.

109 A. Furtwängler, *Aegina* (Munich 1906) 299, 308; D. Ohly, *Glyptothek München* (Munich 1977) 63.

110 In *Iliad* XIX.416–17 Xanthos predicts that Achilles will be killed by a god and a mortal, and Hektor (XXII.358–60) that he will be killed by Paris and

Apollo, but the manner of the god's intervention is not specified. Pindar, *Paean* VI.50–53, tells that Apollo assumed the guise of Paris. Representations of the death of Achilles are few; only one is identified beyond doubt by inscriptions, the Chalcidian amphora (lost, once Pembroke-Hope) published by A. Rumpf, *Chalkidische Vasen* (Berlin and Leipzig 1927) pl. 12. It shows the moment immediately following, but includes Paris with stretched bow. Kemp-Lindemann, *Achilleus* 218–21, admits as probable the scene on a Middle Protocorinthian lekythos, T. J. Dunbabin, *Perachora* II (Oxford 1962) 15–16, and that on a Pontic amphora in Copenhagen (Nationalmuseet 14.006), Hampe and Simon, *Sagen* 49, pl. 19. To those should be added: the Little-Master cup once on the Basel market (supra n. 106); the Late Protocorinthian aryballos in the Louvre (CA 1831), H. L. Lorimer, "The Hoplite Phalanx," *BSA* 42 (1947) 100–102 and more generally 93–100; the alabastron from Perachora, 1517 (*Perachora* II, 142) since, if the artist did not, the ancient owner of the piece knew that the archer was Paris, and scratched in the name. On the Pontic amphora Paris wears a plain pointed cap.

111 *ARV²* 229, no. 38; Friis Johansen, *Iliad* 216–18; see also the volute-krater by the Berlin Painter, British Museum E 468, *ARV²* 206, no. 132; the cup Vatican H 545, *ARV²* 449, no. 2 (manner of Douris); Kemp-Lindemann, *Achilleus* 169.

112 Nagy, *Best* chap. 8, esp. pp. 142–44; W. Burkert, "Apellai und Apollo," *RhM* 118 (1975) 19.

Euphronios and His Fellows

JIŘÍ FREL

Several hitherto unknown vases provide new evidence about Euphronios as painter, as potter, even as a man. My aim here is not an exhaustive study of these vases, but rather to make these new pieces accessible for further research.

Most fascinating among these are two psykters lent to the J. Paul Getty Museum. They are of different shape, but the make is similar and they were painted by the same hand. The more fragmentary psykter (figs. 10.1a–10.1c) represents men wearing chlamydes around their loins and crowns in added red, naked youths and a boy—probably all fishermen, as indicated by many nets in the scene. They are playing a game, pointing out numbers with their hands like Achilles and Ajax represented at a game table, so often depicted in late Archaic painting. The phylacteric inscriptions state the relative success: "Three, three," repeats one of them, while the boy seated high on the nets exclaims, "I have five." The inscription *Leagros kalos* suggests the date. Only the last letter of this name is preserved, but the reconstruction fills the available space well.

Another kind of gathering is represented on the other psykter (fig. 10.2). It takes place in the gymnasium; one of the youths scratches his bottom with a strigil in a back view no doubt inspired from foreshortened drawings of Euphronios, but done with more courage than competence (fig. 10.3). His misspelled name *Anbrosios* is well known from contemporary vases, but the boy next to him folding the mantle eventually became a more famous person: *Euthydikos* must be the later dedicator of the superb kore found on the Acropolis. All the other

figures are courting couples. The most explicit *erastes* and *eromenos* seem to be anonymous (unless *Hegerthos kalos* relates to this boy), while all the others are named. A boy with a mantle (fig.. 10.4), the embroideries of the cloth described by spots of diluted glaze, perhaps an expensive present, is *Andriskos,* and his companion may be *Hegerthos. Melas,* who touches his forehead in a thoughtful gesture, looks after *Antias,* a boy who likes music, for he holds a lyre (fig. 10.5).

The most surprising couple is reserved for the end of this discussion. *Euphronios,* evidently the vase-painter, reaches for the chin of *Leagros,* the most famous beauty of the time (fig. 10.6). Like *Hegerthos, Leagros* is here tagged *kalos.*

Without the names the psykter would be one more sample of a subject frequent in the vase repertory of the late sixth century. But as the figures identified here belong to the cream of Athenian society, the vase in fact might be seen as a historical document. Several of the people represented are praised or even depicted by various other painters of the Pioneer period, some by Euphronios himself; some are mentioned in stone inscriptions; some later became historical celebrities. Their company provides a proper background for the connection between Euphronios and Leagros. The painter often wrote on his vases *Leagros kalos,* putting the most emphatic appraisal of the boy, in this instance, on the lips of a naked hetaira on the Leningrad psykter with an unintentional irony.[1] But who would have suspected a relationship between an aristocratic boy, a coveted inaccessible beauty, and a craftsman from the Kerameikos who was a banausos, an unimportant commoner? Truth or fiction, the

10.1c

10.1a

10.1a, 10.1b, 10.1c. J. Paul Getty Museum, anonymous loan. Psykter by Smikros. Fishermen playing games.

10.2. Getty 82.AE.53, anonymous donation. Psykter by Smikros. Courting.

10.3. Getty 82.AE.53. Ambrosios and Euthydikos.

10.4. Getty 82.AE.53. Hegerthos and Andriskos.

10.5. Getty 82.AE.53. Melas and Antias.

10.6. Getty 82.AE.53. Euphronios and Leagros.

10.1b

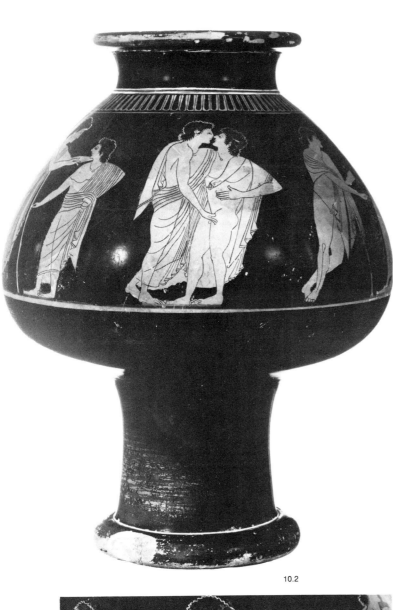

10.2

10.3

10.4

10.6

10.5

gossipy drawing seems to reflect reality; the representation forces another look at the social status of the potters and painters in Athens. Whatever it may be, the personality of Euphronios appears now in a new light. Perhaps the outcry of Euthymides (emphasizing his citizenship by the mention of his father's name) written on the Munich amphora:[2] "Euthymides painted son of Polias as never could have done Euphronios" [split on both sides of the pot] may express with sour humor some jealousy concerning Euphronios' social status. Euthymides' quality of line on the Munich amphora is indeed superb but the composition is insignificant. From his exclamation we also learn something of Euthymides' citizenship.

This is precisely the same time when another parvenu, Themistokles, having not been admitted to an aristocratic gymnasium, successfully used his ascendance and probably also his father's money to promote a new gymnasium; much as we imagine for Euphronios, Themistokles won the favors of a coveted *kalos* in competition with Aristeides, then a young aristocrat of an excellent but poor family. This started a rivalry which made history.

This is not all. Both psykters were painted by Smikros (the courting psykter was attributed independently to this painter years ago by D. von Bothmer who had also read the inscriptions). At first glance the poor drawing may seem unworthy of this pupil of Euphronios. With Smikros' best pieces, like the signed jug in Berlin,[3] one suspects some help from the master, but there are plenty of characteristic features of his style on our two psykters, like the hook-shaped collarbones and hirsute profiles, which are equal to Smikros' signature. And perhaps Smikros wanted to sneak himself into this high-life circle where Euphronios excelled. One of the *paidika* has an eloquent name, Andriskos, meaning "little man," an apt alias for Smikros, the "little one." And the little man sports a luxurious mantle which he must have been given as a present.

Smikros may have succeeded in his social ambitions. He represents himself participating in a symposium and Euphronios depicted his pupil at another banquet.[4] In both cases, the ambience is quite different from the courting gathering on the psykter. The "self-portrait" shows Smikros involved with a girl of pleasure, two of whom participate at the symposium. Euphronios put on record a cultural happening in the banquet attended by Smikros, who is depicted there with a growth of peach fuzz on his jaw. Is Smikros growing out of the *kalos* age? Inspired by the

10.7a

10.7b

wine, a companion of Smikros sings a lyric (inscribed on the vase) which is accompanied by a flutist named Syko. The latter has her better days already behind her; the double chin denotes aging rather than welfare.

Perhaps Syko did not excel only in music. One is tempted to recognize her in the old hag on a cup signed by Phintias.[5] At first she is sitting, her foot under her leg, receiving a calyx-krater as a gift from a youth in need (fig. 10.7a). Perhaps it is Phintias himself. He did paint and perhaps throw similar kraters. In the other scene (fig. 10.7b), she is at the point of competently satisfying whatever her client may have wanted. Three "spare tires" on her belly, hanging breasts, and her triple chin betray her age, but she does not seem to have lost anything of her desirability or professional abilities. If it is not Syko, it must be her clone! Whatever the name is, Phintias' drawing is exquisite. Phintias is known to have been friends with Euthymides;[6] if the proposed identification of Syko is correct, he must have been in some ways close to Euphronios and Smikros too. With the new vases, the everyday life in the Kerameikos becomes much more alive for us today.

One more look at the scene on the "courting" psykter by Smikros. The profiles, which the painter may have wanted to be irresistibly beautiful, nevertheless present rather unattractive stereotypes of people, including the depiction of Euphronios. The young apprentice certainly failed to flatter his master. All the faces have silly eyes and small petulant lips and seem to define greedy village boys, rather than numbers of the Athenian *jeunesse dorée*. It is superfluous to insist that the inscribed figures are general images, not at all individualized portraits. However, there is some perennial repetition of the same physical type. An amusing parallel for the faces on both psykters is provided by an early Byzantine bronze, the head of a youth (fig. 10.8). It may be tempting to explain the similarity by the clumsiness transcending the ages if it were not for the fact that the same physical type appears among the Mediterranean youth even today.

The new Getty vases by Euphronios himself were, in the meantime, published by M. Robertson,[7] which allows us here to condense our discussion.

Three cups thrown by Kachrylion illustrate the beginnings of Euphronios as painter.[8] They are earlier than the vases considered until now as his prime, like the Boston psykter.[9] J. D. Beazley previously attributed the London cup to Oltos,[10]

and without the signature of Euphronios on the Sarpedon cup "one might have thought rather of Oltos."[11] This is surely not the last word. Other attributions to the very young Euphronios may follow and one may fear that he may be overextended at the expense of Oltos and perhaps of other painters.

Euphronios learned his draftsmanship from Oltos, but already at his earliest it is striking how the pupil surpasses the teacher. Indeed, the line follows the model of Oltos, as do many elements of the design like the folds of the drapery, the eyes, the mannered fingertips, the palmettes, even whole figures and also the exuberance of details. But the results are different. Oltos' figures, even at his best, remain flat silhouettes— even the most complicated movement remains two-dimensional.[12] This produces a rather unpleasant contrast when the figures are filled by interior details, like rich embroidery or scales of armor.[13] Also, the Oltian figures often look sturdy, with straggly heads. Euphronios from the outset had a better understanding of proportions, finding instantly the well-rounded heads, as they persist even in his late work. The abundance of inner details (as in the armor in Sarpedon's funerary parade) is functional and enhances the figures. Even at his first stage Euphronios successfully attempts to draw foreshortening, usually occurring in complex movements which are well developed in space. (See the figure of the *pyrrhistes* on the Sarpedon cup, fig. 10.9a–b.) But the main difference concerns composition and ethos. While Oltos decorates, Euphronios develops dramatic narration. The carrying of Sarpedon's body introduced by the slowly marching Akamas (figs. 10.9b, 10.10) reaches an astonishing effect: "Wir tragen keinen König, wir tragen einen Tot."[14] Equally moving is the despair of Thetis (fig. 10.11) who faces the body of her son while his teacher, Phoinix, cannot stand the view and turns away. Oltos must have appreciated the work of his apprentice. Later he even tries to do like Euphronios: for example, his Herakles fighting Kyknos.[15] He succeeds in depicting the resulting melee only in one plane and the dramatic moment does not go beyond external gestures.

One particular aspect of the earliest Euphronios is rather surprising, considering his later career: all three cups are decorated with painstaking care. The drawing is flawless to the last detail of the floral decoration. Oltos, an attentive draftsman himself, must have been pleased with his student. One wonders how much he later approved of the Boston psykter. However,

10.7a, 10.7b. Getty 80.AE.31, anonymous donation. Cup by Phintias. Phintias and Syko (?).

10.8. Private collection. Bronze head, fifth century A.D. Youth.

10.9a

ΣΑΡΠΕΔΟΝ

10.9b

10.10

10.9a, 10.9b. Dallas, private collection. From a cup signed by Euphronios. Youth and Pyrrhistes.

10.10. Akamas carrying the body of Sarpedon, followed by Sleep and Death.

10.11. Getty 77.AE.20, anonymous donation. Cup by Euphronios. Ajax carrying the body of Achilles toward Thetis.

10.11

Euphronios and His Fellows 153

10.12 10.13 10.14

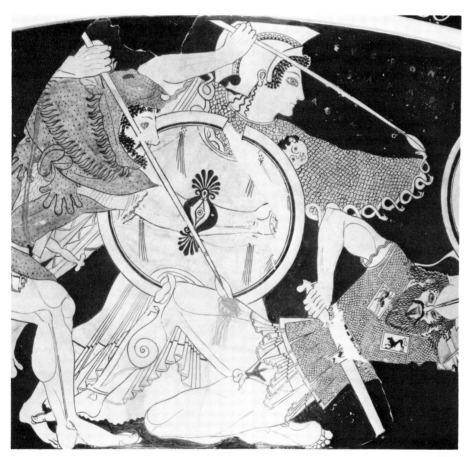

10.15a 10.15b

10.15c

when the mature Euphronios decorates cups again (whatever is lost for us in the meantime) he produces two masterpieces of perfect draftsmanship.[16]

One important circumstance has to be mentioned about the Sarpedon cup. It was restored in antiquity which, by itself, is rather banal; the way the repair was achieved is unique. A bronze sheet collar, covered on the top, open at the bottom, was inserted inside of the stem to secure its join with the body; a bronze rivet goes slightly off-center through the elaborate palmettes in the medallion. Another cup, decorated inside only,[17] is not far from the three others, but the Amazon in the style of depiction is of another nature. Even if very Oltian in appearance, it aspires to the monumental, while the three other cups look rather like miniatures. Euphronios will develop further in this direction.

The calyx-kraters form a distinct group in Euphronios' oeuvre; with the exception of the early piece in Berlin, they go together closely. A. Pasquier, inspired by the discovery of the foot belonging to the Antaios krater in the Louvre and some other new elements, presented (with the help of Bothmer) an excellent survey of them.[18] Several new pieces can be added here.

1 Fragment in Milan (Herakles), *ARV²* 14, no. 5 (difficult to place).

2 Louvre G 33, Dionysos with Satyrs and Maenads, *ARV²* 14, no. 4. Three fragments were recently given to the Louvre: first (fig. 10.12), with the lower part of Dionysos and the right of the Maenads before him, attributed by R. Guy and put in place by Bothmer; the second fragment (fig. 10.13) with the occiput (of a Satyr, following Pasquier); the third giving a section of the rim and the top of a thyrsos (fig. 10.14).

3 New York 1972, 11–10, A/ carrying Sarpedon, B/ arming; Bothmer, *AA* 1976, 485ff., Pasquier, fig. 29.

4 Private collection, Dallas, A/ Herakles and Kyknos, B/ athletes; one of them was Antias—part of the name survives; Robertson, "Euphronios at the Getty" 29ff. (figs. 10.15a–10.15c).

5 Two fragments, Getty 77.AE.86, Athena (and Perseus), Robertson, "Euphronios at the Getty" 27f. (fig. 10.16).

6 Louvre G 103, A/ Herakles and Antaios, B/ Concert (*ARV²* 14, no. 2), Pasquier, figures 8–24 (including the two tiny new fragments recovered miraculously by Bothmer). See also H. Giroux, *Mélanges Maurice Lebel* (1980) 93ff.

10.12. Louvre G 33. Fragment belonging to a Euphronios krater. Part of Dionysos and a Maenad.

10.13. Louvre G 33. Krater fragment. Back of a head.

10.14. Louvre G 33. Krater fragment (rim).

10.15a. Dallas, private collection. Athena assists Herakles slaying Kyknos.

10.15b. Head of Kyknos.

10.15c. Ares and Aphrodite.

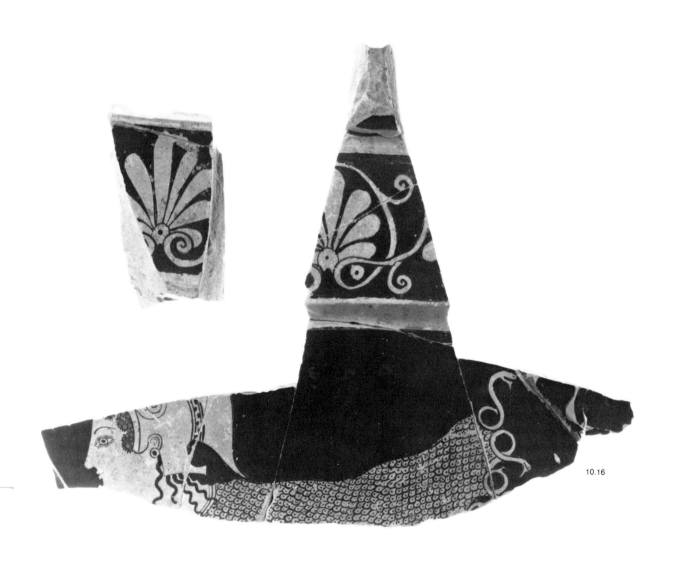

10.16

7 Munich symposium with participation of Smikros, *ARV²* 1619, no. 3 *bis*, *Paralipomena* 322, no. 3 *bis*. *Münchener Jahrbuch* 22 (1971) 229.

8 Louvre G 110, A/ Herakles and the lion, B/ Special kind of *komos*: hopping on greased wineskins performed at the second day of rustic Dionysia (*ARV²* 14, no. 3).

9 Fragment, Getty 77.AE.6 (rider), Robertson, "Euphronios at the Getty" 28f. Beautiful drawing, difficult to place; surely rather late (fig. 10.17).

No. 2 (Louvre G 33) seems earlier than anything else, because of the one-plane composition, and also because of the proportions (see also Pasquier), but it is signed by Euxitheos, as is no. 3 (Metropolitan Museum) which is of absolutely identical form as nos. 4 (private collection, Dallas) and 5 (Getty)—the last, of course, for the preserved rim. These must also be by Euxitheos, to which there can be added nos. 6 (Louvre G 103) and 7 (Munich). No. 8 (Louvre G 110) is of different proportions, but it seems to be of the same make. Euphronios must have systematically decorated Euxitheos' calyx-kraters during a rather short period of time around 510.

Athena's head as represented on kraters nos. 4 and 5 is not too far from the goddess head on Athenian tetradrachmai which the numismatists date about 510–505 B.C.[19] With the exception of the rather earlyish Dionysiac krater in the Louvre (no. 2) and the splendid Munich symposium (no. 7) with a rather simple composition, all the other kraters, at least for the main side, show Euphronios at his best. Dramatic action projects the protagonist in the first plane, while the background provides its accompaniment. The frightened girls attending the fight of Herakles between Antaios appear like a chorus in Attic tragedy. Hermes, messenger of Zeus, will direct the funerary preparations for Sarpedon. Athena interferes, opposing Ares who came to rescue his son who was struck by Herakles. Always a scenic presentation enhances the ethos and dramatic tension of the scene raises it from decoration to *megalographia*. The draftsman is at his best but nonetheless occasionally slips. Euphronios is capable of ignoring or neglecting the secondary sides of his big vases.[20] But sometimes the painter is obviously bored with his work—he doesn't care: for example, the hand of Hermes on the Metropolitan krater, the florals on its rim and under the handles and, to a lesser extent, the florals on the Kyknos krater. The

worst floral is on the Herakles lion krater in the Louvre, where also on the reverse an athlete has hands like scrapers, without nails. This feature reoccurs with the servants on the otherwise marvelous krater in Munich. Indeed, the Boston psykter is not an exception.

The Antaios krater in the Louvre shares with the Metropolitan and the Kyknos kraters (fig. 10.18), and another one by the Dokimasia Painter, the thick concentric circles on the bottom of the foot.[21] Inside, instead of one reserved fillet under the rim, there are five distributed throughout the whole inside; it occurs only on the calyx-krater, probably by Oltos, CA 5359 in the Louvre.[22]

Pasquier demonstrated that another vase is closely connected in time and style with the group of calyx-kraters: the Leningrad psykter.[23]

10.18

The two big parade cups may belong to the same period while the volute-krater in Arezzo, the cup fragment in Tarquinia, and a plate fragment from Brauron in Athens are later,[24] demonstrating how in the last decade of the century Euphronios surpasses his fellows and even himself. The stamnos in Leipzig also may belong to this grouping of very late drawings.[25] The treatment of the kneecap with three vertical segments brings the stamnos close to the figure of the *akontistes* on the Louvre amphora.[26] This may be the very last surviving drawing by Euphronios. Under a magnifying glass, the lines appear rather insecure, suggesting that Euphronios must have been losing his firm grasp; his eyes might have been becoming inapt for close work. This matches Beazley's suggestion, as further developed by J. Maxmin.[27] One must remember Euphronios' dedication on the Athenian Akropolis asking for good health; the fact that the painter was losing his eyesight seems to find confirmation. However, Euphronios was not broken down. He turned to potting and the cups he threw are no less brilliant than his previous drawings. For the last years of the sixth century and the first three decades of the fifth, the best painters will decorate his cups. It has been suggested that even in this field he was a real pioneer

10.16. Getty 77.AE.86. From a krater by Euphronios. Athena.

10.17. Getty 77.AE.6. Fragment of a krater by Euphronios.

10.18. Dallas, private collection: Bottom of the foot.

10.17

in developing the extant shapes. This can be now confirmed by a part of his signature as potter on a fragmentary covered spouted vase decorated by Onesimos at his prime (fig. 10.19). Such a curious shape proves that his repertory must have been broader than we previously thought.

Thus Euphronios knew an easy success both in art and social life. For the former, he used only his talent, reserving perhaps the genius for the latter.

NOTES

1. *ARV²* 16, no. 15.
2. *ARV²* 26, no. 1.
3. *Paralipomena* 323.
4. Stamnos, Brussels, *ARV²* 20, no. 1; calyx-krater. Munich, *ARV²* 1619, no. 3 *bis, Paralipomena* 322, no. 3 *bis.*
5. *ARV²* 1620, no. 12 *bis,* now in the J. Paul Getty museum.
6. *ARV²* 23, no. 7.
7. M. Robertson, "Euphronios at the Getty," *GettyMJ* 9 (1981) 23–34.
8. Private coll. with Sleep and Death carrying Sarpedon; Getty 77.AE.20 with dead Achilles; and London E 41.
9. *ARV²* 16, no. 14 and the Berlin calyx-krater *ARV²* 13, no. 1.
10. *ARV²* 58, no. 51.
11. Robertson, "Euphronios at the Getty" 26.
12. *ARV²* 54, no. 5.
13. For example, the cup in Tarquinia *ARV²* 60, no. 66, or the spendid amphora, signed by the potter Euxitheos, in London *ARV²* 54, no. 4.
14. F. Dahn.
15. Cup in London *ARV²* 63, no. 88, painted ca. 510 B.C., surely imitating the superb calyx-krater by Euphronios.
16. *ARV²* 16, nos. 17, 18.
17. Louvre C 11981, *ARV²* 17, no. 21.
18. A. Pasquier, "Nouvelles découvertes à propos du cratère d'Antée peint par Euphronios," *Revue du Louvre* 31 (1981) 1–9.
19. See M. Price and N. Waggoner, *Archaic Greek Coinage: The Asyut Hoard* (London 1975) 56, pl. XXXII.G and H.
20. One of the most incredible compositions, rich to confusion and very negligent in drawing, occurs on the secondary side: the *askoliasmos* on Louvre G 110.
21. See Pasquier, "Nouvelles découvertes" 9, n. 29.
22. Information owed to H. Giroux.
23. *ARV²* 16, no. 15.
24. *ARV²* 16, nos. 17, 18; *ARV²* 17, no. 19, *AA* 1977, 228; *ARV²* 15, no. 6, *ARV²* 17, no. 23.
25. *ARV²* 15, no. 8.
26. *ARV²* 15, no. 10.
27. *Potter and Painter in Ancient Athens* (London 1944) 34; "Euphronios *Epoiesen:* Portrait of the Artist as a Presbyopic Potter," *Greece and Rome* 21 (1974) 178–80.

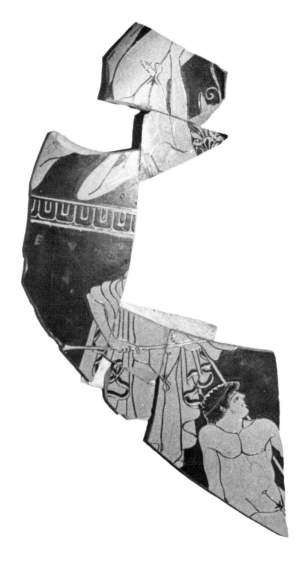

10.19. Getty 81.AE.195, anonymous donation. Fragment of a covered spouted vase signed by Euphronios as potter.

The Centaur's Smile: Pindar and the Archaic Aesthetic

BARBARA HUGHES FOWLER

In Pindar's ninth *Pythian,* Apollo, who has seen the nymph Kyrene wrestling with a lion and fallen in love with her, asks Cheiron if it would be permitted to take her to bed and shear her honey-sweet meadow grass. The Centaur, inspired, smiles greenly, with soft eyebrow, and says, "Hidden are the keys of wise Persuasion."

The reading χλοαρόν, "greenly," printed by C. M. Bowra in his 1947 Oxford edition and by B. Snell and H. Maehler in the 1980 Teubner text, is O. Schroeder's emendation.[1] The manuscripts offer χλιαρόν, "luke-warmly,"[2] or χλαρόν,[3] otherwise unattested but recently taken by E. D. Francis and L. Woodbury as from χαλάω and interpreted as "relaxed" in the sense of cheerful or indulgent.[4] Schroeder saw χλαρόν as the contraction of a Doric form of χλοερός, glossed by Hesychius as χλωρόν "green," ὠχρόν "yellow," νέον "new," ἀπαλόν, "soft." He, therefore, interpreted the green smile as "ein farblos, 'blasses' Lächeln,"[5] which seems altogether too colorless and pale for Pindar. Bowra thought that χλοαρόν suggested the freshness of nature in spring.[6] R. W. B. Burton accepts Schroeder's reading but states that "there is no means of discovering what the phrase χλοαρὸν γελάσσαις can have conveyed in Greek."[7] I, on the contrary, think that there is.

The role of Cheiron as a gentle teacher, tender rearer of children, is one that occurs elsewhere in Pindar. In *Pythian* III.1–7 the wild beast, who had a mind friendly to men, reared Asklepios to become the gentle fashioner of pain's ease. In *Pythian* IV.102–106 Jason declares that he can carry Cheiron's teaching, for he has come from his cave where Chariklo and Philyra, the Centaur's holy daughters, reared him, and in twenty years he has done no deed, spoken no word to offend them. The Centaur, as all Jason's behavior shows, has made him a gentleman.[8] In *Nemean* III.43–49, Achilles, when he lived as a child in Philyra's house, slew lions and wild boars and dragged their heaving bodies back to the Centaur, for the first time when he was six years old—and then ever after. It was Cheiron too who in *Nemean* IV.60–65 stood beside Peleus when he withstood the sharp claws and terrible teeth of lions to marry one of the high-throned Nereids.

There is something particularly poignant about this half-man, half-beast as rearer of gentlemen, mentor of hunting child, protector of human beings against the wild. That he should be gentle, a force for good, is especially affecting when one thinks of the origin of those Centaurs who in *Pythian* II.44–48 are born of Kentauros, the offspring of the wicked Ixion and the cloud-phantom fashioned by Zeus, and the Magnesian mares who dwelt on the spurs of Pelion. "Out they came," as B. L. Gildersleeve puts it, "a host marvelous to behold . . . the dam's side down, the upper side the sire's." And then Gildersleeve comments, "Chiasm is as natural to the Greeks as mother's milk; not so to us."[9] Yes, but the chiasm goes deeper than syntax; it is a matter of biology. The expression τὰ ματρόθεν μὲν κάτω, τὰ δ᾽ ὕπερθε πατρός is in a curious way both abstract and concrete and therefore just slightly humorous.[10] Pindar, despite himself, finds these grotesques appealing.

Elsewhere too Pindar betrays a tenderness for monsters, an interest in births. These seem to go deeper than the accidents of mythological narrative or the emphasis upon genealogy that the epi-

nician demands, for Pindar lavishes upon both babies and beasts the finest of his visual detail. Often too the babies and the beasts are significantly juxtaposed.

In *Pythian* II.72–73 the ape is set, to point a moral, in juxtaposition to children: καλός τοι πίθων παρὰ παισίν, αἰεὶ καλός "pretty is the ape to children, always pretty." In *Pythian* IV the infant Jason is smuggled off by night in crimson swaddling clothes to Cheiron to rear. Other creatures in this ode are not set in immediate context with this baby, but they are an important part of the narrative and they are described with the same jewellike precision. The wryneck which Aphrodite sends for the first time to mortal men bound on its four-spoked wheel is ποικίλαν (IV.214). The adjective may refer to its magic powers, its cleverness, or to its appearance: the wryneck is a speckled bird. It is likely that it includes both notions and that Pindar scarcely distinguished the visual from the abstract image. The oxen which Aietes brings for Jason to yoke and drive breathe ravening fire from tawny jaws and tear the earth with brazen hooves (225–26). The serpent that guards the fleece with most ravenous jaws is greater in both length and breadth than a fifty-oared ship; it is also green-eyed (γλαυκῶπα) and of spangled back (ποικιλόνωτον [249]).

The serpents which in *Olympian* VI nourished (ἐθρέψαντο—"the affectionate middle," as Gildersleeve puts it)[11] the baby Iamos on "venom" of bees were also γλαυκῶπες (45–46). Here, more strikingly than anywhere else in Pindar, is a juxtaposition of baby and beast; here too is his most stunning use of color. Euadne herself was violet-haired (30). She put aside her crimson robe and her silver pitcher to give birth to the prophetic child beneath the dark blue-green thicket. Golden-haired Apollo made Eleithuia and the Fates stand beside her (39–42). The baby itself lay hidden in a bed of rushes, his soft body drenched in the yellow and purple rays of violets (53–56).

Another memorable account of babies, their birth, and almost immediate encounter with beasts occurs in *Nemean* I.35–53. Herakles as he came straightway into the shining light, freed from his mother's birth pang, together with his twin brother, did not escape the notice of golden-throned Hera as he was wrapped in his saffron-dyed swaddling clothes, for she sent snakes with swift jaws, raging to coil themselves about the children. Herakles raised his head and made first trial of battle; clutching the throats of the two serpents with his own (ἑαῖς—a sweet touch)

inescapable hands, he strangled and crushed the breath from their unspeakable limbs. There follows the half-humorous picture of Alkmene rising barefoot from her childbed and Amphitryon rushing, sword in hand, to the rescue. The narrative is alight with detail, tender, humorous, and somehow heroic too.[12]

A certainly humorous version of the same tale occurs in *Paean* XX.10–15 where the little Herakles raised his head, threw off his embroidered swaddling clothes (ποικίλον σπάργανον) to show his physique (ἑὰν . . . φυάν) and "whirled a gleam from his eyes" (ὀμμ]άτων ἀπὸ σέλας ἐδίνασεν), while Alkmene started up unclad from her childbed. "The ordeal," as T. B. Rosenmeyer remarks, "cannot be taken seriously. Like the crab, also sent by Hera, and like the Hydra, the serpents are from the cabinet of horrors from which the black-figure vase painters drew their most delightful grotesqueries."[13]

In *Pythian* I Pindar's description of his most horrific monster, the hundred-headed Typhon, is more tender than terrifying. It was the Cilician cave of many names that tended (θρέψεν) him. One thinks again of an infant or child. Heaven's pillar, snowy Aetna, yearlong nurse (τιθήνα) of sharp ice and snow holds him down. Here τιθήνα construes with χιόνος, but the memory of θρέψεν from above persists and prevails over the detail of his shaggy chest which comes between and which in any case makes him more appealing than not, more human than monstrous, and all but cancels out the fact of his hundred heads. Again, that Pindar calls this monster ἑρπετόν enchants rather than frightens us; it so recalls Alkman's "creeping breed that dark earth feeds" (89.3). Wonder rather than terror exists in the description of him as a τέρας that is θαυμάσιον προσιδέσθαι and a θαῦμα . . . ἀκοῦσαι. Finally, one is awed or moved even to pity at the picture of him shackled beneath the black-leaved peaks and the foot of Aetna where "his jagged bed goads all his back bent against it" (16–28).

Pindar's Typhon is not so benign as the smiling rendition of him on a late-seventh-century Corinthian alabastron with his tail wittily looped to fit the curve at the bottom of the vase (fig. 11.1),[14] nor are his beautiful green-eyed snakes perhaps so naive as the gracefully undulating sea serpent on a wide-awake kantharos from Pindar's native Boeotia.[15] Still, these monsters share with Pindar's babies and beasts those qualities of innocence and humor that appear in all the other hybrid creatures—Gorgons, Harpies, Sirens, Sphinxes, Satyrs, Silens, and Centaurs—that

11.1. The University of Iowa
Museum of Art 1971.273.
Typho. Photo: Courtesy of the
University of Iowa Museum of
Art, Iowa City, Iowa.

11.2. Boulogne-sur-mer, Musée
Municipal 558. Exekias. Ajax
Prepares for his Suicide. Photo:
Courtesy of the Museum.

11.1

11.2

cavort about upon the surfaces of black-figure
vases. No one could ever have taken them
seriously.

Juxtaposition, like that of baby and beast to
express a magical innocence and occasionally
humor, is in literature a recognized Archaic tech-
nique.[16] It may be seen as such in art as well.
The black-figure vase-painters often combined in
a single scene events, such as the recovery of
Helen, the murder of Priam, and the hurling of
Astyanax from the walls, that could not really
have taken place at exactly the same time or in
exactly the same place.[17] Or, more abstractly,
they chose elements of a story as symbols and so
condensed a long or complex narrative into a
single picture. Thus Exekias in portraying the
suicide of Ajax puts a sorrowing palm tree on
one side of him, perhaps to show that the event
occurred in Asia (fig. 11.2)[18] or perhaps, as later
in Sophokles' play, to show him alone with
nature,[19] and his empty armor on the other to
suggest not only his loneliness but, obliquely, the
cause of his suicide.[20] Again, juxtaposition
occurs, iconographically, when Cheiron carrying
a pine branch or one slung with the little car-
casses of beasts and clad,[21] however improbably,
in a himation, received Achilles.[22] As he is him-
self a combination of man and beast, so his attri-
butes as well as his confrontation with Achilles
show him as a hunter from the wild and a civi-
lizer of little men.

Pindar tells stories in much the same way.
Gods are marked by their attributes, usually
gold.[23] Sequences in time are, as in *Pythian* IV,
ignored. Only selected episodes are told: the
beginning, not the end, of Bellerophon's story in
Olympian XIII. Pindar, born in 518 B.C., though
he lived and worked into the era of the Severe
style, seems to have been little affected by it. He
is by common consent the last and finest flower
of the Archaic.[24] It is not surprising then that he
shares a number of techniques with the black-
figure vase-painters, for what, after all, is style
but a way of seeing?

Besides juxtaposition, symbolism, and selec-
tivity Pindar and the black-figure vase-painters
share the quality of decorativeness, ποικιλία,
which had been a favorite concept of the earlier
Archaic lyricists. They used the adjective ποικί-
λος ("variegated") for the most part quite con-
cretely of "embroidered" robes (Iby. 316.1) and
shoes (Anac. 358.3; Sappho 39.2) and headbands
(Sappho 98.11); of Aphrodite's throne (Sappho
1.1); of ducks (Alc. 345.2); of the kingfisher
(Simon. 508.6); of a snake bracelet (Alcm. 1.66–
67); of trinkets (Sappho 44.9). Alkman (Alcm.

93.1) used it of the worm that destroys the vine bud; he may refer to its motion, its appearance, or its character.[25]

Pindar uses the word, concretely, alone or in compounds, to refer to snakes (*Pyth.* IV.249; *Pyth.* VIII.46) and to the Gorgon's head which is "intricate" with snake hair (*Pyth.* X.46); to colts which have "fancy" reins (*Pyth.* II.8); to Herakles' "embroidered" swaddling clothes (*Paean* XX.11). He uses it with perhaps some abstraction of the wryneck (*Pyth.* IV.214). Most often he uses it, literally, of music, referring presumably to the subtle variations of pitch which we think to have been characteristic of Greek music (*Ol.* III.8; *Ol.* VI.87; *Nem.* V.42; fr. 179; fr. 194.2; *Nem.* IV.14; *Ol.* IV.2).[26] Most tellingly, however, he uses it, metaphorically, of his own technique. In *Nemean* VIII.15 he calls his own victory song a "Lydian veil soundingly embroidered" (Λυδίαν μίτραν καναχηδὰ πεποικιλμέναν), and in *Pythian* IX.77 he says that great achievements run always to many words: "to embroider (ποικίλλειν) a few things among the many brings a hearing to the skilled." It is his style then to elaborate a few details from the high adventures of heroes. A part of the embroidery is his use of color.

The version of the Return of Hephaistos which appears on an Attic black-figure neck-amphora from the Medea Group and dates to about 520 B.C. seems particularly Pindaric in both its humor and its poikilia (fig. 11.3). Hephaistos wears a himation which is embroidered with dot-clusters and bordered with color. Dionysos' mantle is equally elaborate. The vine sprays, the ivy on the krater, the five marks on the donkey's fur are all part of the poikilia. The exceptional use of added color—red for the beards, the stripe across the brow for the satyr's hair, the donkey's mane, the two strokes on his thigh, the borders of the garments; white for the chitons, the ivy on the krater, the embroidered dot-clusters on the himatia, the marks in the fur, and the donkey's belly-stripe and muzzle—adds to the Pindaric sense of gaiety.[27]

The wit in this painting lies in the story itself, which is on the François vase and elsewhere treated always with humor.[28] Here, however, there is additional fun. The Satyr, disgruntled apparently at having to carry so heavy a load, shows his teeth and pulls the donkey's tail. The donkey, in turn, snorts or brays, while it is he and not, for a change, the Satyr that is aroused—and sports a pot besides. One remembers Apollo, in *Pythian* X.36, among the ass-sacrificing Hyperboreans who "smiles seeing the upright lust

11.3

11.4

11.3. On loan to the Elvehjem Museum of Art, Madison, Wisconsin. The Medea Group. The Return of Hephaistos. Photo: Courtesy of the Museum.

11.4. Vatican City, Museo Etrusco Gregoriano 344. Exekias. Achilles and Ajax Playing Draughts. Photo: Courtesy of the Museum.

of the lewd beasts" (γελᾷ θ' ὁρῶν ὕβριν ὀρθίαν κνωδάλων).

Pindar's epinicians are songs of glory and so for the most part of joy. Not all, however, is innocence, humor, and gaiety. There are shadows, such as those that fall across the dazzle of sunlight and gold in *Olympian* VII, and there are still darker passages, for Pindar, like the later black-figure vase-painters, sometimes saw the sadness and dignity implicit in some of their favorite—and more gruesome—tales. He remembers in *Isthmian* VIII.49–58 the funeral of Achilles who had "bloodied the Mysian vineyards, drenched them in the black gore of Telephus, bridged for the Atreidae a voyage home, set Helen free, cut with his spear the sinews of Troy. . . . Songs did not forsake him, not even when he died, for the Heliconian maids stood at his pyre and tomb and shed upon him a dirge of many tones. Even the immortal gods thought it fit to bestow upon him, a noble mortal and dead, the hymns of goddesses." So in Nearchos we see in solemn communication with his horses an Achilles whom we can imagine destined for his particular end;[29] in Lydos a compelling grief in the mourner who sings a dirge on a terra-cotta funeral plaque;[30] and a new sobriety and restraint, pensiveness even, in the mourners on a funeral plaque of Exekias.[31]

Pindar brooded too over the suicide of Ajax. He treated it in *Nemeans* VII and VIII and again in *Isthmian* IV. He seems to have been deeply troubled by the injustice of the awarding of the arms; by Odysseus' character; even in one case, in *Nemean* VII, by Homer's treatment of Odysseus, which gave him a better character than he deserved. "Most men are blind of heart," he says, "for otherwise never would mighty Ajax, angered at the weapons, have spiked his heart with the burnished sword" *(Nem.* VII.23–27). Again, "Gossip delights the envious; it fixes upon the noble, tangles not with lesser men. This it was that slaughtered Telamon's son, coiling him over his sword. A great man, with strength of heart, he lies forgotten in the grievous quarrel. The greatest prize goes to the shifty lie. In secret ballots the Danaans favored Odysseus, and Ajax, deprived of the golden arms, struggled in his own gore" *(Nem.* VIII.21–27). And once more, "The skill of lesser men has seized and thrown the better. Witness the might of Ajax that he himself slew, slashing it through in the dead of night, bloodily, with his own sword and incurred blame among the sons of the Hellenes who went to Troy; yet Homer honored him beyond other men and made straight all his valor, giving delight to

men after with the divine words of the rhapsode's staff" *(Isthm.* IV. 52–57). It must have been with the same sense of tragedy that Exekias furrowed the brow of his lone figure and bent him before his sword (fig. 11.2).[32]

Ajax was "best after Achilles at Troy" and the black-figure vase-painters in their many portrayals of Ajax carrying the body of Achilles from the battlefield obviously saw these as among the greatest heroes of Hellas, but Exekias in his painting of the two of them at draughts saw more than this (fig. 11.4).[33] Their richly embroidered mantles, the stylized volutes of their chitons, and the patterned curls of Ajax's hair are not only excellent examples of poikilia, but the extraordinary amount of incised detail gives the impression of light shining through the figures; they appear in fact to be lit from within. This effect together with the luminosity of the painting, the poised composition, the concentrated expressions on the two faces, and the very nature of the black-figure technique which seems to reverse life make these figures more than heroic. They make them immortal mortals.[34] As J. Boardman has put it, "Amasis could see men as men, Exekias could see his men as gods."[35] Pindar did much the same. He saw even his athletes as gods. In the words of J. Finley, "Nearly every poem of Pindar is a metaphor, the terms of which are the victor and the heroes. The likeness is never fully pressed, since to say openly that contemporaries resemble demigods touches impiety. Yet this metaphor is pervasive, not only because each community felt itself in its heroes, which were at once its past, its bond with divinity, and its moral and even physical exemplars, but because Pindar saw reality through such mythic means. As men, yet direct or remote offspring of gods, the heroes imply the gods, and a third dimension thus enters the metaphor."[36] Pindar saw Ajax vindicated, made immortal by Homer; Achilles, "a noble mortal and dead," lamented at his funeral by the dirges of goddesses. He may also have seen mortals made immortal, gods rather than men, by Exekias, if not on his vases, then on the funerary plaques in Athens, where he probably went for his training at least as early as 500 B.C.[37]

There is still another sense in which Exekias seems to have anticipated Pindar. The Munich cup which shows Dionysos sailing in a boat sprouting from its mast a vine laden with grape clusters and surrounded by dolphins reveals a sense of enchantment that appears in certain of the Homeric Hymns and then, except in Pindar, never again (fig. 11.5).[38] By the time of Euripides'

Bacchae it has changed character, lost the delicacy of the passages in Pindar which describe the Island of the Blessed—"there winds from Ocean blow across the island of the blessed; blossoms blaze to gold, on land from the glory of trees; others the water feeds. With these they bind their arms with bracelets and go garlanded in the straight decrees of Rhadamanthys" (*Ol.* II.70–75)—and Elysium: "There blazes for them the strength of the sun below while here it is night. In meadows of red roses the forecourt of their city is [filled?] with trees of frankincense and shadowy [?] and weighted with gold-fruited trees. Some take their joy in horses and wrestling, others in the gaming board and the lyre. Among them there comes to bloom every happiness. Fragrance is ever shed upon that lovely land while they mingle all manner of incense with fire that gleams from afar at the altars of the gods" (*Threni* VII.1–10).

If Pindar saw with the eyes of the sixth-century black-figure vase-painters and so employed some of their techniques—juxtaposition, symbolism, poikilia—and therefore created some of their moods—innocence, humor, grief, dignity, a sense of divinity, and a magical mysticism—he saw perhaps still more strikingly with the eyes of the sixth-century sculptors.

Finley speaking specifically of the role of the Okeanides in Aischylos' *Prometheus Bound* comments: "The parallel is clear to late archaic statuary in its stiff nobility of shape coupled with its minute attention to the rendering of hair, ornament, and dress. It is as if two intense forces were at play, the one toward life as idea, the other toward life as variegation. The immense vitality of the late archaic is in this struggle of impulses, the one simplifying and reducing to form, the other complicating and leading out to a thousand responses to the world. The same conflict is quite as strong in Pindar."[39]

The variegation, the poikilia, to which Finley refers in the statues, has its obvious parallel in Pindar, in his descriptions of snakes and bird, of music, of his own technique in telling a story by the embroidering of details; his use of color may be seen too as a parallel to the painting, particularly of draperies, on the Archaic korai. There are, however, other and more profound similarities in technique which make the sculptors and Pindar partners in the Archaic aesthetic.

B. S. Ridgway lists as characteristic of Archaic sculpture frontality, symbolism, standardization, and decorativeness; decorativeness includes linearity and fractioning.[40] All these, it is clear, are closely allied, and all may to some degree be seen as characteristic of Pindar. He does not tell a story organically, in the round, as it were, but gives us rather a series of pictures, exquisitely illuminated and engraved, but almost without transition one to another.

It is not only the result that makes Pindar's *Odes* similar to Archaic sculpture; it is the process. The Archaic sculptor did not work from wax or clay models. He drew his outline upon the surface of a block of marble and then cut back. In R. Carpenter's words describing the carving of an ear: ". . . such a pattern . . . is applied by the sculptor to the block of his statue by first tracing its discoverable outline in frontal projection, then cutting back the marble around this outline, and lastly grooving into the stone the linear pattern of its interior configuration. As a result of such a procedure, the statue's ear is represented by an isolated patternization solidly attached to the main mass of the marble block and rather uniformly raised above it."[41]

It is in much the same way that Pindar works. In the opening stanzas of *Pythian* IX one can see the literary equivalent of both linearity and cutting back. "I wish," says Pindar, "to sing, proclaiming with the deep-girdled Graces, the brazen-shielded Pythian victor Telesikrates, a blessed man, the garland of chariot-driving Cyrene"—the appositional phrases are the linear pattern grooved into the marble, as it were, of this surface; now comes the first cut back with the first of what the immortal Gildersleeve called the "ringing" relatives[42]—"*whom* the long-haired son of Leto once carried away from the folds echoing to the winds of Pelion and bore in his golden chariot the wild maiden; *whither*"—and here the adverb performs the function of the relative pronoun above and cuts forward into space as that had backward into time—"*whither* he made her mistress of a land rich in flocks, most rich in fruits, to inhabit the lovely blossoming third root of the earth." There follows in the antistrophe the description of the marriage, blessed by Aphrodite, of Apollo and Kyrene, the daughter of Hypseus—and here is another cut back, again into time—"*who* was king of the haughty Lapiths, a hero second in descent from Ocean"—and now we come to still another cut, backward again into time—"*whom* once upon a time in the famed folds of Peneus the Naiad Kreousa, having taken her joy in the bed of Peneus, bore, the daughter of earth." The next cut is not so deep, comes nearer to the surface than did the last two but not quite so close as did the first: "*He* [this is Hypseus; the demonstrative pronoun performs the same linking

11.5. Munich, Staatliche Anti-
kensammlungen 2044. Exekias.
Dionysos sailing. Photo courtesy
of the Museum.

function as did the relatives above] *he* reared the white-armed child Cyrene." The next cut, introduced again by a demonstrative ἁ, comes still closer to the original surface: "*She* did not care for the shuttling ways of the loom." Soon after, at the beginning of strophe β, we have: "*her,* as she wrestled with the savage lion, Apollo came upon (κίχε νιν)." We have come back to the time when Apollo fell in love with her and carried her off in his golden chariot (*Pyth.* IX.1–28).

This cutting back and again forward, often into time but sometimes only in sense, within individual narratives is typical of Pindar. One could supply many examples. Sometimes too almost an entire Ode seems to be cut away from its first statement but then to return, often by steps, at the end to its first surface. Others have seen this as ring composition.[43]

Despite the use of those "ringing" relatives Pindar's style is not syntactic. The relative clauses are really paratactic: they tack on whole pieces of the story. The composition is on the whole, just as in its parts, appositional, which is another way of describing the Archaic style, whether in literature or in art. It is the opposite of organic. Pindar's surfaces are not modulated; he, like the Archaic sculptors, cuts back, then engraves. As they grooved linear patterns for hair and drapery, so he by the addition of epithets or other appositional phrases decorated his individual surfaces.

Ridgway lists as her last characteristic of Archaic sculpture "the quality of *agalma.*" This includes but is not identical with the Archaic smile. The Archaic statue, she says, "for all its physical mass and artificial details, seems light and gay, regardless of the presence or absence of the archaic smile." She concludes that Archaic statues, which she admits have "a different spiritual content from Severe or Classical . . . come perhaps closest to the original meaning of the word agalma: that which delights, a pleasing gift."[44]

Pindar in the first lines of *Nemean* V (1–3) declares that he is not a sculptor (ἀνδριαντοποιός) to make statues (ἀγάλματ') that stand still on their bases. Rather, he would speed his sweet songs from Aegina in every bark and ship. Here he opposes statue to song, but the juxtaposition is in itself suggestive. Elsewhere he calls his songs themselves agalmata. In *Nemean* III.12–13 his Ode will be a gladsome toil, glory (agalma) of the land. In *Nemean* VIII.15–16 immediately after calling his song a Lydian veil soundingly embroidered (πεποικιλμέναν) he refers to it as a Nemean agalma. He seems to

11.6

11.7

11.8

have sensed if not actually to have known that the verb ἀγάλλω, ordinarily translated "honor" or "glorify," means also "decorate." Pokorny gives both *verherrlichen* and *schmücken*.[45]

Pindar seems also to have sensed the etymological connection between ἄγαλμα, ἀγάλλω, and ἀγλαός and actually at times to have played upon it. The best English translation for ἀγλαός is "splendid"; it refers to something that literally shines or to persons or their attributes which are distinguished. An agalma is given to a person who has distinguished himself in the games and is therfore ἀγλαός (*Isthm.* VI.62), and it is, like him, etymologically, a thing which shines.

Pindar uses ἀγλαός in its more literal sense of trees (*Ol.* II.73), of a tomb (*Nem.* IV.20), of a scepter (*Nem.* XI.4), of a court (*Paean* VII.3), of a branch of laurel (Παρθ. II.7), and of the earth (fr. 220.2); more abstractly, of funeral sacrifices (*Ol.* I.91), of athletic contests (*Pyth.* V.52), of endeavors (*Nem.* III.69). The meanings "bright" and "distinguished," that is, "splendid" or "illustrious," are combined in the description of Jason's locks (*Pyth.* IV.82). A man (*Ol.* XIV.7), children (*Isthm.* VI.62), and Poseidon (*Isthm.* VIII.27) are called "distinguished." When, in *Olympian* VIII.11 he calls the prize (γέρας) that attends the victor ἀγλαόν, he seems to sense or actually to play upon the similarity of sound and the identity in meaning of ἄγαλμα and ἀγλαόν. So too in *Olympian* XIII the forecourt of Poseidon of the Isthmus is because of Xenophon's victory ἀγλαόκουρον "shining in youths" (5) and to the Corinthians the blossoming Seasons have offered the glory of victory (νικαφόρον ἀγλαΐαν [14]).

Pindar need not have been a philologist to have connected ἀγλαός with ἄγαλμα. It is commonly acknowledged that the Greeks considered words which sounded alike somehow to have meant alike and on this account to have indulged in what might be thought of as unfunny punning.[46] When Herakleitos (Diels 48) said that life is a bow, he was doing more than making a metaphor. He really heard some mystical connection between βίος and βιός. The statement therefore is perfectly serious and may in fact have given rise to rather than simply have underlined his idea of a tension of opposites.

It is not possible to know whether Pindar knew or sensed the etymological connection of ἄγαλμα and ἀγλαός with γελάω "smile," but it seems likely that a poet with so fine an ear heard the similarities of vowel and consonant and so realized that the "gleam" of the smile was like that of the "gleam" inherent in the adjective that

meant "illustrious" and the gift or award which was a thing that brought "delight," the gleam of a smile to the recipient.

Pokorny gives as related to γελάω, γαληνός "calm" and γελεῖν which Hesychius glosses λάμπειν "to shine" and ἀνθεῖν "to blossom" or, more accurately, "to surface." W. B. Stanford pointed out the meaning of γελάω as "smile" rather than "laugh," the basic notion being that of gleaming—as of the teeth. In Euripides' *Trojan Women* the blood did not "gurgle" but rather "gleamed" from Astyanax's shattered skull.[47]

An agalma when it was an Archaic statue not only brought delight, a smile to the lips of the recipient; it was offered with a smile, and this mysterious smile which appears on the probably votive kouroi and korai of the sixth century was one that Pindar, surely among the most traveled of Greeks, had seen wherever he went.[48]

We shall I hope never know precisely what the Archaic smile meant. It may have been a technical accident. If so, it was a lucky one. The question is complicated by the fact that often what looks like a smile from one angle does not from another.[49] It may be, as Ridgway suggests, a facet of the quality of agalma.[50] This seems appropriate for the votive korai but less so for the dying warriors of the Aeginetan and other sculptures who wear the same smile. That smile seems to me to be, as H. Payne said, "a look expressive of nothing so much as the plain fact of their own animate existence."[51] It seems to reflect the statue's joy at having been released, a living figure, from the inanimate stone[52] like Athena, who in *Olympian* XIII.66–67 stepped, a living vision, straight out of his dream (ἐξ ὀνείρου δ' αὐτίκα ἦν ὕπαρ) to offer to Bellerophon the gold-bedecked bridle. As such it may also reflect the sculptor's delight in having effected that release and perhaps too his desire to make an offering that will please. Nowhere do these qualities seem so apparent to me as in the Peplos kore (fig. 11.6).[53] The smile (γελάω) is illuminated (ἀγλαός) and an ἄγαλμα, an expression of delight that will in turn bring delight. One sees a slightly more tender version of that same smile on the Rampin horseman (fig. 11.7),[54] who was probably a Pythian victor and must as such particularly have caught Pindar's eye,[55] and an equally mysterious but perhaps gentler such smile on the Moschophoros (fig. 11.8).[56]

What then did Pindar mean when he said that the Centaur smiled "greenly"? Cheiron did it, for one thing, when he was inspired (ζαμενής), in a prophetic mood. The smile, then, had a daemonic quality. He did it also with soft (ἀγανᾷ)

11.6. Athens, Akropolis Museum 679. The peplos kore. Photo: DAI, Athens.

11.7. Louvre 3104. The Rampin head. Photo: Courtesy Musée du Louvre.

11.8. Athens, Akropolis Museum 624. The Moschophoros. Photo: DAI, Athens.

eyebrow. This may mean, as some have taken it, with an unfrowning brow, cheerfully. I, however, think that R. Lattimore shows his usual uncanny perception in translating it "with a lift of the brow;" I take it that he means with "mobile" brow, with humorous indulgence. Cheiron, after all, knows that Apollo knows the future as well as he but that he is in love and wants the pleasure of hearing from his mentor of the joys to come. Finally, he did it "greenly."

A basic notion in χλωρός is liquidity.[57] Euripides used the word of a tear (*Med.* 906; *Hel.* 1189). Like most Greek color terms, it connotes or even denotes texture more than what we commonly think of as color. Stesichoros called honey χλωρόν (179a.2) and meant its moist quality as much as he did its yellow-green color. Sappho in saying that she has turned "greener" (χλωρο-

11.9

τέρα) than grass undoubtedly refers to her pallor but also perhaps to the fresh or moist quality of her complexion. (31.14). When Simonides called the nightingale among the leaves of spring "green-necked" (586.2), he may have meant simply that its throat is pale, but it is more likely that he referred by synesthesia both to the color of its throat and the quality of its song among the green leaves of spring.[58] When Bakchylides calls Deianeira "green-necked" (5.172), he may refer to the quality of her living voice,[59] or to the fresh quality of her skin. I think that if he means

anything and is not just using Simonides' adjective in a somewhat perfunctory manner, it is that, by some synesthetic combination of these, she is alive, quick rather than, like Herakles and Meleager who are discussing her, dead.[60] The sense of quickness in χλωρός is apparent in Homer where it is used of "green" as opposed to dry olive wood (*Od.* IX.320) and in both Sophokles and Euripides who use it of blood (Soph. *Trach.* 1055; Eur. *Hec.* 127).

If we now look again at Hesychius' gloss on χλοερός we find approximately the same range of meanings: χλωρόν, the pale green of spring; ὠχρόν, the paler yellow-green of a still earlier spring; νέον, new, young—as of shoots in the spring; ἁπαλόν, soft or delicate—as of young plants and animals in the spring of the year. Homer and the lyric poets used ἁπαλός chiefly of the vulnerable parts of the body (Hom. *Il.* III.371; XVII.49; XVIII.123; XIX.92; Alcm. 3.10; 3.80; Sappho 81.2b; 94.16; Alc. 45.6), but Sappho uses it of chervil (96.13) and Euripides of an infant (βρέφος [*IA* 1285]).

The Centaur's smile is then daemonic (ζαμενής), amused, with the suggestion even of a leer (ἀγανᾷ . . . ὀφρύϊ)—the only other use of γελάω in Pindar is of Apollo "smiling" at the lewdness of the rampant beasts (*Pyth.* x.36); here he asks Cheiron for advice about his own sex life—and it is somehow springlike. It is matutinal, mysterious, and yet tender. It is above all, quick—or *vif*. It reflects the dawn of a world long gone—one in which young girls can wrestle with lions, snakes feed babies on honey, babies strangle snakes in their cradles, and no one comes really to harm—but which exists yet in all vividness in Pindar's own imagination. It comes closest perhaps to the benign smile upon one of the heads of the triple-bodied monster (fig. 11.9),[61] a hybrid like Cheiron himself, from an Archaic poros pediment which Pindar had probably, though not certainly, seen on the Akropolis at Athens early in his career.[62] The Centaur's smile is, in spirit at least, the Archaic smile.

11.9. Athens, Akropolis Museum 35. One of the heads of the triple-bodied monster. Photo: Courtesy of the Museum.

NOTES

1 O. Schroeder, *Pindars Pythien* (Leipzig and Berlin 1922) 82. In these pages I cite the text of B. Snell and H. Maehler, eds., *Pindari Carmina cum fragmentis* I, II (Leipzig 1980, 1975).

2 R. Lattimore (*The Odes of Pindar* [Chicago 1947] 82) translates, "with a cool smile."

3 B. L. Gildersleeve (*Pindar, The Olympian and Pythian Odes* [New York 1890; reprinted Amsterdam 1965] 342) prints χλαρόν, associates it with χλιαρόν, and comments, "We have not here the 'lively' horse-laugh of the other Centaurs; we have the half-smile

of the great teacher." Cf. Wilamowitz, *Pindaros* (Berlin 1922) 268, n. 1: "38 steht eine für uns unverständliche Vokabel χλαρὸν γελάσσαις. Das war überliefert, denn die Scholien zeigen, dass χλιαρόν ein Deutungsversuch der hilflosen Grammatiker war." and L. Illig, *Zur Form der Pindarischen Erzählung* (Berlin 1932) 36, n. 5 on χλαρὸν γελάσσαις: "was wir nicht verstehen."

4 E. D. Francis, " 'Chiron's Laughter' (*Pyth.* 9.38)," *CP* 67 (1972) 288–91; L. Woodbury, "Apollo's First Love: Pindar, *Pyth.* 9.26 ff.," *TAPA* 103 (1972) 564.

5 O. Schroeder, *Pindari carmina* (=T. Bergk, *Poetae Lyrici Graeci*[6] [Leipzig 1923]) 249.

6 C. M. Bowra, *Pindar* (Oxford 1964) 246.

7 R. W. B. Burton, *Pindar's Pythian Odes* (Oxford 1962) 43.

8 R. Lattimore ("Pindar's Fourth Pythian Ode," *CW* 42 [1948/49] 19–25) argues that Jason's good qualities are emphasized throughout to make him a model of behavior for Arkesilas.

9 Gildersleeve, *Pindar* 261.

10 It may also be a parody of Homer's description of the Chimaira, (Hom. *Il.* VI.181: πρόσθε λέων, ὄπισθενδὲ δράκων, μέσση δὲ χίμαιρα).

11 Gildersleeve, *Pindar* 177.

12 T. G. Rosenmeyer ("The Rookie: A Reading of Pindar, *Nemean* I." *CSCA* 2 [1969] 242) remarks, "When Pindar informs us that Heracles wore saffron-colored swaddling clothes, Bury rightly comments that the color was worn by kings and heroes, and compares *Pyth.* 4.232, but fails to see the light touch in what is surely the equivalent of royal purple diapers." C. Segal ("Time and the Hero: the Myth of *Nemean* I," *RhM* 177 [1974] 32), though admitting to touches of humor, declares, I think wrongly, that the "overall tone is one of high seriousness and solemn exultation," and H. Herter ("Ein neues Türwunder," *RhM* 89 [1940] 153) speaks of "heroische Erhabenheit Pindars." *Heroische,* yes; *Erhabenheit,* no.

13 Rosenmeyer, "Rookie" 242–43.

14 University of Iowa Museum of Art 1971.273, published by R. D. DePuma, *Greek Vase-Painting in Midwestern Collections,* eds. W. G. Moon and L. Berge (Chicago 1979) 14–15, no. 10.

15 Paris, Louvre CA 577.

16 B. A. van Groningen, *La Composition littéraire archaïque grecque* (Amsterdam 1958) 29–33; R. A. Prier, *Archaic Logic* (The Hague 1976) 11.

17 Staatliche Museen, Berlin 1685: *ABV* 109, no. 24: Lydos, black-figure amphora showing all three of these.

18 T. B. L. Webster, "Greek Theories of Art and Literature down to 400 B.C.," *CQ* 33 (1939) 176.

19 B. M. W. Knox, *The Heroic Temper: Studies in Sophoclean Tragedy* (Berkeley 1964) 34.

20 Musée Municipal, Boulogne 558: *ABV* 145, no. 18.

21 Staatliche Museen, Berlin A9: *CVA* 1, pl. 5; *Development* 10 and pl. 4.

22 British Museum, Walters Coll., London B 620; P. V. C. Baur, *Centaurs in Ancient Art, the Archaic Period* (Berlin 1912) 102 and fig. 25. *ABV* 434, no. 1.

23 On gold as symbolic of divinity see J. Duchemin, "Essai sur le Symbolisme Pindarique: Or, Lumière et Couleurs," reprinted from *REG* 65 (1952) 46–58 in *Pindaros und Bakchylides,* eds. W. M. Calder III and J. Stern (Darmstadt 1970) 278–89.

24 B. Snell, "Pindars Hymnos auf Zeus," *Antike und Abendland* 2 (1946) 189–92; H. Fraenkel, *Early Greek Poetry and Philosophy* (Oxford 1975) 505.

25 Cf. Alkaios (69.7) who calls the fox ποικιλόφρων.

26 C. Sachs, *The Rise of Music in the Ancient World* (New York 1943) 198–271.

27 Private loan, Elvehjem Museum of Art, Madison, Wisconsin, published by W. G. Moon, *Midwestern Collections* 96–97, no. 56.

28 Museo Archeologico, Florence 4209: *ABV* 76, no. 1; *Paralipomena* 29. Cf. the version of Lydos, Metropolitan Museum, New York 31.11.11: *ABV* 108, no. 5.

29 Athens, Akropolis 611: *ABV* 82, no. 1.

30 Athens, Vlasto Coll., from Spata: *ABV* 113, no. 84.

31 Staatliche Museen, Berlin 1811–26: *ABV* 146, nos. 22–23.

32 Musée Municipal, Boulogne 558: *ABV* 145, no. 18. On Ajax's attraction for Exekias see J. D. Beazley, *Attic Black-figure: A Sketch* (London 1928) 20–21; J. Boardman, "Exekias," *AJA* 82 (1978) 11–25; M. B. Moore, "Exekias and Telamonian Ajax," *AJA* 84 (1980) 417–34.

33 Museo Etrusco Gregoriano, Vatican 344: *ABV* 145, no. 13.

34 Even the gaming board, so often associated with the afterlife (cf. Pind. *Threni* VII.6 and infra), adds to the sense of immortality. Cf. E. Vermeule, *Aspects of Death in Early Greek Art and Poetry* (Berkeley, Los Angeles, and London 1979) 81: "One may wonder whether the famous game between Aias and Achilles at Troy is not more than a simple pastime. One was going to rescue the other, in death, on the battle field, and lose the *aristeia,* the prize of valor."

35 J. Boardman, *Athenian Black Figure Vases* (Oxford 1974) 58.

36 J. Finley, *Pindar and Aeschylus* (Cambridge, Mass. 1966) 40.

37 Staatliche Museen, Berlin 1811–26: *ABV* 146, nos. 22–23. On the location of funerary plaques see J. Boardman, "Painted Funerary Plaques and Some Remarks on Prothesis," *BSA* 50 (1955) 51–66.

38 Staatliche Antikensammlungen, Munich 2044: *ABV* 146, no. 21. W. Burkert (*Griechische Religion der archaischen und klassischen Epoche* [Stuttgart 1977] 258–59 and n. 40) definitely connects the cup with the *Homeric Hymn to Dionysus,* but cf. T. W. Allen, W. R. Halliday, and E. E. Sikes, *The Homeric Hymns* (Oxford 1936) 376: "The metamorphosis of the pirates does not appear on the vases, for the cylix of Execias has no connexion with the Tyrrhenians." E. Simon, *Festivals of Attica: An Archaeological Commentary* (Madison 1983) 93–94, says that the festival of the Pithoigia on the first day of the Anthesteria celebrated the arrival of the god Dionysos from the sea in a ship-chariot and that the Exekias cup shows the same in a mythical picture.

39 Finley, *Pindar and Aeschylus* 45.

40 B. S. Ridgway, *The Archaic Style in Greek Sculpture* (Princeton 1977) 12–13.

41 R. Carpenter, *Greek Sculpture* (Chicago 1960) 36–37.

42 Gildersleeve, *Pindar* 280, on *Pyth.* IV.4.

43 Notably Illig, *Erzählung* 56–67. On ring composition in this Ode see Fraenkel, *Poetry and Philosophy* 447.

44 Ridgway, *Archaic Style* 14.

45 J. Pokorny, *Indogermanisches Etymologisches Wörterbuch* (Bern and Munich 1959) s.v.

46 J. D. Denniston, *Greek Prose Style* (Oxford 1952) 3.

47 W. B. Stanford, *Greek Metaphor* (Oxford 1936) 114–17.

48 Cf. Gildersleeve, *Pindar* xii–xiii: " . . . although we must not suppose that Pindar went whithersoever his song went, he was not a homekeeping man. His long sojourn in Sicily is beyond a doubt. Aigina must have been to him a second home. Journeys to Olympia, to

Delphi, to Nemea, are certain. If he studied under Lasos, he must have studied at Athens, and it is likely that he was familiar with many parts of Greece, that he went as far north as Macedon, as far south as Kyrene."

49 J. Boardman, *Greek Sculpture, The Archaic Period* (Oxford 1978) 88: "An Artemis by them was, says Pliny, set high and her features seemed sad as you approached, joyful as you left, possibly the effect of an archaic smile viewed close from below and head-on at a distance, respectively." See too his fig. 205.2, views head-on and from below of the Theseus from the Temple of Apollo at Eretria. Cf. Ridgway, *Archaic Style* 107: "At viewer's level, such korai tend to look shy or modest; from below they have a more enigmatic, smiling appearance, and the change is considerable." So too the Athena from the Akropolis Gigantomachy appears in many photographs taken at head height to be smiling, almost dreamily, but from below her expression is quite fierce. Cf. Ridgway, *Archaic Style* 208: "She should definitely be seen from below, so that the slant of her features falls into proper position and her expression changes, becoming almost wrathful."

50 Ridgway, *Archaic Style* 14.

51 H. Payne and G. Mackworth-Young, *Archaic Marble Sculpture from the Acropolis* (New York 1950) 4. For other interpretations of the Archaic smile see J. Charbonneaux, *La Sculpture Grecque Archaïque* (Paris 1938) 29; R. Carpenter, *Greek Art, A Study of the Formal Evolution of Style* (Philadelphia 1962) 191; E. Akurgal, *The Art of Greece, Its Origins in the Mediterranean and Near East* (New York 1968) 214; J. J. Pollitt, *Art and Experience in Classical Greece* (Cambridge 1972) 9; Boardman, *Greek Sculpture* 65, 86, 88.

52 The partially carved monumental statue of a Greek god, recently photographed by J. W. and E. E. Myers by balloon for *Archaeology* [November/December 1980] 39), found lying on its back at a quarry on Naxos is a particularly striking example of a figure being released from stone. It is also a good example of cutting back.

53 Athens, Akropolis Museum, Kore 679.

54 Athens, Akropolis Museum 590; Paris, Louvre 3104.

55 Payne, *Marble Sculpture* 8.

56 Athens, Akropolis Museum 624.

57 E. Irwin, *Colour Terms in Greek Poetry* (Toronto 1974) 31–78.

58 Stanford, *Greek Metaphor* 55 and Irwin, *Colour Terms* 73.

59 Irwin, *Colour Terms* 40.

60 Cf. J. Stern, "The Imagery of Bacchylides' Ode 5," *GRBS* 8 (1967) 35–43: "Deianira too like a beautiful plant blooms for a moment before the disaster."

61 Athens, Akropolis Museum 35.

62 J. Boardman (*Greek Sculpture* 153) cautions us against abandoning the hypothesis of a *Tyrannenschutt* after 510 B.C. in favor of that of the *Perserschutt* of 480 B.C.

Paragone: Sculpture versus Painting, Kaineus and the Kleophrades Painter

12

BETH COHEN

In Renaissance Italy a debate centered on a comparison of painting and sculpture: *paragone*—which one was the noblest of the representational arts?[1] Each medium was seen to possess its own unique advantages as well as limitations. From the arguments of Renaissance men versed in ancient and medieval commentary, as from the history of Western art itself, it is possible to conclude that in all classic periods what is possible and appropriate in both style and subject matter for painting may not be for sculpture.

In the civilization of ancient Greece, around the time of the Persian War, there was a most important reorientation, and its effect on art appears to have been iconographical as well as stylistic.[2] A theme, already significant in the Archaic period, Kaineus and the Thessalian Centauromachy, can be shown to document the inception and maturation of the Classical style in the fifth century B.C. In fact, distinctions can be made not only between pre-Classical and Classical, but between painted and sculpted versions of this story. To achieve this end Centauromachies in different media will be examined: on decorated pots, in lost monumental painting, and in architectural sculpture as well. The formal discussion culminated in the Renaissance, but how relevant would the practical application of *paragoni* be now in a consideration of the visual arts in Classical Greece?[3] Perhaps Kaineus can give the answer.

Ancient literary sources provide scattered glimpses into the life of Kaineus, the Lapith warrior, which allow his biography to be reconstructed in outline.[4] Kaineus, it appears, led rather a checkered existence. He was born in Gyrton, Thessaly, as a girl named Kainis.[5] This lovely maiden was raped by the god of the sea, Poseidon. No child resulted from their union; nevertheless, the experience was surely traumatic. Kainis bade the god grant her a wish in compensation: that she be a man and invulnerable.[6] Kaineus, the man, fought valiantly as a member of the Lapith tribe; in this context alone he is mentioned in the *Iliad*.[7] Later sources cloud Kaineus' image with the following incident: he became a king of the Lapiths and out of pride set up his spear in the ground. He sacrificed to it as if it were a god and made others do the same. For such *hubris* Zeus deemed he be punished, and that is how, although invulnerable, Kaineus came to meet his end.[8]

Kaineus participated in the legendary war between Lapiths and Centaurs. The seeds were sown at the wedding feast of Peirithoos, a prince of the Lapith tribe of northern Thessaly.[9] Not only Lapiths attended the wedding. Peirithoos' loyal friend, the Athenian hero Theseus, was invited, as were neighbors—the half-man, half-horse Centaurs. All went well until the equine tribe had too much wine; drunk and seized by lust, the Centaurs tried to rape other wedding guests, as well as the bride.[10] The Lapith men and Theseus fought off the beasts, at the wedding itself, and many months later in a great Centauromachy that raged in the countryside.[11] It is here that Kaineus was set upon with particular fierceness by the Centaurs, perhaps at the instigation of Zeus.[12] The Centaurs attacked with fir trees and boulders—unwrought weapons suitable for such wild creatures.[13] They pummeled Kaineus until the earth opened under his feet and he was buried.[14] Kaineus' invulnera-

bility proved to be only to the iron and bronze weapons of civilized man. Apparently, Kaineus remained alive underground, in an upright position.[15] In Ovid's *Metamorphoses*[16] a bird with wings of fire escaped from the mass of wood and stone under which Kaineus had been trapped. Vergil, on the other hand, appears to have the last word on the Lapith's fate. Aineias encountered Kaineus in the Underworld where once again he is a woman.[17]

Of all the details that may be assigned to Kaineus' life and death by compiling preserved references in Classical texts, only one would be known had we to rely solely upon the testimony of ancient art. The earliest certain representation of this theme occurs on a bronze plaque from Olympia.[18] The caption under the reproduction, in a 1936 publication of it by E. Kunze, reads, *"Kaineus letzter Kampf"*—"Kaineus' last fight."[19] The brave Lapith warrior has already begun to sink into the earth. Flanked by a pair of tree-wielding Centaurs, he appears, or rather disappears, at the very center of a symmetrical composition.[20] Here Kaineus fights with two swords, but has no shield. J. D. Beazley pointed out that the meaning of this doubling goes beyond decorative symmetry. Since Kaineus was invulnerable, he simply did not need a shield—he was free to fight with a weapon in each hand.[21] This special version does recur, but rarely.[22]

The basic symmetrical pummeling composition, on the other hand, endured in Greek art, with only the most minor of variations, from early Archaic times through the Classical period and beyond.[23] A few examples follow. When a black-figure Kaineus, attributed to the Antimenes Painter (fig. 12.1),[24] from the late sixth century B.C. is contrasted with a red-figure one, by the vase-painter Polygnotos,[25] it is immediately striking just how much the angle of the later Kaineus' shield, as well as the twist of his body and the bend of his knee, look three-dimensional. After several generations the major change in the representation of Kaineus has been an increased illusion of space—the compositional formula, however, remains the same.[26] Both the Archaic and the Classical painters delight in the cleverest feature of this conventional image. The ornamental groundline of the vase, by ever so conveniently cutting off Kaineus' legs, becomes the earth into which he sinks. Kaineus graphically disappears before our eyes.[27] The fragment of a red-figured calyx-krater in the University of Chicago is a good illustration of the way this conceit clearly identifies the scene even when very little is preserved.[28] One subject

of the weatherworn, fifth-century B.C. frieze from the Temple of Poseidon at Sounion, the great Thessalian Centauromachy, can most easily be identified by the slab that depicts Kaineus' last stand (fig. 12.2). E. Fabricius was able to note, as early as 1884, that the Sounion Kaineus group looked generally like other representations of the same scene.[29] K. Schauenburg has pointed out the use of the symmetrical Kaineus convention even in the late Hellenistic period on a slab of the frieze from Mylasa in Istanbul.[30]

What has been considered important about the role of Kaineus in the art of the fifth century B.C. is not where or how he makes his appearances,[31] but where he does not appear. The pummeling is absent from the Centauromachy of the south metopes of the Parthenon.[32] Although Pausanias names Kaineus among the Lapiths at Olympia,[33] the pummeling is absent from the west pediment of the Temple of Zeus as well. It has been suggested, "that the designer could not work this cumbrous incident into his composition, and so decided to omit it. Kaineus is not essential to the story, as Theseus is, and may not be present at all. . . ."[34] Did artists abandon the common Kaineus convention in the Classical period because it was too archaic to permit innovation?

Aside from the question of style, whenever Kaineus does not appear there is an iconographical reason for the omission. The designers of both the Olympia pediment, of the 460s B.C., and the Parthenon metopes, of the 440s, have selected a new and different moment in the Thessalian Centauromachy—no longer the subsequent battle in the countryside, favored by Archaic artists, but the fight at the wedding feast of Peirithoos itself.[35] No definite examples of the latter story are preserved in Greek art before the fifth century B.C.[36]

In the sculptural monuments several features clearly distinguish the subject as the new Centauromachy at the wedding feast. The most obvious is the presence of women: carried off and/or struggling with Centaurs.[37] At Olympia one is the lovely bride herself.[38] Secondly, there is a change in the way the participants are armed for battle. Trees and boulders were not available for the Centaurs in the house of Peirithoos, so here they employ as weapons the things on hand at the wedding celebration.[39] On Parthenon metopes, Centaurs use vases, meant to hold refreshments for the feast, to foil their foe.[40] The Lapiths did not attend Peirithoos' wedding in full panoply. In these great monuments of Classical sculpture Lapiths wear nothing but fine cloaks or drapery, which tend to fall behind their

12.1

12.1. New York 69.233.1. Centauromachy (Kaineus). Courtesy Metropolitan Museum of Art.

12.2. Sounion, Temple of Poseidon. Slab of frieze. Centauromachy (Kaineus). (After *AthMitt* 66 [1941] pl. 46).

12.2

12.3

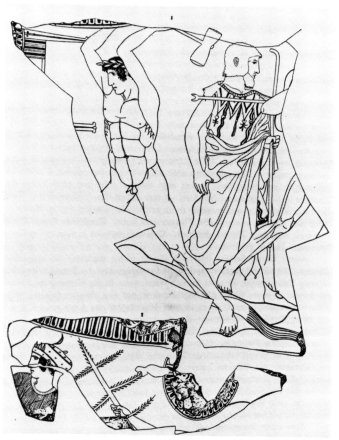

12.4

12.3. New York 07.286.84. Volute-krater. Amazonomachy. On the neck, A, Centauromachy. Courtesy: Metropolitan Museum of Art.

12.4. Berlin 2403. Centauromachy. (After FR II, 247, fig. 88).

shoulders or off their bodies—a convenient excuse for heroic nudity.[41] In the old Centauromachy each Lapith generally wears a helmet, a cuirass and greaves, and carries a shield; he attacks with a spear or a short sword.[42] On Parthenon metopes, granted a few shields are in evidence, but neither body armor nor helmets appear.[43] In other battles represented in Classical art, heroically nude warriors at the least wear their helmets.[44] Hand weapons, originally added in bronze on the Parthenon, and perhaps at Olympia, are no longer preserved.[45] Fortunately, the Centauromachy at the feast is known from Greek vases as well; these supply the missing details. On a red-figured calyx-krater in Vienna, by the Nekyia Painter, firebrands, firewood, spits, and lampstands are employed as weapons.[46] As Beazley observed, on each of a pair of Attic red-figured cups in Boston, as well, the order of the day appears to be spits, lampstands, and broken vases.[47] In pure Centauromachies at the feast, then, the inclusion of Kaineus' end would be impossible, for he had to be rammed through the crust of the earth, out of doors, by means of trees and rocks, not through the floor of Peirithoos' house with lampstands and vases.

A special group of Attic vase-paintings provides an even more colorful rendition of the Centauromachy at the feast. First, on the neck of a volute-krater in the Metropolitan Museum (fig. 12.3),[48] the context of the wedding party is conveyed not only by the use of firebrands and spits as weapons in the fight but by indications of setting: a row of couches topped by soft cushions and a vase still resting on a stand. At the center of the composition, the Centaur attacked by an ax-swinger ducks behind a hastily grabbed cushion—an eye-catching image. The artist of the New York vase, the so-called Painter of the Woolly Satyrs, repeats the theme of Centauromachy at the feast on a volute-krater in the Louvre.[49] Here a Lapith seeks cover behind a raised table, while a spit-wielding Centaur attacks and a frightened woman flees. On the name-vase by the Florence Painter,[50] at the left, a Centaur, who has been using a table for defense, is wrestled down by a Lapith. Finally, on the main fragment from a volute-krater in Berlin by the Niobid Painter (fig. 12.4)[51] we meet the ax-swinger once again and, to the left at the break, part of a table raised in defense by a now-missing Centaur. B. Shefton has pointed out that the table used as a shield, indeed this entire repertory of motives, must originally have been conceived by the mind of a single artist.[52]

For the last century scholars have agreed that these critical vases, as well as the west pediment at Olympia, were all inspired by a common prototype—a monumental wall-painting.[53] There has even been a consensus of opinion on the most likely lost painting. Pausanias tells of the decoration in the Theseion, a sanctuary in Athens, built by Kimon, after the Persian War, to house Theseus' supposed remains.[54] Pictures therein illustrated episodes from the hero's life: his youthful visit to Poseidon, his participation in the Amazon- and Centauromachies. Mikon executed one, but perhaps not all, of the paintings in the Theseion;[55] in a late third-century A.D. emendation and in modern times as well, the name of Polygnotos has been evoked in conjunction with the Amazonomachy and this greatest of Centauromachies.[56]

Despite scanty evidence, one significant feature of the important lost Centauromachy painting has generally been agreed upon: the battle it represented was *limited to* the new fight at the feast.[57] This conclusion rests not merely upon dislike for our hero, Kaineus, but upon the major role played by Theseus, the ax-swinger, in the new Centauromachy. Although he is present at Olympia, Theseus' participation would be especially appropriate for Attica. His inclusion is considered to have been an elaboration originally made for the Theseion, the supreme Cimonian monument in honor of the local Athenian hero.[58] On the New York volute-krater the new Centauromachy is on the *neck* (fig. 12.3), and on other fifth-century vases as well the fight at the feast appears in loose compositions, adapted to friezelike spaces—considered a basic format of large-scale painting.[59] The most widely accepted conclusion has been that there was no room for the Kaineus convention and the old Centauromachy in the countryside among the loftiest achievements of Classical art; the new battle at the wedding feast has now become the preeminent Centauromachy.[60] In terms of the Theseion painting, J. E. Fontenrose and J. P. Barron believe differently. The former would limit it to the old armed Centauromachy, while the latter would join the new fight at the wedding feast to a new, *immediate* armed battle in the countryside for the theme of the same lost work.[61]

It is time to reexamine the evidence. To judge properly the nature and appearance of the Thessalian Centauromachy in the lost Theseion painting, as well as in preserved monuments of the Classical period, it is first necessary to take a closer look at some highlights of the early history of Kaineus and the old Centauromachy in

Greek art. While it is true that the last battle of Kaineus lends itself to symmetry and isolation,[62] this was not the only tradition. On the François vase, the famous Attic masterpiece of ca. 570 B.C., the entire Centauromachy in the countryside appears on the reverse.[63] Here Kaineus is a central image (fig. 12.5). The hero is fully sheathed in hoplite armor and has been half-rammed into the ground by three, rather than the more common two, Centaurs.[64] An extra hand on the job has been effective, for Kaineus is already buried up to his waist—not merely up to his knees as elsewhere (cf. fig. 12.1). It has been pointed out that Kaineus' invulnerability would have made his wearing of armor unnecessary.[65] How impressive, however, is his full bronze panoply in Archaic art! The Kaineus image convinces—the hero is driven into the ground like a human stake.

On the François vase, Kleitias' version appears on the neck, significantly, just under the return of Theseus and the festive dance.[66] This Centauromachy is distinguished not only by the Kaineus-motive, but by the inclusion of the Athenian hero Theseus in an essentially Thessalian story.[67] Most of Theseus' body is lost, but most of his name remains. Although well known, this example has not been given the attention and recognition it deserves—the Athenian connection of Theseus with the Thessalian Centauromachy was first fabricated neither in the fifth century B.C. nor specifically for scenes of the wedding feast.[68] Other Archaic vase-painters, not as exacting as Kleitias, omit the names of the participants in the battle. "Kaineus is one of the most picturesque figures in the legend,"[69] and, therefore, can be identified without an inscription. The same is not true of Theseus; in the sixth century B.C. his role cannot be traced clearly.[70] And by later black-figure, artists prefer Kaineus, not in a battle frieze, but merely in the abbreviated symmetrical convention or in the less ambitious version with a single attacking Centaur.[71]

Kaineus does not become popular in red-figure until the opening decades of the fifth century B.C. Henceforth, he appears most often in the large panels on column-kraters.[72] Now the multiple-Centaur pummeling is sometimes preferred over the symmetrical convention.[73] Frequently, when the two-Centaur convention appears, as on column-kraters by the Pan Painter and Myson, the composition includes a second Lapith dueling with an unseen opponent to be imagined beyond the frames of the vase-panel.[74] The Pan Painter even provides a country setting—a tree, but he has drawn it jutting up, somewhat awkwardly,

between the rear legs of the Centaur at the right. On a column-krater by the Orchard Painter there are not only the trees and the rock wielded by the Centaurs, but rocks that have already been thrown and now rest on the ground beside Kaineus.[75] Although they do not represent it in its entirety, these vases all refer to the encounter on the battlefield as a whole.

Perhaps it is significant, in the light of the broad pictorial nature of some column-krater panels, that by the early 470s B.C., the old Centauromachy also appeared in long friezes on Greek vases of other shapes. On a pointed-amphora in Brussels, by the Syleus Painter, the old Centauromachy runs right around the vase.[76] On a contemporary psykter in the Villa Giulia (fig. 12.6) the scene is represented in a single, continuous frieze, covering the entire upper surface of the body.[77] This Centauromachy of the old type is most extraordinary. It depicts the sound and fury of battle, with details of unusual realism. Beazley pointed to "the pimply noses of the Centaurs" and "the hair in their armpits."[78] A Centaur leaps in the air to join another in pulling the shield of a Lapith away by force.[79]

The Kaineus group of the psykter evokes the conventional ones, but it has been entirely transformed. Earlier, Kaineus may stab one, or both, of the attacking Centaurs, but the beasts continue to barrage him with unflagging Archaic energy.[80] The Villa Giulia Kaineus stabs the branch-wielding Centaur. The short sword enters the throat through the cushion of the beast's full beard; its tip emerges behind his pointed ear. His eye rolls upward in its socket; his strength begins to ebb.[81] His next blow at Kaineus is one that will never be struck. On this vase, he is captured forever in the moment before he will sink to the ground, a lifeless heap.

Kaineus, meanwhile, is about to be hit by the heavy rock wielded by the Centaur, whose face is shown in three-quarter view. In 1910, Beazley cited this vase for one of the earliest occurrences of such freer movement of the face in Greek art, and he went even further: "we may perhaps infer that the three-quarter-head first appeared on a great picture of a Centauromachy; and an imitation of that picture we may find in the Villa Giulia psykter, a vase whose unique realism of detail and liberal use of shading point to some close connexion with a definite work of higher art."[82] In 1975, M. Robertson added, "on the wine-cooler with the Centaur-battle, alongside the foreshortenings and shadings, one Greek is shown with his helmeted head in full back view, and this recurs occasionally on other vases, one

12.5. Florence 4209. Centauromachy (Kaineus). Detail. After R. Bianchi Bandinelli, *Grecia* fig. 276.

12.6. Villa Giulia psykter. Centauromachy (Kaineus). After photo Bothmer Archives.

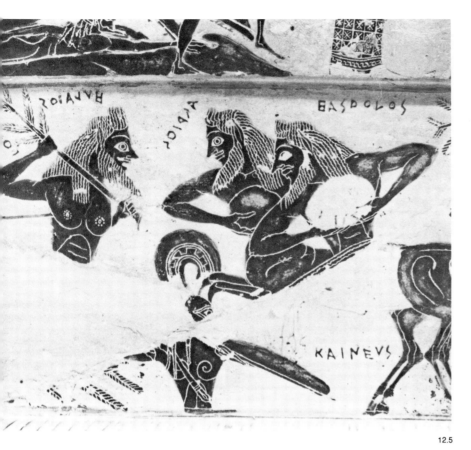

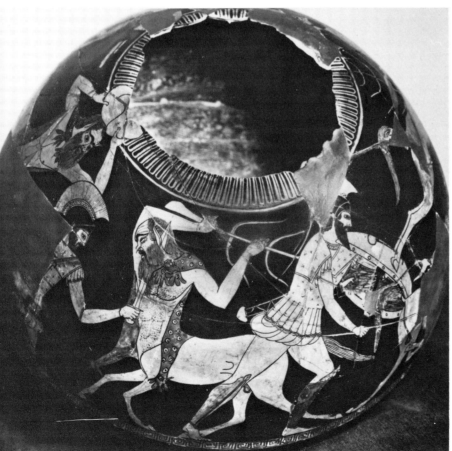

12.5

12.6

again a Centauromachy and no doubt echoing the same big painting. This forces one to think not only of the other side of the figure but of the space beyond into which he must be looking."[83]

Although different in subject matter from the Centauromachy psykter, another early vase with a pictorial frieze has frequently been cited in terms of a connection with a major lost work of art—the famous Iliupersis hydria in Naples by the Kleophrades Painter.[84] While, in the first half of this century, Beazley, as well as others, felt "truly that the spirit of early Polygnotos breathes in the Vivenzio vase";[85] M. Robertson has cautioned that the Kleophrades Painter's sack of Troy is more archaic in motives and composition than what we know of the lost paintings of Polygnotos, through Pausanias' descriptions, as well as through presumed reflections in later vase-paintings by the Niobid Painter.[86] J. Boardman, in "The Kleophrades Painter at Troy," interprets the compelling scene on the Vivenzio hydria as the artist's reaction to the Persian sack of his own city; he thus dates the vase immediately after 480 B.C. and warns against looking for an influence from wall-painting this early in the fifth century.[87] Neither in style nor in date, however, should the Naples hydria be far removed from the Villa Giulia psykter.[88] Just what view ought to be taken on that sometime tradition of linking such early vases with mural painting?

A. Snodgrass' reminder in *Archaic Greece, The Age of Experiment* casts a special light on the time around 480 B.C.:

. . . we do have some factual knowledge which tells against regarding the Persian Wars as an absolute and epoch-making division. . . . many of the writers and artists who became famous in the years immediately after 480 had, naturally, begun their careers well before that date. To name the most conspicuous, Aischylos and Pindar had both reached early middle age by the time of Xerxes' invasion, had formed their styles and had won some fame. . . . The revolution in Greek wall-and panel-painting, which is associated with the names of Polygnotos of Thasos and Mikon of Athens, looks like a clear case of a post-war development, in as much as their most famous works were to be seen in buildings only erected at that time, and indeed on occasion made use of the Persian Wars themselves as subject matter. Closer examination, however, has revealed some interesting features: the influence of this revolution has been detected in Athenian red-figured vases, some of which are thought to date from rather before 480; at least one innovatory painter, Kimon of Kleonai, was believed to have lived in the late Archaic period.[89]

If one is to recognize a stirring in large-scale painting just before or after the Persian War it must be judged as the final fruit in the evolution

12.7a

12.7c

12.7d

12.7b

12.7e

of Archaic style. Should this new impulse be regarded entirely as the culminating effort of the older generation or as representing, in addition, the first effort of the younger generation that was soon to create the Classical style? Snodgrass' remarks on the situation in major painting might possibly be extended. It cannot be ruled out absolutely that Mikon and/or Polygnotos had already been active ca. 480 B.C. Perhaps, before receiving commissions for large murals, these painters first proved themselves on panels. Per-haps their juvenilia, still Late Archaic in style, had decorated buildings that did not survive the war or (and this is even more likely) that simply did not survive until the second century A.D. when Pausanias traveled to Greece. Perhaps such early works were too primitive in appearance to catch the interest of later writers—certainly the paucity of textual references must be regarded with caution. In any event, the revolution in monumental painting was apparently under way before the Cimonian building program of the latter 470s B.C. with which the first works of Mikon and Polygnotos are normally associ-ated.[90]

A closer look at the Kleophrades Painter underscores his special role in this seminal period. In addition to the Iliupersis hydria, another one of his pots that has received much attention in vase scholarship is Louvre G 55 (figs. 12.7a–12.7e). It is the name-vase in B. Philip-paki's Late Archaic Class of the Louvre Kaineus Stamnos.[91] She has described the composition of the vase's pair of pictures "as a loose continuous one"; in his Centauromachy the Kleophrades Painter has skillfully woven the tails and branches of the Centaurs around the stamnos' handles (fig. 12.7e).[92] Here is vase-painting at its best—decoration and shape are truly in accord. The fine Louvre stamnos is one of the few vases included by Beazley in his monograph on the Kleophrades Painter.[93] It happens to be one of the pots Beazley sketched; and the drawings of both sides, reproduced in the plates of his book, are among those that he published during his lifetime.[94] Beazley's description of Louvre G 55 is as follows: "On each side a Lapith, once attack-ing, once defending, between two Centaurs. The Lapith on one side is Kaineus. He was invulner-able, and in the battle slew many Centaurs; but the rest surrounded him and beat him into the ground with fir-trees and rocks. The pictures are drawn in a few lines, with little detail . . . they are full of movement, and the fury of the Cen-taurs is admirably expressed."[95]

The Kleophrades Painter's stamnos, therefore, has been seen as a superb example of the Archaic convention of the symmetrical pummeling. Its Kaineus has received little special attention (figs. 12.7a, 12.7c).[96] E. Pottier's detailed description of 1901[97] has gone unheeded—a close look reveals the expected not to be the case. No other Greek vase known to me preserves an illustration of Kaineus' last battle akin to the Kleo-phrades Painter's. The moment shown is by no means the usual pummeling. Here Kaineus attacks neither Centaur. He has bent his sword arm over his head, not to slash and stab, like the Lapith on side B (fig. 12.7d), but in an instinctive gesture of self-defense (fig. 12.7c). Directly above his head is a rock. This rock is not held by one of the Centaurs; it has already been thrown. Now it is in mid-flight and in an instant will complete its fall. This will be the *coup de grace*. Although, to Pindar[98] he was pushed into the ground by trees and remained alive but buried, according to another source from the fifth century B.C., Akousilaos, Kaineus apparently died by suffoca-tion from a stone placed upon his earthly grave.[99] The fateful object has just been perceived. The Louvre Kaineus looks up at the falling rock with unspeakable fear. His raised arm will do no good; he is completely helpless. The conceit of the Kleophrades Painter's Centauromachy is explicit, but subtle. Here Kaineus' moment of agony is frozen for all time—this picture of action is truly in suspended animation.

Were this a frame from a silent movie the sub-title might well read, ". . . but where has the stone come from?" On the Louvre stamnos the Centaur at the right has both hands occupied with a boulder. The Centaur at the left holds a branch in his right hand; his left hand is hidden behind Kaineus' shield. There are Kaineus vases on which a single Centaur wields more than one weapon;[100] therefore it is possible that the left-most Louvre Centaur threw the stone, but I think not. This wondrous stone has been hurled from farther afield, and the viewer is left to imagine the perpetrator: a third Centaur on a cliff, per-haps, plus the presence and/or intervention of the vengeful Zeus.[101] Although the stone has come from a realm beyond the confines of a vase-painting, the Kleophrades Painter has strict stan-dards for what is possible as pottery decoration; there is no room for additional figures or land-scape on either side of his Late Archaic stamnos. This fine painter's main concern has nothing to do with replicating famous works of art by major artists. As in describing Raphael's relationship to the work of Michelangelo or Leonardo it is not copying of which one would speak so much as

of inspiration. If on similar grounds the Kleophrades Painter's Vivenzio hydria ever continues to tantalize us by an evocation of some lost, early, large-scale original, so must the stamnos. While the Naples Iliupersis appears to telescope a panorama, the Louvre Kaineus is but an excerpt.

Far more than any individual figure on the Vivenzio hydria, the Kleophrades Painter's Kaineus brings to mind a specific character known to have existed in a famous lost painting. It is difficult to forget the final image mentioned by Pausanias in his description of the Hades by Polygnotos in the Lesche of the Cnidians at Delphi, "below . . . is Tantalos suffering as Homer has made him suffer, and terrified in addition by the stone hanging above him."[102] One can imagine Tantalos, thirsty and hungry, standing chin-deep in water that will never touch his lips and beneath trees, bearing fruit that he will never reach.[103] The Tantalos is a truly Classical image. No action takes place; the threatening rock will never fall from the cliff on which it totters above his head. Polygnotos' subject is man's eternal frustration and fear.

The Kleophrades Painter's image is still Archaic, but, in the depiction of helpless human fear, it is comparable to the famous Classical lost Tantalos. Could the conception of both be attributed to a single creator—the great Polygnotos—at earlier and later phases of his career?[104] The truth behind such a conjecture probably can never be ascertained; however, it can be said with certainty that in the last decade of the first quarter of the fifth century B.C. a grand new vocabulary already existed in the realm of painted images. The old Centauromachy had been rethought, not only in terms of a broader compositional format, but of a new sensitivity to both the realism and subtlety possible in battle imagery. Clearly this theme was not hackneyed and canonical, but newly alive and relevant in the Athens that faced the Persian menace early in the fifth century B.C.[105] The evidence given by several Late Archaic vases appears to indicate that, of all themes, the Centauromachy in the countryside is the likely candidate to have played an impressive role in the initial stages of the newly born art of monumental painting. What was to be the fate of this *old* Centauromachy in true Classical painting?

Some knowledge of a master mural-painter of the Classical period is furnished by a mid-fifth-century vase-painter, nicknamed the Niobid Painter by Beazley after the subject on the reverse of a calyx-krater in the Louvre.[106] (See Ridgway pp. 194, 197). According to E. Simon in her study of the obverse of this vase:

There was never any doubt that the Louvre krater by the Niobid Painter is patterned after some great picture of Polygnotan style. Neither the brilliant characterization of the heroes nor the specific Kimonian spirit of the whole is due to this vase-painter. That great painting inspired him is evident also from other vases by his hand. . . . But only single scenes seem to have been copied there, while the Louvre krater preserves something more: a Polygnotan composition, adapted as well as possible to the shape of the calyx-krater. Nowhere in the Niobid Painter's extant work is there again found such a complicated distribution of figures in several levels, a distribution which corresponds to the arrangement of figures in the wall-paintings described by Pausanias.[107]

The identification of the subject of this famous hero scene has been a long-standing problem in scholarship.[108] One recent interpretation has met with the most approval.[109] Barron has argued brilliantly that a mistake in the drawing of male anatomy on this and other vase-paintings must have been copied directly from originals by Polygnotos.[110] On that basis, he revives a modern tradition: Pausanias' commentary on the Theseion also described a fourth painting (for Barron *The Return of Theseus*), and a reflection of this lost work is to be found in the superb "Polygnotan composition" of the Niobid krater obverse.[111] On iconographic grounds this fourth painting is certainly plausible; let us return later to the issue of style.

It is not at all surprising that the Niobid Painter's single, fragmentarily preserved representation of the new Centauromachy has always been given a place of honor in discussions of the Theseion painting (fig. 12.4).[112] Here the ax-swinger, *Theseus,* and a second hero, *Peirithoos,* fight back to back;[113] the white-haired father of the bride flees. Beneath the feet of the hero at the left the hindquarters of a Centaur are preserved—Pausanias' description of the Theseion painting mentions that Theseus has already killed a Centaur, but the rest of the fighting is about equal.[114] Two other features have usually been cited to secure the interpretation of the fragmentary Berlin krater and, therefore, the Theseion painting, as exclusively the new Centauromachy at the wedding feast: the *table* used as a shield by Theseus' opponent and the *woman,* who appears on the smaller fragment.[115] Each of the two krater fragments contains part of the tongue pattern that surrounded the front root of one of the vase's volute handles. It is the sides of the composition on the obverse that have been pre-

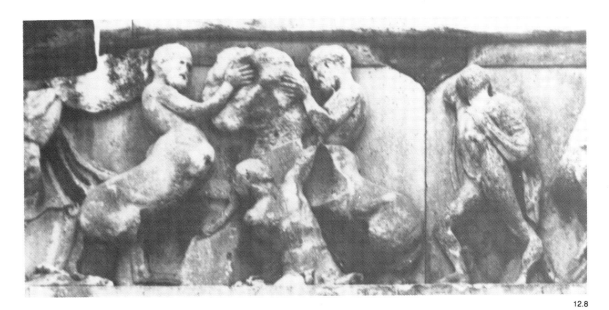

12.8

12.8. Athens, Hephaisteion. Detail of west frieze. Centauromachy (Kaineus). After C. Hofkes-Brukker, *Bassai-Fries* 95, fig. 9.

served, but something of the representation on the lost reverse can be learned from the smaller fragment. A right arm extends, under the handle, from side B to side A; the picture ran clear around the vase, as is the case, for example, on the painter's Amazonomachy volute-krater in Palermo.[116] The Berlin arm must have belonged to a Centaur, for it wields a *branch*. Since the exclusion of rocks and/or branches as weapons has been considered one of the prime criteria for recognizing the new Centauromachy,[117] the subject of the Berlin krater truly could not have been a pure fight at the feast.[118] A Centauromachy in the countryside must have appeared on the lost reverse. A peculiarity of side A is also important: the inclusion of terrain lines; even here the fight at the feast has moved out of doors.[119] This feature never has been explained adequately.

While the fragments by the Niobid Painter suggest, in general, that the Theseion painting would have represented neither the new indoor nor the old outdoor Centauromachy in isolation, they also require that a closer look be taken at the mural's overall composition, at its exact theme, and at just how they should be reconstructed. In order to begin, one must bear in mind both that the lost works in the Theseion, executed in the latter half of the 470s B.C., belonged to the very first datable cycle of large-scale murals known to have existed in ancient Athens,[120] and that this great Centauromachy painting is the earliest documented monumental example of the Thessalian story in any medium.[121] The possibility, therefore, of a broader Centauromachy in the Theseion imparts a heightened importance to the evidence for a close association of the armed battle with the

fight at the wedding feast elsewhere in the art of Classical Greece.

First, in the city of Athens herself, both themes might well be restored to two important programs of sculptural decoration. The armed Centauromachy in the countryside is preserved *in situ* on the continuous frieze at the west end of the Hephaisteion (fig. 12.8).[122] The remains of the west pediment are scanty, but, if E. B. Harrison is correct, the surviving hooves and legs should be restored as the fight at the wedding feast of Peirithoos.[123] Although the various parts of the Hephaisteion's sculptural embellishment were executed at different times, the program for the whole may well have been conceived as a unit.[124] Unity is clearly evidenced in what is known of the elaborate sculptural decoration of the Parthenon. The Centauromachy at the wedding feast appears on metopes from the Doric frieze on the south side of the building's exterior.[125] Once, a second Centauromachy could be found inside the building, according to Pliny, carved on the sandals of Pheidias' chryselephantine statue of Athena.[126] All record of which Centauromachy this was has vanished,[127] but, since the new Centauromachy occurs outside, it is entirely possible that the old Centauromachy was represented inside the temple. How suitable the Lapith Kaineus' disappearance into the earth would be alongside the snake of Erichthonios, the local king born from the earth![128]

Outside of Athens the pairing of the feast and countryside Centauromachies is unquestionable. The least well preserved, but probably the earliest example, can still be found in Attica, on part of the continuous frieze from the mid-fifth-century Temple of Poseidon at Sounion.[129] One slab

clearly contains the Kaineus motive (fig. 12.2), while on others women are attacked by Centaurs. On the frieze from within the cella of the Temple of Apollo Epikourios at Bassae of ca. 400 B.C., Kaineus' last battle in the countryside is shown in a context that includes not only women, but children.[130] Finally on a frieze from the heroon of Gjölbaschi-Trysa the Centauromachy in the countryside includes women and broken vases. Here the left-hand Centaur in the Kaineus group rams the hero into the ground with neither rock nor branch—even his weapon is a vase.[131] These three friezes present contaminated versions—countryside Centauromachies containing elements associated with the feast.[132] How strange the sudden appearance of conflated renditions in the second half of the fifth and early fourth centuries seemed so long as the predominant scholarly view supposed the isolation of the Centauromachy at the feast in monuments of Early and High Classical Greek art! On the other hand, however, do sculptural monuments in which armed battle joins or mixes with feast battle closely reflect the broader Centauromachy in lost Polygnotan painting?

Barron, in fact, has suggested both that the Theseion painting's composition did unite the new feast battle directly with a new, immediate armed Centauromachy in the countryside, and that for this conflation the picture itself was dependent on a lost literary source.[133] He has found evidence for his conclusion in later ancient literature as well as in art:

... there was in antiquity a combined version in which the brawl at the feast led *at once* into a pitched battle outside. This version is to be found very fully reproduced in the twelfth book of Ovid's *Metamorphoses*, 182–535, the story of Kaineus. . . . Certain details show that Ovid's immediate source was Hellenistic; but . . . it does not follow that this version was a Hellenistic invention. In fact, a story in which the outdoor fight followed at once was certainly known in the late fifth century, when it appears unequivocally on three works of sculpture.[134]

Another interpretation, however, of the relationship of the conflated story to the painting is possible. In order to understand fully the representation in the Theseion it is necessary to go beyond the testimony of preserved vases, sculpture, and texts by referring, as well, to what is known of Polygnotos' own lost works. M. Robertson, in an astute reappraisal of Pausanias' description of the Sack of Troy, in the Lesche of the Cnidians at Delphi, has brought out several of this painting's differences from the art of the Archaic period.[135] His brief remarks go beyond his specific intention and imply much about the

nature of painting itself. "The description of Polygnotos' picture shows three great changes: the abandonmant of the single groundline, the inclusion of an area outside of the city (camp, shore, sea) and a change of time."[136] The scattered bits of preserved evidence for the great Centauromachy can now be interpreted more clearly. In the Theseion painting a fight would have been shown breaking out in the hall of Peirithoos' palace at the wedding feast,[137] but soon some of the participants exited through an open door to the garden or courtyard of the palace.[138] Finally, in the out-of-doors, there would have been a progression, not only in space, but in time, and the composition continued as the famous old armed Centauromachy in the countryside.[139]

The saga of Kimon's masterful political maneuvering by means of the successful mission to Skyros, the search there for Theseus' remains, and the subsequent enshrinement of the *hero's bones* in Athens need not be retold here.[140] It is necessary, however, to emphasize the extraordinary position the paintings of the new Cimonian sanctuary must have held in the history of Theseus iconography. Both general themes and specific images employed in these early murals must have been rethought to suit the remarkable nature of the commission. On this auspicious occasion the venerable armed Centauromachy in the countryside would by no means have been changed, but augmented. Now, in the painting, the viewer would not only see the battle, but learn of its cause at a wedding many months earlier. A skirmish on a single day was expanded to epic proportions, in the epic manner.[141] ". . . The barbarity of the centaurs, committing a violation of hospitality, . . . suggests an awareness of the complexity of the human condition, which is very different from the simple battle of man and beast out in the open."[142]

The Theseion Centauromachy need not have depended upon a lost literary source; the expanded story could well have been created expressly for the monumental painting.[143] One must wonder whether the program for its composition was devised by the painter alone, or by painter in conjunction with patron, or with poet.[144] The reconstruction of a Polygnotan original with a tripartite composition that clearly accommodated the entire Centauromachy, new and old, sheds a special light on the complexion of things. The subtle distinctions of time and concurrent changes of locale that gracefully occur in major painting, could easily be misunderstood and/or purposely simplified by other

artists, working in different media. In sum, conflated Centauromachies elsewhere in Classical art, and perhaps such versions in later literature as well, should ultimately depend not upon a retelling of the tale in an unknown early Classical text, but upon a cursory reading of the pictorial vocabulary in the Theseion painting itself. It is neither the general organizational nor thematic principles of the painted composition that later renditions reproduce.

This discussion has not moved so far from the ancient pummeling-convention as might appear to be the case, for the most important issue remains: the question of whether Kaineus was included in the old countryside Centauromachy of the lost *Classical* painting.

The preserved Centauromachies on continuous sculptural friezes of the Classical period differ from each other, both in the whole and in detail. The Kaineus incident, however, is present on all. While the pummelings are not identical, they are bound together by three or four distinctive features. On the Hephaisteion frieze (fig. 12.8) the motive has a new unity—the attacking Centaurs, instead of wielding individual weapons, join forces in lifting a single, heavy rock over the head of our hero.[145] In self-defense, Kaineus raises his shield above his head; the viewer can see its inner surface. The dramatic Bassae frieze appears to relate the next moment: the Centaurs take advantage of Kaineus' raised shield by lowering masses of rock directly upon it.[146] At Gjölbaschi-Trysa, although the Centaurs attack with separate weapons, the motive of Kaineus' shield, raised so that its inner surface shows, has been maintained.[147] Although A. Delivorrias has restored a kneeling Kaineus with a raised arm to the slab of the Sounion frieze,[148] the battered remains (fig. 12.2) appear to indicate another sinking Kaineus with a raised shield. On the Hephaisteion and Bassae friezes, and possibly the Sounion one, Kaineus twists dramatically in space as he lifts his shield; he has now shed his body armor, but not his helmet.[149]

The last important detail can first be documented on the Hephaisteion frieze. The Centaur group is not isolated: a Greek comes to Kaineus' aid (fig. 12.8). He wears a fine cloak, and a petasos, fastened around his neck, hangs at his back.[150] He lunges forward in a broad step; his sword arm, thrown back over his head, is poised for action. His pose recalls that of Harmodios from the Tyrannicides of 477 B.C., and to Homer Thompson he is Theseus.[151] His importance is clear: he displaces the symmetrical pummeling of Kaineus, assuming the central position on the west frieze.[152] Now there is a flickering glimmer of hope for the ill-fated Lapith. On the frieze from Gjölbaschi-Trysa a rescuing hero appears at the right of the Kaineus group as well. At Bassae, once again, a more advanced and a more dramatic stage in the action is shown. The rescuer at the right is already pulling the hair of one of Kaineus' attackers.

The depictions of Kaineus in relief appear to be variations that recall a single prototype;[153] they represent an important pictorial tradition that has not been preserved in Attic vase-painting.[154] If the lifted shield, the helmeted but nude Kaineus, the unified mass of rock and the rescuer at the right all go back to one famous fifth-century example, perhaps it would not be too fanciful to imagine that that lost prototype was a monumental painting in the Theseion, as it has been reconstructed here.[155]

Just why had there ever been a campaign against a role for Kaineus in Classical painting? There appears to have been a lone culprit, a monument, heretofore considered the supreme representative of the fifth-century tradition of Centauromachy, which, in fact, is unique—the west pediment of the Temple of Zeus at Olympia.[156] With the elimination of the other known examples, Olympia is revealed as the only instance in monumental Classical art where the fight at the wedding feast unequivocally appeared alone—in complete isolation from the fight in the countryside. Now it is possible to consider why.

It would have been awkward to combine multiple themes successfully in the composition of a single pediment.[157] As apparently was later to be the case on the Hephaisteion in Athens, the new Centauromachy alone was selected. To suggest the fight at the feast in sculpture, all that would be absolutely necessary, in addition to the Lapith men and Centaurs, is the inclusion of a few women. The elements of setting associated with Peirithoos' house in painting, couches, and cushions, for example, can be omitted with ease. The old Centauromachy, on the other hand, is essentially pictorial in its conception. Rough terrain, trees as setting and/or employed as weapons, and especially the illusion of Kaineus' disappearance would not have been appropriate fare for strongly three-dimensional sculpture during the Classical period—suitable neither for the pediment nor the architectonic metope compositions of a Doric temple. The old Centauromachy is most at home in painting; in sculpture it is best expressed in a pictorial relief such as the continuous frieze. The Centauromachy at the wedding feast appears in isolation at Olympia, for the

Early Classical Doric Temple of Zeus had no Ionic frieze. In modern scholarship, the example of its magnificent pedimental sculpture has distorted attempts to envision a famous lost mural painting.

The final evidence in favor of Kaineus' importance in the Theseion is different in nature. It necessitates taking into account one element that made the "revolution in painting"[158] of the fifth century B.C. truly a *revolution*. Robertson has spoken of an "interest in space for its own sake,"[159] and it is necessary to examine this more closely. As we have seen, the nature of the Classical painter's illusion of the third dimension has been evoked in modern scholarship by means of Pausanias' descriptions of paintings he saw, in which figures were placed up and down the field, as well as by some extraordinary red-figured vases on which strict adherence to a single groundline has been abandoned.[160] There can have been no such thing, however, as *Polygnotan style* in the absolute sense in which the term has been employed. A twenty-five-year span for Polygnotos' career can be documented and his activity may well have stretched longer.[161] Certainly what is known of the artists of Attic vases or of European paintings was true of the "first great painter"[162] as well. Polygnotos' style must have had (as Beazley might have termed it) very early, early, middle, and late periods, and, likewise, the revolution in space, with which he is associated, must have evolved: the formulae for illusion maturing with time.

The justly famous compositional type consisting of figures meaningfully disposed over a high and rocky terrain, which suggests not only up and down, but in and out, certainly had been achieved by ca. 450 B.C., the time of the Classical paintings most fully described by Pausanias, Polygnotos' Iliupersis and Nekyia in the Lesche of the Cnidians.[163] Robertson notes, ". . . it is related to a kind of actual landscape no Greek artist need travel far to find; it was all round Polygnotos at Delphi."[164] Perhaps something of this impressive landscape vista had already been achieved ca. 460 B.C., the time of his Iliupersis in Athens in the Stoa Poikile.[165] In the *early* Theseion paintings of the late 470s B.C., however, the handling of space must have been rather different—in some respects less advanced. This feature has hardly been recognized, let alone described in detail.[166]

The volute-krater in New York by the Painter of the Woolly Satyrs (fig. 12.3) has often figured in discussions of monumental painting, and its thematic juxtaposition of new Centauromachy with Amazonomachy has specifically brought the Theseion to mind.[167] Another "big battle,"[168] again an Amazonomachy, occurs on an equally famous and often discussed New York vase, the calyx-krater by the Painter of the Berlin Hydria.[169] The *revolutionary* style of both pots is similar. Individual figures are impressively characterized and frequently appear in the most eye-catching of foreshortened positions. Here, however, forms are not broadly distributed on many levels; indeed, the compositions are compact, even closely knit. Terrain lines create only a *low* landscape shelf. Feet of several figures are overlapped by the gently rolling ground, and another novel feature appears under the handles of the volute-krater (figs. 12.9a, 12.9b). On each side an Amazon: the one fallen, the other on the lookout[170]—we see their tops, but not much more. The rest of their bodies are concealed behind "hillocks,"[171] and their heads are drawn in frontal face—the audacity of these unusual images is made abundantly clear. The almost-hidden Amazons, however, are not far above/behind the other combatants, but relegated to more or less the same stratum of terrain. Perhaps the spatial vocabulary of landscape is compressed or limited thus here not simply because these pictures are pictures painted on vases, but because this is what space was like in the earliest Classical murals on which the New York kraters appear to depend.[172] (See Ridgway pp. 194, 197.)

Heretofore, it has never been noted that a similarly conservative use of terrain lines recurs in an unquestioned reflection of a Theseion painting: the Niobid Painter's Berlin Centauromachy (fig. 12.4). Both of the surviving fragments of this volute-krater are from the upper portion of the obverse; sections of the tongue pattern at the juncture of body and neck are preserved. The break at the bottom edge of the main fragment must have come just above a meander border delineating the lower limit of the picture field. The majestic forms that have been preserved are not broadly dispersed on different levels, but disposed along terrain lines within a tightly controlled stratum of landscape. The nature of the space might be attributed to the Niobid Painter's adaptation of the subject to the shape of a vase, or, once again, it might suggest something about a famous prototype: the early Centauromachy mural in the Theseion. In the Niobid Painter's rendition, fight in garden court apparently shifted to fight in countryside. In the frieze on the Vienna krater, by the Nekyia Painter, fight in palace hall moves through an open door to fight in courtyard.[173] How harmoniously a tri-

12.9a. New York 07.286.84. Handle Side A/B of figure 12.3. Courtesy Metropolitan Museum of Art.

12.9b. New York 07.286.84. Handle side B/A of figure 12.3. Courtesy Metropolitan Museum of Art.

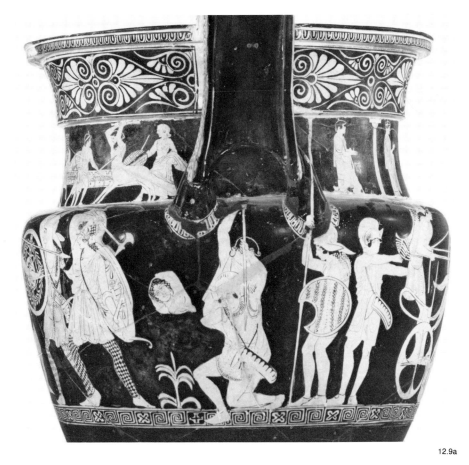

12.9a

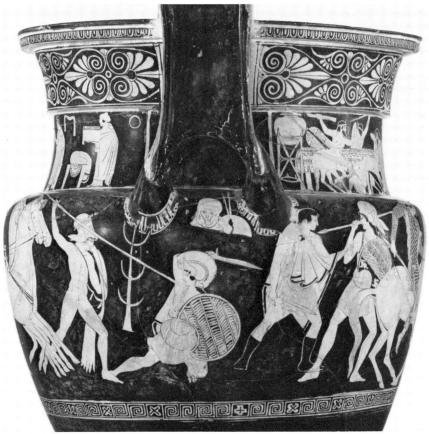

12.9b

partite division in the composition of the lost monumental painting could have functioned! The architectonic backdrop of the couch-lined palace hall (cf. the *neck* of the New York volute-krater [fig. 12.3]) worked in conjunction with low strata of terrain in courtyard and country-side to form a consistent spatial fabric for the whole.

Now we may return to the fourth wall in the Theseion—the place some would like to locate the Polygnotan painting on which the enigmatic hero scene of the Niobid krater depends.[174] That the vase, itself, dates close to the mid-century is not nearly so significant as the fact that the spa-tial construction of the landscape (a steep and mountainous terrain, the figures broadly dis-persed up and down the picture plane) in the painting copied on its obverse could neither have been executed nor conceived in the 470s B.C. The Niobid Painter's lost model, therefore, could not have belonged to the early programmatic mural cycle in the Theseion. His krater's justly famous landscaped panorama must reflect a more mature Polygnotan moment, but I know neither what the original painting represented, nor where it was to be found.[175]

Perhaps the clearest conception of the subtle evolution of Polygnotan space can be obtained by taking as further look at one type of detail rather than at entire compositions. Over the B-A handle of the Niobid krater, behind the Athena of the hero scene, *above* and, hence, further away from the viewer than the goddess, the upper half of a warrior, with his back to us, still can be seen over the top of a hill.[176] This image recalls the earlier New York hidden Amazons, but is more complex than they. Just how beloved such figures, partially or almost entirely, con-cealed by elements of landscape, must have been in Classical painting is known to us not only from examples on vases. The tale has been told, perhaps even more frequently in modern times than in ancient, of an image once painted that became a legend: ". . . of a warrior named Butes (described variously as by Mikon and as one 'of those fighting in the Stoa') only the helmet and an eye appeared over the mountain, and 'quicker than Butes' became a proverb for a job easily done."[177] Butes himself has long since vanished without a trace, but it has been argued that the ultimate (preserved) example of such a spatial trick be recognized in the arrow at the lower right of the Niobid scene on the Louvre calyx-krater,[178] a "Niobid, lying dead in the valley, is only shown to us by the single line of the weapon that inflicted the mortal wound. . . . this little

stroke speaks volumes."[179] In all of these examples the main space-creating device consists of the parts of the human anatomy that are not seen, but imagined behind rock, hill, or mountain.

A vase from the 440s B.C., the pelike in Boston by the Lykaon Painter, preserves a partially concealed figure conceived with extraordinary sophistication (fig. 12.10).[180] Here Odysseus meets the shade of Elpenor in much the way described by Homer.[181] The shade can best be seen in the detail reproduced here (fig. 12.10), the outlines of the landscape in the old drawing.[182] As Beazley has said, "we cannot do better than quote Caskey's description of the vase"[183]

The tall reeds with their tops waving in the wind suggest the proximity of rivers. And the rock at their confluence is represented by the undulating line extending to the upper border of the picture. Elpenor, whose legs from the knees down are hidden in a depression of the ground, leans his body and raised left arm against this rock, the hand grasping a projection from it, while his right hand, planted on another rock, gives him the additional support he needs. Like Agamemnon, who appears later in the story, "no longer had he substance to stand firm or the vigorously free movements such as once filled his supple limbs."[184]

The lines that delineate the rocky projections on the surface of the vase are faded now, but Elpenor is still an extraordinary apparition, even to modern eyes. His curving body-contours move and bend *in space;* his limbs grasp at, swell, or press against *three* different landscape elements.

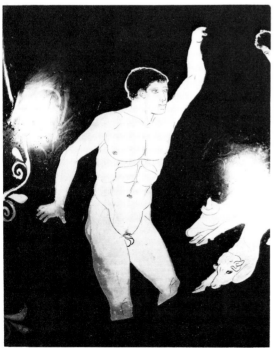

12.10

The setting is here rendered three-dimensional, in a way no earlier hillock ever was, simply by means of the figure-drawing. At last the visible portions of the figure overlapped by terrain suggest landscape depth as much as the conceit of limbs hidden from our eyes. The Boston pelike may not reproduce exactly the Odysseus and Elpenor of the Nekyia in the Lesche of the Cnidians at Delphi,[185] but surely it embodies the spirit of Polygnotan style when fully ripe and most powerful.

These clever examples of figures overlapped by terrain occur on vases dating from the 460s to the 440s. In the conscious creation of the spatial repertory of major painting this trick must have been among the first breakthroughs. But have we not seen something like it before? Herein lies the essential significance of Kaineus. Of all images from Archaic tradition, the pummeling of the Lapith warrior through the crust of the earth most dramatically prefigures this special illusion in the landscape vocabulary of Classical painting. It could be that the revolution began the day a pioneering muralist[186] (Polygnotos?) happened to look at the inveterate Kaineus convention with fresh eyes.

In ancient Greece the interpretations of themes possible in Classical painting and sculpture must, on occasion, have diverged widely. Rarely are we made acutely aware of that distinction by surviving monuments. The shade of Elpenor in the landscape of the Polygnotan pelike in Boston is an eloquent exception, but the opening of this story may well go back to the Kleophrades Painter's Kaineus stamnos in the Louvre, with its falling stone (figs. 12.10, 12.7a, 12.7c).

NOTES

This article is an expanded version of the talk delivered at the Burdick-Vary Symposium; it owes much to J. R. Mertens' careful and perceptive reading of that paper in draft. My thanks go to her, to R. Brilliant for several helpful suggestions, and to D. von Bothmer for reading the final manuscript.

1 For a basic discussion of *paragone* see A. Blunt, *Artistic Theory in Italy 1450–1600* (Oxford 1940) chap. 4; the most recent accounts give references to earlier literature: C. Pedretti, *The Literary Works of Leonardo da Vinci, compiled and edited from the Original Manuscripts by Jean Paul Richter, Commentary* (Berkeley 1977) I, 32, 76–86 and II, 206; and L. Mendelsohn, *Paragoni: Benedetto Varchi's "Due Lezzioni" and Cinquecento Art Theory* (Ann Arbor 1982) part II, chap. 1. L. Mendelsohn and J. H. Beck have aided with references on *paragone*.

2 F. Schachermeyr, *Die frühe Klassik der Griechen* (Stuttgart 1966) gives a comprehensive view of the situation in Greece at this time—not only in the visual arts.

3 For examples of the use of *paragone* in art-historical analysis see J. White, "Paragone: Aspects of the

12.10. Boston 34.79. Detail. Odysseus and the shade of Elpenor. Courtesy Museum of Fine Arts, William Amory Gardner Fund.

Relationship between Sculpture and Painting," in *Art, Science, and History in the Renaissance,* ed. C. S. Singleton (Baltimore 1967) 43–108, for this and the Renaissance interpretation of ancient painting; see also K. Weil Garris Posner, *Leonardo and Central Italian Art: 1515–1550* (New York 1974) 12–15, 19–22, 25, 32, 38–39, 42. On the nature of the writings on art in antiquity see J. J. Pollitt, *The Ancient View of Greek Art: Criticism, History and Terminology* (New Haven 1974) esp. 10–12, 23–24, 30; for the well known *paragoni* of painting and poetry, of tragedy, poetry, and philosophy 40, 43, of artists and orators 60–61, 62, 81. E.g., cf. Pl. *Resp.* x.607.8b–608b; Arist. *Poet.* VI.19–21. No significant tradition of a comparison of painting and sculpture in preserved ancient literature is known to me.

4 For a detailed reconstruction and interpretation M. Delcourt, "La légende de Kaineus," *RHR* 143–44 (1953) 129–50. See also J. G. Frazer's notes to the Loeb Classical Library edition of Apollodorus, *The Library* II (Cambridge, Mass. 1921) 150–51, n. 1; Preller-Robert II, pt. 1, pp. 10–11; W. H. Roscher, *Ausführliches Lexikon der griechischen und römischen Mythologie* II (Leipzig 1890–1897) 894–97.

5 Preller-Robert II, pt. 1, p. 8 on the father—usually given as Elatos, sometimes as Koronos, e.g., Apollodorus, *The Library* I.9.16.

6 E.g., scholiast on Ap. Rhod. *Argon.* I.57; scholiast on Hom. *Il.* I.264; Ov. *Met.* XII.459–532. Delcourt, "légende Kaineus" 130, "aucun poète grec, dans un texte conservé, ne parle du changement de sexe de Kaineus, lequel nous est connu uniquement, en dehors d'Ovide, par des scholiastes et des mythologues;" note the quotation of Akousilaos, *POxy.* XIII, 133–34, 139, and 142 on the derivation of Akousilaos' work from Hesiod. On the sex-change see H. Kenner, *Das Phänomen der verkehrten Welt in der griechisch-römischen Antike* (Klagenfurt 1970) 151–52.

7 Hom. *Il.* I.264.

8 The fullest version is given in the Akousilaos frag. *POxy.* XIII, 133–34, lines 38–97, 139; see also the scholiast on Hom. *Il.* I.264 and the scholiast on Ap. Rhod. *Argon.* I.57.

9 Ov. *Met.* XII.170–536, gives the most complete version of the wedding and war. For the wedding, Servius on Verg. *Aen.* VII.304; for the war Hom. *Il.* I.262–69. No literary version of the fight at the feast on which monuments of fifth-century art might depend has been preserved.

10 On Theseus' role, Plut. *Thes.* 30.1–2. On the friendship of Theseus and Peirithoos, see also J. E. Fontenrose, *RE* XIX, cols. 120–21. On the role, Apollod. *Epit.* 1.21; Plut. *Thes.* 30.3. Cf. a seemingly late addition to the story: Ares started the fight—of all the gods he alone had not been invited to the wedding (Servius on Verg. *Aen.* VII.304–7).

11 Cf. Hom. *Il.* II.740–44 for the tradition that Peirithoos' son by Hippodameia, Polypoetes, was born on the day of the victory over the Centaurs; infra n. 38.

12 *POxy.* XIII, 134, Akousilaos, lines 76–83.

13 In Pindar (fr. 167), the weapons of the Centaurs are fir trees; so too in Apollod. *Epit.* 1.22; cf. Ov. *Met.* XII.507–21 where an entire forest is heaped upon Kaineus. J. D. Beazley mentions that Kaineus' invulnerability was of the same type as that of the Nemean Lion, "Two Swords: Two Shields," *BABesch* 14 (1939) 8, n. 18; on this see also Delcourt, "légende

Kaineus" 137–38.

14 Pind. fr. 167.

15 According to Delcourt, "légende Kaineus" 133, the position suggested by Pindar is the very one in which Kaineus had implanted his own spear in the ground.

16 Ov. *Met.* XII.524–31.

17 Verg. *Aen.* VI.447; see Kenner, *verkehrten Welt* 151–52 on the significance of this sex-change after death; see also Frazer in Apollodorus, *The Library* II, 150, n. 1.

18 R. Hampe and U. Jantzen, *OlBer* I (1937) 85–86, pl. 28.

19 E. Kunze, *Neue Meisterwerke griechischer Kunst aus Olympia* (Munich 1948) fig. 36.

20 On the subtleties of the symmetrical composition of the Olympia plaque see I. Scheibler, *Die symmetrische Bildform in der frühgriechischen Flächenkunst* (Kallmünz 1960) 56–57. These Centaurs' trees are complete to the roots—they were ripped from the ground rather than broken off; in vase-painting this detail is retained in non-Attic fabrics; cf. the Caeretan hydria *AntK* 11–12 (1968–1969) pls. 42, 43.3 and the Uprooter Class, n. 1, *ABV* 589, which is Etruscan, according to D. von Bothmer.

21 Beazley, "Two Swords" 7–8.

22 E.g., *Vasenlisten*³ 501, C 1, C 3: Etruscan hydria, Vienna 406, Beazley, "Two Swords" 7, fig. 5; Ionian hydria, Bonn, Akademisches Kunstmuseum v.2674, K. Schauenburg, "Eine neue Sianaschale," *AA* 1962, cols. 759–62, figs. 11–12; Schauenburg mentions the Etruscan love of symmetry as well.

23 Ibid. cols. 752–54 for this view of the representation of Kaineus.

24 New York 69.233.1 (ex Bastis Coll.), neck-amphora: *ABV* 271, no. 75.

25 Brussels A 134, stamnos: *ARV*² 1027, no. 1; Arias-Hirmer pl. 190.

26 See Scheibler, *symmetrische Bildform* 69–70 for the compositional development in the Archaic period.

27 For the reverse effect, cf. representations of the return of Persephone, e.g., New York 28.57.23: *ARV*² 1012, no. 1, *BMMA* 26 (1931) 246, fig. 2; 247, fig. 3; Dresden 350: *ARV*² 1056, no. 95, *Marburger Jahrbuch für Kunstwissenschaft* 15 (1949/50) 22, fig. 25 and the birth of Erichthonios, e.g., Munich 2413: *ARV*² 495, no. 1, E. Buschor, *Griechische Vasen* (Munich 1969) 190, fig. 202; London E 182: *ARV*² 580, no. 2, *EAA* V (Rome 1963) 626, fig. 781; Leipsig T 654: *ARV*² 585, no. 35, *JdI* 11 (1896) 189, fig. 33a; Berlin 2537: Buschor, *GrVasen* 224, fig. 232. There is no established black-figure tradition for either of these themes; on the former see P. Hartwig, "Die Wiederkehr der Kora auf einem Vasenbilde aus Falerii," *RömMitt* 12 (1897) 89–104. Other major themes with a partially appearing or disappearing figure in Archaic art are different in nature: cf. the birth of Athena, e.g., Louvre CA 616: *ABV* 58, no. 122, J. Charbonneaux, R. Martin, F. Villard, *Archaic Greek Art,* trans. J. Emmons, R. Allen (New York 1971) fig. 61; the birth of Pegasos, e.g., New York 06.1070: *ARV*² 301, no. 3; G. M. A. Richter, *Attic Red-figured Vases, A Survey* (New Haven 1975) fig. 71. See F. Brommer, "Die Geburt der Athena," *RGZM* 8 (1961) 66–83.

28 *ARV*² 1057, no. 107; *Greek Vase-Painting in Midwestern Collections,* eds. W. G. Moon and L. Berge (The Art Institute of Chicago 1979) 211, no. 118.

29 E. Fabricius, "Die Skulpturen vom Tempel in Sunion," *AthMitt* 9 (1884) 348.

30 Schauenburg, "Neue Sianaschale" cols. 751–52 and

fig. 5.

31 One important aspect, heretofore, has not been emphasized: the distinction between definite representations of Kaineus, those in which the hero is shown actually sinking into the earth, and probable ones, those in which a warrior simply crouches between a pair of attacking Centaurs—his legs still entirely above the ground, e.g., Christchurch, N.Z., Univ. of Canterbury 41/57: *Paralipomena* 134, no. 31 *bis*; Schauenburg, "neue Sianaschale" col. 755, fig. 8; Basel, Kambli Coll.: *ABV* 422, no. 6, *Paralipomena* 181, K. Schefold, *Meisterwerke griechischer Kunst* (Basel 1960) 161, no. 145; Naples 2410: *ARV²* 239, no. 18, J. Boardman, *Athenian Red Figure Vases, The Archaic Period, a handbook* (London 1975) fig. 170. On this see P. V. C. Baur, *Centaurs in Ancient Art, the Archaic Period* (Berlin 1912) 40–41. The earliest preserved Kaineus in red-figure is only a probable one, Copenhagen 13407 by Oltos: *ARV²* 59, no. 57; see K. Schefold, *Götter- und Heldensagen der Griechen in der spätarchaischen Kunst* (Munich 1978) 207 and 155, "Der Maler verzichtet auf das Motiv des Versinkens im Boden. Wichtiger ist es ihm, den Helden ganz zu zeigen." Several examples of both definite and probable Kaineus representations in Centauromachies on Attic vases have thus far been overlooked. First, disappearing: Orvieto, Faina 44: *ARV²* 417, no. 2, P. Hartwig, *Die griechischen Meisterschalen der Blütezeit des strengen rothfigurigen Stiles* (Berlin 1893) 551, fig. 64b; Riehen, Gsell Coll.: *ARV²* 351, no. 3, *Vente ix Bâle* pl. 20, 334. Perhaps the partially preserved tondo of the cup Cab. Méd. 534, 527, 538 *bis*: *ARV²* 330, no. 2, in the manner of Onesimos, showed a disappearing Kaineus; cf. Baur, *Centaurs* 40, "It is remarkable that although the Kaineus episode fits very well into a circular space it never occurs on the inside of a cylix." Additions to the "legs above the ground" type: Louvre E 876: *ABV* 90, no. 1, *CVA* Louvre 2 pl. 22.2 and 4; Frankfurt VFβ 285: *Paralipomena* 40, *CVA* Frankfurt am Main 1 pls. 24.1; 25.6; Vienna 871: *ARV²* 1096, no. 3, *CVA* Vienna 2, pl. 95.3; Brussels R 303: *ARV²* 249, no. 6, *CVA* Brussels 1, pl. 8c, is mentioned as Kaineus by J. D. Beazley *The Pan Painter* (Mainz 1974) 11, no. 12; infra n. 72.

32 On Parthenon metopes infra n. 35.

33 Paus. v.10.8.

34 B. Ashmole and N. Yalouris, *Olympia, The Sculptures of the Temple of Zeus* (London 1967) 18. Pausanias' mistaken reference (v.10.8), however, exemplifies the hero's intimate and continued association with the Thessalian Centauromachy—Pausanias, or his guide, assumed Kaineus' presence even though there is no pummeling motive.

35 On the distinction between the two stories, cf. Preller-Robert II, pt. 1, 18–19; C. Hofkes-Brukker in *Der Bassai-Fries in der ursprünglich geplanten Anordnung* (Munich 1975) 46. F. Brommer, *Die Metopen des Parthenon* (Mainz 1967) 239, believes the Centauromachy of the south metopes is not the Thessalian one, but an Athenian one that is not preserved in the literature. The absence of Kaineus plays a role in his conclusion.

36 Baur, *Centaurs* 38. B. Shefton, "Herakles and Theseus on a Red-figured Louterion," *Hesperia* 31 (1962) 353–54 on the new Centauromachy as an adaptation from scenes of Herakles, Nessos, and Deianeira; 353, n. 94 on the uncertain theme of some Centauromachy representations with women in the fifth century B.C.; 355, n. 104 on the problems of identification of

the specific Centauromachy in earlier banquet-fights in Greek art.

37 Hofkes-Brukker, *Bassai-Fries* 46; H. Thompson, "The Sculptural Adornment of the Hephaisteion," *AJA* 66 (1962) 346.

38 Ashmole and Yalouris, *Olympia* 18–19, pls. 110–14. On the different literary traditions of the name of the bride, given either as Deidameia or Hippodameia, see Frazer, Apollodorus, *The Library* II, 149, n. 2.

39 Hofkes-Brukker, *Bassai-Fries* 46; *infra* n. 46.

40 E.g., Brommer, *Metopen* pl. 177, south no. 4; pls. 193, 195, south no. 6; cf. the Carrey drawing pl. 150, fig. 1 (9) and the destroyed metope pl. 151, fig. 2 (23).

41 Parthenon metopes, e.g.: Brommer, *Metopen* pl. 165, south no. 2; pls. 169, 171, south no. 3; pl. 217, south no. 27; pl. 229, south no. 30; figures from the west pediment of the Temple of Zeus, Olympia, e.g.: Ashmole and Yalouris, *Olympia* pl. 86, Lapith youth "Q"; pl. 95, Theseus "M"; pls. 139, 142, Lapith youth "T".

42 E.g., Madrid 10919: *ABV* 247, no. 92, H. Mommsen, *Der Affecter* (Mainz 1975) pl. 98; Brussels R 303, supra n. 31.

43 E.g., Brommer, *Metopen* pl. 173, south no. 4; pl. 199, south no. 11, cf. the Carrey drawing pl. 150, fig. 1 (11); 239 for the various types of weapons employed in Centauromachies in Classical art.

44 E.g.: the Gigantomachy, in the manner of the Peleus Painter, on the calyx-krater, Ferrara T 300: *ARV²* 1041, no. 6, N. Alfieri, P. E. Arias, and M. Hirmer, *Spina* (Munich 1958) pl. 66; the Amazonomachy by Aison on the squat lekythos, Naples RC 239: *ARV²* 1174, no. 6, Arias-Hirmer pl. 205.

45 For preserved evidence of missing hand weapons on Parthenon metopes Brommer, *Metopen* 74, 79, 94, 116; frequently, when right arms and hands are missing it is difficult to ascertain whether weapons were added in bronze aside from the context of the action, e.g., pl. 165, south no. 2; pl. 169, south no. 3; pl. 177, south no. 4; pl. 191, south no. 8; pl. 195, south no. 9; pl. 218, south no. 27; pl. 233, south no. 31; and pl. 210, the destroyed metope, south no. 24. Ashmole and Yalouris, *Olympia* 21: preserved on the west pediment there is evidence of only one knife added in bronze, and this weapon is thought to have been a later addition. On the cuttings for this knife see G. True, *Die Bildwerke von Olympia in Stein und Thon, Olympia die Ergebnisse der von dem Deutschen Reich veranstalteten Ausgrabung* III, eds. E. Curtius and F. Adler (Berlin 1897) 87 and fig. 149.

46 Vienna 1026: *ARV²* 1087, no. 2; *MMS* 5 (1934–1936) 132–33, for a line drawing of the composition *AZ* 41 (1883) pl. 18. On the use of unorthodox weapons in the Centauromachy at the feast J. D. Beazley, CB III 85–87; G. Becatti, *Il maestro d'Olimpia* (Florence 1943) 38. Cf. P. E. Arias, "Dalle necropoli di Spina. La tomba 136 di Valle Pega," *RivIstArch* 4 (1955) 117–19, figs. 23–27 and 116.

47 Boston 00.344: *ARV²* 1319, no. 2, CB III, pl. 104, no. 171; Boston 00.345: *ARV²* 1319, no. 3, CB III, pl. 105, no. 172. Beazley has called attention to the use of a few swords on the Boston cups, CB III, 85–86, and on Vienna 1026 (supra n. 46) the groom Peirithoos alone advances with a sword. See also Hauser in FR III, 42.

48 New York 07.286.84: *ARV²* 613, no. 1.

49 Louvre C 10749: *ARV²* 613, no. 2; *Hesperia* 31 (1962) pls. 109a and b.

50 Florence 3997: *ARV²* 541, no. 1; *EAA* III (Rome 1960)

701, fig. 857, FR, pl. 166.2.

51 Berlin 2403: *ARV*² 599, no. 9; for the sake of clarity in detail line drawings are figured here; the best published photographs: H. Schrader, *Phidias* (Frankfurt 1924) figs. 150–51.

52 Shefton, "Herakles and Thesus" 361 and 364. C. Robert, *Die Marathonschlacht in der Poikile und Weiteres über Polygnot, Hallisches Winckelmannsprogramm* XVIII (Halle 1895) 49, was the first to point out the Polygnotan character of the table-as-shield motive by analogy with reflections of the painting of the death of the suitors in the Temple of Athena Area at Plataea; the lost painting was seen by Pausanias (x.4.1).

53 E. Curtius, "Die Giebelgruppen des Zeustempels in Olympia und die rothfigurigen Vasen," *AZ* 41 (1883) cols. 348–51, first connected Berlin 2403 with the pediment. Robert, *Marathonschlacht* 48–50, first associated both Attic vases and the Olympia west pediment with the lost painting in the Theseion. In this he has been followed by K. Seeliger in Roscher, *Lexikon* II, cols. 1772–78; P. Weizsäcker in Roscher, *Lexikon* III, pt. 2, col. 1772; Schrader, *Phidias* 172, 174–75; E. Pfuhl, *Malerei und Zeichnung der Griechen* II (Munich 1923) 641 and 695; Arias, "tomba 136" 123–26; Hauser in FR II, 246 and 322–24; Buschor in FR III, 288–89; Shefton, "Herakles and Theseus" 355, 361–64; Ashmole and Yalouris, *Olympia* 185; M. Robertson, *Greek Painting* (Geneva 1959) 131 and idem, *A History of Greek Art* (Cambridge 1975) 259. See also: E. Löwy, *Polygnot* (Vienna 1929) 20–24; T. B. L. Webster, *Der Niobidenmaler* (Leipzig 1935) 17; CB III, 87; E. Simon, "Polygnotan Painting and the Niobid Painter," *AJA* 67 (1963) 52.

54 Paus. I.17.2–3 and 6. On Kimon's return of Theseus' bones to Athens and the refurbishing of the Theseion see Plut. *Thes.* 36.1–2; W. R. Conner, "Theseus in Classical Athens," in A. G. Ward, ed., *The Quest for Theseus* (London 1970) 158–59. H. A. Thompson and R. E. Wycherly, *The Agora of Athens, the History, Shape and Uses of an Ancient City Center, The Athenian Agora* XIV (Princton 1972) 20–21, 63, n. 177, 124–25, and 205 on the route of Pausanias; 142, 147 for arguments against the identification of the Theseion with the temple known as the Hephaisteion. On the Hephaisteion, infra n. 122. On the Theseion see also: J. S. Boersma. *Athenian Building Policy from 561/0 to 405/4 B.C.* (Groningen 1970) 51–52; Simon, "Polygnotan Painting" 46–47; Robertson, *HGA* 242–43, 246–47, and 659, n. 155.

55 Paus. I.17.2–3.

56 According to Melanthius quoted in the lexicon of Harpokration, on this see: Robert, *Marathonschlacht,* 46–47; *Agora* XIV, 124; J. P. Barron, "New Light on Old Walls, the Murals of the Theseion," *JHS* 92 (1972) 23; also supra n. 53, Robertson, *Greek Painting* 121–22 and *HGA* 242.

57 Supra n. 53. Cf. infra nn. 61, 116, 118 for the *full* extent of Robert's point of view in *Marathonschlacht* 49, which has been overlooked in the twentieth-century literature.

58 Shefton, "Herakles and Theseus" 362–63. For Kimon's role in the elevation of Theseus in the fifth century B.C. via commemoration in monuments of art, see Conner, "Theseus" 157–64.

59 Paus. I.17.2–3. Robertson, *Greek Painting* 131; for "monumental Amazonomachies" see D. von Bothmer, *Amazons in Greek Art* (Oxford 1957) 163,

60 Cf. Vienna 1026, supra n. 46.

61 Supra n. 53. Only C. Robert, who first realized the relationship of the surviving monuments to a lost painting, is not dogmatic about the separation of the two themes; he says of Berlin 2403 ". . . ob . . . unter dem rechten Henkel die Kaineusgruppe angebracht war, kann natürlich niemand sagen," *Marathonschlacht* 49. The point of view that the Theseion painting was *limited* to the old Centauromachy in the countryside has been held only by J. E. Fontenrose, s.v. "Peirithoos," *RE* XIX, col. 135; perhaps it is of some significance that he connected the lost painting with the west frieze of the Hephaisteion, rather than with the Olympia west pediment and the Attic vases which depict the fight at the feast.

62 E.g., Basel, Kambli Coll.: supra n. 31; Vatican 388: *ABV* 283, no. 9; C. Albizzati, *Vasi Antichi Dipinti del Vaticano* (Rome n.d.) fascicule 6, pl. 55.

63 Florence 4209: *ABV* 76, no. 1; Development 35; Baur, *Centaurs* 12–13, 67; FR pls. 11–12; E. Simon and M. Hirmer, *Die griechischen Vasen* (Munich 1976) pl. 54. M. Bini, M. Cristofani, R. Giachetti, G. Maetzke, M. G. Marzi, A. Perissimotto, "Materiali per servire alla storia del Vaso François," *Bollettino d'Arte, serie speciale* I (Rome 1980) 72–73; 122, fig. 55; 128–29, figs. 66–69; 154, fig. 115; 161, fig. 126; 185, figs. 184–86.

64 Baur, *Centaurs* 39. Schefold, *Götter- und Heldensagen* 155, links the three-Centaur pummeling of the François vase to a four-Centaur version on the Ionian hydria, Bonn, Akademisches Kunstmuseum v.2674, supra n. 22, and postulates a common Attic prototype for both images; infra n. 67.

65 Beazley, "Two Swords" 8.

66 See Beazley (*Development* 33–34) on this special and unusual scene.

67 Schefold, *Götter- und Heldensagen* 154, "Theseus bewährt sich gegen die Kentauren wie Herakles. Es kündigt sich an, dass die Athener ihrem Helden denselben Ruhm verleihen wollen wie Herakles."

68 Cf. Hofkes-Brukker, *Bassai-Fries* 150, n. 8; Shefton, "Herakles and Theseus" 363 and esp., Conner, "Theseus" 143, who emphasizes Theseus' lack of importance on the François vase and in the Athens of the early sixth century B.C. In the Hesiodic description of the shield of Herakles, *Aspis* 178–90, the old armed Centauromachy apparently forms part of the decoration. Significantly, Theseus is included last in the list of combatants, Kaineus first and apparently at the center of the battle composition—clearly the pummeling must be implied. Were this a genuine passage by Hesiod it would provide the earliest known example of this motive in Greek literature or art, as well as evidence for a tradition of Theseus' participation already old when the François vase was created. For the problematic nature of the poem: *The Oxford Classical Dictionary*² (Oxford 1970) 511; however, cf. supra n. 6.

69 *Development* 35.

70 K. Schefold (*Götter- und Heldensagen* 155) would recognize Theseus on the Bonn hydria, Akademisches Kunstmuseum v. 2674, supra n. 22. Could the warrior with the Boeotian shield on the Tyrrhenian neck-amphora, Gotha 12, *ABV* 98, no. 43; *CVA* Gotha 1, pls. 23.1; 24.1; 25.1, be Theseus? In this Centauromachy the unfortunate Kaineus has just been squeezed in at the vase's handle; see Baur, *Centaurs* 20.

71 On the symmetrical convention supra nn. 24, 25, 62.

Cf. single attacking Centaur, e.g.: Frankfurt VF β 307: *ABV* 528, no. 46; *Paralipomena* 264, *CVA* Frankfurt am Main 1 pl. 39.3–4; see also the black-figured amphora in Taranto, *Vasenlisten*³ 501, C 2, *AA* 1956, 221, fig. 16.

72 E.g., Lucerne market: *ARV*² 563, no. 7; Vienna 871: *ARV*² 1096, no. 3; *CVA* Vienna 2, pl. 95.3; the warrior between two Centaurs on this column-krater by the Naples Painter, heretofore, has never been called Kaineus; however, his left foot could well be sinking into the earth.

73 E.g., Palermo, N.I. V 786 (the name-piece of the Kaineus Painter): *ARV*² 511, no. 1; *EAA* IV (Rome 1961) 289, fig. 341; Harrow 50, by the Cleveland Painter, *ARV*² 516, no. 5; *Burlington Fine Arts Club, Exhibition of Ancient Greek Art* (London 1903) pl. 97; infra n. 75. On this see also Baur, *Centaurs* 39.

74 London E 473: *ARV*² 551, no. 13; Beazley, *Pan Painter* pl. 27.1 and see 11, no. 12. The Pan Painter is the first to depict Kaineus as an unbearded heroic youth. Cf. Naples 2410 by Myson supra n. 31.

75 Mariemont G 130: *ARV*² 523, no. 5; *Les antiquités égyptiennes, grecques, étrusques, romaines, et gallo-romaines du Musée de Mariemont* (Brussels 1952) pl. 42. Cf. the column-krater by the Cleveland Painter, Ferrara, sequestro Venezia: *ARV*² 517, no. 6, *AA* 1962, 758, fig. 9, with perhaps a thrown tree as well as a rock. For Harrow 50, supra n. 73, see Beazley, *Pan Painter* 11, no. 12.

76 Brussels R 303: supra n. 31; for an important motive on this vase Beazley, *Pan Painter* 11, no. 12. Cf., for a simplified red-figure Centauromachy frieze, the shoulder of the kalpis by the Leningrad Painter, London 1920.3-15.3, Boardman, *ARFV* fig. 326.

77 *Vasenlisten*³ 501, B 18; FR pl. 15.

78 J. D. Beazley, "Kleophrades," *JHS* 30 (1910) 59, n. 71.

79 Ibid. 53; shield pulling also occurs in a Centauromachy by the Kleophrades Painter on the kalpis Leyden PC 83: *ARV*² 188, no. 71; J. Roulez, *Choix de vases peints du Musée d'antiquités de Leide* (Gand 1854) pl. 11.1. Otherwise, it appears in Amazonomachies, e.g., the calyx-krater in Bologna, FR pls. 75–76.

80 E.g., the Siana cup, now Greenwich, Conn., Mr. and Mrs. Walter Bareiss, on loan to the J. Paul Getty Museum, Malibu, published by K. Schauenburg, *AA* 1962, 749, fig. 2; *Vasenlisten*³ 500, A 19.

81 Cf. the Kaineus by Myson, supra n. 74, who, for once, appears to be dazed by the Centaurs' attack.

82 Beazley, "Kleophrades" 58–59. Contemporary red-figure Centauromachies on Attic cups belong in this context as well, esp. the ones by the Foundry Painter, *ARV*² 402, nos. 20–22; e.g., Munich 2640: *ARV*² 402, no. 22; R. Lullies and M. Hirmer, *Griechische Vasen der reifarchaischen Zeit* (Munich 1953) pls. 81–83.

83 Robertson, *HGA* 241.

84 Naples 2422: *ARV*² 189, no. 74. See the drawing FR 34; the vase has been published many times, e.g., Simon and Hirmer, *grVasen* pl. 128. The Kleophrades Painter's actual name is not known; see J. Boardman, "Epiktetos II R.I.P.," *AA* 1981, 329–31 for proof that the painter signatures of Epiktetos on the pelike Berlin 2170, *ARV*² 185, no. 28 are false, and 331–32 on the scientific analysis carried out by the museum. On the potter signature of Kleophrades see D. von Bothmer, "Ἄμασις, Ἀμάσιδος," *J.Paul Getty Museum Journal* 9 (1981) 1–4.

85 J. D. Beazley, *The Kleophrades Painter* (Mainz 1974) 6, paraphrased from P. Jacobsthal, *Die melischen Reliefs* (Berlin 1931) 170.

86 "Polygnotos in Delphi," *AntK* 13 (1970) 119; in *HGA* M. Robertson places the Vivenzio hydria in chap. 4, pt. V, 233–35, and discusses the revolution in monumental wall-painting in chap. 4, pt. VI.

87 Boardman, "Kleophrades Painter" 11 and 15.

88 S. Drougou, *Der attische Psykter* (Würzburg 1975) 50, dates the Villa Giulia psykter after 475 B.C. on the basis of its painted decoration—but note the Kleophrades Painter also paints beasts (Satyrs) with scraggly beards and faces in three-quarter view on his skyphos Florence 4218: *ARV*² 191, no. 102, *EAA* I (Rome 1958) 900, color pl.; certainly both works must precede the developments of the latter half of the seventies of the fifth century B.C. As we shall see, Barron, "New Light" 32–33, should be mistaken in citing the Villa Giulia psykter as a reflection of the Centauromachy in the Theseion, cf. infra nn. 90 and 175.

89 A. Snodgrass, *Archaic Greece, the Age of Experiment* (London 1980) 208–9. Cf. B. S. Ridgway, *The Severe Style in Greek Sculpture* (Princeton 1970) 6, where it is the importance for art of the devastation of the Persian sack that is stressed.

90 Supra nn. 54 and 58. Cf. S. Woodford, "More Light on Old Walls: The Theseus of the Centauromachy in the Theseion," *JHS* 94 (1974) 164 on the possibility of a Late Archaic wall-painting.

91 B. Philippaki, *The Attic Stamnos* (Oxford 1967) 48, pl. 20, fig. 1; however, only the reverse, the non-Kaineus side of the vase, is illustrated. See also *ARV*² 187, no. 58.

92 Philippaki, *Stamnos* 48.

93 Beazley, *Kleophrades Painter* 5 and 18.

94 Ibid. pls. 24 and 25.

95 Ibid. 5.

96 Cf. Arias, "tomba 136" 169, n. 93. An exception is Baur, *Centaurs* 40, who cites Louvre G 55 among the rare examples depicting Kaineus with his back to the spectator.

97 E. Pottier, *Vases Antiques du Louvre* (Paris 1901) 148.

98 Supra nn. 14 and 15.

99 POxy. XIII, 134, lines 76–83 and 139. Delcourt, "légende Kaineus" 133.

100 E.g., Würzburg 217: *ABV* 694, no. 341; E. Langlotz, *Griechische Vasen in Würzburg* (Munich 1932) 217, pl. 60; Mariemont G 130: supra n. 75.

101 B. S. Ridgway suggests that Zeus' actually having thrown the stone in the Kleophrades Painter's representation might correspond to the encounter of Theseus with the sons of Pallas on the east frieze of the Hephaisteion, on the basis of E. B. Harrison's opinion that Zeus was the unseen stone thrower in the latter monument. On the nature of Centaurs, "who act like rain-swollen mountain torrents" in moving boulders, and on their relationship in this to the power of the gods, see E. B. Harrison, "Alkamenes' Sculptures for the Hephaisteion: Part III, Iconography and Style," *AJA* 81 (1977) 412 and n. 11.

102 Paus. X.31.12; *Pausanias, Guide to Greece I, Central Greece*, trans. P. Levi (Middlesex 1971) 488 and n. 201 on the stone. The stone is also mentioned in Pind. *Ol.* 1.57–58.

103 Hom. *Od.* XI.582–93.

104 Infra 30–31.

105 Woodford, "More Light" 162; J. Six, "Mikon's Fourth Picture in the Theseion," *JHS* 39 (1919) 137.

106 *ARV²* 598; Louvre G 341: *ARV²* 601, no. 22; Webster, *Niobidenmaler* pls. 2.a, b; 5.a, b.

107 Simon "Polygnotan Painting" 52. See also her summary of earlier literature, 43–44, 61–62, and in her own discussion, still the best on the subject, 46.

108 Ibid. 43–44, 61–62; Simon and Hirmer, *grVasen* 133–35.

109 Robertson, *HGA* 255–56, 661, n. 170; W. Biers, *The Archaeology of Greece: An Introduction* (Ithaca 1980) 231, n. 25.

110 Barron, "New Light" 23–24 on the division of the abdominal muscle into four rather than three sections.

111 Ibid. 43–44. For the Theseion as the location for the lost painting, cf. E. B. Harrison's interesting iconographic study, "Preparations for Marathon, the Niobid Painter and Herodotos, " *ArtBull* 54 (1972) 390–402, especially 401.

112 Berlin 2403: supra nn. 51 and 53.

113 Robert, *Marathonschlacht* 49; Weizsäcker in Roscher, *Lexikon* III, pt. 2, cols. 1776–77; Shefton, "Herakles and Theseus" 339, 344, 355, 357–58. Cf. Hauser in FR II, 332 on the possible confusion as to which figure was which hero even in antiquity, and Woodford, "More Light" 158–61, for a different, but unlikely, explanation.

114 Paus. 1.17.2. On the association of Berlin 2403 with the passage in Pausanias: Robert, *Marathonschlacht* 48–49; Hauser in FR II, 246; Simon, "Polygnotan Painting" 52. Cf. Woodford, "More Light" 158–61.

115 See esp. Shefton, "Herakles and Theseus" 355, 361–62 and Fontenrose, *RE* XIX, col. 132 on the Berlin vase.

116 Palermo, N.I. G 1283: *ARV²* 599, no. 2; Arias-Hirmer pls. 176–81.

117 Shefton, "Herakles and Theseus" 359, n. 116; Hofkes-Brukker, *Bassai-Fries* 46.

118 Barron, "New Light" 31–32.

119 Infra n. 133.

120 See Barron, "New Light" 27–28, supra n. 54.

121 Supra n. 53.

122 H. A. Thompson, "The Sculptural Adornment of the Hephaisteion," *AJA* 66 (1962) 345–46. For the sake of clarity the application of the name *Hephaisteion* to this temple is maintained here, but note must be taken of the opinion expressed by Harrison, "Alkamenes' Scuptures III" 421–25; see also supra n. 54.

123 Thompson, "Sculptural Adornment" 346 and pl. 92; E. B. Harrison, "The West Pediment of the Temple of Hephaistos," *AJA* 60 (1956) 178, summary of AIA paper.

124 Thompson and Wycherly, *Agora* XIV, 147.

125 Supra n. 35.

126 Pliny, *HN* XXVI.18.

127 Cf. Fontenrose, *RE* XIX, col. 120.

128 Paus. 1.24.7; see supra n. 27.

129 Supra n. 29; see also A. Delivorrias, "Poseidon-Tempel auf Kap Sounion, neue Fragmente der Friesdekoration," *AthMitt* 84 (1969) 136–42, pl. 65.2 and *Beil.* 1.

130 Hofkes-Brukker, *Bassai-Fries* 46 and 52, for a summary of earlier literature and of problems in the reconstruction of the frieze: F. A. Cooper, *The Temple of Apollo at Bassai, A Preliminary Study* (New York 1978) 143–50.

131 F. Eichler, *Die Reliefs des Heroon von Gjölbaschi-Trysa* (Vienna 1950) 54–55, pls. 4, 5, B2, and B3; for the Kaineus motive pl. 4, B3.

132 K. Schauenburg, "Unteritalische Kentaurenbilder," *ÖJh* 51 (1976/77) 38, fig. 33–36; such is the case on

a Lucanian hydria in Naples, as well, where Lapiths fight with wrought weapons, while Centaurs employ both trees and vases. For the influence of the Bassae frieze on South Italian vases see Watzinger in FR III, 246–47. Note also the Lycian sarcophagus mentioned by Barron, "New Light" 31 and n. 88b.

133 Ibid. 30–33. See also Schrader, *Phidias* 170, who catalogs the seemingly discordant details of the Berlin fragments, but concludes that on Berlin 2403 (fig. 12.4), when complete, traces of the old fight in the countryside were *mixed* with the new story. For Robert, *Marathonschlacht* 49, the terrain lines on Berlin 2403 are an indication of its Polygnotan character, and he would juxtapose in the lost Theseion painting a fight out-of-doors with a fight in the palace.

134 Barron, "New Light" 30–31.

135 Robertson, "Polgnotos in Delphi" 119; see also *HGA* 252.

136 Robertson "Polygnotos in Delphi" 119.

137 E.g., New York 07.286.84 (fig. 12.3): supra n. 48; Florence 3997: supra n. 50.

138 As has been noted by Schrader, *Phidias* 170, and Robert, *Marathonschlacht* 49, a door is actually included in the Centauromachy composition on Vienna 1026: supra n. 46.

139 E. B. Harrison, "The South Frieze of the Nike Temple and the Marathon Painting in the Painted Stoa," *AJA* 76 (1972) 353–78, has demonstrated in detail the tripartite structure, as well as temporal changes in the composition of another famous lost Classical painting.

140 Supra n. 54; see also Six, "Mikon's Fourth" 137.

141 Cf. the structure of the *Iliad:* J. A. Davison, "The Homeric Question," in *A Companion to Homer,* eds. A. J. B. Wace and F. H. Stubbings (London 1962) 258. The wedding of Peirithoos and Hippodameia is perhaps curiously analogous to the wedding of Peleus and Thetis as one at which the seeds for a later war were sown; supra nn. 10 and 11.

142 Woodford, "More Light" 162.

143 Cf. Shefton, "Herakles and Theseus" 355.

144 Cf. Six "Mikon's Fourth" 137.

145 C. H. Morgan, "The Sculptures of the Hephaisteion," *Hesperia* 31 (1962) 223, 227; S. von Bockelberg, "Die Friese des Hephaistieion," *AntP* XVIII, pt. 2 (Berlin 1979) 35.

146 Hofkes-Brukker, *Bassai-Fries* 58–59.

147 Supra n. 131.

148 Delivorrias, "Poseidon-Temple" 137 and *Beil.* 1.

149 On the advanced sculptural style of the figures of Kaineus on these friezes, cf. Morgan, "Sculptures Hephaisteion" 230; Bockelberg, "Friese Hephaistieion" 34, 38, 41, 46.

150 Thompson and Wycherly, *Agora* XIV, pl. 75b.

151 Thompson, "Sculptural Adornment" 345–46; cf. the representation of the Tyrannicides on the red-figured oinochoe, Boston 98.936: Thompson and Wycherly, *Agora* XIV, pl. 79b.

152 Thompson, "Sculptural Adornment" 345; Morgan, "Sculptures Hephaisteion" 222.

153 Ibid. 223; cf. R. Herbig, "Untersuchungen am dorischen Peripteral-Tempel auf Kap Sunion," *AthMitt* 66 (1941) 100.

154 Two Centauromachies by the Niobid Painter are preserved in friezes on the necks of volute-kraters: on Bologna 268: *ARV²* 598, no. 1; *CVA* Bologna, Museo Civico 5, pls. 97.2; 98.3–5, the theme is paired with an Iliupersis on the body and on Palermo, N.I. G 1283: *ARV²* 599, no. 2; Buschor,

GrVasen 192, fig. 204, paired with an Amazonomachy (however, here Herakles and Pholos appear on side B of the neck). The Bologna frieze includes Kaineus, attacked by a single Centaur. For a similarly streamlined Kaineus motive in Classical red-figured pottery, cf. the volute-krater, Bologna 275: *ARV²* 1029, no. 18, *CVA* Bologna, Museo Civico 4, pls. 59.1 (below); 67.3–4, by Polygnotos, the vase-painter.

155 One must wonder whether another element should be restored to the famous mural by analogy with what we know of other works of Greek art: a host of deities. Neither Pausanias' description, nor the reflections on Attic vases provide any clues. Preserved sculptural monuments associate two gods with the scene: Apollo on the west pediment of the Temple of Zeus at Olympia, Ashmole and Yalouris, *Olympia* pl. 105 and 17–18 on the identification of the figure as Apollo, not Peirithoos as in Paus. v.10.8; on the Sounion frieze, Artemis arriving in a chariot, cf. Louvre CA 3482: *ARV²* 613, no. 3; *MonPiot* 55 (1967) pl. 3 and p. 85, fig. 6 top, perhaps accompanied by Apollo, Delivorrias, "Poseidon-Temple" 142 and n. 82, *Beil.* 1; *AthMitt* 66 (1941) pl. 42; and Apollo and Artemis together, in a chariot, on the Bassae frieze, Hofkes-Brukker, *Bassai-Fries* 60–63, slab H 8–523. Did the chariot motive originate in the painting: the twin deities arriving at the feast to come to the aid of the Greeks while the fighting was still about equal (Paus. 1.17.12)? In the central section of the lost painting Theseus had already killed a Centaur, perhaps under the protection of Athena. If this goddess was present she might have been accompanied by the pan-Hellenic hero, Herakles, whose own experience in fighting Centaurs, supra nn. 36 and 154, would have given the Greeks an advantage here. In the final section of the painting any gods in attendance would have been associated with Kaineus and his fate in the countryside Centauromachy: perhaps Poseidon, who granted the sex change and imperfect invulnerability and/or Zeus, who instigated the special fury of the Centaurs. Supra n. 10 on a possible role for Ares.

156 Supra n. 53.

157 See, e.g., E. Lapalus, *Le Fronton Sculpté en Grèce, des Origines à la fin du IVᵉ Siècle* (Paris 1947) 265–318 and 419–20 for a discussion of the evolution of themes, compositions, and the unifying elements of pedimental sculpture.

158 Robertson, *HGA* chap. 4, pt. 6, p. 240.

159 Robertson, *Greek Painting* 128 and 130.

160 Pausanias' detailed descriptions are of the paintings by Polygnotos in the Lesche of the Cnidians at Delphi, x.25.1–31.1. Of the vases, the most famous is the Niobid krater in the Louvre, supra nn. 106–10. Cf. the discussions by Robertson, *HGA* 248–59, *Greek Painting* 122 and 128.

161 See T. B. L. Webster in *OCD²* 855 for a useful summary of the chronology of Polygnotos' oeuvre so far as it can be determined.

162 Ibid.

163 Supra nn. 160 and 161.

164 Robertson, *HGA* 257; also for the ambiguities of this type of spatial construction.

165 Supra n. 161; Robertson, *HGA* 243–44 and 659, n. 150.

166 Woodford, "More Light" 164 makes several suggestions about the "rudimentary stage of development at this time," but apparently does not take heed of this feature in her reconstruction, pl. 15.

167 E.g., Barron, "New Light" 34. Supra n. 48.

168 Bothmer, *Amazons* chap. 10 A, 161–74.

169 New York 07.286.86: *ARV²* 616, no. 3; Buschor, *GrVasen* 204, fig. 214. Bothmer, *Amazons* 165–68.

170 G. M. A. Richter, *Attic Red-figured Vases, a Survey* (New Haven 1975) 102.

171 Ibid.

172 Barron, "New Light" 34, complains about the "somewhat compressed form" of the terrain lines on the New York volute-krater, New York 07.286.84.

173 Supra n. 46.

174 Supra 20 and nn. 109–11.

175 Barron, "New Light" 23–44, indiscriminately associates vases of different styles and dates and with different spatial conventions with the lost mural paintings in the Theseion, e.g., Louvre G 341 (supra n. 106), the Villa Giulia psykter (supra n. 77 [my fig. 12.6]) and New York 07.286.84 (supra n. 48 [my fig. 12.3]). The vertical extension of pictorial space by the use of terrain and architectonic elements achieved during the *High* Classical period is perhaps best perceived and appreciated now in E. B. Harrison's reconstruction of the shield of the Athena Parthenos—the Amazonomachy in relief on its exterior surface, "Motifs of the City-Siege on the Shield of Athena Parthenos," *AJA* 85 (1981) 294–311 and illus. 4. For painting cyles see M. L. Thompson, "The Monumental and Literary Evidence for Programmatic Painting in Antiquity," *Marsyas* 9 (1960/61) 49.

176 Arias-Hirmer 355; Robertson, *HGA* 256–57.

177 Robertson, *HGA* 258 and see 661, n. 173, for the ancient sources. See also idem, *Greek Painting* 130; Six, "Mikon's Fourth" 131; Webster, *Niobidenmaler* 17; Arias-Hirmer 355–56; T. B. L. Webster, "Micon," *OCD²* 686; and Barron, "New Light" 24 and n. 44.

178 Arias-Hirmer pl. 175.

179 Six, "Mikon's Fourth" 131.

180 Boston 34.79: *ARV²* 1045, no. 2.

181 Hom. *Od.* XI.51–83; CB II, 88.

182 CB II, pl. 63.

183 Ibid. 87. Unfortunately, at the last minute, the Museum of Fine Arts, Boston, was unable to provide the photograph requested; in fig. 12.10 a less effective detail has been substituted for the view of the vase which would best illustrate my point.

184 Ibid. 88; L. D. Caskey, "Odysseus and Elpenor in the Lower World," *BMFA* 32 (1934) 39–44.

185 Paus. X.29.8; CB II, 89.

186 The issue of distinguishing between the styles of Polygnotos and Mikon has been avoided here; it should be a subject for a separate study.

Painterly and Pictorial in Greek Relief Sculpture

13

BRUNILDE SISMONDO RIDGWAY

It has justly been said that the most grievous loss in our inheritance of the Greek past is that of ancient painting. Recent excavations in Macedonia, Lycia, and South Italy have filled some gaps, and scholars working with literary sources have attempted to fill others, providing plausible reconstructions of lost compositions through brief references by ancient authors. A third approach has traditionally been that of looking at artistic manifestations in other media to isolate elements of the lost art: figured vases, mosaics, and sculpture. It is specifically on the field of Greek relief sculpture that I shall comment here—occasionally architectural relief, but primarily funerary and votive. Although I shall omit perhaps the most famous of all painted relief monuments—the Alexander sarcophagus—the majority of the works I shall discuss are well known and only a few may have received little attention because of their poor state of preservation. I claim no originality in my presentation, nor do I want to stress a special theme. I only wish to explore a body of material from a specific point of view: the connection or affinity with painting.[1]

In this respect, let me clarify the meaning of my title. Although dictionaries define both "painterly" and "pictorial" as adjectives referring to the painter's art, I shall use painterly to indicate the technique by which some details of relief compositions are added solely in paint, rather than being carved; pictorial will instead refer to illusionistic effects of spatial penetration and depth perspective. Such effects were in many cases produced or at least greatly enhanced by the use of paint, so that no fine line can be drawn between painterly and pictorial; but the inclu-

sion in one category rather than the other has been arbitrarily determined—by me—on the presence or absence of landscape elements, be they of the natural or of the man-made variety, such as buildings or walls.[2]

As is well known, all ancient sculpture, whether in the round or in relief, was painted.[3] But it is relief carving which bears closest affinities with monumental painting. Here too, distinctions should be made. There is a form of high relief which is by nature closer to statuary in the round. Because architectural sculpture had to be viewed from a considerable distance, emphasis on an eloquent silhouette was usually accompanied by strong projection from the background, so that the play of light and shadow helped in the perception of the composition.[4] Votive or funerary plaques, however, were normally set up at eye level, or at least closer to the viewer, so that even very low relief could be perceived, especially against a painted background. This form of relief depends primarily on drawing techniques and therefore partakes of all the formal devices open to painting. Indeed, some gravestones were entirely rendered in paint, either freely applied to a marble slab or kept within engraved outlines. But this form of painted "sculpture" is almost indistinguishable from painting itself and we shall not review it here.[5] We shall instead concentrate on the "painterly" details, such as those added to the relief of a warrior on Aristion's famous gravestone, by Aristokles (fig. 13.1).[6]

Here the human figure is fully rendered, albeit in very low relief. Blue paint for helmet and greaves, a red background, and a reddish tinge for the man's flesh are all "normal" traits of

ancient painted sculpture, as well as the coloring of eyes, lips, and hair, including beard and mustache. Painterly details are rather the star and the lion's head on the flaps of the cuirass, the meander fillet encircling the chest and a peculiar object, too faded today to be identified, hanging from a red cord and suspended just below Aristion's right breast, that even early descriptions call simply an "ornament." To be sure, all these details could easily have been carved as well, and Aristokles, in this case, might have taken the fastest way out. In numerous instances, however, the painter supplied details which the sculptor would have been hard put to render in relief. Good examples are the chariots on the east frieze of the Siphnian Treasury, the necklace that Hegeso is lifting from her jewel box—as well as her sandal straps—the dipper being plunged into the alabastron by the seated lady on the Thasian Funerary Banquet relief. Other typical painterly additions are the cords of musical instruments, or red flames upon altars.[7]

A different type of painterly detail is exemplified by the mantle on the Anavyssos stele. This fragmentary gravestone has been interpreted as a mother holding a child, presumably to commemorate the death of both in childbirth. A similar stele, of later date, shows the mantle in relief, but it is legitimate to ask whether the difference lies in sculptural skill or rather in approach.[8] Conceivably, the sculptor of the Anavyssos stele was trying to convey the sense of a variety of planes, with the foreground occupied by the two human faces and the garment very much confined to the background. This use of paint to imply recession in space is attested in Egyptian painting, which inevitably must have influenced Greek art as much as Egyptian sculpture and architecture did. In a famous scene from the Fifth Dynasty mastaba of Ty at Sakkara, men and cattle are shown crossing a ford. The water has been rendered by means of tinted and wavy ridges; an effect of transparency and penetration has been obtained by *painting* the human legs into the relief area indicating the stream, so that two visual planes are effectively suggested.[9] A more dramatic example comes from the Temple of Hatshepsut at Deir el-Bahari (fig. 13.2). In this Eighteenth Dynasty boat scene, three rowers are carved in low relief, but a fourth man busy at the sails is rendered exclusively in paint, probably to imply that he stands farther away from the viewer, well within the boat. Here too the sculptor may have decided to resort to paint in order to avoid problems of overlapping; or this additional figure may represent an afterthought

or a late correction to an omission. But the implication of spatial recession is too strong to be overlooked, and we may well ask whether a similar intention was at work in the Anavyssos stele.

To be sure, nothing quite as drastic as this Egyptian mixture of painting and relief has survived from Greece, but S. Karouzou has recently suggested reconstructions that may be as startling in their import. The dense composition of fifth-century votive reliefs contrasts with those of the fourth century which often leave ample empty space over the heads of worshipers; since these are rendered in smaller scale than the divinity, Karouzou has advanced the hypothesis that stoai or other architectural elements were originally painted into the empty background. Similar structures could have been added to reliefs showing miraculous cures, to suggest the locale of the healing process. This is an important proposal which deserves serious consideration.[10]

That architectural elements could be part of Classical Greek compositions is attested, even if indirectly, by the so-called Lokroi pinakes, terracotta plaques made between approximately 500 and 450 B.C., of which at least one type shows two divine images within a temple (fig. 13.3).[11] Other evidence, of a different kind but equally pertinent, shows that naiskos-stelai in the Kerameikos cemetery had coffers rendered exclusively in paint, and even in perspective arrangement.[12] In addition, many archaistic and neo-Attic reliefs, such as the famous "Dionysos' Visit to Ikarios," are known in versions with elaborate buildings in the background.[13] However, these had always been considered additions by the later copyists; in the Lokroi pinax the temple is an integral element of the context, rather than a distant vista; and even some of the reliefs cited by Karouzou appear within an architectural frame (such as a tiled roof), which would conflict with any additional painted structure.

Some fourth-century masters seem to have resorted to entirely different solutions. A votive relief on display in the National Museum in Athens (figs. 13.4a and 13.4b)[14] shows the familiar procession of worshipers, here grouped by couples; the third couple is accompanied by a small child. The four women who close the procession include a servant holding a large cista over her head and partly overlapping the anta that forms the right edge of an architectural frame—a tiled roof—close to the worshipers' heads. At the head of the procession, a *hierodoulos* bends over the sacrificial pig. At right angles to the plane of this

13.1. Athens, N. M. 29. Grave stele of Aristion, by Aristokles. Photo: Bryn Mawr College.

13.2. Berlin Museum 14332. Egyptian relief of a boat from Temple of Hatshepsut, Deir el-Bahari. After H. Fechheimer, *Die Plastik der Ägypter* (Berlin 1923) pl. 147.

13.3. Lokroi pinax with worshiping scene. Reconstructed drawing, after H. Prückner, *Die lokrischen Tonreliefs* (Mainz 1968) 17, fig. 1.

13.1

13.2

13.3

13.4a, 13.4b. Athens, N. M.
1377. Votive relief to Asklepios.
Photo: DAI, Athens.

13.5. Metopes of the ship Argo
from the Sikyonian Treasury.
Reconstructed drawing, after P.
de la Coste Messelière, *Au
Musée de Delphes* (Paris 1936)
fig. 8.

13.4a

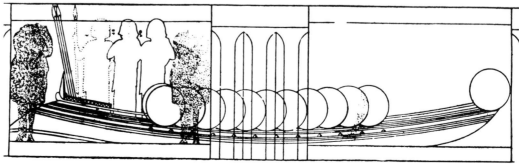

13.5

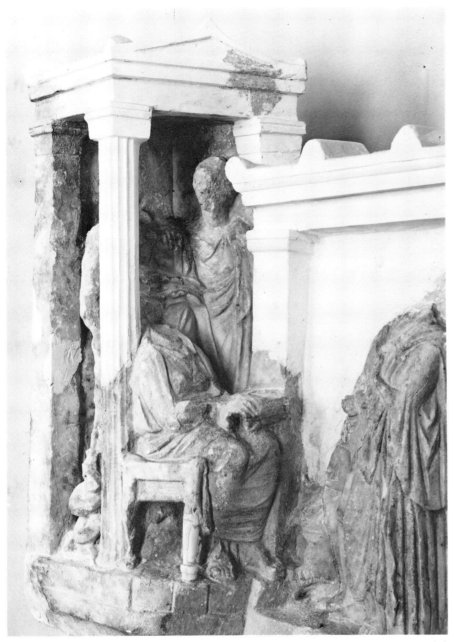

relief, and of greater height, a naiskos contains a seated female figure with a bird under her seat (Epione?), and two standing companions, one of whom can be identified as Asklepios because of his heroic seminudity and the staff around which a snake coils. G. Neumann has recently suggested that fourth-century votive compositions tried to reconcile the widening gap between deity and worshiper by gathering them on a common meeting ground—the stoa.[15] But it is clear that the sculptor of the Athenian relief meant more than a separation of structures or an identification of divine and human nature by means of different buildings; by carving his relief out of a single but unequal block he tried to emphasize

spatial relationship, and it is from this point of view that the monument interests us. Equally interesting is the gradation of decoration; additional figures in very low relief appear over the short sides of the slab: a *peplophoros* with *polos* and two torches on the left, and a frontal herm on the right face. Finally the back of the monument is so carefully finished that a painted composition has been suggested; this would have made the work not an amphiglyphon but an amphiprosopon.[16] The presence of additional decoration on the short sides would have led the viewer's eye toward the rear, while the lower level of these side reliefs would have formed a gradual transition from the high projection of the front to the painted back. Although this solution may seem purely sculptural, *pictorial* intentions appear obvious.

Equally ambivalent, if less explicitly pictorial, is the rendering of an earlier fragmentary relief in the Akropolis Museum, showing Athena seated on a rocky elevation in front of a naiskos, here also rendered higher in level than the rest of the plaque.[17] Within the naiskos, a frontal idol stands behind a *trapeza* or a barrier. Once again, it is not the subject of the composition which concerns us, important as it may be for the cult image of Athena Nike, but rather the difference in planes, and the suggestion of figures being blocked from view by objects in the foreground.

That such effects had been sought after as early as the sixth century is shown by the so-called Sikyonian metope with the Argo ship, now in the Delphi Museum (fig. 13.5).[18] Here a variety of overlapping planes are suggested by the frontal horses ridden by the Dioskouroi, the ship itself with its series of shields over the gunwale and the musicians standing within it. But even more impressive would the effect have been when the original sequence of two metopes showed the Argo gliding, as it were, behind the intervening triglyph. Yet this composition, daring as it might have been for its early date, is still basically set over one groundline, against an empty background. The strongest effects of pictorialism occur instead when figures are staggered at different levels over uneven ground containing elements of landscape. This arrangement in space within relief sculpture used to be considered possible no earlier than the Hellenistic period, but many Classical examples exist and we shall briefly review a few of them here.

That the idea originated in monumental painting, probably Polygnotan, seems undoubted. The best evidence is the famous Orvieto calyx-krater by the Niobid Painter where figures stand

13.6

on, or disappear behind rises in the ground, and the occasional tree provides a suggestion of open countryside. This vase is so frequently shown in vase-painting handbooks that we tend to forget how *atypical* of the Niobid master this rendering is; inspiration from a different medium is therefore indisputable.[19] In sculpture, the occasional tree occurs as early as the Corfu pediment, but it does not make a landscape. It may, however, be an identifiable attribute, such as the olive tree of Athena on the stele recording the Parthenon Treasurers' account.[20]

This symbolic use of natural elements recurs on a complex votive work from approximately the turn of the fifth century. Known from several fragments in Athens and some in London and Padua, Telemachos' dedication to Asklepios has now been reconstructed in two different versions. Of the two, the earlier (1968) is by L. Beschi (fig. 13.6).[21] He visualized a tall pier carrying an inscription topped by a relief branch and a figured scene on all four sides; only a male leaning on a staff in front of a woman can be made out on one of the large faces, while a horseman appears on one short side. The man with the staff may be Asklepios confronted by his daughters, the rider one of the Dioskouroi, matched by his brother on the opposite short side. What the other large face depicted can no longer be recovered. Above this frieze a wider block serves as a bracket capital. One wide face shows a male spear-bearer accompanied by two dogs and standing in front of a wall pierced by three openings, within which horses' heads and humans appear. The opposite face retains some of the elements of a typical "funerary banquet": an *oinochoos* and a reclining male, who holds a lyre. A snake rears between the foot of the *kline* and a puzzling object perhaps being held by the young servant. Beschi argued that this is a theatrical mask and that the reclining lyre player is Sophokles, who was the first to receive Asklepios in his house, at the god's arrival in Athens. The *doryphoros* on the opposite face would be one of Asklepios' sons, with the second son and daughters perhaps appearing with the horses within the background structure. Zeus and Athena on one side, and Artemis with Aphrodite(?) on the other complete the decoration of the four faces.

This bracket capital supported the main votive plaque, an amphiglyphon. The main face was reconstructed by Beschi to show Hygieia sitting on a *trapeza* in front of an anta, near a standing Asklepios. A dog crouches under the table, which rests on a figured dado with a procession of worshipers. While this scene takes place inside the temenos, the opposite relief face depicts the outer precinct wall with its propylon. Behind the wall looms a barren tree on which a stork perches: a clear allusion to the Pelargikon on the slopes of the Akropolis. Next to the elaborate gate (with pedimental snakes, and cocks on the raking cornice) stands a naked male figure on a pedestal. Beschi argued that it represents a statue, probably the hero Talos/Kalos mentioned by literary sources as having a *heroon* nearby. Beschi believed that the relief was set up in duplicate at the two ends of the Asklepieion, whence one of the replicas was taken to Italy at an undetermined date.

A different reconstruction (fig. 13.7) was suggested in 1975 by E. Mitropoulou, who was able to take into account an additional fragment acquired by the British Museum in 1971.[22] This shows part of the frieze of worshipers decorating the *trapeza,* but one of the figures depicted as

13.6. Telemachos' monument. Reconstructed drawing after L. Beschi, *ASAtene* 45–46, n.s. 29–30 (1967–1968), figs. 22a–d on p. 411.

13.7. Telemachos' monument. Reconstructed drawing after E. Mitropoulou, *A New Interpretation of the Telemachos Monument* (Athens 1975) figs. C–D on pp. 60–61.

13.7

13.8

13.9

13.10

13.11

13.8. Vienna. Kunsthistorisches Museum. *Heroon* of Gjölbaschi-Trysa, Lycia. Exterior southeast wall, Block A 4. City siege scene. Photo: Courtesy W. A. P. Childs.

13.9. Vienna, Kunsthistorisches Museum. *Heroon* of Gjölbaschi-Trysa, Lycia. Interior west wall, Blocks A 7/8, B 9. City siege scene. Photo: Courtesy W. A. P. Childs.

13.10. Eleusis Museum 51. Pythodoros votive relief. Photo DAI, Athens.

13.11. New York 29.47. Fletcher Fund. Battle relief. Photo: Courtesy of the Metropolitan Museum of Art.

male on the Athenian counterpart has here been turned into a scantily clad female. Mitropoulou therefore believes that the two versions as known are not contemporary, but that one represents a modified or free copy of the first. She disagrees with Beschi also in some identifications and in the restoration of both bracket and top plaque, which she makes wider, with room for additional figures.

I have dealt at some length with this monument because its fragmentary state and complex reconstruction have effectively kept it away from sculptural handbooks. It is immaterial for our purposes to argue in favor of either Beschi's or

Mitropoulou's version. What is important is that a sculpture safely dated around 400 B.C. can be shown to incorporate pictorial elements traditionally assigned to the Hellenistic period. The division of the bracket capital into two zones, with a wall pierced by "windows" peopled by horses and humans is a feature of *Totenmahl-reliefs* supposed to have originated in Asia Minor 200 years later.[23] In the main plaque, the lonely tree with the stork, behind the wall, may still represent "hieroglyphic" landscape important for its identifying function rather than for its spatial effect. But there is no denying the depth penetration suggested by the scene on the pier capital. Can any such rendering be cited, earlier than ca. 400?

Some evidence exists, but highly fragmentary and tantalizingly indirect. The most surprising perhaps comes from the east pediment of the enormous Olympieion at Akragas, which is known from literary sources to have depicted a Gigantomachy. M. Bell tells me that the scene must have been in relief (not simply painted, as some advocate) and that fragments show groundlines at different levels, as in the Niobids' krater.

But the monument with the greatest impact on all subsequent sculpture was probably the Shield of the Athena Parthenos by Pheidias (447–438 B.C.). Some neo-Attic reliefs recovered from the Piraeus harbor had been seen to intimate the presence of landscape elements in the original work, but replicas disagreed among themselves in the inclusion or omission of columns and walls, and the animated poses of warriors and Amazons required only difference in levels. Therefore, when the Toronto Museum set up a scale model of the famous monument, only undulating terrain served as broken groundlines for the various actors in the composition. Yet one specific figure, known to scholars as The Amazon Falling Headlong, occurred with systematic regularity in many replicas and demanded a more complex scenario. E. Harrison has now argued that the entire Akropolis fortifications and the city gates were shown on the shield, and that the Amazon in question was depicted falling during an attempt to scale the citadel wall.[24]

Whether or not this precipitating figure came into the Greek repertoire from an Oriental source is a matter of debate. A similar image (fig. 13.8) appears in that vast sampler of reliefs which is the Lycian *heroon* at Gjölbaschi-Trysa, but the highly weathered state of the stones prevents certainty in identifying all scenes as Greek mythological subjects. That some of the iconography came from Greece, perhaps through pattern books reproducing monumental painting, seems assured, but the Lycians probably adapted the scenes to suit their own meanings and purposes. When two different subjects appear superimposed, and only the peculiar treatment of the joints introduces elements of landscape, it is easy to stress the Greek component. But a more Oriental flavor is apparent in the scenes occupying both courses of the wall, with the human figures steeped in atmosphere and dominated by elements of a man-made background seen in perspective, with convincing spatial penetration (fig. 13.9). Because the *heroon* is Lycian, Assyrian parallels come spontaneously to mind. The iconography of the soldier falling off the wall appears, for instance, in some reliefs of Assurbanipal at Nineveh (inherited perhaps, in turn, from Egyptian prototypes). From the same palace, a scene of a lion hunt shows the use of staggered groundlines, with a galloping horseman seemingly telescoped by distance.[25] But different levels of terrain are also depicted in Greek originals of the late fifth century.

The best known is probably the Pythodoros relief (fig. 13.10).[26] This fragmentary plaque shows a cavalry encounter on two levels, the upper probably to be visualized as farther from the viewer, on a hillside—an impression strengthened by faint lines in the background suggestive of distant mountains. Since the dedicant is epigraphically mentioned as a hipparch, it is logical to recognize him as one of the riders, although the specific occasion cannot be pinpointed. The addition of paint would have made the rocky ground clearer and the total effect more pictorial. A second relief, of the early fourth century, (fig. 13.11) in New York,[27] may show Greeks against Lycians, as suggested by the long hair and the beardless faces of the fighters wearing chitoniskoi. The warrior fleeing to the right held a spear rendered in color: a painterly addition easy to reconstruct. More difficult to explain is a peculiar undulating line vertically spanning the overhead field just above the shield of the fallen man. It coincides with an impurity in the stone, and could perhaps be considered a flaw magnified by the uneven depth of the background, but the curves look too regular to be fortuitous. Several authors have considered them an element of landscape, without however advancing a more precise explanation. A tree would hardly have been given such a regular outline, nor would a trophy, and a vertical river seems too naive a rendering for so sophisticated a scene. A hypothetical mounted figure in the

missing portion of the relief could account for the ample overhead, but this is definitely a case where our comprehension is hampered by the loss of paint.

More openly descriptive is the well-known Torlonia relief (fig. 13.12).[28] Its interpretation is open to debate, but the divine nature of the horseman in the center is clarified by the smaller scale of the worshiper. A naiskos in the background contains a cult image, while two deities flank it, sitting on rocky elevations. This is only one of several late fifth-century representations of gods and goddesses within a natural landscape, which probably derived their inspiration from painted pinakes in a popular vein. The sacred character of the environment is at times suggested by the inclusion of votive plaques: a monument within the monument, as for instance on a fragmentary relief from Delphi.[29] A realistically textured tree shades a deity, probably Dionysos, sitting on a rock against which an animal reclines; a worshiper in reduced scale approaches the god from the right.

Rocky seats and animals occur in a variety of contexts, but often allude to a god or hero, or to a heroized dead. A striking composition (fig. 13.13) has again been recovered by Beschi, who to the known fragments has been able to add a new piece in the Akropolis museum.[30] A Dal Pozzo drawing had previously assured the connection between a fragmentary boat and a seated figure accompanied by a dog and rendered at much larger scale. This general schema is known from later Classical gravestones, as for instance the stele of a hunter from Thespiaë. What is unusual in the Akropolis relief is not only the fact that it too, like the Telemachos monument from the Asklepieion, was executed in two replicas—one at present in Aquila, Italy—but that the natural environment is a seascape as well. As reconstructed by Beschi on the evidence of the scattered fragments, the so-called Lenormant relief depicts a trireme in full movement, with several figures reclining on its deck. In the distance, on a promontory overlooking the boat, a hero sits with his dog: perhaps Paralos, Beschi suggests, after whom a famous Athenian state trireme was named. Historical arguments would date the relief toward the end of the fifth century.

Of pictorial import is the wide smooth band below the trireme documented by the Lenormant fragment proper. It was undoubtedly filled with waves rendered in paint; this painterly detail was then supplemented by the pictorial effect of the hero sitting in the background. Painterly and pictorial mix again in the Athenian gravestone of Demokleides (fig. 13.14), who appears disconsolately sitting on a ship whose outline only is rendered in relief.[31] Paint would have detailed the various parts of the boat and the sea, while the general scale is sufficient to convey an effect of atmospheric reduction. Demokleides probably met his end in a naval encounter of the Peloponnesian war, as indicated by the rostrate ship on the relief, but many later gravestones adopt the image of a man sitting on a rocky promontory near the waves to commemorate more common occurrences of death at sea. One example has been found in Chios, and several more are now in display in the Mykonos Museum, coming from Rhenea.[32]

Seascapes can be found in unexpected places. Painterly waves on the neck of Helios' horses, on the Parthenon east pediment, must have added

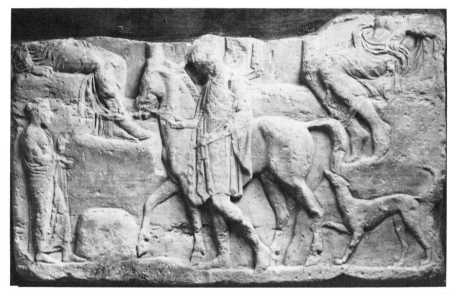

13.12

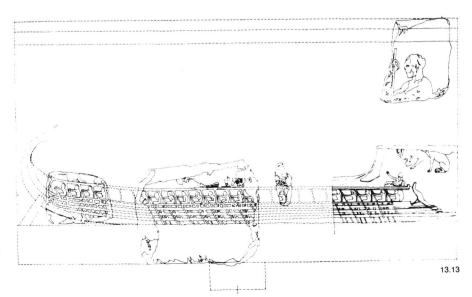

13.13

to the pictorial effect of the animals emerging from the deep: in this case the all-too-impenetrable cornice of the temple, in an illusionistic rendering that violates, to some extent, structural reality.[33] Other painterly effects on the same building may have included, according to E. Simon, a thunderbolt flashing between the contestants on the west gable, but this theory can at present be supported only by indirect evidence and representations on vases.[34] That monumental painting was concerned with sources of illumination and reflection of light we know through the literary sources.[35] An echo may be caught on the east frieze of the Great Pergamon Altar. The empty eye socket of a giant fighting against Zeus has suggested the theory that a red-glass paste once filled it, to convey fiery reflection from the thunderbolt held in Zeus' hand. Simon has now

advanced a different hypothesis: the giant has been blinded by the eagle of Zeus, and the eye socket is empty, once painted red, probably, to convey the bleeding wound.[36] In either case, painterly "pictorialism" is obvious.

A thunderbolt added in metal may have formed part of a mid-fourth-century relief from the Athenian Asklepieion (fig. 13.15), important for its rendering of landscape despite its fragmentary condition.[37] Because of its findspot, the plaque has been read as depicting the birth of Asklepios, or rather, the moment when the child is found by the goatherd Aresthanas on Mount Titthion, where the baby had been abandoned by his mother Koronis: an interpretation strengthened by the peculiar, breast-shaped rendering of the mountain. The story is told by Pausanias (II.26.4) on his visit to Epidaurus. The

13.14

13.15

infant had been fed by Aresthanas' goat and guarded by his dog. When the man went to look for his animals, discovered the baby, and tried to pick him up, he was startled by a flash of lightning. The Athenian relief may therefore show the diminutive figure of Aresthanas in the foreground, accompanied by two dogs and approaching a cave where a snake seems to be sitting on a cloth over a cista. Presumably the baby would have appeared in the now-lost section of the relief. Above the cave is the nipplelike peak of a mountain, in a hieroglyphic rendering of its name, and on it rests the hand of a large female figure, obviously a divinity because of her scale. She may be Leto or Artemis. A palm tree in the background ensures the connection with Apollo, and the towering male figure behind the mountain peak has in fact been identified with Asklepios' father. Another theory suggests Zeus, and places a thunderbolt in his raised right hand. Be that as it may, the scene is important because of its rendering of landscape, with different levels suggested, both in terms of elevation and of depth. This pictorial character bespeaks a wooden pinax as possible prototype.[38]

The view that some of these landscape reliefs may have originated from "popular" art—the simple painted votive offerings of people who could not afford the more expensive carvings—has long been advocated. Confirmation comes from the fact that many of these stone "translations" were offered to animistic deities, important in popular religion. Conversely, it can be argued that a natural frame was logical for creatures thought to inhabit springs and caves. Such a habitat is depicted in a complex relief from Mount Parnes, near Athens (fig. 13.16), where the mountain itself appears both in its physical aspect and as a personification, half emerging from the rocky ground. On various elevations stand or sit several rustic figures: Pan, making a greeting gesture; a young man near a herm of Priapos, perhaps the hero Kynnes; a personification of the river Achelous as a dignified man partly hidden by the ground and holding a cornucopia, flanked by an animal. The three Nymphs in the foreground are of a well known type, but the relief is made unusual by the added elements and by the lion-head waterspout toward which the Nymphs move. It was pierced for use, and when in position it would have flowed with water cascading into the small basin carved into the plaque.[39]

The date assigned to this relief has varied from the late fifth to the mid-first century B.C. Surely dated to ca. 330 B.C. is however another monu-

ment excavated in the Athenian Agora and dedicated by the historically known Neoptolemos of Melite, a friend of Lykourgos.[40] Although the scene with the many divinities is open to different interpretations, here we need be concerned only with the pictorial aspects of the rendering: the figures at various levels, the utilization of the ground, the effect of depth and penetration into space, enhanced by the cavelike frame. This spa-

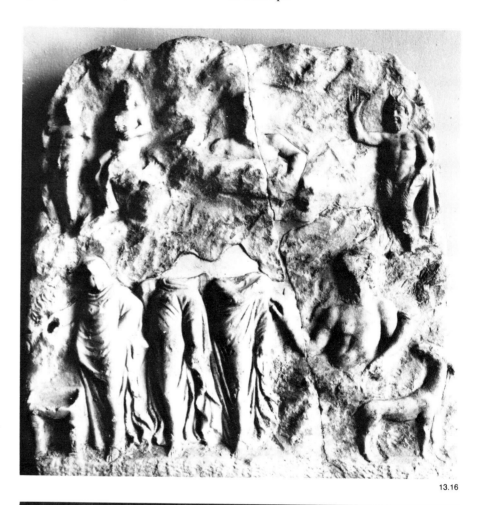

13.16

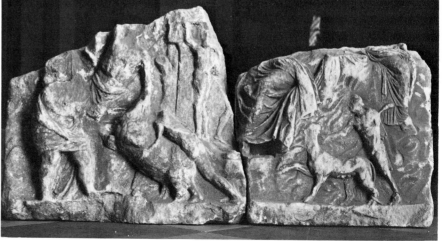

13.17

tial achievement is largely a conquest of the fourth century, but its harbingers can be found in the fifth. The Archandros relief, from the area of the Athenian Asklepieion, though very sculptural in the rendering of the deities in the foreground, adds definite painterly and pictorial touches with the appearance of Pan in his cave, doubtless completed in paint and suggesting a recession of planes.[41]

Such spatial experimentation was not the exclusive prerogative of Athenian masters. A Boeotian relief of ca. 375 B.C. attempts an even more daring rendering, by presenting a cave *in section,* with a snake rearing inside it to confront two worshipers.[42] Impressive in its control of landscape is a fragmentary relief in the Volo Museum, of early Hellenistic date (fig. 13.17).[43] Dionysos and Ariadne sit on rocky ground, surrounded by small Satyrs. One leans over the god's legs and is now partly obliterated by a break. A second turns his back to the viewer, while adorning a votive pinax set on an elevation. A third plays with a panther below Ariadne's seat. To the left of the composition, a large, now headless animal (a ram?) engages two Satyrs and a corpulent Silen, who surround the beast from various levels, while a Maenad is partly effaced by the left break. The pervasive rocky landscape in this Dionysiac tableau, once undoubtedly enhanced by vivid colors, finds a vague counterpart in an object of the minor arts, the famous Derveni krater.[44] Here *Metalmalerei* has been used to provide differentiation, while the rocky background is given texture by relief and stippling. One wonders whether a monumental painting of a similar subject lies behind both monuments.

It is generally assumed that the Hellenistic period perfected the techniques of spatial penetration and illusionistic foreshortening. Yet two trends can still be seen active side-by-side toward the end of the second century B.C. One, exemplified by the famous Munich relief,[45] repeats the formula of the open-air shrine, with the participants basically on one level, and depth and space suggested by the tree and monuments in the background, as well as by the overhead space and the curtain providing a theatrical backdrop. The second type displays figures on various levels of a natural landscape, as shown for instance by the famous "Apotheosis of Homer" relief by Archelaos of Priene.[46] Despite its Hellenistic complexity and symbolism, the scene follows along the lines of the fifth-century Pythodoros relief, with little physical contact from tier to tier and a rather paratactic arrangement of actors.

But the pictorial elements are obvious in the many background details, the foreshortened objects, and the overlapping poses.

Yet for all its technical achievements, the Hellenistic period spells the virtual end of a form of the genre, or, rather, replaces it with comparable effects in other media and techniques. With its taste for the paradoxical, the Hellenistic period can produce sculpture in the round that imitates painting, painting reproducing or mimicking sculpture in the round, three-dimensional pieces that appear flattened like a relief and relief sculpture of such projection as to verge on the freestanding. The first hint of the tendency may have appeared in monumental bronze groups, notably "Alexander's Lion Hunt" at Delphi made by Leochares and Lysippos.[47] Although the original statues are lost, descriptions suggest a

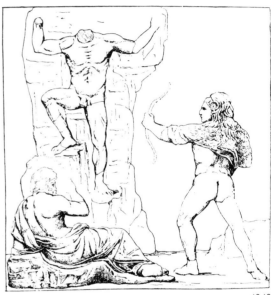

13.18

tableau with figures staggered along different planes. To the possible parallels in mosaics and sarcophagi we may now add the facade painting of the Vergina tomb currently attributed to Philip II, where distant hills and uneven ground formed the scenario for a lion hunt. Relief run wild and almost detached from its background appears on the Great Pergamon Altar, where virtually freestanding giants crawl over the grand staircase.[48] Conversely, in the interior, the lower projection of the Telephos frieze, with its many levels and background indications strongly partakes of the appearance of painting. Finally, and still in Pergamon, relief tableaux could be created by carving figures in the round and placing them in such compressed proximity as to suggest the flat surface of a pinax. The well-known "Freeing of Prometheus" (fig. 13.18) has been considered a

13.16. Athens, N. M. 1879. Nymph relief from Mount Parnes. Photo: Courtesy R. M. Gais.

13.17. Volo Museum. Dionysiac relief. Photo: DAI, Athens.

13.18. Pergamon "relief" with freeing of Prometheus. Drawing after *AvP* 7.2, fig. 168a on p. 177.

sculptural rendering of a painting by Euanthes, in an almost perverse reversal of illusionistic techniques.[49]

The next step along these lines is obvious and will find its greatest application during the Roman period. Rather than creating a landscape backdrop to relief figures, statuary in the round is immersed into a wild natural landscape. The Sperlonga groups have given us the most dramatic example of such pictorialism in Classical art.[50] But the rest of this story belongs with Roman art.

NOTES

1 This is the text of a paper that was presented with the help of many illustrations. Regrettably, these cannot all be included in the written version. Reference will therefore be made, not necessarily to the main publication, but to the most accessible source of plates and figures, to provide visual commentary to my text.
 I wish to stress that I have intentionally kept my approach factual rather than theoretical; I have therefore avoided reference to literary discussion, by both ancient and modern authors, on the use of perspective and landscape in ancient painting. Readers are referred to comments and bibliography in M. Robertson, *A History of Greek Art* (Cambridge 1975) passim, and in V. J. Bruno, *Form and Color in Greek Painting* (New York 1977).

2 It could be argued that a wall or a curtain as a background, in front of which figures are linearly arranged, is no more suggestive of depth penetration than a blank background, and that overlapping planes are not per se indicative of spatial recession. However, a sequence of overlapping planes, or a background wall, implies a conscious alignment of figures at different depths, albeit on the same groundline. I have therefore taken such arrangements to imply spatial awareness, thus pictorialism, on the part of the sculptor.

3 The most extensive treatment of this topic is P. Reuterswärd, *Studien zur Polychromie der Plastik: Griechenland und Rom* (Stockholm 1960).

4 For a discussion of how this projection of architectural sculpture was perceived, and in turn reproduced by a painter, see V. J. Bruno, "The Painted Metopes at Lefkadia and the Problem of Color in Doric Sculptured Metopes," *AJA* 85 (1981) 3–11, with specific analysis of the Parthenon metopes.

5 It is also impossible to review here the interesting phenomenon of the Boeotian gravestones in dark limestone, on which the main figure is rendered in outline and paint against a roughened background. The technique is closer to engraving and painting than to relief carving, and the experiment seems to have been short-lived, from ca. 420 to 400 B.C. See W. Schild-Xenidou, *Boiotische Grab- und Weihreliefs archaischer und klassischer Zeit* (Munich 1972) 176–78, catalog nos. K 43–48. See also Robertson, *HGA* 423 and n. 167. It could be argued that gravestones are carved in low relief during the Archaic period, but that the Classical stelai show considerably higher renderings, to the point of having figures almost entirely in the round by ca. 330 B.C. Since, however, monuments in low relief are never totally discarded, my statement remains valid.

6 Athens, N. M. 29. G. M. A. Richter, *The Archaic Gravestones of Attica* (London 1961) no. 67, figs. 155–58; a detailed description of the color scheme on the stele is given by A. Conze, *Die attischen Grabreliefs* I (Berlin 1893) no. 2 and pl. II.1.

7 Many such examples are listed in Reuterswärd, *Polychromie*. See also R. Lullies and M. Hirmer, *Greek Sculpture* (New York 1960) pl. 48: center (Siphnian Treasury, east frieze), pl. 187 (Hegeso stele). For the Thasian relief and the theory of the dipper see B. S. Ridgway, "The Banquet Relief from Thasos," *AJA* 71 (1967) 307–9.

8 Anavyssos stele: Athens, N. M. 4472; Richter, *Archaic Gravestones* no. 59, figs. 151–53. L. A. Schneider, *Zur sozialen Bedeutung der archaischen Korenstatuen* (Hamburg 1975) 52–53, has argued that the relief represents *eromenos* and *erastes,* rather than a mother and child. The suggestion is intriguing, and seems supported by comparisons on vases; however, subjects appropriate for the minor arts were not necessarily considered appropriate for sculpture. In addition, the Anavyssos area has yielded several funerary monuments, but a homosexual subject would seem unlikely for a gravestone (would both figures be dead, as traditional on Attic gravestones?), and not better suited for a votive relief. I therefore retain the traditional reading of the composition. For the comparable example with mantle in relief, see the stele of Ampharete, Athens, Kerameikos Museum: C. W. Clairmont, *Gravestone and Epigram* (Mainz 1970) pl. 11, no. 23; late fifth century B.C.

9 Comparisons with Egyptian painting have been made, e.g., by Robertson, *HGA* 240–42. For the scene in the Mastaba of Ty see K. Lange and M. Hirmer, *Egypt* (New York 1957) pls. 70–71. The tomb has been dated ca. 2450 B.C. The Temple of Hatshepsut at Deir el-Bahari is dated ca. 1470 B.C.

10 S. Karouzou (Karusu), "Bemalte attische Weihreliefs," in *Studies in Classical Art and Archaeology: A Tribute to P. H. von Blanckenhagen* (Locust Valley, N.Y. 1979) 111–16; her fifth-century example is pl. 33.1 (Athens, N. M. 1338); her suggestion is made for a fourth-century relief in Brauron (her pl. 33.2) and one from the Athenian Asklepieion (her pl. 34.1–2, Athens, N. M. 1367). Several other possible examples are mentioned in her text.

11 Lokroi pinax: for a reconstruction of the entire plaque see H. Prückner, *Die lokrischen Tonreliefs* (Mainz 1968) 17, fig. 1 (drawing).

12 See, e.g., A. Brueckner, *Der Friedhof am Eridanos* (Berlin 1909), coffers from naiskos of Agathon son of Agathokles, p. 69, fig. 39, and p. 71, fig. 43 for a drawing of the plot including the painted stele; coffers of the naiskos of Dionysios, p. 77, fig. 46 and reconstructed drawing of the plot, p. 82, fig. 49.

13 "Dionysos' Visit to Ikarios" (or to a dramatic poet): C. M. Havelock, *Hellenistic Art* (New York 1971) fig. 174; for the possibility that the buildings in the background were added by copyists see her commentary on pp. 202–3.

14 Relief to Asklepios, Athens, N. M. 1377. For a complete description and a view of the side reliefs see J. N. Svoronos, *Das Athener Nationalmuseum* (Athens 1908) 294–323, no. 74, pl. 48. For a recent discussion and a good illustration of the front see G. Neumann, *Probleme des griechischen Weihreliefs* (Tübingen 1979) 51 and pl. 29.

15 Neumann, *Probleme* 78–79.

16 For the suggestion that the back was painted, see Svoronos, *Nationalmuseum* 295. For another monu-

ment having one side painted and one decorated in relief see Karouzou, "Bemalte" 111 and pl. 32.1–2 (Athens, N.M. 1750); she suggests the term amphiprosopon.

17 The relief is recomposed from many frags. (inv. 4734, 2605, 2447). See Neumann, *Probleme* 61, nn. 35–36 and pl.37a; L. Beschi, "Contributi di topografia ateniese," *ASAtene* 45–46, n.s. 29–30 (1967/68) 533–34 and fig. 16.

18 For a discussion of the composition of the Sikyonian metope see P. de la Coste-Messelière, *Au Musée de Delphes* (Paris 1936) 186–87, fig. 8.

19 This point is made particularly by J. P. Barron, "New Light on Old Walls: The Murals of the Theseion," *JHS* 92 (1972) 20–45, esp. 23–24; the vase is illustrated here on pl. 1.

20 For the tree on the Corfu pediment see, e.g., the reconstructed drawing in Lullies and Hirmer, *Greek Sculpture* 57, fig. 1 (caption for pls. 16–19). The tree occurs near the giant kneeling in front of Zeus. The stele recording the Parthenon Treasurers' accounts is dated to 410 B.C. by the archonship of Glaukippos: Louvre 831, J. Charbonneaux, *La Sculpture Grecque et Romaine au Musée du Louvre* (Paris 1963) 124 (with illus.)

21 L. Beschi, "Il Monumento di Telemachos, fondatore dell'Asklepieion ateniese," *ASAtene* 45–46, n.s. 29–30 (1967/68) 381–436, with summary of previous bibliography. The lengthy inscription which accompanied the reliefs gives an account of the construction works in the sanctuary carried out from 420/19 to 412/11. Beschi dates the reliefs to ca. 394 because of stylistic similarities with Dexileos' stele, but grants a strong fifth-century influence on the carvings. The Padua frag. has now been published in F. Ghedini, *Sculture Greche e Romane del Museo Civico di Padova* (Serie Collezioni e Musei Archeologici del Veneto XII, Rome 1980) 15–18, no. 1. Ghedini's account, which closely follows Beschi's, does not include mention of the new British Museum frag. (see infra n. 22); the Padua relief is considered a faithful copy, only slightly later than the Athenian monument, and dated to the first decade of the fourth century.

22 E. Mitropoulou, *A New Interpretation of the Telemachos Monument* (Athens 1975). The British Museum fragment (London BM 1971.1-25.1) was briefly mentioned in *JHS-AR* 18 (1972) 61, fig. 4, no. 4. Mitropoulou dates the original relief to the end of the fifth century. In the votive plaque proper she identifies the hero Amynos in the "Asklepios" next to Hygieia, and assumes that the god was depicted in the now-missing section. On the bracket capital she reconstructs a second standing man matching the first, with Asklepios standing in the center. The head which Beschi connects with the spear-bearer should—in Mitropoulou's opinion—be shifted to the right and be connected with the central Asklepios.

23 Much has recently been written on this type of votive/funerary relief, but the specific reference is to R. N. Thönges-Stringaris, "Das griechische Totenmahl," *AthMitt* 80 (1965) 1–99, esp. p. 43.

24 Shield of Athena Parthenos: for the Toronto model and the research which led to the reconstruction, see N. Leipen, *Athena Parthenos, a Reconstruction* (Toronto 1971) 41–46 and fig. 82. The question is updated and a reconstruction with city walls is provided by E. B. Harrison, "Motifs of the City-Siege and the Shield of the Athena Parthenos," *AJA* 85 (1981) 281–317. M. Andronikos kindly tells me that

the chryselephantine parade shield from the royal tomb at Vergina includes rocky ground and may contribute to our understanding of the Pheidian shield.

25 The reliefs of Gjölbaschi-Trysa have been recently examined from the point of view of the landscape element in them: W. A. P. Childs, *The City-Reliefs of Lycia* (Princeton 1978); see esp. figs. 9 and 20, and pls. 5.1 and 13.2–17. See also their mention in J. Borchhardt, "Zur Darstellung von Objekten in der Entfernung. Beobachtungen zu den Anfängen der griechischen Landschaftsmalerei," in *Tainia*, Festschrift R. Hampe (Mainz 1980) 257–67, esp. pp. 264–65 and nn. 37–41,for the question of whether these reliefs should be considered valid evidence for Greek painting. Assyrian parallels are mentioned by Childs, *City-Reliefs;* cf. his pls. 26, 27. For the Assurbanipal reliefs see E. Strommenger and M. Hirmer, *5000 Years of the Art of Mesopotamia* (New York 1964), pl. 237 (siege of Hamanu) and pl. 249 (lion hunt). Assurbanipal rigned from 668 to 627 B.C.

26 Pythodoros relief, Eleusis Museum 51; for a good illustration see, e.g., W. Gauer, "Die griechischen Bildnisse der klassischen Zeit als politische und persönliche Denkmäler," *JdI* 83 (1968) 118–19, esp. p. 145, fig. 15, and p. 146. For a chronological discussion see C.W. Clairmont, "Gravestone with Warriors in Boston," *GRBS* 13 (1972) 49–58, esp. p. 55 and pl. 4.1. Because of the historical associations, the relief is dated between 413 and 410 B.C.

27 Relief, New York 29.47; G. M. A. Richter, *Catalogue of Greek Sculptures* (Cambridge, Mass. 1954) 55, no. 81, pl. 66a. See also *Aspects of Ancient Greece* (Allentown Art Museum, Allentown, Pa., 1979) 152–53, no. 74, with discussion and additional bibliography. The relief is probably datable around 380 B.C. Good photo in BrBr 646d.

28 Torlonia relief: see, e.g., H. Kenner, "Griechische Theaterlandschaften," *ÖJh* 47 (1964/65) 44–47 and fig. 31; fig. 32 on p. 46 provides a schematic drawing of the landscape. See also Beschi, "Contributi" 511–36, esp. pp. 515–17 and fig. 2; dated to the end of the fifth century.

29 Delphi relief: M-A. Zagdoun, *FdD* 4:6 (1977) 23, no. 4, fig. 15; dated to the last quarter of the fifth century.

30 Lenormant relief (named after the former owner of the main frag.): L. Beschi, "Rilievi votivi attici ricomposti," *ASAtene* 47–48, n.s. 31–32 (1969/70) 85–132, esp. pp. 117–32; see p. 127, fig. 24 for a reconstruction with all the frags. Cf. also M. S. Brouskari, *The Acropolis Museum: A Descriptive Catalogue* (Athens 1974) 176–77, fig. 379, Akropolis. 1339 (the Lenormant fragment). For the Dal Pozzo drawing see Beschi, "Rilievi" 123, fig. 21. The Theban stele is also illustrated by him, p. 125, fig. 23. The newly attributed frag. is Akropolis 2544, p. 124, fig. 22.

31 Stele of Demokleides: Athens, N. M. 752, Conze *Grabreliefs* no. 623, pl. 122; dated ca. 400 B.C.

32 Chian grave stele: J. Boardman, *Excavations in Chios, 1952–1955: Greek Emporio, BSA* supp. 6 (London 1967) 186, pl. 71. The stelai from Rhenea are published by M-T. Couilloud, *Délos* 30 (Paris 1974) 167–75, 292–98, pls. 63–70.

33 For a good photo of Helios' horses on the Parthenon see F. Brommer, *Die Skulpturen der Parthenon-Giebel* (Mainz 1963) pls. 23 and 25.3.

34 E. Simon, "Die Mittelgruppe im Westgiebel des Parthenon," in *Tainia* 239–55.

35 In his account of the oeuvre of Apelles, Pliny (*HN* XXXV.79ff.) mentions that he painted Alexander the

Great holding a thunderbolt, and that he tended to depict subjects which supposedly cannot be represented, such as thunder, lightning, and thunderbolts. In *HN* XXXV.138, Pliny mentions that Antiphilos depicted a "boy blowing on a fire," which illuminated both the boy's face and the total room. A similar effect in sculpture seems to be suggested by Pliny (*HN* XXXIV.88) when he described a group made by Nikeratos: Alkibiades and his mother performing a sacrifice by the light of torches.

36 For a summary of previous theories, with a new suggestion, see E. Simon, *Pergamon und Hesiod* (Mainz 1975) 18–19, n. 90 and pl. 15.

37 Birth of Asklepios relief: Athens, N. M. 1351. A detailed description occurs in Svoronos, *Nationalmuseum* 268–70, pl. 49.3. A mid-fourth-century date is suggested in this and later sources.

38 It is interesting to note an approximately contemporary parallel in architectural sculpture: as is well known, the Temple of Athena Alea at Tegea had decorated metopes over the porches, with figures carved separately and doweled to the background. Only frags. of these figures have been recovered, but the preserved blocks of the underlying architrave had inscribed the names of some of the characters in the metopal scenes. Since the names are not engraved on a straight line, but appear staggered, the possibility exists that the figures were placed at different levels within the panels, so as to correspond to the uneven alignment of the inscriptions. For a recent discussion of the sculptures from Tegea, see A. F. Stewart, *Skopas of Paros* (Park Ridge, N.J. 1977) esp. p. 46.

39 Relief from Mount Parnes: Athens, N. M. 1879. A detailed description can be found in Svoronos, *Nationalmuseum* 577–80, pl. 97. For a discussion of the various dates given to this plaque by different scholars see R. M. Gais, "Some Problems of River-God Iconography," *AJA* 82 (1978) 359–60, n. 16, fig. 9.

40 Neoptolemos' dedication, Athens, Agora Museum I 7154; see Neumann, *Probleme* 54, pl. 31a. Good detailed photographs and a chronological discussion can be found in H. A. Thompson, "Dionysos among the Nymphs in Athens and in Rome," *JWalt* 36 (1977) 73–84.

41 Archandros relief: Athens, N. M. 1329; Svoronos,

Nationalmuseum 243–44, pl. 44. A recent photo appears in Travlos 142, fig. 192. The relief is dated to the end of the fifth century.

42 Boeotian relief, in Berlin: see C. Blümel, *Die klassisch griechischen Skulpturen der Staatlichen Museen zu Berlin* (Berlin 1966) 65, no. 74 (K 92), fig. 111. The relief is dated to the first half of the fourth century.

43 Volo relief: it is discussed by K. Schefold in his text to BrBr 785b (Munich 1939) 22–23, fig. 2 on p. 21. It is briefly mentioned by F. Matz, "Ariadne oder Semele?" *MarbWinckProg* (1968) 113, pl. 10.

44 Derveni krater: see the complete illustration and publication in E. Youri, *Ho Krateras tou Derveniou* (Athens 1978). A good account also in K. Schefold, "Der Basler Pan und der Krater von Derveni," *AntK* 22 (1979) 112–18. The underside of the skin on the Satyr's shoulders is inlaid with copper to provide color contrast; the rough ground is stippled; the wreath around the vase has silver leaves.

45 Munich relief: see, e.g., Havelock, *Hellenistic* 199–200, no. 168, fig. 168 (dated late second century); Lullies and Hirmer, *Greek Sculpture* pl. 268 and caption on p. 104 (dated Late Hellenistic).

46 "Apotheosis of Homer" relief: see, e.g., Havelock, *Hellenistic* 200–201, no. 170, fig. 170. The main publication is by D. Pinkwart, "Das Relief des Archelaos von Priene," *AntP* 4 (1965) 55–65, pls. 28–35; dated ca. 130.

47 The description is given by Plutarch (*Alex.* 40). See, e.g., B. S. Ridgway, "The Setting of Greek Sculpture," *Hesperia* 40 (1971) 345.

48 Pergamon altar, crawling giants: see, e.g., Lullies and Hirmer, *Greek Sculpture* pl. 251.

49 Freeing of Prometheus panel: for a discussion see, e.g., Ridgway, "Setting" 349–50 and nn. 48–52. For illustrations see, e.g., M. Bieber, *The Sculpture of the Hellenistic Age²* (New York 1961) figs. 485–87. Dates suggested for the composition oscillate between 150 and 85 B.C. The Telephos frieze of the Pergamon altar has been treated in detail by K. P. Stähler, *Das Unklassische im Telephosfries* (Münster 1966).

50 The bibliography on the Sperlonga groups is increasing steadily. For the official publication see B. Conticello and B. Andreae, "Die Skulpturen von Sperlonga," *AntP* 14 (1974).

Attic Vase-Painting and the Home Textile Industry

14

EVA C. KEULS

Herodotos (v.12) tells a story of two Paeonian men, who sought to enlist the favor of the Persian king Dareios by bringing him their sister, a woman "tall and comely," who was also a prodigious worker: she could simultaneously tote a full water jug on her head, lead a horse by the reins, and spin wool as she went along. The improbable vision of Herodotos' Paeonian wonder woman may be considered a wishful male fantasy of the benefits that could conveniently be extracted from the human female. The athletic labors by which Dareios was enticed included the two tasks most consistently and most universally assigned to women in the Mediterranean world, namely water-carrying and woolworking. To be sure, in the Attic literature of the Classical age, especially the comedy of Aristophanes and the courtroom speeches, we learn of a number of other trades and occupations of women, but most of these seem to have been practiced outside or on the fringes of the respectable citizen society, or in periods of exceptional duress. From Demosthenes (57.45) we learn that in time of hardship Athenian citizen women became wet nurses, wage laborers, and grape pickers for pay. Women sold practically everything, but especially foodstuffs, on the marketplace, so, for example, Aristophanes' female "seed-market cereal-and-vegetable vendors" (*Lys.* 457). Not, however, without tarnishing their standing as ladies of class, as Euripides' mother, the greengrocer, must have found to her chagrin. Some other female professions, such as matchmaking and midwifery, were probably practiced mainly by post-menopausal women, who were beyond the pale of many of the social restrictions affecting wives of childbearing age.

The canonical role of water-carrying and textile-working as fully sanctioned female occupations is evidenced by the fact that they are deeply embedded in the religious-mythological thought of the Classical age. For the connection of women and water-carrying (see Moon pp. 109–10) we only have to think of the many cults which featured ceremonial hydrophoria rituals, most of them performed by women (although some, as for example the πλημοχόαι at Eleusis, were carried out by men);[1] of the myth of Amymone, scouring the parched plains of Argos in search of water, one of the more popular pictorial motifs with both Attic and Italiot vase-painters; and of the myth of the other Danaids, purified of bloody crime through a water-carrying ordeal, a theme which goes back to the Danaid tetralogy of Aischylos, if my reconstruction is correct.[2]

The myths and rituals surrounding woman's textile-processing activities are too pervasive to survey here. They reflect on the one hand the perception of spinning and weaving as a major element in the enculturation of the female, a kind of initiation mechanism second in importance only to that of marriage. The weaving of a new peplos for Athena Polias, and its solemn presentation to the goddess every four years by Athenian virgins, is but one indication of this symbolic function of woolworking. On the other hand textile-making imagery also reflects man's awe and fear of his incarcerated female, who, though defeated and exploited, held ineluctable and ominous powers over his life and soul. Woven garments feature heavily in the myths of female rebellion against the male order: Klytaimnestra and Medea use items of clothing as tools of

revenge against their men; Deianeira unwittingly does in Herakles with a poisoned garment. In the Prokne-and-Philomela myth, a woven tapestry is the indispensable instrument of retribution. The very thread of men's lives is allotted, spun and snipped by women, the Moirai. Perhaps the most telling of the textile myths is that of Arachne, as adapted by Ovid from Greek sources (*Met.* VI.5–145). Arachne not only had the hubris of vying with Athena in domestic skill, but also committed the imprudence of weaving into her tapestry pictures of the deceitful dalliances of gods with mortals, a topic understandably offensive to the virgin goddess on several scores. Athena hurled a shuttle at the hapless girl, and Arachne, in despair, hanged herself, an inevitably textilic mode of suicide for Athenian women. Athena saved Arachne by turning her into a spider in the nick of time. The image of the spider spinning away in the dark recesses of the earth is not only an apt metaphor for the lives of Athenian women during the height of Attic civilization, it also reflects the Athenian man's fear of the web of treachery being woven for him at home. Economics and psychology meet in the history of the textile industry.

It is the purpose of this essay to make some observations on the iconography of spinning and weaving on Attic vases, and to dwell briefly on the motif of water-carrying, since it features revealing analogies with, as well as divergences from, that of textile-making. The two chores both manifest the economic exploitation of women as a source of cheap labor, but the societal consequences of each are different, in fact opposite: home textile-working was and, in some parts of the world still is, a mechanism for the restriction of women to private quarters; the fetching of water from a public well or fountain brings women out of the seclusion of the home into the public area; in other words, it makes them cross social boundaries, a circumstance of which the vase-painters, as we will see, were fully aware.

The motif of women fetching water in hydriai at fountain houses is represented on scores of Attic vases, most of them hydriai themselves, and most of them in the black-figured technique. Scholars have connected these vase-paintings, quite plausibly, with the construction of the famous Enneakrounos (nine-spouted) fountain and other well houses, as part of the public building program in the agora area during the tyranny of Peisistratos and his sons (Moon pp. 109–10). There is, however, a deeper significance in these scenes than a gesture of gratitude for a public facility: we know from excavations that to accommodate the public structures a number of private houses were torn down and smaller, presumably family-owned wells were filled in.[3] In other words, a function which previously had taken place in the privacy of the courtyard now was transferred to the public zone, with social and sexual consequences perhaps not anticipated by Peisistratos' planners. The vase-painters clearly made pictorial capital out of the social interaction which took place at the public fountain houses.

A fountain-house scene in the Vatican (fig. 14.1) shows five busy women with their hydriai, gesticulating, i.e., exchanging rapid conversation, as they pass each other on their way to and from the well. A black-figured hydria in Naples (fig. 14.2) features a double-headed fountain-house with mature women and young girls at work. One mother has brought her little son, who is perched on her right hand in an improbable position. The girl in front of the fountain-head at the right has abandoned her waterpot under the spout and is playing with a ball, apparently to the dismay of her mother to the left, who seems to be admonishing her. Not all social interaction in fountain scenes is quite so innocent: several of them show scenes of sexual molestation for which the water-carrying ritual provided an outstanding opportunity. In fact, several treatments of the motif reveal an aspect of voyeurism which we will find repeated in vase-paintings of textile-working scenes.

The composition on a hydria in the Vatican (fig. 14.3) perhaps intends to be merely humorous: it shows two women and two men—slaves, it would seem, judging by their simple loincloths—at a fountain house with four heads; the inner spouts have the customary lions' heads, humorously called κρηνοφύλακες (or fountain guardians) in Greek; the outer fountains are in the shape of mule's heads. The woman and the slave on the right are gesticulating: it seems that the slave has elbowed the woman out of her rightful place at the lion's head fountain and she has to make do with the mule's head spout. A scene on another hydria again in the Vatican (fig. 14.4) shows a slave with ugly knobby knees molesting a woman who has just arrived at the fountain. Her raised arm indicates protest. On the left a woman with an empty waterpot on her head holds a flower in her left hand and reaches out toward the slave with her right: is she trying to restrain him or competing for his attention?

A full elaboration of the theme of molestation-at-the-well may be seen on a hydria in Detroit

14.1. Vatican 426. Water carriers conversing at fountainhouse. Photo: Courtesy Musei Vaticani.

14.2. Naples S.A. 12 (Heydemann). Women, girls, and a child at fountain house.

14.3. Vatican 417. Women and slaves fetching water. Photo: Courtesy Musei Vaticani.

14.4. Vatican 427. Slave accosting woman at fountain house. Photo: Courtesy Musei Vaticani.

14.1

14.2

14.3

14.4

by the Pig Painter, from the early fifth century, one of the few instances of group scenes at fountains in the red-figured technique (fig. 14.5). On the far left a man sneaks up from behind on a woman with an empty pot on her head. She pushes the man away with her right hand and raises the left in protest. In the center another woman has put her water pitcher on the ground to keep a would-be lover at bay. She gesticulates with her left hand; hence it appears she is trying to dissuade her accoster. Behind her a third water carrier approaches with a full hydria on her head. She is turning around to give warning to the woman who is busy filling her hydria and, probably because of the noise of running water, is as yet unaware of what is going on.

It brings to mind the lamentation of the chorus of women in the *Lysistrata,* who are arriving on the Akropolis to put out the fire started by their antagonists:

> At last I'm here, barely could I fill
> my hydria from the spring at dawn, on
> account of the crowd and the noise
> and the clatter of jugs. I snatched mine
> away, jostled as I was by slaves and
> scoundrels. . . . (Ar. *Lys.* 327–29)

This passage seems to indicate that the use of the public fountain houses by citizen women was not completely unthinkable in the later fifth century B.C., despite the implication of Herodotos' comment on prehistoric Athens:

> . . . the daughters and children of the Athenians used to fetch water at the fountain called "The Nine Springs," for at that time neither they nor any of the other Greeks had any household slaves. (Hdt. VI.137)

At any rate, most representations of water-fetching in red-figure show, not elaborate public fountain houses, but small, more modest wells, probably to be imagined as located within the confines of a private property. The sex appeal of the young lady pictured on a red-figure kylix in Milan (fig. 14.6) is underscored by a *kale* inscription. This scene and several variants of the same composition are featured on the tondos of kylikes whereby their frivolous nature is further brought out.

That the simple and arduous labor of women aroused male erotic fantasies is perhaps best documented by the following two scenes. Figure 14.7 shows a krater in Tübingen, conceivably based on a Satyr play: it features a girl at a rustic-looking water pump, surprised by randy Satyrs. A painting on the shoulder of a hydria in Leningrad (fig. 14.8) depicts a mature man ogling one girl at a fountain house, while behind him another one is sitting on the ground naked, masturbating.

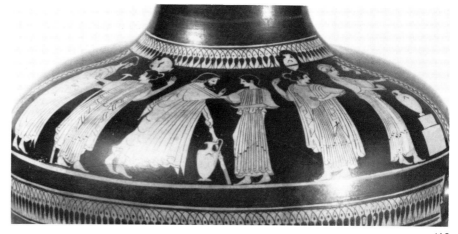

14.5

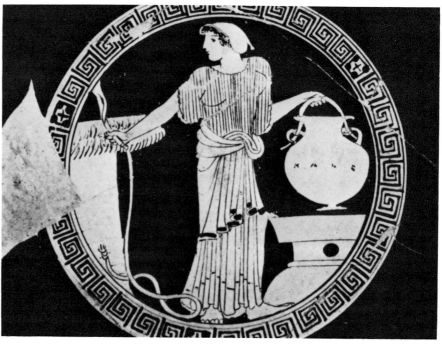

14.6

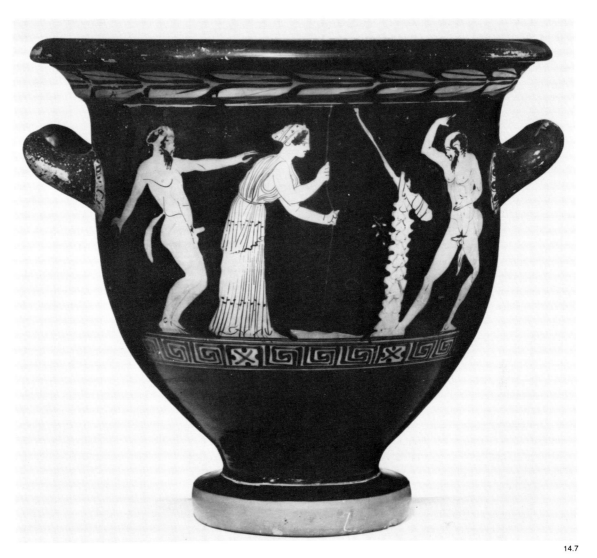

14.7

14.5. Detroit 63.13. Red-figured hydria by the Pig Painter. Men molesting women at fountain house. Photo: Courtesy of the Detroit Institute of Arts.

14.6. Milan 266. Girl fetching water at well.

14.7. Tübingen 1343. C. Watzinger, *Griechische Vasen in Tübingen* (1924) E 105, pl. 29, pp. 47–48. Satyrs importuning girl at water pump.

14.8. Leningrad 1612 (St.). Red-figured hydria in the style of Epiktetos. Two men and a woman at fountain.

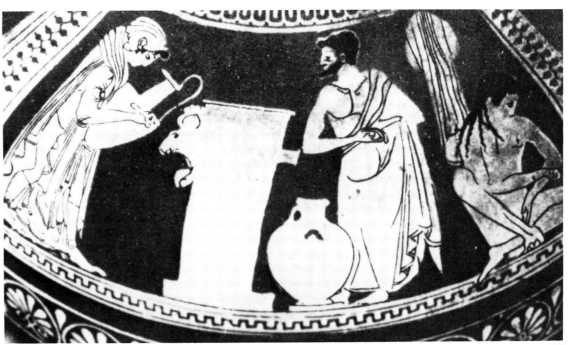

14.8

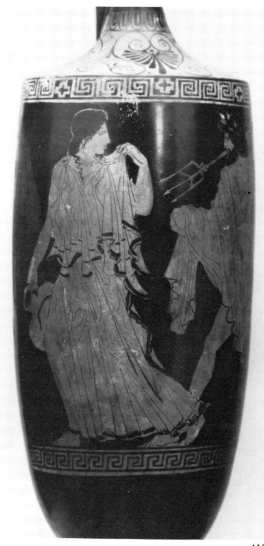

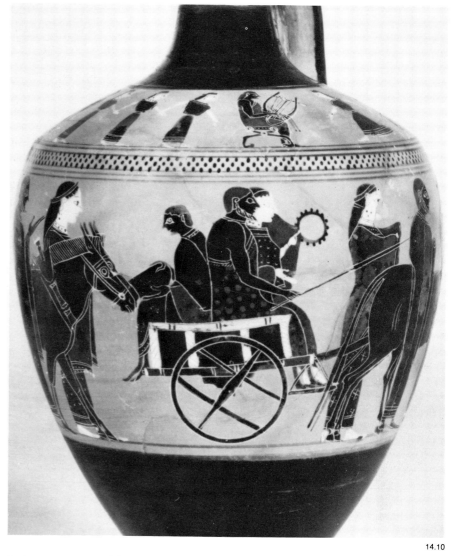

There are several myths in which women are raped at or abducted from a well, but the most popular mythological codification of the theme of water-carrying and sex was the motif of Poseidon and Amymone. The vase-painters featured the myth either with inclusion of a Satyr or Satyrs who molested Amymone as she was searching for water, an element surely derived from Aischylos' Satyr play *Amymone,* or they depicted the pair alone, as one sees on a lekythos in New York (fig. 14.9). In the well-known story, Poseidon rescued Amymone from the molestations of the Satyr; he then raped her himself and showed her the well at Lerna in compensation for her virginity, the ancients' notion of a happy ending. It is only one of the numerous myths of mortals raped by gods, which gain sudden popularity in Attic art at around 480 B.C.[4] In fact, the entire theme of violation at the well, which I have attempted to highlight here, should be seen as but one of the manifestations of the peculiarly

Attic conception of love as aggression and domination. I in this regard recall the group scene at the fountain on the shoulder of the hydria in Detroit (fig. 14.5) on which the distasteful topic of sexual molestation is treated with such charm and good humor.

The topic of water-fetching has served as a prelude to our discussion of textile-making, because the two pictorial themes both seem to share the elements of a male-centered viewpoint, voyeurism, and the erotic appeal of the submission and humble labors of women.

Illustrations of textile-processing in private houses are found only sporadically in black-figured pottery, but have survived by the hundreds from the great period of Attic red-figured production. I should state at the outset that the customary view of such scenes as realistic glimpses into the *gynaikonitides* or women's quarters of ordinary houses and the nitty-gritty of everyday life is, in my opinion, erroneous. The indoor

14.9. New York 17.230.35. Red-figured lekythos by the Phiale Painter. Poseidon about to rape Amymone. Photo: Courtesy Metropolitan Museum of Art (Rogers Fund, 1917).

14.10. New York 31.11.10. Black-figured lekythos by the Amasis Painter. Arrival of wedding procession at the groom's house. Photo: Courtesy Metropolitan Museum of Art (Purchase, 1956, Walter C. Baker Gift).

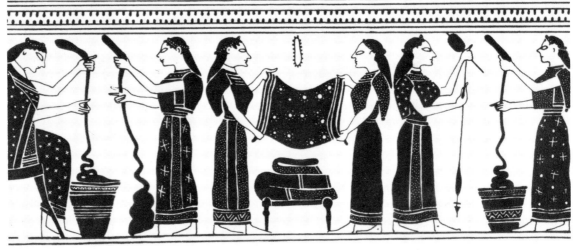

14.11b

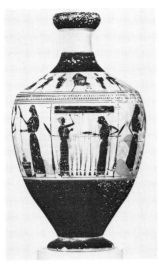

14.11a

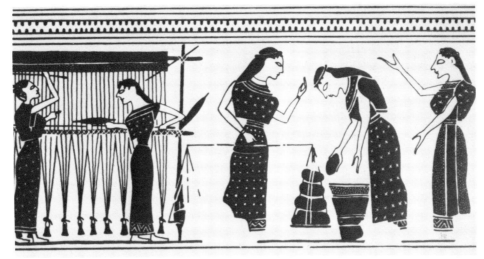

14.11c

14.11a. New York 56.11.1 Black-figured lekythos by the Amasis Painter. Woolworking scenes. Photo: Courtesy Metropolitan Museum of Art (Fletcher Fund 1931).

14.11b. New York 56.11.1. Detail.

14.11c. New York 56.11.1. Detail.

scenes are as much based on observation as were Athenian notions that women conceive during menstruation or that their mental disorders are due to their wombs traveling through the chest cavity, not to mention Aristotle's remark (*Hist. An.* 501b) that women have fewer teeth than men, which is said to have elicited the quip from Bertrand Russell that "Aristotle would never had made this mistake if he had let his wife open her mouth once in a while." Even though many decorated vessels were destined for use by women, such as pyxides and alabastra, the *gynaikonitis* scenes reflect a male-centered viewpoint. They are semiotic in nature, and use repetitious pictorial stereotypes laden with conventional associations, most of them sexual-maternal in nature.

Any discussion of the Attic iconography of textile-making inevitably begins with the well-known lekythos by the Amasis Painter in New York which dates from before the codification of the motif.[5] It should be shown with its compan-ion piece, also in New York, because the two together provide a continuous synopsis of the fate of the young bride. On the former (fig. 14.10) she is shown being taken to the house of the groom in the traditional mule cart. Her new mother-in-law, *omen absit,* awaits the couple at the threshold of her new abode. The second lek-ythos (fig. 14.11a) provides the panorama of what awaits the bride in her new life: endless labor at spindle and loom (details in figs. 14.11b and 14.11c). The vase-painting contains three instances of what is throughout the most funda-mental iconographic clue for the textile-process-ing industry, the workbasket or kalathos, perhaps from the root *kloth-* to spin. It does not include the element which was to find special favor with later vase-painters, that of the card-ing of the textile fibers over the bared knee. The lekythos by the Amasis Painter is a candid and informative illustration of the different labors entailed by the production of textiles. One's

attention is drawn to the fact that the painter has placed the loom in the center of his composition, which is where it belongs, inasmuch as weaving is the most fundamental as well as the most skilled of the different phases of textile manufacture. It was not until the age of red-figure pottery that artists developed, for the portrayal of domestic scenes, a vocabulary of iconographic codes, whereby such motifs could be charged with specific symbolic content.

Beginning in the late Archaic age, locales are often graphically defined: since the basic assumption of the ancients, unlike our own, is that events take place out-of-doors, indoor settings are identified by pieces of furniture or by objects hung on walls. The *gynaikonitis* is often indicated by a closed door (figs. 14.12, 14.13). This convention, especially frequent on pyxides, confirms the literary sources which suggest that women were commonly locked up in their quarters, as was still customary in some rural areas of Sicily until not long ago.[6] A single column, apparently alluding to a colonnade around an inner courtyard of the house, may serve the same purpose (fig. 14.14). Occasionally the two elements are combined.

In the domestic representations the structural unit of communication is the pictorial form rather than the literal meaning conveyed. Two examples illustrate this contention. The first indication of the priority of form over function is the confusion in *gynaikonitis* scenes of two objects of similar form but diverse application, namely the hand mirror and the distaff, a phenomenon first brought to my attention by D. Johnson, one of my more gifted students.[7]

The not-too-shapely lady on a red-figure dish (fig. 14.15), shown at her toilette beside a laver, is looking at herself with some satisfaction in a hand mirror. The woman in the domestic scene on a hydria in London (fig. 14.16) is depicted as she is spinning wool with a drop spindle from a distaff. The latter in most cases probably does not consist of completely raw wool, but of the presorted fibers which are the result of the preliminary carding, because sometimes threadlike fibers or roves are shown.

On a red-figure hydria in Munich (fig. 14.17) an analogous family scene, this time including a young boy, is presented. (Incidentally, children in *gynaikonitis* settings are virtually always boys, a circumstance probably not to be taken as proof of female infanticide, but as an indication that girl children were conceptually nonexistent.) On a lekythos in Athens (fig. 14.18) a distaff is hanging on the wall, not a mirror, because little balls

14.12

14.13

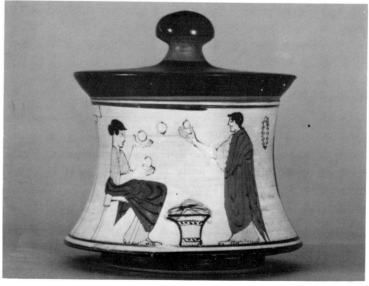

14.14

14.12. Heidelberg 66.10. Women's quarters with closed door. Photo: Courtesy of the Archäologisches Institut, Heidelberg.

14.13. Berlin F 2261. Women's quarters with closed door.

14.14. Toledo, Ohio 63.29. Women's quarters with woolworkers and courtyard column. Photo: Courtesy of the Toledo Museum of Art.

14.15. Antiquities market, Basel 1977. Woman at her toilet, looking into mirror.

14.16. London E 215. Spinning scene. Photo: Courtesy of The Trustees of the British Museum.

14.17. Munich 476. Spinning scene with boy. Photo: Museum.

14.18. Athens 12890. Red-figured lekythos by the Providence Painter. Woman folding garment, distaff overhead. Photo: Museum.

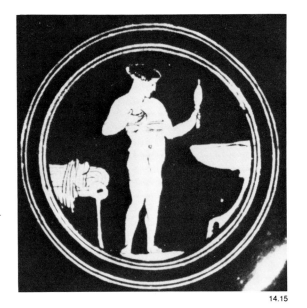

14.15

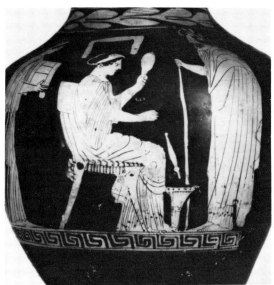

14.16

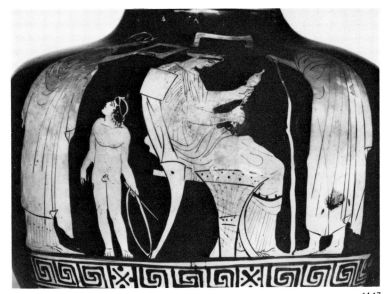

14.17

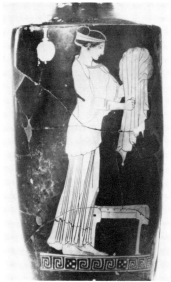

14.18

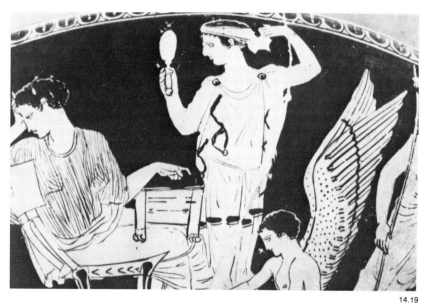

14.19

14.20

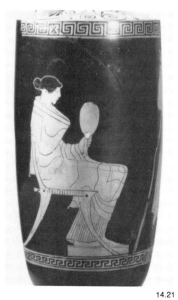

14.21

14.22

14.19. Berlin F 2536. Kylix by the Painter of Berlin 2536. Lilly B. Ghali-Kahil, *Les enlèvements et le retour d'Hélène*, Paris 1955, no. 15, p. 61. Woman primping and looking into mirror.

14.20. Oxford 537. Women's quarters. Woman with mirror. Photo: Courtesy Ashmolean Museum.

14.21. New York 26.60.78. Red-figured lekythos by the Sabouroff Painter. Man facing woman with distaff or mirror. Photo: Courtesy Metropolitan Museum (Fletcher Fund 1926).

14.22. Louvre CA 1329. Clothed and naked women at grave stele. Photo: Chuzeville, Courtesy Musée du Louvre.

14.23. Chiusi 1831. The mourning Penelope with her son Telemachos. Photo: Courtesy W. G. Moon.

14.24. Würzburg 521. Women's quarters, with cithara player. Photo: Museum.

14.25. University of Durham, England. Lady with hand loom. Photo: Courtesy of the University of Durham Museum.

of wool are protruding from it. The primping lady on a kylix in Berlin (fig. 14.19) (she is an apparently anonymous companion of Helen, who sits musing on the left) is looking at herself in a mirror. And what about the seated beauty on a pointed amphoriskos in Oxford (fig. 14.20), who is stroking her loosened curly hair? Only her pose reveals that she, too, is holding a mirror, but the object in her hand is shaped exactly like a distaff. In a number of vase-paintings it is unclear whether a mirror or a distaff is meant, as on a lekythos by the Sabouroff Painter in New York (fig. 14.21).

Were all these painters careless or did they address viewers with keener eyes than ours? Neither is likely. Apparently the confusion was deliberate, or at least semiconscious, inasmuch as both forms conveyed the same meaning, that of feminine grace and charm. That the interchangeability of two objects so dissimilar in purpose reflects a male-centered viewpoint is clear, because to the woman herself it would make a great deal of difference whether she would be leisurely primping or engaged in the arduous task of spinning.

To conclude this discussion of the deliberate confusion between the two objects, I show a white-ground lekythos in the Louvre (fig. 14.22), which one conjecturally takes to feature a pictorial play on them. Doing service to the stele we see on the left a clothed lady with a distaff overhead and on the other side a naked woman, surely a hetaira, with a mirror. Or is it the other way around?

The other instance of form over verity is derived from illustrations of weaving. The elaborate stand-up loom which we saw on the leky-

thos by the Amasis Painter appears very rarely in red-figure: I show it here on a rather celebrated picture of the mourning Penelope with Telemachos (fig. 14.23). Instead a number of *gynaikonitis* scenes feature women with what may be a small handloom or perhaps a tapestry loom or, as some will have it, an embroidery frame—in any case a luxury implement. As S. Pomeroy has pointed out in a recent article, the pose of women holding the handloom closely echoes that of women playing the lyre.[8] (She might have added that women holding book rolls or wreaths are regularly depicted in analogous attitudes.[9]) Two vase-paintings are shown as representative of many featuring the "seated-lady-with-object" scheme. Again compositional form is more significant than articulate meaning (figs. 14.24, 14.25).

Does the abandonment of the loom by the vase-painters indicate that women no longer engaged in weaving in their homes? As Pomeroy has pointed out to me, Plato mentions a male weaver (*Resp.* 370d–e) and some industrial weaving may well have been carried out in male workshops, but there is ample evidence in literature that the weaving of fabrics for clothing continued to be performed within the family, and loom weights have regularly been found in large numbers in private dwellings of the fifth and fourth centuries. Then why do the full-size looms disappear from vase-paintings, whereas spindles and wool baskets are ubiquitous? Apparently the associations of the kalathos, the spindle, and the dainty handloom were aesthetically pleasing or symbolically meaningful; those of the larger looms were not. (To protect my friend Pomeroy from dispute I should note that the latter infer-

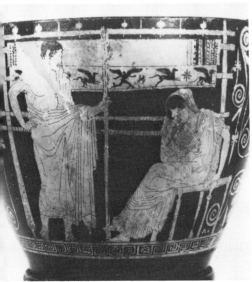

14.23

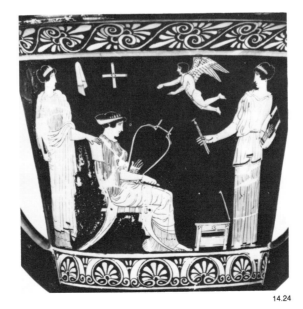

14.24

14.25

14.26a

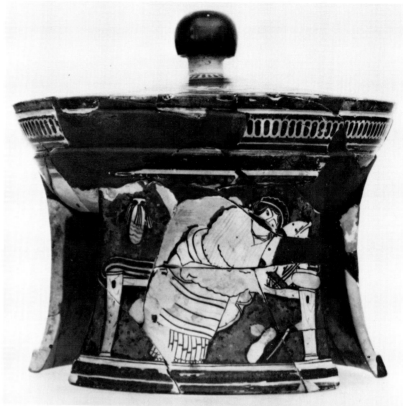

14.26c

14.26b

14.27

14.26a. Athens 1584. Hard-working spinster. Photo: Museum.

14.26b. Athens 1584. Spinster and sleeper.

14.26c. Athens 1584. Spinster and sleeper.

14.27. Houston, Museum of Fine Arts, Annette Finnigan Collection. White-ground lekythos by the Bowdoin Painter. Lady with kalathos on a funerary lekythos. Photo: Courtesy of the Museum of Fine Arts, Houston.

14.28. Vatican 16554. Aithra with kalathos pursued by Poseidon. Photo: Courtesy of the Musei Vaticani.

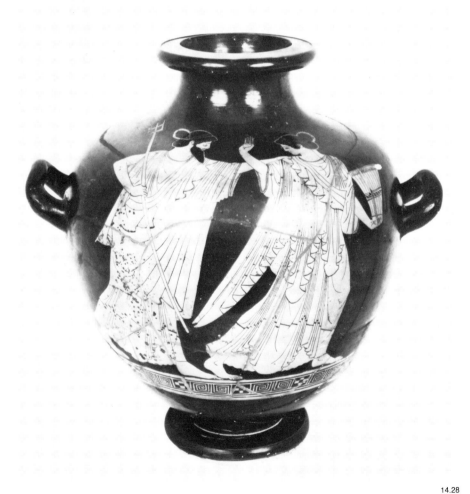

14.28

ence drawn from the vase-paintings is mine and not hers.)

Inevitably, both the hydria and the woolworking implements, especially the kalathos, became symbols, not only of women's lives, but also of the virtues of industry and submissiveness associated therewith. Only a few of the illustrations lay pictorial stress on the strenuous labor involved in textile-making.

A shallow pyxis with large openings in the sides, so as to form a low tripod (figs. 14.26a, 14.26b, 14.26c) shows on one panel a husky spinster, with what we might call a stenographer's spread from too much sitting. She is bent over with the effort of her work. In the other panels a woman rests from her labors on a couch, and a third worker, also a spinster, is perhaps summoning the sleeper back to work. Not infrequently ladies appear with their textile-making attributes on white-ground lekythoi, where they seem to anticipate the accolade extended to deceased women on Roman gravestones: *domi mansit, lanam fecit:* she was a good woman; she stayed home and made wool (fig. 14.27).

But there is another side to the iconography of the woolworking industry, namely the erotic one, in which it parallels that of the water-carrying activity of women. With regard to woolworking, one might call this phenomenon the "Lucretia syndrome." For in the Lucretia legend, not without cause connected with the origins of the Roman Republic, the brutish Sextus Tarquinius rapes the lovely and virtuous Lucretia, not only on account of her beauty, but because he finds her late at night, industriously spinning away with her handmaidens. So Mephistopheles, in the Faust story, does not lead his acolyte to a voluptuous odalisque but to an innocent and virtuous maiden in pigtails. The crossover phenomenon is curious because it reveals that men delighted in transgressing the very boundaries of female behavior which they themselves had set up for their convenience and utility. Livy's explanation (*Per.* 1.57) for Sextus' behavior is worded, with a succinctness worthy of Tacitus, *tum forma cum castitas incitat:* "He was aroused by both her beauty and her chastity." This phrase could serve as the title of the Attic iconographic motif of Poseidon pursuing Aithra, the mother of Theseus, because this rape victim appears in red-figured pottery with a woolworking basket (fig. 14.28). (Possibly this attribute indicates here that she had already mated with Theseus' father Aigeus.[10]) If you will recall the popular motif of

Poseidon pursuing Amymone with her waterpot, we have two neatly parallel instances of the sex appeal of female drudgery. Why Poseidon alone among the gods should be so susceptible to these exponents of domestic industry, one is at a loss to explain. Needless to say, the protagonists of the Greek myths fare better than Sextus Tarquinius and Lucretia: Roman myths tend to be more punitive than the Greek ones. In the domain of ordinary mortals, too, the textile-working activities of women in the *gynaikonitis,* always as conceived, described, and depicted by men, were fraught with erotic associations. One can mention only a few of them.

There is a clear element of voyeurism in scenes of the carding of fibers (a phase in the processing of textiles), which we have not yet seen in any illustrations. For this operation, the woman propped up one leg on a low footstool or support frame, and passed the wool over her knee for sorting. For the protection of the knee women might use a terra-cotta protective cover, called an *onos* or *epinetron.* L. Kahil has offered a variant nomenclature: she argued, very plausibly, that not the knee cover, but the foot support was called *onos* or *ass.*[11]

The fact that several of such scenes occur in the tondos of kylikes is in itself an indication of salacious implications, as are the associations of accompanying iconographic elements. On a cup in Florence (fig. 14.29) we see the alabastron, an oil flask used by women, the sexual implications of which are amply spoofed by Aristophanes,

especially in the *Acharnians* (1063), where Dicaiopolis uses one to demonstrate how a bride should massage her husband.[12]

The better-known cup by Douris in Berlin has on the outside a *komos* of men, and in the tondo a scene of similar composition as the previous one, but with more elaboration (fig. 14.30). There are two kalathoi in the scene, but only the seated figure is using hers; the other woman has placed hers on the *kline* behind her, and she is making the familiar gesture of lifting a tip of her garment, sometimes called *anakalypsis,* which nearly always seems to have connotations of sexual surrender or at least nubility (*pace* my revered colleague, K. Schefold, who holds, with others, that it indicates mere greeting).[13] One may but briefly recall here that we saw it previously in the person of Amymone, as she was being pursued by Poseidon and that the same gesture is made by Semele as she is about to be destroyed by Zeus, occasions which do not seem to call for *freundliches Grüssen.*

As illustrations of the associations of wool-working and conjugal relations, two vases both allude to the latter with a standard pictorial motif, namely a half-opened door through which a part of a *kline* may be glimpsed (figs. 14.31, 14.32a). A pyxis in the Louvre (fig. 14.31) (appropriately reproduced by Flacelière in his *L'amour en grèce*) features two women, one with a handloom and the other, seated, with a distaff, it seems; the seated lady, surely, is the wife. A lebes gamikos (figs. 14.32a, 14.32b) depicts the

14.29. Florence 3918. Carding scene.

14.30. Berlin 2289. Red-figured kylix by Douris.

14.31. Louvre CA 587. Women outside the bridal chamber. Photo: Chuzeville, Courtesy Musée du Louvre.

14.32a, 14.32b. Berlin 2406. The two duties of the bride: spinning and sex. Photo: Courtesy Antikenmuseum, Staatliche Museen.

14.29

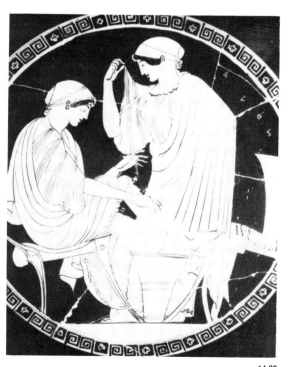

14.30

14.31

14.32a

14.32b

preparation of the bride—her kalathos is shown beside her—and the same bride about to enter the bridal chamber.

A hydria by the Orpheus Painter in New York, from the latter part of the fifth century, reflects the preoccupation with wedding preparations and the rather sultry atmosphere which characterizes the interior scenes created during that period (figs. 14.33a, 14.33b). The presumed bride is seated on the left, already wearing the bridal tiara, but still spinning away busily. She is the very picture of Ischomachos' demure and obedient bride so unctuously described in the *Oeconomicus* of Xenophon. Eros, whose presence, of course, points to the future happiness of the couple, holds out a pair of shoes, tentatively identified by G. M. A. Richter as the wedding slippers, the νυμφίδες, mentioned in Hesychius.[14] One wonders if the seventeenth-century Flemish and Dutch painters, who used the slipper frequently as an iconographic clue pointing to future fornication, or the danger thereof, had any knowledge of the ancient symbol of the *nymphides*. Note again in this vase-painting the striking absence of the loom.

R. F. Sutton, Jr., who has been presenting excellent papers on the confrontation of male and female in Attic vase-painting, showed this same hydria to a recent AIA congress (1980), along with other later *gynaikonitis* scenes, to bolster his view that a romantic conception of marriage was emerging in Attic culture, *grosso modo,* during the Peloponnesian War, a conclu-

sion which, unfortunately, I cannot follow.[15] A difference in social climate is to be noted here, to be sure, but labor and subservience are still the keynotes of the wife's role.

The ideal of industriousness and especially the tie between sexual desirability and willingness to toil, as I have tried to document with vase-paintings, are notions which in the Greek cultural milieu could only pertain to women. In the male sphere of Attic society, at least in theory, an aristocratic scorn for labor and handicraft, contemptuously called "banausic," prevailed. Men and women moved in different ethical as well as social spheres, as Aristotle noted with a rather surprising candor:

The specific virtue of woman with respect to her body is beauty and height, and with respect to her soul prudence and love of labor (*philergia*) without vulgarity.　　　　　　　　　　(Arist. *Rh.* 1361a)

The philosopher's corresponding virtues of the male are prudence and courage (*andria*).

So far we have been voyeurs ourselves and peeked only at the domestic textile industry as it was practiced inside the home. Woolworking implements, however, are also present in the more public domain of the hetairai, and in the remainder of this essay I propose to touch upon a few points of iconographic confusion between these two different spheres.

As in all societies where a pronounced double standard of sexual behavior prevails, the domains of the respectable women and of the

14.33a

14.33b

hetairai were strictly separated in Classical Athens. (Topographically, in this case, they were not necessarily far apart for, as I have argued, the symposia, with or without hetairai, normally took place in the men's quarters or *andrones* of houses, a kind of space intermediary between the private area of the home and the public meeting grounds of the polis.[16] Part of the attraction of the hetairai in Classical Athens was probably this circumstance that they mediated between the two artificially separated spheres of men's lives.)

Attic vase-paintings showing the interaction of men and women usually leave no doubt as to whether they are set in the domain of respectable women or that of prostitution. Although some styles of clothing and hairdo seem characteristic of hetairai, these do not provide reliable clues for identification, because high-class professionals adopted the appearance and mannerisms of ladies. Absence of clothing provides a more dependable criterion, as does the pose of reclining on a dining couch, a position apparently strictly taboo to citizen women as smacking of notions of equality. The kylix or flat drinking cup was also barred from the world of respectable women, perhaps no wonder considering the type of motifs which decorated them, but may be used by hetairai whether or not men are present.

One frequent iconographic indication of mercenary sex is an oblong money pouch, presumably made of leather or cloth, sometimes shown tied together with a string (fig. 14.34a). Most often it is handheld by the customer; occasionally it is suspended in the air, as an identifying clue. To my knowledge it is never shown in the

14.33a. New York 17.230.15. Red-figured hydria by the Orpheus Painter. Preparations for a wedding: Eros with the bridal slippers. Photos: Courtesy Metropolitan Museum of Art (Rogers Fund, 1917).

14.33b. New York 17.230.15. Detail. The bride.

14.34a, 14.34b. Toledo, Ohio 72.55. Red-figured kylix by Makron. Hetairai negotiating with customers with money. Hetairai negotiating with customers without money. Photos: Courtesy of the Toledo Museum of Art.

14.34a

14.34b

hands of the recipient, nor does the latter ever reach out for it. In fact, as we will see, typically the person to whom the money is offered does not take any note of it. In other words, the money pouch, called *ballantion* in Greek, does not indicate a specific commercial transaction, but an ability to pay.

The outsides of kylikes are favorite fields for scenes of negotiation between hetairai and their clients, as they are for the banquet scenes which follow the deals made. A great amount of pleasantry and humor is expended on such pictures, which apparently were dearer to the hearts of the artists than the *gynaikonitis* scenes. I show here the outside of a kylix by Makron, who has been called the Woman Painter (figs. 14.34a, 14.34b). The jest appears to be that the two men in figure 14.34a have the wherewithal: they hold purses in their left hands and flowers in their right. The men on the other side, however (fig. 14.34b), have to make do with persuasion. The one on the right seems successful in establishing credit: his right hand, which also holds a flower, gesticulates and his woman smiles as she holds out a fillet. The man leaning on his walking stick on the left apparently is not as fortunate: he is empty-handed and his lady, while brandishing a flower in his face, has turned away from him and is about to walk off.

In the fifth century B.C. cash bought homosexual favors as well. If the black-figured vases do not deceive us, pederastic sex in the sixth century was nourished by more symbolic gifts, namely of animals, live or dead. The tondo of a cup by Douris in New York (fig. 14.35) depicts a man and a youth negotiating. The pouches appear frequently in palaestra scenes, and seem to indicate a mercenary tie not necessarily between mature man and young boy, but also between young boys of approximately equal age (fig. 14.36).

A curious feature of the purse symbol is that it appears mainly where money determines sexual and familial relationships, not in scenes in which purely commercial transactions take place. We do possess, after all, a number of vase-paintings depicting various manufacturing and sales establishments, but the characteristic money pouch in the hand of either a buyer or a seller is largely unknown.

On the shoulder of a hydria in Rhodes (fig. 14.37), one sees women at work in a textile establishment, probably a *gynaikonitis*, although no specific clue indicates as much. Apparently the man on the left, who has an empty sack in his hand, has just provided them with a supply

14.35

14.36

14.35. New York 52.11.4. Red-figured kylix by Douris. Erastes and eromenos discussing money. Photo: Courtesy Metropolitan Museum of Art (Rogers Fund 1952).

14.36. Würzburg 488. Two boys, a money purse overhead. Photo: Museum.

of wool, which is being passed on from woman to woman, and will soon be stored in the kalathos. The purveyor, of course, may belong to the establishment, and perhaps he bought the goods on the marketplace, but some iconographic indication of payment effected might have been in order. In a charming scene inside a shoe shop (fig. 14.38), a woman is being fitted for a pair of sandals. Her husband or guardian on the right gives instructions, but there is no indication that he is prepared to pay for the merchandise.[17]

In view of the above peculiarity of the money pouch as an iconographic stereotype, it has widely been assumed by scholars that whenever a man offers it to a woman, he is always and exclusively in the market for sexual services. But this assumption leads to a problem: what are we to make of a number of pictures in which a man offers a money pouch to a woman who is busy at woolworking, a type of scene which has not been too widely noted, but which is numerous enough to constitute a genre. I reproduce two examples, one on an alabastron, and one on a pelike (figs. 14.39, 14.40).

The alabastron scene by the Pan Painter (fig. 14.39) is the more significant of the two, since it shows the lady busily spinning from a distaff, while her servant girl (not shown) handles more of the familiar textile implements. This spinster is especially strikingly disinterested in the money proffered. There are two major schools of thought about scenes which combine elements of spinning and money pouches or related inducements such as proffered pieces of jewelry or other gifts. Both of the theories are locked in binds of

14.37. Rhodes 13261. Woolworking scene with two men, one holding a sack.

14.38. Boston 01.8035. Shoemaker's shop. Photo: Courtesy Museum of Fine Arts, Boston (Pierce Fund, purchased from E. P. Warren).

14.39. Berlin 2254. Red-figured alabastron by the Pan Painter. Spinster, man with money, and maid. Photo: Courtesy Antiken-Sammlung, Staatliche Museen zu Berlin.

14.40. Athens 1441. Man with money, woolworker, and attendant.

14.37

14.38

14.39

14.40

14.41

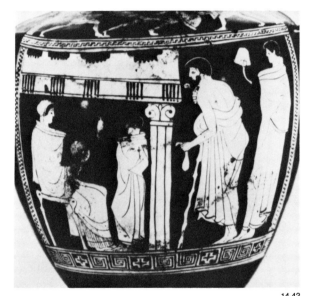

14.42

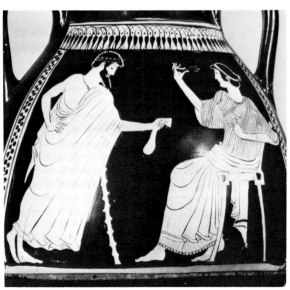

14.43a

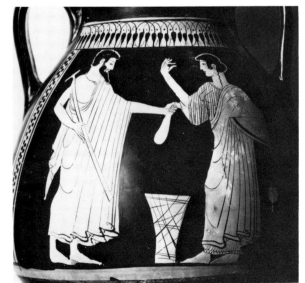

14.43b

dogmatism. J. D. Beazley, in a book review of 1931 and in his book *Der Pan-Maler,* defended the thesis that spinning is so closely bound up with associations of virtue and respectability that it must always convey this notion.[18] Ergo, the men with money pouches are bringing money to their wives, bringing home the bacon, so to speak.

In an opposing view, first proffered by A. von Salis[19] and most often cited from a seminal article by G. Rodenwaldt of 1932, entitled "Spinnende Hetären," it is argued that the lucky recipients of the money are μεγαλόμισθοι or topnotch hetairai who adopted the ways and symbols of respectability in order to wring higher fees out of their customers.[20] This is an ingenious theory, which evokes shades of Jean Genet's *The Balcony,* and of my own native city of Amsterdam, now the whoring capital of the Western world: in the red-light district of that city one can observe prostitutes in their show windows, dressed in exotic disguises, such as hula dancers and geisha girls, but also, yes, done up as frumpy Dutch housewives in aprons. In the context of fifth-century Attica such charades are not only unattested but highly unlikely: despite the erotic fantasies about domestic life which the vase-paintings document, from what we can surmise about conjugal relations in Classical Athens, it would seem that a man would rather see his wife disguised as a hetaira than his companion for the evening masquerading as his wife.

Rodenwaldt showed convincingly that Beazley's equation "spinning means housewife" cannot be maintained: too many vase-paintings combine elements of woolworking and prostitution. I show but one instance of my own: one outer half of a kylix by the Euaion Painter, showing two youths in the customary negotiation with hetairai, and a seated lady in the center, perhaps the madam of the establishment, with a spindle in one hand and a distaff in the other (fig. 14.41). But Rodenwaldt *cum suis* fell into another trap of dogmatism: their thesis is based on the notion that the money pouch must *always* denote sex, just because it *often* does.

I point to two scenes with men bringing money pouches to women where the sexual interpretation does not fit: if either one of the stern-looking women in figures 14.42 and 14.43a had tried to practice prostitution, she would probably have starved to death. Moreover on the hydria (fig. 14.42) the pouch-bearer is accompanied by a male child and a youth, his sons, one supposes. Is the whole family on an excursion to the neighborhood whorehouse? Surely not, not even in Classical Athens.

As a last piece of evidence, I would like to point to both sides of the pelike in Schloss Fasanerie (figs. 14.43a, 14.43b): on the reverse of this pot, in carefully balanced composition, we see the same man offering a money pouch to a more gracious woman, with a wreath in her hair (fig. 14.43b). Clearly the two women are his wife and a prostitute, often similarly juxtaposed in art and literature. We therefore must come to the conclusion that despite the social and moral barriers created in Attic society between whore and housewife, iconographically speaking there is a considerable overlap between their respective domains. Hetairai spin and weave (the small handloom is also represented in hetaira scenes); respectable women are confronted by men with money, as are hetairai and *Lustknaben.*

I would now ask you to recall the previously developed contention that, in this coded system of representation, pictorial form is more meaningful than literal function. I propose to interpret the money pouch as the symbolic expression of the power of money in human relations. In the pederastic and hetaira scenes it represents not the actual money paid, but the fact that money controls the interaction between the participants. In the domestic scenes, I suggest, the pouch symbolizes the fact that it is the man who holds the purse strings. The money purse was in fact, in the interpretation I would submit, an economic phallus. The circumstance that the object is remarkably genital in appearance is perhaps not wholly incidental.[21]

14.41. Berlin 31426. Red-figured kylix by the Euaion Painter. Spinster and two hetairai negotiating.

14.42. Maplewood, Noble Collection. Man with money, boy and youth confronting woman.

14.43a. Adolphseck, Schloss Fasanerie 41. Photos: Courtesy Staatliche Kunstsammlungen, Kassel.

14.43b. Adolphseck, Schloss Fasanerie 41. Reverse of 14.43a. Man with money and hetaira.

NOTES

1 See N. J. Richardson, *The Homeric Hymn to Demeter* (Oxford 1974) 180.

2 *The Water Carriers in Hades: A Study of Catharsis through Toil* (Amsterdam 1974).

3 See T. Leslie Shear, Jr., "Tyrants and Buildings in Archaic Athens," in *Athens Comes of Age: From Solon to Salamis* (Princeton 1978) 4–6. For a catalog of fountain scenes, see B. Dunkley, *BSA* 36 (1935–36) 198–204.

4 On rape motifs in fifth-century vase-paintings see S. Kaempf-Dimitriadou, *Die Liebe der Götter in der attischen Kunst des 5. Jahrhunderts v. Chr.* (Bern 1979).

5 On the Greek textile industry see H. Blümner, *Technologie und Terminologie der Gewerbe und Künste bei Griechen und Römern* I (Leipzig 1875) 90–194; R. J. Forbes, *Studies in Ancient Technology* IV (Leiden 1956). H. Michell, *The Economics of Ancient Greece* (Cambridge 1940) 179–292.

6 Xen. *Oec.* IX.5; Ar. *Thesm.* 415–22.

7 See D. Johnson, "The Wool Basket and the Money Pouch: Textile Working as a Home Industry in Ancient Greece," *Equity* (April 1981) 26–33.

8 "Supplementary Notes on Erinna," *ZPE* 32 (1978)

17–22.

9 For women holding book scrolls in analogous pos-
 ture see, e.g., red-figured hydriai E 190 and E 209 in
 the British Museum, CVA III, 1, c, pls. 86.3 and 89.1.

10 As in Apollod. *Bibl.* III.15.7; Hyg. *Fab.* 37 names
 Poseidon as Aithra's first lover.

11 *AntK* Beiheft 1 (Bern 1963) 19.

12 Cf. J. Henderson, *The Maculate Muse: Obscene
 Language in Attic Comedy* (New Haven 1975) 120.

13 For this view see H. Kenner, *Weinen und Lachen in
 der griechischen Kunst* (Vienna 1960) 17; K. Sche-
 fold, *Frühgriechische Sagenbilder* (Munich 1964) 90;
 G. Neumann, *Gesten und Gebärden in der grie-
 chischen Kunst* (Berlin 1965) 41, n. 134.

14 G. M. A. Richter, *Red-Figured Athenian Vases in the
 Metropolitan Museum of Art* (New Haven 1936)
 173–74. Richter suggests that the lady on the right,
 fig. 14.33b, is the bride, but the figure seems too
 mature.

15 R. F. Sutton, Jr., "Weddings on Attic Red-Figure Pot-
 tery," 28 December 1980 (AIA Abstracts).

16 "The Hetaera and the Housewife: The Splitting of
 the Female Psyche in Greek Art," forthcoming in
 Meded.

17 A cup by Phintias in Baltimore, *ARV²* 24, no. 14,
 showing a youth who holds a purse looking at two
 vases, is described by Beazley as "youth buying a
 vase" and comes closest to alluding to an exchange
 of money and merchandise. No seller is shown, how-
 ever.

18 J. D. Beazley, *JHS* 51 (1931) 121; *Der Pan-Maler* (Ber-
 lin 1931) 24 no. 59.

19 A. von Salis, *Theseus und Ariadne* (Berlin 1930) 5.

20 G. Rodenwaldt, "Spinnende Hetären," *AA* 1932,
 7–21. See also R. Herbig, "Verkannte Paare," in *Neue
 Beiträge zur klassischen Altertumswissenschaft,*
 Festschrift B. Schweitzer (Stuttgart 1954) 270–71; J.
 F. Crome, "Spinnende Hetairen?," *Gymnasium* 73
 (1966) 245–47.

21 Athenaeus (XI.783f.) compares the money purse to a
 similarly shaped object with male associations,
 namely the aryballos or short, round oil flask. In fact,
 he notes, the *balantion* (he spells it with one λ) is
 sometimes called "aryballos."

Mythological Repertoire of Brauron 15

LILLY KAHIL

The sanctuary of Artemis at Brauron, on the east coast of Attica, was excavated between 1948 and 1963 by the Greek Director of Antiquities, J. Papadimitriou,[1] who also excavated the other important sanctuary of Artemis in Attica, the sanctuary of Halai Araphenides which is nearby.[2] Though Brauron was at one time extremely prosperous it was always a sanctuary where the offerings showed so much consistency, such a unity, that one can try to analyze the meaning of their iconography as soon as one has grown familiar with the mythological, religious, and cultural background of the sanctuary (and I use these three terms because they are intimately linked together).

As one would expect, in this region of Attica where the goddess Artemis is most specially honored, her iconography is particularly rich and adapted (if I may express myself so) to the myths that concern her and to the rites practiced in her honor. As is evident often elsewhere, rituals and myths are inseparable, rituals being more than once only understandable through myths, and myths being sometimes created a posteriori, to explain ancient rituals no longer intelligible to the congregation. Without the rich discoveries—especially in the Brauron sanctuary—the significance of many details in the goddess's personality and cult would forever have escaped us, and many literary references and epigraphical texts found in Athens would have remained mysterious to us. Thus, myth and ritual will be inseparable for our iconographic study which, in addition to the cultural background of the site, must be considered basic to any efforts toward understanding the nature of Artemis.

Among the ancient texts, one of the most explicit and in many ways the most exciting is Euripides' *Iphigeneia in Tauris,* in which Orestes, the son of Agamemnon, has traveled to Tauris in Scythia to capture the famous wooden statue of Artemis venerated by the Scythians. He is made prisoner and brought to the temple of Artemis to be sacrificed. In the temple he meets his sister Iphigeneia, priestess of Artemis and in charge of the sacrifice. The poet follows here the version that Iphigeneia has not been sacrificed in Aulis by Agamemnon but that a deer has been substituted for her. Brother and sister recognize each other, steal the statue of the goddess, and flee with her to Greece. There are various other incidents, and they are finally saved by Athena, who predicts their destiny and orders the Greeks to worship Artemis as *Tauropolos* in Halae whereas Iphigeneia is to become priestess of Artemis in *Brauron.*

And now, Orestes, study my commands to you,
for you, though far away, can hear the goddess speak.
Proceed, taking the statue with you, and your sister.
But when you come to Athens the divinely built,
you will find there is a place in Attica, the last
before the border, across from the Karystian mount,
a sacred place, which is called Halai by my people.
There found a temple (and install the image there),
named from the Tauric country and your wanderings,
when you labored hard, ranging through the land of
 Greece,
stung by the Furies. People for the rest of time
shall sing her praise as Artemis Tauropolos.
Establish there this custom: at the festival,
to atone for your uncompleted sacrifice,
let a sword be held to a man's throat, and blood be
 drawn,
for religion's sake, so that the goddess may have her
 rights.

15.1

15.2

Iphigeneia, on the sacred terraced ground
of Brauron, you must keep the keys for Artemis.
There, when you die, you shall be buried. They shall
 bring
to you in dedication the fine-woven clothes
which wives, who die in the pangs of childbirth, leave
 behind
in their houses.

(Eur. *IT* 1446–67, Trans. R. Lattimore)

The Attic soil has preserved the memory of this legend and of the cult reality of it. The sanctuary of Artemis Tauropolos has been discovered at Halae Araphenides, on the eastern coast of Attica facing Euboea and Carystus (exactly as described by Euripides) about 35 km from Athens, and the sanctuary of Artemis Brauronia has been identified about 7 km south of the other. The text of Euripides will always remain essential for the mythology of Artemis and particularly for the Attic Artemis; and together with the excavations in Brauron, in Halae, and in Aulis[3] (Boeotia) it contributes greatly to our understanding of the relationship between the goddess and her priestess Iphigeneia.

We must recall here a few facts about Brauron: when the first traces of a cult, certainly already of Artemis, appear in Brauron at the foot of the small Akropolis, this Akropolis had already known a period of flourishing civilization from the Neolithic period to the end of the Mycenaean period. Yet no trace of cult appears before the middle or just a little before the middle of the eighth century B.C. At this date, near the site of the future temple of Artemis and the *heroon* of Iphigeneia, a bothros was filled with Geometric pottery (of which the most ancient pieces go back to about the second quarter of the eighth century B.C., while the greater part of the

material belongs to the second half of the century) (figs. 15.1 and 15.2). This date corresponds very well with the period when most of the cults were organized in Greece[4] and when the first temple structures appeared. From the recent excavations of the Greeks, we know now that in Halae (Artemis Tauropolos) exactly at the same period as at Brauron, Geometric pottery has also been found[5] not far from the temple of Artemis, at the site of a little temple or *heroon*.

From the moment Artemis becomes known to us in Attica and more specially in Brauron, she appears as the heir of the great Aegean or Aegeo-Anatolian goddess, a goddess of fertility, fertility of humans as well as of animals and this characteristic, one of the most important ones, enables us to understand much better some chthonic aspects that her cult preserves and that her iconography perpetuates. But as well as a goddess of fertility Artemis appears as the hunting goddess par excellence, huntress as well as patroness of the animals with whom she is especially linked. These characteristics, contradictory only in appearance, have roots in the farthest past and it is her aspect as huntress that survives longest in art and literature. One must also realize that for the Greeks and especially for the Athenians, Artemis becomes very early, I think, a patroness of social and civic life, which is also closely linked to her other aspects and thus to her origins. The documents of Brauron and Attica show us these different elements melded together and give the personality of the goddess a very particular richness.

The text of Euripides helps us to clarify the relationship between Artemis and Iphigeneia, and thus the primary character of the deity as

goddess of fertility and procreation. But the character of Iphigeneia, as it appears in *Iphigeneia in Tauris,* contains very probably the elements of an ancient heroine, herself epitomizing fertility, but with a chthonic aspect which is still felt in the time of Euripides. It is to her and not to Artemis that garments of fine texture (εὐπή-

νους ὑφάς Eur. *IT* 1465) of the women who died in childbirth (1466) are given, while Artemis Brauronia herself (and for this we have ample proof) is more the goddess of happy deliveries. Yet, in Classical times, the ancient personality of Iphigeneia is overshadowed by the much better known figure of the daughter of Agamemnon, who was to be sacrificed in Aulis, so that the Greek fleet was able to leave for Troy. One wonders if the personalities, the chthonic heroine and the daughter of Agamemnon were originally the same. They might well have been, the connection being the idea of sacrifice. This intimacy between goddess and heroine that Euripides presents clearly in his texts is mirrored too in the topography of the sanctuaries, in the proximity of temple and *heroon*. But it is most visible in the iconographical repertoire of Brauron, to which our attention should now be turned.

One of the most ancient representations of Artemis the great goddess, with a *polos* and without any other specific attributes, is a small bronze sphyrelaton of the late seventh century B.C., a unique piece, as yet unpublished. It cannot be included in any particular series and represents the essence of the goddess and her power as a *Potnia* or mistress of the animals in general, whereas her quality of goddess of the fertility of humans is most simply emphasized in the Brauronian repertoire by statuettes figuring Artemis as a *kourotrophos* (or "child-nursing" as it translates) (fig. 15.3).[6] But soon much more elaborate representations appear, from the beginning of the sixth century B.C. on. Among the most frequent types in Archaic and Classical times, we find the "torch-bearing" Artemis. I speak of this aspect first for it is difficult to attribute the torch to one particular characteristic of the goddess; in fact this "light-carrying" Artemis, Artemis *Phosphoros,* may be either the goddess of nature, or the protectress of humans (procreation and fertility) or the huntress who brings death. In Brauron she is well illustrated and in many circumstances the torch appears as one of her favorite attributes, maybe even as often as the bow, which is most usually associated with her (fig. 15.4).[7] On a fourth-century relief she even can carry two torches in one hand.[8] This torch-carrying Artemis has been very often connected with another torch-bearing divinity, with Hekate, a very ancient goddess herself, celebrated by Hesiod, and with whom Artemis shares many attributes; it is sometimes impossible to distinguish them iconographically. Hekate's functions are often very close to those of Artemis; in fact a text of Aischylos' *Suppliants* (674–77) directly

15.1. Brauron Museum. Geometric vase fragment. Photo: Emile, Athens.

15.2. Brauron Museum. Fragment of Geometric skyphos. Photo: Emile, Athens.

15.3. Brauron Museum κ 2629. Terra-cotta statuette. Photo: Constantopoulos, Athens.

15.4. Brauron Museum κ 2615. Terra-cotta plaque. Photo: Constantopoulos, Athens.

15.3

15.4

15.5. Brauron Museum 1180. Marble relief. Photo: Constantopoulos, Athens.

15.6. Brauron Museum 1179. Head from marble relief. Photo: Constantopoulos, Athens.

15.5

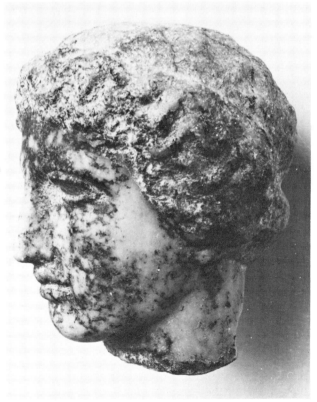

15.6

assimilates her to Artemis. The chorus prays for the Argives: "and that other guardians be always renewed, we pray; and that Artemis-Hekate watch over the childbed of their women. . . ." In this role of goddess of fertility as she appears in Aischylos, Artemis-Hekate is not different from Artemis Brauronia. The chthonic character of Hekate has long ago been recognized and her association with Iphigeneia, who is sometimes identified as Hekate, is confirmed by the literary texts.[9] The frequent presence of the torch in the hands of Artemis brings this goddess nearer not only to Hekate but to the combined Iphigeneia-Hekate.

Other documents also, I think, emphasize this aspect. The famous relief of Brauron found by Papadimitriou in 1958[10] called "the relief of the Gods" (fig. 15.5), which alas is fragmentary, represents a group of deities: from left to right, Zeus, seated, in front of him Leto, standing, a veil on her head (looking like Hera), Apollo and a young woman arriving from the right, running, who probably carried one torch in each hand. At this point the relief is broken, but one can still recognize the hooves and traces of hooves of two animals, probably stags. This relief, which we could date about 430–420 B.C. and which may well have been made by a follower of Pheidias,[11] is of excellent quality. It has been usually interpreted as figuring Zeus and the Triad: Leto, Apollo, and Artemis, Artemis being followed by two animals (stags or deer). From the same relief, however, a small head has also been recovered. It seems to face in the direction opposite to that of the four figures on the right, that is, looking from right to left (fig. 15.6).[12] Furthermore, the curvature of the preserved part of the relief invites us to suppose, after the break, a quite considerable space, sufficient in any case for the artist to figure a mounted chariot drawn by stags. The little head may well belong to the figure driving the chariot. Who is she? One could think very plausibly of Iphigeneia, but it is much more probable that it is the goddess herself who is arriving triumphantly in a chariot drawn by her favorite animals, stags or does; Iphigeneia should be recognized in the young woman running in front of the chariot. This seems the best way to understand the direction of the eyes of the four figures on the left, full of expectation, awaiting the arrival, the *epiphaneia* of Artemis. This is difficult to prove, *bien entendu,* and, at present, no other fragments of this relief have been found; it is still possible that there are some in the basement of the Brauron Museum though they could not be considerable. But the motive

of an Artemis in a chariot drawn by deer exists and appears both on Attic and on non-Attic vases of the fifth century, as for instance on an Attic krater from the Painter of the Woolly Satyrs in the Louvre[13] or on another krater from the Louvre, this time from a Boeotian fabric.[14]

Next one must consider a series of representations which were first recognized at Brauron and which provide illustration of Artemis in her role as a goddess of fertility, as patroness of humans and their offspring. Those representations are important evidence of the rites celebrated in Brauron in relation to the etiological legend. Another Greek text, from Aristophanes' *Lysistrata,* thus is finally explained thanks to the new iconographical finds at Brauron:

Ἑπτὰ μὲν ἔτη γεγῶσ' εὐθὺς ἠρρηφόρουν·
εἶτ' ἀλετρὶς ἦ δεκέτις οὖσα τἀρχηγέτι·
κᾆτ' ἔχουσα τὸν κροκωτὸν ἄρκτος ἦ Βραυρωνίοις
κἀκανηφόρουν ποτ' οὖσα παῖς καλὴ 'χουσ'
ἰσχάδων ὁρμαθόν.

I, who to her thoughtful tender care my happiest memories owe,
Bore, at seven, the mystic casket;
Was, at ten, our Lady's miller; then the yellow Brauron bear;
Next (a maiden tall and stately with a string of figs to wear)
Bore in pomp the holy Basket.
(Ar. *Lys.* 641–48, transl. B. B. Rogers)

Already in antiquity much attention had been paid to this passage and the scholiasts tried to explain the *arkteia* as the rite performed by the bears at the Brauronia. They quoted an etiological legend where a she-bear belonging to Artemis had been killed by the brother of an Athenian girl whom the bear had wounded. Subsequently a plague broke out in Athens and Apollo predicted that it would only stop if the Athenians consecrated their daughters as bears to the goddess, which they did; the rite was called the *arkteia*. Another scholion put forth that during the sacrifice of Iphigeneia it was not a deer that was substituted to the goddess but a bear, and that the sacrifice of the bear took place at Brauron and not at Aulis.[15] All these texts confirm at least one thing—the importance of the bear in the cult of the Attic Artemis. At Brauron numerous vases and vase fragments, hundreds and hundreds of a particular Archaic shape, kraters (or more accurately krateriskoi with double handles, and having a very old-fashioned conical base) have been discovered all over the sanctuary. These vases and their scenes provide fresh insight into the very strange *mysterion* of Brauronian ceremony. And this particular class is not confined to Brauron. It was also used on other Attic sanctuaries

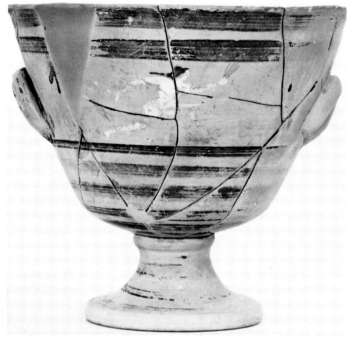

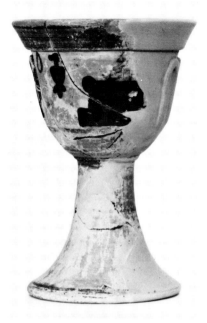

15.7. Brauron Museum 546.
Krateriskos. Photo: Emile,
Athens.

15.8. Brauron Museum 542.
Krateriskos. Photo: Emile,
Athens.

15.9. Brauron Museum 572.
Fragment of a krateriskos.
Photo: Emile, Athens.

15.10. Brauron Museum 567.
Fragment of a krateriskos.
Photo: Emile, Athens.

of Artemis, at Halae where it was not found in the temple of Artemis itself but in the little temple or *heroon* nearby, excavated some years ago. These same krateriskoi are found at Mounichia (Piraeus), at Eleusis in the Cave of the Nymphs, in Athens itself in the Sanctuary of Artemis Aristoboule,[16] a few scattered pieces have come from the Agora, and, very significant I think, some pieces come from the Akropolis.[17] These black-figured krateriskoi all date from the sixth and fifth centuries B.C. and represent, whenever they have figured decoration, a race of little girls who are either naked (fig. 15.7),[18] or dressed mostly in short chitons, holding torches or wreaths in their hands (fig. 15.8),[19] or perhaps show a slower ritual dance toward an altar where a fire is lit. The procession is again most of the time executed by girls dressed or naked (fig. 15.9).[20] That race and that procession or ritual dance always lead to an altar and near the altar (or behind) a palm tree is very often depicted (fig. 15.10).[21] It is noteworthy that on a number of those vases the girls are naked, which is a very unusual feature in Greek art of that period.

Those images certainly represent the *arktoi* of Aristophanes, those girls whom the scholiasts have said were between five and ten years of age and have noted that the girls wore the *krokotos,* the yellow dress, because it reminded one of the skin of the bear that they were imitating during the ceremony.[22] And these curious iconographical documents can be compared to the numerous statues of girls in marble, holding their pets in their hands, found during the excavations of Brauron. These all date later, to the fourth and third centuries, and these statues provide the first real depictions of children's faces in Greek art. They too probably represent in many cases the little "novices" consecrated to the goddess, accomplishing in the Brauron sanctuary an initiation rite preceding the age of puberty, and guaranteeing later for them a fertile marriage. We must not be astonished to find, now and then, the image of baby boys or little boys.[23] As a goddess of fertility, Artemis may well receive from a grateful woman an image of a male descendant!

In former studies I have shown that the scenes figured on these krateriskoi, executed in black-figure, represent one or two essential moments of the initiation rite performed by the girls. We have still no clue concerning the real purpose of these vases. Only one document, a fragment of a red-figured krater or krateriskos gives us an indication. It shows, in front of an altar, a krateriskos, standing obliquely, tilted toward the ground. This must mean that a liquid was being poured onto the ground. Around the krateriskos running girls are once more figured in black silhouette.[24]

Scholars have amply discussed the liaison between Artemis and the bear; in fact it has been suggested that Artemis had been in the beginning a bear goddess. It is certain that earlier theriomorphism of some divinities in Greece persisted for many generations. As mentioned already, Iphigeneia herself is very much linked to the bear. Euripides (*IT* 1465) calls her the *kleidouchos* of Brauron implying that it was at Brauron, not at Aulis, that she was sacrificed and that a bear and not a deer was at the last minute substituted for her. I do think now even more that it is an allusion to this version (which I would like to call the Brauronian version) which is represented on some curious fragmentary kraters, but with the shape of krateriskoi, published by me some years ago.[25] All three of the fragmentary vases (from a private collection) are in Attic red-figure technique and date from the third quarter of the fifth century. Two depict the sacred race of the girls.

On the first vase on one side one sees the preparation of the sacred race of the little girls. Women and girls alternate in position, the girls in short chitons either preparing to "take off" or already running; the women, surveying their dresses, hold ritual objects, among them baskets. On the other side the race has already begun and the girls are very much animated. On the second vase of the same shape the girls seem to be older. They run naked, holding a wreath in their hands. Over the double handle of the vase a palm tree is drawn, and before the palm tree is an animal turned to the right, very certainly the bear who attends the ritual which is held in its honor. We may note that a woman with arms extended was probably also running looking at the bear, and is preceded by running naked girls. On the third fragment, it is not only the ritual of the race that is figured but I think the *mysterion* itself, celebrated very probably during the Brauronia, those penteteric festivals in which the little girls dressed in their saffron robes took a major part.

On one side the holy triad (Leto, Artemis as huntress, and Apollo) are figured. Only Artemis is acting and she shoots her arrow at a fawn who is bounding away above the handle. On the other side a young man is represented, naked, maybe leaning slightly against a rock (?). In the middle a woman is figured "full-face," in chiton and himation, slightly moving to the right, raising her arms in a gesture of invocation, of awe or of

prayer which can be compared to the gesture of the goddess on a terra-cotta plaque from the Athenian Agora.[26] Man and woman are wearing masks of bears and the scene is closed by another fawn establishing, thus, continuity with the other side of the vase.

Here is the representation of the *mysterion* itself, which the literary texts have never provided so far. In the presence of the Holy Triad, invisible yet visible to the eyes of the believers, the priestess of Artemis, the bear priestess, performs the rite, in the presence of a young priest (?) at her side, who also wears the bear mask. We have here what I would like to think is the illustration of a passage in Hesychius: "Arktos (the bear), the animal, and the priestess of Artemis,"[27] which until now remained obscure. Going one step further one can ask, who is this bear-priestess? During the Classical period she must have been certainly a woman serving the goddess, but for the worshipers was she not Iphigeneia, the first priestess of the sanctuary, the *kleidouchos* of Euripides?[28]

The ritual nudity of the young girls during the sacred race also poses an interesting problem, a nakedness unusual except in very few Greek rites. It has been compared once again to the act performed by Iphigeneia at the moment of her death in Aischylos' *Agamemnon* (239). The chorus tells us that the servants are lifting Iphigeneia to drag her toward the altar while she "lets fall on the ground her saffron colored robe." I do not know for certain if we can really accept the slightly different reading of the usual text of Aristophanes (*Lys.* 645) proposed by C. Sourvinou-Inwood, following in this instance the text of the Ravenna manuscript: κατα χέουσα τὸν κροκωτὸν ἄρκτος ἦ Βραυρωνίοις "I was a bear, shedding the saffron robe at the Brauronia"; instead of reading: κᾆτ ἔχουσα τὸν κροκωτὸν . . . "wearing the *krokotos* I was a bear at the Brauronia."[29]

In any case, the nakedness of the girls can be explained as a renewal of the gesture of Iphigeneia who also abandons her yellow robe at the crucial moment of her initiation, the passage from life to death. The girls similarly are passing from the stage of children to that of women. This places the accent quite strongly on the chthonic aspect of Iphigeneia, but this is not wishful thinking for her whole legend is centered around her death and her rescue. A beautiful white-ground lekythos by Douris in Palermo shows her being led by Teukros to her sacrifice which is to be performed on an altar flanked by a palm tree.[30] One also remembers the sentence of

Hesiod's *Catalogue of Women:* "Iphigeneia by the will of Artemis became Hekate."[31]

The ceremonies performed by the Brauronian girls have certainly influenced the iconographical repertoire of Brauron (and of other Artemis cults also). Processions and dancers appear frequently on vases, which are no longer ritual vases like the krateriskoi. We can see women dancing to the sound of the *diaulos* and the procession very often leads to or goes around an altar where a fire is burning (fig. 15.11).[32] But one of the most curious and fascinating documents comes from a slightly later period at the end of the fifth century or the beginning of the fourth. On a fragmentary amphora girls of the type of the *kalathiskos* dancers are represented with a rare technique of added clay (fig. 15.12).[33] The dance, it seems quite clear, is one of the essential elements of the ritual of Artemis.

Does one really have to distinguish our Artemis, goddess of the fertility of humans—as she appears in Brauron in cult, in ritual, in myth, and in iconography—from the huntress Artemis who is a constant force in ancient Greece, whom we see in Brauron figured in many different ways . . . shooting her arrow, dressing in a long chiton, or rushing forward in a short chiton covered by a deerskin? This latter aspect of her iconography by which she is known everywhere till the very end of the Greco-Roman world is also an inheritance of the very complex reality, the *Potnia Theron,* from the Aegean and Anatolian world. It is still by this name, *Potnia Theron,* that she is called in Homer (*Il.* XXI.270) and even if other feminine goddesses in ancient Greece preserve certain aspects of the Potnia or mistress it is certainly Artemis to whom this name has been applied most justly. We can recognize her on images of the early Archaic period, standing between wild animals which she dominates, or birds, preferably water birds or fish.[34] She is often represented winged, a characteristic she has kept from her Oriental origins and one which Greek art will sometimes remember.[35]

Everywhere in the Greek world, and Attica confirms it, this "outdoor Goddess"—it is difficult to translate adequately Wilamowitz's expression "Göttin des Draussen" (*Glaube der Hellenen* [1931] 177)—prefers her sanctuaries to be near the dunes as at Halae, near the rivers and marshes as at Brauron (and also elsewhere, for instance, in Sparta), near the springs as in Aulis. She needs the proximity of nature, peopled by wild animals, lions and stags, all sorts of deer, birds and fishes. . . . And the iconography follows. It seems an easy step to pass from this

15.11. Brauron Museum 526. Fragment of a bowl. Photo: Emile, Athens.

15.12. Brauron Museum 502. Vase fragment. Photo: Emile, Athens.

15.13. Brauron Museum 1157. Marble relief. Photo: Constantopoulos, Athens.

15.11

15.12

15.13

Potnia to the Classical huntress who roams in the forest, briskly dressed, her hair sometimes long, sometimes in a sakkos or even cut short like a young boy. She sometimes keeps her wings as a souvenir of her past and carries her torch or her bow. . . . She can also, on occasion in Brauron, be represented riding a bull[36] and this must not astonish us, for at Halae she was "Tauropolos," as we mentioned earlier.

In this ambience we understand much better her attitude of purity, of virginity, so essential to her personality, a purity that she requires from her companions (like Kallisto).[37] For whoever violates it is condemned to death. This virginity is that of wild nature, untamed like the goddess herself. Only apparently does there seem to be contradiction with the fertility aspect of Artemis who, as Artemis-Eileithyia, presides over happy deliveries and prepares little girls for their destinies as mothers. We have here a contrast, but not a contradiction. Purity is a demand, not asexuality. This quality of purity she displays in the hunt bringing death to stags and deer—for she is *Elaphebolos*—and this is in fact a ritual death; hunting is here assimilated to a sort of sacrifice that requires purity. Once again the ancients had appreciated this characteristic of the goddess. Aischylos in his *Agamemnon* (136ff) reminds us that the "pure Artemis is in anger when a bird of prey attacks a pregnant hare" for, in her kindness . . . "she protects the tender sucklings of all the animals in the field." This aspect appears constantly in her iconography, be it by way of terra-cottas, vases, or sculpture. On a marble relief she is figured caressing a goat and her kids (fig. 15.13)[38] and a pinax shows her seated near her favorite deer, from which animal she has in certain places (in Olympia, in Elis) derived the surname of *Elaphia* for, like all hunters, she loves the animals and protects their young. Iconography shows her often as patronizing the animals of the hunt, but nonetheless, she lays down the rules. Whoever disobeys her deserves death. It is in this sense that we have to understand the death of Aktaion often represented at Brauron, a prey to the goddess and to his own dogs. Though she sometimes performs the punishment herself, more often it is performed by the hunter's dogs who no longer recognize him and take him for a stag.

So Artemis appears to us (and in Brauron the two characteristics are particularly developed) as a goddess of life and death. The death is a ritual death, that connects her with the sacrifice of Iphigeneia and with sacrifice in general and thus she is both the goddess of procreation and of rit-

ual purity. As a goddess of fertility she protects women and thus receives the attributes of a *kourotrophos* (fig. 15.3),[39] a surname which she sometimes shares with Hekate. In Brauron, she more specifically receives the garments of the women who had a happy delivery and her iconography is thus specially connected with the life of those women who, at least theoretically, had been her novices, her little "bears," before entering into married life and bringing, *à leur tour,* their own children to the goddess. The repertoire of Brauron preserves in an astonishing way these essential features of the goddess and of her effect on humans. On a beautiful marble relief from the fifth century, she is figured seated. A little girl is approaching her, but we cannot, alas, recognize what the goddess herself is doing; she may be holding a piece of cloth—some have thought she is weaving,[40] but it is not the right gesture.

Among the pottery excavated at Brauron were found many vase shapes which seem to pertain to women's activity, as do the scenes depicted on them. For instance, the number of votive epinetra (the thigh guards worn in the working of wool) is considerable, some of them depicting women at their work; other scenes are more general, what I would call "indifferent representations."[41] The same can be said of the numerous pyxides with all sorts of representations: marriage ceremonies, myths often concerned with love stories such as Menelaos retrieving Helen.[42] Incense burners, thymiateria, are numerous[43] and on their stems appropriate myths are often found (for instance, Peleus and Thetis, Achilles and Cheiron). Plates are popular, too; one with the extraordinary representation of dancers preparing themselves for a performance has been called the bikini-plate[44] (fig. 15.14). On another, also in red-figure, we even can see a kiss. One shape which is especially connected with the sanctuary is the lebes gamikos, not only in normal height, but very often in miniature (fig. 15.15).[45]

Some fascinating mythological scenes seem particularly appropriate to Brauron. One is connected with the life of the goddess herself and shows once more how consistent the Brauronian repertoire is. There is perhaps a unique representation of the little Artemis in her mother's arms on the leg of a tripod-pyxis (fig. 15.16).[46] Here a female child is dressed in a short chiton and is carried by a woman; on the right and left are two female "demons" dressed in short chitons and winged; each holds a lotus bud in one hand and a staff in the other. The two winged females are very probably the Eileithyai, who so fre-

quently appear on representations of the birth of Athena and can be winged as on the amphora of the Princeton Painter in the Princeton University Museum (inv. no. 138). Our fragment may be just a little earlier than the Princeton Painter's amphora (ca. 540 B.C.) and close to Lydos. Other birth legends, better known, appear at Brauron, for instance, the birth of Athena on a black-figured plate[47] painted in the manner of Exekias, and of divine or heroic children, maybe the little Achilles presented to Cheiron.[48] One finds as well legends of love or amorous pursuit, like Danae and the golden rain on a cup by the Brygos Painter, or Amymone at the fountain on a white-ground cup, by the Stieglitz Painter.[49] On an acorn-type lekythos one sees Adonis leaning on Aphrodite.[50] From the present state of the dig, the proportion of scenes concerning more especially men's life and pleasures (symposia, palaestra scenes) is very rare in comparison with scenes more especially concerning women's life and myths, and the vase shapes follow exactly the same trend. The drinking cups, some of them very beautiful, admittedly, are few compared with the other shapes, especially the pyxides and the plates.

One should now return to Artemis as we have seen her at Brauron as goddess of fertility and procreation, as goddess of the hunt. We have shown that these characteristics are not contradictory; on the contrary, for the goddess appears with her bow and equally often with her torch, her favorite attribute at Brauron. The use of fire, it should be remembered, is constant in the ritual of divinities who exercise a certain power over nature. In this regard the little girls dedicated to her, the "bears," are also often carrying torches while they run around an altar.

This last feature brings up another aspect of the divinity: Artemis is a goddess of civic life, as well as goddess of the outdoors. The ancient texts already had recognized this aspect. Artemis, as the *Homeric Hymn* says, "the huntress with shafts of gold, loves archery and the slaying of wild beasts in the mountains, the lyre also and dancing and thrilling cries and shady woods and . . . the cities of the upright men" (*Hymn to Aphrodite* 1.18–20). It is very probable that this aspect, so remarkable in the historical period, is also an inheritance from her past, as one form of the great Aegean goddess, protectress of the palace and of the town. On the other hand we have seen that Artemis is the real "mistress of sacrifice," a sacrifice she herself performs as the huntress par excellence. In the beginning, the sacrifices connected with her cult may also have

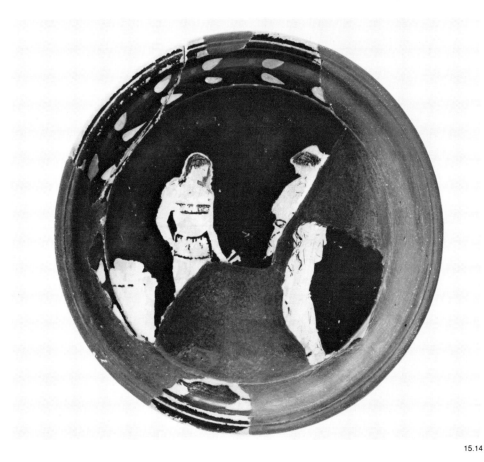

15.14

15.15

15.14. Brauron Museum 721.
Plate. Photo: Emile, Athens.

15.15. Brauron Museum 453.
Miniature lebes gamikos. Photo:
Emile, Athens.

15.16. Brauron Museum 531.
Fragment of a tripod pyxis.
Photo: Emile, Athens.

15.16

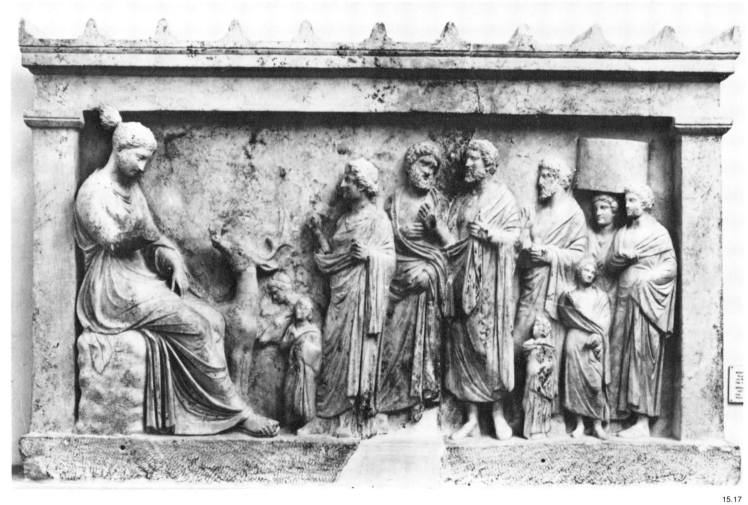

15.17. Brauron Museum 1153.
Marble relief. Photo: Constan-
topoulos, Athens.

15.17

16.1

16.2

16.1. Ashmolean Museum, Oxford. Stater of the Letaioi, ca. 540–511. Ithyphallic Silenus and Nymph.

16.2. Ashmolean Museum, Oxford. Stater of the Orreskioi, ca. 510–480. Centaur and a Nymph.

16.3. Ashmolean Museum, Oxford. Triple stater of the Tyntenoi, ca. 540–511. Bearded man between two oxen.

16.4. British Museum. Stater of the Ichnaioi, ca. 540–511. Bearded warrior holding a prancing horse.

16.3

16.4

memorate part of his fertility cult. The Centaur and the Nymph in his arms belong to another fertility cult.

The attribution of the Centaur and Nymph series to the Letaei is assured by the inscription ΛΕΤΑΙΟΝ on some of the coins, usually regarded as the earliest in the series. But the Silenus and Nymph series, being uninscribed, is attributed to the same people only on the grounds of style and theme, together with a few rare coins portraying a Centaur. The attribution has been questioned; yet it is the more probable in a matter where one can argue only in terms of probability.

For the coins of Ichnae we are helped by historical information. Pella and Ichnae, cities west of the Axius, lay on the coast in our period (Hdt. VII.123.3), their territory was Paeonian (Thuc. II.99.4), and the non–Greek-speaking Paeonians used the services of various Greek craftsmen for lettering their coins (three separate kinds of *chi* occurred). Ichnae was clearly a center for export and import in the Paeonian period of power; no doubt it ceased to be so when the Macedones acquired it toward 500 B.C.[11] Ichnae minted very heavy silver coins, up to 29.20 grams, and therefore had large quantities of the metal. Yet there are no silver mines west of the lower or middle Axius. Some of the coins portray a bearded man between two oxen (fig. 16.3) and on the reverse a four-spoked wheel inside an incuse square. Exactly the same subjects occur on another coinage of equally heavy pieces which carry the inscription TYNTENON.

I have identified these people with the Atintanoi of later times, who lived near Resen and were thus close to the silver mines of "Damastium."[12] It is probable, then, that Ichnae obtained silver from the Tyntenoi and so used the same devices. Another subject which they shared was a bearded man holding a prancing horse and on the reverse a wheel with reinforced spoking inside an incuse square (fig. 16.4). The Paeonians and the Tyntenoi had religious views in common; for the bearded man in each case was probably a god, and Paeonia was famous for its wild cattle, including the aurochs (Hdt. VII.126). The god is probably shown to be taming the cattle and the horse. It is a mistake to give him a Greek name, whether Ares or Hermes;[13] for he had a Paeonian name and in the north a Tyntenian name.

On the subject of divine names we may learn from a later coin, of the time of Philip and Alexander, which carries on the reverse the name of the Paeonian king Lykkeios in the genitive as the

issuing authority and on the obverse a male head and the inscription ΔΕΡΡΩΝΑΙΟΣ. It is probable that the head represents a god and the inscription defines him as the "Derronaean god" (fig. 16.5a, 16.5b). His name was evidently Derron or Darron, since Hesychius mentions "Darron, a Macedonian deity, to whom they sacrifice on behalf of the sick" (s.v. "δάρρων"); and his tribe was the Derrones whose name occurred on early coins inscribed ΔΕΡΡΟΝΙΚΟΝ, ΔΕΡΟΝΙΚΟΝ, ΔΕΡΡΟΝΙ, ΔΕΡ, ΔΕΡΡΟ and ΔΕΡ-ΡΟΝΙΚΟΣ, this last being analogous to ΔΕΡΡΩΝΑΙΟΣ on the later coin.[14] Specimens have been found at Štip, the successor in name and place of Astibus, the capital of the Paeonian kings perhaps before and certainly after 511 B.C.

The very heavy pieces in this coinage, up to 41.21 grams, show a bearded man walking beside or driving in an ox-drawn car; he too is probably a Paeonian god (figs. 16.6, 16.7). As fifteen coins of these people were in the hoard at Asyut, we may infer that they were issued in the second Paeonian period, that is, after 511 B.C. To an overlap with this period we should perhaps refer the five coins of Ichnae with the same theme which were found in the Asyut hoard. Many coins of the Derrones have a triskeles on the reverse. As none with a triskeles occurred in the Asyut hoard, this type was minted either in the first Paeonian period or after ca. 477 B.C.[15] There is no doubt that the Derrones coined over a long time, since the names of three persons, apparently kings, were placed on coins of this period.[16] On some coins the god holds a caduceus, and this has led Greek numismatists to call him Hermes; but again he was a Paeonian and not a Greek god, and the caduceus-type of symbol occurs also on coins of the Bisaltae and later of the Macedones. The discovery of a caduceuslike pendant in an Early Iron Age burial of a priestess at Vergina shows that it was at home in the area ca. 800 B.C.; this is true also of the four-spoked wheel and the eight shaped ornament (the latter is found on the Bisaltic coinage).[17] The coins of the Bisaltae are known from the Greek lettering in more than one form of the alphabet on most but not all of their heavy pieces, which run up to 34.10 grams. The inscriptions are ΒΙΣΑΛΤΙΚΟΝ, ΒΙΣΑΛΤΙΚΩΝ, and ΒΙΣΑΛΤΙΚΟΣ, the last perhaps referring to the deity. The coins show a naked warrior with two spears standing beside a horse and on the reverse a quadripartite incuse square. One Bisaltic octobol with these emblems carries two letters in ligature Æ, which from the analogy of the coins of the Derrones with ΕΧ, ΕΚΓΟ . . .

16.5a 16.5b

16.6 16.7

and of "Geta, king of the Edones," is likely to be the first letters of the name of the king of the Bisaltae. The same two letters in ligature Æ, appear on the "goat" coins (fig. 16.8). As no other issues have these two letters alone and as no others use a ligature, it is apparent that the Bisaltic octobol and the goat coins were issued by the same authority.[18] If he was a king, then he was probably the king described by Herodotos (VIII.116) as "king of the Bisaltae and the Crestonian land" at the time of Xerxes' expedition in 480 B.C.; and at that time "Bisaltia" extended to Argilus on the coast of the Strymonic Gulf (Hdt. VII.115.1). The naked warrior on the coins was evidently Rhesos, who was "king among the Bisaltae" (Strab. 7, fr. 36), famous for his horses in the *Iliad* and worshiped "as a divine spirit in his silver-veined land" according to the *Rhesus,* ascribed to Euripides (970ff.) This was the worship of the Bisaltic homeland (οἱ αὐτόχθονες in Strab. 7 fr. 36), which lay around Mount Dysoron.[19] The Crestonaei were a separate tribe (Thuc. IV.109.4) with their own war god, Kandaon (Lycoph. *Alex.* 937), and their own worship of Dionysos, concerned with the fertility of the seasons (*Mir. Ausc.* 122). The goat on the coins was evidently associated with the worship of Dionysos here as

16.5a, 16.5b. Fitzwilliam Museum, Cambridge. Tetradrachm of Lykkeios (also spelt Lyppeios), ca. 358–334. Head of Apollo/Herakles wrestling with a lion.

16.6. Ashmolean Museum, Oxford. Overweight coin of the Derrones, ca. 540–511. Ox drawing a car on which a driver sits.

16.7. British Museum. Overweight coin of the Derrones, ca. 540–511. Ox drawing a car on which a driver sits.

16.8

16.9

16.10a

16.10b

16.11

16.8. British Museum. Stater of the Bisaltai before 478. Kneeling goat with back-turned head and symbol.

16.9. British Museum. Triple stater of the Orreskioi, ca. 540–511. Man with two spears between two oxen.

16.10a. British Museum. Overweight coin of the Laiaioi, ca. 540–511. Ox drawing a car on which a driver sits.

16.10b. Reverse of figure 16.10.a. Pegasos with furled wings walking.

16.11. Ashmolean Museum, Oxford. Tetradrachm of the Laiaioi, ca. 500–460. Walking Pegasos with three blobs.

elsewhere. The Bisaltic kingdom was conquered by the Argeadae (Strab. 7, fr. 11), as the royal tribe of the Macedones was called, and Alexander I became king of the whole area late in 479 B.C.

The Rhesos coins, as we may call them, are rare in hoards—six as compared to eighty-four "Lete" coins—and they have been found in late hoards only. The Asyut hoard had none; but it did have four goat staters in "exceptionally fine condition," which should thus belong to the last years of the Bisaltic king.[20] It seems, then, that we should attribute to chance the absence of large Rhesos coins of the Bisaltae at Asyut; for they are linked in time to the goat coins by the shared letters in ligature ⅍.[21]

Coinages which we shall attribute to places east of the Strymon and to the upper Strymon Valley had many themes in common with those coinages which we have considered. Thus the Centaur with a Nymph in his arms, which occurred on coins inscribed ΛΕΤΑΙΟΝ, is portrayed in the same manner on the coins of the Orrescii, of which some thirty-seven examples were found in the Asyut hoard; on the coins of Thasos, twenty-nine being in the Asyut hoard; and on coins of the Zaielii, Dionysii, Pernaei, and Laeitikoi.[22] The coins of the Orrescii in the

Asyut hoard have been attributed to phases extending from ca. 510 to 480/475 B.C.[23] If so, the coins of the Orrescii with other themes should be dated before 510 B.C. and so into the period of Paeonian power. Those themes are a man between a pair of oxen (fig. 16.9) and a man leading a prancing horse, and they occurred also on the coins of the Ichnaei and of the Tynteni which we have already ascribed to that period. Another point in common between the Orrescii and the Ichnaei is a dolphin, which means that they had access to the sea. The theme of a Silenus and a Nymph, common in the uninscribed coinage which has been usually attributed to Lete, is found on coins inscribed ΣΙΡΙΝΟΝ ("of the people of Siris"), capital of the Siriopaeones (Hdt. VIII.115.3 and V.15.3), presumably before they suffered at the hands of the Persians ca. 511 B.C.

Last we may mention the Laeaei, a Paeonian tribe of the upper Strymon Valley (Thuc. II.97.2), which issued very heavy coins up to 32.08 grams with ΛΑΙΑΙ inscribed between the feet of an ox drawing a car on which a driver sits (figs. 16.10a, 16.10b), as on coins of the Derrones, and on the reverse a horse with furled wings and three large dots beside it (fig. 16.11). The horse is often called by the Greek name Pegasos but presum-

ably had a Paeonian name which was different.[24] The Asyut hoard has yielded eleven tetradrachms with just such a horse and in nine cases with three large dots beside it, and on the reverse a quadripartite incuse square; thus, although uninscribed, they should be attributed to the Laeaei. While the coins of the Asyut hoard should be dated generally to ca. 495–479 B.C., the very heavy ones which share a theme with the Derrones may be placed in the late sixth century.[25]

We have seen that many themes were shared by two or more tribes, for instance the Centaur and the Nymph, and we have attributed this to cults and worships of a similar nature in different parts of our area. There are also symbols which are common to two or more coinages. The helmet is very frequent, representing the war god or goddess of the particular tribe; a circle of dots, perhaps representing the sun, appears in the field or in the hand of a Nymph; a rose, reminiscent of the "sixty-petalled roses growing wild in the gardens of Midas" (Hdt. VIII.138.2), is a token of nature's fertility. Other symbols were probably of religious significance: cranes on coins of the Bisaltae, geese (fig. 16.12) on what was probably an issue by the Edones,[26] frogs or salamanders perhaps of the Strymonian Basin, and even the *kausia* or felt hat peculiar to this part of the Balkans. Greek writers saw connections between the Phrygians who had lived in the gardens of Midas and the Paeonian tribes, and they may well have been correct.[27] The Thracian tribes were regarded as different; Herodotos (v.7) attributed to these tribes the worship of Ares, Dionysos, and Artemis and to the kings of the tribes a worship of Hermes from whom they traced their descent. With the possible exception of Dionysos these were not the Thracian names for their deities but the Greek names for similar deities.[28]

The map (see p. 246) shows the probable locations of the mints. The locations are based in part upon the records of the deposits of gold and silver in the area which I put together in *A History of Macedonia* (I, 12ff., 312ff., and II 69ff). The three cities which issued coins—Ichnae, Lete, and Siris—were active certainly in the period of Paeonian power from ca. 550 down to perhaps 505 B.C. at Ichnae and 511 B.C. at Lete and Siris.[29] Otherwise only tribes and kings appear as the issuing authorities. As I understand it, the inland powers—Tynteni, Derrones, Laeaei—issued coins throughout the period 550–480 B.C.; elsewhere Ichnae flourished only under Paeonian control, Lete changed hands perhaps from Thracians initially to Paeonians

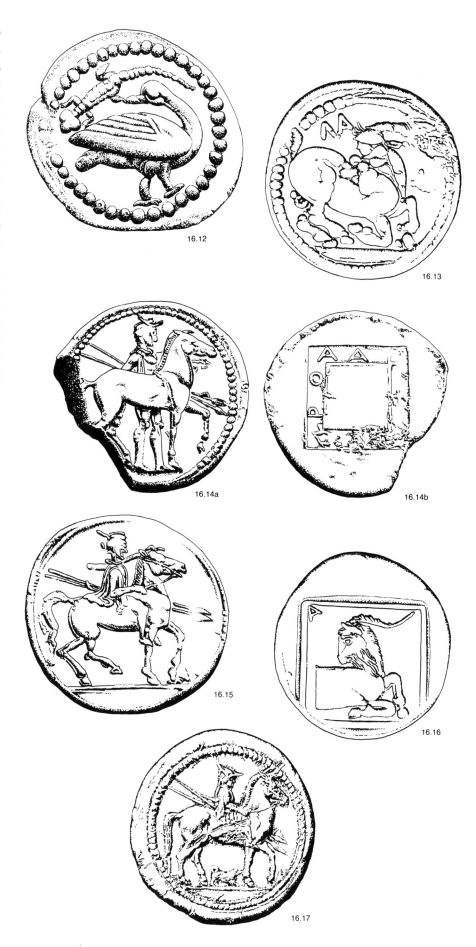

16.12

16.13

16.14a

16.14b

16.15

16.16

16.17

and then back to the Edoni, the Bisaltic region from Paeonians to Edones and then Bisaltae, the area of Siris from Thracians initially to Siriopaeones and then Edones, while the tribes of the Pangaeus mountain[30] seem to have held their mines throughout the period and the Dionysii were successful in resisting encroachment on the mainland by the Thasians.[31] An important point to note about the map is the absence of gold and silver deposits in the lands occupied by the Macedones down to 480 B.C. For that reason—and their backwardness in other respects—they issued no coinage.

For some thirty years the monarchical state of the Macedones was subject to Persian suzerainty. At some time around 500 B.C. it wrested Ichnae and Pella from the Paeonians and gained control of the important Axius crossing and the area round the head of the Thermaic Gulf to the east of the river (see Hammond and Griffith, *Macedonia* II, 58ff.), no doubt with the approval of their Persian overlord. Then, perhaps in the years 483–481 B.C., Alexander I established some control over the tribes of Upper Macedonia west of the Axius River (ibid., 63ff.), again with Persian approval and perhaps aid. Alexander and his leading Macedonians entered a wider world in the service of Xerxes, and they were quick to take advantage of the changing balance of power when the Persian forces retreated in disorder late in 479 B.C. "The Argeadae (probably the royal tribe of the group of tribes called Macedones), as they were called, and the Chalcidians of Euboea (i.e., in the prongs of Chalcidice) established themselves as masters of all these peoples (i.e., of the Edoni and Bisaltae between the Axius and the Strymon)."[32]

Alexander's advance to the Strymon gave him control of mineral wealth for the first time: the gold of Crestonia and of Mygdonia near Lete, and the rich mine from which he drew a talent of silver a day (Hdt. V.17.2), a yield exceeding the total revenue of Thasos in her best years (Hdt. VI.46.3). This new wealth in gold enabled him to dedicate gold statues of himself, probably life-size, at Delphi and Olympia in honor of his liberation and his victory over Persia.[33] And he proceeded at once to issue coinage from the Bisaltic mint, using the current Bisaltic types. The goat staters were continued with the substitution of ΛΑ for Δ (fig. 16.13); and ΛΑ was added to the goat diobols. The Rhesos octadrachms continued with the substitution of ΑΛΕΞΑΝΔΡΟ for ΒΙΣΑΛΤΙΚΟΝ on the reverse (figs. 16.14a, 16.14b); and the Rhesos octobols with the omission of Ⓐ (it has survived on only one coin on

the horse's crupper) and with the addition of ΑΛΕΞΑΝΔΡΟ on the reverse. The new lettering has its own message. The coinage is issued now on the authority of "Alexander," who is named either in full in the genitive case or in short in retrograde ΛΑ and in later issues ΑΛΕ and Α. The coinage was evidently the possession of Alexander as king; for no coin is inscribed ΜΑΚΕΔΟΝΟΝ which would have been the equivalent of the tribal inscriptions ΒΙΣΑΛΤΙΚΟΝ, ΔΕΡΡΟΝΙΚΟΝ, ΟΡΡΕΣΚΙΟΝ, and so on. The transition from Bisaltic money to Alexander's money was so rapid, because "the bold-scheming son of Amyntas," as Pindar called him, was conducting an ambitious campaign in the Strymonian Basin. It is attested in a most striking manner by the numismatic evidence, which I have set out.

This new interpretation involved a rearrangement of the groups proposed by D. Raymond for the coinage of Alexander, since she had placed these Alexander octadrachms late in her group II ca. 465–460 B.C. The arguments which I adduced in favor of a rearrangement[34] were strengthened decisively by the discovery of one such "Rhesos" octadrachm in the Asyut Hoard, laid down soon after 479 B.C.; for being the only Alexander coin in the hoard it must have been at or near the start of his coining in late 479 or early 478 B.C.[35]

Alexander soon discontinued these issues except for the Rhesos octobol. Instead he introduced for his coins a rider with two spears, the type suggested by fig. 16.15; on the reverse sometimes a goat's head (fig. 16.16), sometimes a crested helmet, and sometimes the forepart or the head of a lion. The rider's horse is large by Greek standards of the time; it may represent stock bred from the Nesaean horses of the Persians in Europe; and it is sometimes accompanied by a dog, evidently a hunting dog. The rider sits well forward; he wears the Macedonian cloak (chlamys), the *kausia* or felt hat, and a diadem of which the ends hang down behind his neck (fig. 16.17). He is equipped for hunting and not for war, and the diadem is the mark of royalty, so that we may conclude we are looking at Alexander I in person, a man not ashamed to dedicate gold statues of himself at Delphi and Olympia. The goat's head continues the theme of the Bisaltic goat but with less emphasis; it was appropriate to the worship of Dionysos in Crestonia and in the homeland of the Macedones. The crested helmet is for a god or goddess of war of the Macedones. The head of a lion is appropriate both to royalty and to the royal hunt, for which the lions of the Macedonian

16.12. Ashmolean Museum, Oxford. Diobol (?) of the Edones from ca. 510–480 onward. Goose and salamander.

16.13. British Museum. Stater of Alexander I from 478 onward. Kneeling goat with back-turned head and symbol.

16.14a, 16.14b. Ashmolean Museum, Oxford. Octodrachm of Alexander I, 475–452. Man with two spears beside a walking horse / square surrounded by ΑΛΕΞΑΝΔΡΟ.

16.15. Ashmolean Museum, Oxford, Tetrobol of Perdikkas II, ca. 445–424. Mounted man with two spears.

16.16. Ashmolean Museum, Oxford. Tetradrachm of Alexander I, ca. 459–452. Forepart of a goat with back-turned head and symbol.

16.17. Cab. Méd, Paris. Octodrachm of Alexander I, ca. 459–452. Mounted man with two spears and a hunting dog below the horse.

mountains were reserved. The other new type which Alexander introduced was a horse unattended and on the reverse a goat's head or a crested helmet; these were on light tetrobols. The Macedonian king was addicted to horsemanship; it is clearly an aristocratic coinage.

The lesser emblems on his coinage were all of religious significance: a crescent moon connected probably with the worship of Artemis; the caduceus of Hermes; and the vine leaf or ivy leaf of Dionysos. We can speak now in terms of Greek gods; for Alexander himself was of the finest Greek blood, that of the Temenidae of Argos[36] descended from Herakles, and his subjects west of the Axius were Greek-speaking. But these emblems occurred also on other coinages of the Thraco-Macedonian area. There they were the signs of comparable religions.

During his long reign—to ca. 452 B.C.—Alexander was at war with rival contenders for the possession of the Strymon Basin, in particular the Edones and the Athenians. There is an indication in the coinage that the Edones drove Alexander back in the latter part of his reign. Some of the goose coins which we ascribed earlier to the Edones carried the letter H standing on my interpretation for HΔONEON. Now there are two issues of light tetrobols with the horse unattended and a helmet on the reverse; one carries the letter A (for Alexander) and the other the letter H standing for HΔONEON. On this second issue the helmet is of a different type, the horse is much slighter, and the technique is inferior. It may be then that the second issue is that of the Edones when they gained possession of the area west of the Strymon and minted their version of the local tetrobol.[37]

The coinage in the latter part of Alexander's reign shows signs of some impoverishment. For the light tetrobols are of an alloyed metal which shows discoloration. It has been suggested that this weaker coinage was used for local purposes only;[38] but it seems doubtful to me whether the Macedonian state was sufficiently bureaucratic to control the distribution of its currencies. If we are right in believing that the Edones acquired the Bisaltic mine in particular, this will explain the inferiority of Alexander's tetrobols. For Alexander had no resources of silver in the original kingdom, and his resources were not such that he could purchase large stocks of silver ore.

During this period ca. 479–452 B.C. the Edones kept control of their own mines despite the attacks by the Athenians, whom they defeated decisively at Drabescus in 464 B.C., and the local tribes continued to exploit the mines of Mount Pangaeus. Farther inland the Tynteni seem to have traded westward with Epidamnus and Apollonia; the Derrones continued to issue coinage, probably for a time in the name of a king Dokimos; and the Laeaei likewise, perhaps with a king called Bastares. Thasos and then Athens had control of the mines on the mainland facing the island.

Alexander left at least five sons. Rivalries between these sons and then between their descendants lasted into the reign of Alexander the Great and were often a source of weakness to the kingdom. This was so in the 440s and it seems that Bisaltia broke away and became an independent kingdom; for the coins of Mosses revive the Rhesus type of a man with two spears beside a horse and are of a different weight from Macedonian coins. The name may perhaps be connected with "Mossynon in Thrace," where cattle were fed on fish (Ath. VIII.345e); that is by Lake Prasias in Bisaltia as in Herodotos V.16.4. The final heir to Alexander, Perdikkas II, showed the signs of his impoverishment by coining only tetrobols and those not continuously. He put on his coins Π or ΠΕΡ at first and in the latest period only ΠΕΡΔΙΚ, and he used the traditional emblems for his tetrobols: the unattended horse (fig. 16.18) with the helmet on the reverse, and the rider with two spears (fig. 16.15) and the forepart of the lion on the reverse, and as occasional symbols the dog and the caduceus. No doubt he was anxious to stress his legitimacy in succeeding Alexander, and the rider may be Perdikkas himself. He introduced new devices which stressed the connection of the royal house with Argos as a putative or actual ally during the Peace of Nikias (Thuc v.80.2 and 83.4): these were the head of Herakles and on the reverse a bow and a club with the letters ΠΕΡ and a horse galloping and on the reverse the forepart of a boar, a club, and ΠΕΡ. These references to Herakles and his Labors were to be a recurring theme on the coinage of the Macedonian kings. Perdikkas reached lower levels of impoverishment than Alexander had done; for he produced tetrobols of copper (a metal available in Pindus) with a plating of silver, a debasement of τὸ βασ-ίλειον νόμισμα mentioned by Polyaenus IV.10.2.

His son and successor Archelaos was helped by the decline and then the defeat of Athens in the Peloponnesian War. He coined in good silver and had larger coins, didrachms with Alexander's themes—a rider with two spears, an unattended horse (fig. 16.19a) and the forepart of a goat, the last probably in connection with the story of goats being concerned in the foun-

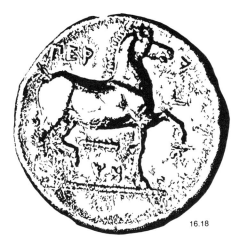

16.18

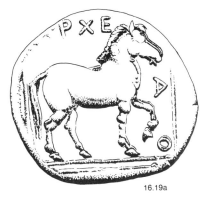

16.19a

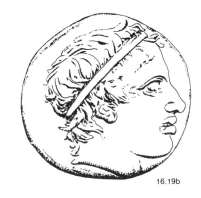

16.19b

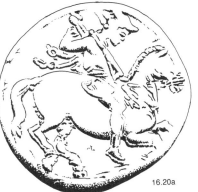

16.20a

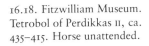

16.18. Fitzwilliam Museum. Tetrobol of Perdikkas II, ca. 435–415. Horse unattended.

16.19a. Ashmolean Museum, Oxford. Didrachm of Archelaos II (413–399). Horse unattended.

16.19b. Ashmolean Museum, Oxford. Reverse of figure. Young male head with short hair bound by a band.

16.20a. Ashmolean Museum, Oxford. Didrachm of Amyntas III within the period 390–370. Rider with spear ready to strike.

16.20b. Ashmolean Museum, Oxford. Reverse of figure. Lion biting and pawing a spear.

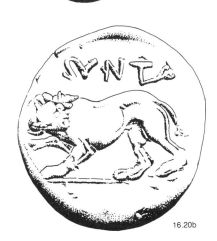

16.20b

dation of Aegeae, which was promoted at this time. He introduced for the first time a young male head with short hair and a headband (not a normal diadem as it has no ribbon ends); it is the head probably of a Macedonian god, for it is continued under later kings (fig. 16.19b). On smaller coins Archelaos used the Herakles emblems of his father (Euripides' play *Archelaos* stressed the connection) and added a wolf head, and also a new device, a standing eagle with back-turned head and raised wings, associated perhaps with Zeus, the father alike of Herakles and of Macedon, the eponymous ancestor of the Macedones. He was the first king to coin in copper, mined within his kingdom. On this he placed the head of a lion and on the reverse either a running boar or a running ox, perhaps reminiscent of the royal hunts. He put his name in full on his coins ΑΡΧΕΛΑΟ or in abbreviation.

After Archelaos came a period of six years with five kings from rival branches of the royal family. The descendants of Perdikkas, namely Aëropos and his son Pausanias, used on their silver the emblems of the young male head with a headband and an unattended horse, and on their bronze the forepart either of a springing lion or of a running boar; these they took over from Archelaos except for the springing type of lion. Amyntas II, "the Little," the first in his branch to attain the throne, brought Pan, a Corinthian helmet, and the forepart of a wolf into the repertoire. But the winner in the struggle and the founder of the new line, Amyntas III, chose to emphasize the claim of the house to descent from Herakles. His coinage was at first underweight in silver and he coined more in bronze than in silver to judge by the surviving coins; he may have regained possession of Bisaltia late in his reign, when he agreed to support Athens in her attempt to win Amphipolis. His devices were the head of Herakles, the club, and the wild boar; the unattended horse with a caduceus brand; and on a full-weight didrachm a hunting scene with a rider raising his spear on a prancing horse (fig. 16.20a) and on the reverse a lion biting and pawing a spear (fig. 16.20b). His heir, Alexander II, coined only in bronze during his brief reign, and the subsequent coins were those of Perdikkas III (showing that Ptolemy was not king but regent). Alexander introduced a new emblem, the thunderbolt, and Perdikkas put the head of Herakles on all his coins and on the reverse a horse unattended, a lion teasing a spear, an eagle with closed wings, and a butting bull—the last completely new to Macedonia but portrayed on the contemporary coinage of Aenea. Perdikkas

issued some silver didrachms but most of his coins were in bronze. The economic weakness of the realm is apparent also from the fact that Greek cities on the coast of the Thermaic Gulf were issuing their own coins of bronze in this troubled period: Pydna, some emblems being those of Amyntas III; Methone, with a lion biting a spear as on the coins of Amyntas III and Perdikkas III; Aenea, sharing the butting bull with Perdikkas III; and Dikaia, also with the butting bull. Inland Apollonia in Mygdonia too was independent, placing a head of Apollo and a marsh bird or fish on her bronze coins.[39]

The strongest state in the hinterland was that of Bardylis the Illyrian and the prolific mining and coining center, Damastium,[40] was probably within his realm. The ingot (fig. 16.21) and the miner's pick appeared on their coins as evidence of their business, but the inspiration of their fourth-century coinage came from the powerful Chalcidian League and from Larissa in Thessaly. The silver tetradrachms of the Damastini had the head of Apollo laureate and on the reverse a tripod, both as on coins of the Chalcidian League; and the drachmai had the head of a goddess, as on coins of Larissa. No doubt the native names for the god and the goddess were different from their Greek names. The distribution of the Damastine coins is in the central Balkan area and in Paeonia. This no doubt reflects the orbit of

Bardylis' trade and influence, whereas the trade in silver ingots was probably with the Greek cities and especially with Epidamnus and Apollonia. Another mining center began to operate farther north ca. 365 B.C. with the lettering ΔΑΠΑΡΡΙΑ on its coins, which portrayed the ingot. The center too lay within the realm of Bardylis,[41] the overlord perhaps of a local king Daparrias.

As we turn to the coinage of Philip II, we may pay a tribute to the splendid publication of G. Le Rider.[42] His detailed research has made it possible to allocate Philip's coins to groups with a high degree of confidence. However, the dating of the groups and the allocation of them to specific mints are still uncertain. Le Rider believes that Philip coined from 359 B.C. not only in silver but even in tetradrachms. But the poverty of his predecessors' coinages and the shattering of Macedonia's strength by Bardylis in that year make such a belief inappropriate on historical grounds. It is very doubtful whether he had access even to the silver mine in Bisaltia, since Apollonia in Mygdonia, for instance, was independent of the Macedonian state. Let us follow the historical evidence first. In 358 B.C. he reduced the Paeonians and again in 356 B.C. (Diod. XVI.4.2 and 22.3), but he did not take over their rich mines; instead he (and Alexander after him) let the king of 356 B.C. continue coin-

16.21. Ashmolean Museum, Oxford. Drachm of Damastion ca. 395–380. A portable ingot.

16.22a, 16.22b. Fitzwilliam Museum, Cambridge. Gold stater of Philippoi from 356 onward. Head of Herakles/Tripod with head of a horse to right.

16.23a, 16.23b. Fitzwilliam Museum, Cambridge. Tetradrachm of Philippoi from 356 onward. Head of Herakles/Tripod with dolphin to right.

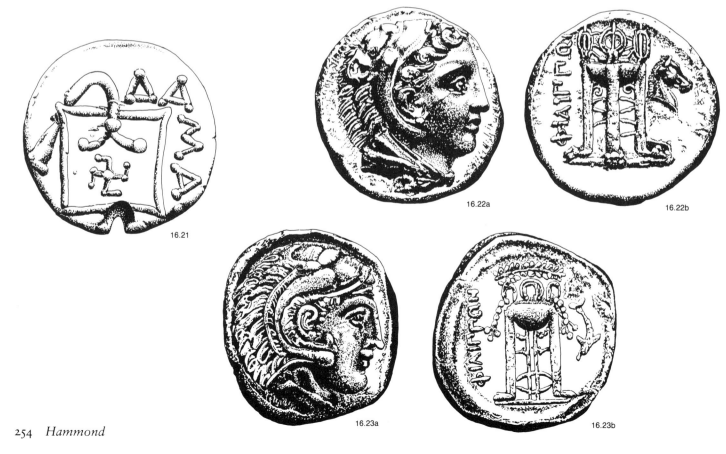

16.21

16.22a

16.22b

16.23a

16.23b

16.24. Ashmolean Museum, Oxford. Tetradrachm of the Damastinoi ca. 358–336. Tripod with the symbols HPAKΛEIΔO and KH.

16.25a, 16.25b. Fritzwilliam Museum, Cambridge. Gold half-stater of Philip from 356 onward. Head of Herakles/protome of a springing lion and kantharos.

16.26. Ashmolean Museum, Oxford. Tetradrachm of Philip II from 348 onward. Racehorse ridden by a victorious jockey.

16.27. Athens, N. M. Tetradrachm of Philip II from 348 onward. Racehorse ridden by a victorious jockey.

ing his silver tetradrachms in his own name "Lyppeios" (M. N. Tod, *Greek Historical Inscriptions* [Oxford 1948] no. 157). Also in 358 B.C. he defeated Bardylis decisively and later that year extended his authority to Lake Lychnitis (Ochrid) and thus brought under his control the very rich mines of the Damastini. He let them go on coining in their own name. Then in 356 B.C. he captured the Thasian mining town on the mainland, Crenides, which he renamed Philippi and allowed to coin in its own name. The Thasians of the mainland had coined in gold with the head of Herakles, and on the reverse a tripod, and these types were continued by Philippi (figs. 16.22a, 16.22b, 16.23a, 16.23b) both in gold and in silver, apparently without any significant interval.

The attributions of these coinages are known through the lettering upon them. And some other letters reveal the influence of Philip in the background: some issues of the Damastini and of Philippi have the same letters for the minting officers HPAKΛEIΔO (fig. 16.24), KHΦI or KH, and others have ΔH in both cases.[43] This shows a degree of control by Philip, probably from 356 B.C. onward, and we may surmise that he took a tax in ingots in each case. Now in XVI.8 Diodoros summarized the growth of Philip's power, mentioning the advance to Lake Lychnitis, the capture of Amphipolis, Pydna, and Potidaea, the

alliance with the Chalcidian League, and the capture of Crenides. It is the last episode which changed the fortunes of Philip: "by installing equipment he so increased the hitherto utterly scanty and inglorious output of the local gold mines that they could yield him a revenue of more than a thousand talents" (Diod. XVI.8.6). We infer from this that Philippi coined on the small scale of its predecessors,[44] the Thasians, and the bulk of the new yield in gold and silver went to Philip. Similarly from Damastium he may have drawn a large amount of silver in the form of ingots by 356 B.C.

If we are correct, Philip first had large resources in gold and silver in 356 B.C. Naturally he began to coin in his own name, not however in terms of the famous gold "philippeioi" which Diodoros (XVI.8.6) said came later. Whereas Philippi issued gold staters, Philip issued gold half-staters, quarter-staters, and eighths of staters with the same type as those of the Thasians and Philippi, namely the head of Herakles wearing the lionskin and on the reverse either his own type, for example, a springing lion (figs. 16.25a, 16.25b), the foreleg (? of a goat), and a trident, or those of the Thasians, the club and bow or the drinking tankard (kantharos) associated with Herakles. His silver coins had the same obverse but a new device on the reverse: a naked jockey on a racehorse (figs. 16.26, 16.27), which com-

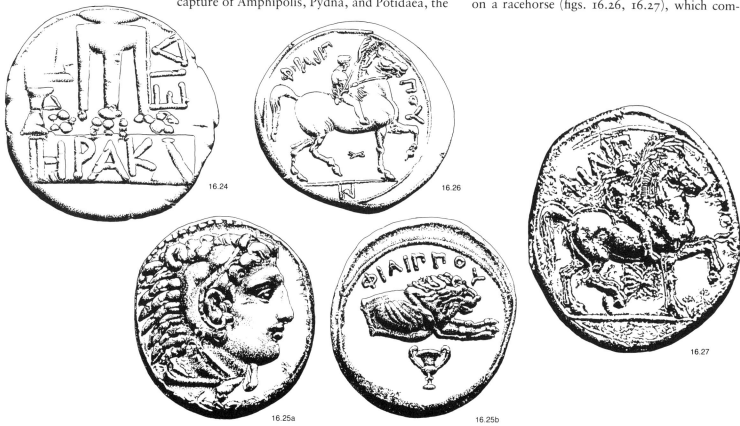

16.24 16.26

16.25a 16.25b 16.27

memorated his victory of 356 B.C. at Olympia (Plut. *Alex.* III.8). The same obverse and the same reverse appeared on Philip's larger bronze coins. The allocation of these types with the head of Herakles and the naked jockey to Philip's first period of coining between 356 and 348 B.C., as stated in my text of 1974, has been made entirely independently by M. J. Price in 1979 in his review of Le Rider's book.[45]

The mint which Philip used was presumably Pella, named as Macedonia's mint and connected with the sea (Strab. 7 frs. 20 and 23). Pella could serve Damastium as Ichnae had done, for it was well protected and it was central to the kingdom.[46]

The second phase of Philip's coinage began in 348 B.C. with the defeat and disbandment of the Chalcidian League, which had hitherto issued a finer and more prolific coinage than the king in gold, silver, and bronze. Their devices were the head of Apollo laureate and on the reverse a kithara (fig. 16.28b). It was only on the latest issues that Apollo had long hair (fig. 16.28a); these issues were followed by Philip's first gold staters with the same long-haired Apollo and on the reverse a two-horse chariot at the gallop (fig. 16.29), probably winning at Olympia in 348 B.C. (recorded by Plut. *Mor.* 105 A). These staters were the "philippeioi," to which Diodoros referred at XVI.8.6 as a later development. For Philip now acquired the gold and silver mines of the Chalcidians at Stratoniki and also copper mines. Probably at this time too he issued silver tetradrachms for the first time, and he put on them the head of Zeus (fig. 16.30a) and on the reverse the naked jockey on the racehorse or a bearded horseman wearing the petasos and the cloak and raising one hand in salutation. This horseman is probably Philip himself (fig. 16.30b) as he alone was entitled to wear the diadem with ribbon ends. He also issued silver tetrobols with the head of a young man, clean-shaven and wearing a headband (as on the coins of Archelaus and some of his successors), and on the reverse the jockey and the racehorse.

It is clear that Philip was immensely proud of his victories in the games at Olympia; they conferred glory on his house and his people and represented him as a leading personality in the world of Greek city-states. He showed on his coins the heads of gods: Herakles, ancestor of the royal house, worshiped at Aegeae and Pella; Apollo, who granted him victory over the perfidious Chalcidians and the sacrilegious Phocians; and Zeus, ancestor of the royal house, of the Macedones, and of the Greek peoples. The young man

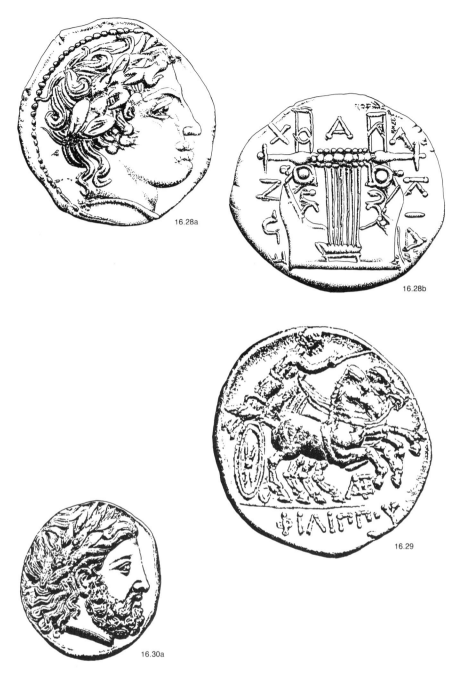

16.28a

16.28b

16.29

16.30a

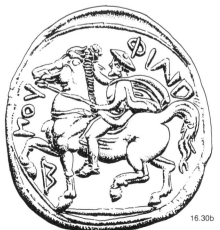

16.30b

16.28a, 16.28b. British Museum. Tetradrachm of the Chalkidian League c. 350–348. Long-haired Apollo laureate/cithara.

16.29. Athens, N. M. Gold stater of Philip II from 348 onward. Two-horse chariot at the gallop.

16.30a, 16.30b. Ashmolean Museum, Oxford. Tetradrachm of Philip II from 348 onward. Head of Zeus laureate/bearded rider wearing petasos, tunic, and cloak on a high-stepping horse.

wearing a headband was probably a local god or hero, perhaps Karanos, the mythical founder of the dynasty; and he appeared very frequently on the bronze coins, which were intended primarily for local circulation in Macedonia. In putting a portrait of himself on his coins he was imitating his famous predecessor, Alexander I.

NOTES

I am most grateful to M. J. Price for points which he made to me in correspondence before his publication of the Asyut Hoard.

1 C. M. Kraay, *Archaic and Classical Greek Coins* (London 1976) 148 places the beginnings of coinage in this area somewhere in the third quarter of the sixth century; M. J. Price, *Coins of the Macedonians* (London 1974) 3 "sometime around 550 B.C. the first coins were struck in the area"; and M. J. Price and N. M. Waggoner, *Archaic Greek Coinage: The Asyut Hoard* (London 1975) 119 favor a downdating of such coinages in general "by some 15–20 years."

2 For the chronology of Peisistratos' second exile see my article "The Family of Orthagoras," *CQ* n.s. 6 (1956) 51.

3 See my account of these coinages in N. G. L. Hammond and G. T. Griffith, *A History of Macedonia* II (Oxford 1979) 69–91, written before August 1974 apart from some information about the Asyut Hoard which M. J. Price very kindly gave to me (see Hammond and Griffith, *Macedonia* II, V–VI).

4 Or as tribute payable to Persia.

5 On the other hand, the natives chose the emblems, e.g., a Centaur. Thus although Homer called a Centaur ὀρεσκῷος any resemblance between that word and the name Ὀρρέσκιοι of the natives who put a Centaur on their coins was a matter of chance and not, as Price and Waggoner, *Asyut* 34, suggest, of design.

6 The last is cited by Kraay, *Coins* 139, n. 4.

7 Thus the Asyut Hoard produced *inter alia* ΛΑΕΙΤΙΚΟΝ. Price and Waggoner, *Asyut* 34 take it to be a variant of ΛΑΙΑΙ and to be a neuter accusative with which, e.g., *nomisma* may be supplied. I believe it to be the name of a hitherto unknown people and to be a genitive plural like the others, e.g., ΟΡΡΕΣΚΙΟΝ. We see the full expression in ΝΟΜΙΣΜΑ ΕΔΟΝΕΟΝ ΒΑΣΙΛΕΟΣ ΓΙΤΑ.

8 Allocation by hoards in Hammond and Griffith, *Macedonia* II, 88.

9 Price and Waggoner, *Asyut* 120: "most of the coins in the hoard may well have arrived in Egypt only some 10 or 15 years before burial." They did not draw any conclusions from the absence of the Lete coins in the hoard.

10 Kraay, *Coins* 148–49, writing before the report of the Asyut Hoard, put the start of the Lete coinage sometime in 550–525 B.C. and the end probably in 480 B.C. Price and Waggoner, *Asyut* 34f. put the start among the earliest coins of the area and the latest perhaps after 490 B.C.

11 I proposed ca. 510–505 as the date, Hammond and Griffith, *Macedonia* II, 64; but there are five coins of the Ichnaei in the Asyut Hoard, which are best explained if the Paeonians held Ichnae until nearer 500 B.C. If the Macedones had been coining at that time, they would not have done so at Ichnae on the very border of their territory.

12 Ibid. 75.

13 As numismatists often do from their familiarity with Greek coinages.

14 Hammond and Griffith, *Macedonia* II, 75f.; numismatists usually call the god "Apollo."

15 Price and Waggoner, *Asyut,* prefer the later period, which may well be correct.

16 See Hammond and Griffith, *Macedonia* II, 76.

17 M. Andronikos, *Vergina* I (Athens 1969) 255, fig. 90, 258, figs. 96, 97; N. G. L. Hammond, *A History of Macedonia* I (Oxford 1972) fig. 17*t* with p. 335 (together with a pendant of three double axes), fig. 18*t*, and fig. 20*g* (from Vitsa).

18 See Hammond and Griffith, *Macedonia* II, 77–81 and 105 for references. J. Svoronos, *L'hellénisme primitif de la Macédoine* (Paris 1919) interpreted the significance of the uses of ligature as I have done, but he attributed both types of coin to the Derrones, because he assumed that ⅃ stood for ΔΕΡΡΟΝΙΚΟΝ (the shortest form of their name on a coin is ΔΕΡ). H. Gaebler, *Die Antiken Münzen von Makedonia und Paionia* I (Berlin 1906), II (Berlin 1935) attributed them separately to the Bisaltae and to the Macedones. The idea that the ligature should be read as ΕΔ and stand for ΕΔΕΣΣΑΙΟΝ, that is the citizens of the city Edessa in western Macedonia, is not acceptable until we have evidence that the Macedones were coining so early and that Edessa was the coining center of the Macedonian state. The belief that Edessa was also called by the name "Aegeae" and was therefore the capital of the Macedonian state has been challenged, I hope successfully, in Hammond, *Macedonia* I, 156f.

19 Strabo's description was based probably on Hekataios who wrote at the turn of the century (see Hammond and Griffith, *Macedonia* II, 56) and thus dates the Bisaltic expansion to ca. 500 B.C. at the latest. Strabo 7, fr. 36, contrasts the autochthonous Bisaltae with "those who crossed over [the Axius River] from Macedonia," i.e., during the expansion of the Macedones summarized by Thucydides (II.99).

20 The series as a whole should date back to 500 B.C. or so, since Kraay, *Coins* 141 believed from their style and varieties that the goat coins were issued "over several decades."

21 Price and Waggoner, *Asyut* 38f., follow Gaebler, *Antike Münzen* in attributing the goat coins to Aegeae, meaning "Bleaters," and they account for the absence of Bisaltic Rhesos coins at Asyut by putting the date of the coins later and in particular to the years ca. 475–465 B.C., when the Athenians were operating on the coast of the Strymonic Gulf.

22 The last name is found only on a coin in the Asyut Hoard; see n. 7 supra.

23 Price and Waggoner, *Asyut* 34f.

24 Confusion with the Greek Pegasos has led some to assume that a Greek city issued these coins; as Price and Waggoner rightly observe, the weight standard argues against that view.

25 Kraay, *Coins* 141 attributes several decades to the minting of the Pegasos coins.

26 See Hammond and Griffith, *Macedonia* II, 81f.

27 Strabo 7, fr. 38, probably deriving from Hekataios.

28 The Thracian names were Kotys or Kotytto for the war goddess of the royal tribe, the Edones (Strab. 470, citing Aischylos), and perhaps Bendis for Artemis, goddess of animals. The war-god of the Crestonaeans was Kandaon, as we have noted, and his name may share its origin with the war god of the Macedones "Xandos" *vel simile* (for whom see J. N.

Kalléris, *Les anciens Macédoniens* I (Athens 1954) 237–38).

29 The Paeonians developed cities early (Hdt. v.15.2–3), unlike the Thracians.

30 Belonging to the group known as the Satrae who had never been subjugated according to Herodotos (VII.111.1); the group extended far inland (see Hammond and Griffith, *Macedonia* II, 72, n. 1).

31 Perhaps named after "the hill of Dionysos" (App. *BCiv.* IV.106).

32 Strabo 7, fr. 11; this corresponds to Thucydides' account in II.99 of the expansion of the Macedones, which is expressed in terms not of tribes but of areas, ending with "Crestonia and Bisaltia" to the east.

33 Hdt. VIII.121.2 ὁ Μακεδὼν Ἀλέξανδρος ὁ χρύσεος and Dem. XII.21.

34 Hammond and Griffith, *Macedonia* II, 105ff.

35 So Price and Waggoner, *Asyut* 38f., placing the Rhesos octadrachms and corresponding octobols as "the first issue of coinage by Alexander ca. 479–475." They, however, place the matching Bisaltic coinage later, ca. 475–465.

36 This rests on the authority of Herodotos VIII.137.1 and Thucydides II.99.3, which should not be called in doubt. The inscribed tripod in Philip's Tomb at Vergina shows the connection of the royal house with Argos in the mid-fifth century.

37 I advanced this view in Hammond and Griffith, *Macedonia* II, 107–8.

38 So Kraay, *Coins* 142.

39 These cities' independence is attested also in the list of Theorodoci for the late 360s, where they are mentioned as separate states (*IG* IV², 95, II, lines 6ff.).

40 See the excellent study of J. M. F. May, *The Coinage of Damastion* (Oxford 1939).

41 May, *Damastion* 164f. argued that these coins were struck at Damastium on silver mined there, but this seems improbable. There are deposits of silver at Tetovo and in the region Metohija-Kossovo.

42 G. Le Rider, *Le Monnayage d'argent et d'or de Philippe II frappé en Macédoine 359 à 294* (Paris 1977). He was not aware of my views which were published only in 1979.

43 As I pointed out in Hammond and Griffith, *Macedonia* II, 668 with n. 4, despite May, *Damastion* 105.

44 As Griffith remarks in Hammond and Griffith, *Macedonia* II, 358, "its surviving examples in gold and silver are not exactly numerous."

45 My views were not published until that year. I had been in correspondence with both Price and Le Rider when I was working on the subject up to 1974 and even later; different views are not without value, despite the criticism voiced by R. M. Errington in *CR* 30 (1980) 78–80. Writing in *NC* 89 (1979) 230ff., "The Coinage of Philip II," Price proposes to reverse the sequence given by Le Rider to the latter's period I and IIB, thus putting the jockey types and the Herakles head types as Philip's first coins, "struck . . . perhaps in 356/5." This agrees with my table in Hammond and Griffith, *Macedonia* II, 667. Price bases his argument on specimens of these coins found in association with pre-348 coins of other places in small hoards, not available to Le Rider or to me.

46 See map in Hammond and Griffith, *Macedonia* II, 150.

A Dionysiac Procession on a Monumental Shape 8 Oinochoe

KONRAD SCHAUENBURG

The privately owned "shape 8" oinochoe which forms the subject of the following pages is remarkable for its shape and style as well as for the subject of its painting (figs. 17.1a–17.1e).[1] The vase has been assembled from numerous fragments, but there is only insignificant restoration.[2] The glaze is dull; a yellowish white overpaint has been used profusely.[3]

The shape of this immense pitcher can be traced back to the Archaic period.[4] The subtype 8A (fig. 17.2)[5] is the earliest attested, followed by 8B (fig. 17.3);[6] still later to appear is shape 8C, of which an especially interesting vase in the Louvre can be given as an example, thanks to the photographs of A. Pasquier (figs. 17.4a, 17.4b).[7] A vase in Laon by one of the followers of Douris is peculiar in having two handles,[8] and there are other variations from the canonical forms, to which B. A. Sparkes has recently drawn attention.[9]

The production of black shape 8 mugs begins in Attica around 480;[10] these are usually ribbed. A peculiarly shaped mug in Philadelphia (MS 4085) combines ribbing with figured decoration (fig. 17.5).[11] Two shape 8 oinochoai are represented on the krater London, British Museum E 506 (fig. 17.6).[12] The use of the so-called Herakles-knot on shape 8 oinochoai also goes back to the fifth century;[13] a black mug in the British Museum is such an example (fig. 17.7).[14] Herakles-knots were very commonly used on plastic astragaloi in Attica, as well as in southern Italy.[15] In Italy, including Etruria, the motif was extremely popular on other shapes as well; we shall have more to say about this later on.

Already from the fourth century one finds an unusual oinochoe from Bourgas decorated with characters of a Dionysiac *thiasos*.[16] It has a double handle, without knots,[17] and is remarkably large (h. 29 cm, d. 25 cm). The potters of small vases in southern Italy were especially fond of shape 8 oinochoai. There are of course some differences in form from the Attic models, but only superficial ones. It is with the black mugs that the resemblance between pieces from the homeland and those from southern Italy is the strongest; it is sometimes very difficult to be sure about the provenance of a particular mug, especially if one cannot examine it in person.[18]

Among the painted vases we find not only the short, squat shape (figs. 17.8a–b, 17.9),[19] favored by the Lampas Painter,[20] but also a slenderer one, for which the oinochoe Bari 5937 may serve as an example (figs. 17.10a–b).[21] In this form, as in its Attic models, the handle is joined at the top directly to the lip; it may, as we shall see, be decorated with the Herakles-knot. The foot can be a low ring, but it is usually molded; the unpainted oinochoe Bari 2480, with knotted handles, is footless. Frequently, as with the oinochoe Bari 5937, just mentioned, a matching lid is preserved.[22]

Another subtype, so far unattested in Attica, is designated by A. Cambitoglou 8M; a vase in a private collection can be given as an example (figs. 17.11a, 17.11b).[23] This shape differs from those already mentioned especially in having a small, ring-shaped handle, which is not joined to the lip. It also does not have the projecting lip of shapes 8A and 8B. In general the neck—unlike that of our example—is not left black, but decorated with rosettes, vines, or other motifs.

Cambitoglou is also responsible for the designation 8N for another shape, for which there are

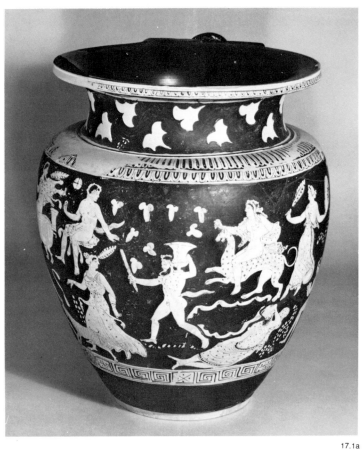

17.1a

17.1c

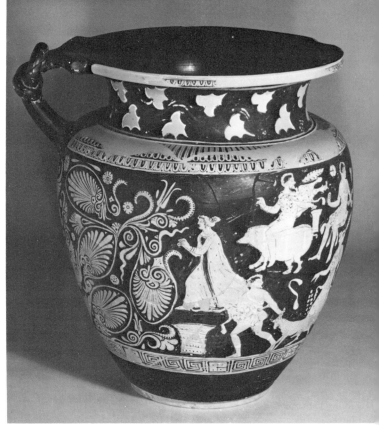

17

17.1e

17.2

17.3

17.4a

17.4b

17.1a. Hamburg, Museum für Kunst und Gewerbe. Private loan. Photo: Museum.

17.1b. Hamburg, Museum für Kunst und Gewerbe. Private loan. Photo: Museum.

17.1c. Hamburg, Museum für Kunst und Gewerbe. Private loan. Photo: Museum.

17.1d. Hamburg, Museum für Kunst und Gewerbe. Private loan. Photo: Museum.

17.1e. Hamburg, Museum für Kunst und Gewerbe. Private loan. Photo: Museum.

17.2. Giessen, University. Photo: D. Widmer.

17.3. Bowdoin College Museum of Art 30.2. Photo: Museum.

17.4a. Louvre CA 2192. Photo: Chuzeville. Courtesy Musée du Louvre.

17.4b. Louvre CA 2192. Photo: Chuzeville. Courtesy Musée du Louvre.

17.5

17.6

17.7

17.9

17.8a

17.8b

17.5. University of Pennsylvania Museum MS 4085. Photo: University Museum.

17.6. London E 506. Photo: Courtesy of the Trustees of the British Museum.

17.7. London 1218. Photo: Courtesy of the Trustees of the British Museum.

17.8a. Essen. Private collection.

17.8b. Essen. Private collection.

17.9. Archäologisches Institut der Universität Göttingen MV F29. Photo: Museum.

17.10a. Bari 5937. Photo: Museum.

17.10b. Bari 5937. Photo: Museum.

17.11a. Private collection. Photo: Robert Burkhardt.

17.11b. Private collection. Photo: Robert Burkhardt.

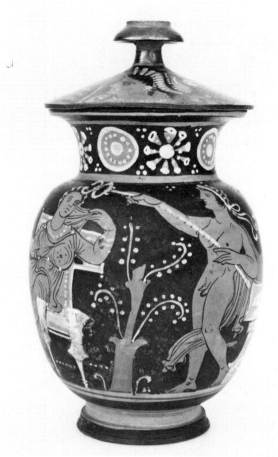

17.10a

17.10b

17.11a

17.11b

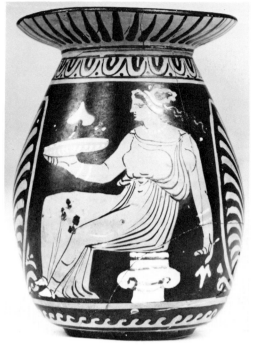

17.12a 17.12b

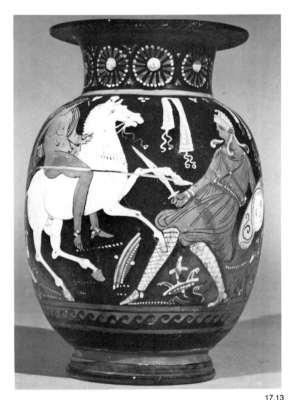

17.13 17.14

17.12a. Hildesheim Pelizäus-Museum 4700. Photo: Museum.

17.12b. Hildesheim Pelizäus-Museum 4700. Photo: Museum.

17.13. Paris, Bibliothèque Nationale 1011.

17.14. Bari 1172. Photo: Museum.

17.15a. Taranto 6578. Photo: Courtesy of Soprintendenza alle Antichità.

17.15b. Taranto 6578. Photo: Courtesy of Soprintendenza alle Antichità.

17.15c. Taranto 6578. Photo: Courtesy of Soprintendenza alle Antichità.

17.16. Amiens O, 12×0, 125. Photo: Courtesy of Musée de Picardie.

a few Attic parallels;[24] the oinochoe Hildesheim 4700 can be offered here as an example (fig. 17.12a–b).[25] These pear-shaped, generally quite small vases do not have an offset neck, but instead a very shallow, funnel-shaped mouth. There is usually a low foot or foot-ring, though occasionally there is no foot at all.[26] Matching lids are comparatively rare with vases of this shape. They were, like those of shapes 8B and 8M, also painted in the Gnathia style.[27] Shape 8B was also occasionally adopted in Etruria.[28] Like shape 8B, shape 8N can have knotted handles;[29] this motif was quite popular in Etruria,[30] but even more so in southern Italy, especially in Gnathia ware.[31]

Shape 8B was also frequently used in the

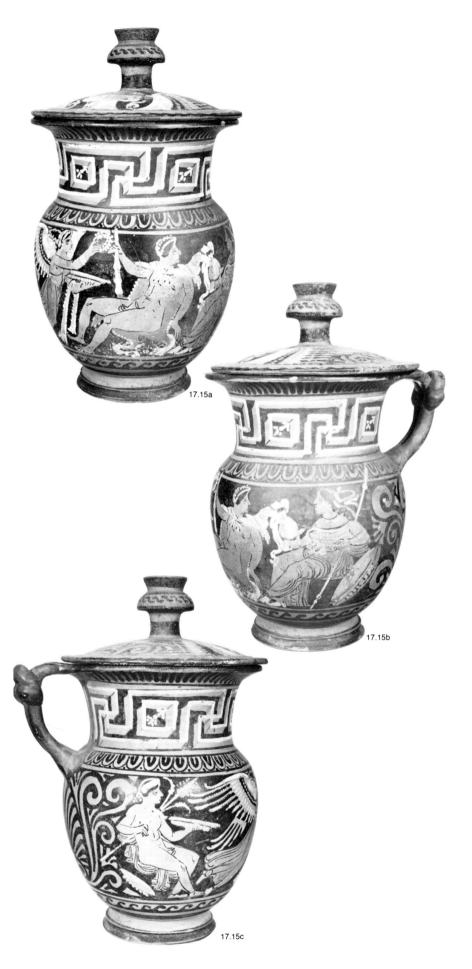

17.15a

17.15b

17.15c

extensive group of South Italian vases—generally rather small ones—with added red.[32] A unique variant of this type is the Lucanian oinochoe with two handles, foot, and offset lip which A. D. Trendall attributes to the Painter of Naples 1959.[33] It is from the circle of this painter, as I shall show, that the painter of our oinochoe comes.

There is a great variety of ornamentation of the neck on painted shape 8 oinochoai. Especially common, as one might expect, are friezes of ivy leaves—very often with white borders (figs. 17.8, a–b)[34]—and laurel wreaths.[35] Friezes of rosettes (figs. 17.9, 17.13),[36] or rosettes alternating with phialai also occur (figs. 17.10a–b).[37] This combination is especially popular in Etruscan art, even outside of vase-painting. The laurel wreath is sometimes arranged symmetrically, with a rosette set in the middle.[38] The meander pattern is also widespread, and often richly elaborated (figs. 17.14, 17.15a–c).[39] One oinochoe, in a private collection, exhibits a unique floral decoration on its neck. On the side is a girl sitting on a throne, on the lid a Nike bust; the handle is double. Another oinochoe, in Amiens, has a peculiar bud frieze (fig. 17.16),[40] as does the oinochoe Naples 2290, which has, in addition, a lid. Rarely, tongues[41] or scroll ornaments are found on the necks of vases of this shape.[42]

A few bigger vases of shape 8 are very richly ornamented. The oinochoe Berlin 3383 has on its neck a frieze of ivy leaves with a central rosette,

17.16

17.17a

17.17b

above which is a dotted cymation and below, a band of scroll ornament (figs. 17.17a, 17.17b).[43] Foggia 132734 also has a wreath with a central rosette (figs. 17.18a, 17.18b);[44] the thin, alternately white and red leaves are perhaps those of the myrtle. On each side is a flower, facing for-ward. The considerably smaller oinochoe Berlin (East) 4541 is similarly ornamented, though it lacks the flowers at each side. Another oinochoe, on the art market, is ornamented in much the same way.[45] Only rarely is the neck of an oino-choe of this shape left undecorated.[46]

17.18a

17.18b

17.17a. Berlin 3383. Photo: Courtesy of Antikenmuseum, Staatliche Museen.

17.17b. Berlin 3383. Photo: Courtesy of Antikenmuseum, Staatliche Museen.

17.18a. Foggia 132734. Photo: Courtesy of Soprintendenza alle Antichità, Taranto.

17.18b. Foggia 132734. Photo: Courtesy of Soprintendenza alle Antichità, Taranto.

17.19a. Naples H 2123, 76.1215. Photo: DAI, Rome.

17.19b. Naples H 2123, 76.1215. Photo: DAI, Rome.

17.19c. Naples H 2123, 76.1215. Photo: DAI, Rome.

<div style="text-align: right;">17.19a</div>

<div style="text-align: right;">17.19b</div>

All the oinochoai discussed so far are Apulian, except for the peculiar two-handled piece, which Trendall calls a "kantharoid krater" and which is Lucanian (see n. 33). As far as I can see, the only Campanian example is a piece in a private collection, which was doubtless made under Apulian influence.[47] The shape 8 oinochoe belongs to a group of shapes, like the lekane and the rhyton and, to a lesser extent, the nestoris, which were manufactured only in one or another of the large South Italian workshops.[48]

The vase with which we began our investigation proves to be significant for more than one reason. First of all, its size is remarkable. Only a few vases of its shape exceed it in size: these are the already mentioned pieces Berlin 3383 (figs. 17.17a, 17.17b)[49] and Foggia 132734 (figs. 17.18a, 17.18b),[50] as well as the previously cited vase in Fiesole[51] and another in Naples (2123; figs. 17.19a–c).[52] The largest, at 57 cm, is the oinochoe in Foggia. Oinochoe of shapes 8M and 8N are rarely more than 10 cm high, and often only 5 cm to 7 cm. The average height of shape 8B oinochoai lies between 12 cm and 18 cm, and rarely exceeds 20 cm (not counting the lid, of course).[53] Of Attic vases of shape 8, so far as I know, only one very fragmentary example from Kavalla reaches monumental proportions.[54] Some Apulian oinochoai of other shapes also exceed the usual dimensions.[55] The majority of oversized South Italian vases date from the late fourth century;[56] the oinochoai in Foggia and Naples, however, are somewhat earlier.

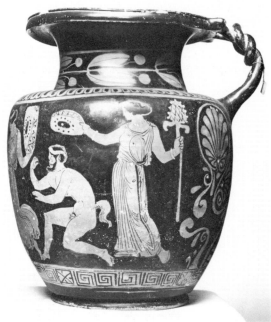

<div style="text-align: right;">17.19c</div>

All five of the oversized Italian vases just mentioned have knotted handles. This motif, widespread in Italian art, is found on small vases, such as shape 8 oinochoai and oinochoai of other shapes,[57] lekanis lids,[58] lekythoi,[59] kantharoi,[60] ring-askoi,[61] and skyphoi;[62] but also on larger vases such as amphorai,[63] hydriai,[64] pelikai,[65] and especially kraters[66]—though these are often small.[67] Many of these vases are black or painted in the Gnathian style. Berlin F 3289 is the only

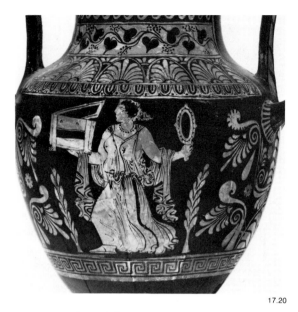

17.20

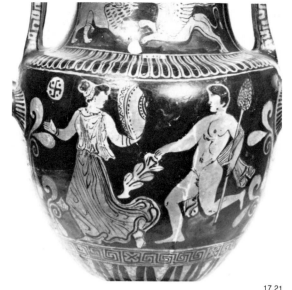

17.21

example of a red-figure krater with knotted handles—according to a thermoluminescence test, kindly arranged by W. Heilmeyer, the handles are modern.

It is not, however, only for its form, but also for its style and its figured decoration that this vase merits our attention. We have already mentioned that all the published South Italian oinochoai of shape 8, with the exception of one privately owned Campanian example,[68] are of Apulian origin. Our immense pitcher, however, can be neither Apulian nor Campanian; its style suggests rather a Lucanian origin. We have already seen that the same basic form was also

used by the Lucanian Painter of Naples 1959;[69] the figures on our vase are especially reminiscent of the work of that very prolific painter. The Painter of Naples 1959,[70] like the painter of our vase, has a special fondness for little bushes and branches. Some examples are the nestorides Compiègne 964 (fig. 17.20)[71] and Oxford 1879.201 (fig. 17.21)[72] On the nestoris Boulogne 143, attributed to the circle of the Painter of Naples 1959, a branch appears on the reverse beside draped youths (fig. 17.22)[73] This motif in this form with draped youths is remarkable;[74] more commonly they hold a small branch in one hand,[75] or leaf volutes and related ornaments appear between them.[76] Also from the circle of the Naples 1959 Painter is the epichysis Manchester IV E 31 (figs. 17.23a, 17.23b),[77] on which the small branches are combined in a peculiar way with a scene of sacrifice. The spots on the panther on our vase are reminiscent of the spotted hide on the lekythos Copenhagen 275, which was painted by the Painter of Naples 1959 himself.[78] The fondness for vertical black stripes on clothing also forms a link between this painter and the painter of our vase.[79]

The ornamentation under the handle of our vase is unusually rich. This is admittedly also true of the other monumental pitchers referred to above, but two elements especially of this ornamentation are also found in the work of the Naples 1959 Painter. One is the curved, often serrated, stylized "fanlike" flower, for which we can refer to the nestoris in Boulogne (fig. 17.22) and the name-vase in Naples (fig. 17.24)[80] as parallels, as well as the krater Geneva 15046 (fig. 17.25)[81] and the amphora Copenhagen Chr. VIII.4.[82] Further parallels are provided by the

17.20. Compiègne 964. Courtesy of the Musée Vivenel.

17.21. Oxford 1879.201 (V432). Courtesy Ashmolean Museum.

17.22. Boulogne 143. Photo: Devos. Boulogne-sur-Mer, Musée.

17.23a. Manchester IV E 31. Courtesy Manchester Museum.

17.23b. Manchester IV E 31. Detail. Courtesy Manchester Museum.

17.24. Naples H 1959 (79.552). Photo: DAI, Rome.

17.25. Geneva 15046. Courtesy Musée d'Art et d'Histoire.

17.22

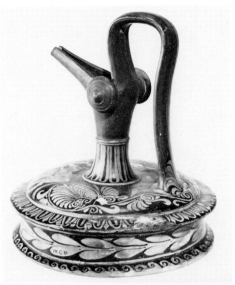

17.23a

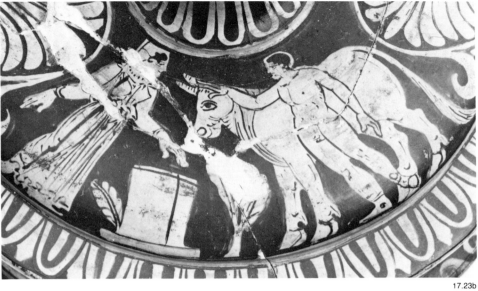

17.23b

17.24

17.25

nestorides Naples 1816, from the circle of the painter (fig. 17.26), and Palermo N.I. 2203, painted by one of his followers (fig. 17.27).[83]

The other ornamental element of interest in this connection is the scattering of balls among the palmettes. This motif is found on many Italian vases—especially in Apulia, but at Paestum as well. The Apulian hydria Berlin F 3290, with its especially splendid handle ornamentation, affords a fine example (fig. 17.28).[84] The motif is

17.26. Naples 1816 (79.561). Photo: DAI, Rome.

17.27. Palermo N.I. 2203. Courtesy of the Museo Nazionale.

17.28. Berlin (West) F 3290. Courtesy of Antikenmuseum, Staatliche Museen.

17.29. Berlin (Ost) F 3146. Courtesy of Antikenmuseum, Staatliche Museen.

17.30. Naples H 1860 (79.559). Photo: DAI, Rome.

17.31. Naples H 3234 (79.566). Photo: DAI, Rome.

17.26

17.27

17.28

17.29

17.30

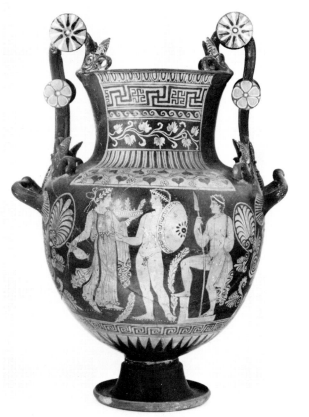

17.31

also found in Etruria, as on the Faliscan oino-
choe Villa Giulia 908.[85] It is, however, also
found in Lucania, on countless vases of the
Painter of Naples 1959 and his circle (fig. 17.29).[86]
That this disk-shaped element really represents a
ball is shown by the fact that on many vases it is
being used as a plaything.[87] The cross and check
pattern that appears on the balls in both their
functions—as playthings and as ornament—has
occasionally led to their correct identification.[88]
This ball-ornament is parallel to the cushion-
ornament which I have investigated in an earlier
article;[89] there too it was possible to show that
in southern Italy and Etruria a real object could
become an element of ornamentation. At the
moment, however, the important fact is that the
ball-element, whether as a real object (i.e., in
play) or as a filling ornament, is extremely com-
mon in the works of the Painter of Naples 1959
and his circle. As a plaything it appears, for
instance, on the nestorides Naples 1860 (fig.
17.30).[90] and Oxford 1879.201 (fig. 17.21).[91]

As we shall see, the painting on our oinochoe
diverges from the usual form of Dionysiac
scenes. The Painter of Naples 1959 also fre-
quently chooses unusual themes.[92] Thus on the
olpe Naples 1924 he represents the battle of Her-
akles and Geryoneus—almost unknown in
southern Italy[93]—and on the reverse of the
amphora 2086 in the same museum is the only
South Italian representation of a dromedary
(though the identification has been challenged).[94]
Finally, we may note that the potter of the nes-
toris Naples 3234 (fig. 17.31), which was perhaps
painted by the Painter of Naples 1959 or a close
follower, has also gone beyond the limits of the
ordinary by ornamenting the handles in a way
quite unparalleled in nestorides;[95] considering the
abundance of vases of this shape, this is not
insignificant. It is thus not surprising that the
only oinochoe of shape 8B from Lucania—and
one of extraordinary size—should have origi-
nated in the sphere of the Painter of Naples 1959.

The remaining elements of the ornamentation
on our vase can be treated in a few words. The
meander is not painted precisely; the elements
follow one another without any discernible
order.[96] The ivy leaves on the neck are outlined
in white. As with the Painter of Naples 1959,
added white is used profusely, but not on the
large area of ornamentation on the handle side.
There are berries between the ivy leaves. On the
lip and shoulder there is a dotted cymation; the
shoulder is also painted with enclosed tongues.

In summary, all the evidence points to the
conclusion that our oinochoe was painted by a

member of the circle of the Painter of Naples 1959, though not by the master. He was, to be sure, no great artist himself, but the painting on our vase is yet more hasty and imprecise—almost completely barbarized. The meander supports this conclusion, since it does not follow the pattern used by the Painter of Naples 1959. For attribution we may aptly compare the works of the Acrobat Painter, one of the followers of the Painter of Naples 1959; for instance, the Leiden nestoris κ 1894/99.1 (figs. 17.32a, 17.32b).[97] On this vase the ball motif appears as a filling ornament; but the similarity to our oinochoe is most evident in the black stripes and the fold patterns of the clothing, and in the imprecise outlines of the figures. Our vase will belong to the painter's late period, and is to be dated around 320 B.C.; it is thus the latest of the monumental oinochoai.

Let us now consider the figured decoration on our vase. Below and to the left of the handle a Silenus sits on a structure of rough stones. He faces left and holds in his outstretched hands a double flute, originally painted white, but now barely recognizable, on which he plays. He wears shoes; as with all the Sileni on the vase, the hair on his body—but not on his limbs—is indicated with hooks, dots, and little circles. This pattern of black hook marks is also used on all the clothing of the figures on the vase. High up and slightly to the right is a small window.[98] In front of this and to the left a Maenad dances on tiptoe; she faces left and her left breast is bare. She wears her hair in a hood; she carries a tympanon in her left hand and a branch in her right. Before her Dionysos, wearing a chlamys, rides a panther toward the left.[99] The animal's hide is sprinkled with hook marks and white spots, as are the skins worn by three of the Sileni and one of the Maenads. The god wears the mitra in his hair. Below the panther appears an irregular outline. It is broken into two sections, one above the other; nevertheless, it suggests a pool, and this is doubtless what the painter intended. Below it a Silenus rests, his upper body propped up and his trunk and head facing the viewer; his eyes are open. The lower part of his body is covered with a mantle decorated with a toothed border; part of the mantle is pulled up to form a pad for his left arm, with which he supports his head. Though part of his face and the top of his head are missing, one can see that he was bearded, like all but one of the Sileni, but almost completely bald on top. The numerous stones between him and the sitting Silenus indicate a rocky landscape. Farther to the left a Silenus advances vigorously, carrying a calyx-krater on his left shoulder and a torch in his right hand. The krater is decorated with white dots, short strokes, and lines. Above it can be seen numerous white-spotted vine leaves. A Maenad looks back at the krater-carrying Silenus; she has her hair in a hood and wears a skin over her long dress. She has black arm rings, a necklace of white dots, and a white earring. A branch projects upward and to the right from behind her head. Above the Maenad a youthful, barefooted Satyr sits on a skin, part of which is thrown over his right thigh; he looks back at the riding god. Farther to the left a bearded, barefooted Silenus also looks back. He is riding on a pig and carries a situla in his left hand. He wears a skin, which is knotted over his breast and billows out behind him. The area above his left arm is filled with a branch. Below the pig a bearded Silenus looks back at a he-goat, its coat represented with tiny hatch marks, and drags it along toward the left. His left hand is covered with a skin; like the krater-carrying Silenus, he wears high boots, which are decorated with white stripes around the tops. Somewhat farther on and toward the top, a hooded, flute-playing Maenad completes the frieze. She wears a long dress with sleeves and with wide black stripes down the middle and a similar border around the bottom. She wears a white earring and a chain of white dots around her neck, and her sleeves are also decorated with white dots. Below her and almost directly to the left stands a large kalathos decorated with white and black dots and lines, as well as a step pattern of alternating colors below the rim. All the Sileni wear a white fillet over the breast, and most have rings on their arms and thighs.

This Dionysiac procession is the largest known on any vase; it is also the most unusual representation of the motif. Among the peculiarities of this painting we may note the old Silenus reclining, though not sleeping, in the midst of the turbulent activity, propped up on his elbow.[100] Indeed, he is not the only character to take no part in the procession; the flute-playing Silenus and the youthful satyr—both represented sitting—are also quite removed from the flow of activity. The outward gaze of the reclining Silenus links him with a tradition, beginning in the early Archaic period, of representations of Dionysos and Sileni with masklike, frontal faces.[101] Reclining Sileni are most commonly symposiasts, who are often shown already overcome with drink,[102] but it is not always entirely clear why a Silenus is reclining. Here, where Dionysos is riding near one of his reclining followers, it is reasonable to guess that he is drunk, but this

17.32a. Leiden κ 1894/99.1. Courtesy of Rijksmuseum van Oudheden.

17.32b. Leiden κ 1894/99.1. Courtesy of Rijksmuseum van Oudheden.

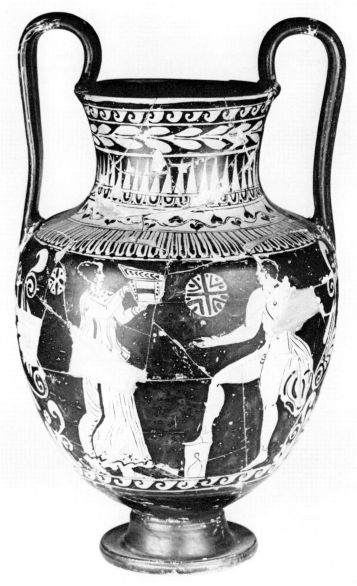

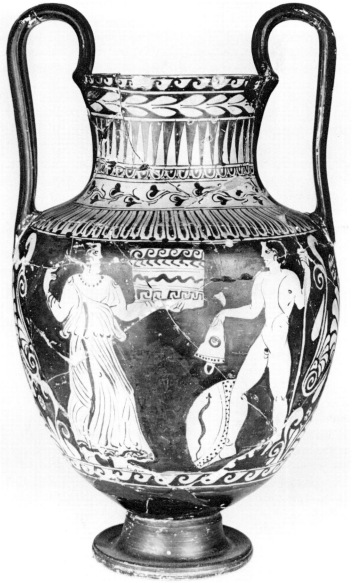

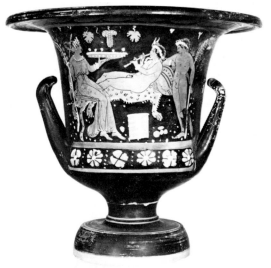

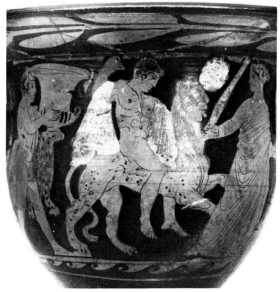

17.33

17.34

cannot be proved absolutely.[103]

The motif represented by the Satyr sitting on the skin to the left of Dionysos is certainly not uncommon, though the members of a *thiasos* sit and lie on skins less often than one might expect.[104] There is, however, a fine example on the calyx-krater Taranto 123768, reproduced here by the kind permission of E. de Juliis (fig. 17.33),[105] on which a young Satyr with goat horns[106] plays the flute reclining on a spread-out skin with a cushion behind his back.

Sileni frequently carry wineskins;[107] although they are more often associated with pointed-amphorae than with kraters,[108] there are also several parallels to our krater-carrying Silenus (see, for example, fig. 17.34). The oldest example of this general motif is of course on the François vase, where Dionysos is represented carrying an amphora. (see Stewart p. 56 and fig. 4.2)

The connection between goats on the one hand and the *thiasos* and the Sileni on the other is complex, and it is constantly being explored anew from different points of view. Sileni can, for instance, accompany goats as herdsmen,[109] or ride on them,[110] or even form a procession with them to the music of the flute.[111] But Sileni leading goats or grasping them from the front are surprisingly rare.[112]

The most amusing motif on our vase is certainly the Silenus riding on a pig. Although a well-known Gnathian krater in Leningrad had already given us an example of a Satyr mounted in this way,[113] the motif was until now unknown in the context of a Dionysiac procession. Otherwise pig riders are a popular theme of Hellenistic koroplastic art. As a rule the riders are children or Erotes;[114] they may crouch or lie on their less-

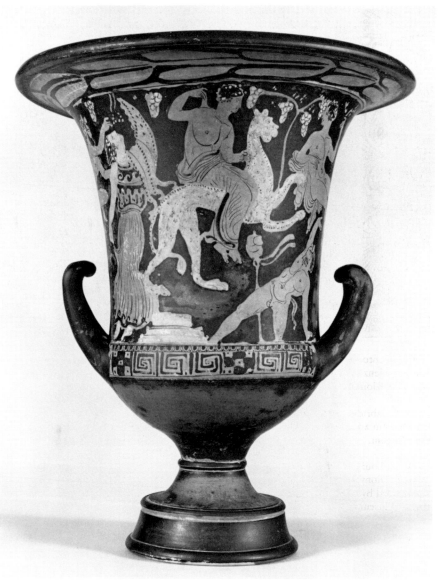

17.35

17.36

17.37

17.33. Taranto 123768. Courtesy Soprintendenza Archaeologica, Museo Nazionale.

17.34. Cambridge, Archaeological Museum 206. Courtesy of the Museum.

17.35. St. Louis Art Museum 31.1921. Dionysos on a panther surrounded by Maenads. Courtesy of Museum.

17.36. Musei Vaticani XXVI.11.36/10B Astarita Collection A 150. Courtesy of the Museum.

17.37. Berlin (West) 5825. Antikenmuseum, Staatliche Museen. Courtesy of the Museum.

than-elegant mounts, or they may be represented riding sidesaddle or astride. The most interesting piece I know of is in Bari, in the Sette Labellarte Collection. This statuette, no doubt of Tarentine origin, represents a Silenus holding a krater and a Maenad holding a cornucopia sitting side-by-side on a pig. This group is to be connected with the long-known pieces representing Sileni—sometimes riding on mules—who carry cornucopiae.[115] Nymphs or Maenads with cornucopiae are much rarer.[116] While in this group the combination pig/Silenus/Maenad/cornucopia obviously refers to the idea of fertility, that is hardly true of our vase. Here there seems to be rather a comic intention. Yet two considerations make this uncertain. For one thing, this interpretation does not fit the Gnathian krater mentioned earlier;[117] for another, the three white fillets that hang down from the pig on our oinochoe show that it has been prepared for sacrifice.[118] (Similar decoration of pigs is otherwise known to me only from Roman art.[119])

The last motif we have to consider is that of Dionysos riding on a wild beast. The association of Dionysos with lions and panthers goes back to the Archaic period. The motif of the panther as the god's draft animal appears already in the late Archaic.[120] He first appears riding lions or panthers in the fourth century;[121] some Attic examples are the bell-kraters Vatican 9105,[122] Louvre G 511,[123] and Cambridge, Archaeological Museum 206 (fig. 17.34),[124] the calyx-krater St. Louis City Art Museum 31.1921 (fig. 17.35) and the sherd in the Vatican, Astarita Collection, A 150 (fig. 17.36).[125] The god sits sometimes sidesaddle, sometimes astride. The animal—on none of these vases a lion—is usually, though not always, marked with spots. In Etruscan art it is especially Sileni (fig. 17.37),[126] or Maenads,[127] that appear on panthers, but for the god himself, so far as I know, the motif is not attested. In the fourth century and the Hellenistic period,[128] however, and especially in Roman art[129] a baby Dionysos is not uncommonly found sitting on a panther, a lion, or a tiger. In Imperial times we again find Dionysos as a youth on a lion or a panther.[130] The motif of Eros riding on a wild animal is also very widespread in late Hellenistic and Roman art, and here the animal is usually a lion.[131]

In southern Italy riders on lions and panthers are quite common. We find not only Eros in this role,[132] but also Satyrs[133] and Maenads.[134] Some unusual applications of the motif are the Nikes riding panthers on the neck of the volute-krater Foggia 132724[135] and the rider wearing a Phry-

17.38

17.39

gian cap below the applied relief on the neck of the krater Naples 3252 (side B). But Dionysos riding a panther is also a favorite motif of South Italian vase-painting (fig. 17.38). The list of known examples of this theme[136] was extended in 1970 by the publication of the Apulian volute-krater then newly acquired by the West Berlin Antikensammlung,[137] and just recently the large amphora in the Cirillo de Blasi Collection could be added to the list (fig. 17.39).[138] On the latter a Satyr leads a spotted panther with a rope. As could be shown at greater length elsewhere, there are numerous examples going back to a very early period both in Etruria and in Greece—somewhat later in southern Italy—of wild animals, especially birds,[139] tied on ropes. Earlier we knew of only one example in a Dionysiac context of a lion led on a rope—on a bell-krater by the Judgement Painter on the art market.[140] Here, however, Dionysos is not riding a panther, but a lion.[141] In Hellenistic and Roman art there is a series of works, especially mosaics and wall-paintings, depicting lions being overcome and leashed by Erotes.[142] The krater mentioned earlier in a certain sense anticipates these representations—partly, however, in that the god's mount is a lion and not a panther. For this motif there are so far no parallels on Attic, South Italian, or Etruscan vases.

NOTES

1 H. 50.5 cm, d. 38.5 cm. I am very grateful to the owner for permission to publish this vase.

2 The rim is chipped; parts of the shoulder and the handle are restored; part of the head of the reclining Silenus is missing. The foot ring is reserved. The lip is molded.

3 E.g., for the fillets around the heads and bodies of the Sileni, parts of the boots, arm and thigh rings, spots on the panther, and the three hanging fillets on the pig. The edges of the ivy leaves on the neck are white, but the overpaint is hardly used anywhere else on the ornament.

4 B. A. Sparkes, "Black Perseus," *AntK* 11 (1968) 3–16, pls. 1–8; B. A. Sparkes and L. Talcott, *The Athenian Agora* XII (Princeton 1970) 70–76. For the term kothon applied to this shape, see I. Scheibler "Kothon—Exaleiptron," *AA* 1968, 389, and B. A. Sparkes, *JHS* 95 (1975) 128–29. For the inscription "hemikotylion" on the oinochoe London F 595, see *Agora* XII, 70.

5 Thanks to the photographs of G. Buchholz, I am able to publish a mug in Giessen (*ARV²* 156, no. 58; H. 10 cm) as an example of this shape. The Painter of Berlin 2268, to whom this vase is attributed, is responsible for the majority of mugs of this shape. For the subject on this so-far-unnoticed piece see H. Raeck, *Zum Barbarenbild in der Kunst Athens im 6. und 5. Jh. v. Chr.* [forthcoming]. A little mug by the same painter in *Hesperia Art Bulletin* XVI [n.d.] 97 also depicts Scythians. The earliest example of this shape is apparently the oinochoe Orvieto, Faina 148 (*ARV²* 77, no. 89, Epiktetos). See also *ARV²* 152, no. 2 (Vienna); *ARV²* 156–57, nos. 51–84; *ARV²* 385, no. 227 (Adolphseck); *ARV²* 779, no. 1 (Athens); *ARV²* 983, nos. 10–12; *CVA* Bonn 1, pl. 23.2–3 and p. 24; *CVA* Stuttgart 1, pl. 29.4, 10; Münzen und Medaillen, *Sonderliste N* (Basel 1971) 14; *Summa Galleries* 4 (Beverley Hills 1978) 11. The mug *ARV²* 1577, no. 17 (Louvre) is peculiar; its only decoration is a horizontal band with the kalos name Epidromos. For black ware see Sparkes, "Black Perseus" 6ff.; Sparkes and Talcott, *Agora* XII, 72–74; *CVA* Gotha 2, pl. 76.2 and p. 26; E. de Juliis found a great fill of black shape 8 oinochoai at Lanosa and Rutigliano; red-figured also: *ARV²* 158, nos. 1–3; *Auktion* 40 (Basel 1969) 89. The oinochoe, *ARV²* 157, no. 79 *bis* (Padula), J. D. Beazley, *Apollo* 2 (1962) 38, figure 11, seems to me to be of shape 8B.

6 *ARV²* 779, no. 9. For the photograph and permission to publish I am very grateful to B. Pelletier, Bowdoin College Museum of Art, Brunswick, Maine. The oldest example seems to be *ARV²* 385, no. 226 (Boston). See also *ARV²* 779, nos. 1–10;

17.38. Paris, Musée du Louvre 6637 97. K240. Courtesy of the Museum.

17.39. Taranto 59. Courtesy of Soprintendenza alle Antichità Puglia, Museo di Taranto.

*ARV*² 805, nos. 77–78 (lost, Oxford); *ARV*² 815, nos. 4–5 (Oxford, Trieste); *ARV*² 871, no. 96 (Copenhagen); *ARV*² 873, no. 28 (Cab. Méd.); *ARV*² 983, no. 13 (Halle); Münzen und Medaillen, *Sonderliste N* 13; *CVA* Copenhagen 4, pl. 158.10–12; a fragmentary piece with two crouching Sileni in the Villa Giulia; *Odeon* (1971) pl. 40 (Palermo). Owls (see *ARV*² 983–84, nos. 10–17) are also found on Italian vases of this shape, e.g., two oinochoai from Bari (Tomba 4); see also fig. 17.4. An oinochoe of shape 8B with a Silenus crawling to the left appeared a few years ago on the Frankfurt market (h. ca. 6 cm). In a private collection there is an oinochoe with a Silenus bent over a wineskin, facing right (inscribed): A. Peredolskaja, *Krasnofigurnye atticheskie vasy v Ėrmitazhe* (Leningrad 1967) pl. 97.2–3. See also *ARV*² 985 (once Agrigento, Giudice Coll., Saint Valentin class). The oinochoe Louvre K 156 is closely related to its Attic models in having a steep neck; it looks South Italian (Apulian?). The same is true for the somewhat larger oinochoe K 601. Cf. K. Schauenburg, *Boreas* 6 (1983)—red-figured also. *Select Exhibition of Sir John and Lady Beazley's Gifts 1912–1966* (1967) no. 305. C. Ede, *Collecting Antiquities* (London 1976) no. 48.

7 Louvre CA 2192, *ARV*² 983, no. 14. Photo Chuzeville. For owls on shape 8 oinochoai, see preceding note. An Etruscan example: *CVA* Milan 1, IV B, pl. 2.4. For shape 8C, see further Sparkes, "Black Perseus," 8–9 (it is quite rare); Sparkes and Talcott, *Agora* XII, 71–72; *ARV*² 311, no. 2; *ARV*² 787, nos. 4–6; *ARV*² 843, no. 143 (Louvre); *ARV*² 873, nos. 29–31; *ARV*² 983–84, nos. 14–17; *CVA* Bonn 1, pl. 23.3; *CVA* Vienna 1, pl. 46.6f; *CVA* Munich 2, pl. 96.4–5 and p. 28; Münzen und Medaillen, *Sonderliste N* no. 12; *CVA* Brussels 2, III Ic, pl. 20.3; several years ago an oinochoe was on the market with a youth in a mantle, holding a phiale in his right hand, a branch in his left hand, and to his left a tree (h. 7.7 cm); Bari 12817 (naked athlete). For black oinochoai, see Sparkes and Talcott, *Agora* XII, 71; this type is also found in Italy. *CVA* Bourges, pl. 9.4; L. Bernabo-Brea, *Meligunis-Lipára* II, pl. 60.3; *Summa Galleries* 3 (Beverly Hills 1977) no. 15; Bari, Malaguzzi coll., 71: a black example in West Berlin. Red-figured also: *Beazley's Gifts* nos. 389 (Attic), 535 (Italian). J. and L. Jehasse, *La Nécropole Préromaine d'Aléria* (1973) pl. 144.98. *Délos* XXI, pl. 40.III. *Beazley's Gifts* no. 312.

8 *CVA* Laon 1, pl. 39.6, 8; *ARV*² 804, no. 73; Sparkes and Talcott, *Agora* XII, 71, n. 12; 73 for black ware and 75 for pitchers with two handles in general. See n. 18 infra for ribbed vases.

9 Sparkes and Talcott, *Agora* XII, 71–76. See esp. p. 71 for straight-sided oinochoai (see n. 11 infra) and pp. 71–72 for the relatively late tall pieces.

10 For the various shapes, see Sparkes and Talcott, *Agora* XII, 72–76, where the Phidias-cup shape is also treated. See also J. R. Green, *Gnathia Pottery in the Akademisches Kunstmuseum Bonn* (Mainz 1976) fig. 3; *CVA* Castle Ashby 1, pl. 53.11 and p. 34; *CVA* Gotha 2, pl. 76.2 and p. 26; *CVA* Gallatin Coll., pl. 31.11; *CVA* Posen, Wielkopolskie Museum, pl. 3.13; *CVA* Bourges, pl. 9.4; *CVA* Rennes, pl. 44.3; *CVA* Warsaw 6, III L, pl. 11.1–3, 7 (no. 2 is very squat); *CVA* Sèvres 1, pl. 23.19, 31, 33; Bernabo-Brea, *M-L* II, 213, pl. 60.1–2. For oinochoai with knobs, which were also made in southern Italy, see J. D. Beazley, *Greek Vases in Poland* (Oxford 1928) 59–60; Sparkes and Talcott, *Agora*

XII, 73–74; *Kerameikos* X 205–6 (F. Homdorf); a piece in Bari, Sette Labellarte Coll.; *CVA* Switzerland 5, pl. 14.15; *CVA* Rennes, pl. 44.8; *CVA* Sèvres 1, pl. 23.29. An oinochoe in the Macinagrossa Coll., Bari, shows a variant form; it has six depressions with bosses in the middle, a seventh smaller depression without a boss below the handle, and yet smaller depressions here and there in the intervening spaces (h. 8.3 cm). For oinochoai with bosses see now also *CVA* Würzburg 2, pl. 31.1–2 (F. Hölscher). Some of the oinochoai mentioned at the end of n. 5 supra, excavated by E. de Juliis, are Italian. There is an inscription on the ribbed oinochoe published in *Deltion* 28β (1973) pl. 20β and p. 32. See also D. E. Strong, *Greek and Roman Gold and Silver Plate* (Ithaca 1966) 48–49 for silver oinochoai. See also *CVA* Mainz, RGZM 2, pl. 41.3; J. Dörig, *Art Antique* (1975) no. 248.

11 *ARV*² 1122, no. 20; Sparkes and Talcott, *Agora* XII, 72 (unique). Here, after a photograph for which I am obliged to G. Edwards. For ribbed Attic vases in general see Sparkes and Talcott, *Agora,* XII, 72, n. 18 (relatively rare among pitchers). For ribbed oinochoai of related shapes see Sparkes and Talcott, *Agora* XII, pl. 11.198–200; *CVA* Karlsruhe 1, pl. 34.11–13 (esp. 11); N. Kunisch, *Antiken der Sammlung Funcke* (1980) on no. 174. For straight-sided oinochoai see n. 9 supra. See also *CVA* Mainz, RGZM 2, pl. 31.8f. *Beazley's Gifts,* on no. 393.

12 Sparkes and Talcott, *Agora* XII, 73, n. 28, I am obliged to D. Williams for the photograph; courtesy of the British Museum. The middle group of the krater is unusual for a mortal *komos.*

13 Literature in J. D. Beazley, *BSA* 29 (1927–1928) 213 and *Vases in Poland* 59–60, 70; Sparkes and Talcott, *Agora* XII, 73, 123 (on vases from the late fifth century). Generally on Herakles-knots: J. Csemegi, *Die Altertümer von Budapest in Régiségei* 15 (1950) 549ff. (I owe this reference to J. Szilagyi); J. Werner, *RGZM* 11 (1964) 176 (on apotropaic significance); B. Neutsch, *AA* 1956, 264 (on decoration); H. Hoffmann and P. Davidson, *Greek Gold* (1965) 220–21; P. Romanelli, *AJA* 66 (1962) 313–15; B. Freyer-Schauenburg and K. Schauenburg, *AntP* XII (1973) 58, n. 50 (on origin and use).

14 London 1218. I am obliged to D. Williams for the photograph; courtesy of the British Museum. Mentioned by Beazley, *Vases in Poland* 60. Kerameikos 8086 is ribbed. See also the cup *ARV*² 1302, no. 28 (Cracow, ca. 440 B.C.), which is, however, painted; in general, Sparkes and Talcott, *Agora* XII, 73, and, for further shapes, p. 162, n. 5 (very squat). See n. 18, infra, at end.

15 Literature in W. Hornbostel, *Kunst der Antike: Schätze aus norddeutschem Privatbesitz* (Mainz 1977) on no. 350 (Schauenburg). See also, for example, *CVA* Warsaw 6, III L, pl. 10.1; a piece in Bari (inv. 861); a piece recently on the Frankfurt market; pieces in Madrid, Istanbul, Leiden, and Naples; Toulouse 26200; several pieces in the Jatta Coll., Ruvo; two in the Ruggiero Coll., Naples; Berlin F 2713 and 2713a. *CVA* Mainz, RGZM 2, pl. 32.1.

16 M. Bakalova-Delijska, *BIABulg* 23 (1960) 253–55 figs. 1–6.

17 For this see Sparkes, "Black Perseus" pl. 6.4 (Yale); Sparkes and Talcott, *Agora* XII, 73; K. Rhomiopoulou, *Deltion* 19A (1964) pl. 45γ (Tübingen); n. 10, supra.

18 See, for instance, *NSc* 20 (1966) 226, fig. 86.3 (from Metapontum); A. D. Trendall, *Vasi Vaticani* III

(Astaria Coll.) pl. 17.6; *CVA* Rennes, pl. 44.3; *CVA* Stuttgart 1, pl. 65 and pp. 74–76 (with literature); G. Lo Porto, *MonAnt* 48 (1973) pl. 24.3.1, 36.3.5; 267, fig. 107.8 (Bari); *CVA* Fiesole 2, pls. 138.3 and 138.5.4 (very thin); *CVA* Parma 2, IV D, pl. 3.8 (nos. 4 and 5 are variants); *CVA* Sèvres 1, pl. 49.35 and 53; *CVA* Verona 1, IV E, pl. 5.5, 6 (variants); *CVA* Braunschweig, pl. 45.1–2, 4–5; *CVA* Amsterdam 2, IV, Er, pl. 3.1ff. (6 and 8 are very thin); *CVA* Switzerland 5, pl. 14.12, 29.2, 9f., 42.12ff., 53.30ff.; a great number of relevant vases in the storerooms of Bari and Naples, but they are as yet unpublished; a large ribbed piece in the Ragusa Coll., Taranto; Bari, Sette Labellarte Coll. nos. 143 (ribbed) and 154; two ribbed pieces in the Macinagrossa Coll., Bari; Gioia del Colle, Amoroso Coll. nos. 21, 22, uninventoried piece (unribbed), 29 (ribbed); Bari, Laconte Coll. nos. 27, 28 (ribbed); a very large vase (ca. 30 cm) in Bari, with ribbing and two handles (see n. 8 supra and Sparkes and Talcott, *Agora* XII, 72); Kiel B 482 and B 566; numerous pieces in the Abruzzese Coll., Bari; West Berlin F 3018 (very low); *CVA* Posen, Wielkopolskie Museum, pl. 5.7, 8; *CVA* Brussels 3, IV E, pl. 3.31 (ribbed, knotted handle). *Beazley's Gifts* nos. 532–34; *CVA* Genova-Pegli, IV Eg, pl. 1.1, 5; *CVA* Amsterdam 2, IV E, pl. 3.2f.; *CVA* Mainz, *RGZM* 2, pl. 30.9, 31.10f.

19 Figs. 17.8a and 17.8b: *RVAp* I, 441, no. 130a; now in a private coll. in Essen (h. 18.5 cm), from the circle of the Iliupersis Painter. I am very grateful to the owner for the photographs and information. Fig. 17.9: Göttingen F 29 (h. 13.3 cm, knotted handle esp. squat). I am very grateful to C. Boehringer for the photograph. This shape is also attested in the Gnathia style; see for instance M. Bernardini, *Vasi dello stile di Gnathia* (Bari 1961) pl. 19.27–28. On the hydria Munich 3266 (A. D. Trendall, *The Red-Figured Vases of Lucania, Campania, and Sicily* [Oxford 1967] 120, no. 602), Orestes carries a vase of this shape. It was thus also known in Lucania. For Campania see further on.

20 A. Cambitoglou, "The Lampas Painter," *BSA* 19 (1951) 39–42; *RVAp* I, 283–86.

21 After photographs supplied by E. de Juliis. The knots come in the middle of the handles, which is unusual.

22 See also, for instance: *RVAp* I, 284, nos. 212–13 (Taranto); *RVAp* I, 295, no. 82 with a groove for the lid (Naples). The lid of the oinochoe Naples, Stg. 568, does not belong. See nn. 34ff.

23 Figs. 11a and 11b after Foto Burkhardt AR 305. Trendall points out the close relationship with an oinochoe in Göttingen (fig. 17.9 here). The oinochoe in figs. 11a and 11b shows links with the Patera Painter, but also with the Dareios Painter. See also Cambitoglou, "Lampas Painter" 40, n. 4. The vase there cited as an Attic parallel (*CVA* Oxford 2, pl. 65.1) does not seem to me to be a convincing comparison piece, esp. in the arrangement of the handles. Figured vases of this type are much rarer than those painted in the Gnathia technique; see for instance, *CVA* Bologna 3, IV Dr, pl. 32.18–19; *CVA* Karlsruhe 2, pl. 72.11; *CVA* Copenhagen 6, pl. 265.1a–b; *CVA* Verona, IV D, pl. 10.5a–b; Sotheby, 20 May 1977, no. 118; a piece with a woman's head in Naples: *CVA* Braunschweig pl. 40.3–4. For unfigured, painted oinochoai of this type, see, for instance, *CVA* Amsterdam 1, IV Dc, pl. 1.7; *CVA* Sèvres pls. 47.14, 48.2, 6, 11; *CVA* Braunschweig pl. 46.1–5; *CVA* Parma 2, IV D, pls. 2.1–2, 3.9; *CVA* Rennes pl.

44.6; *CVA* Zürich 1, pl. 51.7; *CVA* Switzerland 5, pl. 13.8–9, 42.2, 49.9ff., 54.1, 3; *CVA* Warsaw 6, IV D, pl. 24.2; L. Forti, *La Ceramica di Gnathia* (Naples 1965) 78–79 with 91, n. 34; Bari 8259 (Gnathia); *CVA* Copenhagen 7, pl. 276.1–2; G. Dareggi, *Ceramica greca ed italiota nel museo di Baranello*, *Quaderni dell'Instituto di Archeologia dell'Universita di Perugia* 5 (1977) 65, no. 105 (with literature); *CVA* Warsaw, Bibliothèque Krasinski, no. 8 (Poland, pl. 112); Green, *Gnathia Pottery* 10 on no. 20. An example with figured painting and black neck, *MonAnt* 48 (1973) pl. 41.1.3 (Taranto).

24 Cambitoglou, "Lampas Painter" 40. There is an Attic parallel in Athens: P. Wolters, *Zu griechischen Agonen* (Würzburg 1901) 5, fig. 1 and B. A. Sparkes, "Quintain and the Talcott Class," *AntK* 20 (1977) pl. 3.1–4. These vases are from 5 cm to a maximum of 10 cm high.

25 Here, after a photograph for which I am obliged to B. Schmitz; h. 9.5 cm. For the shape see also: *RVAp* I, 284, nos. 222–26; A. D. Trendall, *Taranto nella Civiltà della magna Grecia: Atti del decimo convegno di studi sulla Magna Grecia, 1970* (Naples 1971) pl. 38 (three pieces in Taranto); Berlin F 3398 (knotted handle); *CVA* Bologna 3, IV Dr, pl. 32.17; *CVA* Castle Ashby, pl. 57.8–10; *CVA* Karlsruhe 2, pl. 72.9–10 (knotted handles); *CVA* Copenhagen 6, pls. 265.5 (knotted handle) and 265.6 (lid and knotted handle); *CVA* Limoges, pl. 24.3 (knotted handle) D. Robinson, C. Harcum, and J. Iliffe, *A Catalogue of the Greek Vases in the Royal Ontario Museum, Toronto* (Toronto 1930) pl. 67.383; *CVA* Trieste 1, IV D, pl. 23.9–10; *CVA* Warsaw 4, pl. 52.1; Bari 1119; Bari, piece in the Cirillo de Blasi Coll. (girl sitting on a stone; Eros with a mirror); Bari, piece in the Macinagrossa Coll. (Eros with a phiale sitting on a stone; standing girl with fan, very tall); Kiel, Antikensammlung B 567; numerous vases of this shape in Naples. Bari 208 had formerly only a white overcoating.

26 For example: K. Goethert in *Antiken aus rheinischem Privatbesitz* (Cologne 1973) no. 88; H. Schaal, *Griechische Vasen und figürliche Tonplastik in Bremen* (Bremen 1933) pl. 25.

27 *CVA* British Museum 1, IV Dc, pl. 6.1, 5; *CVA* Karlsruhe 2, pl. 84.3; Bari 22164; *CVA* Braunschweig, pl. 46.9; *CVA* Warsaw 6, IV D, pl. 17.1–2.

28 M. Del Chiaro, "A Caeretan Red-Figured Mug," *StEtr* 30 (1962) 317–19; P. Mingazzini, *Vasi Castellani* II (1971) pl. 205.754. See also Berlin F 3106 (knotted handle) and Louvre K 486 and K 487 (knotted handle).

29 Cambitoglou's assertion, "Lampas Painter" 40, that this shape is never found with knotted handles is incorrect, as is also his assumption that type N always has a foot or foot ring (see, for instance, the footless examples in n. 26 supra).

30 A. Greifenhagen, *Beiträge zur antiken Reliefkeramik* (Berlin 1963) 36. For the Malacena Group, see also *CVA* Cleveland 1, pl. 40.3; Kiel, Antikensammlung B 113. *CVA* Mainz, *RGZM* 2, pl. 26.5. *Beazley's Gifts* pl. 65.493. T. Poggio, *Ceramica a Vernice Nera di Spina, Le oinochoai Trilobate* (1974) 48, 54f.

31 See nn. 32–46 and 57–67.

32 For instance, J. D. Beazley, *Etruscan Vase-Painting* (Oxford 1947) 220–21 (Xenon Group): *CVA* Bologna 3, IV Dr, pl. 32.10; *CVA* Parma 2, IV D, pl. 9.8; *CVA* Rennes, pl. 44.1 E. Simon et al., *Führer durch die Antikenabteilung des Martin von Wagner Museums der Universität Würzburg* (Mainz 1975) 204 on L

830; *CVA* Switzerland 5, pls. 3.15, 13.1–3 (no. 1 tall—15.5 cm—and thin, no. 3 very low); *Galerie Fortuna, Catalogue no. 38* (Zürich 1981); *La Collezione Polese nel museo di Bari* (1970) 258, no. 259; Bari 6851 b (this and the last are very large, almost 15 cm tall); two pieces in the Cirillo de Blasi Coll., Bari; a very squat piece in the same collection; Bari, Sette Labellarte Coll. 122; Laconte Coll. 20, three pieces in the Macinagrossa Coll.; *Summa Galeries* 4 (Beverly Hills 1978) no. 18.20. M. Scarfi, *MonAnt* 45 (1961) 267, fig. 107.8.

33 *Galerie E. Bloch, Catalogue* XVI (Bern 1975), attributed by Trendall (*LCS* supp. III, no. 815) to the Painter of Naples 1959. Because of the two handles, he calls it a kantharoid krater, but see the Attic examples in n. 8 supra.

34 See n. 19 supra. In citing the following parallels I indicate to the best of my knowledge if the vase has a knotted handle (K) or a lid (L): *Antiken aus dem Akademischen Kunstmuseum Bonn* (Düsseldorf 1971) pl. 102 (squat, K); *RVAp* I, 284, no. 218 (private coll.), nos. 219–20 (Oxford; the leaves are small; no. 220 has a knotted handle); *RVAp* I, 295, no. 82 (Naples Stg. 589; L); *RVAp* I, 299, no. 127 (Taranto), and no. 128 (Bochum), now in N. Kunisch, *Antiken der Sammlung J. Funcke* (1980) 176 (squat); *CVA* Copenhagen 6, pl. 265.2; Naples 2288 (L); Schauenburg, *Perseus in der Kunst des Altertums* (Bonn 1960) pl. 36.2 (Leningrad; squat); an oinochoe in Taranto, from Altamura (sitting youth, girl sitting on a capital, Eros with bird sitting on a stone); once Galerie Palladion, Basel (woman drawn by two horses, charioteer, flying Eros, ivy leaves with white borders, K, L); another piece at the same gallery (Dionysos and two Sileni, one with wineskin, ivy leaves with white borders, K); once Geneva market h. 19.9 cm; Maenad, sitting Silenus, sitting Dionysos, Satyr facing left; K); vase in Fiesole (see n. 51 infra; with rosettes in corners). Small vases (under 10 cm) occasionally have no neck ornament at all, like Bari 6295 and 6296 (h. 9 cm) and *CVA* Bologna 3, IV Dr, pl. 32.16; see also n. 46 infra.

35 For example: Schauenburg, *AA* 1977, 287, fig. 4 (Leiden, K), fig. 6 (Manchester, K), and fig. 7 (Geneva); *BSR* 19 (1951) pl. 5.3–4 (Reading, K); *JHS* 74 (1954) 116, no. 1 (Copenhagen), and 118, no. 1 (Lecce); *RVAp* I, 283, no. 208 (Karlsruhe, K), and no. 210 (Milan, Scala); *RVAp* I, 284, nos. 213 and 221 (both Taranto, L); Sotheby, 13 May 1980, no. 156 (K; tall—22.2 cm—and thin); *CVA* Milan 1, IV D, pl. 9.5–8; *CVA* Switzerland 5, pl. 38.1–3 (L) and pl. 49.1–3 (K); Bari 1297, 2257 (K), 3822, 3833, 5934/41 (L), 5938, 6477, 11965 (very thin, K); Naples, Stg. 525 (fluted handle); Bari, Macinagrossa Coll. (squat, Eros flying to the left with a box and a bunch of grapes); Bari, Cirillo di Blasi Coll. (mouth and handle lost, on the left a sitting girl, on the right an altar); Bari, Sette Labellarte Coll. (Dionysos sitting on a skin, Maenad with a box and a mirror); four pieces in Naples (a: woman's head; b: head of Nike with a wing; c and d: kneeling Eros and knotted handles); Louvre K 153 (K); *RVAp* II, Kap. 29, no. 559, Slg. Chini; *Kunst der Antike, Galerie Puhze* (Freiburg) no. 145 (L and K). *CVA* Capua 4, IV D, pl. 116 (K). *CVA* Musée Rodin, pl. 34.7.9 (K).

36 For instance: fig. 17.9 (Göttingen; tongues on the underside of the lip) *RVAp* II, App. Kap. 26, no. 556 (circle of the Patera Painter); fig 20 (*StEtr* 30 [1962] pl. 28; Paris, Biblio. Nat. 1011–h. 22 cm); Sotheby, 16 May 1980, no. 192 (two oinochoai, L and K, dot-clusters between the rosettes); *CVA* Cambridge 1, pl. 45.5 (K); *JHS* 74 (1954) 118, no. 2 (Toronto); Bari 5930/31 (L and K); 5932/33 (L and K), 6431; a piece in Naples (sitting girl); a piece in Bari, Macinagrossa Coll. (squat, K, Eros with wreath and box sitting on a stone); another piece in the same coll. (L, Eros flying to the right with a phiale and a wreath); *RVAp* II, Kap. 29, nos. 271 and 272 (Bari, Larioia Coll.; L and K); oinochoe on the Swiss market (woman's head in three-quarter profile above flowers and rich florals; L and K, h. 22.9 cm). *RVAp* II, Kap. 29, no. 560, Slg. Chini.

37 Dot-clusters interspersed. *Summa Galleries* 4 (Beverly Hills 1978) 26 (K and L; triple-leaf clusters interspersed); Bari 5934/35 (L and K). Rosettes are common on the necks of shape 8M oinochoai (see n. 23 supra).

38 For example: Bari 1295 (K) two pieces in Naples (both with a sitting girl). Bari 11964 (K).

39 Fig. 17.14: Bari 1172 (K). For the photograph I am indebted to the unfailing kindness of E. de Juliis. Figs. 17.15a–c: Taranto (K). For the photograph I am again indebted to G. Lo Porto. See also *CVA* Sèvres, pl. 40.17, 26–28; *CVA* Karlsruhe 2, pl. 72.12 (K); *CVA* Bucharest 1, pl. 36.5–6; *Galerie Fortuna, Catalogue* (Zürich 1980) 22 (double handle, broken meander, frontal woman's head); Bari 1171 (K), 8274 (K), 12923 (L and K).

40 H. 12 cm, K. Here, after a photo for which I am obliged to V. Alemany. Trendall, in a letter, attributes this vase to the circle of the Baltimore Painter. An oinochoe in Naples has flowers on the neck (K, woman's head on the side). A curious device on the neck of Bari 3832 and 3833.

41 For instance: *JHS* 74 (1954) 116 (Lecce).

42 Sotheby, 13 May 1980, no. 187 (K). For the curious oinochoe *CVA* Compiègne, pl. 22.8 (K), h. 19 cm, see K. Schauenburg, *Boreas* 6 (1983).

43 K. Neugebauer, *Führer durch das Antiquarium: Die Vasen* (Berlin 1932) 156. U. Gehrig kindly informs me that the correct height is 50.7 cm (Neugebauer: 50 cm). I am very much obliged to Gehrig for the photograph and to W. Heilmeyer for permission to publish.

44 Illustrated in a group photograph by E. de Juliis in *AttiMGrecia* 12 (1973) pl. 39 (top); *StEtr* 42 (1974) pl. 90b, h. 57 cm, d. of the mouth 40 cm. d. of the foot 25 cm. For the photographs and permission to publish I am, as so often, very much indebted to the generosity of E. de Juliis. He is preparing an exhaustive treatment of the vase. For the very important painting on the body of the vase, compare the New York hydria (07.128.1): Schauenburg, *JdI* 73 (1958) 58–59. Trendall attributes the Foggia oinochoe to the Dareios Painter (*RVAp* II, 562 Kap. 18.71).

45 Two women's heads on the lid, Eros crouching between two sitting girls on the side; knotted handles.

46 For instance: *RVAp* I, 313, no. 299 (Bari, K); *CVA* Nieborów, pl. 1.4 (Poland 128); *CVA* Rosen, Wielkopolskie Museum, pl. 4.5 (Poland 120, once Berlin F 3385). U. Kästner kindly informs me that Berlin F 3384 and 3397 are lost. See also n. 34 supra at end and Bari 6297.

47 W. Hornbostel et al., *Kunst der Antike* (1977) 391, no. 338 (L, squat). They have overlooked the reference in Trendall, *LCS* supp. I (*BICS* supp. 26) 51, no. 473a. See also K. Schauenburg, *Boreas* 6 (1983).

48 For alabastra see K. Schauenburg, "Unteritalische

Alabastra," *JdI* 87 (1972) 258–98. For rhyta, H. Hoffmann, *Tarentine Rhyta* (Mainz 1966) esp. p. 1. For ball-pyxides, Schauenburg *RivIstArch* 2 (1978) 16ff. For nestorides, G. Schneider-Herrmann, *Lucanian and Apulian Nestorides* (1980)—they are rare in Apulia. For lekanides, G. Schneider-Herrmann, *Apulian Red-Figured Paterae with Flat or Knobbed Handles*, BICS supp. 34 (1977). There are numerous observations on this subject in Trendall, *LCS* and *RVAp* I passim.

49 See n. 43 supra.

50 See n. 44 supra.

51 See n. 34 supra; h. 41.4 cm. *RVAp* I, 427–28, no. 68. *CVA* Fiesole 2, pl. 18–20.

52 Here, after D.A.I. Neg. Rome 76.1214–16., h. 33 cm, *RVAp* I, 126, no. 232; by the Lecce Painter. There is an unusual hatching on the wings of the Nike.

53 See n. 35 supra. Sotheby, 13 May 1980, no. 156. See fig. 17.20 here (n. 36 supra; Cab. Méd.). Bari 5930 has a height of 21.1 cm (l. 27 cm). Bari 5932 reaches 20.60 cm (l. 26.7 cm). I owe this information to E. de Juliis.

54 *ARV²* 1691, addenda to 1342–43 (as no. 7); Rhomiopoulou, " Ἐρυθρόμορφη οἰνοχόη τοῦ μουσείου Καβάλας," *Deltion* 19A (1964) 73–78 and pls. 45–49; Sparks and Talcott, *Agora* XII, 70, n. 9. The shape is 8C; unfortunately, it is impossible to reconstruct the height.

55 See, for example, *RVAp* I, 200, no. 67 (Ruvo) and 208, no. 137.

56 See, for example, *RVAp* I, 431 for volute-kraters and lekanides; *CVA* Lecce 2, IV Dr, pl. 32 for a giant pyxis (h. 52 cm), and ibid. pls. 28.5 and 30–31 for skyphoi; K. Schauenburg, "Unteritalische Alabastra," *JdI* 87 (1972) 282 for alabastra; K. Schauenburg, "Eros und Nereiden auf einer apulischen Kugelpyxis," *RivIstArch* 2 (1978) 16; 20, n. 14 end (the pyxis in Naples [81882], mentioned there contrary to the announcement in the text, has unfortunately not been illustrated; h. 40 cm); Three giant loutrophoroi in a private coll. in Bari (by the Baltimore Painter; the largest reaches 113 cm). See also the vases mentioned in n. 55 supra and now the skyphos, Sotheby, 18 May 1981, no. 395.

57 For instance: Green, *Gnathia Pottery* 14–15, pl. 28 (lip missing); *CVA* Bourges, pl. 27.2–3; *CVA* Sèvres, pl. 48.25; *CVA* Warsaw 6, IV E, pl. 28.2, 6; Bernardini, *Vasi Gnathia* pl. 64.3–5; *CVA* Zürich 1, pl. 51.17. For *astragaloi* see n. 15.

58 For instance: Bari 6104 and 6403; two pieces in Foggia (both with two women's heads on the lid); *CVA* Villa Giulia 1, IV Dr, pl. 2.1; *CVA* Switzerland 5, pl. 40.5–6.

59 Bernardini, *Vasi Gnathia* pl. 50.6.

60 For instance: *CVA* Parma 2, IV D, pl. 3.10; Sparkes and Talcott, *Agora* XII, 123. The terminology is, admittedly, ambiguous; many scholars call krateriskoi kantharoi and vice versa. See n. 66 infra.

61 For instance: *CVA* Brussels 3, IV E, pl. 3.16–17; *CVA* Bucharest 2, pl. 35.1; Robinson, *Catalogue Toronto* pl. 83, no. 455; a piece in West Berlin.

62 For instance: *CVA* Bucharest 2, pl. 33.1; *CVA* Goluchow, pl. 50.3; *CVA* British Museum 1, IV Dc, pl. 7.9; Forti, *Ceramica Gnathia* pl. 14a.1 (Taranto), pl. 23c (Bari), pl. 26b (on the market). Compare also pyxides; there are several examples in Bari.

63 For instance: Bari 3385 (Gnathia-style, one handle missing).

64 *CVA* Goluchow pl. 52.7 (black).

65 For instance: several pieces in Foggia; pelike with the so-called wedding painting in Reggio Calabria; pelike in Taranto (girl, youth, from V. Giovanna Giovine). G. Andreassi, *Ceramica italiota a figure rosse nella coll. Chini del museo civico di Bassano del Grappa* (1979) no. 28. *Galerie Puhze* (Freiburg 1981) no. 189, Gnathia. Pelike Louvre K 96.

66 *CVA* Amsterdam 1, IV Dc, pl. 2.1; *CVA* Cambridge 1, pl. 43.30; *CVA* Goluchow, pl. 50.3 (variant type); *CVA* Copenhagen 7, pl. 278.2; *CVA* Limoges, pl. 35.2–3 *CVA* British Museum 1, IV Dc, pl. 1.17, pl. 2.5, pl. 4.10, 14, 17; *CVA* Naples 3, pl. 54; *CVA* Sèvres, pl. 47.2; *CVA* Warsaw 6, IV D, pl. 24.1, 6; Bernardini, *Vasa Gnathia* pl. 20.2–3, pl. 22 passim, pl. 68.15, 17; Dareggi, *Ceramica greca* pl. 43b; Forti, *Ceramica Gnathia* pl. 3a–b (Bari), pl. 14a, 3–4 (Taranto), pl. 25a (Taranto), pl. 26e (on the market); *MonAnt* 45 (1961) 222, fig. 64.1; Robinson, *Catalogue Toronto* pl. 89.528–30; L. Jehasse, *RA* (1980) 299ff. (Aleria); A. Garcia y Bellido, *Hispania Graeca* (1948) pl. 117.49 (from Alicante); J. H. C. Kern, *Gids voor de verzameling van griekse vazen* (The Hague 1955) fig. 17; Bernardini, *Vasi Gnathia* pl. 21.1–2; T. B. L. Webster, *BICS* 15 (1968) 24 and pl. 3c (Oxford); Bari 3199, 3200; krater on its own stand (for which see Schauenburg in W. Hornbostel et al., *Aus Gräbern und Heiligtümern*, 1980, on no. 116) on the market in 1981 (black, with relief figures of women and children on the neck of side A). Compare also the black ware in E. Breccia, *La Necropoli di Sciatbi* (Cairo 1912) pl. 55.

67 Small vases of this sort are sometimes called krateriskoi, "beakers," or kantharoi. See Sparkes and Talcott, *Agora* XII, 123 and n. 60 supra.

68 See n. 47 supra.

69 See n. 33 supra.

70 For this painter see Trendall, *LCS* 142–58, and most recently *LCS* supp. II, 174–75.

71 Trendall, *LCS* 146, no. 802. Photo Hutin. I am much obliged to C. Lapointe for the photograph.

72 Trendall, *LCS* 150, no. 852. For the photograph and permission to publish I am much obliged to M. Vickers. See also among the works of this painter, *LCS* 144, no. 788 and pl. 67.1–2 (krater in Geneva); *LCS* 144, no. 790 (krater in Naples); *LCS* 145, nos. 791 and 798 (nestorides in London and Vienna); 146, nos. 800 and 808 (nestorides in Amsterdam and Altenburg); *LCS* 147, no. 813 (amphora in Brescia); *LCS* 148, no. 826 (lekythos in Munich); *LCS* 149, no. 845 (lebes in Bologna); *LCS* 150, no. 850 (krater in Naples); *LCS* 150, no. 854 (nestoris in Berlin); *LCS* 151, no. 863 (amphora in Turin); *LCS* 153, no. 882 (lekythos in Naples from the circle of the painter).

73 Trendall, *LCS* 153, no. 880. I am very much obliged to A. Seillier for the photograph. From the circle of the painter are the Naples nestoris, *LCS* 152, no. 874 (fig. 17.31 here) and the Naples lekythos, *LCS* 153, no. 882. For the branch see the nestoris, *LCS* 145, no. 798, *JdI* 89 (1974) 158, fig. 26 (Vienna).

74 See, for instance, *RVAp* I, pl. 122.1–2; kraters in Bari, in the Sette Cirillo Coll. and the Museum; a second krater in the Sette Cirillo Coll., 4 (side A; girl sitting on a rock, Satyr); Trendall, *Vasi Vaticani* pl. 31a (krater); bell-krater in Bari, Macinagrossa Coll., by the Split-Mouth Painter (Trendall) (Satyr and Maenad on side A).

75 For instance: *AA* 1976, 226, fig. 21 (amphora in Berlin); Trendall, *LCS* pl. 57.2 (krater in Winchester); K. Schauenburg, "Herakles und Vogelmonstrum auf einem Krater in Kiel," *Meded* 41 (1979) pl. 9.2 (krater in Kiel); K. Schauenburg in "Zwei Phylakenkra-

tere in Privatbesitz," *Scritti in onore di P. Arias* (1981), for Paestum, where this motif is relatively common. See also A. D. Trendall, *Paestan Pottery* (Rome 1936) pl. 10a (krater in London); G. Schneider-Herrmann, *Eine niederländische Studiensammlung antiker Kunst* (1975) pl. 61 (krater); A. D. Trendall, *Greek Vases in the Logie Collection* (1971) pl. 36b.

76 For instance: Schauenburg, *AA* 1973, 222, fig. 2, 231, fig. 19 (kraters in Kiel and Mainz); *CVA* Sèvres 1, pl. 33.6, 14 (kraters); *CVA* Verona 1, IV D, pls. 7.1b. 2b, 8.2b; Dareggi, *Vasi apuli nella collezione Magnini a Deruta* (1975) pl. 13.2 (krater); Trendall, *Vasi Vaticani* pls. 24c, h, 31c, h, k. Further references in *AA* 1973, 226, n. 11.

77 Trendall, *LCS* 154, no. 884. Here, after a photograph for which I am obliged to C. Prag.

78 Trendall, *LCS* 152, no. 872.

79 See, for example, Trendall, *LCS* pls. 67.1–3, 68.1, 3–6, 69 passim.

80 Trendall, *LCS* 146, no. 811. Here, after D. A. I. Neg. Rome 79.533. See also the Naples krater, *LCS* 150, no. 850.

81 Trendall, *LCS* 144, no. 788. I am grateful to C. Dunant for photographs and permission to publish. Note the ornament under the lip and the neck. Overpainted.

82 Trendall, *LCS* 147, no. 815; see also *LCS* 151, nos. 862 and 864, (amphorae in Marseille and Naples).

83 Fig. 17.26: Trendall, *LCS* 153, no. 878. The reference at *LCS* 150, no. 853 to V. Spinazzola, *Le Arti Decorative in Pompei* (Milan 1928) 211.1.2 actually corresponds with this vase, and even in the descriptions the two vases are confused. Here after D. A. I. Neg. Rome 79.560/61. Fig 17.27; Palermo, N.I. 2203 (2261) *LCS* 157, no. 907. Here, after a photograph for which I am very grateful to V. Tusa.

84 Here, after a photograph for which I am obliged to W. Heilmeyer. For the front side, see *JdI* 89 (1974) 147, fig. 13 and for the shape of the handle p. 150. For the latter cf. the Naples hydria Stg. 37 and two other hydriai in Naples (one in the storeroom has lost one handle), both painted in two zones. See also the painted hydria on the Madrid Asteas krater, A. D. Trendall, *BSR* 20 (1952) 5, no. 39, and, for bronze vases, E. Pernice, *Hellenistische Kunst in Pompeji* IV, 15–16. The ball motif is also found below the handle of the oinochoe in Fiesole, mentioned in nn. 34 and 51 and beside the handle attachment on the oinochoe on the market mentioned in n. 34 (Dionysos and Sileni). Some Apulian examples are the hydria Naples H. 3244; the pyxis Bari, Sette Labellarte Coll. 45 (on the top of the flat lid); a lekane frag. in Bari, Parenzan Coll. 111. Paestan examples: a lebes on the art market (side A: sitting girl with phiale-mirror and black underdress, on the left a "Rahmenleiste" with a typical Paestan diagonal bar, side B: sitting youth. Both sit on white vines; there are sharp "pyramids" on the shoulder; the ball motif appears beneath the handles); Trendall, *Paestan Pottery* pl. 19d, krater in the Louvre. Simialar representations occasionally appear on the Attic vases of the fourth century B.C.; e.g., on the lekanis Bari 1256.

85 D. A. I. Neg. Rome 81.846.

86 Fig. 17.29: Berlin F 3146, Trendall, *LCS* 150, no. 854. Some other examples are *LCS* 112, no. 579, (hydria in the Louvre; to appear in *Meded* 44 [1982]); *LCS* 145, no. 789, (nestoris in Vienna); *LCS* 146, no. 808 (nestoris in Altenburg); *LCS* 151, no. 862 (amphora in Marseilles). From the circle of this painter see for

instance *LCS* 153, nos. 876–77 (amphorae in Turin; balls in the ornament and as a filling pattern); *LCS* 154, no. 886 (nestoris in Portland). Also Lucanian is, for instance, the Naples lekythos *LCS* 183, no. 1106.

87 G. Schneider-Herrmann, "Der Ball bei den Westgriechen," *BABesch* 46 (1971) 123ff. H. Schauenburg, "Erotenspiele, 1. Teil," *Antike Welt* 7 (1976) no. 4, pp. 28ff. See also, for example, *CVA* Copenhagen 4, pl. 167.3 (lekythos) and *RVAp* 1. 284, no. 224 (oinochoe in Oxford). Some examples on the work of the Naples 1959 Painter are Trendall, *LCS* 145, no. 793 (amphora in Naples); *LCS* 148, no. 826 (lekythos in Munich); *LCS* 149, no. 845 (lebes in Bologna); *LCS* 150, no. 853 (nestoris in Naples)/ *LCS* 151, no. 865 (oinochoe in the Louvre). See also *LCS* 146, nos. 804 and 808 (nestorides in Turin and Altenburg); *LCS* 149. no. 844 (lebes in Bologna); fig. 17.21 here (nestoris in Oxford).

88 Correctly Schneider-Herrmann (supra n. 87).

89 Schauenburg, "Zu einem unteritalischen Ornament," *RömMitt* 62 (1955) 124–28. Since then, esp. in the area of Sicilian ceramic, considerably more examples have turned up. See esp. Trendall, *LCS* 706 s.v. "cushions" and *LCS* supp. 1, pl. 25.3–4 (pyxis on the market). For Apulian examples see for instance the pyxides Ruvo, Jatta Coll. 1217 and 1454. See also the peculiar vase *CVA* Warsaw 5, pl. 44.1, 3.

90 Trendall, *LCS* 150, no. 853. Here, after D. A. I. Neg. Rome 79.558–58.

91 Trendall, *LCS* 150, no. 852, Schauenburg, *JdI* 89 (1974) 152, fig. 17.

92 For particularly mythological vases of this painter see esp. Trendall, *LCS* 145, nos. 791, 792, 794; *LCS* 146, no. 818; *LCS* 151, no. 862..

93 Trendall, *LCS* 148, no. 836. The only South Italian parallel is the Apulian krater, Berlin F 3258.

94 Trendall, *LCS* 151, no. 864. For the motif see Schauenburg, *BonnJbb* 155–56 (1955–1956) 59–94 and 162 (1962) 98–106. For the bird-scepter on the reverse side see Schauenburg, *RömMitt* 82 (1975) 207–16.

95 Trendall, *LCS* 152, no. 874. Here, after DAI. Neg. Rome 79.566. See *LCS* 144 for his use of the olpe shape, rare in Lucania, and also the lekythos in Munich, *LCS* 148, no. 826, in the obsolete fashion with two friezes.

96 The meander band consists of the following elements (beginning under the handle): rectangle with an upright cross, in each quadrant a dot and a short stroke extending in from the corner, followed by three meanders; rectangle with cross and dots followed by thrice three meanders; rectangle with Saint Andrews cross and dots; three meanders; rectangle with cross and dots; five meanders; rectangle with cross and dots; three meanders.

97 Trendall, *LCS* 156. no. 893. Here, after photographs for which I am obliged to F. Bastet.

98 For this see K. Schauenburg, "Frauen im Festen," *RömMitt* 79 (1972) 10–11 and "Frauen im Festen (Natrag zu 1)," *RömMitt* 80 (1973) 271–73.

99 The old disagreement whether such an animal is meant to be a leopard or a panther is meaningless, since the two names apply to what is zoologically the same animal.

100 For sleeping Sileni see also K. Schauenburg, "Zu einer Situla in Privatbesitz," *Meded* 43 (1981). Compare *AthMitt* 63/64 (1938) pl. 68.1 (krater in Athens); E. Simon in "Ungedeutete Wandbilder der Casa del Citarista zu Pompeji," *Mélanges H. Mansel* 1

(1974) 34 for Maenads, in Imperial times.

101 The best-known example is the Dionysos on the François Vase. For southern Italy see also K. Schauenburg, "Der geschundene Marsyas," *Röm-Mitt* 79 (1972) 321–22.

102 For Sileni reclining at symposia see: Schauenburg, *JdI* 88 (1973) 6ff.; J. Boardman, *Archaic Greek Gems* (London 1968) 53–59; P. Mingazzini, *Vasi Castellani* II, on no. 744; *ARV²* 179, no. 2 (cup in the Faina Coll.); G. Ricci, "Necropoli della Banditaccia," *MonAnt* 42 (1955) 970–71, fig. 231.1 (oinochoe in the Villa Giulia); A. Lezzi-Hafter, *Der Schuwalowmaler* (Mainz 1975) pl. 66c (olpe in the Villa Giulia—Maenads); J. Frel, *Painting on Vases* (1980) 34 (frag. of an oinochoe, Maenad); C. Boulter and J. Bentz, *Hesperia* 49 (1980) 302–3, no. 21 (frag. of a cup—Maenad).

103 See K. Schauenburg, "Silene beim Symposium," *JdI* 88 (1973) 7 and *ABV* 376, no. 220 (Silenus reclining with his upper body erect on a pelike in Boulogne).

104 For Attic examples, see, for instance, J. D. Beazley, "Excavations at Al Mina, Sueidia III: The Red-Figured Vases," *JHS* 59 (1939) 33, no. 84 (frag. from Al Mina) and *CVA* Los Angeles 1, pl. 32.4 (krater). For southern Italy: Trendall, *LCS* 112, no. 577 (oinochoe in the British Museum); *LCS* 114, no. 593 (krater in Naples); *LCS* 172, no. 986 (lost pelike); *LCS* 212, no. 69 (krater in Lipari); *LCS* 260, no. 231 (krater in Palermo); *LCS* 452, no. 2 (krater in Madrid); *LCS* 410, no. 331 (krater in the Louvre); *RVAp* I, 38, no. 20 (hydria in Oxford); *RVAp* I, 172, no. 50 (oinochoe in Toledo—reclining Dionysos). This last motif appears on a krater in Ruvo: H. Sichtermann, *Griechische Vasen in Unteritalien aus der Sammlung Jatta in Ruvo, Bilderhefte des deutschen archäologischen Instituts Rom* 3–4 (1966) pl. 84, Inghirami, *Pitture di vasi etruschi* II, pl. 144—sitting Dionysos; *Hesperia Art Bulletin* 49.16 (bell-krater)—sleeping Maenad; A. D. Trendall and T. B. L. Webster, *Illustrations of Greek Drama* III (London 1971) 3.26 (krater in Naples); an Apulian bell-krater in Florence—sitting Dionysos to his left a Satyr with a wreath, to his right a Maenad with taenia and situla; an Apulian bell-krater on the Swiss market (1981)—a Silenus lying on a panther skin, seen from behind, a wineskin, Dionysos, to the right a sitting, flute-playing Maenad, in the foreground a dog. The krater *RVAp* I, 212, no. 153, pl. 67.3 (Lagioia Coll.) certainly belongs here; the Satyr and the mask indicate that the reclining figure is Dionysos, not a mortal symposiast. Compare also the lekane *RVAp* I, 281, no. 190 (London).

105 *RVAp* I, 380, no. 161.

106 An Apulian rhyton in a private coll. in Bari sheds new light on the old debate whether certain horned youths were meant to be Sileni or *panes*. On this piece two figures stride toward the right; unmistakably recognizable as Sileni, they are bearded and horned. The horns are extraordinarily large. The first Silenus carries a wineskin, the second a wineskin and a torch. On this question see K. Schauenburg, "Zu unteritalischen Situlen," *AA* 1981, 474.

107 Some references in K. Schauenburg, "Herakles Musikos," *JdI* 94 (1979) 51–52, n. 13.

108 For a Silenus with a pointed amphora on his shoulder on a red-figured vase, see *ARV²* 185, no. 31 (krater in the Fogg Museum, Harvard Univ.; another Silenus shoulders a wineskin, a third carries an immense krater in front of himself). For krater-carriers in southern Italy see for instance the Dionysos

on the Naples nestoris, Trendall, *LCS* 113, no. 587, and also: *RVAp* I, 98, no. 236, pl. 28.79 (krater in Leningrad); K. Schauenburg, "Zu einer Situla in Privatbesitz," *Meded* 43 (1981); Gnathia krater Berlin F 3453 (Satyr). For Sileni with amphorae see, for instance, bell-krater Naples H 2041; *Meded* 43 (1981) pl. 28.78; *Finarte* 5 (1963) pl. 43.85b; *CVA* Gotha 2, pl. 82.2; *LCS* 415, no. 363 (krater in Lisbon).

109 For instance: on the red-figured cup, G. Riccioni, *La Tomba della Panatenaica* (1968) 39, no. 24a (Vulci). For goats and Sileni in general, F. Brommer, *Satyrspiele²* (1959) 81, 158ff.

110 For instance: *ABV* 527, no. 17 (oinochoe on the London market); *Galerie Laforet* (Geneva 1980) 19 (black-figured neck-amphora); *Galerie Finarte* (n.d.) pl. 26.54 (skyphos by the Theseus Painter). Dionysos lies on a goat on the stamnos *ARV²* 207, no. 142 (Louvre). A companion example is Trendall, *LCS* 237, no. 80, pl. 93.6 (privately owned). For an example of a Satyr on a ram see the lekythos J. Hemelrijk, *BABesch* 49 (1974) 157 (Anatolia).

111 For instance, on the black-figure pelike Sotheby, 1 December 1969, no. 83. Compare the white-ground lekythos in Naples, *ARV²* 302, no. 13 (draped Silenus advancing behind a goat).

112 For instance: *Hesperia Art Bulletin* XIV, no. 6 (red-figure cup; Silenus leading a goat to the right) and *CVA* Boston 2, pl. 52.1 (black-figure amphora). On the Naples cup *ARV²* 764, no. 5, a Silenus strides toward a goat from the front; here an erotic motif is also possible. For the motif of a Silenus leading a goat in later art, see M. Blanchard, *AntAfr* 15 (1980) 169ff. Apulian bell-krater Madrid 32657.

113 H. Bulle in *Festschrift J. Loeb* (1930) 27, fig. 13. Cp. the lost bell-krater D. A. I. Neg. Rome 77.1181 (Silenus sitting on a pigskin). See now A. Greifenhagen, *AA* 1981, 292–93, fig. 61 (the animal is not identified).

114 For instance: Winter, *Typenkatalog* II (1903) 309; S. Besques, *Catalogue raisonné des figurines et reliefs en terre cuite grecs et romains* (Paris 1972) 69, pl. 94c (grotesque man); A. B. Cook, *Zeus* II (1925) 132, fig. 79 (Baubo in Berlin); M. Velickova, *Catalogue des terres cuites grecques et romaines* (Belgrad 1957) 106; *Galerie Laforet* (Geneva 1980) 51 (Eros); Christie, 28 November–19 December, 1979, no. 206 (a child hangs on to a boar); L. Gatti-Lo Guzzo, *Il Deposito votivo dell' 'Esquilino detto di Minerva Medica* (1978) 32; *StMisc* 25 (1980) 83; Bari 13168; *La collezione Polese nel museo di Bari* (1970) nos. 379, 382 (many examples); Bari Abruzzese Coll. 258 (child lying on a boar); a similar piece in another collection in Bari and in the Sette Labellarte Coll.; Bari, Sette Labellarte Coll. 380 (child riding on a pig). For the general type see Sichtermann, *Griechische Vasen in Unteritalien* on pl. 156, no. 111, and also M. A. Cotton and H. B. Vander Poel, *BSR* 37 (1969) 140. For Isis, see now J. Bermann, *From the Gustavianum Collection in Upsala* (1974) 29ff.

115 K. Schauenburg in *Charites, Festschrift E. Langlotz* (1957) 173–74, with literature.

116 Ibid.; *JdI* 68 (1958) 53–54; and H. Herdejürgen, *Götter, Menschen und Dämonen* (1978) on no. 63.

117 See L. Forti. *RendNap* 32 (1957) 57ff., and pl. 1.

118 For pig sacrifice in general and its recipients see H. Metzger, *Recherches sur l'imagerie Athénienne* (Paris 1965) 116–18.

119 See, however, the krater in Athens with a pig decorated with flowers, Metzger, *Recherches* pl. 48.2.

120 K. Schauenburg, "Zu Darstellungen aus der Sage des

Admet und des Kadmos," *Gymnasium* 64 (1957) 221–23.

121 On this topic in general, see, most recently, H. Metzger, *Les représentations dans la céramique du IV^e siècle*, Bibliothèque des Écoles Françaises d'Athènes et de Rome 172 (1951) 136–39, and F. Matz. *Ein römisches Meisterwerk, JdI* supp. 19 (Berlin 1958) 15–31. To the references given there may be added, for instance: F. Salviat, *BCH* 98 (1974) 501, fig. 3; *De Gyptis à J. César* 49 (1976) (privately owned hydria). See also, for instance: *ARV²* 1431, no.1 (krater in the Mustilli Coll.); *ARV²* 1447, no.2 (krater in Ferrara), now in N. Alfieri, *Spina: Museo archeologico* (Bologna 1979) no. 278; *ARV²* 1449, no. 1 (calyx-krater in Athens); *ARV²* 1694, addenda to 1453–55 (krater, once de Clerq, now in the Louvre) L. Massei, *Gli askoi a figure rosse delle necropoli di Spina* (Milan 1978) pl. 71.2–3 (krater); D. M. Robinson, *Excavations at Olynthus* v (Baltimore 1933) pl. 86, no. 192, krater (panther with wings); pl. 126, no. 285 (frag. of a pelike, Dionysos?); the relief pyxis Berlin 3589. For Eros on the panther, see for instance: *CVA* Budapest 1, pl. 41 (I owe this reference to the kindness of J. Szilagyi); J. Schefold, *Untersuchungen zu den Kertscher Vasen* (Berlin 1934) fig. 80 (pelike in New York); *CVA* Bonn 1, pl. 21.3 (krater) R. A. Higgins, *Catalogue of the Terracottas in the British Museum* II (London 1959) 68, no. 1719 (frag. of a plastic vase, a lion); T. Draus, *JdI* 69 (1954) 40, n. 36 (on Megarian oinochoai); M. Hobling, *BSA* 26 (1923–1924) 306–7, fig. 10n (plastic vase from Sparta, a lion). There is a youth (Dionysos?) on the frag. G. van Hoorn, *Choes and Anthesteria* (Leiden 1951) fig. 314 (Agora Museum). For women on wild animals, see *ARV²* 1337, no. 10 (frag. of a plate in Boston, a lion); *ARV²* 1550, no. 6 (kantharos in New York); G. Trias de Arribas, *Cermicas griegas de la peninsula iberica* (1968) pl. 236 (krater in Jaen); *Excavations at Olynthus* XIII, pl. 66.51 (krater with male and female figures); the Kertscher calyx-krater Athens N.M. 17999; *ABL* 227, no. 41 (lekythos in Naples, Nereid); *Paralipomena* 255, no. 26 (skyphos in Boston, Amazons and lions); red-figure sherd in the Lowie Museum, Berkeley (photograph by E. Bell. Dionysos on a panther. I owe this reference to W. Moon).

122 Matz (*Meisterwerk*) confuses this krater with the krater in Cambridge (fig. 17.34). The Vatican krater is mentioned by H. Metzger, "Bulletin archéologique céramique," *REG* 73 (1960) 126.

123 *ARV²* 1431, no. 2.

124 S. Reinach, *Répertoire des vases peints grecs et étrusques* II² (1922–1924) 382 with literature; W. Leonhard, *Neapolis* 2 (1914) 69; *ARV²* 1453, no. 11. Matz (*Meisterwerk*) and Leonhard confuse it with the Vatican krater. It is identical with the krater: Tillyard, *Hope Vases* no. 314, which Metzger "added" to the list, *REG* 73 (1960) 126.

125 *Bulletin of the St. Louis Art Museum* 7 (1922) 11, fig. 5. I am much obliged to L. Walker for the photograph.

126 Stamnos, West Berlin 5825, Beazley, *EVP* 88, 92. I am much obliged to W. Heilmeyer for the photograph and permission to publish. Some further examples: A. Emiliozzi, *La collezione Rossi Danielli nel museo cicico di Viterbo* (1974) pl. 114.217 (skyphos); a poorly preserved skyphos in Grosseto (Silenus riding toward the right); calyx-krater Florence 4044. Cp. D.A.I. Neg. Rome 74.820 (urn in Grosseto, youthful panther riders among fallen war-

riors); J. Thimme, *StEtr* 23 (1954) 64, fig. 17 (urn is Chiusi); G. Bordenache, *Ciste prenestine* I (1979) 137–38, Perugia 135 (urn with boy on panther); *Archaeologike Ephemeris* 75 (1974) pl. 59b (cup in Chicago).

127 Trendall, *Vasi Vaticani* II, pl. 59g (cup); Situla Louvre s 4181. The plastic vases go back to the fourth century: M. Trumpf-Lyritzaki, *Griechische Figurenvasen des reichen Stils und der späten Klassik* (Bonn 1969) 83, nos. 309–10. Out of the copious material see esp.: J. P. Lauer and C. Picard, *Les statues ptolémaïques du Serapieion de Memphis* (Paris 1955) 185, n. 3; D. Burr Thompson, *Troy, Supplementary Monograph 3: The Terracotta Figurines* (Princeton 1963) 137–38, for the terra-cottas (mostly South Italian); E. Kiss, *Etudes et Travaux* 2 (1968) 268ff. See also I. Scott Ryberg, *An Archaeological Record of Rome* (Philadelphia 1940) 169 and some of the authors mentioned in n. 130 infra.

129 For instance: an altar in Rome, Museo de Terme 29370 (D. A. I. Neg. Rome 74.242); L Foucher, *La maison de la procession dionysiaque à el Jem* (Paris 1963) 118ff.; G. Picard, *RAfr* 398/99 (1944) 5ff.; B. Segall in R. Bowen and F. Albright, *Archaeological Discoveries in South Arabia* (Baltimore 1958) 155–78. The motif appears on gems, bronze reliefs, and esp. mosaics (there is one also at Ancona); it is quite common on bronzes and terra-cottas.

130 For instance: H. G. Horn, *Mysteriensymbolik auf dem Kölner Dionysosmosaik, Beihefte der BonnJbb* 33 (1972) 111–12; R. P. Hinks, *Catalogue of the Greek, Etruscan, and Roman Paintings and Mosaics in the British Museum* (London 1933) 101, no. 35; A. Leibundgut, *Die römischen Lampen der Schweiz* (1977) 151; K. M. D. Dunbabin, *The Mosaics of Roman North Africa* (Oxford 1978) 174–81; Kiss, *EtTrav* 268ff.; Foucher, *La maison* pls. 12, 13 (tigress); E. Schwinzer, *Schwebende Gruppen in der pompeianischen Wandmalerei* (1979) 116ff.; F. Matz, *Antike Sarkophagreliefs,* IV 1, 157–58. See also Leonhard, *Neapolis* 2, 62f.; with the old examples. See now also P. Bruneau, *Exploration Archéologique de Délos, 29, Les mosaïques* (Paris 1972) 78–79 (panther or tiger) for mosaics of the fourth century and later. From the age of Alexander on, the tiger is also found driven or ridden.

131 Often on gems, usually with lions; for instance: *Antike Gemmen in Deutschen Sammlungen* III (Wiesbaden 1970) on Göttingen nos. 44, 147 (P. Gercke) and *Antike Gemmen* I.3 (Munich 1972) on no. 2288 (E. Brandt); *AA* 1895, 227 (gem in Athens); *Münzen und Medaillen, Sonderliste L* (Basel 1969) 56 (gem); *Southesk Collection of Ancient Gems* D 12 (panther); Horn, *Mysteriensymbolik* 107–7; Helbig, *Fuhrer³* 1910, basis in the Villa Albani, see Index B 152; A. Adriani, *Divagazioni intorno ad una coppa paesistica del museo di Alessandria* (Rome 1959) pl. 35, no. 101 (bronze handle in a private coll.). See also: Winter, *Typenkatalog* II, 318 (Eros on a lion or panther); Bari, Labellarte Coll. 215 (statuette of Eros on a lion).

132 Jehasse, *Nécropole* pl. 95.321 (Gnathia krater, white panther); *CVA* Louvre 15, IV E, pl. 16.1–2, pl. 21.1–3, and p. 35 (M. Jentel on Calenian *gutti).* For these last see also K. Masner, *Die Sammlung antiker Vasen und Terrakotten des königlichen österreichischen Museums* (Vienna 1892) no. 570; D. Adamesteanu, *MonAnt* 44 (1958) 257–58, fig. 29; F. Bastet, *Catalogue de la collection de l'université de Leiden* 27.46 (Eros on a panther?). Most Calenian

vases have lions rather than panthers. See also the terra-cotta statuette in Bari, Labellarte Coll. 215 (Eros on a lion).

133 For instance: K. Schauenburg, *RömMitt* 69 (1962) pl. 14.2 (Apulian calyx-krater in Naples).

134 For instance: C. Kern, *Oudheidkundige Mededelingen, Leiden* 41 (1960) pl. 1 (Paestan cup in Leiden); R. Pagenstecher, *Die Calenische Reliefkeramik, JdI* supp. 8 (Berlin 1909) 100, no. 201.

135 To be published by E. de Juliis.

136 For this see Matz, *Meisterwerk,* where he refers also to the group of Calenian vases. His no. B 1, Louvre G 511, is Attic, not Apulian *(ARV² 1431, no. 2).* Fig. 17.38: Matz no. B 3 (Louvre K 240), Trendall, *BSR* 20 (1952) 7, no. 91. Here, after a photograph for which I am obligated to A. Pasquier.

137 A. D. Trendall, *Jahrbuch der Berliner Museen* 12 (1970) 162–68, fig. 6.

138 *RVAp* II, 865, no. 27/40, pl. 327. For the photograph I am again obliged to G. Lo Porto. K. Schauenburg, *AA* (1981) 483, fig. 30f.

139 See now Schauenburg, *AA* 1981, 484, n. 107. To the references there should be added: H. Lohmann, *Grabdenkmäler auf unteritalischen Vasen* (1979) pl. 17.1 (krater in a private coll.), pl. 18.3 (amphora in Bari); on both there is a bird on a string. See also: *RVAp* I, 19, no. 84 (lekythos on the market); *BABesch* 45 (1970) 96, fig. 12 (lekane in Marseille). For the theme in general, see also J. Toynbee, "Graeco-Roman Neck-Wear for Animals," *Latomus* 35 (1976) 269–75.

140 *RVAp* I, 263, no. 23, Schauenburg, *Meded* 41 (1979) pl. 4.8.

141 On an Etruscan skyphos in Ferrara, Dionysos himself holds a panther by a rope.

142 See, for instance: R. Calza et al., *Antichità di Villa Doria Pamfili* (1977) 207; *Repertorium der christlich-antiken Sarkophage* I (1967) no. 765, in the Museo delle Terme (H. Brandenburg). Arkesilaos' group of lions tamed by Erotes was famous in antiquity.

Some Aspects of the Gospel in the Light of Greek Iconography

18

KARL SCHEFOLD

There are many books by theologians about the Classical background of the Gospel, but not a single one written by an archaeologist, in spite of the immense richness of Hellenistic and Roman art. Indeed, the visual arts did not play any important role in the Jewish and early Christian book-oriented religion. The archaeology of Palestine has no direct importance for the understanding of the Gospels.[1] Only from the late third century A.D. did the Christians overcome their lingering aversion to the fine arts, and only after her victory did the Church outgrow her Jewish heritage and adopt many elements from the very Classical culture she had set out to dethrone.

There were contacts between Palestine and the Hellenistic world, nonetheless, even in the arts, which are important for a new understanding of the Gospel. Until now, historians of religion have been more interested in the Imperial period than in the preceding centuries. Examples would include F. Cumont, in his famous book, *The Oriental Religions in Roman Paganism* (Chicago 1911); F. van der Meer and C. Mormann in their *Atlas of the Early Christian World* (London 1958); J. Leipoldt and W. Grundman in their three volumes *Umwelt des Urchristentums* (Berlin 1966, 1976[4]); and most of the authors of the series *Etudes Préliminaires aux Religions Orientales dans l'Empire Romain* (Leiden 1961–80). However, in the Imperial period, as in an Augustan wall-painting, the mystery religions had already lost a good deal of their original vitality. They became doctrinal sects, inferior to the powerful life of early Christianity. At the end of the second century, even in the Church, some formalizing elements are to be observed, for instance, in the pronouncement that all four Gospels were the very word of God. For the understanding of earliest Christianity the Isis religion, as a comparable but contrary phenomenon, has a certain importance. The Hellenistic origins of this competitor, however, may only be understood with the help of archaeological sources, which have generally been disregarded until now.[2]

It is obvious how the early Christians were linked with the Jews by the Old Testament, and how Christ Himself was rooted in this tradition. Conscious of fulfilling the law, He was in reality much more than the law, teaching not only moral doctrines but being Himself the New Life. Christ said: "I am the truth" (John 14:6) and He was what He taught. There is a realm of truth which stands by itself and is beyond argument. His life was the light of men and light needs no proof; it needs only to be seen. Therefore Christ speaks with great authority: "Ye have heard that it has been said by them of old . . . but I say to you . . ." (Matt. 4:21–48).

Christ's vision of all tradition and of man's destiny presupposes a conception of humanity unknown to all pre-Greek civilizations and also to the Old Testament. Though God gave Adam and Eve His own form, a real understanding of man's nature only starts with the Greeks, symbolized first in the vision of Apollo, as W. F. Otto stated.[3] The one big Archaic bronze statue, now known to us since its discovery in Piraeus 1959, should not be called a kouros, but should be recognized as the unique, preserved cult-statue of Apollo (fig. 18.1).[4] During the Archaic period bronze-casting was not universally used as in the Classic period but meant a distinction. Besides,

the Piraeus Apollo has no athletic features like the kouroi, but rather younger features, like one of his followers in the pediment of Antenor's temple of Apollo at Delphi. In the Piraeus bronze, Apollo appears as Leto's newly born child, even though he is already fully present with his whole power: the left fist gripping a bow, the right hand flat with the palm turned upward, perhaps holding a golden bowl. Not only does he punish but he expiates as well. As R. Pfeiffer has shown, among Apollo's commandments, one was a surprising: μετανοεῖ ἁμαρτῶν, "repent, having failed."[5] The god's benevolent right side with the bowl is emphasized more than the punishing one. Thus his right foot advances, not his left one, in contrast to the kouroi; likewise, the long-haired head does not have the upright pride of the kouroi, but is slightly bent, mercifully, but also submissively, because Apollo prophesies Zeus' decisions. Like Apollo we all are blessed by grace and restricted by our nature. The same fundamental conception of humanity was known to Pheidias, as he interpreted it in his sublime Classical way in the Kassel Apollo,[6] but he had to give up the Archaic severity and rigor. Provided that Pheidias knew the Piraeus Apollo, this precious work must be Attic. The head differs from the Kroisos' kouros head more by its divinity than by its style.

Christ presupposes the Attic conception of humanity, as it was formulated later, especially by Isocrates and his Hellenistic followers. Christ does not investigate man's nature as the Greeks do, but He knows it, the lower depths as well as the heights. Like no one in the Old Testament He saw human life as it could be. To follow Christ was like coming into a family of brothers. Thus the kingdom of heaven would be brought about. We should not wait for another world; we have to work for its coming. This is man's first duty, beside which all other duties count for nothing. God is not the God of the dead but the God of the living. That is His answer to the Greek followers of Sokrates' question: What shall we do?

The ancient Jewish question was different. They knew from God Himself the destiny of His people, the way into the promised land in a far future. Like the Jews the early Christians emphasized the contrast to the Greek cult and repudiated those mystery religions' deceitful and delusive practices. And of course, Israel excelled by its holy book, Greece by its art, but both peoples were equally great in the fields of religion and poetry. And we should not forget the Greek costume in which Christ Himself appears upon the

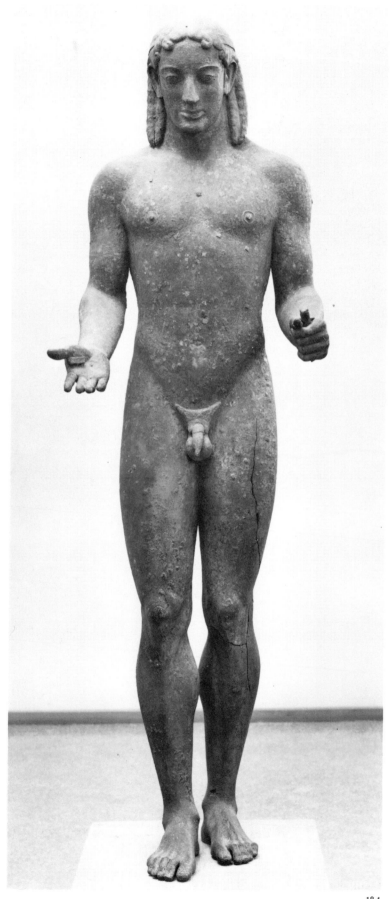

18.1

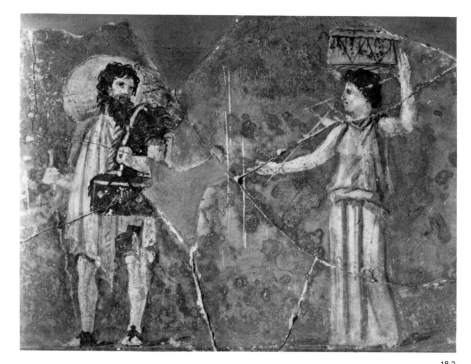

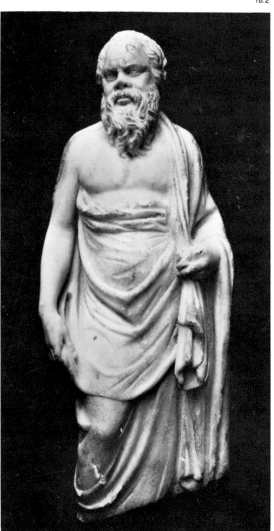

monuments of early Christian art. Christ and His disciples never wear Oriental costumes like the three wise men. This early attire preserves an important tradition, "for the things of the spirit are most plain at their origin and nowhere is the water so clear as close to the source" (Van der Meer). In the famous statue in the Museo delle Terme two traditions are united: the teaching philosopher and the heaven-gazing prince, known since the late portrait of Alexander the Great.[7] This conception of Christ is nearer to the Sermon on the Mount than the later Pantokrator images.

Christ announces the Kingdom of God in the near future to all nations, not only to the Jews, and demands obedience from all, a complete surrender to the will of God. He turns to men and women, to Samaritans, tax collectors, publicans, and outcasts. By this universal conception of humanity Christ transforms the Jewish religion from a national to a universal one, as the Greeks in Egypt transformed the national Isis religion into a world religion.

I regard Christ's relation to His followers as another Greek element. He wandered through the Holy Land, joined with His disciples by His love, like a philosopher of the Cynic school (fig. 18.2). Thus Krates, about 300 B.C., distributed his belongings among his fellow citizens. A beautiful girl from a rich family left all her riches to follow Krates, as a painting from the gardens of the Farnesina shows, a copy of an early Hellenistic original.[8] Just as the Cynics only carried a staff and a wallet, Christ instructed His disciples to take nothing but a staff for the journey (Mark 6:8). The parables in Krates' witty poems sometimes remind one of Christ, for instance his statement "wealth amassed is a temptation to vanity."

Nowhere in the Old Testament do we find a similar personal relationship between a teacher and his pupils as in Christ's understanding of Peter, Matthew, John, the Samaritan woman, Martha, and the Marys, but we do find it in Epicurus' friendship with his male and female pupils and slaves. And even of old, Christian teachers recognized Sokrates' likeness to Christ (fig. 18.3) as an example that a soul could be Christlike by nature,[9] ardently searching for the truth throughout its lifetime. It has recently been shown that Plato's description of the wise man's suffering for the truth anticipates Christ's pains on the cross.[10] In his last hour Sokrates asked his friends to think of the truth and not of Sokrates, and Christ spoke to Pilate: "For this cause came I into the world, that I should bear witness to

18.1. Athens, N. M. Bronze statue from the Piraeus. Apollo. Courtesy of the National Museum, Athens. Photo: Hirmer Fotoarchiv.

18.2. Painting in Rome. Krates and Hipparcheia. Courtesy of Museo delle Terme. Photo: Alinari.

18.3. Marble statuette in London. Sokrates. Courtesy of the Trustees of the British Museum. Archäologisches Seminar Basel.

The Gospel in the Light of Greek Iconography 287

the truth" (John 18:37). Hamilton showed in *Witness to the Truth* that we can use Sokrates "as a stepping-stone to Christ, a first aid in realizing what Christ was."[11] In no original part of the Gospel does Christ claim an elevated position for Himself or allow His disciples to do so. Neither Sokrates nor Christ had a system of thought which could be considered apart from their persons. Sokrates, the Athenian, like Christ, lived his truth and died for it. A life can be more lasting than a system of thought. Saint Paul, as a Roman citizen, was the first to have a Christian system of thought, and churches were later built upon it.

Christ is also near Sokrates in His prayer. Its noble simplicity turns away from the Old Testament's hymnic language and it is far from the ecstasy of the early Church. We find the same simplicity in Sokrates' prayer in Plato's *Phaedrus* (279 B.C.) "Give me beauty in my soul within and may the inward and the outer man be one. May I reckon the wise man rich, and may I have only as much gold as a temperate man can bear or endure." Christ's way of speaking to His father joins the Jewish tradition with the inwardness and the refined knowledge and leading of the soul of Hellenistic philosophy, as mirrored in portraits of philosophers and early Hellenistic poets. I recall, for example, an admirable study, supposed to represent Philemon, and two of the few preserved originals, the representations of Ariston Chios and of Chrysippos.[12] Christ's intimate prayer became too well known to us and too self-evident to be valued enough for its unique content. And we forget how new all of this sentiment was in the Holy Land, for example, the Beatitudes of the Sermon on the Mount, Christ's first recorded speech, and the commandment to love our neighbor as ourself, this cornerstone of Hesperian culture.

Christ was a revolutionary like many Greek philosophers, in contrast to the conservative Jewish tradition. His declaration that He was the Son of God and that God dwells in the hearts of men, was destructive to authority, to the whole Jewish law. The talk of setting men free, free even from the Sabbath, was highly dangerous and presupposes the freedom of Greek thought. But Christ had nothing to do with the fanatic Jewish sectarians. He demanded not political aims but a new humanity, following the will of God. The statement about the imminent end of the world in Matthew, Mark, and Luke, about the frightful calamities which are about to happen and which will usher in the triumph of the Lord, belonged to Jewish tradition. It made its

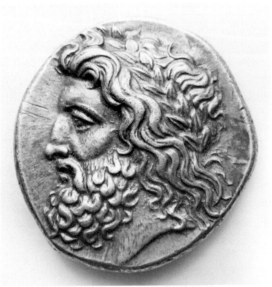

18.4

way into the records of Christ's life, in spite of its being incompatible with the Sermon on the Mount.

As in early Greek thought and in Geometric and Archaic art, we find fundamental notions of life in the Gospel: the herdsman, the door, the way, the light, the bread, the grape, the flower.[13] Christ's language seizes us by its spiritual originality and poetic force, whilst later in Saint Paul's letters thoughtful speculation and theology prevail. The unconditional idealism of the Sermon on the Mount reminds us of Plato's ideology, which was in part realized by late Classical art, for instance, in Leochares' vision of Zeus, praised, as it seems, by Plato himself (fig. 18.4).[14] Plato's criticism of art concerns only the so-called rich style of his youth, whilst the late Classical images of the gods were regarded in all classicistic periods as the utmost approach to the ideal.

In spite of the evident difference between Christian and Classical unconditionalness, today we should dare to see the common call as a beacon on the way to the new life which Christ's Revelation asks us to lead. It does not make sense any more to defend Christianity against the Classical divinities as in late antiquity. Today there are new enemies, Mammon and so-called progress, whilst the Greek gods help us to understand creation. God and the Classical divinities are so different that we are led to misunderstandings to use the same word God for both. We may see the divinities as part of creation, as children of God, as many poets called them. We may call the Classical divinities the peaks which the Greek interpretation of the world reached, but they are never to be compared with the transcendent Creator.

18.4. Silver Stater, Arcadian League. Zeus. Courtesy of the Trustees of the British Museum. Photo: Hirmer Fotoarchiv.

18.5. Cubiculum from Boscoreale, New York. Courtesy of the Metropolitan Museum. Archäologisches Seminar Basel.

18.6. Santa Maria Maggiore. Mosaic in Rome. Pharaoh's daughter with the child Moses and young Moses disputing with Greek philosophers. Courtesy of the Universitätsbibliothek Basel.

18.5

18.6

The Gospels' Greek elements are not to be understood in a simple way, as so-called influences. Yet, even a genius breathes the air of his world. The conception of life in Greece and in Palestine was not so totally different as it is often thought to have been. Similarities abound: the rocks, the olive groves, the pastoral life. Both had holy precincts which could only be entered after purifications, times of fasting, and remaining awake, in order to start a new life. On one of the paintings from the cave near Pitsa we can see a Corinthian family of the late sixth century B.C. approaching an altar of the Nymphs, which, as so often, are not represented. A Jewish procession may have been quite similar.[15] The Greek landscape, like our Catholic countries, was full of sacred places, altars, statues, canopies, caves, and fountains, as one sees in the Hellenistic landscape from Boscoreale, now in New York, inserted in a Roman second-style frame (see fig. 18.5).[16] Jewish life for its part was full of religious laws. Flavius Josephus said: "The Greeks have mysteries during certain seasons whilst to the Jews the whole of life becomes a mystery" (*Ap.* II.189).

After the time of Alexander the Great, the majority of all Jews lived in Greek environments, especially at Alexandria and Antioch. At Alexandria nearly half of the population seems to have been Jewish. There was to be found, in this cosmopolitan and learned city, epic and tragic poetry in Greek form with Biblical themes, Jewish historical and philosophical works in the Greek tradition with Biblical content, and also the famous Sibyllic prophecies and illustrated scrolls, narrating parts of the Old Testament.[17] An example of such a cycle was found on the walls of the synagogue at Doura-Europos, transformed into the late Parthian style, as in the painting of the child Moses, found by Pharaoh's daughter and her servants. There is reason to believe[18] that the famous cycle of mosaics in the church of Santa Maria Maggiore in Rome goes back to an Alexandrian illustrated scroll of the period of Ptolemy II (285–246 B.C.), who ordered the Greek translation of the Old Testament, the first known attempt to translate a book of such length into another language.

One of the mosaics (fig. 18.6) shows the dispute of young Moses with philosophers, alluded to in the Acts of the Apostles 7:22:"Moses was trained in all the wisdom of the Egyptians." Philo of Alexandria also reported this dispute. He spoke not only about Egyptian but also about Chaldaean and Greek philosophers, because in Philo's period the Jews had to deal with all these

people in the vast Roman Empire. Moses' teachers in our mosaic are not Egyptians or Chaldaeans, but Greek philosophers, in garments and attitudes known from the famous mosaics, which have been thought to represent the seven wise men but are now identified as Plato's school.[19] At Alexandria, where we seek the prototype of our mosaic, the Jews had to do with the second great center of Greek philosophy after Athens. So the mosaic preserves an earlier conception of Moses' dispute than Philo and the Acts. The style of the figures confirms the early Hellenistic date. For the Greek background to the Gospel, it is important to note that in the whole cycle of mosaics the Jews are clad in the Greek manner, save some official costumes, and not in one of the many traditional Oriental garments so well known in all periods of Greek art. Like the whole cycle, this mosaic alludes to a scene of the Gospels. This one foretells the young Christ teaching in the temple. The upper part of the mosaic shows Pharaoh's daughter with the child Moses, but here, as often in the cycle, the original is transformed into a typical late antique style to such degree that nearly nothing is left of the early Hellenistic manner.

The original conception is much better preserved on the mosaic representing the drowning of the Egyptians in the Red Sea (fig. 18.7). The Egyptians are riding chariots, a weapon normally out of use in Greece and Rome since the Geometric period. But Hellenistic historians knew chariots as a heroic relic. The respect shown the enemy also seems to be a Greek, not a Roman, conception. The Pharaoh's heroic attitude, brandishing his weapons in spite of getting drowned, reminds us of Philoxenos' painting from about 317 B.C., preserved in the Naples Alexander mosaic, with the tragic vision of the vanquished king of the kings.[20] In Oriental and Roman art the vanquisher usually appears triumphantly high above the adversary, whilst here we feel in the quiet dignity of Moses and his Jews a supernatural power opposed to the mighty king. We already find similar allusions to the superhuman in the art of the early fifth century B.C., then again in early Hellenistic art,[21] and often in our cycle of mosaics. In attitudes and garments the Hellenistic Jewish civilization of Alexandria appears again as a background to the Gospels.

A third mosaic, Joshua's victory over the Amorites, may be understood as a Hellenistic version of Philoxenos' Battle of Alexander.[22] In both works the conqueror has lost his helmet and attacks the enemy, despite the menacing danger,

18.7

18.8a

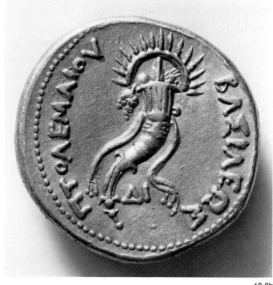

18.8b

surrounded by the rigid lances of his riders. But the style has changed from the earlier closed form to the open one, which is nearer to the high Hellenistic style. The frontal views of late Roman battle-sarcophagi presuppose similar Hellenistic prototypes.[23]

With the Maccabaeans a strong Jewish reaction started against Alexandrian Hellenization, as later the emperor Augustus turned from the Hellenistic free behavior, prevalent during his youth, to the restoration of the Roman religion. But neither the Roman reaction nor the Jewish could extinguish Hellenistic influence. Greek costumes and Greek language continued to play an important role; only art as an expression of religion was reduced to the few symbols known especially from Palestinian synagogues. The mood of prophecy and the longing for a savior, so important in the whole Roman world especially in the first century B.C., found artistic expression mainly outside of Palestine. Especially in Rome, art contains many symbols predicting the return of the reign of Saturn, a golden age of peace. A. Alföldi called his learned discussions of these symbols "The Parens Patriae in Roman Thought" and "Redeunt Saturnia Regna,"[24] quoting Vergil's famous lines: "Now the virgin returns, the reign of Saturnus comes again / A new progeny descends from heaven on high" (*Ecl.* IV.6). And Saint Paul wrote to the Galatians (4:4–5): "When the term was completed God sent his own son, born of a woman, born under the law, to purchase freedom for the subjects of the law, in order that we might attain the status of sons."

The Middle Ages regarded Vergil's lines as a reference to the Virgin and Child, and added this mysterious prediction to the Old Testament's Messianic prophecies. Vergil had meant the renewal of the world and we see the emperor Augustus' idealized portraits behind Luke's famous account and Eusebius' report (*Augustus* 43): "In the forty-third year of the reign of Augustus Jesus Christ, the Son of God, is born in Bethlehem."

The longing for a savior, who would bring back the happiness of Paradise, has an old Oriental tradition and found monumental expression in the early Hellenistic realm of the Ptolemies. They became, in this respect, the teachers of late Roman Republican leaders. On the golden octadrachms struck by his son and successor (fig. 18.8a), Ptolemy III Euergetes appears with the aegis of Zeus, the rays of Helios, and the trident of Poseidon,[25] just as in the local divinity of his town each Egyptian also venerated the forces of other deities. The cornucopiae of the reverse display (fig. 18.8b), once more, the royal diadem with the rays of the sun, because Euergetes brought happiness to humanity, introducing the rebirth of the world as Aion. There is reason to suppose the religion of Isis lies behind this symbolism. The Egyptian cult of Isis became a world religion through the Greeks, as S. Morenz explained.[26] Until the arrival of the Greeks, Egypt had been rather concerned with itself. When the Archaic Greeks came to Egypt, they admired the piety of Isis' Holy Land and discovered an astonishing fact: Isis was not subject to destiny as their own divinities were, but was regarded as the governor of destiny. The famous aretalogies of Isis glorify her almighty power and especially the way in which the princes govern both land and sea in Isis' name,

creating a golden age, as with Ptolemy Euergetes.

The new conception of Isis seems to go back to the Classical period, as her sanctuaries in the Piraeus and at Eretria suggest,[27] but her conquest of the Mediterranean world started with the early Hellenistic period and therefore on the faience oinochoai the queen with her cornucopiae could be represented as Isis,[28] and the king on the coins as donor of happiness in her service. On the late Republican coins the Aion symbolism unveils itself as belonging to the theology of Isis. On M. Plaetorius Cestianus denarii Isis Panthea promises Aion's bliss, characterized by her crowning flower, her corkscrew curls, her cornucopia, Diana's quiver, Roma's helmet.[29] Only during the Imperial period was the Isis religion represented by copies and imitations of Egyptian sculptures and paintings, in order to prove its noble descent in contrast to the other mystery religions. In the Hellenistic period the Isis mission combined Greek forms with a few Egyptian elements to win the favor of the Greeks, as on the faience oinochoai. In the late third century B.C. the divine couple on the mysterious Munich votive relief (fig. 18.9) may only be recognized as representing the great Egyptian divinities by comparison with two variants of the same composition from the late second century B.C.[30] Here the divine couple shows the attributes of Isis and Serapis. In Hadrian's villa the Sileni, which together with caryatids support the entablature around the Canopus, in the first moment, look only Greek, but then we observe that they are standing like Egyptian figures, and are wearing Egyptian tripartite aprons.[31] The early Hellenis-

18.9

tic style suggests prototypes belonging to the famous Canopos near Alexandria. The Isis sanctuary on the Roman Campus Martius seems to have copied the type of the Canopos and is like the sanctuary in the center of the Odyssey Landscapes (fig. 18.10), with the *baitylos,* so often used in Roman landscape paintings, for the Great Goddesses' sanctuary.[32]

Isis appears as the tutelar goddess of Odysseus and his Italian progeny. It seems that a good deal of Greek mythology was interpreted in a similar way, for instance, Helen seems a sort of saint under the protection of Isis.[33] Aphrodite and Artemis were venerated as appearances of Isis, for instance, in the Boscoreale Cubiculum in New York (fig. 18.5), Aphrodite being the Egyptian goddess Hathor, Artemis being Bastet, but both regarded as Isis. Therefore Artemis so often

wears a crown of uraeus snakes. To this Hellenizing tendency of the early Isis mission corresponds the Greek character of the earliest known Greek sanctuary of Isis at Eretria, where very few Egyptian details allude to the authority of the Great Goddess. Behind the Greek veil the Isis religion succeeded in incorporating Classical civilization, as had the Jews in Alexandria and (I argue) as had Christianity since the second century A.D.

Against this rich Hellenistic background we cannot but admire the simplicity of the Gospel and admire how differently the longing for a savior was expressed and fulfilled. This simplicity reminds us again of the early Greek austerity preserved through all ages, especially in the ideals of Herakles and the Cynic philosophers (fig. 18.2). Now we have to turn from this Greek

18.9. Marble votive relief to the great gods, Munich. Hirmer Fotoarchiv.

18.10. Circe. Central scene of the Odyssey frieze in the Vatican. Courtesy of the Universitätsbibliothek Basel.

18.10

aspect of our problem to a Roman one. Since Lessing, we have distinguished between Christ's Revelation and the Gospel proper, the center of Saint Paul's doctrine. In the latter we find more Roman than Greek connections. The experience of suffering strikes us as being an essential feature of the Roman period. Punishment by crucifixion was detested by the Greeks. It was only introduced to the Classical world during the Roman period, in the second century B.C. Thousands of slaves in Italy and in Palestine hundreds of enemies of Alexander Iannai were crucified.[34] In order to understand such terrible events we have to imagine the contemporary creation of the amphitheater, the gladiators and the evildoers being torn to pieces by wild beasts, the dying heroes depicted in wall-paintings and later on the sarcophagi, and already since the late Republican period Laocoon's and Marsyas' torments.[35] Later thousands of martyrs died for their eternal life. Behind all this we find very un-Greek explanations. In Vergil's poem the concept of eternal Rome presupposes Aeneas and Dido's sufferings. Ovid's transformations lead to another life through sufferings, like the heroes' death in wall-paintings and in sepulchral art. The victims in the amphitheater enhance the bravery of the victorious gladiator and the munificence of the leader who pays for the games. Ignatius, bishop of Antioch, was brought to Rome in the eleventh year of Trajan's reign and thrown to the wild beasts. He had written to the Church of Rome (Eus. *Trajan* 4.1): "I desire freely to die for God . . . let me be a bait for the wild beasts, through which I can partake of God . . . coax the wild beasts, that they become my tomb . . . Then shall I be a disciple of Jesus Christ. . . ."

Roman frenzy of suffering is far from the Greek understanding of life. In ancient Greece distress belongs to the tragic situation of mankind—not to be immortal like the gods. But suffering as such never became a value in itself, as in the Roman period. The master of the Group with the Hanging Marsyas studied the psychological effect of the Scythian slaves sharpening the knife; consequently, he tried to show how the invisible may be evident in one of life's extreme situations. Only in Roman copies does the agony of fear, the torture itself, win the Romans' chief interest. Christ's death on the cross, though belonging to this Roman conception of suffering, unveils its mystery on a much higher level. Christ dies not for Himself, but for mankind. No other religion has such a genial, deep interpretation of pain and death, of the mystery of evil, the "sanctuary of suffering," as Goethe called it.[36]

The philosophy of the Imperial period combines a longing for salvation, unknown to the Greek sources, with the Roman mood of suffering. In Italy the philosophers hoped for eternal truth behind the destructibility and the faults of the visible world. The soul demands to return to its sublime homeland. Thus in Plotinus' century (he lived from A.D. 205 to 270) the blessings of the saved souls are represented on sarcophagi, for instance, the stories of Endymion and Jonas.[37] This Roman mood distinguishes Neoplatonism from Platonism: Plato did not aim to overcome the world, but to explain it as having a background of ideas; his teaching does not have a transcendence, but what we may call a descendent tendency. I would like to search for the origin of the Roman philosophical tendency in the concept of suffering which is deeply rooted in Italy; we only have to mention legends like Mucius Scaevola and Etruscan and South Italian sepulchral art.

Saint Paul's preaching differs from the Gospels' commandments by his Roman concern for eternal life. Christ's death and resurrection were the center of his faith, but he passed over what Christ had taught. Saint Paul was deeply concerned about holding up correct ethical conduct to his churches, but he referred rather more to the Old Testament and not to the great ethics of the Sermon on the Mount which is so important for us when we ask: how should we lead the new life for which we are destined by Christ's Revelation? Saint Paul supplements the Gospel by ascertaining: "God designed Him [Christ] to be the means of expiating sin through his sacrificial death . . . all are justified through God's free grace alone, through His act of liberation in the person of Christ" (Rom. 3:24ff.). He forces us to see creation again in the light of grace. God's "everlasting power and deity have been visible ever since the world began to the eyes of reason in the things that he created"(Rom. 1:20).In the same sense God's presence in His creation was glorified from the Psalms to the hymns of the Church.

Christ did not wait for another world like Saint Paul, but He expected the Kingdom of Heaven to arrive on earth soon. He demanded unconditionally that we should obey the will of God. Human nature can never fulfill the commandments, a deficiency which tradition interpets as original sin. But in the same moment Revelation promises grace, and so our life always remains in tension between judgment and grace. Judgment and grace do not follow each other but represent our eternal task, our human tragedy.

The Greek background of the Gospels may open our eyes for new life to which we are destined by grace. The poetical force of the Gospels reminds us, that we have to understand the commandments not only in a moral sense, but in a universal one. Consequently, art gains a new significance. Our Classical and our Biblical traditions must not be seen as in insurmountable contrast, but as complementary to each other. As mankind's highest gift, art allows us to attempt to harmonize with the creation's perfection. The commandment to live not for the flesh but for the spirit may be interpreted as to live in harmony with creation, a task that never can be fulfilled, but aimed for by grace. The severe simplicity of Geometric art and the ethical force of the Archaic Apollo from Piraeus seem to be nearer to the commandments than all other art forms we know, because, as Saint Paul said, the Greeks, "who don't possess the law, carry out its precepts by the light of nature" (Rom. 2:14-15).

NOTES

I would like to thank my friends Birckhead for their information about the work of the late E. Hamilton, too little known in Europe; to my friend N. Koeth for the translation; to Christoph Schäublin for the hint on Josephus, *Contra Apionem;* to the Editor for many corrections in the translation; and to Loretta Freiling for all her help.

1 K. Kenyon, *Digging up Jerusalem* (London 1974). Y. Shiloh, "Excavating Jerusalem," *Archaeology* 33, no. 6 (November/December 1980) 8–17 (bibliography).

2 Even in the excellent analysis by F. Solmsen, *Isis among the Greeks and Romans* (Cambridge, Mass. 1979); cf. this author's recension of M. Malaise, *Inventaire préliminaire des documents égyptiens découverts en Italie* (Leiden 1972), in *Gnomon* 51 (1979) 171–76.

3 W. F. Otto, *Das Wort der Antike* (Stuttgart 1962). Cf. W. Pannenberg, *Gottebenbildlichkeit als Bestimmung des Menschen in der neueren Theologiegeschichte* (Munich 1979) 8.

4 J. Papadimitriou, *Ergon* (1959) 163. Bibliography: K. Schefold, "Die Athene des Piräus," *AntK* 14 (1971) 37, n. 1 and 38, n. 8. M. Robertson, *A History of Greek Art* (Cambridge 1975) 181–84, pl. 53b and 646 nn. 43–46.

5 R. Pfeiffer, "The Image of the Delian Apollo and Apolline Ethics," *JWarb* 15 (1952) 20–32.

6 R. Lullies, *Griechische Plastik*[4] (Munich 1979) pl. 125. C. Karusos, "Zum 'Schreitmotiv' des Kasseler Apollon," in *Neue Beiträge zur klassischen Altertumswissenschaft,* Festschrift B. Schweitzer (Stuttgart 1954) 161–65.

7 W. F. Volbach, *Frühchristliche Kunst* (Munich 1958) fig. 36. K. Schefold, *Die Bildnisse der antiken Dichter, Redner und Denker* (Basel 1943) 186–87. Heavenward-gazing Alexander: H. P. L'Orange, *Apotheosis in Ancient Portraiture* (Oslo 1947) 19–27.

8 Schefold, *Bildnisse* 162–63, no. 3. G. M. A. Richter, *The Portraits of the Greeks* (London 1965) 186, fig. 1079.

9 E. Hamilton, *Witness to the Truth, Christ and His Interpreters* (New York 1948, 1957, 1962).

10 E. Benz, *Der gekreuzigte Gerechte bei Plato, im Neuen Testament und in der alten Kirche* (Mainz 1950) 1029–74. H. Hommel, *Schöpfer und Erhalter* (Berlin 1956) 23–31. A. Alföldi, *Der Philosoph als Zeuge der Wahrheit und sein Gegenspieler, der Tyrann* (Basel 1953). Idem, "Gewaltherrscher und Theaterkönig," in *Late Classical and Mediaeval Studies in Honour of Albert Mathias Friend, Jr.* (Princeton 1955) 15–55.

11 Hamilton, *Witness* 23–41.

12 K. Schefold, "Ariston von Chios," in *Eikones,* Festschrift Hans Jucker, *AntK* Beiheft 12 (Bern 1980) 167, n. 58, pl. 55, nos. 2 and 4.

13 N. Himmelmann, *Über Hirten-Genre in der antiken Kunst* (Mainz 1980). Idem, "Der Mäander auf geometrischen Gefässen," *MarbWinckProg* (1962) 10–43.

14 K. Schefold, "Ante cuncta laudabilis," *RömMitt* 57 (1942) 254–56.

15 K. Schefold, *Die Griechen und ihre Nachbarn, Propyläen Kunstgeschichte* 1 (Berlin 1967) fig. 190.

16 Schefold, *Griechen und Nachbarn* fig. 249.

17 R. H. Pfeiffer, *History of the New Testament Times* (New York 1949) 181–200.

18 K. Weitzmann, *Studies in Classical and Byzantine Manuscript Illumination,* ed. H. L. Kessler (Chicago and London 1971) 45–71, proved that the Jews possessed an apparently well-established representational art, by no means primitive, and that the Santa Maria Maggiore mosaics manuscript model was a Jewish paraphrase of the Old Testament. Some younger archaeologists seem to forget that, like all Roman art, Early Christian art can only be understood as a synthesis of Greek elements: J. G. Deckers, *Der alttestamentliche Zyklus von Santa Maria Maggiore in Rom* (Diss., Bonn 1976). B. Brenk, *Die frühchristlichen Mosaiken in Santa Maria Maggiore zu Rom* (Wiesbaden 1975). C. Kraeling, *The Synagogue: The Excavations at Dura-Europos: Final Report* VIII:1 (New Haven 1956). A. L. Perkins, *The Art of Dura-Europos* (Oxford 1973). J. Gutmann, *The Dura-Europos Synagogue: A Re-evaluation (1932–1972)* (Chambersburg, Pa. 1973).

19 K. Gaiser, *Das Philosophenmosaik in Neapel* (Heidelberg 1980).

20 K. Schefold, "Die Antwort der griechischen Kunst auf die Siege Alexanders des Grossen," *SBMunich* (1979 no. 4) 13 and 29.

21 Schefold, *Griechen und Nachbarn* 100–101 and 137–38.

22 A. von Salis, *Antike und Renaissance* (Zürich 1947) 101, pl. 22b.

23 T. Kraus, *Das römische Weltreich, Propyläen Kunstgeschichte* 2 (Berlin 1967) fig. 244.

24 A. Alföldi, *Der Vater des Vaterlands im römischen Denken* (Darmstadt 1978). Idem, *Chiron* 9 (1979) 553–606; and idem, "The Main Aspects of Political Propaganda on the Coinage of the Roman Republic," in *Essays in Roman Coinage Presented to Harold Mattingly* (Oxford 1956) 63–95.

25 A. Alföldi, "From the *Aion Plutonios* of the Ptolemies to the *Saeculum Frugiferum* of the Roman Emperors," in *Greece and the Eastern Mediterranean in Ancient History and Prehistory,* Studies presented to Fritz Schachermeyr (Berlin and New York 1977) 1–30 and 275–83 pls. A–I.

26 S. Morenz, "Die Begegnung Europas mit Aegypten," *SBLeipzig* 113, no. 5 (1968) 92–100. Idem, *Religion und Geschichte des alten Aegypten* (Weimar 1975) 521–26.

27 P. Auberson and K. Schefold, *Führer durch Eretria*

(Bern 1972) 139–144. P. Bruneau, *Le sanctuaire et le culte des divinités égyptiennes à Érétrie* (Leiden 1975).

28 D. Burr Thompson, *Ptolemaic Oinochoai and Portraits in Faience* (Oxford 1973) 57–59; but cf. K. Schefold, *Gnomon* 51 (1971) 175.

29 A. Alföldi, *Schweizer Münzblätter* 5 (1954) 25–31. Idem, "Redeunt Saturnia regna, IV," *Chiron* 5 (1975) 165–92.

30 K. Schefold, "Origins of Roman Landscape Painting," *ArtB* 42 (1960) 89–90. L. Laurenzi, "Rilievi e statue d'arte Rodia," *RömMitt* 54 (1939) 42–65. Bibliography: Robertson, *HGA* 717, n. 45 and 723, n. 110.

31 K. Schefold, "Aphrodite von Knidos, Isis und Serapis," *AntK* 7 (1964) 58, pl. 16.

32 M. T. Picard-Schmitter, "Bétyles hellénistiques," *MonPiot* 57 (1971) 43–88. K. Schefold, *Wort und Bild* (Basel 1975) 108 and 116. I. Jucker, "Hahnenopfer auf einem späthellenistischen Relief," *AA* (1980) 468.

33 Schefold, *Wort und Bild* 109 and 115–16. Idem, "Der zweite Stil als Zeugnis Alexandrinischer Architektur," in B. Andreae and H. Kyrieleis, *Neue Forschungen in Pompeji* (Recklinghausen 1975) 53–59.

34 Joseph. *AJ* XIII, 380 (= BJ 1.97).

35 Robertson, *HGA* 536. A. Borbein, "Die Statue des hängenden Marsyas," *MarbWinckProg* (1973) 37–52. *Aspects of Ancient Greece* (Allenton Art Museum, Allenton, Pa., 1979) no. 87.

36 Goethe, *Wilhelm Meister,* Wanderjahre, 2.Buch, 2.Kapitel.

37 H. Sichtermann and G. Koch, *Griechische Mythen auf römischen Sarkophagen* (Tübingen 1975) pls. 33–38.

GLOSSARY · BIBLIOGRAPHY · INDEXES

GLOSSARY

added red, a slip (water and clay) containing lead and other trace elements (perhaps manganese) ranging in color from purple to rust brown. This colorful slip was applied before firing and was used on vases to accent decoration, including figures, florals, animals, and parts of the vase itself.

added white, a slip of fine clay (like China clay) applied before firing and used especially to denote the flesh of women.

akontist, an athlete who throws the javelin.

alabastron, a vertical, slender vase with rounded bottom, flat, disklike rim, and narrow neck. It probably contained scented oil and, as the name implies, was first made in stone.

amphiglyphon, carved on both sides.

amphora, a broad-mouthed, two-handled vase for storing liquids; neck-amphora is a variety with the neck set off from the body which was made separately; type A amphora has flanged handles, a flaring rim, and a foot in two degrees; type B amphora has a rim and foot each designed in a continuous, gentle curve.

aryballos, an ancient name now given to a small vase with a narrow neck and flat, broad rim which, like the alabastron, contained scented oil. The Greek word refers to a bag or purse and the shape so named often has a flat, rounded bottom.

baitylos, an aniconic image in stone.

bothros, a pit.

caryatid, a statue of a standing maiden used as an architectural element in place of a column, to support the entablature of a building.

chiton, a tunic made of fine, lightweight material, worn by men and women, often as an undergarment. The chitoniskos is a shorter version.

chlamys, a short mantle or cloak, presumably of heavier material, for riding or traveling.

dipinti, painted inscriptions generally speaking; also a painted mark of identification sometimes relating to the making or merchandizing of the vase, usually found under the foot.

egrapsen, a verb form (accompanied by a signature) which refers to the painting, designing, and/or incising of a vase.

ekphrasis, vivid description; in later antiquity used as a rhetorical device and frequently applied to artificial or fantastic objects.

epinetron, a terracotta covering for the thigh and knee which was used when working wool.

epoiesen, a verb form (accompanied by a signature) which seems to refer to the potting and/or more broadly to the production of a vase.

extispicy, a scene of divining or soothsaying.

Gigantomachy, battle of the gods and giants.

graffiti, marks or words scratched into the vase after firing. These signs seem most often to refer to the manufacture and/or the merchandizing (including price) of the vase.

himation, a long, elegantly folded, rather formal, outer garment worn by men and women. This was worn like cloak over the chiton.

Ilioupersis (Iliupersis), the sack of Troy (Ilion).

incision, a scratching of the surface of the vase for the purposes of adding detail.

janiform vase, molded heads, back to back, which serve as the walls of a vase, with rim, lip, handle added or not.

kalathos, the Greek word for a basket in the shape of a lily. Specialists have applied the term to vases which have similar form. The word is perhaps also related to the Greek word to spin and containers in this form are often shown to hold roves of wool.

kantharos, a deep, footed drinking cup with two high-swung handles.

kentron, a goad.

kerykeion, the caduceus or wand carried by heralds, chiefly by Hermes, and later, modified, associated with Asklepios.

kline, a couch.

kolpos, the blousing or folds made by a loose garment when tied around the waist.

kore, the Greek word for maiden now commonly used to denote Archaic Greek statues of standing maidens.

kothon, a lidded box with three broad legs used to contain cosmetics.

kotyle (or skyphos), a deep cup or small drinking bowl, often with two small horizontal handles.

kouros, the Greek word for youth now commonly used to denote Archaic Greek statues of young men.

kourotrophos, child-caring or nursing.

krater, a large vase, much like a punch bowl, for the mixing of wine and water; the calyx-krater is so named because it resembles the calyx of a flower; column-krater because of its vertical, columnlike handles and entablaturelike upper plate; bell-krater because the shape resembles an inverted bell; krater-iskos is a small krater.

kyathos, a cup with a single, high-swung, vertical handle, probably used as a ladle.

kylix, a broad, rather shallow drinking cup with two horizontal handles; the cup usually has a high stem or foot.

lebes (also dinos), a deep bowl with rounded bottom, set into a stand.

lekane, an ancient word now applied to an all-purpose basin.

lekanis, an ancient name now given to a broad bowl or dish which is lidded.

lekythos, an ancient name for an oil or unguent vase; presently applied to a vase with a tall, slender neck, deep mouth, and flat lip. The vase body varies considerably in size; it is usually slender and vertical but can also be squat. This vase shape is frequently associated with the dead and was used as a funerary gift or offering.

Liegekampf, the German designation for hand-to-hand combat in a crouching position. The term is largely applied to describe a class of scenes of Herakles battling the Nemean Lion. Another mode of depicting their battle has the pair standing more or less erect and this is called, again in German, *Stehkampf.*

mastos, a drinking cup in the shape of a woman's breast. A few of these cups are footed.

nebris, a fawn skin worn especially by Dionysos and the Bacchantes.

obol (diobol or octobol are multiples), a unit of weight (and value).

oinochoe (and olpe), an ancient name now given to a pitcher for pouring liquids, notably wine, as the name implies.

pelike, an ancient name now applied to a squat, pear-shaped amphora which has a wide mouth.

peplos, a heavy robe or tunic worn by women. The mode in which it was customarily worn allows for an overfold at the front and the Ionic variant was pinned in such a way as to form sleeves.

petasos, a hat with a broad rim, mostly worn by travelers, Hermes among them.

phiale, a flat saucer used for libations.

philippeios, large unit silver coin minted by the city which was named after Philip II of Macedon.

polos, a pillbox hat of Eastern origin worn by fertility deities. At one time the shape of the hat may have derived from a measuring cup for grain, which when worn as a hat provided association with fecundity.

protome, the head and shoulders of a human or animal.

psykter, a vase for chilling wine.

pyxis, an ancient name now given to a small container with lid, used as a box, perhaps for cosmetics or jewelry.

relief line, line in thickened slip for detailing scenes on vases, principally in red-figure painting; the line stands out from the surface of the vase.

reserve (or reservation), an area or line on a vase left the natural color of the clay.

rhyton, a vessel chiefly for libations, originally perhaps in the shape of the horn of a bull, the tip often having a small hole through which liquid slowly dripped; later examples seldom have a hole. Frequently these vases are in the shape of an animal's head.

sakkos, a snood, turban, or baglike covering for the hair.

tripod pyxis, see kothon.

Books and articles referred to at least twice in any paper have been listed in the bibliography, except for inventory and sales catalogs and fascicles of the *Corpus Vasorum Antiquorum*. Many titles have been presented in order to provide background reading for the papers in this volume, some titles particularly for the nonspecialist. Where possible an attempt has been made to cite books and other articles written by the contributors, so that readers might see the authors' research interests, notably in iconographic studies. The Editor has included some additional titles which perhaps will be useful to students.

Works cited first in the "general" category are later referred to by short title, for example, *Studies Presented to David Moore Robinson* ii, eds. G. E. Mylonas and D. Raymond (St. Louis 1953) has been written *Studies Robinson*. When an essay or chapter title, in quotation marks, is followed by a short title and page numbers only, the volume is a collection of essays. In this case the full citation of the work can be found in the "general" category, listed alphabetically by title, not by editor. When a title has three or more editors, often only the first author's name is given, followed by *et al.*

Listings for certain ancient personalities have been combined, for example, Bellerophon, Herakles, Orpheus, Perseus, Prometheus, and Theseus. In addition certain topics or personalities may sometimes be found under more than one heading; Bellerophon may also appear under "Fabulous Beasts and Animals," because of his adventures with the Chimaira and Pegasos by which he is known primarily. Likewise, some personalities are mentioned with the god or goddess with whom they are most readily identified, for example, Hekate with Artemis, Pan with Hermes, the Niobids with Apollo and Artemis. It is presumed, however, that the user will read the entire bibliography for those titles which inadvertently might not have been repeated.

Excellent bibliographies for "Potters, Painters, Classes, and Groups" and also for iconographic subjects can be found in John Boardman, *Athenian Black Figure Vases* (Oxford 1974) and *Athenian Red Figure Vases: The Archaic Period* (Oxford 1975). The reader's attention additionally is drawn to the bibliographic information under the various headings in Beazley's books (*ARV*², *ABV, Paralipomena*) and in Frank Brommer, *Vasenlisten zur griechischen Heldensage,* 3rd ed. (Marburg 1973) and *Denkmälerlisten zur griechischen Heldensage* (Marburg 1971). Shorter discussions of iconographic subjects are to be found in E. Haspels, *Attic Black-figured Lekythoi* (Paris 1936) and, as Boardman has listed, in a host of other reference works.

<div align="right">W. G. M.</div>

GENERAL

Abramovitz, K. "Frescoes from Ayia Irini, Keos. Parts II–IV." *Hesperia* 49 (1980) 57–71.

Adamopoulos, I. *Architecture on Attic Vases.* Diss., Univ. of Southampton, in progress.

Adriani, A., et al. *Odeon ed altri monumenti archeologici.* Palermo 1971.

Akurgal, E. *The Art of Greece: Its Origins in the Mediterranean and Near East.* Trans. W. Dynes. New York 1968.

Albizzati, C. *Vasi antichi dipinti del Vaticano.* Rome 1925–1939.

Allen, T. W. Ed. *Homeri Opera* v. Oxford 1912.

Amyx, D. A. *Corinthian Vase Painting of the Archaic Period.* Berkeley forthcoming.

Amyx, D. A. Ed. *Echoes from Olympus: Reflections of Divinity in Small-Scale Classical Art.* Berkeley 1974.

Andreae, B. "Der Zyklus der Odysseefresken im Vatikan." *RömMitt* 69 (1962) 106–17.

Andrewes, A. *The Greek Tyrants.* London 1956.

Andronikos, M. *Totenkult. ArchHom* iii w. Göttingen 1968.

Antiken aus dem Akademischen Kunstmuseum Bonn: Kunst und Altertum am Rhein. No. 19. Düsseldorf 1969.

Anzien, D., et al. *Psychanalyse et culture grecque.* Paris 1980.

Archaeologia Homerica: Die Denkmäler und das

frühgriechische Epos. Ed. F. Matz and H.-G. Buchholz. Göttingen 1967–.

Archaeologica: Scritti in onore di Aldo Neppi Modona. Ed. N. Caffarello. *Arte e Archeologia 9.* Florence 1975.

Arias, P. E. "Dalle necropoli di Spina. La tomba 136 di Valle Pega." *RivIstArch* 4 (1955) 95–178.

Arias, P. E., M. Hirmer, and B. B. Shefton. *A History of 1000 Years of Greek Vase-Painting.* New York 1962.

Arthur Darby Nock: Essays on Religion and the Ancient World. Ed. Z. Stewart. 2 vols. Cambridge, Mass. 1972.

Ashmole, B. *Architect and Sculptor in Classical Greece.* Wrightsman Lectures 6. London 1972.

Athens Comes of Age: from Solon to Salamis. Princeton 1978.

Baker, H. *Persephone's Cave: Cultural Accumulations of the Early Greeks.* Athens, Georgia, 1979. With bibliography.

Bakır, G. *Sophilos.* Mainz 1981.

Bazant, J. *Studies on the Use and Decoration of Athenian Vases.* Prague 1981.

Beazley, J. D. *Attic Black-figure Vase-painters.* Oxford 1956.

Beazley, J. D. *Attic Red-figure Vase-painters.* 2nd ed. Oxford 1963.

Beazley, J. D. "Charinos." *JHS* 49 (1929) 38–78.

Beazley, J. D. *Development of Attic Black Figure.* Berkeley 1951, 1964.

Beazley, J. D. *Greek Vases in Poland.* Oxford 1928.

Beazley, J. D. "Kleophrades." *JHS* 30 (1910) 38–68.

Beazley, J. D. *The Kleophrades Painter.* Mainz 1974.

Beazley, J. D. *The Pan Painter.* Mainz 1974.

Beazley, J. D. *Paralipomena.* Oxford 1971.

Beckel, G. *Götterbeistand in der Bildüberlieferung griechischer Heldensagen.* Waldsassen 1961.

Bell, H. I. "Graeco-Egyptian Religion." *MusHelv* 10 (1953) 222–37.

Bennett, C. G. *The Cults of the Ancient Greek Cypriotes.* Diss., Univ. of Pennsylvania 1980.

Bernardini, M. *Vasi dello stile di Gnathia.* Bari 1961.

Beschi, L. "Rilievi votivi attici ricomposti." *ASAtene* 47–48, n.s. 31–32 (1969–1970) 85–132.

Bianchi Bandinelli, R. "Quelques réflexions à propos des rapports entre l'archéologie et histoire de l'art." *Mélanges Michałowski* 261–74.

Bianchi Bandinelli, R., and A. Giuliano. *Les Étrusques et l'Italie avant Rome.* Paris 1973.

Bielefeld, E. *Schmuck. ArchHom* 1 c. Göttingen 1968.

Biers, W. R. *The Archaeology of Greece: An Introduction.* Ithaca and London 1980.

Birchall, A., and P. E. Corbett. *Greek Gods and Heros.* London 1974.

von Blanckenhagen, P. H. "Daedalus and Icarus on Pompeian Walls." *RömMitt* 75 (1968) 106–43.

von Blanckenhagen, P. H. "The Odyssey Frieze." *RömMitt* 70 (1963) 100–137.

von Blanckenhagen, P. H. "Painting in the Time of Alexander and Later." *Macedonia and Greece in Late Classical and Early Hellenistic Times* 250–60.

von Blanckenhagen, P. H., and B. Green. "The Aldobrandini Wedding Reconsidered." *RömMitt* 82 (1975) 83–98.

von Blanckenhagen, P. H., and C. Alexander. *The Paintings of Boscoreale.* Heidelberg 1962.

Blech, M. *Studien zum Kranz bei den Griechen. Religionsgeschichtliche Versuche und Vorarbeiten 38.* Berlin and New York 1982.

Bloesch, H. *Agalma, Kleinod, Weihgeschenk, Götterbild: Ein Beitrag zur frühgriechischen Kultur und Religionsgeschichte.* Bern 1973.

Bloesch, H. *Antike Kunst in der Schweiz.* Zurich 1943.

Boardman, J. *Archaic Greek Gems: Schools and Artists in the Sixth and Early Fifth Centuries B.C.* London 1968.

Boardman, J. *Athenian Black Figure Vases: A Handbook.* London and New York 1974. With bibliographies for Greek potters and painters and for Greek iconography.

Boardman, J. *Athenian Red Figure Vases: The Archaic Period.* Oxford 1975. With bibliographies for Greek potters and painters and for Greek iconography.

Boardman, J. "Attic Geometric Vase Scenes, Old and New." *JHS* 86 (1966) 1–5.

Boardman, J. *The Cretan Collection at Oxford.* Oxford 1961.

Boardman, J. *Excavations in Chios, 1952–1955: Greek Emporio. BSA* supp. 6. London 1967.

Boardman, J. "Exekias." *AJA* 82 (1978) 11–25.

Boardman, J. "Greek Myths on 'Greco-Phoenician' Scarabs." *Praestant Interna* 295–97.

Boardman, J. *Greek Sculpture: The Archaic Period: A Handbook.* London 1978. With bibliographies.

Boardman, J. *The Greeks Overseas: Their Early Colonies and Trade.* New ed. London 1980.

Boardman, J. "The Kleophrades Painter at Troy." *AntK* 19 (1976) 3–18.

Bölte, F. "Zu lakonischen Festen." *RhM* 78 (1929) 124–43.

Bonfante, L. *Etruscan Dress.* Baltimore 1975.

Borst, M. J. *A Study of the Aesthetics of Archaic Greek Pedimental Sculpture.* Thesis, Michigan State Univ. 1980.

von Bothmer, D. *Greek Vase Painting: An Introduction.* New York [1973].

von Bothmer, D., and J. Mertens. *Greek Art of the Aegean Islands.* Exhibition catalog, organized at the Metropolitan Museum of Art, November 1, 1979–February 10, 1980.

Bouzek, J. "Ein megarischer Becher mit Iliou Persis." *Praestant Interna* 244–47.

Bravo, R. "Une Lettre sur plomb de Berezan: Colonisation et modes de contact dans Le Pont." *Dialogues d'histoire ancienne, Annales Litteraires de l'Université de Besançon* 166 (1974) 135–41.

Brelich, A. *Gli eroi greci e un problema storico-religioso.* Rome 1959.

Brendel, O. *Etruscan Art.* New York and Harmondsworth 1978.

Brisson, L. *Le mythe de Tirésias: Essai d'analyse structurale.* Leiden 1976.

Brize, P. *Die Geryoneis des Stesichoros und die frühe griechische Kunst. Beiträge zur Archäologie 12* (1980).

Brommer, F. "Attische Könige." *Charites* 152–64.

Brommer, F. "Der Bilder der Midassage." *JdI* 56 (1941) 36–52.

Brommer, F. *Denkmälerlisten zur griechischen Heldensage.* Marburg 1971–. Essential for iconographical studies, much bibliographical information.

Brommer, F. *Göttersagen in Vasenlisten.* Marburg 1980.

Brommer, F. *Konkordanzlisten zu alter Vasenliteratur.* Marburg 1979.

Brommer, F. "Mythologische Darstellungen auf Vasenfragmenten der Sammlung Cahn." *AntK* Beiheft 7 (1970) 50–65.

Brommer, F. *Vasenlisten zur griechischen Heldensage.* 3rd ed. Marburg 1973. Essential for iconographical studies, a wealth of bibliographical information.

Brown, L. M. "The Ship Procession in the Miniature Fresco." *Thera and the Aegean World* I, 629–44.

Bruneau, P. *Recherches sur les cultes de Délos à l'époque hellénistique et à l'époque imperiale.* Paris 1970.

Brunnsåker, S. *The Tyrant Slayers of Kritios and Nesiotes: A Critical Study of the Sources and Restorations.* Stockholm 1971.

Buchholz, H.-G. "Bemerkung zum Schiffsfresco von Thera." *Hellas ewig unsre Liebe* 1–14.

Burkert, W. *Griechische Religion der archaischen und klassischen Epoche.* Stuttgart 1977. Important study, with bibliography of archaeological and iconographical material.

Burkert, W. "Kekropidensage und Arrhephoria." *Hermes* 94 (1966) 1–25.

Burkert, W. *Structure and History in Greek Mythology and Ritual.* Berkeley 1979.

Burn, A. R. *The Lyric Age of Greece.* Totowa, N.J. 1968.

Burn, L. M. *An Iconographical Study of the Works of the Meidias Painter and His Associates.* Diss., Lady Margaret Hall, Oxford 1982.

Butterworth, E. *Some Traces of the Pre-Olympian World in Greek Literature and Myth.* Berlin 1966.

Cambitoglou, A. "The Lampas Painter." *BSR* 19 (1951) 39–42.

Cameron, M. A. S. "Savakis's Bothros: A Minor Sounding at Knossos." *BSA* 71 (1976) 1–13.

Cameron, M. A. S. "Theoretical Interrelations among Theran, Cretan and Mainland Frescoes." *Thera and the Aegean World* I, 579–92.

Cameron, M. A. S. "Unpublished Paintings from the 'House of the Frescoes' at Knossos." *BSA* 63 (1968) 1–31.

Camp, J. *Gods and Heroes in the Athenian Agora.* Athens 1980.

Campus, L. *Materiali del Museo Archeologico Nazionale di Tarquinia,* II: *Ceramica attica a figure nere. Piccoli vasi e vasi plastici. Archaeologica* 16 (1981).

Carter, J. "The Beginnings of Narrative Art in the Greek Geometric Period." *BSA* 67 (1972) 25–58.

Caskey, L., and J. Beazley. *Attic Vase Paintings in the Museum of Fine Arts, Boston.* Boston 1931. Valuable commentary on iconographical subjects.

Caskey, M. E. "Notes on Relief Pithoi of the Tenian-Boiotian Group." *AJA* 80 (1976) 19–41.

Cavalier, M. "Les cultures préhistoriques des îles Éoliennes et leur rapport avec le monde Égéen." *BCH* 84 (1960) 319–46.

Chamay, J., and A. Cambitoglou. "La folie d'Athamas par le peintre de Darius." *AntK* 23 (1980) 35–43.

Charbonneaux, J., et al. *Grèce archaïque.* Paris 1968. English trans. London 1971.

Charbonneaux, J., et al. *Grèce classique.* Paris 1969. English trans. London 1972.

Charbonneaux, J., et al. *Grèce hellénistique.* Paris 1970. English trans. London 1973.

Charistērion eis A. K. Orlandos. 4 vols. Athens 1965–1968.

Charites: Studien zur Altertumswissenschaft E. Langlotz gewidmet. Ed. K. Schauenburg. Bonn 1957.

Childs, W. A. P. *The City-Reliefs of Lycia.* Princeton 1978.

Chirassi, I. *Elementi di culture precereali nei miti e riti greci.* Rome 1968.

Clagett, M. *Greek Science in Antiquity.* New York 1956.

Clairmont, C. "Studies in Greek Mythology and Vase Painting." *YCS* 15 (1957) 159–78.

Classica et Provincialia: Festschrift Erna Diez. Eds. G. Schwarz and E. Pochmarski. Graz 1978.

Classical, Mediaeval, and Renaissance Studies in Honor of Berthold Louis Ullman. Ed. C. Henderson Jr. 2 vols. Rome 1964.

Cohen, B. *Attic Bilingual Vases and Their Painters.* New York 1978.

Coins, Culture and History in the Ancient World: Numismatic and Other Studies in Honor of Bluma Trell. Eds. L. Casson and M. Price. Detroit 1981.

Coldstream, J. N. *Deities in Aegean Art: Before and After the Dark Age.* London 1977.

Coldstream, J. N. *Greek Geometric Pottery.* London 1968.

Cook, J. M. *The Greeks in Ionia and the East.* London 1962.

Cook, R. M. *Greek Art: Its Development, Character and Influence.* New York 1972.

Cook, R. M. *Greek Painted Pottery.* 2nd ed. London 1972.

Cook, R. M. "Origins of Greek Sculpture." *JHS* 87 (1967) 24–32.

Corbett, P. E. "Greek Temples and Greek Worshippers: The Literary and Archaeological Evidence." *BICS* 17 (1970) 149–58. With bibliography.

Coulson, W. D. E. *An Annotated Bibliography of Greek and Roman Art, Architecture and Archaeology.* New York 1975.

Courbin, P. *La céramique géométrique de l'Argolide.* Paris 1966.

Cristofani, M. "Materiali per servire alla storia del vaso François." *BdA* 72 (1980) Serie speciale 1.

Crossland, R. A., and A. Birchall Eds. *Bronze Age Migrations in the Aegean.* London 1973.

Culler, J. *Structuralist Poetics.* Ithaca 1975.

Dahl, K. *Thesmophoria: En graesk Kvindefest.* Copenhagen 1976. English summary, with bibliography.

Daremberg, C., and E. Saglio. *Dictionnaire des antiquités grecques et romaines.* Paris 1877–1919.

Davies, J. K. *Athenian Propertied Families.* Oxford 1971.

Davis, E. N. "The Vapheio Cups: One Minoan and One Mycenaean?" *Art Bulletin* 56 (1974) 472–87.

Davis, E. N. *The Vapheio Cups and Aegean Gold and Silver Ware.* New York and London 1977.

Davreux, J. *La légende de la prophétesse Cassandre.* Paris 1942.

Debes, D. *Das Ornament. Wesen und Geschichte.* Leipzig 1956.

Deichmann, F. W. *Rom, Ravenna, Konstantinopel, Naher Osten: Gesammelte Studien zur spätantiken Architektur, Kunst und Geschichte.* Leiden 1982.

Delatte, A. *Herbarius: Recherches sur le cérémonial usité chez les anciens pour la cueillette des simples et des plants magiques.* 3rd ed. Brussels 1961.

Delcourt, M. *Pyrrhos et Pyrrha: Recherches sur les valeurs du feu dans les légendes helléniques.* Paris 1965.

Delivorrias, A. *Attische Giebelskulpturen und Akrotere des fünften Jahrhunderts.* Tübingen 1974.

Demargne, P. *The Birth of Greek Art.* London 1964.

Denniston, J. D. *Greek Prose Style.* Oxford 1952.

Deonna, W. *Le symbolisme de l'oeil.* Paris 1965.

Desborough, V. R. d'A. *The Greek Dark Ages.* New York 1972.

De Simone, C. *Die griechischen Entlehnungen im Etruskischen.* Wiesbaden 1968.

Detienne, M., and J. P. Vernant. *La cuisine du sacrifice en pays grec.* Paris 1979.

Deubner, L. *Attische Feste.* Berlin 1932.

Dierauer, U. *Tier und Mensch im Denken der Antike: Studien zur Tierpsychologie, Anthropologie, und Ethik.* Amsterdam 1977.

Dodds, E. R. *The Greeks and the Irrational.* Berkeley 1951.

Dohrn, T. "Die Etrusker und die griechische Sage." *RömMitt* 73 (1966) 15–28.

Dörig, J. *Art Antique: Collections privées de Suisse Romande.* Geneva 1975.

Dorner, F. K. *Studien zur Religion und Kultur Kleinasiens.* Leiden 1978.

Doty, R. G. *The Macmillan Encyclopedic Dictionary of Numismatics.* New York 1982.

Doumas, C. *The N. P. Goulandris Collection of Early Cycladic Art.* Athens 1968.

Dragma: Martino P. Nilsson, A. D. IV id. iul. MCMXXXIX dedicatum, Skrifter utgivna av Svenska Institutet i Rom. Series altera 1. Lund and Leipzig 1939.

Drexhage, H.-J. *Deutschsprachige Dissertationen zur alten Geschichte 1844–1978.* Wiesbaden 1980.

Drougou, S. *Der attische Psykter.* Würzburg 1975.

Ducat, J. "Fonctions de la statue dans la Grèce archaïque: Kouros et kolossos." *BCH* 100 (1976) 239–51.

Ducat, J. "Les vases plastiques corinthiens." *BCH* 87 (1963) 431–58.

Ducat, J. *Les vases plastiques rhodiens.* Paris 1966.

Dumézil, G. *The Destiny of the Warrior.* Chicago 1970.

Dunbabin, T. J. *The Greeks and Their Eastern Neighbors.* London 1957.

Dunbabin, T. J. *The Western Greeks.* Oxford 1948.

Durand, J. L. "Le rituel du meurtre du boeuf laboureur et les mythes du premier sacrifice animal en Attique." *Il mito greco* 121–34.

Duthie, A. *The Greek Mythology: A Reader's Handbook.* 2nd ed. Edinburgh 1949.

Ebertschäuer, H., and M. Waltz. *Antiken* 1. Munich 1981.

Edwards, R. *Kadmos the Phoenician: A Study in Greek Legends and the Mycenaean Age.* Amsterdam 1979.

Eikones. Studien zum griechischen und römischen Bildnis: Hans Jucker zum sechzigsten Geburtstag gewidmet. *AntK* Beiheft 12. Bern 1980.

Éléments orientaux dans la religion grecque ancienne. O. Eissfeldt et al. Colloque de Strasbourg 22–24 May 1958. Paris 1960.

Enciclopedia dell'arte antica, classica, e orientale. Rome 1973–.

The Ernst Brummer Collection, II: *Ancient Art.* Auction 16–19 October 1979, Galleries Koller, Zurich and Spink and Sons, London. Zurich 1979.

Essays in Honor of Dorothy Kent Hill. Ed. D. Buitron et al. *JWalt* 36 (1977).

Essays in Memory of Karl Lehmann. Ed. L. F. Sandler. *Marsyas* supp. 1. Locust Valley, N.Y., 1964.

Europa. Studien zur Geschichte und Epigraphik der frühen Aegaeis: Festschrift für Ernst Grumach. Ed. W. C. Brice. Berlin 1967.

The European Community in Later Prehistory: Studies in Honour of C. F. C. Hawkes. Eds. J. Boardman, H. A. Brown, and T. G. E. Powell. London 1971.

Evans, A. *The Palace of Minos.* London 1921–1935.

The Eye of Greece: Studies in the Art of Athens. Eds. D. C. Kurtz and B. A. Sparkes. Cambridge 1982.

Farnell, L. R. *The Cults of the Greek States.* Oxford 1896–1909. Reprint New York 1977.

Farrington, B. *Greek Science.* 2 vols. New York 1944–1949.

Faure, P. "Cultes de sommets et cultes de cavernes en Crète." *BCH* 87 (1963) 493–508.

Faure, P. "Cultes populaires dans la Crète antique." *BCH* 96 (1972) 389–426.

Ferguson, J. *Greek and Roman Religion: A Source Book.* Park Ridge N.J., 1980.

Festschrift für Frank Brommer. Eds. U. Höckmann and A. Krug. Mainz 1977.

Festschrift für Friedrich Matz. Eds. N. Himmelmann-Wildschütz and H. Biesantz. Mainz 1962.

Festschrift Paul Arndt. Munich 1925.

Festugière, A. J. *Études de religion grecque et hellénistique.* Paris 1972. Articles on Dionysos, Isis, et al.

Fittschen, K. *Untersuchungen zum Beginn der Sagendarstellungen bei den Griechen.* Berlin 1969.

Forbes, I. *Metamorphosis in Greek Myths.* Diss., Trinity College, Oxford, in progress.

Forschungen und Funde: Festschrift Bernhard Neutsch. Ed. F. Krinzinger et al. Innsbruck 1980.

Forti, L. *La ceramica di Gnathia.* Naples 1965.

Foster, K. *Aegean Faience of the Bronze Age.* New Haven and London 1979.

Foucart, P. F. *Des associations religieuses chez les Grecs, thiases, eranes, orgéons.* Paris 1873. Reprint New York 1975.

Fourlas, A. *Der Ring in der Antike und im Christentum.* Münster 1971.

Fränkel, H. *Early Greek Poetry and Philosophy* Oxford 1975.

Frazer, J. G. Ed. *Apollodorus, The Library* II. Cam-

bridge, Mass. 1921.

Frel, J. *Painting on Vases in Ancient Greece.* Exhibition catalog, organized by Loyola Marymount, Los Angeles, March 20–April 22, 1979.

Friis Johansen, K. *Reliefs en bronze d'Etrurie.* Copenhagen 1971.

Frontisi-Ducroux, F. *Dédale: Mythologie de l'artisan en Grèce ancienne.* Paris 1975.

Fuchs, W. "Zu den Grossbronzen von Riace." *Praestant Interna* 34–40.

Furtwängler, A., and K. Reichhold. *Griechische Vasenmalerei,* I–III. Munich 1904–1932.

Furumark, Å. "Aegean Society." *OpusAth* 12 (1978) 11–17.

Furumark, Å. "Gods of Ancient Crete." *OpusAth* 6 (1965) 85–98.

Gaebler, H. *Die antiken Münzen von Makedonia und Paionia.* 2 vols. Berlin 1906, 1935.

Gais, R. M. "Some Problems of River-God Iconography." *AJA* 82 (1978) 355–70.

Galinski, G. K. *Aeneas, Sicily and Rome.* Princeton 1969.

Gallina, A. *Le pitture con paesaggi dell'Odissea dall'Esquilino.* Rome 1961.

Geagen, H. A. "Mythological Themes on the Plaques from Penteskouphia." *AA* 1970, 31–48.

Gehrig, U., et al. *Führer durch die Antikenabteilung.* Berlin 1968.

Gelzer, T. "Zur Darstellung von Himmel und Erde auf einer Schale des Arkesilaos Malers in Rom." *MusHelv* 36 (1979) 170–76.

Gerhard, E. *Auserlesene griechische Vasenbilder, hauptsächlich etruskischen Fundorts.* Berlin 1840–1858.

Gericke, H. *Gefässdarstellungen auf griechischen Vasen.* Berlin 1970.

Gernet, L. *Anthropologie de la Grèce antique.* Paris 1968. Eng. trans. Baltimore 1982.

Gesell, G. C. *The Archaeological Evidence for the Minoan House Cult and Its Survival in Iron Age Crete.* Diss., Univ. of N. Carolina at Chapel Hill 1972.

Gestalt und Geschichte: Festschrift Karl Schefold. Eds. M. Rohde-Liegle et al. *AntK* Beiheft 4. Bern 1967.

Gigante, L. M. *A Study of Perspective from the Representations of Architectural Forms in Greek Classical and Hellenistic Painting.* Diss., Univ. of N. Carolina at Chapel Hill 1980.

Gildersleeve, B. L. *Pindar: The Olympian and Pythian Odes.* New York 1890. Reprint Amsterdam 1965.

Giuliani, L. *Die archaischen Metopen von Selinunt.* Mainz 1979.

Gli Etruschi e Roma: Atti dell'incontro di studio in onore di Massimo Pallottino, Roma 11–13 Decembre 1979. Rome 1981.

Glynn, R. *A Study of the Iconography and Style of Archaic Etruscan Gems.* Diss., Linacre College, Oxford 1982.

Goldstein, M. S. *The Setting of the Ritual Meal in Greek Sanctuaries: 600–300 B.C.* Diss., Univ. of California, Berkeley 1978.

Götze, H. "Die Entdeckung des Raumes in der griechischen Kunst." *Forschungen und Funde* 507–12. With bibliography.

Gourevitch, D. "Psychanalyse et vases grecs." *MélRom* 90 (1978) 153–60. With bibliography.

Gran Aymerich, J. M. "Compositions figurées et compositions narratives d'époque archaïque en Etrurie." *Mythologie gréco-romaine* 19–27.

Greece and the Eastern Mediterranean in Ancient History and Prehistory: Studies Presented to Fritz Schachermeyr on the Occasion of His Eightieth Birthday. Ed. K. H. Kinzl. Berlin and New York 1977.

Greek Numismatics and Archaeology: Essays in Honor of Margaret Thompson. Ed. O. Mørkholm and N. M. Waggoner. Wetteren 1979.

The Greek Vase: Papers Based on Lectures Presented to a Symposium Held at Hudson Valley Community College at Troy, New York in April of 1979. Ed. S. L. Hyatt. Latham, N.Y. 1981.

Greeks, Celts and Romans. Ed. S. and C. Hawkes. Totowa, N.J. 1973.

Green, J. R. *Gnathia Pottery in the Akademisches Kunstmuseum Bonn.* Mainz 1976.

Greenewalt, C. H. *Ritual Dinners in Early Historic Sardis.* Berkeley 1978.

Grimal, P. *Dictionaire de la mythologie grecque et romaine.* Paris 1963.

van Groningen, B. A. *La composition littéraire archaïque grecque.* Amsterdam 1958.

de Grummond, N. T. "Some Unusual Landscape Conventions in Etruscan Art." *AntK* 25 (1982) 3–14.

Guthrie, W. K. C. *The Greeks and Their Gods.* Boston 1969.

Habicht, C. *Göttmenschentum und griechische Städte.* 2nd ed. Munich 1970.

Hamdorf, F. *Griechische Kultpersonifikationen der vorhellenistischen Zeit.* Mainz 1964.

Hamilton, E. *Witness to the Truth, Christ and His Interpreters.* New York 1948, 1957, 1962.

Hamma, K. C. *Influence and Interpretation in Apulian Vase Painting of the Fourth Century B.C.* Diss., Princeton Univ. 1981.

Hammond, N. G. L. *Alexander the Great: King, Commander, and Statesman.* Park Ridge, N.J. 1980.

Hammond, N. G. L. *A History of Greece to 322 B.C.* 2nd ed. Oxford 1967.

Hammond, N. G. L. *A History of Macedonia* I. Oxford 1972.

Hammond, N. G. L., and G. T. Griffith. *A History of Macedonia* II. Oxford 1979.

Hampe, R. *Frühe griechische Sagenbilder in Böotien.* Athens 1936.

Hampe, R. *Der Wagenlenker von Delphi.* Munich 1941.

Hampe, R., and E. Simon. *The Birth of Greek Art: From the Mycenaean to the Archaic Period.* New York 1981.

Hampe, R., and E. Simon. *Griechische Sagen in der frühen etruskischen Kunst.* Mainz 1964.

Hampe, R., and E. Simon. *Griechisches Leben im Spiegel der Kunst.* Mainz 1959.

Hampl, F. "Kultbild und Mythos: Ein ikonographisch-mythologisches Untersuchen." *Forschungen und Funde* 173–85, Indo-Greco art.

Harrison, E. B. "Iconography of the Eponymous

Heros on the Parthenon and in the Agora." *Greek Numismatics and Archaeology* 71–85.

Harrison, E.B. "Preparations for Marathon, the Niobid Painter and Herodotos." *ArtB* 54 (1972) 390–402.

Haskell, F., and N. Penny. *Taste and the Antique: The Lure of Classical Sculpture, 1500–1900.* New Haven 1981.

Haspels, C. H. E. *Attic Black-Figure Lekythoi.* Paris 1936. Important for iconographical studies.

Hausmann, U. *Hellenistische Reliefbecher aus attischen und böotischen Werkstätten.* Stuttgart 1959.

Haussig, H. *Wörterbuch der Mythologie.* Stuttgart 1961.

Havelock, C. M. *Hellenistic Art.* New York 1971.

Havelock, E. A., and J. P. Hershbell. *Communication Arts in the Ancient World.* New York 1978.

Haynes, D. *Greek Art and the Idea of Freedom.* London 1981.

Heilmeyer, W.-D. "Kopierte Klassik." *Praestant Interna* 52–62.

Heinz, W. "Gemme mit Darstellung des Pothos." *Praestant Interna* 306–10.

Helbig, W. *Führer durch die öffentlichen Sammlungen klassischer Altertümer in Rom.* 4th ed. Tübingen 1963–1972.

Helbig, W. "Eine Heerschau des Peisistratos oder Hippias auf einer schwarz-figurigen Schale." *SBMunich* 1897, II, 259–320.

Hellas ewig unsre Liebe: Freundesgabe für Willy Zschietzschmann zu seinem 75. Geburtstag 15. Februar 1975. Ed. S. Oppermann. Giessen 1975.

Hemberg, B. *Die Kabiren.* Upsala 1950.

Henle, J. *Greek Myths: A Vase Painter's Notebook.* Bloomington 1973.

Herdejürgen, H. *Götter, Menschen und Dämonen: Terrakotten aus Unteritalien.* Basel 1978.

Herrmann, H. V. *Die Kessel orientalisierender Zeit* I: *Kesselattaschen und Reliefuntersätze.* OlForsch VI. Berlin 1966.

Herrmann, H. V. *Omphalos.* Münster 1959.

Heubeck, A. *Schrift.* ArchHom III x. Göttingen 1979.

Higgins, R. A. *Greek and Roman Jewellery.* 2nd ed. London 1980.

Higgins, R. A. *Plastic Vases of the Seventh and Sixth Centuries B.C.: British Museum, Catalogue of the Terracottas* II. London 1959.

Hill, P. V. "Buildings and Monuments of Ancient Rome on Republican Coins." *RIN* 82 (1980) 33–52.

Hiller, F. *Formgeschichtliche Untersuchungen zur griechischen Statue des späten 5. Jahrhunderts v. Chr.* Mainz 1971.

Hiller, H. *Ionische Grabreliefs der ersten Hälfte des 5. Jahrhunderts v. Chr.* Tübingen 1975.

Himmelmann-Wildschütz, N. *Archäologisches zum Problem der griechischen Sklaverei.* Wiesbaden 1971.

Himmelmann-Wildschütz, N. *Über die bildende Kunst in der homerischen Gesellschaft.* Mainz 1969.

Himmelmann-Wildschütz, N. *Über einige gegenständliche Bedeutungsmöglichkeiten des frühgriechischen Ornaments.* Wiesbaden 1968.

Himmelmann-Wildschütz, N. *Zur Eigenart des klas-sischen Götterbildes.* Munich 1959.

Hind, J. "The Tyrannis and the Exiles of Pisistratus." *CQ* 24 (1974) 1–18.

Hinks, R. *Myth and Allegory in Ancient Art.* London 1939.

Historia tou Hellenikou Ethnous. Athens 1970–. Also published in English.

Hoffmann, H. "In the Wake of Beazley: Prolegomena to an Anthropological Study of Greek Vase-Painting." *Hephaistos* 1 (1979) 61–70.

Hoffmann, H. "Knotenpunkte: Zur Bedeutungsstruktur griechischer Vasenbilder." *Hephaistos* 2 (1980) 127–54.

Hoffmann, H. *Sexual and Asexual Pursuit: A Structuralist Approach to Greek Vase-Painting.* Royal Anthropological Institute of Great Britain and Ireland, no. 34. London 1977.

Hoffmann, H. *Ten Centuries that Shaped the West: Greek and Roman Art in Texas Collections.* Houston 1970.

Holloway, R. R. *Influences and Styles in the Late Archaic and Early Classical Greek Sculpture of Sicily and Magna Graecia.* Louvain 1975.

Holloway, R. R. *Italy and the Aegean, 3000–700 B.C.* Archaeologia Transatlantica I (1981).

Hölscher, T. *Griechische Historienbilder des 5. und 4. Jahrhunderts v. Chr.* Beiträge zur Archäologie 6 (1973).

Hölscher, T. "Ein Kelchkrater mit Perserkampf." *AntK* 17 (1974) 78–85.

Hommages à Marie Delcourt. Collection Latomus 114. Brussels 1970.

Hooker, J. T. *Ieros in Early Greek.* Innsbruck 1980.

Hoppin, J. C. *A Handbook of Greek Black-Figured Vases.* Paris 1924.

Hornblower, S. *Mausolus.* Oxford 1982.

Hornbostel, W. *Kunst der Antike: Schätze aus norddeutschem Privatbesitz.* Mainz 1977.

Hornbostel, W., et al. *Aus Gräbern und Heiligtümern: Die Antikensammlung Walter Kropatschek.* Mainz 1980.

Houser, C. "Alexander's Influence on Greek Sculpture: As Seen in a Portrait in Athens." *Macedonia and Greece in Late Classical and Early Hellenistic Times* 228–38.

Humphreys, S. C. *Anthropology and the Greeks.* London 1978.

Hutchinson, R. W. *Prehistoric Crete.* Baltimore 1962.

Huxley, G. L. *The Early Ionians.* London 1966.

Huxley, G. L. *Greek Epic Poetry from Eumelos to Panyassis.* Cambridge, Mass. and London 1969.

Illig, L. *Zur Form der Pindarischen Erzählung.* Berlin 1932.

Image et céramique grecque: Recherches méthodologiques et iconographie d'Héraklès. Ed. F. Thelamon. Rouen, forthcoming. Title is tentative, as are all chapter titles from this work.

Imhoof-Blumer, F. W., and P. Gardner. *Ancient Coins Illustrating Lost Masterpieces of Greek Art.* Reprint Chicago 1964.

Immerwahr, S. A. "Mycenaeans at Thera: Some Reflections on the Paintings from the West House." *Greece and the Eastern Mediterranean in Ancient History and Prehistory* 173–91.

In Memoriam Otto J. Brendel: Essays in Archaeology and the Humanities. Ed. L. Bonfante, H. von Heintze, and C. Lord. Mainz 1976.

An Inventory of Greek Coin Hoards. Ed. M. Thompson et al. New York 1973.

Irwin, E. *Colour Terms in Greek Poetry*. Toronto 1974.

Isler-Kerenýi, C. "Chronologie und Synchronologie attischer Vasenmaler der Parthenonzeit." *Zur griechischen Kunst* 23–33.

Jeffery, L. H. *Local Scripts of Archaic Greece*. Oxford 1961.

Jenkins, G. K. *Ancient Greek Coins*. London 1972.

Joyce, H. *The Decoration of Walls, Ceilings, and Floors in Italy in the Second and Third Centuries A.D. Archaeologica* 17 (1981).

Jung, H. *Thronende und sitzende Götter: zum griechischen Götterbild und Menschenideal in geometrischer und frúharchaischer Zeit*. Bonn 1982.

Kaempf-Dimitriadou, S. *Die Liebe der Götter in der attischen Kunst des 5. Jahrhunderts v. Chr*. Bern 1979.

Kahane, P. P. *Ancient and Classical Art*. London 1969.

Kähler, H. *Das griechische Metopenbild*. Munich 1949.

Käppeli, R., et al. *Kunstwerke der Antike*. Basel 1981.

Karageorghis, J. *La grande déesse de Chypre et son culte*. Lyon and Paris 1977.

Karo, G. *Die Schachtgräber von Mykenai*. Munich 1930.

Kearns, E. *Some Studies in the Significance of the Attic Hero-Cult in the Archaic and Classical Periods*. Diss., St. Hilda's College, Oxford, in progress.

Kenner, H. *Das Phänomen der verkehrten Welt in der griechisch-römischen Antike*. Klagenfurt 1970.

Kerenýi, K. *Antike Religion*. Munich 1971.

Kerenýi, K. *The Heroes of the Greeks*. Trans. H. J. Rose. New York 1959.

Kerenýi, K., and L. M. Lanckoronski. *Der Mythos der Hellenen in Meisterwerken der Münzkunst*. Amsterdam 1941.

Kern, O. *Die Religion der Griechen*. 2nd ed. Berlin 1963.

Kernos: Timetike prosphora ston kathegete Giorgio Bakalake. Thessalonike 1972.

Kienle, H., *Der Gott auf dem Flügelrad*. Wiesbaden 1975.

Kirk, G. S. "Greek Mythology: Some New Perspectives." *JHS* 92 (1972) 74–85.

Kleine Schriften zur Münzkunde und Archäologie. Ed. H. C. Ackerman et al. Basel 1975. Contra Kraay's dating of early Athenian coinage, among other essays by H. C. Cahn.

Kleine, J. *Untersuchung zur Chronologie der attischen Kunst von Peisistratos bis Themistokles*. Tübingen 1973.

Kleiner, D. E. "The Great Friezes of the Ara Pacis Augustae: Greek Sources, Roman Derivatives and Augustan Social Policy." *MélRom* 90 (1978) 753–85.

Klinz, A. *Hieros Gamos*. Halle 1933.

Knell, H. *Die Darstellung der Götterversammlung in der attischen Kunst des VI. u. V. Jahrhunderts v. Chr*. Cologne 1965.

Kraay, C. M. *Archaic and Classical Greek Coins*. London 1976.

Kranz, P. "Frühe griechische Sitzfiguren. Zum Problem der Typenbildung und des orientalischen Einflusses in der frühen griechischen Rundplastik." *AthMitt* 87 (1972) 1–55.

Krauskopf, I. *Der thebanische Sagenkreis und andere griechische Sagen in der etruskischen Kunst*. Mainz 1974.

Kretschmer, P. "Bellerophontes." *Glotta* 31 (1951) 92–103.

Kron, U. "Demos, Pnyx, und Nymphenhügel: Zu Demos Darstellungen und zum ältesten Kultort des Demos in Athen." *AthMitt* 94 (1979) 49–75.

Kron, U. *Die zehn attischen Phylenheroen: Geschichte, Mythos, Kult und Darstellungen. AthMitt* Beiheft 5 (1976).

Kunze, E. *Archaische Schildbänder. OlForsch* II. Berlin 1950. Very important for iconographical studies.

Kurtz, D. C. *The Berlin Painter. Oxford Monographs on Classical Archaeology*. Oxford 1982.

Kutsch, F. *Attische Heilgötter und Heilheroen*. Giessen 1913.

Laager, J. *Geburt und Kindheit des Gottes in der griechischen Mythologie*. Winterthur 1957.

Lagrange, M.-S. "L'exploitation des documents figurés en archéologie et histoire de l'art." *Image et céramique greque*.

La Rocca, E. "Eirene e Ploutos." *JdI* 89 (1974) 112–36.

Lefort des Ylouses, R. "La roue, le swastika et la spirale, symboles antiques du tonnere et la foudre." *Gazette des Beaux Arts* 46 (1955) 5–20.

Lehnstaedt, K. *Prozessionsdarstellungen auf attischen Vasen*. Diss., Munich 1970.

Lewis, E. *The Iconography of the Muses*. Diss., Bryn Mawr College, in progress.

Lewis, I. M. *Ecstatic Religion: An Anthropological Study of Spirit Possession and Shamanism*. Rev. ed. Harmondsworth 1978.

Lexicon Iconographicum Mythologiae Classicae. Ed. J. Boardman, L. Kahil, et al. Zurich 1981–.

Ling, R. "Hylas in Pompeian Art." *MélRom* 91 (1979) 773–816. With earlier bibliography on Pompeian painting.

Ling, R. "Studius and the Beginnings of Roman Landscape Painting." *JRS* 67 (1977) 1–16.

Little, A. M. G. *Roman Perspective Painting and the Ancient Stage*. Wheaton, Ill. 1971. With earlier bibliography.

Lloyd-Jones, H. *Blood for the Ghosts: Classical Influences in the Nineteenth and Twentieth Centuries*. Baltimore 1983.

Lobel, E., and D. L. Page. Eds. *Poetarum Lesbiorum Fragmenta*. Oxford 1955.

Long, C. R. *The Ayia Triadha Sarcophagus: A Study of Late Minoan and Mycenaean Funerary Practices and Beliefs*. Göteborg 1974.

Long, C. R. *The Twelve Gods in Greek and Roman Art*. Diss., Case Western Reserve Univ. 1980.

Lorber, F. *Inschriften auf korinthischen Vasen*. Berlin 1979.

Lowe, J. E. *Magic in Greek and Latin Literature*. Oxford 1929.

Luckenbach, H. "Das Verhältnis der griechischen Vasenbilder zu den Gedichten des epischen Kyklos." *Jahrbücher für klassische Philologie*, supp. 11 (1880)

491–638.

Lullies, R., and M. Hirmer. *Greek Sculpture.* Rev. and enl. ed., trans. M. Bullock. New York and London 1960.

Lullies, R., et al. *Antike Kunstwerke aus der Sammlung Ludwig.* 2 vols. Basel 1982.

Macedonia and Greece in Late Classical and Early Hellenistic Times. Ed. B. Barr-Sharrar and E. N. Borza. *Studies in the History of Art* 10. Washington, D.C. 1981.

Mackay, E. A. *Exekias: A Chronology of His Potting and Painting.* Diss., Victoria University of Wellington, N.Z., 1983.

Mansuelli, G. A. *Ricerche sulla pittura ellenistica.* Bologna 1950.

Marinatos, S., and M. Hirmer. *Kreta, Thera und das Mykenische Hellas.* Munich 1973.

Massarò, V. "Herodotus' Account of the Battle of Marathon and the Picture in the Stoa Poikile." *AntCl* 47 (1978) 458–75. With bibliography.

von Massow, W. "Die Kypseloslade." *AthMitt* 41 (1916) 1–117.

Matz, F. *Göttererscheinung und Kultbild im minoischen Kreta.* Mainz 1958.

Maximova, M. I. *Les vases plastiques dans l'antiquité.* French trans. M. Carsow. Paris 1927.

May, J. M. F. *The Coinage of Damastion.* Oxford 1939.

Mayerson, P. *Classical Mythology in Literature, Art and Music.* New York 1971. For Classical motives in Modern periods.

Mayo, M. Ed. *The Art of South Italy: Vases from Magna Graecia.* The Virginia Museum. Exhibition catalog. Richmond, 1982.

Meautis, G. "Le coffre de Cypselos." *REG* 44 (1913) 240–78.

van der Meer, L. B. *Etruscan Urns from Volterra: Studies on Mythological Representations.* 2 vols. Groningen 1978.

Megas, G. A. *Greek Calendar Customs.* Athens 1958.

Mélanges Mansel. 3 vols. Ankara 1974.

Mélanges offerts à Kazimierz Michałowski. Ed. M.-L. Bernhard et al. Warsaw 1966.

Meola, E. *Terrecotte orientalizzanti di Gela. Monumenti Antichi,* Serie Miscellanea 1 Rome 1971.

Mertens, J. *Attic White-Ground.* New York 1977.

Metzger, H. *Recherches sur l'imagerie athénienne.* Paris 1965.

Metzger, H. *Les représentations dans la céramique attique du IVe siècle.* Paris 1951.

Meuli, K. *Gesammelte Schriften.* 2 vols. Basel 1975.

Meyboom, P. G. "Some Observations on Narration in Greek Art." *Meded* 5 (1978) 55–82. With bibliography.

Meyer, H. *Medea und die Peliaden.* Diss., Göttingen 1978.

Meyer, K. H. "Von kunstgeschichtlicher Werkinterpretation zu Rezeptionsforschung." *Hephaistos* 2 (1980) 7–51.

Meyer-Emmerling, S. *Darstellungen auf tyrrhenischen Amphoren.* Diss., Frankfort 1979.

Milani, L. A. *Il reale museo archeologico di Firenze* I. Florence 1912.

Miller, H. F. *The Iconography of the Palm in Greek Art: Significance and Symbolism.* Diss., Univ. of California, Berkeley 1979.

Miller, S. "Macedonian Tombs: Their Architecture and Architectural Decoration." *Macedonia and Greece in Late Classical and Early Hellenistic Times* 153–71.

Mingazzini, P. *Catalogo dei vasi della collezione Augusto Castellani.* 2 vols. Rome 1925, 1971.

Minto, A. *Il vaso François.* Florence 1960.

Il mito greco: Atti del. Convegno Internazionale (Urbino 7–12 maggio 1973). Ed. B. Gentili and G. Paioni. Rome 1977.

Mommsen, H. *Der Affecter.* Mainz 1975.

Moon, W. G., and L. Berge. *Greek Vase Painting in Midwestern Collections.* Exhibition organized by the Art Institute of Chicago, December 22, 1979–February 24, 1980.

Moran, L. *The Iconography of the Miniature Frescoes from Thera.* Diss., Bedford College, Univ. of London 1981.

Moretti, M. "Tomba Martini Marescotti." *Quaderni di Villa Giulia* 1. Milan 1966.

Morris, S. P. *A Middle Protoattic Workshop from Aigina and Its Historical Background.* Diss., Harvard Univ. 1981.

Motte, A. *Prairies et jardins de la Grèce antique: De la religion à la philosophie.* Brussels 1973.

Moulinier, G. E. *Le pur et l'impur dans la pensée des Grecs, d'Homère à Aristotle.* Paris 1952.

Mühlestein, H. "Namen von Neleiden auf den Pylostäfelchen." *MusHelv* 22 (1965) 155–65.

Münchener archäologische Studien: Dem Andenken Adolf Furtwänglers gewidmet. Munich 1909.

Muscarella, O. W. Ed. *Ancient Art: The Norbert Schimmel Collection.* Mainz 1974.

Muthmann, F. *Mutter und Quelle.* Basel 1975.

Mylonas, G. *The Cult Center of Mycenae.* Athens 1972.

Mylonas, G. *Protoattikos Amphoreus tis Elefsinos.* Athens 1957.

Mythologie gréco-romaine, mythologie périphériques: Études d'iconographie. Colloques internationaux du Centre national de la recherche scientifique, no. 593 [Paris, 17 Mai 1979]. Ed. L. Kahil and C. Auge. Paris 1981.

Napoli, M. *La tomba del Tuffatore.* Bari 1970.

Nauck, A. Ed. *Tragicorum Graecorum Fragmenta.* 2nd ed. Leipzig 1889, 1926.

Nauert, J. P. "The Hagia Triada Sarcophagus: An Iconographical Study." *AntK* 8 (1965) 91–98.

Nelson, L. G. *The Rendering of Landscape in Greek and South Italian Vase Painting.* Diss., State Univ. of New York at Binghamton 1977.

Neue Beiträge zur klassischen Altertumswissenschaft: Festschrift zum 60. Geburstag von Bernhard Schweitzer. Ed. R. Lullies. Stuttgart 1954.

Neumann, G. *Gesten und Gebärden in der griechischen Kunst.* Berlin 1965.

Neumann, G. *Probleme des griechischen Weihreliefs. Tübinger Studien zur Archäologie und Kunstgeschichte* 3. Tübingen 1979.

Neuser, K. *Anemoi. Studien zur Darstellung der Winde und Windgottheiten in der Antike. Archaeologica* 19 (1982).

Nicosia, S. *Teocrito e l'arte figurata*. Palermo 1968.

Nilsson, M. P. *Cults, Myths, Oracles, and Politics in Ancient Greece*. New York 1972.

Nilsson, M. P. *Geschichte der griechischen Religion*. 3rd ed. Munich 1967.

Nilsson, M. P. *Griechische Feste von religiöser Bedeutung*. Darmstadt 1957.

Nilsson, M. P. *The Mycenaean Origin of Greek Mythology*. Berkeley 1972.

Nilsson, M. P. *Opuscula Selecta*. 3 vols. Lund 1951–1960.

Ninck, M. *Die Bedeutung des Wassers im Kult und Leben der Alten: Eine symbolgeschichtliche Untersuchung*. 3rd ed. Darmstadt 1967.

Noble, J. V. *The Techniques of Painted Attic Pottery*. New York 1965.

Oakley, J. "Athamas, Ino, Hermes and the Infant Dionysos." *AntK* 25 (1982) 44–47.

Ohlemutz, E. *Die Kulte und Heiligtümer der Götter in Pergamon*. 2nd ed., Darmstadt 1968.

Ohly, D. *Glyptothek München: Griechische und römische Skulpturen*. Munich 1972.

Oleson, J. "Greek Myth and Etruscan Imagery in the Tomb of the Bulls at Tarquinia." *AJA* 79 (1975) 189–200. With earlier bibliography.

Oliva, P. *The Birth of Greek Civilization*. London 1981. With bibliography.

Oliver-Smith, P. E. *Architectural Elements on Greek Vases Before 400 B.C.* Diss., New York Univ. 1969.

Opuscula. Carolo Kerényi dedicata. Ed. G. Säflund. *Stockholm Studies in Classical Archaeology* 5. Stockholm 1968.

Otto, W. F. *Theophania: Der Geist der altgriechischen Religion*. Frankfort 1975. Sections on major deities.

Oxford Classical Dictionary. Ed. N. G. L. Hammond and H. H. Scullard. 2nd ed. Oxford 1977.

Page, D. L. Ed. *Poetae Melici Graeci*. Oxford 1962.

Page, D. L. Ed. *Supplementum Lyricis Graecis*. Oxford 1974.

Pairault, F. H. *Recherches sur quelques séries d'urnes de Volterra à represéntations mythologiques*. Rome 1972.

Pallottino, M. "Deorum sedes." *Studi Calderini e Paribeni* II, 223–34.

Pallottino, M. *Saggi di Antichità*. 3 vols. Rome 1979.

Panagopoulos, A. *Captives and Hostages in the Peloponnesian War*. Athens 1978.

Papachatzes, N. D. *Pausaniou Hellados Periēgēsis*. 5 vols. Athens 1974–1981.

Papadopoulos, J. *Xoana e sphyrelata: Testimonianza delle fonti scritte*. Rome 1980.

Parke, H. W. *Festivals of the Athenians*. Ithaca and London 1977. With earlier bibliography.

Parlasca, K. "Ein Isiskultrelief in Rom." *RömMitt* 71 (1964) 195–205.

Pasquier, A. "Nouvelles découvertes à propos du cratère d'Antée peint par Euphronios." *Revue du Louvre* 31 (1981) 1–9.

Payne, H. *Necrocorinthia: A Study of Corinthian Art in the Archaic Period*. Oxford 1931.

Payne, H., and G. Mackworth-Young. *Archaic Marble Sculptures from the Acropolis*. 2nd ed. New York 1951.

Peirce, S. M. *Sacrificial Processions in Attic Vase-painting and Votive Reliefs*. Diss., Bryn Mawr College, in progress.

Peredolskaja, A. *Krasnofigurnye attischeskie vasy*. Leningrad 1967.

Pereira, M. H. R. *Greek Vases in Portugal*. Coimbra 1962.

Petrasch, E., and J. Thimme. *Griechische Vasen: Eine Auswahl aus den Beständen des Badischen Landesmuseums*. Karlsruhe 1969.

Pfiffig, A. *Religio Etrusca*. Graz 1975.

Pfuhl, E., and H. Mobius. *Die ostgriechischen Grabreliefs*. 2 vols. Mainz 1977.

Philipp, H. *Tektonen Daidala*. Berlin 1968.

Philippaki, B. *The Attic Stamnos*. Oxford 1967.

Philippson, P. *Thessalische Mythologie*. Zurich 1944.

Picard, C. "Les luttes primitives d'Athènes et d'Eleusis." *RHist* 166 (1931) 1–76.

Piccaluga, G. *Lykaon: Un tema mitico*. Rome 1968. For Busiris, Tantalos, Athamas.

Pingiatoglou, S. *Eileithyia*. Würzburg 1981.

Pinney, G. F. *Prolegomena to a Study of Archaic Attic Red-Figure*. Diss., Univ. of Cincinnati 1976.

Pleiner, R. *Ironworking in Ancient Greece*. Prague 1968.

Pollard, J. *Seers, Shrines and Sirens*. London 1965.

Powell, B. *Athenian Mythology: Erichthonius and the Three Daughters of Cecrops*. Reprint Chicago 1976.

Praestant Interna: Festschrift für Ulrich Hausmann. Ed. B. von Freytag gen. Löringhoff et al. Tübingen 1982.

Preaux, C. *La lune dans la pensée grecque*. Brussels 1970.

Preller, L., and C. Robert. *Griechische Mythologie*. 4th ed. Berlin 1894–1926.

Press, G. A. *The Development of the Idea of History in Antiquity*. Diss., Univ of California, San Diego 1974.

Price, M. J. *Coins of the Macedonians*. London 1974.

Price, M. J. "Paintings as a Source of Inspiration for Ancient Die Engravers." *Coins, Culture and History in the Ancient World*. 69–76.

Price, M. J., and B. Trell. *Coins and Their Cities: Architecture on the Ancient Coins of Greece, Rome and Palestine*. Detroit and London 1977.

Price, M. J., and N. Waggoner. *Archaic Greek Coinage: The Asyut Hoard*. London 1975.

Price, T. H. *Kourotrophos: Cults and Representations of the Greek Nursing Deities*. Leiden 1978. Applies to many goddesses.

Prickett, J. L. *A Scientific and Technological Study of Topics Associated with the Grape in Greek and Roman Antiquity*. Diss., Univ. of Kentucky 1980.

Princeton Encyclopedia of Classical Sites. Ed. R. Stillwell. Princeton 1976.

Prinz, F. *Gründungsmythen und Sagenchronologie*. Munich 1979.

Rackham, O. "The Flora and Vegetation of Thera and Crete before and after the Great Eruption." *Thera and the Aegean World* I, 755–64.

Radke, G. *Die Götter Altitaliens*. Münster 1965.

Radt, S. L. Ed. *Tragicorum Graecorum Fragmenta* IV: *Sophocles*. Göttingen 1977.

Raubitschek, A. *Dedications from the Athenian Akropolis*. Cambridge, Mass. 1949.

Raubitschek, I. *The Hearst Hillsborough Vases.* Exhibition catalog, Stanford Univ., 20 December 1969 to 1 February 1970. Mainz 1969.

Rauscher, H. *Anisokephalie. Ursache und Bedeutung der Grössenvariierung von Figuren in der griechischen Bildkomposition.* 2 vols. Vienna 1971.

Rave, P. O., and B. Stein. *Kunstgeschichte in Festschriften: Allgemeine Bibliographie kunstwissenschaftlicher Abhandlungen in den bis 1960 erschienenen Festschriften.* Berlin 1962.

Real-encyclopädie der classischen Altertumswissenschaft. Ed. A. F. Pauly and G. Wissowa. Stuttgart 1893–1972.

Recueil Charles Dugas. Paris 1960.

Reinhold, M. *Classica Americana: The Greek and Roman Heritage in the United States.* Detroit 1983.

Renfrew, C. *The Emergence of Civilization.* London 1972.

Renfrew, C., and S. Shennan. Eds. *Ranking, Resource and Exchange: Aspects of the Archaeology of Early European Society.* Cambridge, Mass. 1982.

Reuterswärd, P. *Studien zur Polychromie der Plastik: Griechenland und Rom.* Stockholm 1960.

Richardson, E. *The Etruscans: Their Art and Civilization.* Chicago 1964.

Richter, G. M. A. *The Craft of the Athenian Pottery: An Investigation of the Technique of Black-figured and Red-figured Athenian Vases.* New Haven 1923.

Richter, G. M. A. *A Handbook of Greek Art.* New York 1980.

Richter, G. M. A. *Perspective in Greek and Roman Art.* New York 1970.

Richter, G. M. A. *The Portraits of the Greeks.* London 1965.

Richter, G. M. A. *Sculpture and Sculptors of the Greeks.* 4th ed. New Haven 1970.

Ridgway, B. S. *The Archaic Style in Greek Sculpture.* Princeton 1977.

Ridgway, B. S. *Fifth Century Styles in Greek Sculpture.* Princeton 1981.

Ridgway, B. S. "The Setting of Greek Sculpture." *Hesperia* 40 (1971) 336–56.

Ridgway, B. S. *The Severe Style in Greek Sculpture.* Princeton 1970.

Ridgway, B. S., and G. F. Pinney. *Aspects of Ancient Greece.* Exhibition organized by the Allentown Art Museum, September 16–December 30, 1979.

Robert, C. *Die griechische Heldensage: Der troische Kreis bis zu Ilions Zerstörung.* Berlin 1923.

Robert, C. *Oidipus: Geschichte eines poetischen Stoffs im griechischen Altertum.* Berlin 1915.

Robert, C. "Pandora." *Hermes* 49 (1914) 17–38.

Roberts, S. R. *The Attic Pyxis.* Chicago 1978.

Robertson, M. "Early Greek Mosaic." *Macedonia and Greece in Late Classical and Early Hellenistic Times* 240–49.

Robertson, M. "Euphronios at the Getty." *GettyMusJ* 9 (1981) 23–34.

Robertson, M. *A History of Greek Art.* Cambridge 1975. A very valuable resource.

Robertson, M. "The Place of Vase-Painting in Greek Art." *BSA* 46 (1951) 151–59.

Robertson, M. "Polygnotos in Delphi." *AntK* 13 (1970) 119. Summary of presentation.

Robinson, D. M., and E. J. Fluck. *A Study of the Greek Love-Names.* Baltimore 1937.

Rohde, E. *Griechische und römische Kunst in den Staatlichen Museen zu Berlin.* East Berlin 1968.

Rohde, E. *Psyche.* 3rd ed. Tübingen and Leiden 1903. English trans. of 8th ed. by W. B. Hillis. New York 1925, reprint 1972.

Romano, I. B. *Early Greek Cult Images.* Diss., Univ. of Pennsylvania 1980.

Romera, O. *Catalogo de los vasos griegos en el Museo Arqueologico Nacional.* Madrid 1980.

Roscher, W. H. *Ausführliches Lexikon der griechischen und römischen Mythologie.* Leipzig 1893–1921.

Rose, H. J. *A Handbook of Greek Mythology.* 6th ed. London 1958, 1972.

Rosenmeyer, T. G. "The Rookie: A Reading of Pindar, 'Nemean 1,' " *CSCA* 2 (1969) 233–46.

Ruckert, A. *Frühe Keramik Böotiens.* Bern 1976.

Rudhardt, J. *La thème de l'eau primordiale dans la mythologie grecque.* Bern 1971.

Rudhardt, J., and O. Reverdin. Eds. *Le sacrifice dans l'antiquité.* Geneva 1981.

Rumpf, A. "Attische Feste—Attische Vasen." *BonnJbb* 161 (1961) 208–14.

Rutkowski, B. *Cult Places in the Aegean World.* Warsaw 1972.

Rutkowski, B. *Frühgriechische Kultdarstellungen.* *AthMitt* Beiheft 8. Berlin 1981.

Rutkowski, B. "Religious Elements in the Theran Frescoes." *Thera and the Aegean World* I, 661–64.

Ruud, J. M. *Minoan Religion: A Bibliography.* Oslo 1980.

Säflund, G. "Sacrificial Banquets in the Palace of Nestor." *OpusAth* 13 (1980) 237–46.

Sahin, S., et al. *Studien zur Religion und Kultur Kleinasiens.* 2 vols. Leiden 1978.

Sakellarakis, J. "Le thème du pêcheur dans l'art préhistorique de l'Égée." *AAA* 7 (1974) 370–90.

Sakellariou, A. "Un cratère d'argent avec scène de bataille provenant de la IVe tombe de l'acropole de Mycènes." *AntK* 17 (1974) 3–20.

Sakellariou, A. "La scène du siège sur le rhyton d'argent de Mycènes d'après une nouvelle reconstitution." *RA* (1975) 195–208.

Sakellariou, M. B. *Les Proto-Grecs.* Athens 1980.

Sanctuaries and Cults in the Aegean Bronze Age. Ed. R. Hägg and N. Marinatos. Stockholm 1981.

Santoro, M. *Epitheta deorum in Asia graeca cultorum ex auctoribus graecis et latinis.* Milan 1973.

Schachter, A. *Cults of Boiotia.* BICS supp. 38. London 1981.

Schäfer, H. *Principles of Egyptian Art.* Trans. J. Baines. Oxford 1974.

Schäffer, J. "Bemerkungen zum Verhältnis von Malerei und Dichtung in der fr-harchaischen Epoche." *Forschungen und Funde* 417–37. With bibliography.

Schauenburg, K. "Bendis in Unteritalien." *JdI* 89 (1974) 137–86.

Schauenburg, K. "Gestirnbilder in Athen und Unteritalien." *AntK* 5 (1962) 51–64.

Schauenburg, K. "Göttergeliebte auf unteritalischen Vasen." *Antike und Abendland* 10 (1961) 77–101.

Schauenburg, K. "Die Göttin mit dem Vogelszepter."

RömMitt 82 (1975) 207–16.

Schauenburg, K. "Eine neue Sianaschale." *AA* 1962, 745–76.

Schauenburg, K. *Weltkunst aus Privatbesitz. Ausstellung der Kölner Museen Kunsthalle 18. Mai–4. August, 1968.* Cologne 1968.

Schauenburg, K. "Zu Darstellungen aus der Sage des Admet und des Kadmos." *Gymnasium* 64 (1957) 210–30.

Schauenburg, K. "Zu Götterstatuen auf unteritalischen Vasen." *AA* 1977, 582–610.

Schauenburg, K. "Zu griechischen Mythen in der etruskischen Kunst." *JdI* 85 (1970) 28–81.

Schefold, K. "Die Andromeda des Nikias." *Studies Trendall* 155–58.

Schefold, K. *The Art of Classical Greece.* Trans. J. R. Foster. New York 1967.

Schefold, K. "Die Baseler Peliadenschale." *AntK* 21 (1978) 100–106.

Schefold, K. *Die Bildnisse der antiken Dichter, Redner und Denker.* Basel 1943.

Schefold, K. "Das Deuten von Sagenbildern." *Wort und Bild* 87–92.

Schefold, K. *Götter- und Heldensagen der Griechen in der spätarchaischen Kunst.* Munich 1978.

Schefold, K. *Die Göttersage in der klassischen und hellenistischen Kunst.* Munich 1981.

Schefold, K. *Die Griechen und ihre Nachbarn. Propyläen Kunstgeschichte* 1. Berlin 1967.

Schefold, K. *Griechische Kunst als religioses Phänomen.* Hamburg 1959.

Schefold, K. "Kleisthenes." *MusHelv* 3 (1946) 59–93.

Schefold, K. *Myth and Legend in Early Greek Art.* Trans. A. Hicks. New York 1966.

Schefold, K. "La peinture pompeienne: Essai sur l'évolution de la signification." *Collection Latomus* 108 (1972) 1–282.

Schefold, K. "Probleme der pompejanischen Malerei." *RömMitt* 72 (1965) 116–26.

Schefold, K. "Spuren alexandrinischer Theologie in römischen Wandmalereien." *Wort und Bild* 111–19.

Schefold, K. "Statuen auf Vasenbildern." *JdI* 52 (1937) 30–75.

Schefold, K. "Die Überlieferung der griechischen Bildniskunst." *Praestant Interna* 79–90.

Scheibler, I. *Die symmetrische Bildform in der frühgriechischen Flächenkunst.* Kallmünz 1960.

Schiering, W. "Die Naturanschauung in der altkretischen Kunst." *AntK* 8 (1965) 3–19.

Schmidt, E. *Geschichte der Karyatide.* Würzburg 1982.

Schmidt, M. *Der Basler Medeasarkophag.* Tübingen 1969.

Schmidt, M. "Die Entdeckung des Erichthonios. Zu einer neuen Lekythos des Phialemalers und einem ungedeuteten Vasenbild." *AthMitt* 83 (1968).

Schmitt, P., and F. Thelamon. "L'image: Illustration ou document?" *Image et céramique grecque.*

Schneider, L. A. *Zur sozialen Bedeutung der archaischen Korenstatuen.* Hamburg 1975.

Schrader, H. *Phidias.* Frankfurt 1924.

Schroeder, O. *Pindars Pythien.* Leipzig and Berlin 1922.

Schuchhardt, W.-H. *Geschichte der griechischen Kunst.* Stuttgart 1971. Eng. trans. S. MacCormack.

London 1971.

Schwabacher, W. "Pythagoras auf griechischen Münzbildern." *Opuscula* 59–63.

Schweitzer, B. *Mythologische Hochzeiten.* Heidelberg 1961.

Schweitzer, B. *Zur Kunst der Antike: Ausgewählte Schriften.* 2 vols. Tübingen 1963.

Sealey, R. *A History of the Greek City States: 700–338 B.C.* Berkeley 1976.

Seltman, C. *Athens: Its History and Coinage before the Persian Invasion.* Reprint Chicago 1974.

Seltman, C. *The Twelve Olympians and Their Guests.* London 1956.

Senior, M. *Greece and Its Myths.* London 1978.

Servais-Soyez, B. "En révisant l'iconographie de Cadmos." *AntCl* 50 (1981) 733–43.

Shapiro, H. A. *Personifications of Abstract Concepts in Greek Art and Literature to the End of the Fifth Century B.C.* Diss., Princeton 1977.

Shapiro, H. A., K. Kilinski, J. Neils, and L. Turnbull. Eds. *Art, Myth and Culture: Greek Vases from Southern Collections.* New Orleans Museum of Art, exhibition catalog, 1981.

Shaw, M. C. "The Miniature Frescoes of Tylissos Reconsidered." *AA* 1972, 171–88.

Shaw, M. C. "Painted 'Ikria' at Mycenae?" *AJA* 84 (1980) 167–79.

Shefton, B. B. "Attisches Meisterwerk und etruskische Kopie." *Wissenschaftliche Zeitschrift der Univ. Rostock* 16 (1967) 534–41.

Sichtermann, H. *Griechische Vasen in Unteritalien aus der Sammlung Jatta in Ruvo.* Tübingen 1966.

Silberberg, S. R. *A Corpus of the Sacral-Idyllic Landscape Paintings in Roman Art.* Diss., Univ. of California, Los Angeles 1980.

Simon, E. "Boreas und Oreithyia auf dem silbernen Rhyton in Triest." *Antike und Abendland* 13 (1967) 101–26.

Simon, E. *Festivals of Attica: An Archaeological Commentary.* Madison 1983.

Simon, E. *Die Götter der Griechen.* 2nd ed. Munich 1980.

Simon, E. *Meleager und Atalante: Ein spätantiker Wandbehang.* Bern 1970.

Simon, E. *Opfernde Götter.* Berlin 1953.

Simon, E. *Pergamon und Hesiod.* Mainz 1975.

Simon, E. "Die Typen der Medeadarstellung in der antiken Kunst." *Gymnasium* 61 (1954) 203–27.

Simon, E., and M. Hirmer. *Die griechische Vasen.* Munich 1976.

Simon, E., et al. *Führer durch die Antikenabteilung des Martin von Wagner Museums der Universität Würzburg.* Mainz 1975.

Smith, W. S. *Interconnections in the Ancient Near East.* New Haven 1965.

Snell, B., and H. Maehler. Eds. *Pindari Carmina cum Fragmentis.* 2 vols. Leipzig 1975, 1980.

Snodgrass, A. M. *Archaic Greece: The Age of Experiment.* London 1980.

Snodgrass, A. M. *The Dark Age of Greece: An Archaeological Survey of the Eleventh to the Eighth Centuries B.C.* Edinburgh 1971.

Snodgrass, A. M. "Poet and Painter in Eighth-century Greece." *Proceedings of the Cambridge Philological*

Society 205 (1979) 118–30.

Snodgrass, A. M. "Towards the Interpretation of the Geometric Figure-Scenes." *AthMitt* 94 (1979) 49–75.

Sokolowski, F. *Lois sacrées des cités grecques*. Paris 1969.

Solmsen, F. *Isis among the Greeks and Romans*. Cambridge, Mass. 1979.

Stähler, K. P. "Exekias bemalte und töpferte mich." *ÖJh* 48 (1966–1967) 79–113.

Stanford, W. B. *Greek Metaphor*. Oxford 1936.

Stella, L. A. *Mitologia greca*. Rome 1955. Main gods and goddesses.

Stemplinger, E. *Antiker Volksglaube*. Stuttgart 1948.

von Steuben, H. *Frühe Sagendarstellungen in Korinth und Athen*. Berlin 1968.

Stewart, A. *Skopas in Malibu: The Head of Achilles from Tegea and Other Sculptures by Skopas in the J. Paul Getty Museum*. Malibu 1982.

Stewart, A. *Skopas of Paros*. Park Ridge, N.J. 1977.

Streiftog i antikken. Til H. P. L'Oranges 70 Årsdag. Ed. A. Seeberg. Oslo 1973.

Studi in onore di Aristide Calderini e Roberto Paribeni II, *Studi di archeologia e di storia dell'arte antica*. Milan 1956.

Studi in onore di Luisa Banti. Rome 1965.

Studia romana in honorem Petri Krarup septuagenarii. Ed. K. Ascani et al. Odense 1976.

Studien zur griechischen Vasenmalerei. AntK Beiheft 7 (1970).

Studies in Classical Art and Archaeology: A Tribute to Peter H. von Blanckenhagen. Ed. G. Kopcke and M. B. Moore. Locust Valley, N. Y. 1979.

Studies in Honor of Arthur Dale Trendall. Ed. A. Cambitoglou. Sydney 1979.

Studies Presented to David Moore Robinson II. Ed. G. E. Mylonas and D. Raymond. St. Louis 1953.

Studies Presented to George M. A. Hanfmann. Ed. D. G. Mitten, J. G. Pedley, and J. A. Scott. *Monographs in Art and Archaeology* 2. Cambridge, Mass. and Mainz 1971.

Svoronos, J. N. *Das Athener Nationalmuseum*. Athens 1908.

Szeliga, N. *The Dioskouroi on the Roof: Archaic and Classical Equestrian Akroteria in Sicily and South Italy*. Diss., Bryn Mawr College 1981.

Tainia: Roland Hampe zum 70. Geburtstag am 2. Dezember 1978: Dargebracht von Mitarbeitern, Schülern, und Freunden. Ed. H. A. Cahn and E. Simon. 2 vols. Mainz 1980.

Technau, W. *Exekias*. Leipzig 1936.

Termer, H. *Kunst der Antike, Galerie Neuendorf, November* 22–*December* 20, 1978. Hamburg 1978.

Tetzloff, I. *Griechische Vasenbilder: Die Themen, Symbole, Zweck und Form, über den Kult, Verbreitung, Ausstrahlung*. Cologne 1980.

Thera and the Aegean World: Papers and Proceedings of the Second International Scientific Congress. Ed. C. Doumas. 2 vols. London 1978, 1980.

Thiasos: Sieben archäologische Arbeiten. Ed. T. Lorenz. *Castrum Peregrini* 132–133 Amsterdam 1978.

Thiele, G. *Antike Himmelsbilder*. Berlin 1898.

Thiemann, E. *Hellenistische Vatergottheiten: Das Bild des bärtigen Gottes in der nachklassischen Zeit*. Münster 1959.

Thompson, M. L. "The Monumental and Literary Evidence for Programmatic Painting in Antiquity." *Marsyas* 9 (1960–1961) 36–77.

Thompson, S. *Motif-Index of Folk Literature*. 6 vols. Copenhagen 1955–1958.

Tiberios, M. A. *Ho Ludos kai to ergo tou*. Athens 1976.

Tiberios, M. A. *Problemata tes melanomorphes attikes keramikes*. Thessalonike 1981.

Tomlinson, R. A. *Argos and the Argolid*. London 1972.

Tran Tam Tinh, V. *Isis Lactans: Corpus des monuments gréco-romains d'Isis allaitant Harpocrate*. Leiden 1973.

Travlos, J. *Pictorial Dictionary of Ancient Athens*. New York 1971.

Trendall, A. D. *The Felton Greek Vases*. Canberra 1968.

Trendall, A. D. *The Red-Figured Vases of Lucania, Campania, and Sicily*. Oxford 1967. Supp. I, *BICS* supp. 26 (1970). Supp. II, *BICS* supp. 31 (1973).

Trendall, A. D., and A. Cambitoglou. *The Red-Figured Vases of Apulia*. Oxford 1978.

Turcan, R. *Mithra et le mithriacisme*. Paris 1981.

Tyree, E. L. *Cretan Sacred Caves: Archaeological Evidence*. Diss., Columbia Univ. 1974.

Vellay, C. *Les légends du cycle troyen*. Monaco 1957.

Vermaseren, M. J. *Cybele and Attis: The Myth and Cult*. London 1977. With bibliography.

Vermaseren, M. J. *The Legend of Attis in Greek and Roman Art*. Leiden 1966.

Vermeule, C. *Iconographic Studies*. Boston 1980.

Vermeule, E. T. "The Art of the Shaft Graves at Mycenae." *Lectures in Memory of Louise Taft Semple*. Norman, Okla. 1975.

Vermeule, E. T. *Götterkult. ArchHom* III v. Göttingen 1974.

Vermeule, E. T. *Greece in the Bronze Age*. Chicago 1972.

Vermeule, E. T., and V. Karageorghis. *Mycenaean Pictorial Vase Painting*. Cambridge, Mass. 1982.

Villard, F., A. Pasquier, et al. *Mer Egée Grèce de Îles*. Exhibition catalog. 26 April–3 September, 1979. Paris.

Villard, L. "Inventaire et recherche: Une tentative de compromis." *Image et céramique grecque*.

Visser, C. E. *Götter und Kulte im ptolemäischen Alexandrien*. Amsterdam 1938.

Vlachos, S. *Greek Preliminary Sacrifices*. Diss., Bedford College, Univ. of London, in progress.

Voegtli, H. *Bilder der Heldenepen in der kaiserzeitlichen griechischen Münzprägung*. Diss., Basel 1974.

Wallenstein, K. *Korinthische Plastik des 7. und 6. Jahrhunderts vor Christus*. Bonn 1971.

Walter, H. *Griechische Götter, ihr Gestaltwandel aus den Bewusstseinsstufen des Menschen dargestellt an den Bildwerken*. Munich 1971.

Walter, H. *Vom Sinnwandel griechischer Mythen*. Bern 1959.

Wandlungen: Studien zur antiken und neueren Kunst: Ernst Homann-Wedeking gewidmet. Waldsassen 1975.

Warren, P. "The Miniature Fresco from the West House at Akrotiri, Thera, and its Aegean Setting,"

JHS 99 (1979) 115–29.

Warren, P. Minoan Stone Vases. Cambridge 1969.

Wasowicz, A. Obrobka drewna w starozytnej grecji (Woodwork in Ancient Greece). Warsaw 1966. French summary.

Webb, V. Archaic Greek Faience. Warminster 1978.

Webster, T. B. L. Der Niobidenmaler. Leipzig 1935.

Webster, T. B. L. Potter and Patron in Classical Athens. London 1972.

Weiss, H. A. The Hanging Marsyas: The Origin and History of a Statue. Diss., Bryn Mawr College, 1977.

Weitzmann, K. Age of Spirituality, Late Antique and Early Christian Art, Third to Seventh Century. Exhibition catalog 19 November 1977 to 12 February 1978, The Metropolitan Museum of Art.

Weizsäcker, P. "Neue Untersuchungen über die Vase des Klitias und Ergotimos." RhM 32 (1877) 28–67 and RhM 33 (1878) 364–99.

von Wersin, W. Das elementare Ornament. Rawensburg 1940.

West, M. L. Ed. Iambi et Elegi Graeci I. Oxford 1971.

West, M. L. "Stesichorus." CQ 21 (1971) 302–14.

Will, E. Korinthiaka: Recherches sur l'histoire et la civilisation de Corinthe. Paris 1955.

Willetts, R. F. Cretan Cults and Festivals. London 1962.

Wolters, P. Faden und Knoten als Amulett. Leipzig 1905.

Woodford, S. The Art of Greece and Rome. Cambridge, Mass. 1982.

Woodhead, A. G. The Greeks in the West. London 1962.

Wort und Bild: Studien zur Gegenwart der Antike. Ed. E. Berger and H. C. Ackermann. Basel 1975.

Yalouris, N. "Painting in the Age of Alexander the Great and the Successors." Macedonia and Greece in Late Classical and Early Hellenistic Times 263–68.

Younger, J. G. "The Mycenae-Vapheio Lion Group." AJA 82 (1978) 285–99.

Zahn, R. "Das Kind in der antiken Kunst." Staatliche Museen zu Berlin, Forschungen und Berichte 12 (1970) 21–31.

Zur griechischen Kunst: Festschrift H. Bloesch. Ed. H. P. Isler and G. Seiterle. AntK Beiheft 9 (1973).

APOLLO AND ARTEMIS

Amandry, P. La mantique apollinienne à Delphes: Essai sur le fonctionnement de l'Oracle. Paris 1950. Reprint New York 1975.

Bassi, D. Saggio di bibliografia mitologica I, Apollo. Rome 1896.

Benson, J. J. "The Central Group of the Corfu Pediment." Gestalt und Geschichte 48–60. With very valuable bibliography.

Bérard, C. "Architecture érétrienne et mythologie delphique." AntK 14 (1971) 59–73.

Besig, H. Gorgo und Gorgoneion in der archaischen griechischen Kunst. Berlin 1937. See related titles in Mythological Heroes and Mythological Beasts.

Borgeaud, W. "Le déluge, Delphes et les Anthestéries." MusHelv 8 (1951) 185–89.

von Bothmer, D. "The Struggle for the Tripod."

Festschrift Brommer 51–63.

van den Broek, R. Apollo in Asia: De orakels van Clarus en Didyma in de tweede en derde eeuw na Chr. Leiden 1981.

Brommer, F. "Mythologische Darstellungen auf Vasenfragmenten der Sammlung Cahn." AntK Beiheft 7 (1970) 50–65.

Bruns, G. Die Jägerin Artemis: Studie über den Ursprung ihrer Darstellung. Leipzig 1929.

Burkert, W. "Apellai und Apollon." RhM 118 (1975) 1–21.

Burkert, W. "Resep-Figuren, Apollo von Amyklai und die Erfindung des Opfers auf Cypern." Grazer Beiträge 4 (1975).

Chirassi, I. Miti e culti arcaici di Artemis nel Peloponneso e Graeca centrale. Istituto di Storia Antica, Università degli Studi Trieste III. Rome 1964.

Christou, C. Potnia Theron: Eine Untersuchung über Ursprung, Erscheinungsformen und Wandlungen der Gestalt einer Gottheit. Thessalonike 1968.

Clairmont, C. W. "Niobiden." AntK 6 (1963) 23–32.

Colin, J. Le culte d'Apollon Pythien à Athènes. Bibliothèque des Écoles françaises d'Athènes et de Rome 93. Paris 1905.

Cook, R. M. Niobe and Her Children. Cambridge 1964.

Defradas, J. Les thèmes de la propagande Delphique. 2nd ed. Paris 1972.

Devambez, P. "Un cratère à volutes Attique du milieu du ve siècle avant notre ère." MonPiot 55 (1967) 77–104.

Dietrich, B. C. "Some Evidence from Cyprus of Apolline Cult in the Bronze Age." RhM 121 (1978) 1–18.

Dörig, J. "Lesefrüchte." Gestalt und Geschichte 102–9.

Egilmez, E. T. Artemis in Kleinasien. Diss., Mainz 1980.

Fehr, B. "Zur Geschichte des Apollonheiligtums Didyma." MarbWinckProg (1972) 14–59.

Fleischer, R. Artemis von Ephesos und verwandte Kultstatuen aus Anatolien und Syrien. Leiden 1973.

Fontenrose, J. "The Cult and Myth of Pyrrhos at Delphi." CPCA 4 (1960) 191–266.

Fontenrose, J. The Delphic Oracle, Its Responses and Operations, with a Catalogue of Responses. Berkeley 1978.

Fontenrose, J. Orion: The Myth of the Hunter and Huntress. Berkeley 1981.

Fontenrose, J. Python: A Study of Delphic Myth and its Origins. Berkeley 1959.

Frontisi-Ducroux, F. "Artémis bucolique." RHR 198 (1981) 29–56.

Frothingham, A. L. "Medusa, Apollo, and the Great Mother." AJA 15 (1911) 349–77.

Graf, F. "Apollon Delphinios." MusHelv 36 (1979) 2–22.

Greifenhagen, A. "Tityos." Jahrbuch der Berliner Museen, n.s. 1 (1959) 5–32.

Harrison, E. B. "Apollo's Cloak." Studies in Classical Art and Archaeology 91–98.

Heinzel, E. "Zum Kult der Artemis von Ephesos." ÖJh 50 (1974) 243–51.

Hodge, T. "The Mystery of Apollo's E at Delphi." AJA 85 (1981) 83–84.

Hoenn, K. Artemis: Gestaltwandel einer Göttin.

Zurich 1946.

Hoffmann, H. "Eine neue Amphora des Eucharides-malers." *Jahrbuch der Hamburger Kunstsammlung* 12 (1967) 9–34.

Hoffmann, H. "The Oldest Portrayal of the Niobids." *Archaeology* 13 (1960) 182–85.

Hofkes-Brukker, C. *Der Bassai-Fries in der ursprünglich geplanten Anordnung.* Munich 1975.

Hollinshead, M. B. B. *Legend, Cult, and Architecture at Three Sanctuaries of Artemis.* Diss., Bryn Mawr College 1971.

Hooker, E. M. "The Sanctuary and Altar of Chryse in Attic Red-Figure Vase-Paintings of the Late Fifth and Early Fourth Centuries B.C." *Hesperia* 70 (1950) 35–41.

Jacobsthal, P. "Aktaions Tod." *Marburger Jahrbuch für Kunstwissenschaft* 5 (1929) 1–23.

Jacoby, B. *Studien zur Ikonographie des Phaetonmythos.* Bonn 1971.

Jucker, I. "Artemis Kindyas." *Gestalt und Geschichte* 133–45.

Kahil, L. "Apollo et Python." *Mélanges Michałowski* 481–90.

Kahil, L. "L'Artémis de Brauron: Rites et mystère." *AntK* 20 (1977) 86–98.

Kahil, L. "Autour de l'Artémis attique." *AntK* 8 (1965) 20–33. With bibliography.

Kahil, L. "Le 'craterisque' d'Artémis et le Brauronion de l'Acropole." *Hesperia* 50 (1981) 253–63.

Kahil, L. "La déesse Artémis: Mythologie et iconographie." *Greece and Italy in the Classical World. Acta of the XI International Congress of Classical Archaeology, London 3–9 September 1978* (London 1979). 73–87.

Kahil, L. "Quelques vases du sanctuaire d'Artémis à Brauron." *Neue Ausgrabungen in Griechenland. AntK* Beiheft 1 (1963) 5–29.

Kahrstedt, U. "Delphoi und das Heilige Land des Apollon." *Studies Robinson* II, 749–57.

Kerenýi, K. *Apollon: Studien über antike Religion und Humanität.* 2nd ed. Amsterdam 1941.

Keuls, E. C. "Aeschylos' 'Niobe' and Apulian Funerary Symbolism." *ZPE* 30 (1978) 42–68.

Keuls, E. C. "Niobe and Tantalus' Associates." *ZPE* 38 (1980) 43–45.

Kontis, I. "Artemis Brauronia." *Deltion* 22A (1967) 156–206.

Kraus, T. *Hekate.* Heidelberg 1960.

Kunze, E. "Zum Giebel des Artemistempels in Korfu." *AthMitt* 78 (1963) 74–89.

Leach, E. W. "Metamorphosis of the Acteon Myth in Campanian Painting." *RömMitt* 88 (1981) 307–27.

Le Lasseur, D. *Les déesses armées dans l'art classique grec et leurs origines orientales.* Paris 1919.

Lewis, E. *The Iconography of the Muses.* Diss., Bryn Mawr College, in progress.

Mellink, M. J. *Hyakinthos.* Mainz 1943.

Otto, W. *Die Musen und der göttliche Ursprung des Singens und Sagens.* Darmstadt 1956. Also Nymphs.

Parke, H. W., and J. Boardman. "The Struggle for the Tripod and the First Sacred War." *JHS* 77 (1957) 276–82.

Pfeiffer, R. "The Image of the Delian Apollo and Apolline Ethics." *JWarb* 15 (1952) 20–32.

Ridgway, B. "The East Pediment of the Siphnian Treasury, A Reconsideration." *AJA* 69 (1965) 1–5. See also Athena and Zeus.

Roux, G. *Delphes: Son oracle et ses dieux.* Paris 1976.

Schauenburg, K. "Aktaion in der unteritalischen Vasenmalerei." *JdI* 84 (1969) 29–46.

Schauenburg, K. *Helios: Archäologisch-mythologische Studien über den antiken Sonnengott.* Berlin 1955.

Schauenburg, K. "Marsyas." *RömMitt* 65 (1958) 42–66.

Schefold, K. "Die ältesten Bilder von Apollon und Daphne." *Wort und Bild* 93–94.

Sichtermann, H. "Aktaionbilder." *JdI* 71 (1956) 97–123.

Simon, E. "Die Tomba dei Tori und der etruskische Apollonkult." *JdI* 88 (1973) 27–42.

Spartz, E. *Das Wappenbild des Herrn und der Herrin der Tiere in der minoisch-mykenischen und frühgriechischen Kunst.* Diss., Munich 1962.

Thiersch, H. *Artemis Ephesia: Eine archäologische Untersuchung.* Berlin 1935.

Threpsiades, J., and E. Vanderpool. "Themistokles' Sanctuary of Artemis Aristoboule." *Deltion* 19A (1964) 26–36.

Trendall, A. D. "The Mourning Niobe." *RA* (1972) 306–16.

Vermaseren, M. J. *Cybele and Attis: The Myth and the Cult.* London 1977. With bibliography.

Vogelpohl, C. "Die Niobiden vom Thron des Zeus in Olympia." *JdI* 95 (1980) 197–226.

Willemsen, F. "Aktaionbilder." *JdI* 71 (1956) 29–58.

Zerboudake, H. "Helios kai Halieia." *Deltion* 30A (1975) 1–20.

ARES, APHRODITE, AND EROS

Albert, W.-D. *Darstellungen des Eros in Unteritalien. Studies in Classical Antiquity* 2. Amsterdam 1979.

Atallah, W. *Adonis dans la litterature et l'art grecs.* Paris 1966.

Bernoulli, J. J. *Aphrodite.* Leipzig 1973.

Boedeker, D. D. *Aphrodite's Entry into Greek Epic.* Leiden 1974.

Brown, N. O. *Love's Body.* New York 1966.

Delcourt, M. *Hermaphrodite, mythes et rites de la bisexualité dans l'antiquité classique.* Paris 1958. English trans. J. Nicholson. London 1961.

Detienne, M. *Les jardins d'Adonis.* Paris 1972. English trans. J. Lloyd. Hassocks 1977.

Eissfeldt, O. *Adonis und Adonai.* Leipzig 1970.

Fauth, W. *Aphrodite Parakyptusa.* Mainz 1967.

Friedrich, P. *The Meaning of Aphrodite.* Chicago 1978.

Froning, H. "Zum Rheosmythos." *AA* 1971, 30–36.

Furtwängler, A. *Eros in der Vasenmalerei.* Munich 1874.

Greifenhagen, A. *Griechische Eroten.* Berlin 1957.

Grigson, G. *The Love Goddess: Birth, Triumph, Death and Return of Aphrodite.* London 1978.

Hermansen, G. *Studien über den italischen und den römischen Mars.* Copenhagen 1940.

Herter, H. "Die Ursprünge des Aphroditenkultes." *Éléments orientaux* 61–76.

Jentel, M. O. "Quelques aspects d'Aphrodite en Egypt à l'époque hellénistique et romaine." *Mythologie gréco-romaine* 151–56.

Kunstmann, J. *The Transformation of Eros.* Trans. M.

von Herzfeld and R. Gaze. Philadelphia 1964.

Le Lasseur, D. *Les déesses armées dans l'art classique grec et leurs origines orientales.* Paris 1919.

Metzler, D. "Eunomia und Aphrodite: Zur Ikonologie einer attischen Vasengruppe." *Hephaistos* 2 (1980) 73–88.

Olshausen, E. "Eros mit dem Barbiermesser." *AA* 1979, 17–24.

Pfau, W. "Studien zur Ikonographie und gesellschaftlichen Funktion hellenistischer Aphrodite-Statuen." *Hephaistos* 1 (1979) 149–51.

Ribichini, S. *Adonis: Aspetti orientali di un mito greco.* Rome 1981.

Rose, H. J. "Anchises and Aphrodite." *CQ* 18 (1924) 11–16.

Rumpf, A. "Anadyomene." *JdI* 65–66 (1950–1951) 166–74.

Schauenburg, K. "Eros im Temple." *AA* 1981, 344–48.

Schauenburg, K. "Eros und Nereiden auf einer apulischen Kugelpyxis." *Rivista di Archeologia* 2 (1978) 16–22.

Schauenburg, K. "Erotenspiele I." *Antike Welt* 7, no. 3 (1976) 39–52. "Erotenspiele II." *Antike Welt* 7, no. 4 (1976) 28–35.

Sichtermann, H. "Die Flügel der Psyche." *Opuscula* 49–58.

Simon, E. "Aphrodite Pandemos aus attischen Münzen." *SNR* 49 (1970) 5–21.

Simon, E. "Aphrodite und Adonis—Eine neuerworbene Pyxis in Würzburg." *AntK* 15 (1972) 20–26.

Simon, E. *Die Geburt der Aphrodite.* Berlin 1959.

Sokolowski, F. "Aphrodite as the Guardian of the Greek Magistrates." *HThR* 67 (1964) 1–8.

Soyez, B. *Byblos et la fêtes des Adonies.* Leiden 1977.

Zancani Montuoro, P. "La pariglia di Afrodite." *Opuscula* 15–23.

Zancani Montuoro, P. "Persefone e Afrodite sul mare." *Essays Lehmann* 386–95.

Zayadine, F. "L'iconographie d'Al'Uzza-Aphrodite." *Mythologie gréco-romaine* 113–18.

ATHENA AND NIKE

Berger, E. "Die Geburt der Athena im Ostgiebel des Parthenon." *Studien der Skulpturenhalle Basel* 1 (1975) 35–43.

Blatter, R. "Athena beim Parisurteil." *AA* 1980, 523–25.

Borthwick, E. K. "P.Oxy.2738: Athena and the Pyrrhic Dance." *Hermes* 98 (1970) 318–31.

Brommer, F. "Attische Könige." *Charites* 152–64.

Brommer, F. "Die Geburt der Athena." *RGZM* 8 (1961) 66–83.

Brommer, F. *Die Metopen des Parthenon.* Mainz 1967.

Brommer, F. "Zu den Schildreliefs der Athena Parthenos des Phidias." *MarbWinckProg* (1947) 10–19.

Daly, L. W. "Nike and Athena Nike." *Studies Robinson* II, 1124–28.

Ellinger, I. E. "Winged Figures." *Studies Robinson* II, 1185–90.

Fehr, B. "Zur religionspolitischen Funktion der Athena Parthenos im Rahmen des delisch-attischen Seebundes." *Hephaistos* 2 (1980) 113–26.

Floren, J. "Zu den Reliefs auf dem Schild der Athena Parthenos." *Boreas* 1 (1978) 36–67.

Frel, J. *Panathenaic Prize Amphoras.* Athens 1973.

Goulaki, A. *Klassische und klassizistische Nikedarstellungen: Untersuchungen zur Typologie und zum Bedeutungswandel bewegter Figuren.* Diss., Bonn 1981.

Groothand, M. H. "The Owl on Athena's Hand." *BABesch* 43 (1968) 35–51.

Harrison, E. B. "Alkamenes' Sculptures for the Hephaisteion." "Part I, The Cult Statues." *AJA* 81 (1977) 137–78. "Part II, The Base." 265–87. "Part III, Iconography and Style." 411–26.

Harrison, E. B. "Athena and Athens in the East Pediment of the Parthenon." *AJA* 71 (1967) 27–58. Also Herakles.

Harrison, E. B. "Motifs of the City-Siege on the Shield of Athena Parthenos." *AJA* 85 (1981) 294–311.

Herington, C. J. *Athena Parthenos and Athena Polias.* Manchester 1955.

Holland, L. B. "Erechtheum Papers." *AJA* [1924–34].

Isler-Kerenýi, C. *Nike. Der Typus der laufenden Flügelfrau in archaischer Zeit.* Zurich 1969.

Karouzou, S. "Two Statues on a Vase." *Essays Lehmann* 153–59. The Leaning Athena and Herakles Alexikakos.

Kauer, S. *Die Geburt der Athena im altgriechischen Epos.* Würzburg 1959.

Kenner, H. "Flügelfrau und Flügeldämon." *ÖJh* 31 (1939) 81–95.

Kerenýi, K. *Die Jungfrau und Mutter der griechischen Religion: Studie über Pallas Athena.* Zurich 1952.

Kunckle, H. *Der römische Genius.* Heidelberg 1974.

Kunisch, N. "Zur helmhaltenden Athena." *AthMitt* 89 (1974) 85–104.

Leipen, N. *Athena Parthenos.* Toronto 1971.

Le Lasseur, D. *Les déesses armées dans l'art classique grec et leurs origines orientales.* Paris 1919.

Linfert, A. "Die Götterversammlung im Parthenon-Ostfries und das attische Kultsystem unter Perikles." *AthMitt* 94 (1979) 41–47.

Mark, I. S. *Nike and the Cult of Athena Nike on the Athenian Acropolis.* Diss., New York Univ. 1979.

Mathiopoulos, E. *Zur Typologie der Göttin Athena im fünften Jahrhundert vor Christus.* Diss., Bonn 1968.

Michaelis, A. *Der Parthenon.* Leipzig 1870–1871.

Müller, M. *Athene als göttliche Helferin in der Odyssee.* Heidelberg 1966.

Niemeyer, H.G. *Promachos: Untersuchungen zur Darstellung der bewaffneten Athena in archaischer Zeit.* Waldsassen 1960.

Nilsson, M. P. *Die Anfänge des Göttin Athena.* Copenhagen 1921.

Nitzsche, J. C. *The Genius Figure in Antiquity and the Middle Ages.* New York 1975.

Ridgway, B. "The East Pediment of the Siphnian Treasury: A Reconsideration." *AJA* 69 (1965) 1–5. See Apollo and Zeus.

Rolley, C. "Statuette d'Athena Promachos." *RA* (1968) 35–48.

Rotroff, S. I. "The Parthenon Frieze and the Sacrifice to Athena." *AJA* 81 (1977) 379–82.

Schefold, K. "Athene aus dem Piräus." *AntK* 14 (1971) 37–42.

Schiff, F. "Athena Parthenos, die Vision des Phidias." *AntK* 16 (1973) 4–44.

Schmidt, E. "Der Knielauf und die Darstellung des Laufens und Fliegens in der älteren griechischen Kunst." *Münchener archäologische Studien* 249–397.

Schürmann, W. *Untersuchungen zu Typologie und Bedeutung der stadtrömischen Minerva Kultbilder.* In preparation.

Schwabacher, W. "Der Parthenos-Archetyp der hellenistischen Silbermünzen-Athens." *OpusAth* I (1953) 104–14.

Sichtermann, H. "Die Flügel der Psyche." *Opuscula* 49–58.

Simon, E. "Die Geburt der Athena auf der Reliefamphora in Tenos." *AntK* 25 (1982) 39–43.

Stähler, K. "Ein Niketypus vom Zeusthron." *Boreas* 1 (1978) 68–86.

Starcky, J. "Allath, Athèna et la 'Déesse syrienne.' " *Mythologie gréco-romaine* 199–30.

Wescoat, B. D. *The Temple of Athena at Assos: Iconography and Architecture.* Diss., Brasenose College, Oxford, in progress.

Yalouris, N. "Athena als Herrin der Pferde." *MusHelv* 7 (1950) 19–101.

DEMETER AND PERSEPHONE

Anton, H. *Der Raub der Proserpina.* Heidelberg 1967.

Ashmole, B. "Torch-racing at Rhamnus." *AJA* 66 (1962) 233–34.

Bérard, C. *Anodoi: Essai sur l'imagerie des passages chthoniens.* Rome 1974.

Callipolitis-Feytmans, D. "Déméter, Core, et les Moires sur des vases corinthiens." *BCH* 94 (1970) 45–65.

Chirassi, I. *Elementi di culture precereale nei miti e riti greci.* Rome 1968.

Clinton, K. *The Sacred Officials of the Eleusinian Mysteries.* Philadelphia 1974.

Coldstream, J. N. *Knossos: The Sanctuary of Demeter.* London 1973.

Dahl, K. *Thesmophoria: Ein graesk Kvindefest.* Copenhagen 1976.

Graf, F. *Eleusis und die orphische Dichtung: Athen in vorhellenischer Zeit.* Berlin 1974.

Grossman, B. G. *The Eleusinian Gods and Heroes in Greek Art.* Diss., Washington Univ. 1959.

Kerényi, K. *Eleusis: Archetypal Image of Mother and Daughter.* New York and London 1967.

Lehnert, P. A. *Female Heads on Greek, South Italian, and Sicilian Vases from the Sixth to the Third Century B.C. as Representations of Persephone/Kore.* Thesis, Michigan State Univ. 1978.

Metzger, H. *Recherches sur l'imagerie athenienne.* Paris 1965.

Mylonas, G. *Eleusis and the Eleusinian Mysteries.* Princeton 1961.

Nilsson, M. P. "Die eleusinischen Gottheiten." *Opuscula Selecta* II, 542–623. Lund 1952.

Noack, F. *Eleusis, die baugeschichtliche Entwicklung des Heiligtums: Aufnahmen und Untersuchungen von Ferdinand Noack; Mit Beiträgen von J. Kirchner, A. Körte und A. K. Orlandos.* Berlin 1927.

Orlandini, P. "Diffusione del culto di Demetra e Kore in Sicilia." *Kokalos* 14–15 (1968–1969) 334–38.

Peschlow-Bindokat, A. "Demeter und Persephone in

der attischen Kunst des 6. bis 4. Jahrhunderts v. Chr." *JdI* 87 (1972) 60–157.

Pollitt, J. J. "Kernoi from the Athenian Agora." *Hesperia* 48 (1979) 205–33.

Schauenburg, K. "Die Totengötter in der unteritalischen Vasenmalerei." *JdI* 73 (1958) 48–78.

Schwarz, G. "Zwei eleusinische Szenen auf einem Kelchkrater des Berliner Malers in Athen." *AA* 1971, 178–82.

Simon, E. "Neue Deutung zweier eleusinischer Denkmäler des vierten Jahrhunderts v. Chr." *AntK* 9 (1966) 72–91.

Skowronek, S., and B. Tkaczow. "Le culte de la déesse Déméter à Alexandrie." *Mythologie gréco-romaine* 131–44.

Sourvinou-Inwood, C. "Persephone and Aphrodite at Locri: A Model for Personality Definitions in Greek Religion." *JHS* 98 (1978) 101–21.

Thompson, H. A. "Pnyx and Thesmophorion." *Hesperia* 5 (1936) 151–200.

Zuntz, G. *Persephone: Three Essays on Religion and Thought in Magna Graecia.* Oxford 1971.

DIONYSOS AND THEATER

Bayet, J. "Le phénomène religieux dionysiaque." *Critique* 80–81 (1954) 20–30, 132–46.

Bérard, C. *Anodoi: Essai sur l'imagerie des passages chthoniens.* Rome 1974.

Bezerra de Meneses, U. T. "Une représentation probable de Dionysos Dendritès." *BCH* 87 (1963) 309–21.

Bieber, M. *The History of the Greek and Roman Theater.* 2nd ed. Princeton 1961.

Boardman, J. "An Early Actor: And Some Herakles-and-Nereus Scenes." *BICS* 5 (1958) 6–10.

Brea, L. B. *Menandro e il teatro greco nelle terracotte liparesi.* Genoa 1981.

Brommer, F. "Bilder der Midassage." *AA* 1941, 36–52.

Brommer, F. "Delphinreiter: Vasenbilder früher Komödien." *AA* 1942, 65–75.

Brommer, F. *Satyroi.* Würzburg 1937.

Buschor, E. *Satyrtänze und frühes Drama.* Munich 1943.

Calder, W. III. "The Size of Thespis' Chorus." *AJP* 103 (1982) 319–37.

Cambitoglou, A. "Iphigeneia in Tauris: The Question of the Influence of the Euripidean Play in the Representations of the Subject in Attic and Italiote Vase-Painting." *AntK* 18 (1975) 56–66.

Carpenter, T. H. *Development of Dionysian Imagery in Greek Vase Painting: 580–520 B.C.* Diss., Christ Church, Oxford, in progress.

Christopulu-Mortoja, H. *Darstellungen des Dionysos in der schwarzfigurigen Vasenmalerei.* Berlin 1964.

Ciani, M. G. *Dionysos: Variazioni sul mito.* Padua 1979.

Curtius, L. "Pentheus." *BerlWinckProg* 88 (1929) 1–19.

Daumas, M. "L'amphora de Panaguriste et les Sept contra Thebes." *AntK* 21 (1978) 23–31.

Davies, M. I. "The 'Oresteia' Before Aischylos." *BCH* 93 (1969) 214–60. With bibliography.

Detienne, M. *Dionysos Slain.* Trans. M. and L. Muellner. Baltimore 1979.

Devereux, G. "The Self-blinding of Oidipous in Sophokles 'Oidipous Tyrannos.' " *JHS* 93 (1973) 36–49.

Fittschen, K. "Zur Herakles-Nessos-Sage." *Gymnasium* 77 (1970) 161–71.

Flacelière, R., and P. Devambez. *Héraclès: Images et récits*. Paris 1966.

von Freytag gen. Löringhoff, B., and C. de Simone. "Argonautica. Ein etruskischer Spiegel in der Tübinger Sammlung." *Praestant Interna* 271–79.

Frickenhaus, A. "Das Herakleion von Melite." *AthMitt* 36 (1911) 113–44.

Friedländer, P. *Herakles, sagengeschichtliche Untersuchungen*. Berlin 1907.

Friis Johansen, K. *Thésée et la danse à Délos: Étude herméneutique*. Copenhagen 1945.

Froning, H. "Herakles und Dionysos auf einer Schale des 4. Jh v. Chr. in Würzburg." *WürzJbb* 1 (1975) 201–208.

Galinsky, G. K. *The Herakles Theme: The Adaptations of the Hero in Literature from Homer to the Twentieth Century*. Oxford and Totowa, N. J. 1972.

de la Genière, J. "La famille d'Ares en Italie." *Mélanges P. E. Arias*. 1981.

Gentili, B. "Eracle, 'omicida giustissimo.' (Pisandro, Stesicoro e Pindaro)." *Il mito greco* 299–305.

Glynn, R. "Herakles, Nereus and Triton: A Study of Iconography in Sixth-Century Athens." *AJA* 85 (1981) 121–32.

Graf, F. *Eleusis und die orphische Dichtung Athens in vorhellenischer Zeit*. Berlin 1974. Dionysos, Demeter, et al.

Green, A. "Thésée et Oedipe: Une interprétation psychanalytique de la Théséide." *Il mito greco* 137–91.

Greifenhagen, A. *Frühlukanischer Kolonettenkrater mit Darstellung der Herakliden. BerlWinckProg* 123 (1969).

Grollios, A. *Herakles*. Diss., Univ. of Glasgow, in progress.

Guthrie, W. K. C. *Orpheus and Greek Religion: A Study of the Orphic Movement*. London 1935.

Guy, R. "Héraklès et Philoctète." *Image et céramique grecque*.

Hafner, G. "Herakles-Geras-Ogimos." *RGZM* 5 (1958) 139–53. With earlier bibliography.

Hafner, G. "Sinis, der Fichtenbeuger." *AA* 1966, 151–57.

Hampe, R. "Korfugiebel und frühe Perseusbilder." *AthMitt* 60/61 (1935/1936) 269–99.

Hartwig, P. "Herakles and Eurytos." *JHS* 12 (1891) 334–49.

von Heintze, H. "Doppelherme mit Hermes und Herakles." *RömMitt* 73–74 (1966–1967) 253–54.

Herter, H. "Theseus der Athener." *RhM* 88 (1939) 244–86.

Herter, H. "Theseus der Ionier." *RhM* 85 (1936) 177–91, 193–239.

Hiller, S. *Bellerophon: Ein griechischer Mythos in der römischen Kunst*. Munich 1970.

Hiller, S. "Bellerophon—Zur Überlieferung in Bild und Text." *Antike und Abendland* 19 (1973) 83–100.

Hopkins, C. "Assyrian Elements in the Perseus-Gorgon Story." *AJA* 38 (1934) 341–58.

Howe, T. P. "Illustrations to Aeschylos' Tetrology on the Perseus Theme." *AJA* 57 (1953) 269–75.

Hudeczek, E. "Theseus und die Tyrannenmörder." *ÖJh* 50 (1972–1975) 134–49.

Isler, H. P. *Acheloos*. Bern 1970.

Jacobsthal, P. *Theseus auf dem Meeresgrunde*. Leipzig 1911. Also Amphitrite.

Kalza, S. E. *Ho Bousiris en te hellenike grammateia kai tekhne*. Athens 1970.

Karaghiorga, T. *Gorgei kephale*. Athens 1970.

Kardara, C. P. "On Theseus and the Tyrannicides." *AJA* 55 (1951) 293–300.

Karousos, C. "Apo to Herakleion tou Kynosargous." *Deltion* 8 (1923) 85–102.

Karousou, S. *Angeia tou Anagyrountos*. Athens 1963.

Kearns, E. *Some Studies in the Significance of the Attic Hero Cult in the Archaic and Classical Periods*. Diss., St. Hilda's College, Oxford, in progress.

Kerenyi, K. *Prometheus, Archetypal Image of Human Existence*. Trans. R. Manheim. London 1962.

Kirk, G. S. "Methodological Reflexions on the Myths of Heracles." *Il mito greco* 285–97.

Kretschmer, P. "Bellerophontes." *Glotta* 31 (1951) 92–103.

Krieger, X. *Der Kampf zwischen Peleus und Thetis in der griechischen Vasenmalerei*. Diss., Münster 1973.

Lacroix, L. "La légende de Pélops et son iconographie." *BCH* 100 (1976) 327–41.

Linforth, I. M. *The Arts of Orpheus*. Berkeley 1941.

Ling, R. "Hylas in Pompeian Art." *MélRom* 91 (1979) 773–816. With earlier bibliography on Pompeian painting.

Lloyd-Jones, H. "Herakles at Eleusis: P.Oxy.2622 and P.S.I. 1391." *Maia* 19 (1967) 206–29.

Luce, S. B. "Heracles and Achelous on a Cylix in Boston." *AJA* 27 (1923) 425–37.

Luce, S. B. "Heracles and the Old Man of the Sea." *AJA* 26 (1922) 174–92.

Luce, S. B. "Studies of the Exploits of Heracles on Vases." "I: Heracles and the Erymanthian Boar." *AJA* 28 (1924) 296–325. "II: The Theft of the Delphic Tripod." *AJA* 34 (1930) 313–33.

Martin, G. "Golden Apples and Golden Boughs." *Studies Robinson* II, 1191–97.

Meyer, H. *Medeia und die Peliaden*. Rome 1980.

Mingazzini, P. "Le rappresentazioni vascolari del mito dell'apoteosi di Herakles." *MemLinc*, ser. 6, vol. 1 (1925) 417–90.

Moret, J. M. "Le départ de Bellerophon sur un cratère campanien de Genève." *AntK* 15 (1972) 95–106.

Mouliner, L. *Orphée et l'orphisme à l'époque classique*. Paris 1955.

Neils, J. "The Loves of Theseus: An Early Cup by Oltos." *AJA* 85 (1981) 177–79.

Neils, J. *The Youthful Deeds of Theseus: Iconography and Iconology*. Diss., Princeton 1980.

Oakley, J. "Danae and Perseus on Seriphos." *AJA* 86 (1982) 111–15.

Parke, H. W., and J. Boardman. "The Struggle for the Tripod and the First Sacred War." *JHS* 77 (1957) 276–82.

Pfiffig, A. J. Ed. *Herakles in der Bildkunst der etruskischen Spiegel*. Graz 1980.

Phillips, K., Jr. "Perseus and Andromeda." *AJA* 72 (1968) 1–23.

Pinney, G. F., and B. S. Ridgway. "Herakles at the Ends of the Earth." *JHS* 101 (1981) 141–44.

Podlecki, A. J. "Cimon, Skyros and Theseus' Bones." *JHS* 91 (1971) 141–43.

Price, T. H. "An Enigma in Pella: The Tholos and Herakles Phylakos." *AJA* 77 (1973) 66–71.

Richter, G. M. A. "A New Euphronios Cylix in the Metropolitan Museum of Art." *AJA* 20 (1916) 125–33.

Robertson, D. S. "Prometheus and Chiron." *JHS* 71 (1951) 150–55.

Robertson, M. " 'Geryoneis': Stesichorus and the Vase-Painters." *CQ* 63, n.s. 19 (1969) 207–21.

Robertson, N. "Herakles' Catabasis." *Hermes* 108 (1980) 274–300.

Rudhardt, J. "Les mythes grecs relatifs à l'instauration du sacrifice: Les rôles correlatifs de Prométhée et de son fils Deucalion." *MusHelv* 27 (1970) 1–15.

von Salis, A. *Theseus und Ariadne.* Berlin 1930.

von Salis, A. "Zum Löwenkampf des Herakles." *MusHelv* 12 (1955) 173–80.

Schauenburg, K. "Bellerophon in der unteritalischen Vasenmalerei." *JdI* 71 (1956) 59–96.

Schauenburg, K. "Herakles bei Pholos: Zu zwei frührotfigurigen Schalen." *AthMitt* 86 (1971) 43–54.

Schauenburg, K. "Herakles Musikos." *JdI* 94 (1979) 49–76.

Schauenburg, K. "Herakles und Bellerophon auf einer Randschale in Keil." *Meded* 6 (1979) 9–20.

Schauenburg, K. "Herakles und die Hydra auf attischem Schalenfuss." *AA* 1971, 162–78.

Schauenburg, K. "Herakles und Vogelmonstrum auf einem Krater in Kiel." *Meded* 6 (1979) 21–27.

Schauenburg, K. "Herakles unter Göttern." *Gymnasium* 70 (1963) 113–33.

Schauenburg, K. "Eine neue Amphora des Andokidesmaler." *JdI* 76 (1961) 48–71.

Schauenburg, K. "Neue Darstellungen aus der Bellerophonsage." *AA* 1958, 21–37.

Schauenburg, K. *Perseus in der Kunst des Altertums.* Bonn 1960.

Schauenburg, K. "Ein Psykter aus dem Umkreis des Andokidesmalers." *JdI* 80 (1965) 76–104.

Schefold, K. "Pandions Gorge." *Boreas* 5 (1982) 67–69.

Schmitt, M. "Bellerophon and the Chimaera in Archaic Greek Art." *AJA* 70 (1966) 341–47.

Schmidt, M. "Herakliden, Illustrationen zu Tragödien des Euripides und Sophokles." *Gestalt und Geschichte* 174–85.

Schmidt, M. "Ein neues Zeugnis zum Mythos vom Orpheushaupt." *AntK* 15 (1972) 128–37.

Schmidt, M. "Oidipus und Teiresias." *Praestant Interna* 236–43.

Schmidt, M. "Der Tod des Orpheus in Vasendarstellungen aus Schweizer Sammlungen." *Zur griechischen Kunst* 95–105.

Schoeller, F. *Darstellungen des Orpheus in der Antike.* Freiburg 1969.

Schwarz, S. J. *The Iconography of the Archaic Etruscan Herakles: A Study of Three Adventures, Nessos, Pholos and Acheloos.* Diss., Univ. of Maryland 1974.

Schweitzer, B. *Herakles.* Tübingen 1922.

Séchan, L. *Le mythe de Prométhée.* Paris 1951.

Shapiro, H. A. "Hippokrates Son of Anaxileos." *Hesperia* 49 (1980) 289–93.

Shapiro, H. A. "Theseus, Athens and Troizen." *AA* 1982, 291–97.

Shefton, B. "Herakles and Theseus on a Red-figured Louterion." *Hesperia* 31 (1962) 330–68.

Simon, E. "Polygnotan Painting and the Niobid Painter." *AJA* 67 (1963) 43–61.

Simon, M. *Hercule et le christianisme. Publications de la Faculté des lettres de l'Université de Strasbourg,* ser. 2, no. 19. Paris 1955.

Six, J. "Mikon's Fourth Picture in the Theseion." *JHS* 39 (1919) 130–43.

Sjöqvist, E. "Herakles in Sicily." *OpusRom* 4 (1962) 117–23.

Slater, P. *The Glory of Hera.* Boston 1968.

Small, J. P. *Studies Related to the Theban Cycle on Late Etruscan Urns. Archaeologica* 20 (1981).

Sokolowski, F. "Herakles Thasios." *HThR* 49 (1956) 153–58.

Sourvinou-Inwood, C. *Theseus as Son and Stepson: A Tentative Illustration of the Greek Mythological Mentality. BICS* supp. 40 (1979).

Sourvinou-Inwood, C. "Theseus Lifting the Rock and a Cup Near the Pithos Painter." *JHS* 91 (1971) 94–109.

Sparkes, B. A. "Black Perseus." *AntK* 11 (1968) 3–16.

Steiner, A. R. *Herakles and the Lion in Attic Art: 575–450.* Diss., Bryn Mawr College 1982.

Stibbe-Twist, A. "Herakles in Etrurien." *Thiasos* 80–106.

Stiglitz, R. "Herakles auf dem Amphorenfluss." *ÖJh* 44 (1959) 112–41.

Stoessl, F. *Der Tod des Herakles.* Zurich 1945.

Sturgeon, M. C. "A New Herakles Monument at Delphi." *AJA* 82 (1978) 226–35.

Suhr, E. G. "Herakles and Omphale." *AJA* 57 (1953) 251–63.

Vernant, J.-P. "Le mythe 'prométhéen' chez Hesiode (*Théogonie,* 535–616; *Travaux,* 42–105)." *Il Mito greco* 91–106.

Vian, F. "Le combat d'Héraklès et de Kyknos." *REA* 47 (1945) 5–32.

de Visscher, F. *Heracles Epitrapezios.* Paris 1962.

Vojatzi, M. *Frühe Argonautenbilder.* Würzburg 1982.

Walter, O. "Der Säulenban des Herakles." *AthMitt* 62 (1937) 41–44.

Ward, A., et al. *The Quest for Theseus.* London and New York 1970.

Warden, J. *Orpheus: The Metamorphosis of a Myth.* Toronto 1982.

Watzinger, C. "Herakles Menytes." *AthMitt* 29 (1904) 237–43.

Werner, G. "Herakleskule und Donar-Amulett." *RGZM* 11 (1964) 176–97.

Williams, D. "Héraklès, Pisistrate et les Alcméonides." *Image et céramique grecque.*

Woodford, S. "Cults of Heracles in Attica." *Studies Hanfmann* 211–25.

Woodford, S. "Les enfances d'Héraklès." *Image et céramique grecque.*

Woodford, S. *Exemplum Virtutis: A Study of Hercules in Athens in the Second Half of the Fifth Century B.C.* Diss., Columbia Univ. 1966.

Woodford, S. "More Light on Old Walls: The Theseus of the Centauromachy in the Theseion." *JHS* 94 (1974) 158–65.

Woodward, J. M. *Perseus, a Study in Greek Art and*

Legend. Cambridge, Mass. 1937. Reprint New York 1976.

Young, E. *The Slaying of the Minotaur: Evidence in Art and Literature for the Development of the Myth, 700–400 B.C.* Diss., Bryn Mawr College 1972.

Zimmermann, K. "Tätowierte Thrakerinnen auf griechischen Vasenbildern." *JdI* 95 (1980) 163–96.

HOMER AND HOMERIC HEROES

"Achilles." *LIMC* I, 37–200. With bibliographies.

Adkins, A. W. H. "Homeric Gods and the Values of Homeric Society." *JHS* 92 (1972) 1–19.

Adkins, A. W. H. "Homeric Values and Homeric Society." *JHS* 91 (1971) 1–14.

"Aias I and Aias II." *LIMC* I, 312–51. With bibliographies.

Archaeologia Homerica: Die Denkmäler und das frühgriechische Epos. Ed. F. Matz and H.-G. Buchholz. Göttingen 1967–. Most significant series.

Arias, P. "Morte di un eroe." *ArchCl* 21 (1969) 190–203.

Basista, W. "Hektors Lösung." *Boreas* 2 (1979) 5–36.

Beazley, J. D. "Helenēs Apaithēsis." *ProcBritAc* 43 (1957) 233–44.

Beazley, J. D. "Two Swords, Two Shields." *BABesch* 14 (1939) 4–14.

Benardete, S. "Achilles and the Iliad." *Hermes* 91 (1963) 1–5.

Boardman, J. "The Kleophrades Painter at Troy." *AntK* 19 (1976) 3–18.

von Bothmer, D. "The Arming of Achilles." *BMFA* 47 (1949) 84–90.

von Bothmer, D. "The Death of Sarpedon." *The Greek Vase* 63–80.

Bouzek, J. *Homerisches Griechenland.* Prague 1969.

Brilliante, C. *La leggenda eroica e la civiltà micenea. Filologia e critica* 40 (1981).

Brommer, F. "Peliades." *AA* 1941, cols. 53–56.

Buffière, F. *Les mythes d'Homère et la pensée grecque.* Paris 1957.

Bulas, K. *Les illustrations antiques de l'Iliade.* Lvov 1929.

Canciani, F. *Bildkunst.* Part 2: *Homer und die Denkmäler. ArchHom* II N2. Göttingen forthcoming.

Candida, B. "Tradizione figurativa nel mito di Ulisse e le Sirene." *Studi classici e orientali* 19–20 (1970–1971) 212–53.

Carpenter, R. *Folk Tale, Fiction and Saga in the Homeric Epics.* Berkeley 1946. Reprint 1974.

Caskey, L. D. "Odysseus and Elpenor in the Lower World." *BMFA* 32 (1934) 39–44.

Chirassi Colombo, I. "Heros Achilleus—Theòs Apollon." *Il mito greco* 231–70.

Clairmont, C. *Das Parisurteil in der antiken Kunst.* Zurich 1951.

Clark, M. E., and W. Coulson. "Memnon and Sarpedon." *MusHelv* 35 (1978) 65–73.

Clarke, W. M. "Achilles and Patroclus in Love." *Hermes* 106 (1978) 381–96.

Clement, P. "The Recovery of Helen." *Hesperia* 27 (1955) 47–73.

Coldstream, J. N. "Hero-cults in the Age of Homer." *JHS* 96 (1976) 8–17.

Davies, M. I. "Ajax and Tekmessa." *AntK* 16 (1973) 60–70.

Davies, M. I. "The Death of Aigisthos: A Fragmentary Stamnos by the Copenhagen Painter." *OpusRom* 9 (1973) 117–24.

Davies, M. I. "The Reclamation of Helen." *AntK* 20 (1977) 73–85.

Davies, M. I. "The Suicide of Ajax: A Bronze Etruscan Statuette from the Käppeli Collection." *AntK* 14 (1971) 148–56.

Davies, M. I. "Thoughts on the 'Oresteia' before Aeschylos." *BCH* 93 (1969) 214–60.

Davreux, J. *La légende de la prophétesse Cassandre d'âpre les textes et les monuments.* Liège 1942.

Deger-Jalkotzy, S. "Homer und der Orient: Das Königtum des Priamos." *WürzJbb* 5 (1979) 25–32.

Dihle, A. *Homer-Probleme.* Opladen 1970.

Dirlmeier, F. *Die Vogelgestalt Homerischer Götter.* Heidelberg 1967.

Döhle, D. "Die 'Achilleis' des Aischylos und die attische Vasenmalerei." *Klio* 49 (1967) 87–140.

Erbse, H. "Homerische Götter in Vogelgestalt." *Hermes* 108 (1980) 259–74.

Fellmann, B. *Die antiken Darstellungen des Polyphemabenteuers.* Munich 1972.

Ferguson, W. S. "The Attic Orgeones." *HThR* 37 (1944) 61–140.

Fittschen, K. *Bildkunst.* Part 1: *Der Schild des Achilleus. ArchHom* II N1. Göttingen 1973.

Fontenrose, J. "The Cult and Myth of Pyrrhos at Delphi." *CPCA* 4 (1960) 191–266.

Fontenrose, J. "The Hero as Athlete." *CSCA* 1 (1968) 73–104.

Foucart, M. *Le culte des héros chez les Grecs.* Paris 1918.

Frame, D. *The Myth of Return in Early Greek Epic.* New Haven 1978.

Friedrich, P. "Defilement and Honor in the Iliad." *Journal of Indo-European Studies* 1 (1973) 119–27.

Friis Johansen, K. "Achill bei Chiron." *Dragma* 181–205.

Friis Johansen, K. *Ajas und Hektor.* Copenhagen 1961.

Friis Johansen, K. *The Iliad in Early Greek Art.* Copenhagen 1967.

Fuqua, C. "Tyrtaeus and the Cult of Heroes." *GRBS* 22 (1981) 215–26.

Galinski, G. K. *Aeneas, Sicily and Rome.* Princeton 1969.

Ghali-Kahil, L. B. *Les enlèvements et le retour d'Hélène dans les textes et les documents figurés.* Paris 1955.

Griffin, J. "The Epic Cycle and the Uniqueness of Homer." *JHS* 97 (1977) 39–53.

Grube, G. M. A. "The Gods of Homer." *Phoenix* 5 (1951) 62–78.

Güterbock, H. G. "The Hittites and the Aegean World: 1. The Ahhiyawa Problem Reconsidered." *AJA* 87 (1983) 133–38.

Hack, R. K. "Homer and the Cult of Heros." *TAPA* 60 (1939) 57–74.

Hampe, R. *Die Gleichnisse Homers und die Bildkunst seiner Zeit.* Tübingen 1952.

Harrison, E. B. "Iconography of the Eponymous Heros on the Parthenon and in the Agora." *Greek*

Numismatics and Archaeology 71–85.

Hausmann, U. *Hellenistische Reliefbecher aus attischen und böotischen Werkstätten.* Stuttgart 1959.

Haynes, S. "Ein etruskisches Parisurteil." *RömMitt* 83 (1976) 227–31.

Hedreen, G. *The Cult of Achilles.* Thesis, Bryn Mawr College, in progress.

Heidenreich, M. "Zu den frühen Troilosdarstellungen." *MdI* 4 (1951) 103–24.

Heidenreich, M. "Zur frühen attischen Bildschöpfung der Peleushochzeit." *MdI* 5 (1952) 134–40.

Hermary, A. "Images de l'apothéose des Dioscures." *BCH* 102 (1978) 51–76.

Hofkes-Brukker, C. "Die Umformung des homerischen Bildstoffes in den archäischen Darstellungen." *BABesch* 15 (1940) 2–35.

Hohendahl-Zoetelief, I. M. *Manners in the Homeric Epic.* Mnemosyne supp. 63. Leiden 1980.

Hommel, H. "Der Gott Achilleus." *SBHeidelberg* 1980, 1 Abhandlung.

Howald, E. "Sarpedon." *MusHelv* 8 (1951) 111–18.

Huxley, G. L. *Greek Epic Poetry from Eumelos to Panyassis.* Cambridge, Mass. and London 1969.

Irmscher, J. *Götterzorn bei Homer.* Leipzig 1950.

Isler-Kerenýi, C. *Lieblinge der Meermädchen: Achilles und Theseus auf einer Spitzamphora aus der Zeit der Perserkriege.* Zurich 1977.

Jucker, I. "Ein etruskischer Spiegel mit Parisurteil." *MusHelv* 39 (1982) 5–14.

Kearns, E. *Some Studies in the Significance of the Attic Hero-Cult in the Archaic and Classical Periods.* Diss., St. Hilda's College, Oxford, in progress.

Kemp Lindemann, D. *Darstellungen des Achilleus in griechischer und römischer Kunst.* Frankfort 1975.

King, C. "Another Set of Siamese Twins in Attic Geometric Art." *ArchNews* 6 (1977) 29–40.

Kirk, G. *Homer and the Epic.* Cambridge 1965.

Kossatz-Dreissmann, A. "Nestor und Antilochos: Zu den spätarchaischen Bildern mit Leberschau." *AA* 1981, 562–76.

Kullmann, W. *Die Quellen der Ilias (troischer Sagenkreis).* Hermes Einzelschriften 14 (1960).

Lalonde, G. V. "A Hero Shrine in the Athenian Agora." *Hesperia* 49 (1980) 97–105.

Lewis, T. S. W. "Homeric Epic and the Greek Vase." *The Greek Vase* 81–102.

Lorimer, H. *Homer and the Monuments.* London 1950.

Lung, G. E. *Memnon: Archäologische Studien zur Aithiopis.* Diss., Bonn 1912.

Mactoux, M. *Penelope, légende et mythe.* Paris 1975.

Mason, P. G. "Kassandra." *JHS* 79 (1959) 80–93.

Mellink, M. J. "The Hittites and the Aegean World: 2. Archaeological Comments on the Ahhiyawa/Achaians in Western Anatolia." *AJA* 87 (1983) 138–41.

Missonier, F. "Sur la signification funéraire du mythe d'Achille et Penthesilée," *MélRom* 49 (1932) 111–31.

Moore, M. B. "Exekias and Telemonian Ajax." *AJA* 84 (1980) 417–34.

Moret, J.-M. *L'Ilioupersis dans la céramique italiote: Les mythes et leur expression figurée au IVe siècle.* Bibliotheca Helvetica Romana 14 (1975).

Moret, J.-M. "Le jugement de Paris en Grande-Grèce: Mythe et actualité politique." *AntK* 21 (1978) 76–98.

Mota, C. "Sur les représentations figurées de la mort de Troilos et de la mort d'Astyanax." *RA* 50 (1957) 25–44.

von der Mühll, P. *Der grosse Aias.* Basel 1930.

von der Mühll, P. *Kritisches Hypomnema zur Ilias.* Basel 1952.

Müller, F. *Die antiken Odyssee-Illustrationen in ihrer kunsthistorischen Entwicklung.* Berlin 1913.

Mylonas, G. "Homeric and Mycenaean Burial Customs." *AJA* 52 (1948) 56–81.

Nagy, G. *The Best of the Achaeans: Concepts of the Hero in Archaic Greek Poetry.* Baltimore and London 1979.

Nock, A. D. "The Cult of Heroes." *HThR* 37 (1944) 141–73.

Otto, W. F. *The Homeric Gods: The Spiritual Significance of Greek Religion.* Trans. M. Hadas. Boston 1954. Reprint London 1979.

Pestalozzi, H. *Die Achilleis als Quelle der Ilias.* Zurich 1945.

Pfister, F. "Studien zum homerischen Epos: Epos und Heroenkult." *WürzJbb* 3 (1948) 147–53.

Prayon, F. "Todesdämonen und die Troilossage in der frühetruskischen Kunst." *RömMitt* 84 (1977) 181–97.

Price, T. H. "Hero-cult and Homer." *Historia* 23 (1973) 129–44.

Raab, I. *Zu den Darstellungen des Parisurteils in der griechischen Kunst.* Frankfort 1972.

Rebuffat, R. "Le meurtre de Troilos sur les urnes étrusques." *MélRom* 84 (1972) 515–42.

Redfield, J. *Nature and Culture in the Iliad: The Tragedy of Hector.* Chicago 1975.

Richardson, E. H. "The Icon of the Heroic Warrior: A Study in Borrowing." *Studies Hanfmann* 161–68.

Rivier, A. *La vie d'Achille illustrée par les vases grecs.* Paris 1936.

Robert, C. *Archäologische Hermeneutik.* Berlin 1919. Reprint New York 1975.

Robertson, D. S. "The Food of Achilles." *CR* 54 (1940) 177–80.

Robertson, M. "Ibycus: Polycrates, Troilus, Polyxena." *BICS* 17 (1970) 11–15.

Roller, L. E. "Funeral Games in Greek Art." *AJA* 85 (1981) 107–19.

Rose, H. J. "The Degradation of Heroes." *Studies Robinson* II, 1052–57.

Sadurska, A. *Les tables iliaques.* Warsaw 1964.

Schauenburg, K. "Achilleus als Barbar: Ein antikes Missverständnis." *Antike und Abendland* 20 (1974) 88–96.

Schauenburg, K. "Achilleus in der unteritalischen Vasenmalerei." *BonnJbb* 161 (1961) 215–35.

Schauenburg, K. "Äneas und Rom." *Gymnasium* 67 (1960) 176–91.

Schauenburg, K. "Ilioupersis auf einer Hydria des Priamosmaler." *RömMitt* 71 (1964) 60–70.

Schauenburg, K. "Zu griechischen Mythen in der etruskischen Kunst." *JdI* 85 (1970) 46–60.

Schefold, K. "Archäologisches zum Stil Homers." *MusHelv* 12 (1955) 132–44.

Schefold, K. "Erscheinungen der Götter Homers."

Wort und Bild 43–52.

Schefold, K. "Gestaltungen des Unsichtbaren auf frühklassischen Vasen." AthMitt 77 (1962) 130–39.

Schefold, K. "Das homerische Epos in der antiken Kunst." Wort und Bild 27–42.

Schefold, K. "Sophokles' Aias auf einer Lekythos." AntK 19 (1976) 71–78.

Schefold, K. "Statuen auf Vasenbildern." JdI 52 (1937) 29–75.

Schefold, K. "Tod des Patroklos." Homenaje a Garcia Bellido II. Revista de la Universidad Complutense 25 (1976) 101–3.

von Scheliha, R. Patroklos: Gedanken über Homers Dichtung und Gestalten. Basel 1943.

Scherer, M. R. "Helen of Troy." BMMA 25 (1967) 367–83.

Scherer, M. R. The Legends of Troy in Art and Literature. New York 1963.

Schoeck, G. Ilias und Aithiopis. Zurich 1961.

Severyns, A. "Pomme de discorde et jugement des déesses." Phoibos 5 (1950–51) 145–72.

Shapiro, H. A. "The Judgment of Arms on an Amphora in Kansas City." BABesch 56 (1981) 149–51.

Siebert, G. "Aeneas' Flucht auf einer Beinschiene im Musée de la Ville de Haguenau." Praestant Interna 289–94.

Simpson, R. H., and J. F. Lazenby. The Catalogue of Ships in Homer's Iliad. Oxford 1970.

Stähler, K. P. Grab und Psyche des Patroklos: Ein schwarzfiguriges Vasenbild. Münster 1967.

Stewart, A. Skopas in Malibu: The Head of Achilles from Tegea and Other Sculptures in the J. Paul Getty Museum. Malibu 1982.

Stinton, T. C. W. Euripides and the Judgement of Paris. London 1965.

Touchefeu, O. "Images sans text: La mort d'Astyanax." Image et céramique grecque.

Tsagarakis, O. "Homer and the Cult of the Dead in Helladic Times." Emerita 48 (1980) 229–40.

Vellay, C. Les légendes du cycle troyen. Monaco 1957.

Vermeule, E. T. "The Boston Oresteia Krater." AJA 70 (1966) 1–22.

Vermeule, E. T. "The Vengeance of Achilles: The Dragging of Hektor at Troy." BMFA 63 (1965) 34–52.

Vernant, J. P. "Thétis et le poème cosmogonique d'Alcman." Hommages Delcourt 38–69.

Webster, T. B. L. From Mycenae to Homer. London 1958.

Webster, T. B. L. "Homer and Attic Geometric Vases." BSA 50 (1955) 38–50.

Whitman, C. Homer and the Heroic Tradition. Cambridge, Mass, 1958.

Wiencke, M. I. "An Epic Theme in Greek Art." AJA 58 (1954) 285–306. Considers the Little Iliad and Iliupersis. With bibliography.

Willcock, M. M. "The Funeral Games of Patroclus." BICS 20 (1973) 1–22.

Williams, D. "Ajax, Odysseus and the Arms of Achilles." AntK 23 (1980) 137–45.

Woodford, S., and M. Loudon. "Two Trojan Themes: The Iconography of Ajax Carrying the Body of Achilles and of Aeneas Carrying Anchises in Black Figure Vase Painting." AJA 84 (1980) 25–40.

Zindel, C. Drei vorhomerische Sagenversionen in der griechischen Kunst. Berlin 1974.

Zschietzschmann, W. "Homer und die Attische Bildkunst um 560." JdI 46 (1931) 45–60.

MYTHOLOGICAL BATTLES

Berger, E. "Der neue Amazonenkopf im Basler Antikemuseum—Ein Beitrag zur hellenistischen Achill-Penthesileagruppe." Gestalt und Geschichte 61–75.

Bielefeld, E. Amazonomachia. Halle 1951.

von Bothmer, D. Amazons in Greek Art. Oxford 1957.

von Bothmer, D. "An Attic Black-figured Dinos." BMFA 46 (1948) 42–48. Calydonian Boar hunt.

Brandt, R. "Blantgruder og giganter." Streiftog i antikken 71–79.

Daltrop, G. Die Kalyonische Jagd in der Antike. Hamburg 1966.

Del Chiaro, M. "An Etruscan Gigantomachy from Caere." AA 1970, 346–53.

Dörig, J., and O. Gigon. Der Kampf der Götter und Titanen. Lausanne 1961.

DuBois, P. Centaurs and Amazons: Women and the Prehistory of the Great Chain of Being. Ann Arbor 1982.

Eckstein-Diener, B. Mothers and Amazons: The First Feminine History of Culture. Trans. J. P. Lundin. New York 1965, 1973.

Hölscher, T., and E. Simon. "Die Amazonenschlacht auf dem Schild der Athena Parthenos." AthMitt 91 (1976) 115–48.

Klein, H. Die antiken Amazonensagen in der deutschen Literatur. Leipzig 1919.

Kleiner, F. S. "The Kalydonian Hunt: A Reconstruction of a Painting from the Circle of Polygnotos." AntK 15 (1972) 7–19.

Krieger, X. Der Kampf zwischen Peleus und Thetis in der griechischen Vasenmalerei. Diss., Münster 1973.

Mayer, M. Die Giganten und Titanen in der Antiken Sage und Kunst. Berlin 1887.

Minns, E. H. Scythians and Greeks. Cambridge 1913.

Moore, M. B. "Lydos and the Gigantomachy." AJA 83 (1979) 79–99.

Neils, J. "The Group of Negro Alabastra: A Study in Motif Transferal." AntK 23 (1980) 13–23. Negroes and Amazons.

Robert, C. Die Marathonschlacht in der Poikile und weiteres über Polygnot. Hallisches Winckelmannsprogramm 18 (1895).

Rothery, G. C. The Amazons in Antiquity and Modern Times. London 1910.

von Salis, A "Die Gigantomachie am Schilde der Athena Parthenos." JdI 55 (1940) 90–169.

Schlörb, B. "Beiträge zur Schildamazonomachie der Athena Parthenos." AthMitt 78 (1963) 156–72.

Schneider-Hermann, G. "The Dance of the Amazons." Studies Trendall 171–76.

Vian, F. La guerre des Géants: Le mythe avant l'époque hellénistique. Paris 1952.

Vian, F. Répertoire des gigantomachies figurées dans l'art grec et romain. Paris 1951.

Walter, H. "Gigantomachien." AthMitt 69/70 (1954/1955) 95–104.

See also "Warfare and Seamanship" and "Animals and Fabulous Beasts."

ANIMALS AND FABULOUS BEASTS

Anderson, J. K. *Ancient Greek Horsemanship*. Berkeley 1961.

Anderson, J. K. "Stymphalian and Other Birds." *JHS* 96 (1976) 146. With reference to earlier articles on birds.

Arnold, R. *The Horse-Demon in Early Greek Art and His Eastern Neighbors*. Diss., Columbia Univ. 1972.

Aruz, J. C. *Zoomachies in Aegean Art*. Diss., Univ. of London, in progress.

Ashmead, A. "Greek Cats." *Expedition* 20, no. 3 (1978) 39–47.

Baur, P. V. C. *Centaurs in Ancient Art: The Archaic Period*. Berlin 1912.

Belson, J. D. *The Gorgoneion in Greek Architecture*. Diss., Bryn Mawr College 1981.

Benton, S. "Cattle Egrets and Bustards in Greek Art." *JHS* 81 (1961) 44–55.

Besig, H. *Gorgo und Gorgoneion in der archaischen griechischen Kunst*. Berlin 1937.

Blinkenberg, C. "Gorgone et lion." *RA* 20 (1924) 267–79.

Bodson, L. "Les Grecs et leurs serpents. Première résultat de l'étude taxonomique des sources anciennes." *AntCl* 50 (1981) 57–78.

Brein, F. *Der Hirsch in der griechischen Frühzeit*. Diss., Vienna 1969.

van den Broek, R. *The Myth of the Phoenix According to Classical and Early Christian Traditions*. Leiden 1972.

Brommer, F. "Bellerophon." *MarbWinckProg* (1952/1954) 3–16.

Brommer, F. "Bilder der Midassage." *AA* 1941, 36–52.

Brommer, F. "Dreileibige." *MarbWinckProg* (1947) 1–4. With earlier bibliography.

Brommer, F. "Eine frühe attische Amphora mit Greifen." *Jahrbuch der Berliner Museen* 4 (1962) 1–16.

Brommer, F. "Okeanos." *AA* 1971, 29–30.

Brommer, F. *Satyroi*. Würzburg 1937.

Brown, W. L. *The Etruscan Lion*. Oxford 1960.

Bruneau P. "Le motif des coqs affrontés dans l'imagerie antique." *BCH* 89 (1965) 90–121.

Buchholz, H.-G., I. Maull, and G. Jöhrens. *Jagd und Fischfang*. ArchHom II J. Göttingen 1973.

Buschor, E. "Kentauren." *AJA* 38 (1934) 128–32.

Buschor, E. "Das Krokodil des Sotades." *MJb* 11 (1919) 1–43.

Buschor, E. *Meermänner*. Munich 1941.

Cahn, H. A. "Die Löwen des Apollon" *Kleine Schriften zur Münzkunde und Archäologie* 17–25.

Calvet, J., and M. Cruppi. *Le bestiaire de l'antiquité classique*. Paris 1955.

Candida, B. "Tradizione figurativa nel mito di Ulisse e le Sirene." *Studi classici e orientali* 19–20 (1970–1971) 212–53.

Christou, C. *Potnia Theron: Eine Untersuchung über Ursprung, Erscheinungsformen und Wandlungen der Gestalt einer Gottheit*. Thessalonike 1968.

Croon, J. H. "The Mask of the Underworld Daemon: Some Remarks on the Perseus-Gorgon Story." *JHS* 75 (1955) 9–16.

Dawson, W. R. *The Bridle of Pegasus*. London 1930.

Delebeque, E. *Le cheval dans l'Iliade*. Paris 1951.

Delplace, C. *Le griffon de l'archaïsme à l'époque imperiale*. Brussels 1980.

Demisch, H. *Die Sphinx: Geschichte ihrer Darst. von d. Anfängen bis zur Gegenwart*. Stuttgart 1977.

Dierauer, U. *Tier und Mensch im Denken der Antike: Studien zur Tierpsychologie, Anthropologie und Ethik*. Amsterdam 1977.

Dörig, J. "Frühe Löwen." *AthMitt* 76 (1961) 67–80.

Dunbabin, T. J. "Bellerophon, Herakles and Chimaera." *Studies Robinson* II, 1164–84.

Durand, J. L. "Le rituel du meurtre du boeuf laboureur et les mythes du premier sacrifice animal en Attique." *Il mito greco* 121–34.

Edlund, I. E. "Meaningful or Meaningless? Animal Symbolism in Greek Vase-Painting." *Meded* 7 (1980) 31–35.

Edmunds, L. *The Sphinx in the Oedipus Legend*. Beiträge zur Klassischen Philologie 127. Königstein 1981.

Engelmann, R. "Bellerofonte e Pegaso." *AdI* 46 (1874) 5–37.

Erlenmeyer, M. L. "Über griechische und altorientalische Tierkampfgruppen." *AntK* 1 (1958) 53–68.

Friis Johansen, K. "Der Er Uglen." *Meddelelser fra Ny Carlsberg Glyptotek* 99–118. Copenhagen 1975.

Frothingham, A. L. "Medusa, Apollo, and the Great Mother." *AJA* 15 (1911) 349–77.

Gericke, T. "Die Bändigung des Pegasos." *AthMitt* 71 (1956) 193–201.

Gropengiesser, H. "Sänger und Sirenen: Versuch einer Deutung." *AA* 1977, 582–610.

Hampe, R. "Korfugiebel und frühe Perseusbilder." *AthMitt* 60/61 1935/1936 269–99.

Hancar, F. *Das Pferd in prähistorischer und früher historischer Zeit*. Munich 1955.

von Heland-Weissglas, M. *Figurativ vasdekor i Korint*. Diss., Stockholm 1970. Animals on Corinthian vases.

Herberger, C. F. *The Riddle of the Sphinx: The Calendric Symbolism in Myth and Icon*. New York 1979.

Hirsch, E. S. "Painted Decoration on the Floors of Bronze Age Structures on Crete and the Greek Mainland." *SIMA* 53 (1977) 32–46. Octopus as a symbol of deity.

Hopkins, C. "Assyrian Elements in the Perseus-Gorgon Story." *AJA* 38 (1934) 341–58.

Horsley, J. A. *Monsters in Early Etruscan art*. Diss., Newnham College, Cambridge 1981.

Howe, T. P. "The Origin and Function of the Gorgon-Head." *AJA* 58 (1954) 209–21.

Jongkees, J. H. "Notes on the Coinage of Athens. VIII: The Owl of Athens." *Mnemosyne* ser. 4, vol. 5 (1952) 28–41.

Kadletz, E. *Animal Sacrifice in Greek and Roman Religion*. Diss., Univ. of Washington 1976.

Karaghiorga, T. *Gorgeie Kephale*. Athens 1970.

Karaghiorga, T. "Die Göttin auf dem Kamel." *AthMitt* 84 (1969) 87–102.

Kenna, V. E. G. "Studies of Birds on Seals of the Aegean and Eastern Mediterranean in the Bronze Age." *OpusAth* 8 (1968) 23–38.

Klingender, F. D. *Animals in Art and Thought to the End of the Middle Ages*. Ed. E. Antal and J. Harthan. Cambridge, Mass. and London 1971.

Kozloff, A., et al. *Animals in Ancient Art from the Leo Mildenberg Collection*. Bloomington 1981.

Kretschmer, P. "Bellerophontes." *Glotta* 31 (1951) 92–103.

Küster, E. *Die Schlange in der griechischen Religion und Kunst*. Giessen 1913.

Laffineur, R. "Le symbolisme funéraire de la chouette." *AntCl* 50 (1981) 432–44.

Leichfried, J. *Der Hase in der antiken Kunst*. Diss., Graz 1979.

Levi, D. "Gleanings from Crete." *AJA* 49 (1945) 270–93.

Lloyd-Jones, H. *Mythical Beasts*. London 1980.

L'Orange, H. P. "The Apotropaic Lion Head and the Arena Lion on 3rd Century A.D. Sarcophagi." *Studia Krarup* 132–37.

Lullies, R. "Die lesende Sphinx." *Neue Beiträge zur klassischen Altertumswissenschaft* 140–46.

Malten, L. "Das Pferd im Totenglauben." *JdI* 29 (1914) 179–256.

Malten, L. "Der Stier in Kult und mythischem Bild." *JdI* 43 (1928) 90–139.

Marinatos, S. "Die Eulengöttin von Pylos." *AthMitt* 83 (1968) 167–74.

Markman, S. *The Horse in Greek Art*. Baltimore 1943.

Matz, F. "Kretische Sphingen." *JdI* 65 (1950) 91–102.

Matz, F. "Zu den Sphingen vom Yerkapu in Bogazköy." *MarbWindkProg* (1957) 1–6. With earlier bibliography.

Meillier, C. "La chouette d'Athena." *REA* 72 (1970) 9–11.

Meuli, K. "Griechische Opferbräuche." *Philolobia für Peter von der Mühll* 185–98. Basel 1946.

Mode, H. *Fabeltier und Dämonen in der Kunst*. Stuttgart 1974.

Moore, M. B. "Horses by Exekias." *AJA* 72 (1968) 357–68.

Moore, M. B. *Horses on Black-Figured Greek Vases of the Archaic Period*. Diss., New York Univ. 1971.

Ohly, D. "Die Chimaeren des Chimaeramalers." *AthMitt* 76 (1961) 1–11.

Pollard, J. *Birds in Greek Life and Myth*. London and Boulder, Colo. 1977.

Pottier, E. "La chouette d'Athene." *BCH* 32 (1908) 529–48.

Poursat, J.-C. "Notes d'iconographie préhellénique: Dragons et crocodiles." *BCH* 100 (1976) 461–74.

Rakatsanis, D. "Antike Quellenzeugnisse zur Existenz des Löwen in Hellas." *Forschungen und Funde* 367–70.

Rhyne, N. A. *The Aegean Animal Style: A Study of the Lion, Griffin, and Sphinx*. Diss., Univ. of N. Carolina at Chapel Hill 1970.

Richardson, E. "The Wolf in the West." *Essays Hill* 91–101.

Richmond, J. *Chapters on Greek Fish-Lore*. Hermes Einzelschriften 28 (1973).

Roes, A. "The Origin of the Chimaera." *Studies Robinson* II, 1155–63.

Rowland, B. *Animals with Human Faces*. Knoxville, Tenn. 1973.

Sakellarakis, J. "Das Kuppelgrab A von Archanes und das kretisch-mykenische Tieropferritual." *PZ* 45 (1970) 166–98.

Schauenburg, K. "Das Motiv der 'Chimairophonos' in der Kunst Unteritaliens." *Studies Trendall* 149–54.

Schauenburg, K. "Unteritalische Kentaurenbilder." *ÖJh* 51 (1976–1977) 17–44.

Schauenburg, K. "Zur thebanischen Sphinx." *Praestant Interna* 230–35.

Schiffler, B. *Die Typologie des Kentauren in der antiken Kunst*. Frankfurt 1976.

Schlieben, A. *Die Pferde des Altertums*. Wiesbaden 1969.

Schmidt, M. "Bellerophon and the Chimaera in Archaic Greek Art." *AJA* 70 (1966) 341–47.

Scullard, H. H. *The Elephant in the Greek and Roman World*. London 1974.

Shear, L. T., Jr. "Tyrants and Building in Archaic Athens." *Princeton Symposium* 10–20.

Shepard, K. *The Fish-Tailed Monster in Greek and Etruscan Art*. New York 1940.

Simon, E. *Das Satyrspiel Sphinx des Aischylos*. *SBHeidelberg* 5 (Winter 1981).

Spruytte, J. *Études expérimentales sur l'attelage: Contribution à l'histoire du cheval*. Paris 1977. With earlier bibliography.

Stebbins, E. B. *The Dolphin in the Literature and Art of Greece and Rome*. Menasha, Wis. 1939.

Stupperich, R. "Eulen der Athena in einer Münsterschen Privatsammlung." *Boreas* 3 (1980) 157–73.

Thompson, D'A. W. *A Glossary of Greek Birds*. London 1936.

Thompson, D'A. W. *A Glossary of Greek Fishes*. London 1947.

Das Tier in der Antike: 400 Werke ägyptischer griechischer, etruskischer und römischer Kunst aus privatem und öffentlichem Besitz. Catalog of an exhibition held at the Archäologisches Institut der Universität Zürich, 21 September—17 November 1974. Zurich 1974.

Vigneron, P. *Le cheval dans l'antiquite gréco-romaine*. Nancy 1968.

Vogel, M. *Chiron der Kentaur mit der Kithara*. 2 vols. Bonn 1978.

Walla, M. *Der Vogel Phoenix*. Vienna 1969.

Walter, H. "Sphingen." *Antike und Abendland* 9 (1960) 63–72.

Weicker, G. *Der Seelenvogel in der alten Litteratur und Kunst*. Leipzig 1902.

Wilson, L. M. "Contributions of Greek Art to the Medusa Myth." *AJA* 24 (1920) 232–40.

Yalouris, N. *Pegasus: The Art of the Legend*. Trans. H. Zigada. N.P. 1975.

Yalouris, N. "Stesichoros' Fable." *Studies Trendall* 185–87. Tale of the horse and the stag.

For the horse see also "Warfare and Seamanship."

LIFE, SPORT, DEATH, AND BURIAL

Alexiou, M. *The Ritual Lament in Greek Tradition*. Cambridge 1974.

Andronikos, M. *Totenkult*. ArchHom III w. Göttingen 1968.

Bakalakis, G. "Ein Lutrophoros Athen (Ex Schliemann) Berlin 3209." *AntK* 14 (1971) 74–83.

Bazant, J. *Studies on the Use and Decoration of Athenian Vases*. Prague 1981.

Beardsley, G. H. *The Negro in Greek and Roman*

Civilization. Baltimore 1929.

Beazley, J. D. "Battle-Loutrophoros." *Museum Journal* 23 (1932) 5–22.

Bilinski, B. *Agoni Ginnici: Componenti artistiche ed intellettuali nell' antica agonistica Greca.* Warsaw 1979.

Bilinski, B. *L'agonistica sportiva nella Grecia antica.* Rome 1959.

von Blanckenhagen, P. H. "Puerilia." *In Memoriam Otto J. Brendel* 37–41.

Blümel, C. *Sport der Hellenen: Ausstellung im Deutschen Museum zu Berlin veranstaltet vom Organisationskomitee der XI Olympiade und dem Generaldirektor der Staatlichen Museen.* Berlin 1936.

Blümel, C. *Sport und Spiel bei Griechen und Römern.* Berlin 1934.

Boardman, J. "A Curious Eye Cup." *AA* 1976, 281–90. Anakreontic scene.

Boardman, J. "Heroic Haircuts." *CQ* 67 (1973) 196–97.

Boardman, J. "Painted Funerary Plaques and Some Remarks on Prothesis." *BSA* 50 (1955) 51–66.

Boardman, J., and E. LaRocca. *Eros in Greece.* London and New York 1978.

Böhme, R. *Der Sänger der Vorzeit.* Bern 1980.

Bonfante-Warren, L. "Etruscan Dress as Historical Source." *AJA* 75 (1971) 277–84.

Boutros, L. *Phoenician Sport: Its Influence on the Origin of the Olympic Games.* Amsterdam 1981.

Brelich, A. *Paides e Parthenoi. Incunabula Graeca* 36 (1969).

Bruckner, A. *Palästradarstellungen auf frührotfigurigen attischen Vasen.* Diss., Basel 1954.

Bruns, G. *Küchenwesen und Mahlzeiten. ArchHom* II Q. Göttingen 1970.

Buchholz, H.-G. *Würdezeichen. ArchHom* I D. Göttingen forthcoming.

Buchholz, H.-G., et al. *Jagd und Fischfang. ArchHom* II J. Göttingen 1973.

Buffière, F. *Eros adolescent: La pédérastie dans la Grèce antique.* Paris 1980.

Buler, A. J. *Sport in Classical Times.* London 1930.

Burkert, W., and H. Hoffmann. "La cuisine des morts: Zu einem Vasenbild aus Spina und verwandten Darstellungen." *Hephaistos* 2 (1980) 107–12.

Buschor, E. *Grab eines attischen Mädchens.* Munich 1939.

Büsing-Kolbe, A. "Eine neue Kitharaspielerin." *MarbWinckProg* (1972) 60–66.

Camporeale, G. "Le scene etrusche di protesi." *RömMitt* 66 (1959) 31–44.

Chamay, J. *Linos ou l'education intellectuelle d'après la céramique attique—de Chiron à Socrate.* Diss., Geneva 1980.

Chapman, R., and K. Randsborg. Eds. *The Archaeology of Death.* Cambridge, Mass. 1982.

Clark, L. *Looms and Weaving in Ancient Greece.* Thesis, Univ. of Wisconsin 1983.

Cloché, P. *Les classes, les métiers, le trafic.* Paris 1931.

Corbett, P. E. "Greek Temples and Greek Worshippers: The Literary and Archaeological Evidence." *BICS* 17 (1970) 149–58. With bibliography.

Corrigan, E. H. *Lucanian Tomb Paintings Excavated at Paestum 1969–1972: An Iconographic Study.*
Diss., Columbia Univ. 1979.

Coulomb, J. "Les boxeurs minoens." *BCH* 105 (1981) 27–40.

Croon, J. H. *The Herdsman of the Dead: Studies on Some Cults, Myths and Legends of the Ancient Greek Colonization Area.* Utrecht 1952.

Crouwel, J. H. *Chariots and Other Means of Land Transport in Bronze Age Greece.* Amsterdam 1981.

Dahl, K. *Thesmophoria: En graesk Kvindefest.* Copenhagen 1976. English summary, with bibliography.

Delatte, A. *Herbarius: Recherches sur le cérémonial usité chez les anciens pour la cueillette des simples et des plants magiques.* 3rd ed. Brussels 1961.

Dentzer, J.-M. "Aux origines de l'iconographie du banquet couché." *RA* (1971) 215–58.

Deussen, P. "The Nuptial Theme of Centuripe Vases." *OpusRom* 9 (1973) 125–33.

Devereux, G. "Greek Pseudo-homosexuality and the Greek Miracle." *SymbOslo* 42 (1967) 69–92.

De Vries, K. "East Meets West at Dinner." *Expedition* 15, no. 4 (1973) 32–39.

Dohan, K. E. *Hypodemata: The Study of Greek Footwear and Its Chronological Value.* Diss., Bryn Mawr College 1982.

Dörig, J. "Von griechischen Puppen." *AntK* 1 (1958) 41–52.

Dover, K. J. "Classical Greek Attitudes to Sexual Behaviour." *Arethusa* 6 (1973) 59–73.

Dover, K. J. *Greek Homosexuality.* London 1978.

Dover, K. J. *Greek Popular Morality in the Time of Plato and Aristotle.* Oxford 1974.

Drerup, H. *Griechische Baukunst in geometrischer Zeit. ArchHom* II O. Göttingen 1969.

Dubois, P. *Centaurs and Amazons: Women and the Prehistory of the Great Chain of Being.* Ann Arbor 1982.

Dunkley, B. "Greek Fountain-Buildings Before 300 B.C." *BSA* 36 (1935–1936) 142–204.

Dwyer, E. J. *Pompeian Sculpture in Its Domestic Context: A Study of Five Pompeian Houses and Their Contents. Archaeologica* 28 (1982).

Ebert, J. *Zum Pentathlon der Antike.* Berlin 1963.

Eckstein, F. *Handwerk. ArchHom* II L: Part 1, *Die Aussagen des frühgriechischen Epos.* Göttingen 1974. Part 2, *Die archäologischen Zeugnisse.* Göttingen forthcoming.

Eckstein-Diener, B. *Mothers and Amazons: The First Feminine History of Culture.* New York 1973.

Egar, J.-C. *Le sommeil et la mort dans la Grèce antique.* Paris 1966.

Emmanuel, M. *La danse grecque antique d'après les monuments figurés.* Paris 1896.

Fehr, B. *Orientalische und griechische Gelage.* Bonn 1971.

Finley, M. I., and H. W. Pleket. *The Olympic Games: The First Thousand Years.* London 1976.

Fischer-Hansen, T. "Yet Another Human Sacrifice." *Studia Krarup* 20–27. With bibliography.

Fleischhauer, G. *Etrurien und Rom. Musikgeschichte in Bildern* II, no. 5. Leipzig 1964.

Forbes, R. J. *Bergbau, Steinbruchtätigkeit und Hüttenwesen. ArchHom* II K. Göttingen 1967.

Franzius, G. *Tänzer und Tänze in der archaischen*

Vasenmalerei. Diss., Göttingen 1973.

Gardiner, E. N. *Greek Athletic Sports and Festivals.* London 1910. Reprint Dubuque 1970.

Garland, R. S. J. *Greek Burial Customs.* Diss., Univ. College London, in progress.

Gassowska, B. "Cirrus in Vertice—One of the Problems in Roman Athlete Iconography." *Mélanges Michałowski* 421–27.

Gates, C. *From Cremation to Inhumation: Burial Practices at Ialysos and Kameiros During the Mid Archaic Period, 625–525 B.C.* Los Angeles 1983.

Gericke, H. *Gefässdarstellungen auf griechischen Vasen.* Berlin 1970.

Ginouvès, R. *Balaneutike: Recherches sur le bain dans l'antiquité grecques.* Paris 1962.

Gnoli, G., and J.-P. Vernant. Eds. *La mort, les morts dans les sociétés anciennes: Colloque sur l'idéologie funéraire, Ischia, Naples, 6–10 December 1977.* Cambridge, Mass. 1982.

Goldstein, M. S. *The Setting of the Ritual Meal in Greek Sanctuaries: 600–300 B.C.* Diss., Univ. of Califorinia, Berkeley 1978.

Greenewalt, C. H. *Ritual Dinners in Early Historic Sardis.* Berkeley 1978.

Gross, W. H. *Handel. ArchHom* II M. Göttingen forthcoming.

Haas, G. *Die Syrinx in der griechischen Bildkunst.* Diss., Vienna 1978.

Hall, A. *Greek Model Pomegranates.* Thesis, Bryn Mawr College, in progress.

Harris, H. A. *Greek Athletes and Athletics.* London 1964. Reprint Bloomington 1979.

Harris, H. A. *Sport in Greece and Rome.* London 1972.

Harris, H. A. *Trivium Greek Athletics and the Jews.* Cardiff 1976.

Havelock, C. M. "Mourners on Greek Vases: Remarks on the Social History of Women." *The Greek Vase* 103–18.

Havelock, E. A., and J. P. Hershbell. *Communication Arts in the Ancient World.* New York 1978.

Heinemann, K. *Thanatos in Poesie und Kunst der Griechen.* Munich 1913.

Higgins, R. A., and R. P. Winnington-Ingram. "Lute-Players in Greek Art." *JHS* 85 (1965) 62–71.

Himmelmann-Wildschütz, N. *Archäologisches zum Problem der griechischen Sklaverei.* Wiesbaden 1971.

Hoffmann, H. *Sexual and Asexual Pursuit: A Structuralist Approach to Greek Vase-Painting. Royal Anthropologist Institute of Great Britain and Ireland,* no 34. London 1977.

Homann-Wedeking, E. *Sport und Spiel. ArchHom* III T. Göttingen 1978.

Iakovidis, E. "Mycenaean Mourning Custom." *AJA* 70 (1966) 43–50.

Immerwahr, H. R. "Book Rolls on Attic Vases." *Classical, Medieval, and Renaissance Studies Ullman* 17–48.

Immerwahr, H. R. "Inscriptions on the Anacreon Krater in Copenhagen." *AJA* 69 (1965) 152–54.

Jacobsthal, P. *Greek Pins and Their Connexions with Europe and Asia.* Oxford 1956.

Jannot, J. R. "L'aulos étrusque." *AntCl* 43 (1974) 118–42.

Jannot, J. R. "La lyre et la cithare: Les instruments à cordes de la musique étrusque." *AntCl* 48 (1979) 469–507.

Jeanmaire, H. *Couroi et Courètes: Essai sur l'éducation spartiate et sur les rites d'adolescence dans d'antiquité hellénique.* Lille 1936. Reprint New York 1975.

Johnston, A. "Hunting Scenes on Greek Vases." *Connoisseur* 196 (November 1977) 160–69.

Jucker, I. "Frauenfest in Korinth." *AntK* 6 (1963) 47–61.

Jünther, J. *Die athletischen Leibesübungen der Griechen.* I: *Geschichte der Leibesübungen.* Vienna 1965. II: *Einzelne Sportarten.* Vienna 1968.

Kachler, K. G. "Der Tanz im antiken Griechenland." *Antike Welt* 3 (1974) 2–14.

Kahil, L. "Loutrophore à fond blanc au Musée du Louvre." *Gestalt und Geschichte* 146–58. Discussion of oriental elements at the end of the Peloponnesian War, of the type of vase and its iconography, with earlier bibliography.

Karouzou, S. "An Underworld Scene on a Black-figured Lekythos." *JHS* 92 (1972) 64–73.

Karydi, E. "Schwarzfigurige Lutrophoren im Kerameikos." *AthMitt* 78 (1963) 90–103.

Keuls, E. C. "Aeschylos' 'Niobe' and Apulian Funerary Symbolism." *ZPE* 30 (1978) 42–68.

Keuls, E. C. The Hetaera and the Housewife: The Splitting of the Female Psyche in Greek Art." *Meded.* Forthcoming.

Keuls, E. C. *Water Carriers in Hades: A Study of Catharsis Through Toil.* Amsterdam 1974.

Keuls, E. C. "The Wool Basket and the Money Pouch: Textile Working as a Home Industry in Ancient Greece." *Equity* (January/February 1981).

Klein, U. "Das Naturhorn (kéras) als griechisches Musikinstrument." *Gymnasium* 74 (1967) 139–41.

Knigge, U. "Ein rotfiguriges Alabastron aus dem Kerameikos." *AthMitt* 79 (1964) 105–12. Love scene.

Koch-Harnack, G. *Knabenliebe und Tiergeschenke: Ihre Bedeutung im päderastischen Erziehungssystem Athens.* Berlin 1983.

Koelbing, H. M. *Arzt und Patient in der antiken Welt.* Zurich 1977.

Laser, S., et al. *Hausrat. ArchHom* II P. Göttingen 1968.

Lawler, L. B. *The Dance in Ancient Greece.* London 1964.

Lefkowitz, M. R. *Heroines and Hysterics.* Toronto 1981.

Lefkowitz, M. R. *Women in Greece and Rome.* Toronto 1977.

Licht, H. *Sittengeschichte Griechenlands.* 2 vols. Dresden 1925–1928.

Lintott, A. *Violence, Civil Strife and Revolution in the Classical City: 750–330 B.C.* Baltimore 1982.

Lohmann, H. *Grabmäler auf unteritalischen Vasen.* Berlin 1979.

Marcadé, J. *Eros Kalos.* Paris 1962.

Marinatos, S. *Haar- und Barttracht. ArchHom* I B. Göttingen 1967.

Marinatos, S. *Kleidung. ArchHom* I A. Göttingen 1967.

Marrou, H. I. *Histoire de l'education dans l'antiquité,* 6th ed. Paris 1965, Madison 1982, paper.

Masaraki, D. W. "Ein Aulos der Sammlung Karapanos." *AthMitt* 89 (1974) 105–21.

Mavrogordato, J. "Modern Greek Folk-Songs of the Dead." *JHS* 75 (1955) 42–53.

Méautis, G. *L'âme hellénique d'après les vases grecs.* Paris 1932.

Mehl, E. *Antike Schwimmkunst.* Munich 1927.

Meiggs, R. *Trees and Timber in the Ancient Mediterranean World.* Oxford 1982.

Michaelides, S. *The Music of Ancient Greece: An Encyclopedia.* London 1978.

Miller, H. F. *The Iconography of the Palm in Greek Art: Significance and Symbolism.* Diss., Univ. of California, Berkeley 1979.

Motte, A. *Prairies et jardins de la Grèce antique: De la religion à la philosophie.* Brussels 1973.

Müller, V. K. *Der Polos die griechische Götterkrone.* Berlin 1915.

Musikgeschichte in Bildern II: *Musik des Altertums.* Ed. H. Besseler, M. Schneider, and W. Bachmann. Leipzig 1961.

Mylonas, G. "Homeric and Mycenaean Burial Customs." *AJA* 52 (1948) 56–81.

Nauerth, C. *Vom Tod zum Leben: Die christlichen Totenerweckungen in der spätantiken Kunst.* Wiesbaden 1980.

Neils, J. "The Group of Negro Alabastra: A Study in Motif Transferal." *AntK* 23 (1980) 13–23. Negroes and Amazons.

Neubecker, A. J. *Altgriechische Musik: Eine Einführung.* Darmstadt 1977.

Neuburger, A. *The Technical Arts and Sciences of the Ancients.* Trans. H. L. Brose. London 1930.

Patrucco, R. "L'attivita sportiva di Sparta." *Archaeologica* 395–412.

Patzer, H. *Die griechische Knabenliebe.* Frankfurt 1982.

Picard, C. *La vie privée dans la Grèce classique.* Paris 1930.

Pixton, M. R. *The Evidence of Cult for the Role of Women in Ancient Greek Society.* Diss., Wadham College, Oxford, in progress.

Pöhlmann, E. *Denkmäler altgriechischer Musik.* Munich 1970.

Pomeroy, S. *Goddesses, Whores, Wives and Slaves: Women in Classical Antiquity.* New York 1975.

Poursat, J.-C. "Les représentations de danses armées dans la céramique attique." *BCH* 92 (1968) 550–615.

Prickett, J. L. *A Scientific and Technological Study of Topics Associated with the Grape in Greek and Roman Antiquity.* Diss., Univ. of Kentucky 1980.

Prudhommeau, G. *La danse grecques antiques.* 2 vols. Paris 1965.

Raeck, W. *Zum Barbarenbild in der Kunst Athens im 6. und 5. Jahrhundert v. Chr.* Bonn 1981.

Richter, G. M. A. *The Archaic Gravestones of Attica.* London 1961.

Richter, G. M. A. *The Furniture of the Greeks.* London 1966.

Richter W. *Die Landwirtschaft im homerischen Zeitalter.* ArchHom II H. Göttingen 1968.

Robert, C. "Thanatos." *BerlWinckProg* 39 (1879) 1–44.

Robertson, M. "A Muffled Dancer and Others." *Studies Trendall* 129–34.

Robinson, D. *Necrolynthia: A Study in Greek Burial Customs and Anthropology. Olynthos* XI. Baltimore 1943.

Roebuck, C. Ed. *The Muses at Work.* Cambridge, Mass. 1969.

Rolle, R. *Die Welt der Skythen. Stutenmelker und Pferdebogner: Ein antikes Reitervolk in neuer Sicht.* Lucerne 1980.

Roller, L. E. "Funeral Games in Greek Art." *AJA* 85 (1981) 107–19.

Roller, L. E. *Funeral Games in Greek Literature, Art, and Life.* Diss., Univ. Pennsylvania 1977.

Roos, P. "The Start of the Greek Foot-Race." *OpusAth* 6 (1965) 149–56.

Sakellarakis, J. "Le thème du pêcheur dans l'art préhistorique de l'Egée." *AAA* 7 (1974) 370–90.

Savi, F. *I gladiatori: Storia, organizzazione, iconografia. Gruppo Archeologico Romano-Quaderni* 12 (1980).

Schauenburg, K. "Erastes und Eromenos auf einer Schale des Sokles." *AA* 1965, 845–67.

Schauenburg, K. "Die Totengötter in der unteritalischen Vasenmalerei." *JdI* 73 (1958) 48–78.

Scheffer, C. *Acquarossa* II. Part 2: *Cooking and Cooking Stands in Italy, 1400–400 B.C.* Rome 1981.

Schlesinger, K. *The Greek Aulos.* London 1939.

Schmidt, R. *Die Darstellung von Kinderspielzeug und Kinderspiel in der griechischen Kunst.* Vienna 1977.

Schmidt-Colinet, C. *Die Musikinstrumente in der Kunst des alten Orients. Archäologisch-Philologische Studien, Abhandlungen z. Kunst-, Musik-, und Literaturwissenschaft* 312 (1981).

Schnitzler, L. "Darstellungen von Vorderasiaten auf griechischen Vasen." *ZDMG* 108, n.s. 33 (1958) 54–65.

Seltman, L. *Wine in the Ancient World.* London 1957.

Shapiro, H. A. "Courtship Scenes in Attic Vase-Painting." *AJA* 85 (1981) 133–43.

Sheldon, M. H., et al. *Varieties of Human Physique.* Berkeley 1940.

Simon, E. *Mind and Madness in Ancient Greece.* Ithaca 1978.

Sittl, C. *Die Gebärden der Griechen und Römer.* Leipzig 1980.

Slater, P. E. *The Glory of Hera: Greek Mythology and the Greek Family.* Boston 1968.

Slater, W. J. "Artemon and Anacreon: No Text Without Context." *Phoenix* 32 (1978) 185–94.

Snowden, F. M., Jr. *Before Color Prejudice: The Ancient View of Blacks.* Cambridge, Mass. 1983.

Snowden, F. M., Jr. *Blacks in Antiquity.* Cambridge, Mass. 1970.

Snowden, F. M., Jr. "Iconographical Evidence on the Black Populations in Greco-Roman Antiquity." *The Image of the Black in Western Art* I, 133–245. New York 1976.

Sparkes, B. A. "The Greek Kitchen." *JHS* 82 (1962) 121–37.

Sparkes, B. A. "Treading the Grapes." *BABesch* 51 (1976) 47–64.

Staveley, E. S. *Greek and Roman Voting and Elec-*

tions. London and Ithaca 1972.

Steingräber, S. *Etruskische Möbel. Archaeologica* 9 (1979).

Stern, E. M. "Kinderkännchen zum Choenfest." *Thiasos* 27–37.

Stevenson, W. E., III. *The Pathological Grotesque Representation in Greek and Roman Art*. Diss., Univ. of Pennsylvania 1975.

Sutton, R. F. *The Interaction between Men and Women Portrayed on Attic Red-Figure Pottery*. Diss., Univ. of N. Carolina at Chapel Hill 1981.

Tartaglia, L. C. *Marriage Scenes on Attic Vases*. Diss., Wadham College, Oxford, in progress.

Thimme, J. "Die Stele des Hegeso als Zeugnis des attischen Grabkults." *AntK* 7 (1964) 19–29.

Thompson, J. G. *Sport, Athletics, and Gymnastics in Ancient Greece*. Diss., Pennsylvania State Univ. 1981.

Thönges-Stringaris, R. N. "Das griechische Totenmahl." *AthMitt* 80 (1965) 1–99.

Tölle, R. *Frühgriechische Reigentänze*. Waldsassen 1964.

Toynbee, J. M. C. *Death and Burial in the Roman World*. Ithaca, N.Y. 1971.

Tsagarakis, O. "Homer and the Cult of the Dead in Helladic Times." *Emerita* 48 (1980) 229–40.

Vatin, C. *Recherches sur le mariage et la condition de la femme mariée à l'époque hellénistique*. Paris 1970.

Vermeule, E. T. *Aspects of Death in Early Greek Art and Poetry*. Berkeley 1979.

Vermeule, E. T. "Some Erotica in Boston." *AntK* 12 (1969) 9–15.

Vermeule, E. T., and S. Chapman. "A Protoattic Human Sacrifice." *AJA* 75 (1971) 285–93.

Vickery, K. F. *Food in Early Greece*. Urbana, Ill. 1936.

Vorberg, G. *Glossarium Eroticum*. Rome 1965.

Vos, M. F. *Scythian Archers in Archaic Attic Vase-painting*. Groningen 1963.

Wanschler, O. *Sella Curulis: The Folding Stool, an Ancient Symbol of Dignity*. Copenhagen 1980.

Warren, L. B. *Early Etruscan Dress: Studies in Early Italian Art and Culture*. Diss., Columbia Univ. 1966. Also Baltimore 1975.

Weege, F. *Der Tanz in der Antike*. Halle 1926. Reprint Hildesheim and New York 1976.

Wegner, M. *Griechenland. Musikgeschichte in Bildern* II, no. 4. Leipzig 1963, 1970.

Wegner, M. *Musik und Tanz. ArchHom* III U. Göttingen 1968.

Wegner, M. *Das Musikleben der Griechen*. Berlin 1949.

Weiler, I. *Der Sport bei den Völkern der alten Welt*. Darmstadt 1981.

Wernicke, K. "Die Polizeiwache auf der Burg von Athen." *Hermes* 26 (1881) 51–75.

White, K. D. *Country Life in Classical Times*. London 1977.

Wiedemann, T. *Greek and Roman Slavery*. Baltimore 1981.

Wiesner, J. *Fahren und Reiten in Alteuropa und im alten Orient*. 2nd ed. Hildesheim 1971.

Wolters, P. *Faden und Knoten als Amulett*. Leipzig 1905.

Yalouris, N., et al. *Athletics in Ancient Greece: Ancient Olympia and the Olympic Games*. Athens 1976.

Zahn, R. "Das Kind in der antiken Kunst." *Staatliche Museem zu Berlin, Forschungen und Berichte* 12 (1970) 21–31.

van Zelst, L. "Physical Science in the Study of Greek Vases." *The Greek Vase* 119–34.

WARFARE AND SEAMANSHIP

Ahlberg, G. *Fighting on Land and Sea in Greek Geometric Art*. Stockholm 1971.

Åkeström, Å. "On the Mycenaean Chariot." *OpusAth* 12 (1978) 19–37.

Alföldi, A. "Die Herrschaft der Reiterei in Griechenland und Rom nach dem Sturz der Könige." *Gestalt und Geschichte* 13–47.

Anderson, J. K. *Ancient Greek Horsemanship*. Berkeley 1961.

Anderson, J. K. *Military Theory and Practice in the Age of Xenophon*. Berkeley 1970.

Anderson, J. K. "New Evidence on the Origin of the Spur." *AntK* 21 (1978) 46–48.

Best, J. G. P. *Thracian Peltasts and Their Influence on Greek Warfare*. Groningen 1969.

Boardman, J. "Heroic Haircuts." *CQ* 67 (1973) 196–97.

Borchhardt, J. *Homerische Helme: Helmformen der Ägäis in ihren Beziehungen zu orientalischen und europäischen Helmen in der Bronze- und frühen Eisenzeit*. Mainz 1972.

Bovon, A. "La représentation des guerriers Perses et la notion de barbare dans la 1re moitié du ve siècle." *BCH* 87 (1963) 579–602.

Bronson, R. L. "Chariot Racing in Etruria." *Studi Banti* 89–106.

Buchholz, H.-G., and J. Wiesner. Eds. *Kriegswesen. ArchHom* I E. 2 vols. Göttingen 1977, 1980.

Bugh, G. R. *The Athenian Cavalry from the Sixth to the Fourth Centuries B.C.* Diss., Univ. of Maryland 1979.

Burkhardt, H. W. *Reitertypen auf griechischen Vasen*. Diss., Munich 1906.

Cahn, H. A. "Dokimasia." *RA* (1973) 3–22.

Cartledge, P. "Hoplites and Heroes: Sparta's Contribution to the Techniques of Ancient Warfare." *JHS* 97 (1977) 11–27.

Cassola Guida, P. *Le armi defensivi dei micenei nelle figurazioni*. Rome 1973.

Casson, L. *Ships and Seamanship in the Ancient World*. Princeton 1971.

Crouwel, J. H. *Chariots and Other Means of Land Transport in Bronze Age Greece*. Amsterdam 1981.

Delebeque, E. *Le cheval dans l'Iliade*. Paris 1951.

Gray, D. *Seewesen. ArchHom* I G. Göttingen 1974.

Greenhalgh, P. A. L. *Early Greek Warfare*. Cambridge 1973.

Hafner, G. *Viergespanne in Vorderansicht: Die repräsentative Darstellung der Quadriga in der griechischen und der späteren Kunst*. Berlin 1938.

Hannah, P. A. *The Representation of Greek Arms and Armour in the Art of the Fifth and Fourth Centuries*. Diss., Sommerville College, Oxford, in progress.

Hanson, V. D. *Warfare and Agriculture in Ancient Greece*. Diss., Stanford Univ. 1980.

Hencken, H. *The Earliest European Helmets: Bronze Age and Early Iron Age.* Cambridge, Mass. 1971.

Hill, D. K. "Chariots of Early Greece." *Hesperia* 43 (1974) 441–46.

Hoffmann, H. *Early Cretan Armorers.* Cambridge, Mass. 1972.

Johnstone, P. *The Sea-Craft of Prehistory.* London 1980.

Kaeser, B. H. *Zur Darstellungsweise der griechischen Flächenkunst von der geometrischen Zeit bis zum Ausgang der Archaik: Eine Untersuchung an der Darstellung des Schildes.* 1981.

Kenfield, J. F., III. "The Sculptural Significance of Early Greek Armour." *OpusRom* 9 (1973) 149–56.

Kilian, K. "Zur Darstellung eines Wagenrennens aus spätmykenischer Zeit." *AthMitt* 95 21–31.

King, C. "The Homeric Corslet." *AJA* 74 (1970) 294–96.

King, C. A. K. *Military Equipment in Homer and on Attic Geometric Vases.* Diss., Univ. of N. Carolina at Chapel Hill 1969.

Kroll, J. "An Archive of the Athenian Cavalry." *Hesperia* 46 (1977) 83–140.

Kunze, E. *Archaische Schildbänder. OlForsch* II. Berlin 1950.

Latacz, J. *Kampfparänese, Kampfdarstellung, und Kampfwirklichkeit in der Ilias, bei Kallinos und Tyrtaios.* Munich 1977. Battle practices in Homeric and later times, as determined in speeches, etc.

Lippold, G. "Griechische Schilde." *Münchener archäologische Studien* 399–504.

Littauer, M. A. "The Military Use of the Chariot in the Aegean in the Late Bronze Age." *AJA* 76 (1972) 145–57. With bibliography.

Markle, M. M. "Macedonian Arms and Tactics under Alexander the Great." *Macedonia and Greece in Late Classical and Early Hellenistic Times* 86–111.

von Mercklin, E. *Der Rennwagen in Griechenland.* Diss., Leipzig 1909.

Metzger, H., and D. van Berchem. "Hippeis." *Gestalt und Geschichte* 155–58.

Meuli, K. *Der Griechische Agon: Kampf und Kampfspiel im Totenbrauch, Totentanz, Totenklage, und Totenlob.* Cologne 1968.

Morrison, J. S. *Long Ships and Round Ships: Warfare and Trade in the Mediterranean, 3000 B.C. to 500 A.D.* London 1980.

Morrison, J. S., and R. T. Williams. *Greek Oared Ships, 900–322 B.C.* London 1968.

Ormerod, H. A. *Piracy in the Ancient World.* London 1924. Reprint Chicago 1967.

Poursat, J.-C. "Les représentations de danses armée dans la céramique attique." *BCH* 92 (1968) 550–615.

Raeck, W. *Barbarendarstellungen in der attischen Kunst des 6. und 5. Jahrhunderts v. Chr.* Diss., Bonn 1980.

Richardson, E. H. "The Icon of the Heroic Warrior: A Study in Borrowing." *Studies Hanfmann* 161–68.

Rougé, J. *Ships and Fleets of the Ancient Mediterranean.* Trans. S. Frazer. Middletown, Conn. 1981.

Roux, G. "Meurtre dans un sanctuaire sur l'amphore de Panaguristé." *AntK* 7 (1964) 30–41.

Saulnier, C. *L'armée et la guerre dans le monde étrusco-romain.* Paris 1980.

Schauenburg, K. "Achilleus als Barbar: Ein antikes Missverständnis." *Antike und Abendland* 20 (1974) 88–96, pls. 1–9.

Schauenburg, K. "Siegreiche Barbaren." *AthMitt* 92 (1977) 91–100.

Schröder, B. "Thrakische Helme." *JdI* 27 (1912) 317–44.

Sekunda, N. *The Equipment of Cretan Archers in the First Millennium B.C.* Diss., Univ. of Manchester 1981.

Shefton, B. B. *Greek Arms and Armour.* Newcastle upon Tyne 1978.

Snodgrass, A. *Arms and Armour of the Greeks.* London and Ithaca 1967.

Snodgrass, A. *Early Greek Armour and Weapons, from the End of the Bronze Age to 600 B.C.* Edinburgh 1964.

Spruytte, J. *Études expérimertales sur l'attelage: Contribution à l'histoire du cheval.* Paris 1977. With earlier bibliography.

Treziny, H. "Navires attiques et navires corinthiens à la fin du VIIIe siècle à propos d'un cratère géometrique de Megara Hyblaea." *MélRom* 92 (1980) 17–34.

Verst, A. *Archäische griechische Schildzeichen.* Diss., Salzburg 1980.

Vigneron, P. *Le cheval dans l'antiquité gréco-romaine.* Nancy 1980.

Vos, M. F. *Scythian Archers in Archaic Attic Vasepainting.* Groningen 1963.

Welwei, K.-W. *Unfreie im antiken Kriegsdienst* I. Wiesbaden 1974.

Wiesner, J. *Fahren und Reiten. ArchHom* I F. Göttingen 1968.

Williams, R. T. "Early Greek Ships of Two Levels." *JHS* 78 (1958) 121–30.

Wrede, W. "Kriegers Ausfahrt in der archaisch-griechischen Kunst." *AthMitt* 41 (1916) 221–374.

Zimmermann, K. "Tätowierte Trakerinnen auf griechische Vasenbildern." *JdI* 95 (1980) 163–96.

See also "Mythological Battles."

INDEX OF ARTISTS

Polygnotos, 172, 175, 177–79, 180, 182–83, 184, 186
Poteidan Painter, near the, 51 *n.* 29
Priam Painter, 97–114, 140
Princeton Painter, 240
Providence Painter, 217 *fig.* 14.18
Psiax, 81, 102, 113, 124–25, 130, 132, 136, 139; near, 136

Red-line Painter, 81
Rycroft Painter, 102

Sabouroff Painter, 219
Sakonides, 80

Samos Painter, 48
Smikros, 150–51, 157
Sophilos, 41, 58–63, 69, 70, 96 *n.* 34, 243
Sosias, 134–36
Split-Mouth Painter, 280 *n.* 74
Stieglitz Painter, 240
Swing Painter, 75, 79, 80, 81, 102, 132
Syleus Painter, 176

Taleides Painter, 129
Tenean-Boiotian Group, 134
Theseus Painter, 113, 282 *n. 110*
Thorvaldsen Group, 129

Three-line Group, 82
Timiades Painter, 142 *n.* 42
Tithonos Painter, 96 *n.* 32
Triptolemos Painter, 131, 139
Tydeus Painter, 51 *n.* 33
Tyrrhenian Group, 102, 132

Vatican G 57, Group of, 119, 125

Woman Painter, 226
Wooly Satyrs, Painter of the, 175, 184, 235

Zeus, temple at Olympia, 183–84

50.14.2 (A 5832.50.137): 75 (*ABV* 133, no. 7; *Paralipomena* 55)

GENERAL INDEX

"Achillean" statues, 140

Achilles: and the golden amphora, 55–56, 64, 65, 66; ash spear of, 64–65, 66; Pursuit of Troilos, 64–65, 68; *podōkēs,* 65; savage side of character, 65; Funeral Games of Patroklos, 65, 68; death of, 65, 68, 133, 140–41, 145–46 *n.* 110; dragging of Hektor's body, 114, 117 *n.* 23; residence of, 133; cult of, 133–34, 139; link with Scythia, 133–39; *ekphora* of, 134; duel with Hektor, 141; reared by Cheiron, 159; in Pindar, 163

Adrastos, 130

Aegean Bronze Age civilization: representation of armor, 7–8; appearance of people, 7–10, 12; representation of architecture, 8, 12; trade, 8–9

Aëropos, coinage of, 253

agalma, 166–67

Aithiopis, 133–34, 137–39. *See also* blacks; Ethiopians; Memnon

Ajax: in Pindar, 163; on black-figure, 163

Akastos, king of Phthia, in the Hunt of the Calydonian boar, 63–64

Aktaion, death of, 239

Alexander I: expansion of power, 251; coinage of, 251–52; Temenid, 252

Alexander II, coinage of, 253

Alkaios, 127, 134, 139

Alkmene, 160

Alkmeonidai, 87, 106

Amazon Falling Headlong, 201

Amazonomachy, 184

Amazons, 131–32. *See also* Scythian archer

Amphiaraos: departure scene of, 41–43; in a chariot, 109

Amymone, 209, 214, 222

Amyntas II, coinage of, 253

Amyntas III, coinage of, 253

anakalypsis, gesture of sexual surrender, 222

anthropological contrast, 121

Antilochos: Neleid, 89–90; on Attic vases, 90–91

apagoreuein, 80–81, 98, 145 *n.* 100

Aphrodite, connection with Artemis, 243

Apollo, 285–86; as Paris, 140–41; and Kyrene, 159; temple at Bassae, 182, 183

Arachne, 210

Archelaos, coinage of, 252–53

architectural elements: evidence of political metaphor in, 102–4; pictorial detail in, 194–97

Aretē, 66–68

Argeadae, royal tribe of the Macedones, 249, 251

Argive Geometric: compared to Attic, 16, 24–25; significance of iconography, 16–25

Ariadne, and Theseus, 66

arkteia. See mysterion

Arktinos of Miletus, author of the *Aithiopis,* 139

arktoi, initiates at Brauron, 237–38, 240

armor, evidence for dating from vase-painting, 127

Artemis: sanctuary at Brauron, 231–32, 240; goddess of civic life, 232, 240–43; goddess of fertility, 232–37, 238–40, 243; early representations of, 233; *Potnia Theron,* 233, 238–40; *Phosphoros,* 233–35, 243; in a chariot drawn by a deer, 235; as a bear-goddess, 237–38; connection with Aphrodite, 243; "teamed" with Athena, 243

artists: choice and adaptation of scene, 43, 49, 52 *n.*54, 97, 114;

social status in Athens, 97, 147–50; political orientation, 101

Asklepios: reared by Cheiron, 159; birth of, 203–4

asymmetrical composition, 66

Asyut coin hoard, 246, 248, 249, 250, 251

Athena Alea, temple at Tegea, 208 *n.* 38

Athena Parthenos, 181; shield of, 201

Athenians, personages represented on vases, 147–50, 151

Bakkhylides, use of color terms, 168

ballantion: money pouch, 225–26, 230 *n.* 21; and textile-working, 226–29

Bardylis, the Illyrian, coinage of, 254

Basile, shrine with Neleus and Kodros, 94

bellyband, used on pole horses, 81–82

Bisaltae, coins of, 248–49, 250, 252

blacks: on head vases, 119–20, 121–22; in Athens, 120; as warriors, 120, 121; near Greece, 120–21; in Scythian garb, 131. *See also* Ethiopians

Boeotian shield: compared to the Dipylon shield, 27, 29–31; existence of, 29, 31, 32–33; construction of, 29–30; heroic representations on, 31; derivation of name, 32; representations at Persepolis, 32; archaeological evidence for, 32–33

Boxer rhyton from Hagia Triada, 10

Brauron, sanctuary of Artemis, 231–32, 240. *See also* Artemis

bridal scenes, 215, 222–24

Butes, spatial trick, 185

Calydonian boar, Hunt of the, 63–64, 68

Centauromachy, Thessalian, change

in representation, 171, 172–75, 180–84

chariots: use of, 28–29; charioteer and rider motif, 81, 83–84; scenes of departure by, 98–101, 102, 106, 109; scenes of, appeal to the Etruscans, 106, 109

Cheiron: rearer of gods and heroes, 159; prophetic, 167–68

Chest of Kypselos, 38, 41, 49

Christ, attire in early Christian art, 286–87

Christianity: and the fine arts, 285, 295 *n.* 18; Greek humanity as transformed by Christ, 286, 287–88

coins, "Macedonian," symbols on, 250

color terms, Greek, 168

Corinthian vase-painting: scenes on larger vases, "quasi-mural," 43–45; heroic scenes in, 44; use of motif in, 49

corslet, linen, heroic equipment, 127

Crestonaei, 248

Damastium, mine and mint, 254, 255

Danaids, 22, 23, 209

Darron. *See* Derron, Macedonian deity

Derron, Macedonian deity, 248

Derrones, coins of, 248, 250, 252

Diktys, 139

Dionysiac procession, 272–76

Dionysos: with the golden amphora, 55–56; celebrated at Athens, 109–10; riding a wild animal, 272, 275–76

Dipylon shield: heroic determinative of, 27; identification of, 27–28; existence of, 29

distaff, confusion with hand-mirror, 216–19

distributional relations: paradigmatic, 67–69; syntagmatic, 67–69

Diver, Tomb of the, at Paestum, 113

double ax, use of, 34 *n.* 72

Edones, coins of, 250, 252

ekphora, representations of, 134

Eleusis, association with Peisistratos, 94

Elpenor, shade of, met by Odysseus, 186

Epidauros, stone rhyton from, 11

epinetron. See onos, textile-working implement

erastes, representations of, 136, 147, 206 *n.* 8

eromenos, representations of, 147, 206 *n.* 8

Ethiopians, 131–32, 132–33, 136, 137. *See also* blacks

Etruscans: scenes popular with, 106–9; adoption of Greek images by, 109; buried vases with dead, 113

Eustathius, 139

extispicy, scenes of, 91, 130, 131

figure-of-eight shield, 27, 28

fountain houses, representations of, 210–14

fountains, private, on red-figure, 212

fountains, public: built by Peisistratos, 210; use by citizens, 212

fountain scenes: on hydriai, 109–10; political symbolism in, 109–10

"free" painting: distinguished from mural and monumental, 37–38. *See also* monumental painting; mural painting

games, representation of, 147

"generalized heroic": in Geometric art, 15, 25, 26–27; in Archaic art, 25

genre scenes, 113

Geometric art: content of, 15; influences on, 15, 23–24; separate panels, reading of, 19, 23–24; conceptual code of, 23–24; representations of myth in, 25–26, 27

golden amphora, 55–56, 64, 65, 66, 69–70. *See also* SOS amphora

Gospels: Greek elements in, 285–93, 294–95; Roman elements in, 293–94

graffito, 75

gymnasium, representation of, 147

gynaikonitis, 214–19, 222, 224, 226

Hades, wounded by Herakles, 94

hand-mirror, confusion with distaff, 216–19

head vases, Attic: antecedents of, 119, 121–22; shapes and subjects of, 119–22; use of, 121

Hekate: associated with Artemis, 233–35, 240; identified with Iphigeneia, 235, 238

Hephaisteion, sculpture of, 181, 183

Hephaistos, Return of, 66, 67, 68, 162

Herakles: vs. the Hydra, 45–49; vs. the Nemean Lion, 78, 79–81; *apotheosis,* 93–94, 98, 101–2, 106–9, 113–14; capture of Kerberos, 94; wounding of Hades, 94; international middle class hero, 101, 109; in the Garden of the Hesperides, 104, 116 *n.* 21; vs. Alkyoneus, 104, 116–17 *n.* 22; vs. Triton, 106; worshiped by the Etruscans, 109; battling a serpent at a fountain, 116 *n.* 21; birth of, 160

Hermes, celebrated at Athens, 109–10

heroic scenes, contemporary image for, 31–32

hetairai: domain of, 224–25; identification of, 225–26; and textile-working, 229

Homer: life and work of, 29; as conscious antiquary, 31

Homeric poems, elements omitted from, 137

horse: in Argive Geometric, 16–22; named on vases, 82, 84, 98–101; on black-figure, 98–101

humanitarianism: growing awareness

of ca. 500, 114; Attic and Hellenistic conception of, presupposed by Christ, 286, 287, 288

Hunting and Fishing, Tomb of, at Tarquinia, 113

Hydra. *See* Herakles

Ichnaei, coins of, 247, 248, 249, 250

Iolaos. *See* Herakles

Iphigeneia: priestess of Artemis, 231–32, 233, 238; relationship with Artemis, 232–33; daughter of Agamemnon, 233; identified with Hekate, 235, 238; sacrificed at Brauron, 237; as bear-priestess, 238

Isis, religion of, 285, 291–93

Isocrates, 286

Jason, taught by Cheiron, 159

Jews: religion of, transformed by Christ, 286–87, 288; in Greek environment, 289

juxtaposition of motifs, 160–61, 176, 184; heroic and genre, 78; babies and beasts, 159–61; wife and hetaira, 229

Kaineus: life and death, 171–72, 179; representations of, 172–84

kalathos, woolworking implement, 215, 219, 221, 224, 227

kalos names: Stesias, 82, 84; Epilykos, 119; Hegerthos, 147; Leagros, 147

Kandaon, war god of the Crestonaei, 248, 259 *n.* 28

kantharoi, face, origin of, 119, 125

Kea, miniature fresco from, 7, 11

Kerberos. *See* Herakles

Knossos, fragmentary stone rhyton from, 10

Kodros: king of Athens, 87; shrine with Neleus and Basile, 94

Komotini stele, 140

Krates, the cynic, 287

Laeaei, coins of, 249–50

landscape: Aegean Bronze Age, 5–6, 11–12; in vase-painting, 113. *See also* spatial representation

landscape reliefs, origin from "popular" art, 204

Letaei, coins of, 246–47, 249, 250

lettering, variant, on coins, 245

loom, representations of, 215–16, 219–21

Lucretia, 221

Lykkeios, Paeonian king, coins of, 247–48

Macedones, 249, 251, 253

marriage scenes, appeal to the Etruscans, 109

Medontidai, 87

Memnon, 90, 131–33; compared to Achilles, 133

Messianic prophesies: Oriental tradi-

DESIGNED BY HARVEY RETZLOFF DESIGN
COMPOSED BY LANDMANN ASSOCIATES, INC., MADISON, WISCONSIN
MANUFACTURED BY MALLOY LITHOGRAPHING, INC.
ANN ARBOR, MICHIGAN
TEXT AND DISPLAY LINES ARE SET IN SABON

Library of Congress Cataloging in Publication Data
Main entry under title:
Ancient Greek art and iconography.
Bibliography: pp. 301–332.
Includes indexes.
1. Art, Greek—Themes, motives—Addresses, essays,
lectures. I. Moon, Warren G.
N5633.A53 1983 709'.38 83-47765
ISBN 0-299-09250-X